10th Edition

Graphic Artists Guild Handbook: Pricing & Ethical Guidelines

Credits

Graphic Artists Guild

Executive Director Steven R. Schubert National President Jonathan Combs

Editorial

Project director Paul Basista, CAE Project manager Sara Love Project consultant Simms Taback Supervising editor/writer Susan E. Davis Research & coordination Patricia McKiernan

Design & Production Art direction Sara Love

Cover art Richard McGuire

Book design & prepress Ali Karp | alink newmedia alink@earthlink.net

Cover printing Phoenix Color Corp.

Interior printing & binding Maple Vail Book Manufacturing Group

Publishing

Publisher Graphic Artists Guild, Inc. Distributors to the trade in the U.S. by North Light Books: An imprint of F&W Publications, Inc. 1507 Dana Avenue Cincinnati, OH 45207 800.289.0963

Direct-mail distribution Graphic Artists Guild 90 John Street, Suite 403 New York, NY 10038 800.500.2672 | www.gag.org

Copyright © 2001, 1997, 1994, 1991, 1987

by the Graphic Artists Guild, Inc. except where noted.

All rights reserved. No part of this book may be reproduced in any form or by any electronic or mechanical means including information storage and retrieval systems without written permission from the Graphic Artists Guild, except reviewers who may quote brief passages to be published in a magazine, newspaper, or online publication.

ISBN: 0-932102-11-5 1 2 3 4 5 6 7 8 9 ®

Dedication

To Simms Taback who, over the last two decades, has devoted his vision and insight to developing this publication into the best-seller that it is today. Each edition of this book, which has truly had an impact on our profession, was carefully directed by Simms, who still watches over it today.

	ĥ	
vi	Foreword	
vii	President's Prologue	~
viii	Acknowledgments	
xi	Introduction	
1	Professional Relationships	2
	Working with Illustrators	4
	Working with Graphic Designers	12 19
	Sources of Illustration & Design Talent Marketing & Self-Promotion	20
	Ethical Standards	21
2	Legal Rights & Issues	26
	Copyright	29
	Work for Hire	44
	Rights of Celebrity & Privacy	48
	Moral Rights	51
	Resale Royalties	53
	Practices Governing Original Art	53 54
	Laws Defining Fair Practices	54 54
	Trademarks Trade Dress	56
	International & Canadian Copyright	58
3	Professional Issues	62
	Deductibility of Artwork	64
	Sales Tax	64
	Employment Issues	71
	Cancellation & Rejection Fees ("Kill Fees")	75
	Speculation	76
	Contests & Competitions	77
4	Technology Issues	82
	Professional Practices Influenced by Technology	85
	Pricing Considerations	91
	Legal & Ethical Issues	93
	Health Issues	100
	The Labor Market	101
5	Essential Business Practices	104
	Part I: Preparation	106
	Part II: Negotiation	114
	Part III: Keeping Track	120
	Part IV: Collecting	124
	Part V: Reuse & Other Markets	134
6	Salaries & Trade Customs	152
	Employment Conditions	155
	Salaries	156 156
	Design & Production Job Categories Trade Practices in Two Disciplines	160

7	Graphic Design Prices & Trade Customs	164
	The Agreement	167
	Trade Practices	167
	Corporate Graphic Design	169
	Branding Design	172
	Advertising & Promotion Design	173
	Collateral Design	176
	Publication Design	179
	Book Jacket or Cover Design	182
	Book Design	184
	Book Packaging Design	187
	Lettering & Typeface Design	188
	Retouching & Photo Illustration	192
	Environmental Graphic Design	195
	Exhibition & Display Design	197
	Broadcast Design	200
	Greeting Card & Novelty Design	200
	Chart & Map Design	203
	Production Artist	204
8	Web Design & Other Digital Media Practices	206
	Ready for the Internet & New Media?	208
	The Digital Marketplace	209
	Web Site Design	210
	Computer Games	222
	Software Programs	224
	Other Digital Markets	224
	Glossary	225
9	Illustration Prices & Trade Customs	228
	Historical Overview	230
	Overview	231
	Advertising Illustration	231
	Preproduction Illustration	244
	Onscreen Artwork in Motion Pictures, Television, & Video	249
	Corporate & Institutional Illustration	250
	Book Publishing	254
	Editorial Illustration	265
	Package Illustration	271
	Fashion Illustration	274
	Greeting Card, Novelties & Retail Goods Illustration	278
	Medical Illustration	282
	Scientific (Biological) Illustration	286
	Technical Illustration	288
	Architectural/Interior Illustration	292
	Dimensional (3-D) Illustration	295
	Marbling (Marbled Printing)	300
	Postage Stamp Illustration	302
10) Cartooning Prices & Trade Customs	306
	Magazine Cartooning	308
	Editorial Cartooning	311

	Newspaper Syndication	311
	Electronic Publishing	314
	Comic Books	314
	Original Cartoon Books or Collections	319
	Reprints	319
	Licensing & Merchandising	320
11	Animation Prices & Trade Customs	322
	Computer Animation	324
	Other Forms of Animation	326
	Animation Is Multicultural	326
	Careers in Animation	326
	Job Markets	327
	Salaries	328
	Pricing	329
12	Surface Design Prices & Trade Customs	332
	Computer-Aided Design Changing Industry	335
	Types of Surface & Textile Design	336
	Licensing & Royalties	337
	Working with Representatives	341
	Trade Practices	341
13 Standard Contracts & Business Tools		344
	Why Have Contracts?	346
	Seven Basic Types of Contracts	347
	What a Contract Should Include	350
	Using Contracts	355
	Negotiations	357
	Before Calling a Lawyer	359
	When to Call a Lawyer	360
	Glossary	362
	All-Purpose Illustrator's Letter of Agreement	366
	All-Purpose Purchase Order	368
	Artist-Agent Agreement	370
	Artwork Inventory Form	372
	Computer-Generated Art Job Order Form	373
	Computer-Generated Art Invoice	375
	Digital Media Invoice	377
	Graphic Designer's Estimate & Confirmation Form	380
	Graphic Designer's Invoice	382
	Illustrator's Estimate & Confirmation Form	384
	Illustrator's Invoice	386
	Illustrator's Release Form for Models	388
	Licensing Agreement (Short Form)	389
	Licensing Agreement (Long Form)	390
	Magazine Purchase Order for Commissioned Illustration	393

Contents

	Nondisclosure Agreement for Submitting Ideas	394
	Surface/Textile Designer-Agent Agreement	395
	Surface/Textile Designer's Estimate & Confirmation Form	401
	Surface/Textile Designer's Holding Form	403
	Surface/Textile Designer's Invoice	404
	Web Site Design & Maintenance Order Form	405
14	The Graphic Artists Guild	408
	Long-Range Goals	410
	History of the Guild	410
	Taking Action	416
	Member Benefits & Services	418
	National Board of Directors	419
	The Graphic Artists Guild Foundation	420
	The Graphic Artists Guild Legal Defense Fund	420
	On Joining the Guild	421
	Graphic Artists Guild Membership Application	421
15	Resources & References	422
	The Graphic Artists Guild Bookshelf	424
	Recommended Reading	426
	Useful Publications	427
	Industry Directories	428
	Talent Databases	428
	Related Organizations	428
	Merchandise Markets, Shows, & Expositions	429
	Some Useful Web Sites	430
	Glossary	431
•	Index	442
•	Graphic Artists Guild	453

Membership Application

Foreword

Twenty years ago I was working as the art director of a women's business magazine whose ethic was, by and large, about success. I gave assignments to illustrators and photographers based upon a relatively limited budget. Understanding the need for a start-up publication saving money it might not yet have, we were all cautious. The artists I used mostly went along with this editorial policy, happy to have a nice printed piece. Naturally I regretted not being able to pay on a higher scale.

Then unfortunately my fiance became gravely ill, and I had to leave my job. The editors and the art associate were kind enough to offer me a regular illustration assignment—a single-page article requiring three or four spot illustrations each time. The remuneration for this was \$250. Even at the inflation economy of the time, it seemed like a lot of work for the money. Now I knew both sides of the coin.

For the past 14 years I've been art director for Alfred A. Knopf Publishing. A different industry, still editorial, but similar in the way the money works—low fees but no glossy advertising supporting the pages. So far I've managed to increase the rates for jacket art and design, though it has been uphill and still has room for improvement. When cornered for an answer on pricing, I can always turn to the *Pricing & Ethical Guidelines* for back-up for the sake of the artist working away in the night hours. Try to remember.

Carol Devine Carson

Vice President and Art Director The Knopf Publishing Group

President's Prologue

The Perfect Accessory

This 10th edition of the *Graphic Artists Guild Handbook: Pricing & Ethical Guidelines* encompasses the experience and wisdom of countless graphic arts professionals from all around the country. Over the years since its inception in 1973, it has emerged as the leading resource for people in the business of buying and selling illustration and design.

It has become an indispensable tool for both buyers and sellers because of its unique editorial voice that respects both sides of the business equation. Where the *Handbook* helps freelancers to better run their studios, it helps art and design buyers to better understand the needs and rights of the talented people with whom they seek to work. Together we can create better contracts and working conditions that value the creator's role, give credit where credit is due, and honor the creative process on both sides of the transaction. The stronger the freelance market and the more opportunities for artists and designers, the stronger the position for all graphic artists wherever they work.

Go into most bookstores today, and you find an array of accessories to enhance your reading experience, such as book lights, embroidered bookmarks, or even zip-up book covers to protect a paperback. If you are a designer, illustrator, or a professional in a related field, I want to suggest the perfect accessory for your new copy of the *Handbook*: membership in the Graphic Artists Guild. It supplements the *Handbook* in many ways, giving you a powerful activist platform from which to shape the future of the visual communications industry. Joining the Guild provides the perfect opportunity to protect and defend the many aspects of the graphic arts community detailed in this book, and it also allows you to give back to the industry by strengthening and promoting it. You'll find, as so many others have, that Guild membership is not only the perfect accessory to the *Handbook* but also the perfect accessory to your working life.

Jonathan Combs

National President

Producing the Handbook

Revising the *Graphic Artists Guild Handbook: Pricing & Ethical Guidelines* is a massive undertaking that involves the coordination and input of dozens of volunteers and staff. Their expert contributions ensure that this new edition contains the most current and reliable information. The individuals and organizations listed here have donated their time and expertise to this project. Their participation is responsible for its continued success. The last edition sold more than 70,000 copies—more than any other single edition. We expect the 10th edition to do even better.

Special thanks are due to Paul Basista, the Graphic Artists Guild's Executive Director from 1986 to 2000, who contributed greatly to the evolution and success of the past several editions. Under his skilled direction the book emerged as an industry best-seller and the standard reference for graphic artists and their clients.

Special thanks are also due to members of the Guild's Graphic Design Issues Committee—chair Susanne Murtha, Lauri Baram, Pete Friedrich, Sue Gutbezahl, Hae Yuon Kim, and Susan Mathews— and to DK Holland and Emily Ruth Cohen for their careful review of the graphic design chapters (Chapters 1, 3, 6-8); Daniel Abraham, Esq., Leslie Ellen Harris, Esq., and Nancy Wolff, Esq. for reviewing Chapter 2, Legal Rights and Issues; to Jeff Yerkey for rewriting Chapter 8, Web Design and Other Digital Media Practices; to Mark Hurwitt for adding a section on Alternative Comic Books to Chapter 10, Cartooning Prices and Trade Customs; to Tom Sito, President of Motion Picture Screen Cartoonists, Local 839, IATSE, for updating Chapter 11, Animation Prices and Trade Customs; to Zsuzsi Dahlquist of the Textile/Surface Design Department at the Fashion Institute of Technology for supervising the rewrite of Chapter 12, Surface Design Prices and Trade Customs; to Kate Godfrey and Bud Peen for writing the new text for Chapter 13, Standard Contracts and Business Tools; and to Claudia Karabaic Sargent for reviewing Chapter 13.

Thanks are also due to Susan E. Davis, supervising editor and writer; Ali Karp, graphic designer; Richard McGuire, cover illustrator; Patricia McKiernan, research and coordination; Eric Hirsch, Ph.D., statistician; Katherine G. Ness, copyeditor and proofreader; Sara Carrier of the Maine Proofreading Service, indexer; and Simms Taback for his continued guidance and assistance.

Sara Love

Project Manager Publications Committee, Graphic Artists Guild

Michael Adams Michael Allison Barbara Arlen Irene Avery **Carol Bancroft** Bruce Beattie Ted Bell Mary M. Bono Steve Brodner Katherine Brown-Wing Lou Brooks Ernest Burden Frederick H. Carlson Carol Devine Carson **Bill Charmatz** George Chiang Stanley Church Seymour Chwast Robert W. Clarida Jonathan Combs Tad Crawford, Esq. Margaret Cusack Lloyd Dangle Thomas Denari Leo & Diane Dillon John Donaldson Nancy Doniger Michael Doret Elaine I. Duillo Robert Dunlavev John Ennis Shelley Evenson Janice Everett Teresa Fasolino Joe Feigenbaum **Charles Field** Mike Fleishman Mort Gerberg Karyn Lynn Gilman Tim Girvin Roz Goldfarb Melanie Hope Greenberg

Ellen Greene Sam Gross Sue Gutbezahl Neil O. Hardy **Brett Harvey** Jody Hegarty Mark Hess Gerard Huerta Steve Hulett Harriet Kasack Gary Kelly Arnetta Kinney Ray Kinlock Fred Koenigsberg Christina Jackson Scott Johnson Christine Labate Polly M. Law Katherine Lenard Ellie Lipetz James Montalbano Wilson McClean William T. McGrath James McMullan Greg Manchess Eileen Mislove Vicki Morgan Kent Myers Robert Newman Kenneth Parsons **Todd Pierce Billy Pittard** Adam Read Stuart M. Rees John Reiner Ellen Rixford Marilyn Rose Sharon Rothman **Rob Saunders** Jeff Seaver Edward Seltzer Glen Serbin

Laura Smith Jim Spiece **Kitty Stauros** Glenda Rogers Stocco Eric Theise Pino Trogu Jean Tuttle Gregory T. Victoroff, Esq. **Rosemary Volpe** Lvnda Weinman Michael Wertz William B. Westwood Michael Whelan Jennie Yin David Young Brian Zick Nell Znamierowski American Institute of Graphic Arts American Society of Architectural Perspectivists

Aquent

Association of Medical Illustrators

Broadcast Design Association

The Bureau of Labor Statistics

Canadian Association of Photographers and Illustrators in Communication

Children's Book Illustrators Group

Creative Access

Fashion Roundtable

Joint Ethics Committee

Letter Arts Review

The Licensing Letter

Motion Picture Screen Cartoonists, Local 839, IATSE

National Cartoonists Society

Optimum Design & Consulting

Serbin Communications

Society of Broadcast Designers

Society of Children's Book Writers and Illustrators

Society of Environmental Graphic Design

Society of Graphic Designers of Canada

Society of Illustrators

Type Directors Club

U.S. Copyright Office

And the many anonymous Guild members and nonmembers who returned the pricing surveys that are the basis for the most current pricing data.

Acknowledgments

Colophon: The preliminary art direction for the 10th edition of the *Graphic Artists Guild Handbook: Pricing & Ethical Guidelines* was sketched on paper. The layout was heavily influenced by the whimsical illustrations on the cover, and every attempt was made to merge a simple and demure book format with artwork that was playfully energetic.

This book was created using QuarkXPress 4.1, Microsoft Word 2001, Adobe Photoshop 6.0, and Adobe Illustrator 8.0 on a Macintosh G3, running Mac OS 9.04. The interior text is set in Univers by Adobe with Courier Web addresses and Wingdings dingbats. Suburban by Emigre appears on the cover.

The first edition of the *Graphic Artists Guild Handbook: Pricing & Ethical Guidelines* was published in 1973 as a 24-page booklet. By word of mouth it sold out the first printing in only a few weeks. This is the 10th edition of the *Handbook*. It's now a 464-page book.

The *Handbook* is a cooperative effort. Through the years, hundreds, perhaps thousands, of graphicarts professionals have contributed their expertise to it, making it the most widely read reference book in our industry. The 9th edition alone went to press five times, putting 70,000 books into circulation. That's why the Handbook is often referred to as "the Bible" of the industry.

Besides providing guidelines for prices and fees based on up-to-date surveys, each new edition is totally revised, reedited, redesigned extensively updated. It's a considerable investment. But that is what is necessary to keep abreast of our rapidly changing graphic arts universe so as to provide the very latest information affecting the sale of artwork and design. That's why the *Pricing & Ethical Guidelines* is the indispensable resource for practitioners and buyers alike.

It is important to remember, too, that the *Handbook* seeks to be as neutral and objective as possible. Its main aim is to provide a help-ful environment, with the understanding that fees and terms are always negotiable.

A number of chapters have been totally reworked for this edition. All the chapters about graphic design have been thoroughly reviewed, with a new section about how graphic designers work added to Chapter 1, Professional Relationships. Chapter 4, Technical Issues, was critiqued, and Chapter 8, Web Design and Other Digital Media Practices, was brought up to date. Chapter 12, Surface Design Prices and Trade Customs, was completely rewritten to include the latest information in that field. The comprehensive introductory text in Chapter 13, Standard Contracts and

Introduction

Business Tools, is entirely new, reflecting the current focus on equitable contracts. And, most importantly, the pricing charts throughout the book are based on the latest surveys and then reviewed by outstanding practitioners in all the disciplines.

The *Handbook* is a work in progress that has grown and changed through the years. It will continue to do so as the visual communications business changes to meet global needs. But our original mission and purpose for the book remain the same as when the introduction to the first edition was written 28 years ago:

"It is not the intent of this document to suggest minimum or maximum prices. The Guild is mindful of the newcomer struggling to establish himself and of the fledging company seeking to survive against financially stronger competition. It is also aware of the established professional whose reputation enables him or her to command a fee commensurate with their time and talent.

"Beyond the goal of supporting equitable prices, the Guild has a commitment to raise the ethical standards of the profession. There are many abuses. Some stem from ignorance of established criteria, but many stem from malicious attempts to take advantage of theunwary, the inexperienced, and the unorganized. It is the Guild's aim to change these conditions."

Simms Taback Past National President

1

ψ

Virtually all areas of commerce and communications use the graphic arts. Graphic artists often specialize, focusing their talents to serve particular markets within the communications industry such

as magazine or book publishing, or they work for corporations, manufacturers, retailers, advertising agencies, broadcasting companies, or for-profit and nonprofit institutions. Clients may be individuals, small This chapter provides an overview of how illustrators and graphic designers conduct business, and it examines the many professional relationships they may encounter during their careers. Ethical standards for doing business with graphic artists are stressed.

companies, or conglomerates. Some clients purchase art and design on a regular basis, and many are first-time, one-time, or infrequent buyers. However clients work, the graphic artist has to present a professional face to all buyers.

[3]

Graphic artists include two primary groups of visual communicators: illustrators and graphic designers. Illustrators create the entire spectrum of commercial artwork for reproduction, and graphic designers create all types of visual communication in print and digital media. It's important to understand what illustrators and graphic designers do—and how they differ—in order to understand how to initiate and sustain professional relationships with them. Establishing and maintaining good working relationships between graphic artists and clients is vital to the health and prosperity of the profession.

Working with Illustrators

A client may commission artwork from an artist directly or indirectly, through an artist's representative or other agent. Clients occasionally contract with an art director, design firm, studio, or agency to hire artists for a particular project. The Guild recommends that a written agreement be signed by both parties prior to beginning the work. For more information about contracts, refer to Chapter 5, Essential Business Practices, and Chapter 13, Standard Contracts and Business Tools.

The client

As experts in their fields, clients must communicate their needs and objectives to graphic artists in terms of the product and the market. Using their particular style and expertise, artists offer the client solutions to the visual communications problem posed. Ethical professional practices, as well as the ability to describe problems effectively and to envision winning solutions, form the practical basis of a successful partnership between client and artist.

During initial meetings the artist and client discuss the design problem in terms of the client's objectives and possible solutions, fees, usage, and contract terms. These discussions create a relationship that addresses the concerns of both parties.

Regular art buyers usually have staff specifically responsible for all purchasing: art directors or other employees with expertise in commissioning art assignments. In a large corporation, for example, the art director, art buyer, or stylist probably has some experience in professional practices and pricing.

The art director

In many organizations, art directors manage a number of projects or accounts simultaneously. They are responsible for finding the artists, negotiating the terms of the job, and supervising the assignment to ensure its proper execution within prescribed budgeting and time constraints. Art directors base their choices of talent for a project on their knowledge of the client's concerns and on the diverse styles of the artists available. To find artists, an art director consults talent sourcebooks, advertising directories, and major trade publications. In addition, an art director may call in artists to review their portfolios or check out artists' Web sites, place ads in publications or with professional organizations (such as the Graphic Artists Guild's Jobline News, described in Chapter 14, The Graphic Artists Guild), or contact employment services.

When speaking with artists, art directors need to be familiar with the project's time schedule, the budget, how the artwork will be used, and a variety of other factors. Artists then negotiate appropriate rights, terms, and fees with the art director. The art director may then send the artist a confirming purchase order, or the artist may send the art director a proposal or contract and, later when turning in the artwork, an invoice and delivery memo. The factors used to determine the terms of agreement are thoroughly described throughout this book.

Advertising agencies

Artwork for advertising agencies is usually purchased by an art director and an art buyer who work together to select the artist to be used on a job. An art buyer is responsible for calling in a selection of artists' portfolios for review by the creative group, who choose an artist based on the style of art needed and the portfolio submitted. After an artist is selected, the art buyer and the artist are mutually responsible for negotiating the purchase of usage rights from the artist as well as the budget, schedule, trafficking, and invoicing of each assignment.

At the time of assignment, most agencies provide artists with a purchase order that details the rights purchased, ownership of the art, delivery dates for sketch and finish, prices for the completed assignment, the cancellation fee at sketch and finish stages, and any additional expenses that will be covered, such as delivery charges or shipping. All terms in a purchase order or contract are open to negotiation until agreement is reached by both parties.

When both parties have signed the purchase order, it signifies that an understanding or contract has been reached between them. As independent contractors, artists should take responsibility for sending a contract that sets out the understanding. A Letter of Agreement does this nicely; for a sample form, see Chapter 13, Standard Contracts and Business Tools. Rights purchased may be in any or all of a number of categories, all of which should be spelled out in the purchase order. Each artist should decide independently how to price each usage of his or her work. Roughly in order of increasing value, some of these categories are:

 In-house presentation and research: Usage is generally purchased at the lowest rates in the advertising market, since the material will

Professional Relationships

be used only in-house for presentation or in front of small groups. Agreements permitting more extensive uses generally require that additional fees must be paid.

- Testmarket: Artworkishistorically purchased at low rates for use in a limited number of markets. As in in-house use, an artist's agreement should stipulate the need for additional fees if use is expanded.
- Displays, trade shows, and public relations.
- Electronic: Use is growing in popularity and frequency as Internet communications expand. These rights may be purchased in addition to other rights and should receive additional payment (for instance, a percentage of the publication fee).
- Point-of-purchase: Usage includes all pointof-sale materials such as signs, leaflets, shopping cart posters, catalogs, brochures, counter displays, and so on.
- Outdoor: All posters that are not point-ofsale, including those used for billboards, painted bulletins, transit, and bus shelters, are in this category.
- Publication: Usage includes newspapers, magazines, Sunday supplements, in-house publications, and any material included as part of a publication, such as freestanding inserts or advertorials.
- TV use: Only television rights.

The above categories are for the purchase of limited rights, which may range from one-time to extensive use. All rights granted are clearly detailed in the purchase order, including a specific market, medium, time period, and geographic region: for example, national (region) consumer magazine (medium) advertising (market) rights for a period of one year (time). Exclusivity within the markets purchased is usually guaranteed. Noncompeting rights may be sold elsewhere, unless the purchase order stipulates otherwise. Sale of the original artwork or sale of the copyright (which is sometimes erroneously called a buyout) is a separate transaction.

Artists should note that many clients who use their artwork for high-exposure products and services may seek to purchase multiple rights involving longer periods and more media, regions, and markets. Fees should be adjusted accordingly.

- Unlimited rights: The purchase of all rights connected with the product for all media in all markets for an unlimited time. Longstanding trade custom also provides that artwork may be reproduced by the artist for self-promotion, and the artist may display the work. The artist also retains the copyright.
- Exclusive unlimited rights: The artist may not sell any use to anyone else. The artist retains authorship rights and may reclaim these rights after 35 years. The artist may display the work or use it for self-promotion. Sale of the original art is a separate transaction.
- Buyout: This vague term, though widely used, means different things to different people. It is an imprecise term that can lead to misunderstandings—most often to an artist's disadvantage. Often it refers to sale of the copyright to a work of art, which should be avoided at all cost. (For a thorough discussion of this point, see the Copyright section in Chapter 2, Legal Rights and Issues.) The Guild recommends that specific usage rights sold and the status of ownership of the original art be explicitly stated in any agreement.

Brokers

Most brokers do not represent talent exclusively but rely instead on their contacts among clients and their knowledge of various talents to put together a deal. As with studios, some projects can be quite complex, and most of the points raised in the sections on studios and representatives would apply. It cannot be emphasized too strongly that the artist should make sure to establish price, relative responsibilities, and working conditions before accepting any assignment. In the absence of a formalized artist/agent agreement, artists should establish a price they consider adequate for the work, leaving the broker free to negotiate above that price and keep the difference as a commission.

Packagers

Packagers, who work predominantly in book publishing, coordinate all the components of a project and either present the finished concept to publishers for execution or manufacture the books themselves and deliver bound volumes to the publisher. Just like a publisher, packagers contract with illustrators, designers, and writers, and all negotiations should be handled as if the packager were a publisher. Because of the relatively small size and weak financial strength of packagers as compared with publishers, the importance of a written agreement cannot be overemphasized.

Working with artist's representatives

Illustrators, textile designers, and other creatives need to connect effectively with their markets. Some artists are as adept at solving visual problems as they are at soliciting business, researching new markets, coordinating directory ads, designing and following up on promotions, and negotiating contracts and rights. But others are more skilled at solving visual problems than at marketing or promoting their own talent.

In an ideal world, artists would only concentrate on creating their art. The next best thing is having a representative or agent who spends time, energy, and resources seeking work for artists. Professional representatives, skilled at representing an artist's interests, are often more adept at negotiations, resulting in better terms and higher fees than artists could secure on their own. For artists who are comfortable delegating business tasks, a professional agent can contribute thousands of dollars in additional revenue and hours of additional creative time to the artist. This arrangement is very cost-effective for the artist because representatives are compensated only when they find work for their clients; it is therefore in their interests to find the best outlets for their artists. Although the agent works for the artist, the best artist–agent relationships are mutually beneficial partnerships.

But not every situation is ideal. If an artist feels that he or she is just another portfolio, or if a representative continually fails to secure work for an artist while insisting on receiving commissions for work secured directly by the artist, such relationships should be critically evaluated. Some agents will lowball fees to ensure a good personal relationship with a buyer, at the expense of the artist whose interests they're pledged to protect. Obviously, relationships with representatives who engage in questionable practices should be avoided. In that case, having any agent may be worse than having no agent.

Finding a suitable representative

Representatives who handle a number of artists often concentrate on a particular style or market. For example, some may represent artists with a highly realistic, painterly style, while others may concentrate on humorous work. Some representatives have cultivated strong contacts in advertising, while others have an extensive network in the editorial or children's book market. Artists need to research which representatives are able to best serve their needs. When an artist thinks his or her career has reached the point where it would benefit from professional representation, the following should be considered:

- Be objective about your talent and stature. A reputable agent is interested in representing highly marketable talent—a successful artist who no longer has time to cold-call new clients or follow up with existing clients. Although an entry-level artist could benefit from the services of a representative, it is unlikely that most agents would be interested in risking time and resources on someone who is untried and unknown. But there are exceptions if the artist has a style that will sell.
- Identify and target your market. A frank appraisal of one's work and target market is necessary to make the best match with a rep. Someone with a sketchy, humorous style would be wasting her time with an agent who represents predominantly painterly styles. Similarly, if one's work is best suited for the editorial or book cover market, pursuing a representative with a strong agency clientele would not be very productive, though reps will, on occasion, seek out artists with strong potential to cross over into other markets. In other cases a rep with only one fashion illustrator will push for that artist, should opportunities arise, but the fashion illustrator needs to make sure the rep has contacts in that market. Opportunities will rarely come up for a fashion illustrator among children's book artists. Having a clear vision of your work and the direction in which you want to go is essential. You need a rep who shares that vision and wants to pursue that direction.
- Seek aesthetic compatibility. An artist needs to know that his or her work fits
 well with the other artists represented. Even if an artist might seem to
 compete with other artists in a group, a good rep won't sign an artist unless
 sufficient work is available. Or an artist may deliberately select a rep where
 there's no possibility of competing with artists who have similar styles.

A good place to research the talent and clients handled by particular representatives is in the major sourcebooks and talent directories (for further

information, see the Sources of Talent section later in this chapter). American Showcase, The Black Book, The Graphic Artists Guild Directory of Illustration, RSVP, The Workbook, and others display many pages of advertising that are placed, in whole or in part, by artist's representatives. Interested artists can easily determine with which representatives they are most likely to fit. Similarly, agents looking to represent additional talent often use these books to locate suitable unrepresented artists.

The artist should then contact the representatives to see if they are interested in seeing samples of his or her work. When sending samples, it's important to note that published work is not necessarily as important as imaginative work. Artists should always trust their own first impressions; as the rep impresses the artist, so he or she will impress prospective clients.

If an artist feels compatible with an agent and the agent is interested in setting up a partnership, references should be checked. Every business professional entering into a long-term relationship with another professional should always check references. The best place to start is by talking with artists currently with the rep, as well as with those formerly represented. Talking to other artists is the best way to find out who's great and who's not even good among the sizable number of representatives working in the industry. If an artist has difficulty locating certain artists, the Guild may be able to help locate them.

Among the questions that should be answered are: How much work did the representative generate over the year? Did the agent promotes artists individually or as a group? Was the relationship productive for both parties? Were payments received promptly? Did the representative pay an equitable share of advertising and promotional expenses? What financial commitments for yearly promotional costs did the artist have to carry? How were disputes, if any, resolved? If the relationship was terminated, why and on what terms?

Talking with clients who have worked with the rep is another option. It's reasonable to ask a prospective rep for clients' direct phone numbers; how the rep responds will provide clues to the rep's business ethics. Another helpful practice is visiting the agent's office to see the physical layout, how portfolios and artists' samples are handled, and what business procedures are used.

Artists' representatives have the authority to act on behalf of the artists they represent. They can obligate the artist legally, but only in matters agreed to in the artist/representative contract. Therefore all terms and conditions of artist/representative arrangements should be discussed in detail, negotiated as needed, and confirmed in writing. Artists should have a lawyer read any contract and make certain the terms are clearly understood before signing. The Guild's Artist/Agent Agreement and Surface/Textile Designer–Agent Agreement can be found in Chapter 13, Standard Contracts and Business Tools. If a more casual relationship is preferred, the Guild recommends that both parties, at the very least, sign a memo that spells out each person's responsibilities.

The most important issues to be considered when negotiating an artist/agent agreement are:

 Commissions and fees: Traditionally, artists pay reps a commission of 25 to 35 percent for all jobs executed, excluding expenses. The majority pay 25

percent, with artists outside the United States paying the higher rate. Textile design commissions have historically ranged from 25 to 50 percent of the fees paid, excluding expenses. Expenses not billable to the client are generally subtracted from a flat fee before the commission is computed. Expenses billed to the client as line items on an invoice are normally reimbursed to the one who incurred the expenses and are paid separately from any commission. Policies concerning stock and reuse sales should be discussed and negotiated in detail.

- House accounts: Ongoing clients the artist contacted and developed before getting a rep are called "house accounts." Most artists do not pay commissions on house accounts that they service themselves, and they generally pay a lower commission on house accounts the rep services. A problem may occur when the artist initiates contact with a client, but no jobs appear until after a rep agreement is signed. Artists may quickly become dissatisfied with a rep if they have to pay commissions on accounts they feel they cultivated. To avoid this problem, the artist and rep should negotiate up front how work that materializes from such clients will be handled.
- Exclusivity or nonexclusivity: Reps usually expect an exclusive arrangement with an artist at least for North American markets. However, reps who work exclusively with artists often agree that the artist may continue to work directly with any previously established house accounts.

In one kind of nonexclusive relationship, artists are free to promote their work in all markets, even those handled by the representative. In another nonexclusive arrangement, representatives handle only certain markets, such as advertising or publishing, or certain geographic areas, and artists retain the right to promote their work in other areas. What needs to be taken into account is when an art director who changes jobs has a personal relationship with one rep and doesn't want to call another one.

Exclusivity or nonexclusivity is a crucial issue in any contract, since artists must feel that all their work will be marketed in the best possible manner. Representatives who ask for exclusive contracts should be willing to identify the other artists whom they represent, so artists can ascertain that they won't be competing against other artists in the group or lose jobs that might otherwise go to them. Artists who accept a rep's demand for exclusivity may wish to consider negotiating exclusivity for their particular style or genre within a rep's group. Countless artist/rep arrangements are possible and negotiable, given the potential for mutual benefit for both parties.

 Expenses: While all expenses are negotiable, artists are generally responsible for those related to their art, including the duplication of chromes and other display material. The rep provides the portfolio, but the artist retains ownership of the material in it. Any agreement should state that these pieces remain the property of the artist and that they will be returned to the artist upon termination of the relationship.

Reps are generally responsible for their selling expenses like phone calls, overnight deliveries, messengers, insurance, and entertaining clients. Directory advertising and direct mail promotion expenses are generally split in the same ratio as commissions, with the rep paying 25 to 35 percent. However, artists should pay only their share of actual costs, not published rates. Artists should expect that any savings from discounted page rates, printing, or other expenses will be passed along to them.

Reps should get the artists' authorization ahead of time for any expenses the artists are obligated to pay, such as costs for directories, Web sites, and promotional mailings. These expenses should be billed separately to the artists, never deducted from artists' fees. In fact, all monetary transactions between artist and rep should be kept strictly separate. If they aren't, that's cause for concern.

 Billing procedures: Whether it is wiser for the agent or the artist to handle billing will depend on the negotiated agreement. Whichever party handles billing is obligated to send the other copies of all purchase orders and invoices. If a purchase order does not exist, a copy of the canceled check should be supplied. One practical benefit of this procedure is that if the person handling the billing dies, declares bankruptcy, or reorganizes, the other party has proof of what is owed.

If the rep handles billing, it's his or her job to maintain an up-to-date record keeping and reporting system to inform artists about their finances. If a rep is not keeping an artist regularly informed about all billing and payment transactions, that is a sure sign of a problem, and the artist should move quickly to terminate the relationship.

However, accurate record keeping is not just the rep's responsibility. The Guild recommends that artists maintain complete records of all paperwork and log any oral decisions. Keeping on top of finances and making sure payments are timely is in the artist's best interests.

- Timely payment: If artists believe that payments are taking longer than they should, they may request that the rep copy all incoming checks so they may see the dates when they were mailed. If the rep refuses, artists may request that all payments go directly to them.
- Finder's fee: Occasionally, a special opportunity is presented to an artist by an agent or broker, even though a formal relationship does not exist between the artist and agent. Traditionally, in such special circumstances, it's not unusual for the agent to receive a finder's fee of 10 percent of the negotiated fee or advance. Because no formal relationship exists, this is usually a one-time fee, and should further work be assigned by that client, no additional commissions would be due. Very occasionally, an artist will ask a rep to negotiate a difficult deal that the artist has secured for 10 percent or more on a one-time basis.
- Differences: Even in the best of relationships, differences may arise between artists and reps. Reps may become dissatisfied with artists who refuse good jobs for what seems to them to be no apparent reason. Artists may resent paying commissions to reps who they feel aren't doing enough to generate more work. The rep and the artist must clearly express their concerns and find out why the work is not coming. Perhaps the rep needs to try a new marketing approach, or the artist needs to develop a new style. If the relationship can't be remedied, the artist may need a different rep. In that case, they need to terminate their agreement amicably.

• Termination: This is a sensitive area for both artist and agent. Each party should be able to terminate on 30 days' written notice. However, an agent may receive commissions after the termination date on work that was generated from an account developed by the agent for an agreed-upon period of time—usually three months after the termination date. If an agent has represented an artist for more than six months, the right to receive commissions after termination. For example, after two years of representation, the agent would receive commissions for six months after termination. Royalty compensation on assignments contracted during the association continues until the client ceases payment on those projects.

The circumstances in each case differ, but artists rarely agree to give agents commissions on assignments obtained more than six months after the effective termination date. Of course, if an agent is entitled to receive a commission on an assignment obtained within the agreed-upon time, even if it was not started until after the end of the termination period, it is due even if the client's payment arrives after that time. However, this right should not apply to house accounts. If an artist doesn't want to continue to pay commissions to a former rep, a lump sum settlement may be preferable and may be negotiated based on the previous year's earnings.

All termination terms should be agreed upon at the beginning of a relationship. Most agents do not show artists' work during termination periods unless an artist specifically requests it. And agents should be sure to forward all inquiries about the artist to the artist. Agents should return to the artist all artwork, portfolios, tearsheets, promotions, and any other imagery created solely by the artist at the end of the 30-day termination period, if not sooner.

 Bankruptcy: Very rarely, a rep has been known to declare bankruptcy and not pay artists' fees. The best way for artists to prevent that is to be sure the artist/agent contract contains a clause that prohibits the agent from commingling the artists' fees with the agent's income and expenses.

Here are a few things an artist should and should not do if the worst happens:

- •••• An artist may file a proof of claim with the court. This form is usually attached to the notice of the bankruptcy case mailed to creditors (or it can be obtained from a bankruptcy lawyer). This places the debtor on formal notice of the amount claimed to be owed, and will give the artist a share of whatever payments are made to creditors.
- Depending on the amount of money at stake, an artist may, singly or with a group of similarly affected artists, consult a bankruptcy lawyer, who can evaluate the contractual provisions of the artist/agent agreement to see if the artist has any rights to payments, any possible lien rights, or any possibility of personally suing the agent outside of the bankruptcy case (to do the last, one has to get the permission of the bankruptcy court in what is referred to as "dischargeability litigation"). The artist may even be able to make a claim against the bank.
- ••• An artist should not try to collect his or her portion of a fee directly from a client. Once bankruptcy has been declared, an estate is created which

includes all the property in which the agent has an interest. Therefore, a bankruptcy petition operates as an automatic stay, which legally bars the artist from trying to collect a debt from the bankrupt agent, and may even bar the artist from trying to collect from the client. It's the bankruptcy court's responsibility to decide whose money is whose.

In Chapter 7 bankruptcy cases, a bankruptcy trustee is appointed to reduce the estate to cash and make distributions. If the artist goes to a client and asks for his or her portion of the fee, the bankruptcy trustee can go to the court and argue that the artist has violated the automatic stay by collecting money owed to the bankruptcy estate. If the court rules in the artist's favor, he gets to keep the money and the trustee loses. If the court rules in the trustee's favor, the artist has to hand over the money and may be liable for a significant additional sum for knowing violation of the automatic stay. The trustee may not contest the matter, but that may not be a risk the artist wants to take.

- ••• An artist should not file a claim in small-claims court because that also violates the automatic stay. (Any action in violation of the automatic stay is legally considered a nullity, whether the person knows about the bankruptcy or not.) A knowing violation of a stay could be considered contempt of court and subject the violator to legal sanctions, which could be damaging to the artist's case.
- In a Chapter 7 bankruptcy case, the contract between the artist and agent is automatically terminated when the agent files for bankruptcy. A letter from the artist informing clients of the severed relationship would be appropriate (though it won't resolve the collection issues discussed above). In a Chapter 11 bankruptcy case, however, the artist may not be able to terminate the contract (for reasons that are too complex to discuss here), in which case a letter to clients would not be a good idea.

Legally, the rep works for the artist and is obligated to protect and promote the client's interests. Yet, legalities aside, the most practical, win-win model is that the artist and the rep are two independent businesses working together to improve both businesses. The best scenario is a rep and an artist who work symbiotically so that both businesses grow. It's in the rep's best interests to see an artist succeed. It's in the artist's interests to help establish his or her rep's reputation in the field.

Working with Graphic Designers

Graphic designers are hired to communicate ideas. Whether they design books or billboards, movie posters or television graphics, corporate identity programs or Web sites, designers take the client's message and, by selecting a combination of type, color, imagery, and texture (which is often contributed by printing techniques), transform the content into an informative, persuasive piece of visual communication.

To be effective, graphic designers need to combine aesthetic and strategic judgment with project management skills to create effective, timely marketing strategies for their clients. Most often they execute projects at the client's request, taking the client's need and formulating an effective selling tool, product, promotion piece, or strategy to meet a specific objective. Sometimes they

collaborate with market researchers and public relations specialists to help formulate design concepts. Often they are called upon to advise clients on what they should be doing, diverting them from a tried-and-true approach to a more daring one.

Graphic designers have to play a multitude of roles when working with clients, including acting as consultants, teachers, and even shepherds. Often client's questions provide opportunities for designers to help clients understand how best to present and promote themselves, which is the purpose of a consistent, imaginative corporate identity program, for example.

Although one typically thinks of graphic design as print, today's designers often need to be ahead of the curve and consider how their design solution will work on the World Wide Web or in three dimensions as well as in print. Such repurposing of design is essential today when multiple applications are in demand. (For more discussion of designing for electronic media, see Chapter 8, Web Design and Other Digital Media Practices.)

<u>Client relationships</u>

Because graphic design exerts such a tremendous influence on a company's image, service, or product, most businesses consider it a necessary component of their overall business strategy. Clients hire graphic designers to develop and provide a marketing approach and a creative direction for their visual communication needs and then to coordinate all production details through final delivery. In providing this service, designers often coordinate their art direction and design services with copywriters, illustrators, photographers, and printers and bill the client for the entire package. As professional consultants, they are able to assess the feasibility of a project based on their experience, knowledge of the market, and available resources. However, there are many pros and cons to this all-inclusive practice, and designers may choose instead to have all vendors bill the client directly.

Sometimes, though, clients choose to develop a project and then bring in a designer. This is usually inefficient, since many decisions will already have been made about things requiring a designer's input, which may lead to unnecessary delays, additional costs, and inadequate solutions. The earlier that designers are called in to consult on a project, the more efficient it is for them to help develop the most effective solution for a design objective. The designer can contribute a fresh perspective, strategy, and aesthetic viewpoint that influence the project's impact, cost-effectiveness, and success.

A client may seek a long-term relationship with a graphic designer or design firm, particularly when planning a series of projects that need design continuity. When such a relationship is envisaged, a designer may be retained as a consultant during the early stages of a project to help strategize, plan, schedule, and budget.

However, many design clients do not work with designers on a regular basis and are therefore unaware of the trade customs and procedures designers follow. To find a designer, a prospective client should ask friends, business colleagues, and graphics industry professionals (such as illustrators, photographers, or printers) to recommend design firms and study examples of their work. If you see pieces you admire, find out who designed them and investigate their professional background. Be sure to inquire about the designer's specialties, reputation, dependability, and working relationships. Then invite designers to bring in a range of work in a variety of budget categories to provide an overview of their capabilities as well as anything that may be relevant to the anticipated project.

In addition to the client listening, questioning, and knowing what to look for in a design firm, some factors that may affect a client's decision to hire a designer include:

- Talent/expertise: Talent may be difficult to define, especially for corporate clients who like to rely on measurable standards when conducting business. Clients must often judge design talent based on such intangibles as perceptions of the designer's presentation and the designer's ability to effectively communicate an understanding of the client's needs and objectives. Standard measurements of talent/expertise are based on evaluation of the firm's portfolio, references, and design proposal (described below). The client needs to assess if the designer developed an idea or concept successfully as well as if he or she used type, color, paper, ink, and imagery effectively for the message and the intended audience. Does the work command attention and have impact? Does it fulfill its function and purpose? Did the designer find innovative ways to solve unique problems?
- **Chemistry:** In any creative process, personalities count, and being able to communicate easily is essential. Clients need to establish a comfortable working rapport with designers.
- Reputation: It may be prudent to interview clients or vendors whom designers have worked with to see if they have been team players, delivered on time, stuck to the budget, and paid their bills in full. If necessary, run a credit check.
- **Capacity**: The scope and scale of the client's project, and/or the design firm's capability to accommodate a client's special needs, often dictate the choice of the design firm.
- Location: While today's electronic technology makes proximity to the client less and less important, geographic closeness may facilitate better communication. A face-to-face relationship may create a stronger bond and perception of involvement than one that exists only on the telephone or online. But this is certainly not true in all cases, and conducting business at a distance is becoming more frequent all the time, especially if the designer's location is an advantage to the client.

Bidding on a project

Designers are chosen to work on projects in several ways. They either respond to a request for proposal or, most often, prepare their own proposal in competition with other design firms.

Request for proposal or design brief

Many times when a client needs a designer for a major project, the client prepares a request for proposal (RFP) or a design brief that contains all the background information, objectives, and specifications for the project that a design firm needs to create and submit a proposal. The RFP is a great tool for client and designer alike because it focuses on all aspects of a future project. It helps the client get bids that are based on the same specifications so the client is able to compare "apples and apples." And it gives the designer all the information needed to formulate an accurate estimate and proposal without endlessly questioning a prospective client.

However, there are drawbacks of responding to an RFP. One is that designers generally don't know whom they are competing against. Did the potential client send the RFP to 50 firms, or did the client do some research and offer the RFP to a preselected group of three firms? (This can easily be resolved by asking the client to whom RFPs were submitted.) Another drawback is that sometimes a highly developed RFP leaves the designer out of the critical phase of advising and helping to plan the client's marketing strategy. Nevertheless, receiving a well-developed RFP is usually a positive indication of an organized client and is a time-saver for the designer.

However, writing proposals is a very time-consuming process, and it's often difficult to assess the prospective client. Designers need to determine, using whatever criteria they find appropriate, whether or not the project is interesting or lucrative enough to spend hours preparing the RFP.

The following headings and specifications are included in a typical RFP or design brief:

Background: Information about the company or organization, including its size and primary services or products.

Audience: General information about who the target audience is (this helps convey the general scope of the project).

Objectives: Objectives can be as broad and general as "keeping the audience informed about our company," or it can be as specific as "get registered users of our product to order the upgrade."

Vehicle: What is the piece to be created? A brochure, newsletter, Web site, identity program, packaging, or other item?

Look and feel: General direction about company positioning and its target market: for example, "a cutting-edge design that appeals to tech-savvy Gen-X readers who surf the Internet daily" or "a down-to-earth style that appeals to college-educated women over 50."

Specifications: Rights needed. Finished size. Folds. Colors. Quantity. Self-mailer?

Time frame: Goal date to have printed pieces by. (Is a specific event or mailing distribution date being targeted?)

Preliminary schedule (if available): Copy provided date. Initial concepts due. Revisions due. Final art due.

Professional Relationships

Other questions: Will the designer handle printing? Are there other services that the designer must provide, such as finding writers, photographers, and illustrators? What is the final deliverable? Disk, film, or printed piece?

Proposal review criteria: How will the client choose the designer? Will there be an interview? Should the designer include a portfolio with the proposal?

Developing a design proposal

Many times in bidding for a project, graphic designers develop their own proposals. They use initial meetings and research to understand the client's objectives and conceptualize possible directions (see pages 16-17). They also determine the target audience, desired response, and the overall effect to be achieved. Responsible clients communicate clearly at the beginning of a project any limitations such as budget and deadlines and all the elements they will provide, such as text, photographs, artwork, or charts.

It is important for both client and designer to discuss specific directions about what is being bid upon. Being specific ensures that both parties will be able to avoid surprises in the scope and estimates of the project once the proposal is accepted.

Based on these initial discussions, designers establish their fees, often taking a combination of factors into consideration, including scope of services (what they will provide), project value, usage, market conditions, schedule, client budget (what can be done for the money allotted to the project), hours expended, and gut instinct. The value the client expects to derive from the work is an increasingly important factor. For example, a company desiring top talent to develop a new identity program may be willing to pay a substantially higher fee than one calculated solely on expended time. Conversely, a designer may create a company greeting card for a long-term client as a client accommodation for substantially less than the time expended. While it may help a designer to walk through a project step-by-step, calculating the time needed for every activity and multiplying that time by the appropriate rate(s), the designer should view that information as a material guideline and not discuss projected

What to Include in a Proposal

The proposal reflects many of the following factors: overview, objectives, and requirements of the project; research; art and/or copy to be developed by the designer; typography and other production services, printing requirements, and intended use of the printed piece; and schedule. Additionally, designers frequently prepare documents explaining subcontractor (such as illustrator or photographer) relationships and billing procedures. Then, after the proposal is approved, a contract is issued that details the terms of the specific relationship.

A proposal begins with an overview—a clear and concise description of the project. It includes a disclaimer that says that any prices and fees quoted are based on rough specifications of the items listed; if the items change, fees will change accordingly.

Proposals, like the projects they reflect, are divided into parts. These include a description of design and production; a description of fees; a payment schedule for the phases of work involved; rights, usage terms, and conditions; and collateral material to help sell the designer's abilities to the client.

Defining and describing the phases for a project helps facilitate the billing process and ensures the work will not proceed to the next phase until payment is received according to the agreed-upon schedule. These checkpoints also give clients very clear and tangible input at appropriate times as the project develops.

Parts & phases of a proposal

Part 1: Design and production

- ••• Phase 1, Design: Describes the design phase of the project fully, including what form the design presentation will take, how many versions will be presented, the client approval process, and the time schedule for this phase.
- ••• Phase 2, Layout preparation: After client approval of the design phase, explains the production process, including assigning illustration and/or photography, copywriting, typesetting, proofreading, supervision of those components, exact print/production time estimates, client approval schedules, and time required.
- •••• Phase 3, Final production: After client approval of the previous phases, final production begins. Depending on the end product(s) a design firm has been commissioned to produce, this phase may be a matter of going on press and/or supervising the fabrication or manufacturing of products within a prescribed schedule. If designers are involved with developing Power Point presentations, Web sites, and multimedia presentations, programming them is part of this phase.

Some designers may prefer to divide their process into five phases: phase one: orientation; phase two: design development; phase three: design execution; phase four: prepress/production; and phase five: on press. Feel free to devise a system that is the easiest and most workable for you.

Part 2: Fees

Fees and expenses may be handled in a number of ways. During the first phase, the design office may arrange to bill on a project basis. If clients prefer to be billed on a project basis, they usually establish an acceptable cap on the total

amount billed. The project is outlined in briefer form than for Part 1, including the fees required for design, copywriting, photography, illustration, and so on.

It is important to explain what these fees include (design, layout, type specification, preliminary proofreading, production, and so on) and, more importantly, what they do not include (out-of-pocket expenses, author's alterations, overtime charges, photographic art direction, long-distance travel, and such). The latter expenses, including markups for account handling and supervision (typically 15 to 25 percent), should be stated and estimates of charges should be included if possible.

When supplying production prices for printing, be sure to state that these estimates are based on rough specifications and are budget estimates only. More exact quotations can be furnished at the time the final design mechanicals or comprehensives are reviewed by the printer.

Part 3: Payments

Many design projects are quoted and billed by phase, with an initial fee representing 30 percent of the total estimated fee and reimbursable expenses. An outline of the payment schedule should be provided.

Another method of payment is a monthly breakdown of the fee in equal increments (often called a retainer). This method allows the designer to predict income over a long project and discourages the client from attaching a value to each phase that may be misleading since few projects follow the phase development in a strictly sequential way.

Part 4: Rights, usage, and credit

Discuss usage, ownership of rights and artwork, credit lines, approvals, interest charged for late payments, and any other terms (such as sales tax, confidentiality, or termination) deemed necessary. For clarification of these items, see the standard contracts in Chapter 13, Standard Contracts and Business Tools.

Signature lines for both client and designer and the date that the agreement is signed should follow. A signed original and a copy should be retained by both parties.

Part 5: Collateral material

Include material that will help sell your abilities to the client. These may include background material or biographies, awards, and a list of other clients and examples of work completed for them.

hours with the client. As a rule, the designer's work should be judged for its value, as are the services of an experienced consultant or advisor, rather than by the time expended, as is the work of a vendor.

Once designers assess all these variables, they write a design proposal that spells out both the scope of services and client responsibilities and the estimated fees, expenses, and schedules. The proposal also includes many of the following factors (as necessary): an overview of the client's market, objectives and requirements of the project, research, art and other components that will be developed or commissioned by the designer, typography, programming and other production services, projected printing requirements, intended use of the printed piece, and schedule. In addition, designers frequently prepare documents explaining relationships with subcontractors (illustrators or photographers), billing procedures, and contract terms.

The information supplied in the proposal is only for the design directions already discussed, specified, and agreed upon by the client and designer at their initial meetings. Since clients often compare a number of proposals before choosing a designer for the job, a proposal should be clear and thorough enough to be reviewed without the designer present.

The organization and appearance of a design proposal can be crucial in winning a job, especially when a design firm is competing against others. A proposal's appearance reflects a designer's ability and expertise as much as the information contained within it. Consequently, proposals should be organized logically, well written, well designed, and professionally presented.

When preparing a proposal for a new client, it helps to include collateral material such as promotion pieces, reprints of published work, examples of similar projects produced by the designer, biographies of the designer and subcontractors involved in the project, and so on.

It is customary for project descriptions and cost proposals to be submitted to clients as a complimentary service. However, creative proposals—those entailing solutions to a client objective—are billable. Any fees and expenses incurred on a client's behalf and with the client's consent are billable.

If the client accepts the proposal, the terms and conditions expressed in writing are signed by authorized representatives of both the client and the designer or design firm. Always make at least two copies of the proposal for both client and designer to retain as original signed copies if the commission is accepted. When signed by both client and designer, a proposal is legally binding as a contract. It is important to note that any changes requested by the client in service or responsibility beyond the scope outlined in the design proposal are considered "author's alterations" (AAs) and are billable. Additional services may include changes in the extent of the work, in the scheduling, and in the complexity of elements and/or changes after client approval has been given for a specific stage, including concept, design, composition, and production of files. AAs can become expensive to the client because changes are usually billed at an hourly rate. They may also increase the difficulty of completing the project within the time scheduled, causing overtime charges. It is the designer's responsibility to keep the client informed of any additional services that may be required by issuing timely change orders outlining the changes and to obtain the client's approval, also in writing, of related additional costs before any changes are implemented and additional fees incurred.

Standard contracts, like those in Chapter 13, Standard Contracts and Business Tools, do not provide the detailed explanatory material required in proposals for complex, multiphased projects. Those proposals are much more comprehensive than the contracts provided in this book, which can, however, be used as outlines or models.

Getting started

Once the agreement is signed, the designer begins researching the project in greater depth. Before exploring any design directions, the designer reviews his or her findings with the client to make sure they are in alignment. Then, with various design concepts in mind, the designer prepares a presentation showing general directions and formats for the project. Depending on the client's needs and the understanding between the client and the designer, the presentation may be "tight" or "loose." Preliminary renderings, or "comps" (an abbreviation for "comprehensives"), show the layout of the piece and are presented to the client for approval. Once approved or revised and approved, the designer begins assembling

the elements and services necessary to carry out the project within the client's agreed-on budget and time frame.

With the client's approval and/or involvement, the designer makes key decisions on the specific look of the work, including the use of illustration or photography. Since many clients don't buy art on a regular basis, it is the designer who negotiates with individual artists on the client's behalf and within the scope of the client's approved art budget. In this regard, designers often assume the responsibility for educating the client on the intent, content, and ethics of trade customs and copyright law.

Designers must also remember their own responsibility to the artists whose work they are considering. The increased practice of using images from artists' portfolio and talent sourcebooks at the presentation or comp stagewithout permission-prompted the Graphic Artists Guild to initiate the "Ask First" campaign to educate designers, art directors, and other art buyers to respect private intellectual property and the copyright laws that govern it. Art or photography should not be copied or swiped for any use, including client presentations or comping, without the creator's permission. In addition, portfolios must be returned intact and in good condition (an unfortunate side effect of misusing sample work without permission has been damaged artwork and portfolios).

Subcontracting

Design firms, art directors, or other art buyers who assume creative control of a project for a client often subcontract with independent contractors for work they cannot create themselves. Payment is due from these contractors in a timely manner, no matter when they receive payment from the client. Separate subcontractor agreements should be signed by the designer and the independent contractor.

Employment & recruitment agencies

Employment agencies in various cities around the country refer graphic designers to clients for a fee. They operate in the same way that most employment agencies do but specialize in visual communications markets. Often these agencies are listed in trade magazines and the telephone book.

Recruitment and search agencies (most often referred to as headhunters) are a unique talent resource for a firm in need of specialized employees. To the person seeking a position, they represent an employment resource that might not be readily available through other channels. These agencies are actually a variation on an employment agency. While employment agencies place individuals in jobs and receive payment from the person placed, recruitment firms are hired and paid by clients who need to fill specific positions. These agencies receive the job description from the client, and their task is to find the proper person. Client relationships are confidential, and job descriptions need not be made public. They are, nonetheless, subject to equal opportunity employment laws.

Recruiters often place ads in local newspapers to advertise positions. Because the recruiting agency's fees are paid by the client seeking an artist and not by the artist who is placed in the position, the term "fee paid" in the advertisement indicates that the job candidate has no financial obligation to the agency. (For more about employment, see the Employment Issues section in Chapter 3, Professional Issues, and The Labor Market section in Chapter 4, Technology Issues.)

Sources of Illustration & Design Talent

Several resources are available to clients and graphic artists to find and/or promote talent. Among the most widely known and used are the advertising directories. These directories generally showcase a specific type of work, such as illustration or graphic design. Artists purchase space in a directory where they display representative work they choose and list a contact address for either the artist or the artist's representative. Other annual publications are compilations of juried shows. Directories and annuals also provide another important service: They provide references for the types and styles of work being done in the field. Among the best-known national directories for illustration are American Showcase, The Black Book, Chicago Talent, The Graphic Artists Guild Directory of Illustration, New York Gold, RSVP, and The Workbook. Directories of juried shows for illustration include American Illustration, Art Directors Annual, and The Society of Illustrators Annual and for design The AIGA Annual, Art Directors Annual, The Black Book, Communication Arts Design Annual, Graphis, Print Regional Annual, and The Workbook. Many publications sponsor juried shows in areas of special interest such as dimensional illustration, humorous illustration, and international design and illustration.

All the graphic design magazines also hold yearly competitions and feature the winners in special annual issues. Directories and magazine annuals can be purchased directly from the publishers or at most art supply stores and well-stocked bookstores.

The World Wide Web is emerging as a valuable resource for viewing and finding talent. Illustrators and graphic designers can showcase their work on their own Web sites or on a site devoted to the work of many artists, such as www.designscout.com or www.ispot.com. It behooves graphic artists to take advantage of the many marketing possibilities offered by the Internet.

Guild resources

Some Graphic Artists Guild Chapters collect information on employment possibilities available in their areas. Others offer a number of different forms of referral services. The National Office provides the *JobLine News*, a weekly national newsletter listing job opportunities in all areas of the graphic arts, ranging from independent contractor to part-time, long-term, and full-time staff positions. (For more information, see the Taking Action section of Chapter 14, The Graphic Artists Guild.)

Marketing & Self-Promotion

One of the most vital, but frequently neglected, aspects of being a graphic artist—this applies to all illustrators and graphic designers who function as independent contractors—is marketing and self-promotion. Every graphic artist needs to see it as a top priority in maintaining a consistent, steady flow of work. It's best to avoid the obvious dilemma: When it's busy, there's no time for it; when it's not, it's too late.

Graphic artists need to show potential clients what they're doing and position themselves advantageously to develop ongoing client relationships or to get more work or a better type of work. Promotion also enhances the studio's image or identity. It shows a creator's thinking: his or her ability to innovate, attract attention, and articulate a unique style or approach. To be effective, graphic artists need to schedule promotions at key intervals throughout the year. Or try to make a memorable statement at least once a year. Even sending out a tearsheet with a recent illustration or a press release about the latest award in a trade magazine annual acts as a timely reminder. Including an enticing reference to a Web site is doubly helpful.

An essential aspect of good marketing is compiling and maintaining a list of contacts and updating it at least once a year to keep it fresh and relevant. Lists targeted to particular industries can be purchased, or you can ask for referrals from current clients, business acquaintances, suppliers, or generous colleagues. Marketing consultants are also available who can help graphic artists develop lists and devise mailings based on what's worked for other clients in the past.

Keys to successful marketing include establishing a clear identity for a studio or firm, targeting clients you want to work with, and routinely reminding prospective clients of your services through ongoing promotion.

- Identity: Pinpointing the kind of work you want to do, what interests you most, and what you
 do best helps define a clear identity for your studio or firm. If you have trouble doing that, it
 may be useful to hire a management consultant to help you devise a marketing plan.
- Target clientele: Defining the kind of clients you want and then creating a market strategy
 is critical. If you want to develop new business in a particular area like banking or health care,
 research areas in those organizations that might need your services and send direct mailings
 to them.
- Ongoing promotion: Staying on the client's radar screen is vital. Though most people don't like sending out cold mailings or making cold calls, they are traditional ways of attracting new business. However, do them only if you enjoy doing them; otherwise, they may be a waste of time.

It may help to think of your career as a long-term promotion or identity campaign. It's actually a building process. It lets clients know you have longevity and staying power. If you persist, it should pay off, but you have to be willing to invest both time and money to make it work. Whatever you do, make sure you get noticed. The first rule of promotion is to get the client's attention. (For books about marketing and self-promotion, see Chapter 15, Resources and References.)

Ethical Standards

The Graphic Artists Guild, established by graphic artists, is mandated by its constitution to monitor, support, and foster ethical standards in all dealings between graphic artists and art buyers. This is accomplished through Guild programs for members, through cooperation with related organizations, and through legislative activity on local, state, and federal levels. As part of this responsibility, the Guild has a Grievance Committee that addresses issues of professional relations to help members resolve disputes with clients over violations of agreements and commonly accepted trade standards. As with all other Guild programs, these committees draw from members' experiences in the field, track industry standards, and publicize any changes in the field that affect contracts and trade practices. (For more information about the Guild's history of promoting ethical standards, see Chapter 14, The Graphic Artists Guild.)

The Code of Fair Practice for the graphic communications industry

The intention of the Code of Fair Practice, drafted in 1948, was to uphold existing law and tradition and to help define an ethical standard for business practices and professional conduct in the graphic communications industry. Designed to promote equity for those engaged in creating, selling, buying, and using graphics, the code has been used successfully since its formulation by thousands of industry professionals to create equitable business relationships. It has also been used to educate those entering the profession about accepted codes of behavior. The ramifications of a professional's behavior (both positive and negative) must be carefully considered. Though the code does provide guidelines for the voluntary conduct of people in the industry, which may be modified by written agreement between the parties, each artist should individually decide, for instance, whether to enter art contests or design competitions, provide free services, work on speculation, or work on a contingent basis. Each artist should independently decide how to price work.

After the Joint Ethics Committee, which initiated and sponsored the code, was disbanded in the late 1990s, the Guild convened a working committee to revive and update the code so that it would address new technologies, legislation, and industry practices. While the only other industry groups beside the Guild to endorse the revised code as of March 2001 when this book went to press are the Advertising Photographers of New York (APNY), the Society of Illustrators, and the Society of Photographers and Artists Representatives (SPAR), an ongoing effort is being made to publicize the new code and win wider endorsement.

As used in the following text, the word "artist" should be understood to include creative people and their representatives in such fields of visual communications as illustration, graphic design, photography, film, and television.

The Code of Fair Practice

ARTICLE 1. Negotiations between an artist or the artist's representative and a client shall be conducted only through an authorized buyer.

ARTICLE 2. Orders or agreements between an artist or artist's representative and buyer should be in writing and shall include the specific rights which are being transferred, the specific fee arrangement agreed to by the parties, delivery date, and a summarized description of the work.

ARTICLE 3. All changes or additions not due to the fault of the artist or artist's representative should be billed to the buyer as an additional and separate charge.

ARTICLE 4. There should be no charges to the buyer for revisions or retakes made necessary by errors on the part of the artist or the artist's representative.

ARTICLE 5. If work commissioned by a buyer is postponed or canceled, a "kill-fee" should be negotiated based on time allotted, effort expended, and expenses incurred. In addition, other lost work shall be considered.

ARTICLE 6. Completed work shall be promptly paid for in full and the artwork shall be returned promptly to the artist. Payment due the artist shall not be contingent upon third-party approval or payment.

ARTICLE 7. Alterations shall not be made without consulting the artist. Where alterations or retakes are necessary, the artist shall be given the opportunity of making such changes.

ARTICLE 8. The artist shall notify the buyer of any anticipated delay in delivery. Should the artist fail to keep the contract through unreasonable delay or nonconformance with agreed specifications, it will be considered a breach of contract by the artist. Should the agreed timetable be delayed due to the buyer's failure, the artist should endeavor to adhere as closely as possible to the original schedule as other commitments permit.

ARTICLE 9. [new] Whenever practical, the buyer of art-work shall provide the artist with samples of the reproduced artwork for self-promotion purposes.

ARTICLE 10. There shall be no undisclosed rebates, discounts, gifts, or bonuses requested by or given to buyers by the artist or representative.

ARTICLE 11. Artwork and copyright ownership are vested in the hands of the artist unless agreed to in writing. No works shall be duplicated, archived, or scanned without the artist's prior authorization.

ARTICLE 12. Original artwork, and any material object used to store a computer file containing original artwork, remains the property of the artist unless it is specifically purchased. It is distinct from the purchase of any reproduction rights.[□] All transactions shall be in writing.

ARTICLE 13. In case of copyright transfers, only specified rights are transferred. All unspecified rights remain vested with the artist. All transactions shall be in writing.

ARTICLE 14. Commissioned artwork is not to be considered as "work for hire" unless agreed to in writing before work begins.

ARTICLE 15. When the price of work is based on limited use and later such work is used more extensively, the artist shall receive additional payment.

ARTICLE 16. Art or photography should not be copied for any use, including client presentation or "comping," without the artist's prior auth-

orization. If exploratory work, comprehensives, or preliminary photographs from an assignment are subsequently chosen for reproduction, the artist's permission shall be secured and the artist shall receive fair additional payment.

ARTICLE 17. If exploratory work, comprehensives, or photographs are bought from an artist with the intention or possibility that another artist will be assigned to do the finished work, this shall be in writing at the time of placing the order.

ARTICLE 18. [new] Electronic rights are separate from traditional media, and shall be separately negotiated. In the absence of a total copyright transfer or a work-for-hire agreement, the right to reproduce artwork in media not yet discovered is subject to negotiation.

ARTICLE 19. All published illustrations and photographs should be accompanied by a line crediting the artist by name, unless otherwise agreed to in writing.

ARTICLE 20. The right of an illustrator to sign work and to have the signature appear in all reproductions should remain intact.

ARTICLE 21. There shall be no plagiarism of any artwork.

ARTICLE 22. If an artist is specifically requested to produce any artwork during unreasonable working hours, fair additional remuneration shall be paid.

ARTICLE 23. All artwork or photography submitted as samples to a buyer should bear the name of the artist or artists responsible for the work. An artist shall not claim authorship of another's work.

ARTICLE 24. All companies that receive artist portfolios, samples, etc., shall be responsible for the return of the portfolio to the artist in the same condition as received.

ARTICLE 25. An artist entering into an agreement with a representative for exclusive representation shall not accept an order from nor permit work

to be shown by any other representative. Any agreement which is not intended to be exclusive should set forth the exact restrictions agreed upon between the parties.

ARTICLE 26. Severance of an association between artist and representative should be agreed to in writing. The agreement should take into consideration the length of time the parties have worked together as well as the representative's financial contribution to any ongoing advertising or promotion. No representative should continue to show an artist's samples after the termination of an association.

ARTICLE 27. Examples of an artist's work furnished to a representative or submitted to a prospective buyer shall remain the property of the artist, should not be duplicated without the artist's authorization, and shall be returned promptly to the artist in good condition.

ARTICLE 28. Interpretation of the Code for the purposes of arbitration shall be in the hands of a body designated to resolve the dispute, and is subject to changes and additions at the discretion of the parent organizations through their appointed representatives on the Committee. Arbitration by a designated body shall be binding among the parties, and decisions may be entered for judgment and execution.

ARTICLE 29. Work on speculation; Contests. Artists and designers who accept speculative assignments (whether directly from a client or by entering a contest or competition) risk losing anticipated fees, expenses, and the potential opportunity to pursue other, rewarding assignments. Each artist shall decide individually whether to enter art contests or design competitions, provide free services, work on speculation, or work on a contingency basis.

Artwork ownership, copyright ownership, and ownership and rights transferred after January 1, 1978, are to be in compliance with the Federal Copyright Revision Act of 1976.

 \fbox \fbox The original Article 28 has been deleted and replaced by Article 29.

The Graphic Artists Guild's National Grievance Committee

Misunderstandings and disputes in the graphic communications industries, much as in others, are inevitable due to the nature of business interactions. However, the Guild believes that much contention results from lack of awareness, or disregard, of common standards of professional practices. Such problems, the Guild believes, can be reduced and mutually beneficial and productive business practices can be advanced through discussion and negotiation. Therefore the National Grievance Committee seeks to improve professional relations between artists and buyers by fostering an ongoing dialogue with all involved parties. Through the activities of this committee, the Guild seeks to contribute to a broader and fuller understanding and commitment to professional standards of practice.

Both formal and informal communication between the Guild and major buyers has existed since the Guild's inception. One reason the Guild has been able to keep lines of communication open is by acknowledging the legitimate concerns of both sides of professional issues. However, the Guild also investigates members' problems and pursues solutions on their behalf.

Some Guild Chapters have their own Grievance committees that assist local members in resolving violations of agreements and disputes of commonly accepted trade standards and in preventing the occurrence of grievances by promoting accepted business and legal procedures. Depending on the unique factors of each case, the committee's assistance generally involves a number of steps, as needed, to resolve the issue. These include guiding the member's efforts to resolve the grievance through negotiation with the client; Guild intervention with the buyer on the member's behalf; and mediating, if requested by both parties, to achieve a private settlement.

The National Grievance Committee serves Guild members at large and may also be called upon, as needed, to intervene in a local grievance. If further action becomes necessary, other relevant alternatives may be proposed by the committee, including arbitration, small-claims court, various collection methods, lawyer referral, or litigation. (For more information on alternatives, see the Collecting section in Chapter 5, Essential Business Practices.)

Guild Grievance committees encourage artists and art buyers of all disciplines to report unprofessional practices. It's important to make such information widely available and to take every opportunity to promote ethical practices. Members wishing to report unprofessional practices should forward them to their Chapter committee or to the National Grievance Committee. Grievance Committee assistance is available only to members of the Graphic Artists Guild; those wishing assistance should contact their Guild Chapter or the National Office.

Publishing articles about ethics

The National Grievance Committee focuses attention on business conduct by initiating research into specific issues and producing articles for industry and Guild publications. The selection of topics results both from monitoring industry practices and from correspondence received by the committee.

The Guild periodically publishes a "Graphic Artists Be Aware" or "Caveat Creator" column to inform its membership of, and acknowledge advancements or problems in, artist/buyer practices. The column, which appears in national and local Guild newsletters, cites individual buyers and companies that have improved terms for art commissions as a matter of policy or are disrespectful of artists. The advances may have resulted from negotiations with the Guild, from communication with the Gievance Committee, or through independent efforts. Likewise, by publicizing cases of flagrant, repeated, or unresolved unprofessional practices, the Guild warns the graphic arts community of unethical or unfair practices. At the same time, the Guild puts such practitioners on notice that they can no longer take advantage of artists with impunity. The Guild's National Office requests notification about both types of practices.

In writing the U.S. Constitution, our nation's founders recognized the need to stimulate the spread of learning and the dissemination of ideas by creating protection for creators of intellectual property. Article I, This chapter discusses the many legal aspects Section 8 empowers Congress to involved in doing business as a graphic artist. "promote the progress of science Of paramount concern is understanding and and useful arts by securing for protecting copyright both in the United States limited times to authors and and internationally. But other issues like work inventors the exclusive right to for hire and fair practices are also included. their respective writings and discoveries." This established the foundation for our copyright laws, which acknowledge artwork as intellectual property that is traded in the marketplace as a valuable economic resource.

In today's visual world, the works created by graphic artists are among the most powerful vehicles for communicating ideas in our society. A successful illustration can single-handedly sell a product. A successful logo can single-handedly evoke a company's goodwill in the public mind. A successful poster can single-handedly move an entire population to action.

Like other creative professionals—actors, musicians, dancers, writers, photographers graphic artists occupy a special place in our society and economy. Their unique vision, skill, and style enable them to attract clients, sell their work, and earn their livelihood. Like other professionals, graphic artists provide their highly skilled services and creative input within a framework of professional standards and ethics. But the work of graphic artists is vulnerable and requires the maximum protection of our laws, not only to prevent unauthorized exploitation but also to ensure that artists can continue to work without economic or competitive disadvantages.

The Graphic Artists Guild's constitution and membership mandate is to "promote and maintain high professional standards of ethics and practice, and to secure the conformance of all buyers, users, sellers, and employers to established standards." Further, the Guild seeks to "establish, implement, and enforce laws and policies...designed to accomplish these ends." The organization's legislative agenda, therefore, is based on the needs and desires expressed by its members and its constitutionally mandated goals.

One of the primary goals of the Graphic Artists Guild is to help buyers recognize the value of graphic art to their businesses and the importance of fair and ethical relationships with graphic artists. The Guild upholds the standard of a value-for-value exchange, recognizing that both client and artist contribute to a successful working relationship.

The Guild monitors and influences public policy developments, including legislative initiatives at the local, state, and federal levels, and regulatory actions by a range of agencies. Some initiatives include local proposals concerning sales and use taxes; state laws to encourage fair practices and protect artists' authorship rights; federal legislation closing the workfor-hire loophole of the U.S. Copyright Act, strengthening protections against infringement, and creating tax equity for artists; developing a national standard for artists' authorship rights (known as "moral rights"; discussed below); and extending the copyright term to conform to the European standard of life plus 70 years. The Guild has drafted model legislation and lobbied locally and nationally on these issues. Its early successes in California, Massachusetts, New York, and Oregon created a wave of interest in artists' rights legislation. With Guild involvement, Georgia passed legislation that strengthens artists' protections against copyright infringement. The Guild spearheaded the "Ask First" initiative, organizing a coalition of creators and publishers organizations to advance a copyright awareness campaign designed to educate users of images about appropriate and ethical practices. The Guild also reached out to gallery artists in the finearts communities by cofounding Artists For Tax Equity (AFTE), a coalition representing nearly 1 million creators that successfully lobbied Congress for exemption from an onerous tax provision. In addition, Guild testimony before both House and Senate subcommittees helped advance copyright protections and keep the 1999 hike in the copyright registration fee at an affordable level.

Copyright

Graphic artists' livelihoods depend on their ability to claim authorship of the pieces they produce. They build their reputations—and therefore their ability to attract clients and build a career—on the basis of past performance. Indeed, artists' careers succeed or fail because of their skill and style in communicating the ideas and messages society needs to disseminate. Artists' rights to control the usage of their original creative art are defined primarily by copyright law, which also provides the basis for pricing and fair trade practices.

Copyright law was created to extend limited monopolies that provided economic rewards and protections to artists and other creators. This encourages the dissemination of ideas, thereby serving the public interest. The current copyright law (Copyright Act of 1976) became effective January 1, 1978.

In 1998 the Digital Millennium Copyright Act (DMCA) was enacted; it implements two 1996 World Intellectual Property Organization copyright treaties. The bill's most significant feature is that it affirms that copyright applies in digital network environments as well as in print, film, and recording media. The bill makes it a violation of U.S. law to circumvent any copyright protection mechanism in the digital environment and to remove any copyright management information that owners of intellectual properties attach to a digital document. The law also limits infringement liability for online service providers who unwittingly transmit material that infringes on a copyright. Finally, it clarifies and strengthens the continuing policy role of the Copyright Office. (For a more complete discussion of the DMCA, see the Digital Millennium Copyright Act section later in this chapter.)

A bundle of rights

An artist's copyright is actually a bundle of individual rights. These broadly include the rights to copy (commonly known as the "right of reproduction"), display, distribute, perform, or create a derivative work from an existing work. Each specific use can be transferred outright or licensed separately for a specific length of time. Fees are determined primarily by the value agreed upon for the specific rights. Any rights not transferred explicitly remain the property of the creator.

The ability to sell or license limited usage, or limited rights, to a work of art for a fee is an issue of basic fairness. The true value of a work, however, is difficult to determine (particularly before the work has been executed), considering that the potential economic life of the work is the length of time granted by copyright law, currently the author's life plus 70 years. Therefore, negotiations over the price of a commissioned work are normally based on the initial rights the client wishes to purchase.

Transferring rights

An agreement to transfer any exclusive (but not nonexclusive) rights, or to transfer all rights (which are by their nature exclusive), must be in writing and signed by the artist or the artist's agent. Those rights not specifically transferred in writing are retained by the artist. Nonexclusive rights, which can be transferred to more than one client at a time, may be transferred orally.

For contributions to collective works such as magazines, anthologies, and encyclopedias, where there is no signed agreement, the law presumes the transfer of only nonexclusive rights for use in that particular collective work. All other rights remain vested with the artist. Exclusive or all-rights transfers must be in writing to be valid.

Copyright is separate from the physical art and is sold separately. State laws in New York and California require the transfer of the original, physical art to be in writing. These laws were passed after successful lobbying by artists to stop clients from insisting that transactions transferring only reproduction rights also included the sale of the original.

Termination of rights transfers

Transfers of copyright may be terminated by the artist or his or her heirs during a five-year period beginning 35 years after execution of the transfer. This "right of termination or reversion" feature of the 1978 copyright law is particularly important when transfers or licenses are for exceptionally long periods of time and when artists who have since become successful wish to regain rights to their early work.

Artists or their heirs whose grants of rights are approaching 35 years should contact the Copyright Office for forms and procedures. The formalities of termination are detailed; the exact form of notice is specified by, and must be filed with, the Copyright Office. (For the Copyright Office address, see the section on Registering Copyright below or Chapter 15, Resources and References.) Artists will lose the opportunity to reclaim rights to their creations, unless the grants otherwise terminate, if they fail to comply with the proper procedures.

The right of termination does not apply to works that have been sold as work for hire (the artist has forfeited authorship in such sales), nor does it apply to transfers of copyright interests made through a will.

Licensing rights

Licensing copyright rights to a client to use a work for a particular purpose for a particular length of time means the artist is still the owner of the copyright for any uses not licensed and wholly after the term of the license has expired. For instance, an artist can license the right to make copies of a work, display it, and make derivative works from it. Each of these licenses has a value that may be much higher than the value of selling it outright and transferring all rights to the buyer. The market will determine those values; what has no particular value today may have great value tomorrow. If artists license rather than transfer rights, they will be able to take advantage of any value the work may have down the road or any uses that were not thought of when it was created.

For example, an artist creates an illustration for a magazine cover, but then the magazine wants to use it for a promotional poster. The magazine has to go back to the artist for another license to use it on the poster and pay the artist an additional fee for that use. If a graphic designer is hired to create a logo for a company that wants widespread use of the logo on all its products and merchandise, the designer must be paid accordingly for transferring all the rights to the company so it can use the design in any way it wants. (The designer may want to stipulate in the agreement that he or she may use the logo for promotional purposes.) However, if a designer is only paid to create a company logo for stationery and business cards, then it must be spelled out in writing that the company cannot use the logo for other uses, such as on uniforms and for a 20-foot sculpture on the company campus.

Licensing is a business decision. Only the individual can decide what terms or length of time best suit the client and the situation. When in doubt, it's always good business to keep, control, and defend copyright rights. Samples of short- and long-term licensing agreements are provided in Chapter 13, Standard Contracts and Business Tools.

2 Legal Rights & Issues

Transfer of electronic rights

A 1999 landmark legal ruling addressed the issue of electronic licensing as applied to freelance authors. However, its influence is potentially much broader; it could affect the terms for electronic licensing of work by all independent creators. (See also the Legal and Ethical Issues section in Chapter 4, Technology Issues.)

The U.S. Court of Appeals overturned a 1997 district court opinion in *Tasini v. The New York Times*, which ruled in favor of a number of publishers (including *Newsday*, a subsidiary of Times-Mirror; Time Inc. Magazine Company, a subsidiary of Time Warner; Mead Data Central Corp., former owner of Lexis-Nexis, a subsidiary of MeadData; the Atlantic Magazine Company; and University Microfilms International, a division of Bell & Howell) and against a number of authors who owned copyrights to individual articles previously published in periodicals. The authors claimed infringement by the publishers and owners of electronic databases who made the articles available on electronic databases without the authors' permission or additional compensation. The district court held that the publishers were protected by the privilege of "collective works" under Section 201(c) of the Copyright Act. The Court of Appeals for the Second Circuit reversed that ruling. The publishers then appealed that ruling to the Supreme Court, which will decide the case in Summer 2001.

The authors based their copyright claim on the fact that the copyright each owned to his or her individual articles was infringed when the publishers, after printing the articles, provided them to electronic databases without the authors' consent or additional payment. The publishers did not dispute that the authors owned the copyright to their individual works. Rather, the publishers asserted that they each owned the copyright in the "collective works" that they produced and were afforded the privilege, under Section 201(c), of "reproducing and distributing" the individual works in "any revision of that collective work." The issue for the Court of Appeals was whether one or more of the electronic databases could be considered a "revision" of the individual periodicals from which the articles were taken, as the district court originally held.

Section 201 provides that as to "contributions to collective works (such as an article, illustration, or a photograph), the copyright in each separate contribution is distinct from the copyright in the collective work as a whole (such as a magazine or newspaper) and is vested initially in the author of the contribution (the writer/photographer/illustrator)." A collective work is defined as a "work, such as a periodical issue, anthology or encyclopedia, in which a number of contributions, consisting of separate and independent works in themselves, are assembled into a collective whole." In other words, there are two distinct copyrights: the individual copyright of the contributors and the copyright to the collective work of the publisher, which covers the selection and arrangement of the articles and contents but not the contents itself.

The language the Court of Appeals was asked to construe is found in Section 201(c), which affords a privilege to authors of collective works: "In the absence of an express transfer of the copyright or of any rights under it, the owner of copyright in the collective work is presumed to have acquired only the privilege of reproducing and distributing the contribution as part of that particular collective work, any revision of that collective work, and any later collective work in the same series."

The Court of Appeals found that the most natural reading of the "revision" of "that collective work" clause is that the Section 201(c) privilege protects only later editions of a particular issue of a periodical, such as the final edition of a newspaper. The court found that this interpretation protects the use of an individual contribution in a collective work that is somewhat altered from the original in which the copyrighted article was first published, but that is not in any ordinary sense a "later" work in the "same series."

Relying on the statutory definition of a "collective work" (which lists as examples "a periodical issue, anthology, or encyclopedia"), the court found support for its reading of the revision clause. While issues of periodicals are often updated by revised editions, anthologies and encyclopedias are altered through the release of a new version, which would be a "later collective work in the same series." Therefore the court rejected the publishers' contention that electronic databases are revised, digital copies of collective works and found that it could not be squared with basic canons of statutory construction.

The court noted that "there is no feature peculiar to the databases at issue in this appeal that would cause us to view them as 'revisions.' NEXIS is a database comprising thousands or millions of individually retrievable articles taken from hundreds or thousands of periodicals. It can hardly be deemed a 'revision' of each edition of every periodical that it contains." The Court of Appeals further determined that if the republication is a "new anthology" or a different collective work, it is not within the privilege of Section 201(c).

Therefore, both the use of print-only articles on databases such as Lexis and the "image-based" representation of complete pages included in CD-ROM compilations are not protected by the publishers' Section 201(c) privilege. If a "new product" is created, for example, that does not fall within the narrow definition of a revision of a compilation. To hold otherwise, the court concluded, would create a right in a collective work that would cause the exception to swallow the rule, giving publishers rights in a collective work that would in effect subsume the exclusive rights reserved to the individual contributors.

Only one author in the Tasini case had a written contract with his publisher that required payment for additional uses of the article. The Court of Appeals rejected the lower court's ruling that the authors were not due additional compensation and ruled that they should be paid for all uses of their articles in electronic and digital databases. **Z** Legal Rights & Issues

Copyright notice

Although current copyright law automatically protects original artwork from the moment of its creation even without inscribing a copyright notice, failing to place one on artwork may make it vulnerable to so-called innocent infringers, who may claim they did not know the work was protected. Since the requirement to inscribe a copyright notice on a work ended in March 1989, users should safely assume a work is protected by copyright even if no notice is affixed. However, it is best for artists to have their copyright notice appear with their work whenever it is published, placed on public display, or distributed; this helps avoid certain risks of infringement. The copyright notice can be placed on the back of an artwork or, when it is published, adjacent to the artwork. Other reasonable placements of the copyright notice for published works are specified in Copyright Office regulations. Pieces in an artist's portfolioshould have copyright notices on them, including published pieces when the artist retains the copyright.

The elements that make up a copyright notice are Copyright or ©; the name of the corporation or the artist's name, an abbreviation of the name, or an alternate designation by which the artist is known; and the year of first publication: © Jane Artist 2001, for example. The form and placement of the notice should be understood by artist and client and should be reflected in a written agreement. When use of the art has been temporarily granted to a client, the notice should preferably be in the artist's name; however, it may be placed in the client's name for the duration of the use.

If copyright in a work is not being sold, but rather a license is being issued for the use of the work, then a client may affix the © notice in his or her name only if the license is for an *exclusive* use. The client's other alternative would be to obtain a copyright for the collective work in which the licensed work is contained.

Registering copyright

Current copyright law automatically "protects" original artwork from the moment it is created, even without a copyright notice. Protection means that an artist retains the right to assert a claim for copyright infringement even if he or she has not registered the work in question. This is an improvement over previous law, when copyrights were lost permanently if a work was published without registration or with incorrect notice. But the bulk of the benefits the copyright law offers to artists are still available through formally registering art with the Copyright Office. Registration creates a useful record for future transactions. All artworks can be registered, whether or not they are published.

Registration establishes a public record of the artist's claim to authorship and is a necessary prerequisite to asserting any copyright claim in court. As long as a work is registered any time from its creation to three months after first publication (known as "timely registration"), then the court will consider this timely registration to be prima facie evidence of copyright ownership in court. Prima facie evidence means that the burden is on the other party to disprove its validity, rather than on the plaintiff to prove that the copyright is valid. A benefit of registering the work within the specified period is that the artist is entitled recover statutory damages for any to infringement that occurs during the threemonth grace period and, of course, any infringement that occurs after registration. Additionally, timely registration allows the prevailing party to receive attorney's fees at the judge's discretion. This is useful when evaluating whether an infringement worth pursuing.

Damages are considered by a court only after infringement has been proven. If a work has been registered in a timely fashion and before an infringement has occurred, the court determines recovery by multiplying the number of infringements times an amount specified by the copyright statute: a sum between \$500 and \$20,000 that the court considers just. Because this range is determined by the statute, these are called "statutory damages." If the copyright owner can prove to the court that the infringement was willful and not inadvertent, the statutory damages may be increased to \$100,000.

In 1999 Congress passed an amendment to the Copyright Act. This increases the statutory damage range from \$750 to \$30,000. It also increases willful infringement damages from \$100,000 to \$250,000.

There are many incentives, both positive and negative, for following the procedures and ensuring timely registration. If a work is not registered within three months of publication, registration will not be considered prima facie evidence by the court. Additionally, if an infringement occurs before registration, the right to attorney's fees and statutory damages is lost. Recovery will be limited to the amount of actual damages that can be proven: whatever profits may be attributed to the infringement. That puts a major burden on the artist pursuing an infringement claim. In addition, he or she will have to prove copyright ownership, actual damages, and the infringer's gross profits. After that, the infringer must then prove what portion of the profits are not attributable to the copyrighted work. Since an artist never knows when an infringement may occur, it is prudent to register early. Not only are statutory damages easier to obtain than actual damages, they tend to run much higher.

	995 eutrin: American Julie 90, 2000 - Afler nach mei Glabyman, Christian garaillaghtaght on Gall Kultai 762 nach fee istearmaan	FOR Work of the Visual Arts UNITED STATES COPYRIGHT OFFICE
		VA VAU EFFECTIVE DATE OF REGISTRATION
	DO NOT WRITE ABOVE THIS LINE. IF YOU NEED MORE SPACE, USE A SEPARATE	
	TITLE OF THIS WORK V	NATURE OF THIS WORK V See instructions
	PREVIOUS OR ALTERNATIVE TITLES	RIGHTAL IIIUGTRATION
	Publication as a Contribution If this work was published as a contribution to a periodical, serial, or collect contribution appeared. THE of Collective Work V	ion, give information about the collective work in which the
	If published in a periodical or serial give: Volume ♥ Number ♥ Issue I	Date ♥ On Pages ♥
	NAME OF AUTHOR ▼	DATES OF BIRTH AND DEATH Year Born Y Year Died Y
NOTE	Was this contribution to the work a "work made for hite"? Wes OR No No Contribution to the work a No No N	Was This Author's Contribution to the Work Anonymous? Yes No If the answer to eith of these questions is of these questions is of these questions is detailed instructions. Pseudonymous? Yes No Yes, see detailed instructions.
the "author" of a "work made for hire" is generally the employer, not the employee (see instruc- tions). For any part of this	NATURE OF AUTHORSHIP Check appropriate bosten) See Instructions 3 Otimensional sculpture Aug 2.Dimensional arwork Photograph Text Reproduction of work of art	-
work that was "made for hire" check "Yes" in the space provided, give	NAME OF AUTHOR V	DATES OF BIRTH AND DEATH Year Born ♥ Year Died ♥
the employer (or other person for whom the work was prepared) as "Author" of that part, and	Was this contribution to the work a "work made { / him?" Author's Nationality or Domicile have d Contry We control to the work a "work made / him?" One Control to the work a Control to the work a Control to the work a Domiciled in	Was This Author's Contribution to the Work Anonymous? Yes No Pseudonymous? Yes No Pseudonymous? Yes No
leave the space for dates of birth and death blank.	NATURE OF AUTHORSHUP Check appropriate basics) See Instructions 3-Dimensional scalapture Map 2-Dimensional arwork Photograph Text Reproduction of work of at 2-levelty design Architectural w	
3 a	Year in Which Creation of This Work Was Completed 2000	articular Work Day Year Year Ala
See instructions before completing this space.	COPYRIGHT CLAIMANT(S) Name and address must be given even if the claimant is the same as the autor given in space 2 V GILDA LOGIOS 123 STAMMATELCO ST.	APPLICATION RECEIVED
	Transfer if the chaimant(s) named here in space 4 is (are) different from the subor(s) named in space 2, give a brief statement of how the chaimant(s) obtained ownership of the copyright.	TWO DEPOSITS RECEIVED
LANGULTY MEDIUM	MORE ON BACK Complete all applicable spaces (numbers 5-9) on the revene side of this page.	DO NOT WRITE HE

Fortunately, registration is relatively easy. Form VA (visual arts), and the new, easier Short Form VA, are used to register pictorial, graphic, or sculptural works, including works originally created by computer and multimedia. The submitted form should be accompanied by one copy of the work if it is unpublished, or two copies if it is published, and the \$30 registration fee. Tearsheets are acceptable for published work, though the Copyright Office prefers the best edition of published work. Transparencies, photographs, photocopies, and videotapes are acceptable for both published and unpublished work, as long as all the copyrightable content of the artwork is shown. Originals should never be sent to the Copyright Office for registration purposes. The artist should keep photocopies of all work submitted with each registration form for easy reference.

2 Legal Rights & Issues

Other registration forms may be needed at certain times by graphic artists. If audiovisual work is created, including motion pictures, then Form PA is appropriate. When an artist creates both art and text in a work, and the text predominates, Form TX should be used and the description should indicate "text with accompanying art." Generally, Form TX is also used to register computer software, including any graphics that are part of screen displays generated by the software. All forms come with line-by-line instructions, but these instructions must be specifically requested from the Copyright Office.

The Copyright Office supplies free registration forms with instructions; specific circulars numbered 40, 40a, 41, and 44 are especially helpful. Information may be obtained by

	EXAMINED BY	FORM VA		
	CHECKED BY			
		FOR COPYRIGHT OFFICE		
		USE ONLY		
DO NOT WRITE ABOVE THIS LINE. IF YOU N PREVIOUS REGISTRATION Has registration for this work, or for an	IEED MORE SPACE, USE A SEPARATE CONTINUATION SHEET.	ali manganganganganganganganganganganganganga		
Yes XNo If your answer is "Yes," why is another registration being so	ought? (Check appropriate box.)			
a.		0		
 in its is the first application submitted by this author as copyright claims in This is a changed version of the work, as shown by space 6 on this application 				
If your answer is "Yes," give: Previous Registration Number V	Year of Registration 🔻			
DERIVATIVE WORK OR COMPILATION Complete both space a. Preexisting Material Identify any preexisting work or works that this work	e 6a and 6b for a derivative work; complete only 6b for a compilation. rk is based on or incorporates. ♥	<u></u>		
		a b		
		See instructions before completing		
Material Added to This Work Give a brief, general statement of the material that has been added to this work and in which copyright is claimed. V				
		b		
DEBOSIT ACCOUNT 15th printing for it to be describe a Description	sit Account established in the Copyright Office, give name and number of Account.			
Name V	Account established in the Copyright Office, give name and number of Account.	7		
		a		
CORRESPONDENCE Give name and address to which correspondence	ce about this application should be sent. Name/Address/Apt/City/State/ZIP $\pmb{\nabla}$	b		
123 STAMATELOS ST.		D		
ASTORIA, NY 00000				
Area code and daytime telephone number > (000) 000.0000	Fax number > (000) 000, 0000			
Email I LIVE HERE QANY LINK. COM				
CERTIFICATION [•] I, the undersigned, hereby certify that I am the		0		
check on	aly one A author	× ×		
	owner of exclusive right(s)			
	authorized agent of	sive right(s) A		
of the work identified in this application and that the statements made	e by me in this application are correct to the best of my knowledge.			
Typed or printed name and date \checkmark If this application gives a date of p GULDA LATAS	publication in space 3, do not sign and submit it before that date.			
Handwritten Agnature (X)				
- His with				
Certificate Name V	Complete all necessary space Sign your application in space			
nailed in (1) DA 1000	SEND ALL 3 ELEMENTS IN THE SAME PACKAGE:	J		
window Number/Street/Apt V	1. Application form 2. Nonretundable filing fee in chu	ack or money As of July 1, 1995,		
othis 123 STAMATELOG ST.	onder payable to Register of Copyr 3. Deposit material	Form VA is \$30.		
ASTORIA, NY 00000	Ubraty of Congress Copyright Office 101 Independence Avenue, S.E. Washington, D.C. 20359-6000			
17 U.S.C. 6 505(a). Any person who knowingly makes a later meteration of a	Washington, D.C. 20559-6000 I material fact in the application for copyright registration provided for by section 409, or in any written	Internet fied in connector		
with the application, shall be fined not more than \$2,500.	a material fact in the application for copyright registration provided for by social 409, or in any written in on RECYCLED PAPER OU.S. GOVERNMENT PRINTIN			

writing to Information Section LM-401, Copyright Office, Library of Congress, 101 IndependenceAve., S.E., Washington, DC20559-6000. Once received, the forms should be reserved as masters and photocopies used for future registrations.

Forms can also be downloaded from the Copyright Office Web site (lcweb.loc.gov/ copyright/), which is directly linked from the Graphic Artists Guild Web site (www.gag.org). These forms allow you to insert the text into the form on the computer and then print out the completed form, which is then mailed with the appropriate deposits and the \$30 filing fee to the Copyright Office. It is also possible to register works electronically through the new Copyright Office electronic Registration, Recordation, and Deposit System (CORDS), which may be found at www.cords.loc.gov/.To take advantage of CORDS, the registrant must open an account with Copyright Office; full instructions appear on the site.

Completed forms and artwork documentation should be mailed to Register of Copyrights, Copyright Office, Library of Congress, 101 Independence Ave., S.E., Washington, DC 20559-6000. Be sure to include the ZIP code in your return address and a daytime telephone number where you can be reached. The accompanying example of a completed VA form is for a published illustration appearing in a book.

It is recommended that applications be sent by an express mail service with which one has an account rather than by regular mail. Courier services offer a more accurate record of delivery than the U.S. Postal Service (unless a package is registered, sent by certified mail, or a return receipt is requested) and less likelihood of damage or loss in transit. It is essential to have an accurate record of the delivery date and proof of delivery, in the event that it is necessary to expedite a registration in progress for the purpose of filing a lawsuit or to trace an application in the rare instance that it is lost during processing. The Copyright Office receives more than 600,000 registrations annually, so an immediate acknowledgment or receipt of an application will not be sent. The registration process normally takes between 16 and 24 weeks. If there is any difficulty or question about the registration, the Copyright Office will contact the registrant during that time. If the application cannot be accepted, a letter will be sent explaining why it has been rejected. After registration is granted, the registrant will receive a certificate from the Copyright Office that takes effect from the date the application (complete with fee and deposit) was received in acceptable form. An artist does not have to receive the certificate before publishing, copying, or displaying a registered work, nor does the artist need permission from the Copyright Office to place a notice of copyright on any work.

Group registration

Any number of unpublished artworks may be grouped under a single title and registered together on Form VA for a single \$30 fee. However, they must be grouped together in a way that makes it possible to identify them later in the event that copyright registration becomes an issue. For example, a series of drawings may be given a name or date and the individual drawings numbered: for example, "Spring Still Life Series, 2000, drawings 1-15." Or a videotape containing up to 2,400 images may be submitted (as long as each image appears for at least three seconds) and registered as "Drawings by Artist, Series 1, 2000." Only one \$30 fee is required, and the art does not have to be registered again when published.

"Unpublished work" includes any work that has not been published at the time it is sent to the Copyright Office. Even if an artist knows that the work will be published the next week, if it is unpublished at the time a completed application is sent to the Copyright Office, it may be registered with other works as unpublished work.

2 Legal Rights & Issues

Inexpensive group registration is also available for published artwork that appeared in periodicals within a one-year period and that included the individual artist's copyright notice, if the works were not work for hire and all have the same copyright claimant. In that instance, Form GR/CP must be completed in addition to the appropriate VA or Short VA forms. One copy of the entire newspaper section or periodical in whicheachcontributionwasfirstpublishedmust also be included. Note that while Form GR/CP allows group registration of work covering an entire year, the postpublication grace period for the strongest copyright protection is only three months. It would be wise for an artist who works for a great many periodicals and newspapers to submit group registration forms four times a year to ensure the strongest copyright protection.

Automatic copyright renewal

The Copyright Act of 1909 required that copyrights expiring after the initial 28-year term had to be renewed by submission of a specific renewal form to extend protections for another 28 years (the renewal registration fee is \$20). Because of this onerous provision, many valuable works, such as the famous Frank Capra movie "It's a Wonderful Life," fell into the public domain, to the detriment of their creators or the creators' heirs. In 1992 the Automatic Renewal Act was passed to protect the "widows and orphans" of authors who did not, or could not, register the copyright's renewal. The law provides that copyrights secured prior to 1978 live out their 28-year first term and, if renewed, an additional 47-year second term. Although this renewal term is automatically provided, the Copyright Office does not issue a renewal certificate for these works unless a renewal application and fee are received and registered in the Copyright Office. Works initially created after 1978 are automatically protected for the lifetime of the author plus 70 years, without need for renewal, but with no renewal available thereafter. As with pre1978 copyrights, the act provides for termination of long-term grants of rights.

The law places special terms on copyrights initially secured from 1964 through 1977. Their 47-year renewal term begins automatically without a renewal application when the 28year first term expires. However, there are benefits to voluntarily submitting an application for renewal registration in the twenty-eighth year, including:

- If the copyright owner registers and then dies before the year ends, the renewal term belongs to the estate. Otherwise, it belongs to the person(s) who, on the last day of the twenty-eighth year, is/are statutorily entitled to the renewal term in the event of the author's death. These are, first, the surviving spouse and children; if none survive, the author's executor; or if no will was executed, his or her next of kin.
- The certificate of registration constitutes prima facie evidence of the validity of the copyright renewal and the facts stated in it. This is a major advantage if the copyright is infringed during the renewal term.
- In some circumstances, the registration prevents use in the renewal term of films and other derivative works based on the author's work. For example, where the author licensed the derivative right for both terms but died before the twenty-eighth year, failure to renew registration in that year permits continued use of the derivative work, though not the making of new versions of it.
- A voluntary renewal application can also be filed at any time during the second term to obtain added protection against infringement (because a registration form is considered "presumptive evidence"), but it does not necessarily yield such benefit. A twentyeighth-year renewal application is advisable for 1964 to 1977 copyrights in works that may have continuing commercial value. A renewal registration made after the twentyeighth year may carry evidentiary weight, the extent of which is determined within the discretionary powers of the court.

<u>Fair use</u>

Copyright owners have the exclusive right to reproduce or sell their work, prepare derivative works (such as a poster copied from a painting), and perform or display their work. (The owner of a copy of the work may also display it.) Anyone who violates these rights is infringing on the copyright and can be penalized and prevented from continuing the infringement.

There are, however, some limitations on artists' exclusive controls of their work. One such limitation allows for so-called fair use of a copyrighted work, including use for such purposes as news reporting, teaching, scholarship, or research. Copyright law provides for the consent necessary to use works in these ways by others. The law does not define fair use specifically, but courts will resolve the question of whether a particular use was fair by examining, for instance, the purpose and character of the use; the nature of the copyrighted work; the amount and substantiality of the portion used in relation to the copyrighted work as a whole; and the effect of the use on the potential market for, or value of, the copyrighted work. For example, a magazine may use an artist's work to accompany or illustrate an article about the artist's life. Fair use also permits artists to display a work executed for a client on a non-work-for-hire basis in their portfolio.

Fair use is a permissible defense against an accusation of infringement that may be used both by the artist incorporating items in his or her work and by someone using the artist's work without permission. Because the boundaries of fair use are vague, it is a defense that can be easily abused. Fair use protects the use of quotations in commentaries and reviews and, by extension, protects parody, satire, and caricature. Because of this "free speech" aspect, fair use is often put forth as a justification for free usage in situations where use should clearly be compensated. One example is in academic settings, where works may be copied and distributed to a class rather than purchased, to the detriment of the market for the author's work. The free speech aspect of fair use is also cited by ideologues opposed to the concept of copyright protection, who wish to enjoy the benefit of others' creativity without being burdened by the necessity of paying for what they use. These "information-wants-to-be-free" advocates forget that all creative work comes at a price. Creators deserve to be compensated for their work; when their compensation is safeguarded, the public benefits, for the promise of compensation creates an atmosphere where creativity flourishes.

A few artists and designers who expect the copyright laws to protect their own work sometimes abuse the rights of other artists and designers. For example, creators of collage often cite "fair use" as a defense for appropriating pieces of another's work. Even if only a small portion of the work is used, that alone may not be sufficient to mitigate the infringement. Collage artists are better off relying on public domain sources, creating their own materials, or obtaining permissions.

Similarly, some agencies and design firms routinely use published and unpublished images without permission to develop comps for client presentations and other such uses. If the four "fair use" factors were applied to these circumstances, the defense against infringement would fail. (In 1996 the Guild organized 16 industry organizations behind the "Ask First" campaign, which is a copyright awareness program intended to end unauthorized use of images in client presentations.)

In 1993, a Working Group on Intellectual Property Rights was formed as part of the Clinton administration's Information Infrastructure Taskforce. The Working Group decided to convene a Conference on Fair Use (CONFU) to bring together copyright owner and user interests to discuss fair use issues and, if appropriate and feasible, to develop guidelines for fair uses of copyrighted works by librarians and educators. Meeting regularly in public session, CONFU grew from the forty groups invited to participate in the first meeting in September 1994 to the approximately 100 organizations that finally participated in the process.

In December 1996, the Working Group issued an Interim Report that included three sets of proposed guidelines dealing with digital images, distance learning, and educational multimedia. However, after two years of meetings and negotiations among the participants, they were unable to come to a consensus on guidelines. As a result, some groups have accepted the proposed guidelines and others have not. The final Report on the Conference on Fair Use is available on the U.S. Patent and Trademark Office Web site (www.uspto.gov).

Risks of invasion & infringement

All illustration or design has the potential for invasion of privacy or copyright infringement problems. For example, the advertising or trade use of a living person's name or likeness without permission is an invasion of privacy, and claims may be in the hundreds of thousands of dollars for an infringement. "Advertising or trade" means virtually all uses other than factual editorial content of magazines, newspapers, books, and television programs; it includes print and TV ads, company brochures, packaging, and other commercial uses. Public and private figures are protected equally.

The test of "likeness" is whether an ordinary person would recognize the complainant as the person in the illustration. It needn't be a perfect likeness. The best protection in these cases is a signed release from the person whose likeness is used (for a model release, see Chapter 13, Standard Contracts and Business Tools), and any contract should provide for this if a problem is likely to arise.

If an artist copies another work—a photograph, for example—in making an illustration, the photographer or copyright holder might sue for copyright infringement. The test of an infringement is whether an ordinary person would say that one work is copied from the other; the copying need not be exact. Given the substantial amount of photography used as reference for illustration, as well as the frequent incorporation of photographs into designs, everyone, particularly freelance artists, should exercise extreme caution in this area. Of course, common themes and images, such as squares or triangles, are in the public domain and may be used freely. Infringement requires copying substantial portions of a work, so a mere similarity in style or concept will not automatically constitute an infringement.

Because of the privacy and infringement risks, many advertisers and publishers carry special liability insurance to cover these types of claims. That, however, may not provide complete protection, particularly for the freelance artist, who may be sued along with the client. Sometimes clients insist that artists incorporate images that might infringe on someone's right of privacy or copyright. Artists need to incorporate an indemnification clause in their agreements that hold the artist harmless in this situation.

A sample indemnification clause reads as follows: "You [client] agree to indemnify and hold [artist] harmless against all claims, including but not limited to claims of copyright or trademark infringement, violations of the rights of privacy or publicity or defamation, arising out of use of [the work]." Many contracts today require an artist to warrant that the work does not infringe on any other work, and they demand that the artist hold the company harmless for any action arising from breach of this warranty. It is possible to rewrite and limit these clauses to minimize the artist's liability. For example, artists can rewrite the warranty clause so that they are not responsible for infringements arising from any reference or textual material provided by the client. Artists can also limit the warranty so that it does not infringe "to the best of the artist's knowledge and belief." And they can limit liability to judgments arising from an actual breach of warranty, rather than any action taken against the company.

Compulsory licensing

A provision of copyright law dealing with compulsory licensing permits a noncommercial, educational broadcasting station to use certain published work without the artist's consent so long as the station pays the government-set royalty rate. (However, some published works, such as dramatic ones, are not covered by this license.) If the broadcaster doesn't pay the license fee, or underpays it, the use will be considered an infringement.

Programs produced independently for airing on public stations are eligible for compulsory licenses, but the license does not extend to secondary (after-broadcast) markets such as merchandising, toys, books, or videocassette sales.

The Copyright Royalty Tribunal Reform Act passed by Congress on December 17, 1993, established copyright arbitration royalty panels (CARPs) that set rates of compensation for the use of musical, graphic, sculptural, and pictorial works by noncommercial educational broadcasting stations. The law also allows interested parties to negotiate voluntary agreements instead of invoking a CARP. Three panelists are chosen from lists of arbitrators provided by arbitration associations. Two of them are appointed by the Librarian of Congress upon the recommendation of the Register of Copyrights, and those two choose the third panelist from the same list.

A CARP convenes every five years and weighs evidence presented by copyright users (the Public Broadcasting System, National Public Radio, college and religious stations) and copyright owners (ASCAP, BMI, SESAC, and organizations representing visual artists) before deciding on rates of compensation. Rates are set for unlimited broadcast use for three years from the date of the first broadcast use under the schedule. Succeeding broadcast use periods require the following additional payment: second three-year period, 50 percent; each three years thereafter, 25 percent.

Users are required to make payments to each copyright owner no later than July 31 of the calendar year for uses during the first six months of that calendar year and no later than January 31 for uses during the last six months of the preceding calendar year.

Users are also required to maintain and furnish, either to copyright owners or to the offices of generally recognized organizations representing the copyright owners of pictorial, graphic, and sculptural works, copies of standard lists containing the works displayed on their programs. These lists should include the name of the copyright owner, if known; the specific source from which the work was taken; a description of the work used; the title of the program on which the work was used; and the date of the original broadcast of the program.

If the Public Broadcasting System and its stations are not aware of the identity of, or are unable to locate, a copyright owner who is entitled to receive a royalty payment, they are required to retain the required fee in a segregated trust account for three years from the date of the required payment. After the three-year period expires, no claim to such royalty fees is considered valid.

2 Legal Rights & Issues

Copyright extension

As a participating member in the Coalition of Creators and Copyright Owners, the Graphic Artists Guild has long advocated extending the term of United States copyright law from life plus 50 years to life plus 70 years, which brings it into harmony with most other Berne Convention signatories. The Copyright Term Extension Act, passed by the 105th Congress and signed into law by President Clinton in 1998, did just that. Approximately 20 organizations in the coalition supported extending the term of copyright for the following reasons, among others:

- Artists and other authors now live longer, and the term of copyright needs to reflect that. Further, currently created works now have greater value for longer periods of time.
- A longer term of copyright is good for American business. United States copyright and related industries account for more than 5 percent of the gross national product and export goods and services totaling more than \$60 billion per year. More than 5.5 million Americans work in copyright industries, and they account for over 5 percent of the nation's employment.
- Term extension allows the United States to continue to be a leader in international copyright. Intellectual property generally, and copyright in particular, are among the brightest spots in our balance of trade. Copyrighted works the world wants are overwhelmingly those created in the United States.
- The primary reason for passage of this law was to bring U.S. copyright terms into harmony with other Berne Convention signatories so that European copyright owners would not have an unfair advantage over U.S. rights' holders.
- Term extension discourages retaliatory legislation and trade policies by other countries. The European community extends protection to foreign copyrights under the "rule of the shorter term," which limits protection in the European community to the length of the term in the home country. Failure to extend the United States term would protect United States copyrights for the shorter term of life plus 50 only, while protecting European copyrights for the longer term. This would have placed United States copyright holders at a tremendous disadvantage in the global marketplace.
- Worldwide harmonization facilitates international trade and a greater exchange of copyrighted property between countries.

For reasons of simplification, the 20-year term extension was applied across the board to all copyrights, including works for hire, which have been extended from 75 to 95 years. This is a major drawback for artists seeking to reclaim their copyright. The Graphic Artists Guild strenuously opposed lengthening the copyright term of works for hire, as it might provide an incentive for more work-for-hire agreements. However, it is too soon to tell whether the extension will affect the negotiating relationship between artists and clients. More importantly, since work for hire does not exist in most other countries that signed the Berne Convention, this extension creates disharmony with practices in other countries.

Digital Millennium Copyright Act

The Digital Millennium Copyright Act (DMCA) of 1998 added several new sections to copyright law, one of which is of particular concern to graphic artists. Section 512 defines and protects online service provider liability by preventing a service provider from being sued for copyright infringements carried by its service in relation to the following four areas: transitory communications (e-mail), system caching, storage of information on systems or networks at the direction of users (Web sites), and information location tools (browsers).

While this may not seem of benefit to graphic artists, it does have important ramifications in two areas: the removal or blocking of infringing material and the terms of service imposed by online service providers. The first area is of particular concern because of the *Kelly v. ArribaVista* case. Photographer Les Kelly sued ArribaVista for vacuuming his images off the World Wide Web and displaying them on its commercial search engine without his knowledge or permission. In November 1999 the U.S. District Court ruled that the search engine's unauthorized copying and display of Kelly's copyrighted images falls under "fair use" and that the DMCA had not been violated as Kelly had charged. Because of the huge impact this decision can have on the DMCA and on intellectual property rights on the Web, Kelly is appealing the ruling (as of the time this book went to press in March 2001) with the aid of the Graphic Artists Guild Legal Defense Fund (for more information, see that section in Chapter 14, The Graphic Artists Guild).

The ArribaVista site now (ditto.com) and browser are "information locators" within the meaning of Section 512. To avoid liability, such a provider must not know that the material on its site is an infringement. If it has the right and ability to control the infringing activity, the provider must not receive a financial benefit directly attributable to the activity. Upon receiving notice of infringement, the provider must expeditiously remove or block access to the material.

In the case of ditto.com, the site will remove material upon receiving objections. Whether these individual removals will be sufficient to protect a site where the entire activity appears to be based upon using infringed images until objections are received, or whether the court on appeal will address the overall infringement procedure of the site, remains to be seen.

If an entity qualifies as a service provider (for criteria see the Copyright Office Web site lcweb.loc.gov/copyright) and (1) adopts and reasonably implements a policy of terminating in appropriate circumstances the accounts of subscribers who are repeat infringers, and (2) accommodates and does not interfere with "standard technical measures," it will not be liable for the infringements of subscribers. This means that the service provider cannot interfere with a copyright owner's watermarking or other protective measures.

To avail themselves of the protections offered in Section 512, service providers must file the name of a designated agent with the Copyright Office to receive notification of claimed infringements. The service provider is eligible for limitation from liability only if it does not have actual knowledge of the infringement. Section 512 (c)(3) provides for a notice and takedown procedure, under which a copyright holder submits a notification to the provider's designated agent. The notification, made under penalty of perjury, must describe the elements of the infringement. To retain its exemption from liability, the service provider must promptly remove or block access to the material identified in the notification.

The service provider is protected against claims from the allegedly infringing subscriber by having taken down the material, but it must promptly notify the subscriber that it has done so. The subscriber may serve a counternotification, under penalty of perjury, that the material was wrongly removed. Unless the copyright holder files an action against the subscriber, the service provider must put the material back up within 10 to 14 business days after receiving the counternotification.

This procedure offers graphic artists and other copyright holders rapid relief from online infringements pending resolution of a copyright dispute, rather than requiring a matter to be first adjudicated through the court system. Note, however, that to preserve blocking or disabling the claimant must file a court action in a very short period of time. A completed copyright registration is necessary to embark on any court action. Given the long lead time that registration requires (between six and eight months), it is clearly unwise to leave work unregistered and particularly unwise to post any unregistered work online.

The requirements of Section 512 generally specify that the service provider must not modify transmitted material, must not have knowledge that the material is infringing, and must not receive any financial benefit directly attributable to the infringing activity. This raises interesting issues regarding provider terms of service. Many service providers claim for themselves a nonexclusive copyright interest in their subscribers' material as part of their terms of service. These have included claims of the right to alter the work, prepare derivative works, and make use of the works in various ways that potentially offer financial benefit. The requirements of Section 512 call the legality and enforceability of these terms of service claims into question.

Section 512 is designed to render the service provider as neutral a conduit as possible. As the service provider cannot know in advance whether material from a particular subscriber is infringing or not, it must treat all material with equal impartiality in order to retain its immunity from liability. It therefore seems that any term of service under which a service provider demands a copyright interest in a subscriber's work has the potential to remove the service provider from the liability protection that the DMCA provides. This aspect of the new law has not yet been explored in the courts.

The obvious conclusion is that all creators should register their work and familiarize themselves with the provisions of Section 512 so that they may be prepared to make use of the protections it offers. To learn more about Section 512 and other aspects of the DMCA, visit the Copyright Office Web site (lcweb.loc.gov/copyright).

States liable for copyright infringement

The U.S. Copyright Act, in establishing sanctions (monetary damages, fines, injunctions) against infringement, intended these sanctions to apply to "anyone who violates any of the exclusive rights of the copyright owner." According to the Copyright Office, "anyone" was meant to include states, state institutions, and state employees. But in 1985, the Supreme Court ruled in a five-to-four decision that the Eleventh Amendment to the Constitution, which generally grants states immunity from lawsuits and monetary judgments in federal courts, could not be negated by Congress except by explicit and unequivocal language. Subsequent courts decided that under this test the Copyright Act's language was not specific enough and so opened the door for many state-funded institutions to use copyrighted materials without permission, without paying or giving credit, and without fear of reprisal from the copyright owner.

In 1990 Congress corrected this inequity by passing the Copyright Remedy Clarification Act. Now states and their agents are once again subject to all penalties and sanctions for copyright infringement. Grassroots lobbying by the Guild and its members helped obtain passage of this new law.

Further information on copyright

For further information on copyright, artists can send for a free copy of the Copyright Information Kit from the Copyright Office, Information and Publications Section, Library of Congress, 101 Independence Ave., S.E., Washington, DC 20559-6000; consult the Copyright Office Web site at www.loc.gov/copyright; or call the Public Information Office at 202.707.3000 for recorded information available 24 hours a day, 7 days a week. Information specialists are on duty from 8:30 a.m. to 5:00 p.m. (EST) Monday through Friday except holidays (the TTY number is 202.707.6737). Application forms for registration or informational circulars can be requested from the Forms Hotline at 202.707.9100. Allow two to three weeks for delivery. The Copyright Office will accept photocopied forms if they are clear, legible, and on a good grade of $81/2" \times 11"$ white paper, suitable for automatic feeding through a photocopier. The forms should be printed in black ink, back to back and head to head (so when the sheet is turned over, the top of page 2 is directly behind the top of page 1).

\rightarrow Work for Hire

"Work for hire" is a provision of the U.S. Copyright Act intended as a narrow exception to the general rule that the artist or author who actually creates the work owns the copyright to it. The provision transfers authorship and ownership to the employer or other hiring party who commissions the work, leaving the artist with no rights whatsoever. While such a result may be justifiable in a traditional employment setting, the freelance artist, considered to be an independent contractor for all purposes except copyright, has no access to the usual employee benefits that may compensate for the loss of that copyright and the future earnings it may represent.

Under the law, a work made for hire can come into existence in two ways: an employee creating a copyrightable work within the scope of employment; or an independent contractor creating a specially ordered or commissioned work in one of several categories, verified by a written contract signed by both parties and expressly stating that it is a work for hire.

2 Legal Rights & Issues

An employed artist is usually defined as one who works at the employer's office during regular business hours on a scheduled basis, is directed by the employer, and works with tools supplied by the employer. (An artist in this relationship with an employer is an employee who is entitled to employment benefits and has taxes withheld from his or her paycheck.) For further details, see the *CCNV v. Reid* section below and the Employment Issues section of Chapter 3, Professional Issues.

However, even as an employee an artist may negotiate a separate written contract with the employer, apart from the employment agreement, that transfers copyright ownership to the artist in some or all of the work created in the regular course of employment. And it is also possible, though highly unusual, for an artist working under a work-for-hire agreement to receive royalties according to a written contract.

Work created by a freelance artist can be work for hire only if the following two conditions are met: the artist and client sign an agreement stating that the work is for hire; and it falls under one of the following nine categories as enumerated in the law:

- 1. A contribution to a collective work (such as a magazine, newspaper, encyclopedia, or anthology).
- 2. A contribution used as part of a motion picture or other audiovisual work.
- **3.** A supplementary work, which includes pictorial illustrations, maps, and charts, done to supplement a work by another author.
- 4. A compilation (new arrangement of preexisting works).
- 5. A translation.
- 6. An atlas.
- 7. A test.
- 8. Answer material for a test.
- **9.** An instructional text (defined as a literary, pictorial, or graphic work prepared for publication and with the purpose of use in systematic instructional activities).

Works that fall outside these categories, like sculpture, are clearly ineligible to be work for hire, even with a signed contract. Not so clear are works like comic books, print advertising, or Web sites. Some clients may add fallback language in a work-for-hire contract that provides for all-rights transfers if a work is deemed not for hire. However, creators should resist signing such contracts and should challenge them if a commissioned work does not fall within the specified categories. Ultimately, the courts may have to determine a particular work's eligibility.

These criteria apply only to work done on special order or commission by an independent contractor. If there is no written agreement, if the agreement does not specifically state that the work is made for hire, if such an agreement is not signed, or if the work does not fall into one of the above categories, then there is no work for hire, and the artist automatically retains authorship recognition and copyright ownership.

By signing a work-for-hire contract, a freelance artist becomes an employee only for the purposes of copyright law and for no other purpose. In addition to losing authorship status, the artist receives no salary, unemployment, workers compensation, or disability insurance benefits; nor does he or she receive health insurance, sick pay, vacation, pension, or profit-sharing opportunities that a company may provide to formal, salaried employees. When a freelance artist signs a work-for-hire contract, the artist has no further relationship with the work and cannot display, copy, or use it for other purposes such as in the artist's portfolio without relying on a claim of fair use. The client, now considered the legal author, may change the art and use it again without limitation.

Some clients still attempt to gain windfall benefits from work for hire where there was no signed agreement by claiming that extensive supervision, control, and direction made the artist an employee, and therefore the work was for hire. The Supreme Court resolved the issue in *CCNV v. Reid* (see below), affirming that in virtually all cases commissioned works executed by independent contractors cannot be works for hire unless the work falls into one of the nine specified categories listed above and a written agreement stating the work is for hire has been signed by both parties.

The Graphic Artists Guild is emphatically opposed to the use of work-for-hire contracts. Work for hire is an unfair practice that strips the artist of the moral right of paternity—the right to be recognized as a work's author (see section on Moral Rights below). It gives art buyers economic benefits and recognition that belong to the creative artist. Such contracts devalue the integrity of artists and their work by empowering buyers to alter the work without consulting the artist and by preventing artists from obtaining any payment for the future use of their work.

Work for hire abuses

Clients who insist on a work-for-hire arrangement may resort to other means that, while unethical, are not prohibited under current copyright law. Some businesses coerce freelancers by denying assignments to artists who do not accept work for hire. Some clients attempt to designate a work as for hire after the fact by requiring that the artist endorse a payment check or sign a purchase order on which work-for-hire terms appear (usually in fine print). Unless this confirms a previous oral agreement, artists who encounter this should request a new payment check (see *Playboy Enterprises, Inc. v. Dumas* below) or cross out the unscrupulous statement.

Some work-for-hire contracts understood by the artist to be for a single project may actually have work-for-hire language that covers all future work. Artists entering the industry are especially vulnerable to such blanket work-forhire agreements; unfortunately, by the time they have the reputation to resist work for hire, clients already have the artist's agreement on file.

With the growth of technology, and as-yetunimagined vistas opening in corresponding media, many clients have begun adding increasingly broad rights-ownership language to contracts. Artists should be alert to any clauses buying "all electronic rights" or "all rights in all media now in existence or invented in the future in perpetuity throughout the universe." These overly broad grants of rights effectively give the purchaser indefinite and unspecified use of a creator's work without additional compensation or input into uses. Such clauses can be as damaging to artists as traditional work-for-hire arrangements; artists lose valuable sources of future income and control over their images and reputations. Historically, artists and other creators have

2 Legal Rights & Issues

been able to withstand such onslaughts by negotiating strenuously both individually and collectively. (For more information on artists' negotiating options, see Chapter 5, Essential Business Practices.)

CCNV v. Reid

In 1989 the Supreme Court ruled unanimously that the employee clause in the Copyright Act could not be applied to independent contractors. However, if the relationship between the artist and the hiring party was determined to be one of conventional employment based on the application of a rigorous test of thirteen factors (based on English common law), then the created work would be considered made for hire.

The landmark case pitted freelance sculptor James Earl Reid against homeless advocate Mitch Snyder and the Community for Creative Non-Violence (CCNV) over a commissioned sculpture created by Reid but conceived and partly directed by Snyder. Even though there was no written contract between the parties, and even though sculpture does not fall into any of the nine categories of specially ordered works, the District Court found Reid to be an employee because he was under Snyder's "supervision and control" and awarded the copyright to CCNV.

The factors the Supreme Court relied upon in deciding James Reid's employment status were:

- The hiring party's right to control the manner and means by which the product was accomplished.
- The skill required.
- The source of the "instrumentalities" and tools.
- The location of the work.
- The duration of the relationship between the parties.
- Whether the hiring party had the right to assign additional projects to the hired party.

- The hired party's discretion over when and how long to work.
- The method of payment.
- The hired party's role in hiring and paying assistants.
- Whether the work was part of the regular business of the hiring party.
- Whether the hiring party was in business.
- The provision of employee benefits.
- The tax treatment of the hired party.

The Court made it clear that no one of these factors is determinative, but that all factors must be examined. In applying them to the Reid case, the Court found Reid clearly to be an independent contractor, not an employee.

The practical consequences of this landmark decision are that some clients have reexamined their policies of insisting on work for hire, determining that it is more desirable and economical to purchase only the specific rights needed. Those clients who insist on work for hire must comply strictly with the requirement for written agreements that state expressly that a work is for hire.

Although the Supreme Court decision narrowed one loophole, it may have widened others. Under the "joint authorship" provision of the Copyright Act, a work may be presumed to be a collaborative effort between the artist and the client, granting each party the right to exploit the work independently of the other without regard to the importance of their respective contributions—if each party's contribution is copyrightable-so long as profits are accounted for and divided equally. In the Reid case, for example, it was ultimately decided that the sculptor retained the right to make two- and three-dimensional copies of the work, while CCNV retained the right to make such two-dimensional copies as Christmas cards and posters.

Playboy Enterprises, Inc. v. Dumas

The practice of introducing back-of-check contract terms, used by some clients to force a work-for-hire arrangement, was severely limited by a 1995 federal court decision in the case of *Playboy Enterprises Inc. v. Dumas*. Let stand by the U.S. Supreme Court, the Second Circuit Court of Appeals unequivocally rejected declarations of a for-hire agreement after the contract was fulfilled. However, the Appeals Court did not agree, as the Graphic Artists Guild argued in its amicus curiae brief, that work-for-hire agreements must be established in writing before work begins.

The case of *Playboy Enterprises v. Dumas* resulted from an attempt by the widow of artist Patrick Nagle, Jennifer Dumas, to sell originals of her husband's work after his death that had been commissioned by *Playboy*. He had endorsed checks with work-for-hire language on the back; therefore, claimed *Playboy*, the company was the legal author of the work and sued the widow for copyright infringement.

The Court decided "that the written requirement can be met by a writing executed after the work is created, if the writing confirms a prior agreement, either explicit or implicit, made before the creation of the work." The language of the decision may unfortunately open the door to a flood of court actions if unscrupulous clients claim there was an "implicit" work-for-hire agreement, prior to creation, when in fact none existed.

The Graphic Artists Guild strongly recommends that artists and clients confirm all assignments in writing before work begins, detailing the terms of the agreement and the specific rights licensed. This professional practice avoids any confusion, misunderstanding, or legal action concerning the rights sold.

Artists confronted with work-for-hire language on the back of checks may consider crossing it out and writing "deposited without preconditions" to mitigate the attempted rights' grab.

Rights of Celebrity & Privacy $^{\Box}$

Thanks to Robert W. Clarida, an associate in the New York law firm of Cowan, Liebowitz & Latman and an expert on intellectual property issues, for contributing this section. The material is reprinted in a slightly abridged form from the Guild News.

Artists are occasionally asked by clients to reproduce or imitate images of public figures, buildings or landmarks, or another artist's work. The potential for right of publicity infringement in such cases is serious and underscores the need for including indemnification clauses protecting artists in all contracts.

The right of publicity

Unlike copyrights and trademarks, the right of publicity is not created by federal law but by the laws of each individual state. These laws vary greatly in their details, but most states recognize a general right for a person to control the commercial use of his or her name, likeness, and other aspects of "personal identity." In an obvious example, every state in the union would prohibit The Gap from selling T-shirts bearing the likeness of Monica Lewinsky without her permission. Some states have enacted statutes to govern these rights, some rely on "common law" principles developed by the courts, and some, like California, recognize both. Not surprisingly, these state laws are extremely inconsistent. In New York, the right of publicity is written into the state Civil Rights statute, which provides that "any person whose name, portrait, picture or voice is used within this state for advertising purposes or purposes of trade without the written consent" of the subject may be sued for injunctive and monetary relief. Significantly, this right extends to "any person" in New York, not merely to celebrities or people in the public eye. So in New York, at least, it's illegal to market a sketch of the corner grocer as a poster for Boar's Head cold cuts, no matter how unknown he may be.

In California, the statute covers largely the same conduct as the New York law but can also protect the rights of the deceased, both famous and obscure. Under New York law, once a person is dead they have no more right of publicity: witness throngs of vendors selling unauthorized John Lennon merchandise outside the Dakota apartment building where Lennon used to live. So long as those vendors sell their wares only in New York, and do not otherwise violate the trademark laws (merchandise that suggests a false endorsement by the singer might be actionable under the federal Lanham Act, for example, even if it did not violate state law), they are doing nothing wrong, because under New York law Lennon's right of publicity died with him (Wisconsin law also limits coverage to living people).

However, those same vendors could not operate legally in California. The California statute allows the heirs or survivors of a deceased "personality" to continue to control that person's right of publicity for 50 years after death, provided they register with the Secretary of State and pay a small fee. Indeed, even without filing the necessary paperwork, the heirs of a deceased person can enjoin unauthorized uses in California; but they cannot recover monetary damages until they have complied with the statutory formalities.

Other states go even further in granting postmortem rights of publicity, with Indiana and

2 Legal Rights & Issues

Oklahoma protecting the right for 100 years after death and Tennessee, home of the late Elvis Presley, recognizing it in perpetuity, so long as it continues to be used for commercial purposes. Other states, such as Washington, provide for a 10-year postmortem right for ordinary people but offer 75 years of protection for those whose images have "commercial value." Accordingly, it seems safe to assume that even the long-deceased may have enforceable rights of publicity somewhere.

Exceptions

There are several limitations and exceptions to the right of publicity, most importantly those involving First Amendment protection for "newsworthy" images. The same likeness of Monica Lewinsky that would be prohibited on a T-shirt may be permissible as an illustration for an article in a commercial publication if two conditions are met. First, the image must bear some reasonable relation to the content of the article. Second, the article must concern a matter of legitimate "public interest," a broad concept that encompasses everything from hard news to celebrity gossip. As the courts have defined it, virtually any story or article will qualify as a matter of public interest, so long as it is not merely an advertisement in disguise. Moreover, if the story itself is legitimate and the image is reasonably related, the likeness can also be used on posters and billboards advertising the publication, on the theory that the protected nature of the initial use extends to advertisements for the protected speech.

In addition, both California and New York recognize a "fine-art" exception, also rooted in the First Amendment. The California statute exempts "single and original works of fine art," which would appear to be limited to unique works, not including mass-produced reproductions. It is unclear whether the term "fine art" in this section is intended to apply only to works of "recognized quality," as determined by expert opinion, or to any original work in a graphic or sculptural medium. It is also unclear whether "works prepared under contract for commercial use" could qualify for the exemption. (The California Art Preservation Act defines "fine art" as meaning only works "of recognized quality," but not including works made under contract for commercial use, while the California Resale Royalties Act applies to "an original painting, sculpture, or drawing, or an original work of art in glass." The right of publicity statute does not include any definition of the term "fine art.") However, the statute does clearly provide that as with newsworthy publications, advertisements for legitimate works of fine art, such as gallery posters, do not violate the statute.

In New York, there is no direct statutory language regarding fine art, but the courts have recently interpreted the statute to exempt two- and three-dimensional works of art from the law. In *Simeonov v. Tiegs*, the Civil Court held that an artist who created a plaster casting of model Cheryl Tiegs could "sell at least a limited number of copies" of the work without violating Tiegs' right of publicity because such activities did not amount to a use of her likeness "for purposes of trade." In this case, the New York statute was read to permit the sale of reproductions, at least in small numbers, to avoid creating a possible conflict between the state statute and the First Amendment.

Obtaining permission: when and from whom?

If none of the exceptions apply to a particular project, and the subject has not been deceased for at least 100 years, a graphic artist may decide that permission is required. If possible, think about this issue sooner rather than later. Under both the New York and California statutes, the subject's written consent must be obtained before the use occurs. Finally, it is necessary to obtain permission from all the proper parties. In a recent case, *Wendt v. Host International, Inc.*, a corporation licensed the rights to make life-size robotic replicas of the characters "Norm" and "Cliff" from the TV series *Cheers.* Even though the copyright owner of the show granted permission, George Wendt and John Ratzenberger, the actors who portrayed the characters, brought a successful action for violation of their rights of publicity under California law.

There has been some discussion in recent years about creating a single federal right of publicity statute that would eliminate the confusing inconsistencies in the various state laws, but no such change in the law is expected anytime soon. Until it happens, the prudent graphic artist has only two choices: master the byzantine laws of all 50 states or get those model releases.

Legal case

One 1995 case that threatened the artist's right to reproduce a trademark in a painting involved the use of celebrity animals and images associated with professional sports. Visual artist Jenness Cortez was sued by the New York Racing Association (NYRA) in July 1995 for her use of the Saratoga Race Track, including the use of the word "Saratoga," in her original paintings, etchings, and lithographs. The NYRA claimed the right to a portion of the income derived from the sales of her work. In August 1996 a U.S. District Court dismissed the case, saying Cortez's work was covered by the First Amendment. In a strongly worded decision affirming that artists can include trademarked images or symbols in their paintings, the judge noted, however, that the artist does not have the right to gratuitously include trademarks that are not already part of a particular scene. Though Cortez was subsequently sued by the owner and agents of the horse Cigar for trademark infringement and unauthorized use of the horse's image, that case was also settled in Cortez's favor in 1997.

Owners of some landmark buildings have begun trying to restrict the use of images of their buildings under trademark law. See the section on Trademarks below.

Moral Rights

Moral rights are derived from the French doctrine of *droit moral*, which recognizes certain inherent personal rights of creators in their works, even after the works have been sold or the copyright transferred. These rights stand above and distinct from copyright.

The doctrine traditionally grants to artists and writers four specific rights:

- The right to protect the integrity of their work to prevent any modification, distortion, or mutilation that would be prejudicial to their honor or reputation.
- The right of attribution (or paternity) to insist that their authorship be acknowledged properly and to prevent use of their names on works they did not create.
- The right of disclosure to decide if, when, and how a work is presented to the public.
- The right of recall to withdraw, destroy, or disavow a work if it is changed or no longer represents their views.

The Berne Convention

Moral rights have long been an integral part of copyright protection laws in most European nations but were largely rejected and ignored in the United States. In 1886 the United States refused to join the Berne Convention, a worldwide multinational treaty for the protection of literary and artistic works that accepted moral rights as a matter of course. Member nations participating in Berne are required to frame their copyright laws according to certain minimum standards and to guarantee reciprocity to citizens of any other member.

However, after 100 years, economic realities and skyrocketing foreign piracy forced the United States to seek entry into the Berne union. By that time, the 1978 Copyright Act had brought the United States closer to other Berne standards. For example, duration of copyright was extended from a term of 28 years, renewable only once, to the life of the creator plus 50 years. Regulations eliminating the necessity of placing a notice on a work as a requirement for bringing a lawsuit were also implemented.

Several states have enacted various forms of moral rights statutes, due in great part to the Guild's involvement. Certain moral rights elements have also been protected in state and federal courts, which saw them as questions of unfair competition, privacy, or defamation. The totality of the American legal system, therefore, persuaded Berne administrators that the United States qualified for membership.

In 1988 the United States became the eightieth country to sign the Berne Convention, thereby extending protection to American works in 24 nations with which the United States had no separate copyright agreements. This also succeeded in stemming the loss of billions of dollars in royalties to copyright owners. Although works are now protected the moment they are created, and the Berne Convention does not require copyright notice, it is still advisable to affix a copyright notice (© Jane Artist 2001 or Copyright, Jane Artist, 2001) because it bars the defense of innocent infringement in court and also because it affords international copyright protection in those countries that are members of the Universal Copyright Convention (UCC), which still requires a copyright notice on a work. Although foreign works are currently exempt from American registration requirements (until the law is changed), American works still have to be registered with the U.S. Copyright Office before their creators can sue for infringement, statutory damages, and attorney's fees.

The Visual Artists Rights Act

Most of the cases that have brought moral rights problems to the public's attention revolve around mutilation of works of fine art. Some memorable cases include Pablo Picasso's "Trois Femmes," which was cut into one-inch squares and sold as original Picassos by two entrepreneurs in 1986; the destruction and removal of an Isamu Noguchi sculpture from a New York office lobby; and the alteration by the Marriott Corporation of a historic William Smith mural in a landmark Maryland building.

A much publicized case in the graphic arts arena involved Antonio Vargas's series "The Vargas Girls," which ran in *Esquire* magazine. After Vargas's contract with *Esquire* expired, the magazine continued to run the series under the name "The Esquire Girls" without giving Vargas credit. Vargas brought *Esquire* to court but lost the case. The court found that he had no rights left under the contract, even the right to his own name.

Moral rights legislation at both the state and federal levels has been proposed and supported vigorously by the Graphic Artists Guild since the late 1970s. Successes in California (1979), New York (1983), Maine and Massachusetts (1985), and other states established the momentum to advance a federal version.

By presenting testimony about the problems that illustrators and designers face, the Graphic Artists Guild has been able to broaden state legislation. For instance, members of the Graphic Artists Guild have strongly argued that the appearance of their artwork with unauthorized alterations or defacement can damage an otherwise vital career. The state bills the Guild helped to pass recognize artists' ongoing relationships with the work they create.

The Visual Artists Rights Act was finally enacted by Congress in 1990. Unfortunately, though a positive first step toward comprehensive moral rights legislation, the act has limited application and, ironically, may invalidate, through federal preemption (discussed below), many state statutes that may be far more protective.

The law covers only visual arts and only one-of-a-kind works that are defined as paintings, drawings, prints, photographs made solely for exhibition, and sculptures, existing in a single copy or in a limited edition of 200 or fewer copies, signed and numbered consecutively by the artist. Specifically excluded are any kind of commercial or applied arts (advertising, promotion, packaging); posters, maps, charts, and technical drawings; motion pictures and other audiovisual works; books, magazines, newspapers, and periodicals; electronically produced work; any work for hire; and any noncopyrightable work.

The moral rights protected are limited to those of attribution and integrity. Any distortion, mutilation, or other modification of a work must be intentional. Mere natural deterioration is not actionable unless caused by gross negligence. In addition, the act places two burdens on the artist: to prove that a threatened action would be "prejudicial to his or her honor or reputation" and, to prevent destruction of a work, to prove that it is "of recognized stature." Since no guide-lines are provided for either standard, their meaning will have to be determined in the courts on a case-by-case basis.

The law stipulates that these rights exist exclusively with the artist during his or

her lifetime and may not be transferred. They may be waived, but only by an expressly written and signed agreement. In the case of a joint work, each contributing artist may claim or waive the rights for all the others. The act also contains special provisions for removal of works that are parts of buildings (murals or bas reliefs), including a procedure to register such works.

A potential problem of the law is that it invokes the doctrine of federal preemption and can be read to supersede any existing state laws that protect equivalent rights against mutilation and defacement. Among the questions that will probably have to be answered in the courts are whether the state statutes, many of which apply to other visual works or extend greater protections, are completely preempted or only partially so, and whether they may be invoked after the death of the artist.

Resale Royalties

Another time-honored French doctrine, like moral rights, that transcends rights of copyright and ownership of the original work in most Berne signatory countries is known as *droit de suite*. It grants to creators a share in the value of their works by guaranteeing a certain percentage of the sale price every time a work is resold.

In the United States such rights, known as resale royalties, exist only in California. A provision for resale royalties had been part of the original draft of the Visual Artists Rights Act, but it was later dropped because of strong opposition from art dealers, auction houses, and museums. Under the act's authority, the Copyright Office conducted a study of adoption of resale royalty legislation and recommended against it, concluding that anticipation of potential royalties does not provide proper incentive for artists to be creative. Incredibly, the study suggested that resale royalties might actually have an adverse economic impact on artists, because buyers, anticipating having to pay a future royalty, might lower the amount they were willing to pay. The Copyright Office did suggest, however, that the issue be reexamined if the European community decided to harmonize existing *droit de suite* laws to extend resale royalty to all member states.

Practices Governing Original Art

Well-known illustrators can command high prices for the sale of original art. Many graphic artists also sell their work through galleries, to collectors, and to corporations. Original art may be exhibited, used as portfolio pieces, given as gifts, or bequeathed as part of an estate. Concern for protecting ownership of an original work stems not only from artists' interests in obtaining additional income from the sale of the original, but also from their interest in protecting their reputations and careers.

Ownership of the physical art, while separate from ownership of copyright, is similarly vested with the artist from the moment it is created. Selling the artwork does not transfer any rights of copyright to the buyer, just as selling the right of reproduction does not give a client any claim to the physical artwork.

The work may be given to the client temporarily so reproductions can be made, but the client must take reasonable care of it and return it undamaged to the artist. Of course, separate fees can be negotiated with a client or any other party who wishes to buy the physical artwork. The artist who wishes to sell original art should stipulate on the invoice or bill of sale the extent of any copyright interest that is also being sold with the original. To be able to license any copyright interest he or she has decided to keep, the artist should also keep a reproduction-quality transparency on file.

Laws Defining Fair Practices

The Fair Practices Act, signed into law in Oregon (Sections 359.350 to 359.365 of Rev. Stat., 1981), California (Section 988 of Civil Code, 1982), and New York State (Sections 1401 & 1403 of Arts & Cultural Affairs Law and "Artists' Authorship Rights" Law, Article 12-J of General Business Law, 1983), clarifies who owns the original work of art when reproduction rights are sold. This legislation was drafted by the Guild's attorneys based on concerns raised by Guild members.

The act provides that an original work of art can become the property of a client only if it is sold in writing. The passage of this act reinforces one of the premises of the copyright law: that works of art have value beyond their reproduction for a specific purpose and that this value rightly belongs to the artist who created them. The Fair Practices Act prevents clients from holding on to originals unless they have written sales agreements with the creator. In those states where it applies, this act solves problems that can arise when clients believe they have obtained ownership of the original art when in fact they have only purchased rights of reproduction, or when they believe they have obtained an original through an ambiguous oral agreement.

In Oregon and California the law also provides that any ambiguity as to the ownership of reproduction rights shall be resolved in favor of the artist. For artists whose livelihoods depend on resale of reproduction rights and on sales of original works, the law is critical.

Another important piece of legislation that prevents unauthorized reproduction of artwork was enacted by a Georgia statute in 1990. The Protection of Artists Act requires commercial printers to obtain written affidavits from their clients attesting that the artist has authorized the reproduction of the work when the printing of the art (painting, drawing, photograph, or work of graphic art) costs \$1,000 or more. Echoing the federal copyright law, the Georgia law separates the ownership of artwork from the right to reproduce it and puts clients on notice that bills of sale or purchase orders must state explicitly the extent of the rights purchased. Any client or printer who uses or reuses artwork without the written permission of the artist is subject to misdemeanor penalties. The Atlanta Chapter of the Guild was instrumental in getting the law passed.

Trademarks

A trademark may be a word, symbol, design, or slogan, or a combination of words and designs, that identifies and distinguishes the goods or services of one party from those of another. Trademarks identify the source of the goods or services. Marks that identify the source of services rather than goods are typically referred to as service marks (the Graphic Artists Guild logo, the Guild's service mark, appears in print with an ®). Normally, a trademark for goods appears on the product or its packaging, while a service mark is usually used to identify the owner's services in advertising. The protection given to trademarks and service marks is identical, and the terms are sometimes used interchangeably.

While a copyright protects an artistic or literary work and a patent protects an invention, a trademark protects a name or identity. For example, Adobe® is the word used as the trademark for certain software products, Mickey Mouse is a

Z Legal Rights & Issues

trademarked character for Disney, and Amtrak is a service mark for railroad service. Sounds, such as jingles, can also be used as trademarks, as can product shapes or configurations such as McDonald's distinctive golden arches.

Trademark protections can last indefinitely if the mark continues to be used for source identification. A valid trademark gives the owner the right to prevent others from using a mark that might be confusingly similar to the owner's mark. If anyone else uses the mark for similar goods or services, and it is similar in sound, connotation, or appearance, then the first user can prevent the late comer from using the mark. The test for infringement is whether there would be a likelihood of confusion as to the source of the goods and services.

For maximum trademark protection, a party using a trademark in interstate commerce should register it for \$245 with the U.S. Patent and Trademark Office (PTO), Washington, DC 20231. It is recommended that a search be conducted to determine whether the trademark is already in use by another party, since the application fee will not be refunded if the application is rejected. Basic information about trademarks can be obtained by calling the PTO at 800.786.9199 or consulting the PTO Web site at www.uspto.gov.

To date, 78 locations around the country have been designated as Patent and Trademark Depository Libraries. The depository receives a CD-ROM database directly from the PTO from which information can be retrieved free of charge via public access terminals. Library personnel will answer general—but not legal questions and provide preliminary instructions on how to conduct a search. Current listings of attorneys and agents specializing in patents and trademarks are also available at the depository. Call the PTO for the location of the nearest library.

The owner of a federal trademark registration may give notice of registration by using the ® symbol, which can only be used after the mark is registered. Trademark owners who do not have federal registration must use the symbol [™] for trademarks. The symbol [™] is used for service marks, for which registration is not required.

While not mandatory, federal registration protects the trademark throughout the United States, even in geographical areas in which the trademark is not used. Federal registration is legal evidence of trademark ownership and the exclusive right to use it in interstate commerce. As in copyright, someone with a federal registration can file infringement suits in federal courts and be eligible for special remedies, including attorneys' fees and damages, when infringement is proved.

A relatively new application of trademark law is being attempted by the owners of landmark buildings, such as the Chrysler Building, Rockefeller Center, or the Flatiron Building in New York City, who are trying to prevent use of illustrations or photographs of their buildings on everything from advertising to note cards and textbooks. The problem is now trickling down to the illustrator and graphic artist who works either on assignment for a client or selling stock. Clients are becoming gun-shy in the face of demand letters by large corporate building owners requiring that creators of images supply property releases or clear the usage rights. In many cases this simply results in another type of work being chosen for the job. No own wants to risk legal action or having to pull an advertisement after it has been created. Few creators can afford to be caught in a lawsuit over usage rights.

However, some suits have been filed. For instance, the Chrysler Building demanded that Fishs Eddie, a Manhattan tableware store, cease selling a line of "212" dishes, claiming that the illustration on the tableware violates its trademark of the Chrysler Building. (The dishes contain illustrations of iconic buildings from the jazz age, including the renown Chrysler spire.) The New York Stock Exchange, alleging trademark violation, has sued a casino in Las Vegas for building a model of its facade on their gambling floor. The artist Karen Nangle, known for her drawings of historic buildings in Savannah, Georgia, has received demands from the current owner of the city's Mercer/Williams House to cease distributing her cards of the house based on an alleged trademark violation.

While it is clear that owners of landmark buildings are going to continue to use trademark and any other laws to attempt to restrict the reproduction of their buildings, how the courts will apply the law of trademarks to buildings is still in the offing. Also in the balance is what significance this will have for creators and publishers of related images. Already publishers are avoiding the skylines of Dallas, Disneyland, and Las Vegas.

However, it is important to note that a 1999 ruling by the Federal District Court for the Northern District of Ohio held in favor of photographer Chuck Gentile against the Rock & Roll Hall of Fame. It denied the museum's request to stop the sale of a poster with a night photograph taken by Gentile of the Rock & Roll Hall of Fame. The ruling stated that (1) the Rock & Roll Hall of Fame's building design was not used as a trademark, so the poster could not infringe trademark rights; (2) Gentile did not use the poster as a trademark, so he was not infringing any alleged trademark rights; and (3) the use of the identifying phrase "Rock & Roll Hall of Fame" under the photograph was fair use and did not infringe any trademark rights.

While this decision cannot be construed to mean that no photograph or illustration of a building could ever violate a trademark, it seems very difficult after this decision for the owner of a building to convince a court that an image of a building infringed any trademark rights. This decision supports the position that in most situations a photograph or illustration of a building does not violate the building owner's trademark and additional permission is not required by law. Since trademark infringement turns on issues of confusion as to the origin of goods and services, it is still advisable to analyze each use on a case-by-case basis.

Trade Dress

Artists and designers need a way to protect against copycats who skim away cream assignments by passing off work at a lower fee. However, a style cannot be protected. The relatively new concept of "trade dress"—that part of trademark law that protects an established "look"—may be an important alternative for artists and designers to protect their works.

While copyright protects the tangible expression of an idea fixed in some tangible, reproducible format (written word, music, or image), "[t]he purpose of a trademark, service mark or trade dress is 'to identify one seller's goods and distinguish them from goods sold by others' " (McCarthy's *Trademarks and*

Z Legal Rights & Issues

Unfair Competition). "Trade dress is essentially [a work's] total image and overall appearance" and is "defined by its overall composition and design, including size, shape, color, texture, and graphics." Generally, the law governing trade dress (the Lanham Act) permits civil actions against any person whose false or misleading representation of fact is likely to cause confusion "as to the origin, sponsorship, or approval of his or her goods, services, or commercial activities by another person." An artist should be able to protect his or her work from unfair competition as long as it has a distinctive look and the identity of the creator is inherent to the work's value.

For example, in a 1986 Missouri case of particular interest to designers, Hartford House Ltd. claimed that Hallmark Cards' Personal Touch product line was confusingly similar to certain Blue Mountain Cards it produced. "The district court determined that the overall appearance or arrangement of features, i.e., the trade dress, of Blue Mountain's 'Airbrush Feelings' and 'WaterColor Feelings' lines of greeting cards had acquired a secondary meaning [and] that there was a likelihood of confusion among card purchasers as to the source." Here, " secondary meaning" implies that the public's perception of Blue Mountain as a source of greeting cards was more significant than its perception of any particular card. The district court granted a preliminary injunction.

Hallmark appealed, but the Court of Appeals affirmed the lower court's decision that certain greeting cards were protected under trade dress since they functioned as an origin of source and that trade dress is ascertained by looking at the functionality of the whole and not individual features. Since Hallmark could have used other designs that were not so similar to Blue Mountain's as to make them virtually indistinguishable, Hallmark was prohibited from marketing or advertising certain cards in their Personal Touch line that were determined to cause consumer confusion.

It's important to note that the Blue Mountain case does not "mean that artistic style is protectable under trademark law." The court was more specific: "Blue Mountain has not been granted exclusive rights in an artistic style or in some concept, idea or theme of expression. Rather, it is Blue Mountain's specific artistic expression, in combination with other features to produce an overall Blue Mountain look, that is being protected. This protection does not extend the protection available under trademark law and does not conflict with the policy of copyright law."

Given that unfair competition by imitators is one of the critical issues affecting the graphic arts industry today, it is vital for artists to understand trade dress law so that they can include it in their defensive arsenal. Trade dress "includes the design and appearance of the product as well as that of the container and all elements making up the total visual image by which the product is presented to consumers." In addition, "[t]o create trademark or trade dress rights, a designation must be proven to perform the job of identification. If it does not do this, then it is not protectable as a trademark, service mark, trade dress, or any other exclusive right."

The challenge for artists and designers is to prove that their services are eligible for "branding," like any other business that provides services or manufactures products, and convince the courts that these "services" are distinctive and protectable as trade dress.

International & Canadian Copyright[—]

Thanks to Lesley Ellen Harris, a copyright and new-media lawyer who consults on United States, Canadian, and international copyright matters, for the information contained in this section. She is the author of *Canadian Copyright Law* and Digital Property: Currency of the 21st Century. For more information about her, see www.copyrightlaws.com.

Any discussion of this subject begins with the proviso that there is no such thing as international copyright law. Each country has its own copyright laws; there is no single international copyright law. However, artists are protected under each country's laws through the copyright relations their home country shares with other countries.

In practical terms, this means that a U.S. artist is protected by copyright in most other countries, although that protection may be to a different degree than in the United States. For example, moral rights, discussed earlier in this chapter, are protected differently depending on the country. In some countries, such as France, there is much greater moral rights protection for all creators of copyrighted works than in many other countries. In other countries, such as Canada, moral rights protection for visual and fine artists does not extend as far as it does, for example, in France, but the protection extends to all creators of copyright materials, unlike in the United States.

Copyright laws around the world protect artists and provide them with negotiating power. All copyright laws are based on the same principles. The copyright laws provide a certain copyright culture within a country and help set industry standards in contractual relationships. For instance, because of the work-for-hire provision in the U.S. Copyright Act, in certain industries, such as the film industry, writers and other creators assign all their rights. In Canada, where there is no work-for-hire provision, screenwriters retain the copyright to their scripts and license the rights to a licensee/producer to make a film out of it.

As the graphic communication industries adapt to the global economy, graphic artists can easily reside in one country while serving clients in another. Political boundaries no longer limit business relationships between artists and buyers, though U.S. immigration laws do set quotas that limit the number of professionals who live and work in the United States. (However, highly qualified professionals can be awarded special visas if a union like the Guild finds they have exceptional credentials.) Canadian and European artists often serve U.S. clients and vice versa. Given the phenomenal expansion of the global economy, which can only continue to grow, it is in the Guild's interests to improve standards for all graphic artists around the world. Establishing contact and signing agreements with graphic arts unions or organizations in other countries will help ensure that all artists compete on talent and portfolio, not on price.

The following section highlights and contrasts the important features of Canadian copyright law as it applies to the visual communications industries.

Canada/United States rights

 Registering copyright: Copyright is automatic in Canada and always has been. There is a voluntary registration system but, unlike in the United States, no deposit system where artists send in a copy of their works. Canadian registration of copyright works and licenses relating to works has much less stringent provisions than in the United States. Canadians will find much more space in U.S. contracts devoted to copyright registration and documentation issues (often standard clauses). Further, there are no copyright notice provisions under Canadian copyright law, although Canadian creators generally include a copyright notice to remind the public that copyright does exist in their works.

- Duration of copyright: There is no renewal of copyright in Canada, nor are there any works that fall into the public domain and that then may once again be protected by copyright. With only two exceptions, a literary or artistic work in Canada is protected for 50 years after the death of the author. Engravings (defined in the law as "etchings, lithographs, woodcuts, prints, and other similar works, not being photographs") published at the time of an author's death are subject to the life-plus-50 rule. And photographs made on or after January 1, 1944, are protected for 50 years from the end of the calendar year when the initial negative or other plate was made from which the photograph was directly or indirectly derived or, if there was no negative or other plate, from the making of the initial photograph. Engravings unpublished at the time of an author's death are protected until publication and for 50 years thereafter. A work that is being exploited in Canada and the United States may be licensed for a part of the duration of copyright or for its full term.
- Reversionary interest proviso: In Canada, where the author of a work is the first owner of the copyright (it is not a product of employment, a government work, or a commissioned engraving, photograph, or portrait), any copyright acquired by contract becomes void 25 years after the author's death. This does not mean that the term of copyright is affected. It means that, if specific conditions apply, any subsequent owner of copyright will lose his or her rights 25 years after the author's death. At this time, the copyright becomes part of the author's estate, and only the estate has the right to deal with the copyright. Conditions affecting this reversion include when the author disposes of the copyright by will for the period following the 25-year limit. Thus, the reversion may be avoided by the author bequeathing copyright for the period between 25 and 50 years after his or her death.

It also does not apply where a work is part of a collective work or a work or part there of has been licensed to be published in a collective work such as a magazine or an encyclopedia.

- **Commissioned works:** Under Canadian law, a special rule applies only to commissioned engravings, photographs, or portraits. For these works, the person ordering the work is deemed to be the first owner of the copyright if the following conditions are met:
 - •••• The person ordering the work has offered valuable consideration, such as money or services.
 - ••• The work was created because of the order and was not created prior to the order being made.

This holds true provided there is no agreement between the commissioner and the creator stating that copyright subsists with the creator of the work.

While at first glance this appears to be more limited than U.S. work for hire, it is in fact more broad. Unlike in the United States, where it must be agreed in writing that a work is for hire, it is assumed in Canada that the commissioning party owns the rights unless a written agreement exists to the contrary. That's why U.S. artists who assume they retain their rights under a Canadian contract that contains no mention of ownership of copyright may be in for a nasty shock. When the art purchaser is based in Canada, it is highly likely that the contract will be based on Canadian law.

Canadian law is limited to three very specific types of works, but insofar as published illustrations are regarded as "commissioned engravings," the provision applies to all commissioned illustrations, and not merely those in the nine categories delineated under U.S. law. Thus, a U.S. artist dealing with a Canadian company should make sure that the disposition of rights is clearly spelled out and that he or she fully understands any unfamiliar terminology.

- Employment works: In Canada, three criteria must be met in order for works made during employment to belong initially to the employer:
 - ••• The employee must be employed under a "contract of service."
 - ••• The work must be created in the course of performing the contract.
 - ••• There must not be any provision in a contract that states that the employee owns the copyright (such a contract need not be in writing).

One important distinction between the U.S. work-for-hire and the Canadian employment works provision is that in Canada, notwithstanding that the employee does not own the copyright, the employee continues to retain the moral rights. An employee can never license these moral rights, though he or she can waive them.

- Digital rights: Although an agreement may govern only one jurisdiction, say, North America, certain rights, such as those for the Internet or World Wide Web, are not necessarily subject to geographical division. This means that by virtue of licensing Internet rights, artists are granting a worldwide license.
- Moral rights: Under Canadian law, there are three types of moral rights:
 - ··· The right of paternity.
 - ··· The right of integrity.
 - ··· The right of association or disclosure.

These rights are discussed at length in the section above on Moral Rights (especially The Berne Convention).

Even when an artist transfers copyright, and even where the work is owned by an employer, the artist has moral rights unless they are waived. Moral rights in Canada last for 50 years from the date of a creator's death (at the end of that calendar year). Upon death, they can be passed to an artist's heirs, but not otherwise transferred. However, artists can agree not to exercise one or more of their moral rights, and this is something artists working with a Canadian company should be aware of.

The United States has moral rights protections for limited works of visual art under the Visual Artists Rights Act (see section above). The duration depends on when the work was created and/or transferred. If the work was created after June 1, 1991, the rights endure for the life of the artist. If the work was created prior to June 1, 1991, and the title has not been transferred to another party, the rights have the same term as ordinary Section 106 rights, as determined by Sections 302–304. If the artist transferred the work prior to June 1, 1991, he or she has no moral rights to the work.

 Fair use/dealing and exceptions: Canada does not have a fair use provision but has a similar, though much narrower, provision known as the "fair dealing provision." Generally, it is used only for quotes from a book or article and does not apply beyond that except, for example, in cases of multiple copying for classroom use as in the United States.

In addition, Canada has fewer exceptions that allow free uses of copyrighted materials. However, with the passage of a 1999 copyright revision bill, there are many more exceptions than in the past, primarily for schools, libraries, archives, and museums. Even with the changes, in certain circumstances, a U.S. artist may find that certain free uses of work in the United States may be uses for which permission must be requested and paid for in Canada. The converse is also true: Canadian artists may find that there may be free uses of their work in the United States for which they would be paid in Canada. Generally, such provisions cannot be reversed by contract but are subject to the copyright statutes in the respective countries.

Z Legal Rights & Issues

- Government works: In Canada, the government owns the copyright to works produced by its employees, and sometimes by independent contractors/consultants, and any use of government works requires permission from the government. Thus, a Canadian artist whose work incorporates some government works will probably have cleared copyright to that work before including it in his or her work. However, a U.S. artist may not have cleared copyright to a U.S. government work incorporated in his work; in this situation, although permission may not be required from the U.S. government for use of the work in the United States. permission will be required when the same work is used in Canada. Therefore, an American artist should be careful in making any warranties and representations regarding copyright clearance of works incorporating any government materials when those works are used in Canada.
- Governing law: Parties to an agreement are generally free to choose the state/province whose law will govern the agreement. That is usually settled by negotiation. Especially when work is to be created, performed, or delivered in more than one jurisdiction, the contract should state under which jurisdiction the contract is to be interpreted. It is usually in the artist's best interests to have their own state/province's law govern the contract for ease of access to a lawyer in that jurisdiction as well as for convenience (especially when considering costs) should court action be necessary.

Remember that an agreement on governing law does not in itself determine the jurisdiction where a suit may be filed but only the law under which that suit will be decided. It is possible to agree that a contract will be judged by U.S. law and adjudicated in Canada, or vice versa. It is also possible, and more desirable, to agree upon the governing law without specifying a jurisdiction for adjudication, which leaves the aggrieved party with the freedom to file suit in the most convenient location.

However, more and more agreements are now subject to mediation and binding arbitration in a place halfway between the cities of the contracting parties. This can at least limit costs and travel time. A lawyer should be able to ensure that the laws of another jurisdiction are compatible with any contractual relationship.

Note: The above information does not constitute legal advice; proper advice should be sought where necessary.

A variety of factors affect the way artists and designers work. Changes in business practices, taxation, copyright, or other laws can dramatically affect a creator's business. So can emerging trends or prac-

tices that vary from accepted customs. Here are some of the major factors artists, designers, and their clients should be aware of when working on visual communications projects. This chapter provides a roundup of important business issues, including taxation, employment status, cancellation and rejection fees, working on speculation, and entering contests and competitions, and is designed to aid both buyers and sellers of graphic art.

Deductibility of Artwork

There is a popular misconception that artists donating their art to a charitable organization may deduct the "fair market value" of the work. Current law, in fact, distinguishes between "personal property" and "inventory." While anyone may donate personal goods to any charity and deduct the fair market value, businesses may deduct only the actual cost of producing the item. Artists, therefore, may deduct only the cost of producing the work: the price of the canvas, paint, and other materials. But if an artist sells an original work, the buyer may donate that piece of personal property and deduct the amount paid for it. As a result, historically, artists have either withheld their valuable originals or sold them to private collectors.

Legislation signed into law by President Clinton on August 10, 1993, contained a number of significant provisions affecting tax-exempt charitable organizations described in section 501(c)(3) of the Internal Revenue Code (IRC). Since January 1, 1994, deductions have not been allowed under section 170 of the IRC for any charitable contribution of \$250 or more unless the donor has a contemporaneously written substantiation from the charity. The responsibility for obtaining this substantiation lies with the donor, who must request it from the charity. The charity is not required to record or report this information to the Internal Revenue Service (IRS) on behalf of donors. Generally, if the value of an item (or group of like items) exceeds \$5,000, the donor must obtain a qualified appraisal and submit an appraisal summary with the return claiming the deduction.

Sales Tax

States have widely different policies in regard to sales tax. In those that have one, the rate usually ranges from 3 to 9 percent, and it is levied on the sale or use of physical property within the state. A number of exemptions exist, including special rules for the sale of reproduction rights.

Generally, sales tax is applicable for end sales or retail costs only, not for intermediate subcontracting. An artist may have to file forms showing that materials were intermediate and thus not taxable. Services, including the services of transferring reproduction rights, are not subject to sales tax. Transfers of physical property to a client (original art or designer's mechanicals) are generally not subject to sales tax if they are part of a project that will later be billed to a client by a design firm or other agent; however, a resale certificate may have to be obtained.

Variations by state

Many tax laws are unclear in relation to the graphic communications industry, though efforts have been made to clarify them (see the New York State section below). If artists are doubtful about whether to collect the tax, it is safest, of course, to collect and remit it to the state sales tax bureau. Note, however, that one accountant advised that if you do charge sales tax, and it is found during an audit that you shouldn't have, you are liable to repay that amount to the client. If artists should collect the tax but don't, they, as well as their clients, remain liable. However, it may be difficult to try to collect the tax from clients on assignments that have been performed in the past if an audit or another review determines that sales tax is owed.

The following examples of California, Massachusetts, Minnesota, and New York illustrate the great variation in state sales tax regulation.

3 Professional Issues

California

Following a random audit in 1993, the Board of Equalization (BOE), one of California's taxing agencies, ruled that children's book and stamp illustrator Heather Preston was required to pay sales taxes on four years' worth of royalties for book and rubber stamp illustrations. But she found peculiar catches: The authors of the books Preston illustrated, who turned in hard-copy manuscripts, owed no sales tax on their royalties. And had Preston sent the work electronically, rather than in hard copy, she would likely not have owed sales tax. On June 21, 1996, following an unsuccessful appeal to the BOE, Preston filed a lawsuit to recover sales taxes and interest on the ground that the BOE had improperly attempted to treat the grant of use rights as a transfer of tangible property.

The BOE considers even a temporary transfer of hard-copy artwork or the transfer of digital artwork on a storage disk to be a transfer of "tangible personal property" and therefore subject to sales tax. Written work is recognized as "authorship," which renders the transfer of tangible elements, such as a physical manuscript, "incidental to the true object" of the sale and, therefore, excluded from tax. Transfers of tangible personal property are considered taxable unless specifically exempted by the State Legislature.

Preston lost her case at trial, and the California Court of Appeals rejected her appeal on procedural grounds. However, in Spring 2000, the California Supreme Court agreed to hear Preston's case. The Graphic Artists Guild wrote the Supreme Court in support of Preston's appeal and filed an *amicus curiae* (friend of the court) brief in the case. As of March 2001 when this book was printed, *Preston v. Board of Equalization* awaited a hearing by the state's highest tribunal.

Shortly before Preston filed her original suit, cartoonist Paul Mavrides won an appeal of his back taxes assessment. Mavrides's case, which was supported by the American Civil Liberties Union, the California Newspaper Publishers Association, the Cartoonists Legal Defense Fund, and more than 30 other organizations, differed in significant respects from Preston's. In Mavrides's case, the BOE attempted to collect sales tax from cartoonists for the first time following the 1991 repeal of the newspapers' exemption from the sales tax. The ruling in his successful appeal was made narrowly, exempting the work of cartoonists who both drawthe pictures and write accompanying script as authors when their work is published in books, magazines, or newspapers but not when in greeting cards, posters, or displays.

In 1996, the Northern California Chapter of the Graphic Artists Guild determined that a s urprisingly high percentage of its membersestimated as high as 20 percent—had been subject to sales tax audits. Members reported widespread inconsistency, errors, and overzealous enforcement by auditors. In concert with the Guild's National Public Affairs Committee, the Chapter began working to change California's tax law so that illustrators, graphic designers, and photographers would have the same exclusion from sales tax that authors of written manuscripts enjoy, based on equal treatment under federal copyright law and California civil code. Subsequently, the Guild was the lead sponsor of two bills in the California Legislature, both of which failed to pass in a form adequate to provide the necessary relief. As of March 2001 when this book was printed, a third bill, SB 1720, awaited action in the California State Senate.

In 1999, the Guild represented California's graphicarts industry as an interested party when the Business Tax Division of the BOE began a major revision of the 1974 regulation affecting the advertising industry. The Guild was successful at having provisions inserted in the new regulations that set uniform conditions where none previously existed, greatly cut the tax burden on graphic artists, and reduced their exposure to audits. The following were approved by the BOE and went into effect on January 5, 2000:

- Reduced the taxable portion of graphic design and illustration jobs based on the fact that part of the fees paid are for "conceptual services" rendered. The regulation presumes that 75 percent represents a reasonable allocation for these nontaxable services.
- Excluded Web site design and hosting from taxation, as well as transfers of artwork by remote communications (modem).
- Limited taxability of reuse and royalties to one year from the time of contract.
- Excluded the design of environmental signage from taxation.
- Applied changes to the advertising regulation uniformly to other industries where artists and designers are affected.

It is important to note that artists who take advantage of any of these exemptions must be sure to separate taxable and nontaxable charges on all invoices and carefully document the exemptions.

All artists and designers engaged in business in California are required to obtain a California seller's permit and to comply with applicable sales and use tax regulations. Businesses that do not have these permits are exposed to more extensive audits and face additional penalties than those that comply.

While it is not required, the Graphic Artists Guild strongly recommends that artists working in California take advantage of a provision in the California Taxpayers Bill of Rights and obtain binding information by filing a document called a "Section 6596 Query." This is a personal letter from you to the BOE requesting information on how sales tax regulations specifically apply to your individual business. Answers given over the telephone are nonbinding and frequently inaccurate, but a written response from the BOE provides protection from contrary interpretations by an auditor during an audit.

Massachusetts

Beginning in the 1990s the Department of Revenue in Massachusetts attempted to tax activities that had previously been tax exempt, including the creation of preliminary artwork; logos designed for corporate use; and services in conjunction with newspapers, magazines, and periodicals. A movement was organized to resist these changes, but no legislation or rulings clarifying these issues have yet been passed or established.

Minnesota

In 1993 Minnesota passed a rule that the sale of an advertising brochure is no longer considered the sale of "tangible personal property" (a physical product rather than a service or intellectual property such as reproduction rights); it is now considered part of the sale of a "nontaxable advertising service." Since an ad agency sells a nontaxable service, it must pay tax on all taxable "inputs" (all the components of an advertising product provided by outside vendors such as illustration, photography, or copywriting) used to create the brochure, including commissioned artwork. In most cases inputs can no longer be purchased tax free, so illustrators may have to collect sales tax when selling work used in advertising brochures.

New York State

For years many practitioners in New York State were being told different things by different people, including accountants and other professionals, and consequently faced substantial sales tax assessments if audited. Beginning in 1990, a coalition of the American Institute of Graphic Artists (AIGA), the Graphic Artists Guild, and the Society of Environmental Graphic Designers (SEGD) met with representatives of the New York State Sales Tax Authority to establish guidelines about how graphic designers and illustrators should charge sales tax for their services. The following guidelines, which answer the two most frequently asked questions about sales tax, were reviewed and approved by the New York State Tax Department in 1992.

- When are graphic designers and illustrators expected to charge sales tax on their services, and when are their sales exempt from tax?
- When are graphic designers and illustrators expected to pay sales tax on the materials, equipment, and services they buy, and when are those purchases exempt from tax?

Charging sales tax

Sales tax law imposes a tax on the sale of tangible personal property. Many local authorities add their own sales tax to that imposed by the state. The resulting sales tax must be charged in addition to the rest of the sale, stated as a separate item on any invoice, and paid by the purchaser. Payment of sales tax by the seller (in this case the graphic designer or illustrator), or failure to itemize it on an invoice, is prohibited. Mixing taxable with nontaxable items on an invoice makes the entire invoice subject to sales tax.

Exemptions from charging sales tax

Six areas of exemption relevant to graphic designers and illustrators include:

- Items terms for resale: When tangible personal property passes through intermediate owners, taxes are deferred until it reaches the final purchaser. An example is any item purchased in a store. Sales tax is paid by the end customer at the over-the-counter sale; the retailer doesn't pay tax when purchasing from the wholesaler; the wholesaler doesn't pay it when purchasing from the manufacturer. Consequently, any item purchased for resale may be purchased tax-exempt if the purchaser has a properly completed resale certificate. The responsibility for collecting the tax then falls on the seller when the item is sold to the final purchaser.
- Exempt use: If the final sale is for an exempt use—for instance, promotional materials delivered to a client in New York that will be distributed out of New York State—the vendor must verify the tax-exempt status by obtaining an exempt use certificate from the purchaser.
- Sales to exempt organizations: Nonprofit and educational institutions and most federal and New York State governmental agencies have tax-exempt status. In this instance, the vendor must verify the tax-exempt status by obtaining an exempt organization certificate or government purchase order from the purchaser.
- **Grants of reproduction rights**: At the end of a creative process, if specified restricted rights are only transferred, but there is no transfer of ownership of tangible personal property (the original, physical artwork or 50,000 brochures), the transaction is not taxable. Grants of rights are not subject to sales tax.
- **Tax-exempt services:** Purchases of certain services that do not result in the transfer of tangible personal property are, by their nature, not taxable. For example, professional fees for consultation services provided by doctors, attorneys, or accountants are not taxable.
- Out-of-New York State sales: The sale of work to out-of-state clients, delivered out-of-state, is not subject to sales tax. However, there must be evidence of out-of-state delivery.

Payment & collection of sales tax

Whether a graphic designer's or illustrator's services are taxable depends upon whether there is a final transfer of tangible personal property. If there is, the entire contract is taxable, including all consultations, designs, preparation of artwork, and so on. If the graphic designer or illustrator sells the rights to comps, mechanicals, computer data, printed materials, or fabricated materials such as exhibits or signs to the client, the graphic artist's services are considered to be transferable personal property.

The results of graphic designers' or illustrators' services are not considered transferable personal property if they do not provide printing or fabrication services, if they grant reproduction rights only, or if ownership of all the designs, comps, mechanicals, or computer data remains with the creator and are transferred only temporarily for reproduction, to be returned—unretouched, unaltered, undisplayed—to the artist.

In most cases, graphic designers and illustrators may discover that some of their projects are taxable and some are not. The importance of setting up taxable and nontaxable work in separate contracts cannot be stressed enough. Graphic designers and illustrators must remember that the onus is always on them to prove that a project is nontaxable. Therefore, all agreements, invoices, and digital layouts or illustrations should have very clear language stating that ownership remains with the graphic artist, that only rights for reproduction are being granted, and that any graphic representations or artwork are being transferred temporarily solely for the purpose of reproduction, after which they are to be returned—unretouched, unaltered, undisplayed—to the graphic designer or illustrator.

Corporate identity and logo programs are a special case. Conceivably, one could state in a contract that only specific, limited reproduction rights are being granted. In practice, however, the prospect of a client not having complete rights to their own logo or corporate identity system is not credible. Therefore, such a project is considered a taxable sale.

If you are required to charge sales tax, you should consult an experienced accountant to determine your specific responsibilities. You will have to register as a vendor and, as a collector of taxes on the state's behalf, will be issued a resale number enabling you to purchase certain materials, free of tax, for the creation of products to be resold to your clients.

Exemption documents needed

Graphic designers and illustrators need two basic exemption documents when making tax-exempt purchases: the resale certificate and the exempt use certificate. The resale certificate is only for items or services that are part of the item being sold—for example, the illustration board used to make a mechanical. The exempt use certificate is for items used in the production of the final product that do not become an actual part of it—for example, watercolors used to create an illustration that will be scanned into a computer and sent to the client electronically. Resale certificates cannot be used to purchase anything that does not substantially result in the tangible property being created.

3 Professional Issues

Graphic artists are required to keep accurate records (1) of all items so purchased and (2) for which projects they were used. They are also required to retain the subsequent invoice that indicates that sales tax has been charged on that item directly or on the item into which it has been incorporated. It is essential that graphic designers and illustrators keep clear, thorough records of all projects, including all purchases for each project, so that in the event of an audit they can accurately show that they paid sales tax on purchases that required sales tax to be paid.

A graphic designer or illustrator is entitled to purchase services or materials for resale or production without paying tax, even if sale of the final product will be exempt from tax—for example, to an exempt client or if the final product will be shipped out of New York State.

The resale certificate may not be used if the services do not result in a sale, such as when unrestricted reproduction rights are granted or if the contract is for consultation alone, with no tangible end result. On such projects, the designer must pay tax on all equipment, supplies, and services used.

Equipment, such as computers and laser printers, that is used predominantly for the production of work for sale (more than 50 percent of the time) may also be purchased exempt from sales tax by submitting an exempt use certificate to the vendor. However, this means that if only half the artist's work results in taxable sales and this equipment is used only half the time on design work, then the equipment is actually being used only 25 percent of the time to produce work for sale and is therefore subject to full tax when purchased.

Special considerations in New York City

On certain purchases, only New York City sales tax (currently 4 percent) is payable; New York State sales tax (currently 4.25 percent) is not. These purchases are:

- Consumable materials used to produce work for sale that are not to be passed along to the client as part of the final product, including knife blades, masking tape, tracing paper, sketch paper, and markers.
- Maintenance and repair services for equipment used predominantly to produce work for sale, such as a computer, laser printer, fax machine, or copier.
- Freelance services used during the production of work for sale, including those employed to work on presentation materials or digital layouts that are part of a contract on which sales tax will be charged.

When any of the above items or services are purchased, the graphic designer or illustrator must use a valid resale or exempt use certificate to be exempt from the state sales tax, even though the local city tax is being paid.

From a practical standpoint, it is easy to ascertain whether the services of independent contractors are subject to the New York City tax because they work on specific projects. With consumable materials and maintenance and repair, it is not always as clear. It may be simpler to pay the full New York City sales tax rather than guess which projects they may be used on.

Graphic artists working in New York City also need to be aware of the other special considerations concerning their purchases:

- If most projects are not taxable, it may be simpler to pay tax on all the equipment, supplies, and services you purchase, just to be on the safe side and to simplify matters in the event of an audit.
- Where projects may result in a taxable sale, it is permissible to divide the project into two entirely separate contracts, one that is taxable and one that is not. For example, if a client wishes the designer or illustrator to provide printing and fabrication services, you can set up one contract for design and production of the artwork and an entirely separate contract for printing and fabrication. The design and production contract must specify the transfer of limited reproduction rights only, and the client must be able to terminate the relationship and go elsewhere for printing or fabrication services. A separate contract providing printing services is taxable (subject to the other relevant exemptions described above, such as exempt purchaser or out-of-state delivery).

It is essential to keep the two contracts entirely separate: separate proposals, separate agreements, and separate invoices. If any part of a contract is taxable, the entire project is taxable. There cannot be a contract where some items are taxable and some are not.

The Graphic Artists Guild strongly recommends that graphic artists consult experienced accountants or tax lawyers to determine tax liabilities under these guidelines. Because of their familiarity with an artist's business, these professionals are best suited to answer questions. An alternative is to contact the New York State Department of Taxation and Finance, Sales Tax Instruction & Interpretation Unit, Room 104A, Building 9, State Campus, Albany, NY 12227; 800 CALL TAX (800.225.5829); or www.tax.state.ny.us. If a graphic artist finds that any ruling is contrary to these guidelines, notify the Graphic Artists Guild immediately.

Taxes when using freelance suppliers

It is important for freelance graphic designers and illustrators to understand that services they use, such as those of freelance typographers, are taxable. All freelancers must charge sales tax on their services to the graphic designer or illustrator unless the exemptions outlined above apply. When the graphic designer's or illustrator's services result in a taxable sale, he or she may issue a resale certificate to the freelancer for the work.

In certain circumstances, artists who use freelance services should, for their own protection, pay any tax due directly to the state—for example, if the freelancer is a student and not registered as a vendor or if the freelance supplier does not bill and collect the tax. A specific fill-in section on the sales tax reporting form, entitled "Purchases Subject to Use Tax," is provided for this purpose.

When a freelancer works on a project that does not result in a taxable sale for the artist—where reproduction rights only are being granted to the client—then the artist must pay full tax on the freelancer's fee.

As part of routine record keeping, graphic designers and illustrators should keep carefully receipted invoices from freelancers showing that, where appropriate, sales tax has been charged and paid. If the evidence is not clear-cut, sales tax authorities will expect the artist to pay the taxes.

Employment Issues

Portions of this section were reprinted from Communication Arts with permission of Tad Crawford. ©Tad Crawford, 1993.

Clients should be aware that the Internal Revenue Service takes a dim view of independent contractor relationships. From the government's perspective, employers use so-called independent contractors to evade employment taxes. If independent contractors are hired, the employer should be able to justify this designation in the event of an audit. If the IRS successfully reclassifies independent contractors, the very existence of a firm can be threatened. (For a complete discussion of work for hire, consult the Work for Hire section in Chapter 2, Legal Rights and Issues.)

In recent years the Internal Revenue Service has cracked down on advertising agencies, design firms, publishers, and others by examining whether artists providing graphic design, illustration, or production services are actually freelancers or employees. In audit after audit, the IRS has determined that so-called freelancers are, in fact, employees based upon their analysis of the actual working relationship between the client and the graphic artist. Especially vulnerable to IRS scrutiny, and a significant risk to the hiring party, are those artists who work as full-time freelancers. One West Coast comic book publisher, for example, went out of business after six-figure penalties were imposed by the IRS for misclassifying its employees as independent contractors.

There are advantages and disadvantages to each classification for both the artist and the hiring party. Independent contractors are paid a flat fee, simplifying the employer's bookkeeping; and depending on the freelancer's fee structure, the art buyer may realize significant savings on taxes, insurance, and other fringe benefits. Independents retain some control over their copyrights, time, and business tax deductions for materials, overhead on private work space, and so on. But independents always risk loss of payment when work is rejected or canceled or when they work on speculation, while employees are guaranteed at least the legal minimum wage.

Social Security tax (FICA)

When classified as an employee, 7.65 percent of a graphic artist's gross income up to \$60,600 is paid by the employer; the remaining 7.65 percent of the total Social Security payment is withheld from the artist's paycheck. Independent contractors must pay the full 15.3 percent FICA tax on their adjusted gross income.

Benefits & insurance

All employees are entitled to receive unemployment, disability, and workers' compensation insurance coverage. Depending upon specific company policy, employers may also be obligated to provide optional fringe benefits such as paid vacations, comprehensive medical and hospitalization insurance, employer-funded pension plans, or profit-sharing to every employee. Independent contractors must purchase their own disability coverage and have no access to unemployment insurance or workers' compensation. Furthermore, independent contractors must provide their own vacations, medical coverage, and retirement plans.

Tax deductions

Independent contractors can reduce their taxable income significantly by deducting legitimate business expenses. Employees may also deduct expenses, but only for the amount exceeding 2 percent of their adjusted gross income.

Job security

Employees do not enjoy the freedom of working for whom they want, as independent contractors do, but they do enjoy the security of a regular paycheck. However, the downsizing trend that began in the late 1980s has given longtime employees a greater sense of insecurity about their employment status than they may have had previously.

One advantage employees have is the legal right to organize for the purposes of collective bargaining, a right denied to most independent contractors. The Graphic Artists Guild has represented one group of employees in a collective bargaining agreement with their employer, Thirteen/WNET Educational Broadcast Television in New York City, since November 1993. Since then, the Guild has broadened the definition of graphic artists eligible for union representation and benefits and improved attributions and program credits. The latest contract, a three-year agreement from July 1, 1998, guarantees 14 to 27.5 percent salary increases during the length of the contract, with a \$1,000 signing bonus, and improved medical, holiday, and vacation benefits.

Work for hire

Independent contractors are recognized as the authors of their work and control the copyright unless they sign a contract that specifically states the work is a "work for hire." In contrast, all work created by employees, unless otherwise negotiated, is done as work for hire, which gives authorship and all attendant rights to the employer. Negotiating those rights back, while possible, is not easy.

Determining employee status

The IRS has a 20-factor control test (Revenue Ruling 87-41, 1897-1CB296) that it uses to clarify the distinction between employees and independent contractors. The control test is easy: Is the person subject to the control of or by the firm?

Unfortunately, however, the guidelines are too general to resolve every situation. Often some factors suggest employee status, while others suggest independent contractor status. Key factors that the IRS looks at include:

- **Instructions**: Is the worker required to obey the firm's instructions about when, where, and how work is to be performed? If the firm has the right to require compliance with such instructions, the worker is likely to be an employee.
- Training: Training a worker suggests that the worker is an employee. Training may consist only of having a more experienced employee fill in the newcomer on office procedures, or he or she might be required to attend meetings or read files and/or correspondence.
- Integration: If a worker's services are part of a firm's operations, this suggests that the worker is subject to the firm's control. This is especially true if the success or continuation of the firm's business depends in a significant way upon those services.
- **Personal services**: If the firm requires that the services be performed in person, this suggests control over an employee.

3 Professional Issues

- Use of assistants: If the firm hires, directs, and pays for the worker's assistants, this indicates employee status. On the other hand, if the worker hires, directs, and pays for his or her assistants, supplies materials, and works under a contract providing that he or she is responsible only to achieve certain results, that is consistent with independent contractor status.
- **Ongoing relationship**: If the relationship is ongoing, even if frequent work is done on irregular cycles, the worker is likely to be an employee.
- **Fixed hours of work**: That suggests the worker is an employee controlled by the firm.
- **Full-time work**: If the worker is with the firm full-time, that suggests the firm controls the time of work and restricts the worker from taking other jobs. That shows employee status.
- Work location: If the firm requires that the worker be at the firm's premises, that suggests employment. That the worker performs the services off-premises implies being an independent contractor, especially if an employee normally has to perform similar services at an employer's premises.
- Work flow: If the worker must conform to the routines, schedules, and patterns established by the firm, that is consistent with being an employee.
- Reports: A requirement that reports be submitted, whether oral or written, suggests employee status.
- Manner of payment: Payment by the hour, week, or month suggests an employee, while payment of an agreed-upon lump sum for a job suggests an independent contractor.
- **Expenses**: Payment of expenses by the firm implies the right to control company expenses, and thus suggests employment status.
- **Tools and equipment**: If the firm provides tools and equipment, it suggests the worker is an employee.
- **Investment**: If the worker has a significant investment in his or her own equipment, that implies being an independent contractor.
- **Profit or loss**: Having a profit or loss (due to overhead, project costs, and investment in equipment) is consistent with being an independent contractor.
- **Multiple clients:** Working for many clients suggests independent contractor status. However, the worker could be an employee of each of the businesses, if there is one service arrangement for all clients.
- Marketing: If the worker markets his or her services to the public on a regular basis, that indicates independent contractor status.
- **Right to discharge**: If the firm can discharge the worker at any time, that suggests employment. An independent contractor cannot be dismissed without legal liability unless contract specifications are not met.
- Right to quit: An employee may quit at any time without liability, but an independent contractor may be liable for failure to perform, depending on the contractual terms.

A matter of intention

The IRS even may argue that workers with a very peripheral connection to the firm—for example, mechanical artists or illustrators—are employees. The penalties for unintentional misclassification of an employee are serious, but not nearly as serious as the penalties for intentional misclassification. If the misclassification is unintentional, the employer's liability for income taxes is limited to 1.5 percent of the employee's wages. The employer's liability for FICA taxes that should have been paid by the employee is limited to 20 percent of that amount. The employer has no right to recover from the employee any amounts determined to be due to the IRS. Also, the employer is still liable for its own share of FICA or unemployment taxes. Interest and penalties may be assessed by the IRS, but only on the amount of the employer's liability.

On the other hand, if the misclassification is intentional, the employer may be liable for the full amount of income tax that should have been withheld (with an adjustment if the employee has paid, or does pay, part of the tax) and for the full amount of both the employer and employee shares of FICA (though some of it may be offset by employee payments of FICA self-employment taxes). In addition, the employer is liable for interest and penalties computed on far larger amounts than when the misclassification is unintentional.

Precautions & safeguards

After conducting a careful review of how their workers should be classified under the IRS's 20-factor control test, a client or firm may remain uncertain of what is correct. A wise approach is to err on the side of caution and, when in doubt, classify workers as employees.

If the firm believes a worker is an independent contractor, the two parties should negotiate a carefully worded contract that accurately sets forth the parties' agreement and is legally binding. To be most effective, in the event of an IRS challenge, the contract should state that the worker is an independent contractor according to the 20-factor test. The contract must then be adhered to by the parties. If a firm already has such a contract in place, it should be reviewed with the IRS test in mind and to confirm whether the parties are in fact following its terms.

To protect themselves from an IRS audit and any potential penalties, many clients treat every artist as an employee, even those who are clearly independent. In such cases, clients withhold appropriate taxes from creative fees and issue end-of-year W-2 forms rather than a Form 1099. To counter the potential loss of copyright (since works created by employees are considered works for hire unless otherwise negotiated), artists should clearly establish themselves as independent contractors, preserving authorship and copyrights; attempt to reclaim the rights to their works from the hiring party through negotiation; or authorize a labor organization such as the Graphic Artists Guild to represent them to negotiate equitable fees, benefits, and rights.

3 Professional Issues

Cancellation & Rejection Fees ("Kill Fees")

Historically, cancellation and rejection fees are practices that have been widely accepted by clients and artists alike, even when contracts are verbal or no cancellation or rejection provision is included in a written document. Whether they are paid, and where on the spectrum a particular cancellation or rejection fee is set, depends upon the specific circumstances of each case and upon the artist's determination to require such fees to be paid in an amount commensurate with the effort invested. For example, if preliminary work is unusually complex or the assignment requires completion on a very short deadline, artists may demand higher cancellation or rejection fees. Another consideration often taken into account is whether the graphic artist declined rewarding assignments from other clients in order to complete the canceled assignment in a timely manner.

Traditionally, freelance graphic artists are entitled to remuneration if a job is cancelled or rejected according to the following conditions:

Cancellation provision

According to current and historical data, clients usually pay the artist a cancellation fee if the assignment is canceled for reasons beyond the artist's control.

- If cancellation occurred prior to the completion of the concept or sketch phase, current data indicate the average cancellation fee is approximately 25 percent of the original fee for illustrators and approximately 40 percent for graphic designers.
- If cancellation occurred after the completion of preliminary work and prior to the completion of finished work, current data indicate the cancellation fee is between 30 and 65 percent (with an average of approximately 50 percent) for illustrators and between 45 and 100 percent (with an average of nearly 80 percent) for graphic designers.
- If cancellation occurred after the completion of finished work, the average cancellation fees currently range between 65 and 100 percent of the original fee, with the median response to the Guild's survey being 100 percent.
- Historical data indicate that all necessary and related expenses (such as model fees, materials, or overnight shipping fees) are paid in full.
- In the event of cancellation, the client obtains all the originally agreed-upon rights to the use of the completed work upon payment of the cancellation fee (except in royalty arrangements; for more information on that, see Chapter 5, Essential Business Practices). Even though the client chooses not to exercise a particular reproduction right at this time, that right is transferred to the client when the purchase is completed with payment. Depending upon the understanding between the parties, the specified right may revert back to the artist if not exercised within a specific period of time.
- If preliminary or incomplete work is canceled and later used as finished art, usually the client is contractually obligated to pay the unpaid balance of the original usage fee.
- Graphic artists and clients may agree to submit any dispute regarding cancellation fees to mediation or binding arbitration.

Rejection provision

According to current and historical data, clients may agree to pay the artist a rejection fee if the preliminary or finished artwork is found not to be reasonably satisfactory and the assignment is terminated.

- If rejection occurred prior to the completion of the concept or sketch phase, current data indicate the average rejection fee to be approximately 21 percent of the original fee.
- If rejection occurred after the completion of preliminary work and prior to the completion of finished art, current data indicate the rejection fee to be between 27 and 58 percent (with an average of approximately 42 percent).
- If rejection occurred after the completion of finished art, the average rejection fees currently range between 53 and 100 percent of the original fee, with 100 percent the median response to the Guild's surveys.
- All necessary and related expenses are customarily paid in full.
- In the event of rejection, the client has chosen not to obtain any rights to the use of the artwork. Therefore, many artists refuse to permit rejected work to be used for reproduction by the client without a separate fee.
- Artists and clients may agree to submit any dispute regarding rejection fees for mediation or binding arbitration.

Speculation

Speculative ventures, whether in financial markets or visual communications industries, are fraught with risk. Individuals who choose this course risk loss of capital and incur expenses. Artists and designers who accept speculative assignments, whether directly from a client or by entering a contest or competition, risk not being paid for the work, take valuable time from pursuing other paying assignments, and may incur unreimbursed expenses. In some circumstances, all the risks are placed on the artist, with the client or contest holder assuming none—for example, buyers who decide only upon completion of finished art whether or not to compensate the artist. This situation occurs in agreements where payment depends on "buyer's satisfaction" or "on publication." Typically, when a prospective client requests that work be created on speculation, there is too little information available to the artist to create a truly successful work because a true partnership has not been created due to the tentative nature of the speculative project.

Nonetheless, it is important to stress that many individual artists and designers, acting as entrepreneurs, create their own work and exploit those works in any variety of ways. That is one way that truly innovative work is produced. For example, if an artist's book proposal is accepted by a publisher who agrees to pay an advance against a royalty on sales, the artist and the publisher are sharing the risks on their mutual investment. The compensation to both parties is speculative, meaning both depend on the market response to the product.

Each artist should decide individually whether to enter art contests or design competitions, provide free services, work on speculation, or work on a contingent basis. Each artist should decide independently how to price the work. The purpose of this book is to inform the artist fully so that he or she may decide independently how to price the work and negotiate a fair agreement.

3 Professional Issues

Contests & Competitions

In 1980 the Graphic Artists Guild, together with Designers Saturday (DS), a furniture manufacturers association, developed a competition to meet two goals: to produce high-quality art for the DS annual show and to provide a competition that was ethical and appropriate for professional artists. Around the same time, the Guild received complaints from artists around the country concerning the unethical nature of most contests they were asked to enter. The results of the experiment with DS were so successful that the Guild decided to see if other competitions and contests could be structured to accomplish the goals met by the DS model.

In an effort to gain a clearer picture of the competition scene nationwide, the Graphic Artists Guild Foundation, with a supporting grant from the National Endowment for the Arts, conducted a nationwide survey of art and design competition holders, as well as an informal poll of jurors and competition entrants.

The findings of the surveys revealed that:

 By far, the largest and most expensive competitions are those operated by associations ancillary to the advertising industry, such as art directors' clubs and graphic design industry trade magazines. The purpose of these competitions is to honor excellence within their own communities. While these competitions do not require that original art or graphic design be submitted, the sponsoring organizations often charge high entry fees for members and nonmembers alike. These competitions generally attract the highest volume of entrants.

Historically, contests requiring the submission of new, original artwork have attracted the fewest number of entries from professional artists. Most professional artists reported that they did not want or could not afford to take time from income-producing projects to create original work for a contest on a speculative basis. The most popular type of competition for this group is based on work already produced or published.

- In most cases, the process for selecting a jury for competitions appears to be quite good. However, jurors noted that often the criteria or process for judging the work is vague or poorly articulated.
- Another inappropriate requirement is for all-rights transfers by all entrants to the contest holder.

The 1980 study resulted in the establishment of a list of guidelines for fair competition for three types of art contests or competitions: competitions held by art-related organizations or associations to award excellence in the field, contests where all entries are created specifically for the contest and where the winning entries are used for commercial purposes, and contests held by nonprofit organizations or where the winning entries are used for nonprofit purposes. The principal purpose of the guidelines is to enable competition or contest holders and entrants to make their own independent judgments concerning the way fair contests and competitions should be run and whether and on what terms to participate in them.

<u>Competitions held by art-related</u> <u>organizations or associations to</u> award excellence in the field

- The call for entry shall clearly define all rules governing competition entries, specifications for work entered, any and all fees for entry, and any and all rights to be transferred by any entrants to the competition holder.
- Jurors for the competition and their affiliations shall be listed on the call for entry. No juror or employee of the organization holding the competition shall be eligible to enter the competition.
- Criteria for jurying the entries and specifications for the artwork to be submitted in all rounds shall be defined clearly in the call for entry as a guide to both entrants and jurors.
- Deadlines and process for notification of acceptance or rejection of all entries shall be listed in the call for entry.
- **5.** Any and all uses for any and all entries shall be listed clearly in the call for entries, with terms for any rights to be transferred.
- 6. For the first round, tearsheets, slides, photographs, or other reproductions of existing work shall be requested in order to judge the appropriateness of style, technique, and proficiency of the entrants. This round shall result in the choice of finalists. If samples from this round are not to be returned to the entrants, that fact shall be clearly listed in the call for entries.
- If the competition ends in an exhibition, hanging or exhibition fees paid for by the entrants shall be listed in the call for entries.
- 8. After the first round, the jury may request original art for review. The competition holder shall insure all works against damage or loss until the work is returned to the artist. All original artwork shall be returned to the artist. Any fees charged to the artists for the return of artwork shall be clearly listed in the call for entry.

- **9.** Artwork shall not be altered in any way without the express permission of the artist.
- **10.** All entries and rights to the artwork remain the property of the artist unless a separate written transfer and payment for the original has been negotiated.
- **11.** If work exhibited by the competition is for sale, any commission taken by the competition holder shall be listed in the call for entries.

<u>Contests where all entries are</u> <u>created specifically for the contest</u> <u>and where the winning entries are</u> <u>used for commercial purposes</u>

- The call for entry shall clearly define all rules governing contest entries, specifications for work entered, any and all fees for entry, and any and all rights to be transferred by any entrants to the contest holder.
- Jurors for the contest and their affiliations shall be listed on the call for entry. No juror or employee of the organization holding the contest shall be eligible to enter the contest.
- Criteria for jurying the entries and specifications for the artwork to be submitted in all rounds shall be clearly defined in the call for entry as a guide to both entrants and jurors.
- Deadlines and process for notification of acceptance or rejection of all entries shall be listed in the call for entry.
- Any and all uses for any and all entries shall be clearly listed in the call for entries, with terms for any rights to be transferred.
- 6. For the first round, tearsheets, slides, photographs, or other reproductions of existing work shall be requested in order to judge the appropriateness of style, technique, and proficiency of the entrants. This round shall result in the choice of finalists. If samples from this round are not to be returned to the entrants, that fact shall be clearly listed in the call for entries.
- 7. The number of finalists chosen after the first round should be small. The finalists

shall then be required to submit sketches or comprehensive drawings for final judging.

- 8. Agreements shall be made with each finalist prior to the beginning of the final stage of the work (Graphic Artists Guild contracts or the equivalent can be used). The agreements shall include the nature of the artwork required, deadlines, credit line and copyright ownership for the artist, and the amount of the award.
- **9.** Any work of finalists not received by the required deadline or not in the form required and agreed upon shall be disqualified. All rights to the artwork that has been disqualified shall remain with the artist.
- 10. The winners shall produce camera-ready or finished art according to the specifications listed in the call for entry. Artwork submitted shall not be altered in any way without the express permission of the artist.
- 11. The value of any award to the winners shall be at least commensurate with fair market value of the rights transferred. The first-place winner shall receive an award that is significantly greater than that of other winners.
- 12. The contest holder shall insure original artwork in its possession against loss or damage until it is returned to the artist.

<u>Contests held by nonprofit organ-</u> <u>izations or where the winning entry</u> <u>is used for nonprofit purposes</u>

- The call for entry shall clearly define all rules governing contest entries, specifications for work entered, any and all fees for entry, and any and all rights to be transferred by any entrants to the contest holder.
- 2. Jurors for the contest and their affiliations shall be listed on the call for entry. No juror or employee of the organization holding the contest shall be eligible to enter the contest.
- **3.** Criteria for jurying the entries and specifications for the artwork to be submitted in all rounds shall be clearly defined in the call as a guide to both entrants and jurors.

- Deadlines and process for notification of acceptance or rejection of all entries shall be listed in the call for entry.
- **5.** Any and all uses for any and all entries shall be clearly listed in the call for entries, with terms for any rights to be transferred.
- **6.** For the first round, tearsheets, slides, photographs, or other reproductions of existing work shall be requested in order to judge the appropriateness of style, technique, and proficiency of the entrants. This round shall result in the choice of finalists. If samples from this round are not to be returned to the entrants, that fact shall be clearly listed in the call for entries.
- The number of finalists chosen after the first round should be small. The finalists shall then be required to submit sketches or comprehensive drawings for final judging.
- 8. Agreements shall be made with each finalist prior to the beginning of the final stage of the work (Graphic Artists Guild contracts or the equivalent can be used). The agreements shall include the nature of the artwork required, deadlines, credit line and copyright ownership for the artist, and the amount of the award.
- 9. Any work of finalists not received by the required deadline or not in the form required and agreed upon shall be disqualified. All rights to the artwork that has been disqualified shall remain with the artist.
- 10. The winners shall produce camera-ready or finished art according to the specifications listed in the call for entry. Artwork submitted shall not be altered in any way without the express permission of the artist.
- 11. The value of the award should, if possible, be commensurate with the fair market price for the job, though exceptions may be made depending on the budget and use of the artwork for the contest.
- **12.** The contest holder shall insure original artwork in its possession against loss or damage until it is returned to the artist.

Some problems persist

Thanks to these guidelines, many unethical and problematic practices relating to contests and competitions no longer exist. However, over the intervening years, graphic artists have raised other concerns: Who is judging the work? Is the work or the artist being judged? Are competitors who are unknown and unconnected treated as fairly as those whose work is familiar to judges? In 1998, in an effort to keep informed about the latest practices, the Guild sent surveys to 40 associations, publications, sourcebooks, and paper companies that sponsor competitions and contests. They were asked a number of questions, including: Are entrance fees reasonable? Is speculative work required? What rights are entrants asked to give up? How are submissions handled and returned? What are the odds of winning? Twenty-one competition holders responded.

The results of the survey were both reassuring and disturbing. On the one hand, the study indicated that most sponsors of annual competitions are reputable organizations making good-faith efforts to design fair and ethical contests and competitions. They are not guilty of the kinds of questionable practices engaged in by one-shot contest holders, such as the manufacturer who requests original artwork created on speculation to which the artist must sign over all rights. On the other hand, the study revealed that some contests are still conducted in ways that are ethically ambiguous.

The most troubling area involves judging. When entries are identified by artist, the likelihood increases that judges will vote for friends and colleagues or for names they recognize. Of course there is no way to prevent judges from recognizing an entrant's work, even without an attached name. And in certain cases, like book competitions, it's impossible to remove the name of the illustrator. But more could be done to create a firewall between judges and judged. A numerical coding system would ensure both anonymity and proper identification of entries. Entrants could be asked to mask their signatures and credit lines from flat art and disks.

Being a competition judge can add a prestigious feather to an artist's or designer's cap, but it also seems to improve the chances of winning. The temptations are inevitable when judges are permitted to enter their own work, no matter what safeguards exist. Though the competition holders surveyed insisted that their rules prevent bias and promote impartiality, the Guild's analysis of the judging did raise some questions about the appearance of bias, at the very least. Of course, all entrants should be asked to warrant that no other creator's work was infringed in the creation of the submitted piece.

Some artists refuse to enter certain competitions because they believe their work won't be chosen by the judges. Though that may seem unlikely to some, it's not if competition and contest holders draw continually from the same pool of judges. Competition and contest holders could eliminate bias and promote impartiality by both excluding judges from competitions and looking for ways to expand the pool of judges so competitions and contests don't appear to be closed enterprises. These measures would open up the process and create conditions that would allow new, unfamiliar talent to emerge.

3 Professional Issues

What is the real value of contests and competitions to the award winners, and how does that compare with the value derived by the sponsors? It's difficult to measure the benefits to winners because they involve intangibles like exposure and prestige. But trade publications have much to gain. Not only are competitions and contests a source of considerable revenue from entrance fees (\$25 to \$35 an entry), magazines fill their award issues with work they don't have to commission.

Contests and competitions may be part of the mix of every graphic artist's marketing plan. But entering them requires time, energy, thought, and money. Artists and designers need to analyze the various competitions and contests with care, weigh the value of the awards offered, estimate the chances of winning, and evaluate whether safeguards create an open, even-handed contest or competition.

Graphic Artists Guild Foundation Seal of Compliance

As a service to competition and contest holders and entrants, the Graphic Artists Guild Foundation will review calls for entry to ascertain whether they meet the minimum standards listed in the guidelines. If contest and competition holders meet these standards, they are eligible to carry the Graphic Artists Guild Foundation's Seal of Compliance for ethical competition and contest calls for entry. A sliding-scale fee for reviewing calls for entry is available to accommodate the budgets of both nonprofit and for-profit competitions. For further information, contact the Graphic Artists Guild Foundation, 90 John St., Suite 403, New York, NY 10038.

The change from traditional to electronic publishing, image making, and image processing has transformed the technology, the terms, and the jobs that were familiar to clients

and graphic artists since the advent of hot type and offset printing in the Middle Ages. The scope of this change is as revolutionary as the introduction of the Gutenberg movable-type printing press was in its day. The impact

This chapter discusses the ongoing effect technology is having on all aspects of the visual communications industry-from the way graphic artists create their work to how it is reproduced. Also covered are related legal, ethical, health, and employment issues.

of the computer on global graphic art and commun-

ication industries is truly revolutionary.

Today commissioned design and illustration are primarily electronic in final form. The explosive growth of the Internet and the World Wide Web and the widespread acceptance of e-commerce, CD-ROMs, interactive televisions, and computers to study, play games, browse visual files, respond to ads, access entertainment, and read books, magazines, and newspapers all point to new opportunities for illustrators and designers. (See Chapter 8, Web Design and Other Digital Media Practices.)

However, the computer also raises a number of concerns: the high costs of purchasing, maintaining, and upgrading hardware and software; the time and effort required to learn a particular program and keep abreast of the latest applications; legal and ethical issues raised by the ease of copying and altering computer-generated or reflective artwork scanned into a computer, which places new or extended uses of copyrighted material in jeopardy; and workplace changes involving a revolution in job responsibilities, functions, health concerns, and compensation levels.

Respect for the skills of graphic artists who have mastered these technologies may be on the upswing in some fields where it is also reflected in the compensation paid. At the same time, many employers are attempting to redefine their office staff trained in the rudiments of desktop publishing as graphic artists or, likewise, to portray skilled graphic artists as low-level, templike secretarial help. And some buyers of graphic art services continue to abuse markets with insistent attempts to obtain extended rights or work-for-hire authorship transfers from artists at less-than-market rates, creating a windfall of media-ready assets for the buyer.

Some entrepreneurs have set themselves up in the business of supplying ready-made electronic art. They hire illustrators to create clip art for rights-free CD-ROMs that provide some upfront income and minimal royalties, plus wide exposure of an artist's work. Buyers of the CD-ROMs are then free to copy or alter the art without further compensation to the illustrator. (See the Rights-Free Distribution section later in this chapter and the Reuse and Other Markets section in Chapter 5, Essential Business Practices.) Stock house sales of specific rights to an artist's work provide some additional income from existing work without loss of rights and give some measure of protection, though they generally yield lower fees. Many veteran artists believe that both these efforts are driving creators out of the illustration business as salaries or prices fall, inexpensive art proliferates, and sources of future income are diminished. (To find out what the Graphic Artists Guild is doing to address these trends, see the Campaign for Illustration section in Chapter 14, The Graphic Artists Guild.)

One thing is certain: Technology will continue to exert a powerful influence on the graphic arts industry. The best way graphic artists can protect themselves from technology's often overwhelming effects is by staying on top of such issues as professional practices, pricing considerations, ethical and legal concerns (especially copyright), health issues, and the labor market.

Professional Practices Influenced by Technology

Both graphic designers and illustrators have had to change how they do business because of technology.

Issues for graphic designers

The designer consults with the client, creates a concept and a layout, and specifies type for the client's copy in a page layout program. The designer researches or assigns photography or illustration; scales and crops the visual images; oversees the creation of color separations; prepares the final digital file for the printer; obtains client approvals; and buys and oversees paper stock, printing, die cuts, cutting, binding, and shipping.

Photographs and illustrations are scanned in, first, in low resolution for scaling, cropping, and positioning in the electronic page layout. Other illustrations and charts may be created in drawing programs, stored in any of a number of file formats, and imported into the layout. Then the artwork is scanned in a high-resolution form and may be retouched electronically to correct for scanning defects or damaged originals. Any alterations or other manipulation should be done either by the original artist or with permission. Finally the high-res images are positioned in the electronic page layout.

Electronic color separation is handled using the designer's software. However, the way color appears on today's computer screens, though close to the way it will appear on a printed piece, is not exactly the way it will be printed. Translating color from a light-based RGB monitor to an ink-based CMYK printing press can never be perfect. For that reason numerical breakdowns of colors are used both on the computer and on the press so that the printed colors will appear as the designer intended. Responsibility for color separation and the corresponding skill of trapping (an advanced technical registration skill that helps avoid misregistration by creating overlapping areas of adjacent colors) are among the more difficult areas of current client/artist/vendor communication for graphic designers and illustrators.

The computer files are then outsourced to a service bureau to be made into film separations or sent directly to a printer that has such capability. Preparing all this electronic information for accurate translation to the image setter is called "electronic production," "preparation for prepress," or "preflighting." It is sometimes shortened to "prepress," though prepress is, more accurately, the actual production of the output materials on machines.

Designers, service bureaus, and printers now have overlapping, and often varying, in-house capabilities. Designers must be familiar with the abilities and quality levels of their suppliers: Which service bureau scans the best high-res image? Should the designer find an alternate vendor to handle color separations and provide film? What kind of proofs should the client see and at what stages?

Precautionary steps

General guidelines to improve prepress preparation of electronic files are available from the Scitex Graphic Arts Users Association. However, following the computer-ready electronic files (CREF) guidelines is not enough to ensure that a particular job will be compatible with a desired end result. No guidelines can be fully comprehensive for this continually changing industry, and none reflect the requirements of all imaging centers. Nor are they a legal defense absolving a graphic artist of financial responsibility if electronic files are not printed or reproduced correctly.

Graphic artists should obtain specific guidelines from the intended imaging center and the printer, in writing if possible, at the beginning of each project as it is often difficult to determine who is to blame and who must absorb the cost of corrections when things go wrong. Each job is different, but the graphic artist should be sure to provide the correct scan resolution when preparing all electronic files for prepress and thoroughly discuss desired line screens (2X line screen times the percentage of enlargement or reduction) with the printer before the job goes on press. A comprehensive schedule of proofing for each project should also be arranged among client, designer, imaging center, and printer.

If the graphic artist has prepared electronic files for prepress correctly according to the imaging center's guidelines, the artist is not likely to be financially responsible for imaging errors. However, software/hardware incompatibilities between artist and center are common, though problems may be difficult to trace on many occasions. Problems in fonts, software, or hardware owned by the imaging center and certain industrywide problems may not be the fault of any party; solving them is considered part of the imaging center's overhead. Errors resulting from poor communication, misunderstanding, or faulty equipment are corrected by the responsible party. For this reason, all instructions should be written and confirmed, and proofing schedules adhered to.

Areas of possible problems between designers and clients

Now that both designers and clients work electronically, certain types of problems may arise. The client may be tempted to micromanage a work in progress, requesting many changes and alternatives or making many unnecessary changes. It is more efficient if the client reserves comments and changes until the designer presents the work at appropriate stages of the project.

Clients sometimes assume that electronically produced comps are finished art or that such work can be revised in a jiffy without cost. They may not understand that even seemingly simple changes, for example, in the size of a logo, require fine-tuning (at an additional cost) if quality is to be retained. Designers must continually educate clients about software and hardware limitations and clearly explain the parameters of work included in each job estimate.

Since designers do all type styling, letterspacing,kerning,andcustomizingin-house,theclient is usually billed for this work, and this service should be itemized separately on the estimate. If copy is not supplied in a compatible software format, the client is usually billed for the cost of conversion. The job estimate can specify which approach will be used.

It is in the designer's best interests to discuss all intended uses before a job begins so that he or she can present an appropriate estimate that reflects all rights being bought and any physical property—disks or films—being transferred. Care must be taken to specify the limits of the rights being transferred for fonts, commissioned art, style sheets, and other copyrighted data that a client wishes to purchase. A client may wait until a job is nearly finished before requesting ownership of a digital file or template of a design, so it is best if these rights are negotiated before an invoice for the complete job is submitted.

Ownership of electronic files

A major area of misunderstanding between clients and designers involves the ownership of

4 Technology Issues

electronic files (especially with the increasing use of PDF files; see below) and all related monetary transactions. Some clients routinely expect that electronic files will be turned over to them without cost. However, there is no reason to change the historical practice of separating the sale of original work from the sale of usage rights. Ownership of the electronic file is a sale of extended usage rights to a design, which is priced differently than limited or one-time use. Similarly, creating a template for ongoing use by a client should also be handled separately. Unless terms are clearly defined, sticky situations may occur when clients are sent PDF files or when designers are sent another designer's electronic files for a job.

Unlike illustration, graphic design work is not specifically protected by copyright. However, designers need to use specific, well-written contracts because they can give designers the same protections as copyright. Therefore, designers need to define and protect usage rights in all contracts with clients (for example, see the Graphic Designer's Estimate and Confirmation Form and the Graphic Designer's Invoice in Chapter 13, Standard Contracts and Business Tools). Designers also need to spell out usage rights on all disks, CD-ROMs, and any documentary material accompanying the product as well as PDF files and Web sites.

For example, the following statement should be put on a label on a disk or CD-ROM that is sent to a client: "This disk/CD-ROM and all information contained herein is the property of Designer. This disk may not be copied or otherwise transferred, and must be returned to Designer within thirty (30) days of use, unless otherwise provided for by contract."

The following statement should appear at the beginning of a PDF file or on a Web site: "The Designer retains ownership of all original art-work, design elements, and other graphic information contained herein. All rights except for those explicitly transferred herein are retained by the Designer. Such artwork, design elements, and other graphic information may not be copied or otherwise transferred, and

must be returned to Designer within thirty (30) days of use unless otherwise provided in the Designer/Client Agreement."

Adobe Acrobat PDFs

A paradigm shift has occurred. Using Adobe Acrobat PDF (Portable Document Format) files means designers can instantly send designs generated on both Macs and PCs anywhere in the world to be viewed on an Acrobat Reader. When used properly, the PDF technology has brought about revolutionary changes in how designers present designs to, and acquire approvals from, clients and how they distribute final art to publishers or printers.

This comping, soft-proofing, file preparation, and transfer method allows designers to convert layouts using Adobe Acrobat Distiller into relatively small files that can be viewed and printed with accurate fonts, colors, and print-quality-resolution photographs. Or the same files can be e-mailed to dispersed marketing, account, and corporate contacts involved with a particular project, be they in a cybercafe in Amsterdam, a corporate office in Tokyo, or a home office in Cleveland. The same files can then be e-mailed back with comments and approvals.

Time and expenses spent printing, packing, and shipping are drastically reduced, as are approval time frames and time-to-market schedules. A new value-added aspect to the process is that if the client has a color printer, as many corporate clients do, they can generate full-color prints of designs and use them for review and approval with more traditional-minded colleagues.

Another growing use of PDFs is to send final advertising art to newspapers and magazines for separation and printing. The process of preparing files is different for each publisher. The publisher's production department should have an instructional sheet or PDF explaining the entire process to its specifications. If the publisher does not yet have them, continue working through traditional means. Do not become a guinea pig to help the firm work out the bugs in its system! Once prepared, the PDF is either e-mailed or placed on an area of a Web server through a file transfer protocol (FTP). The method is similar to moving a file from one computer folder to another. However, it takes place over the Internet. If the files are then digitally written to the plates, this results in tremendous savings to the client on color film and matchprint output.

Although PDF technology promises amazing changes in how designers do business, there are downsides. Designers must factor in production time needed to distill files and prep e-mail correspondence. That generally takes less time than traditional output methods, but the client isn't going to see any real savings at this phase, though the designer may see a slight increase in productivity. Also, if the work was created on a Mac and the client has a PC, it's a good idea to doublecheck it on a PC-compatible computer before sending it out; this means having access to a PC.

Color calibration on individual monitors varies dramatically. A client may have an older, darker monitor that does not show accurate color, so, for example, a medium purple could easily turn to black. In that case the client can check the designs for type, content, and composition but not color. Or the designer may need to send the client Pantone chips, a final laser print, or matchprint proof produced by traditional means.

PDF technology also raises critical issues about retaining control of one's work, which can lead to copyright and usage rights problems. Because all the fonts and art are generally embedded in the file, perfect copies can be distributed internally or on the Internet with no way for the designer to track usage.

Issues for illustrators

The artistic approaches to electronic illustration are as varied as in traditional media, though the methods of conceptualizing and researching an illustration remain much the same. Access to one's own previously created art, stock photography, copyright-free art, or other reference material may speed up a particular job or mean that some research is done on-screen or online.

Many illustrators first rough out their drawings on paper and fax the sketch they select to the client for approval. Or they scan the selected sketch into the computer, import it into a software program, and submit it to the client by e-mail. Some illustrators use the sketch as a rough template for the finished illustration. Other illustrators draw and revise their illustration directly on the computer. Still others take a collagelike approach, scanning their own photographs, drawings, or other reference material into the computer to use as elements in the finished piece. (Care must be taken that such material is in the public domain or that permission is obtained from the copyright owner. For more information, see the Legal and Ethical Issues section below.) Yet other illustrators use the computer only at the very end of the creative process to add type or tweak color. Of course drawing, typography, and color are all only as flexible and variable as the artist's software program allows.

Once the illustration is completed as an electronic file, the illustrator must now prepare the work for the client's designated output. If it is to go directly to print or color separations from a digital state, the artist may deliver the illustration electronically by modem or by a portable storage medium like a disk. Since electronic illustrations tend to require huge amounts of storage, large storage

Technology Issues

media may be required, which can be delivered to the client by messenger or express mail. To protect their copyright and work inventory, artists should keep a backup copy of the finished art at least until the illustration is safely returned.

If the client requests a transparency or other nondigital form of art, the output cost is billed to the client and ownership of the tangible copy remains with the artist. If film output is requested, the client is billed for the film. (It is important to note that the client's receipt of film does not automatically confer reproduction rights other than those agreed upon. Multiple- or long-term usage must be specifically negotiated.) The art director may order color proofs before printing for client approval and so that the artist or designer may make any final adjustments. (California artists should note that the form of delivery has an impact on whether or not they owe sales tax, also known as a "use" tax. See the Sales Tax section in Chapter 3, Professional Issues.)

Color separations can be readily created from full-color electronic art using several software programs. Unlike mechanical overlays, however, preparation of electronic color separations requires trapping by the designer. (Trapping is a highly technical registration skill that is not yet an automatic feature of current illustration programs, though some stand-alone automatic trapping programs exist.) Many designers prefer to have printers handle trapping.

If illustrators are asked to deliver film output of trapped color separations, they become responsible for the quality of the film, the accuracy of the trapping, and to some extent the appearance of the final printed art (see the following section). However, such concerns are traditionally outside most illustrators' areas of expertise and are regarded as the printer's concerns. If the illustrator provides accurate trapping, it is a billable expense.

Areas of possible problems between illustrators & clients

 Sketches: Clients may assume that the sketch they are viewing, especially when seen on-screen, is complete or close to completion, when in fact much more work may be required to ready the drawing, even if approved, for delivery.

At the sketch stage, clients may mistakenly assume that multiple concepts, color treatments, or sketches for an assortment of proposed page layouts are easy, quick, and cost-free. Good communication between a client and an illustrator about artistic requirements and what the illustrator usually supplies may help avoid this kind of potential conflict.

In current trade practice, the number or scope of sketches that the illustrator presents before an additional fee is negotiated is generally discussed and included in the letter of agreement between artist and client. A change in the shape of an illustration, unless occurring quite early in the sketch stage, is considered a revision and is usually billed.

 Trapping: Illustrators may be asked to produce color-separated illustrations that are compatible with a variety of page-composition programs and printing specifications. Providing such specialized technical services (dismantling an illustration and assigning the appropriate colors and traps to the individual components) raises questions about the illustrator's training, billing, and responsibility for the final printed appearance of the art.

In traditional media it is not unusual for illustrators, particularly those who work in cut-shape techniques or in fields where full-color printing is not used, to create preseparated art. Pricing for it has historically ranged between that for black-and-white and full-color art. Since the potential for creating electronic color separations and trapping exists in some illustration programs, some illustrators may choose to master those techniques to enhance their artistic options and marketability.

However, trapping is traditionally a function of production, not illustration. Illustrators who assume this responsibility also assume liability for corrections and costs if something goes wrong in the printing. Clients and illustrators should be aware that even if the illustrator or the designer handles trapping, the printer must be available to provide the exact technical information necessary to determine trap widths (which vary for each job according to printing conditions, paper stock, and so on). Printers may also prefer their own trapping system, and usually have superior trapping technology and expertise (choosing colors to trap over or under one another is a demanding skill).

Trapping is a technical production expense that is, according to industry sources, separated from the creative fee-for-rights. (Clients may not understand the intricacies of trapping or may think the computer "just takes care of it.") Regardless of who provides this service, a client's project budget should allow for it.

 File maintenance: In current practice, clients are responsible for maintaining an illustration in good condition after its delivery to ensure successful printing and safe return. Electronic files require special care in this regard, as many storage media are vulnerable to loss or damage.

A client holding a backup of electronic art for use in the near future should, with the artist's permission, make additional backups. How-ever, this does not grant any additional rights of reproduction. Clients who delay printing or who have purchased long-term rights to a work should make transparencies or any necessary archival backups. Illustrators are responsible for having their own back-up copies for tracking work inventory and copyright protection.

Output methods

Work produced digitally can be output in many ways—from low- to very-high-resolution print or photographic methods. Resolution, when referring to printed results made from electronic data, means the number of dots per inch (dpi) used to render the electronic information on the output. The more dots per inch, the higher the quality of the image.

Resolution in printing is measured on a continuum of quality—from 72 dpi of a coarse, low-res printer through 3,600 dpi of high-res image setters. (Higher-resolution output methods are sometimes called *image setting*; in general, they provide resolution at or above 900 dpi.)

Black-and-white paper and film output: A variety of machines are available that output computer files onto slick resin-coated paper (RC paper) and positive or negative film (the film is used to print color separations, which the printer then uses to make color separation plates). Resin-coated paper provides perfect reproduction quality, analogous to photostats or the repro copy once used for mechanicals.

While sometimes produced in-house, image setting is usually provided by service bureaus or imaging centers. Most output vendors have preprinted guidelines to assist the graphic artist or page composer in preparing a disk that is fully compatible with the intended output method and equipment. Advance communication between graphic artist and imaging center is essential for a successful result.

 Digital color output: There are many different brands of color printers, ranging in capability from low to high resolution. Graphic artists must become familiar with them and choose the right one to fit the desired mix of quality and cost for each

Technology Issues

project. Thermal wax (thermal transfer), ink jet, color laser copier, and dye sublimation are four common printer types, and each manufacturer and model varies in capability.

Raster image processors (RIPs) are hardware devices or software that interpret digital information sent to the printer or image setter. (This applies to digital proofs as well as digital color output.)

- Digital proofs: Digital high-end proofs for checking color can be made from electronic files. Although the quality available from digital color printers is constantly being improved, many graphic artists continue to rely on traditional matchprints and bluelines for final client approval before print being able to check for color accuracy, graphic artists can spot errors, such as areas mistakenly specified as overprints, that won't show up on an Iris print.
- Traditional media output: Traditional media output like photographic transparencies can be output from files via a number of

software programs. Digital cameras now record images that can be imported into imaging software.

Transparencies can be made in various sizes and resolutions from electronic files by an output device called a film recorder. CD-ROMs are also used to store photographic output (photo CDs), notably the work of Web or multimedia designers.

Direct digital output: Computer-generated art may go to production for direct-to-plate printing without ever being seen on a reflective surface. The original screen image is faithfully reproduced, with resolution based on the file's specifications.

Many presentations are made directly from a computer monitor or, after being output from the computer on different media, are used in slides, overheads, or videos. In-house or external communications may take place directly by modem or networks between computers, or artwork may be stored on a Zip disk or CD-ROM.

Pricing Considerations

Both designers and illustrators surveyed consider the computer itself, as the medium by which they create design or final art, a major factor in the general pricing structure. However, the scale and scope of the project, the intended use and the market, the turnaround time and deadline, the rights of reproduction being purchased, and all the other usual factors in the industry are still considered of primary importance when structuring the initial creative fee for computer-generated art and design.

However, computer use has compressed job skills in many fields, making it a challenge to define and break down the different billable services involved in a project. Graphic artists also frequently incorporate into their estimates overhead costs, such as invested capital, training, and necessary downtime when troubleshooting problems that are inherent when using hardware and software.

Pricing computer-generated art & design

Graphic artists and clients have found that pricing computer-generated art and design requires good artist-client communication, production management skills, and a careful periodic review of costs and time use. Specific factors to be considered include:

 Overhead: Assessments of studio overhead may be needed to cover purchases of hardware and software and to plan for future maintenance, upgrades, and business growth. Formal training costs must be included as overhead, along with a budget for continuing professional education. Graphic artists working on desktop computers may initially invest \$10,000 or more in hardware and software to meet their clients' needs effectively. This does not include training time, upgrade requirements, and time lost due to hardware and software problems.

- Time: A graphic artist may find it more efficient to work on a computer, or it may take longer than work produced with traditional media. Yet having all the data on a project in a digital file can save time when moving from comps to finishes, making alterations, or creating multiple applications from one overall concept. When graphic artists create their own libraries of images and layouts, time can be saved when the opportunity arises to use stored information. However, it may take a long time to learn and to use many software programs; hardware has speed limits; and any time involved with traditional media and necessary approval time must also be scheduled.
- Creative fee/production costs breakdown: Most graphic artists using computers reported in a recent survey that they structure their pricing by separating their creative fee from their expenses (including any work done outside the studio). Like any business, the artist simply bills for each service provided and adds customary markups when appropriate.

At first it may appear to be more difficult to separate out the many components of an electronic publishing project. Scanning, typesetting, image manipulation, page composition, prepress, and color separation preparation all seem to blend into the continuum of producing a job in-house. The graphic artist may feel there is no clear point at which creation is complete and production begins. Such refinements as scaling, moving, and kerning seem to continue throughout the electronic production process.

Once identified, the time, overhead, or skill required for each stage of production may not correspond to the figures both artists and clients have been accustomed to. Artists have found that billing accurately, either by an hourly rate or by fee for services, may prove that some stages cost more than when using traditional methods, while other production stages may be simpler, faster, and less expensive.

Graphic artists report that forcing electronic production into earlier pricing structures doesn't work. New price breakdown categories such as scanning, image manipulation, page composition, creation of color separations, and trapping more accurately reflect services performed using the latest creative and production methods. In the long run, introducing current production steps in the billing process will improve artist-client understanding and help minimize arguments over revisions or errors.

Postproduction costs for imaging center output (such as video, transparencies/ slides, film), use of removable media, delivery services (including messenger services and overnight couriers), rental of peripheral equipment, and purchase of specific software to meet a job requirement are typical expenses that are billed separately to the client. Other expenses to be reimbursed may include subcontractors' fees, supplies, travel, and long-distance phone calls. Also, consultations or client meetings may sometimes be billed separately.

4 Technology Issues

While 15 to 20 percent markup may be common in some fields, most illustrators, for instance, must submit actual receipts. Expenses should be approved by the client in the original estimate and should be billed no higher than 10 percent over without client approval (unless job specifications change, which should be confirmed in writing). (For more information, refer to Chapter 13, Standard Contracts and Business Tools.)

Revisions are probably the single largest factor affecting the final charge. Ongoing communication keeps the client informed about revisions that must be billed. This can sometimes mean several adjustments to the original cost estimate. Taking care of that while the job is underway avoids an unpleasant incident when the client receives the final bill. It also allows the client to limit or stop revisions before budget allocations or deadlines run out.

Design projects are especially vulnerable to soaring revision costs when clients believe that changes are easy to make and when it's not clearly spelled out when, how often, and in what form clients may approve work in progress. As deadlines approach, approval time may be compressed or skipped—a shortsighted tactic that may result in high correction costs. Client awareness and clear communication about when revisions become chargeable is necessary.

Another area prone to revision charges is in prepress costs where a page composition or imaging center error or software bugs can cause problems as a job goes to output or to press. Careful communication with the imaging center about specifications required to make the graphic artist's electronic files compatible and usable by image setters and printers is necessary. The creation of accurate color separations is a particularly fine operation and must be carefully monitored by the graphic artist.

Legal & Ethical Issues

The laws of copyright apply to electronically created art and design as they do to any visual or audiovisual work. The copyright protection occurs at the time the work is created and is vested in the creator except in the case of a traditional, salaried employee, where copyright is held by the employer unless otherwise negotiated. Certain nonexclusive rights may be transferred verbally, but transfer of exclusive rights or of the copyright itself must be done in writing. It is also possible to copyright computer source codes as text, protecting the work as it is expressed in fundamental computer language. (For general information about copyright, see the Copyright section in Chapter 2, Legal Rights and Issues.)

State of current legal practice

Electronic artwork and design are affected mainly, though not solely, by the following copyright ownership provisions: control of the rights of reproduction, the creation of derivative works, distribution, performance, and display of the work. The easiest way to avoid copyright infringement is to make sure that permission has been obtained in advance, in writing, and for any intended use of copyrighted art, such as making a composite.

Rights of reproduction

Reproduction rights give the copyright owner the exclusive right to reproduce or make copies of the image. Grants of reproduction rights may be limited in the number of copies, length of time, geographic area, exclusivity, market, edition, and so on, as agreed by the rights purchaser and the copyright owner. (For a discussion of the 1999 *Tasini v. The New York Times* case that defines rights of reproduction in electronic media, see the Transfer of Electronic Rights section in Chapter 2, Legal Rights and Issues.)

Retrieving a copy of art in digital form on a screen is probably exempt from infringement under a copyright exception for loading programs. However, scanning a work into a computer, for example, does constitute making a reproduction. Court cases have held that substantive editing of movies for television constitutes infringement.

A case is in litigation, as of the time this book went to press in March 2001, that involves failure to pay for second-use rights. The case may also help define what constitutes a derivative work (see below). Eighteen plaintiffs in Teri J. McDermott, CMI, et al. v. Advanstar Communications, Inc. are suing the largest U.S. publisher of medical and trade magazines for allowing their illustrations, for which they only granted first North American print rights, to be reprinted in at least 27 countries around the world over a period of more than 20 years. In addition, the artists were able to document instances of cropped signatures, intentionally dropped attributions, and cases where the images were intentionally changed, cropped, flopped, and recolored.

Derivative works

A derivative work is one that is based on one or more preexisting works. It may be termed a modification, adaptation, or translation, and applies to a work that, according to copyright law, is "recast, transformed or adapted." Most substantial alterations, including editorial revisions, of an image probably constitute creation of a derivative work. A derivative work created with the permission of the original copyright holder is itself copyrightable. Created without permission, it probably constitutes infringement.

The creator of the derivative work has rights to contributions that may be considered original and copyrightable from their additional creative input but has no rights to the underlying work (whether it was copyrighted or copyright-free). The degree of originality is weighed by courts in deciding whether a derivative work is itself copyrightable.

In most cases combining images in an electronic composite constitutes the creation of a derivative work of each of the contributing images. A derivative work in which both the original and the second artist have equal, tangible creative input can be a joint work, with copyright held by both parties, if such agreement is made at the time of the work's creation (see Joint Works section below).

The dividing line between an unauthorized derivative work that infringes on another copyright owner's rights and a new original work that may make reference to an existing image is still blurred. Some court cases have established several important criteria to help determine whether a work is derivative:

- Substance (importance of the borrowed content's quality): How much of the meaningful content of a work has been reproduced? This may be a very small portion of a work in terms of size but the crucial nugget that delivers the main idea. Another measure of substantial content is whether the element taken is unique, recognizable, or identifiable.
- Extent of work copied (sheer volume): How much, literally, of a work has been reproduced? While the specific quantity of permissible copying can only be determined in court, that situation is generally to be avoided.
- Access: Did the second artist have access to the original work? If so, a court or jury may infer that a work was copied intentionally.

Most copyright infringement cases depend on a "person-in-the-street" test: If the lay observer, seeing the original art and the altered or copied work side by side, says that copying took place, infringement exists. Juries are required to search for similarities, not differences, in arriving at a decision.

A retouched photograph, for example, where the final image is not substantially different from the original, would probably not be considered a derivative work. Courts have found such changes to be primarily mechanical and thus not original. But the courts may view changes resulting from digital image manipulation as artistic, rather than mechanical, thereby creating substantial originality.

A preexisting work of art or design used as a base from which a substantially different final work is developed will not likely be held to be a derivative work. This makes it all the more compelling for graphic artists to specify grants of rights with regard to image manipulation upfront and in writing.

Distribution rights

The right to control distribution of a work remains the copyright holder's unless it is sold. Once sold, that particular item may be resold, passed on, rented, and so on, though it still may not be copied or used for derivative works.

While pending legislation may clearly define electronic transmission as copyright, it is assumed that electronic distribution is considered the same as distributing a printed version of a work. Purchase of electronic rights is negotiated separately. Technology can now be used to imbed in any type of work-text, image, or computer source code-electronic copyright management information that identifies rights holders, permitted uses, exclusions, and appropriate fees for a particular use. Electronic delivery systems permit potential users to choose a work, indicate intended uses, and pay appropriate usage fees with the click of a mouse.

4 Technology Issues

Royalty-free distribution

Some entrepreneurs have been selling an artist's entire inventory, royalty-free, on CD-ROM disks. Others are commissioning artists to supply a large number of pieces of art on a particular theme or in a certain style for sale on CD-ROMs. They offer artists royalties on sales of the physical CD-ROM, but the artist is not paid royalties for any additional uses and the rights are sold outright. Purchasers of the resulting royalty-free art have access to hundreds of images they may use in any way, such as altering, manipulating, combining, or otherwise changing, for placement on products, in ads, or as characters in feature films.

Many artists are concerned about the impact royalty-free art is having on the industry. While participating artists may generate significant money upfront, many artists feel that flooding the market with low-cost images is lowering the value of images overall. Clients, they believe, are reluctant to commission original works when low-cost images are readily available. This is particularly worrisome when the art director or designer can take copyrightfree works and manipulate or combine them to create new artwork. Some graphic artists who do this are going so far as to copyright the new artwork under their own name, as well as split copyright ownership with stock agencies through which their work is distributed.

Others, however, believe that such practices broaden the recognition of an artist's work and clients will still be interested in new and original material. Royalty-free art also makes available, say proponents, otherwise costly work to clients who ordinarily could not afford first-time-rights fees.

Both proponents and opponents of these practices agree that such availability is likely to reduce the amount of newly commissioned art and may reduce some fees. A long-term alternative scenario is the institution of a mechanism for monitoring rights purchases similar to those in the music and theater industries. To address this trend, the Graphic Artists Guild has initiated the Anti-Royalty-Free Initiative as part of its Campaign for Illustration (for more information on the campaign, see Chapter 14, Graphic Artists Guild). Part of this initiative is an ad dramatizing the risks to artists of selling work on a royalty-free basis and alerting art buyers to the consequences of supporting that practice. The Guild is placing this ad on a regular basis in the trade press and in the Guild's *Directory of Illustration*.

Performance rights

Performance rights may need to be licensed explicitly in work for certain multimedia, such as broadcasting a video or producing a slide show. A court held in one case that a video game was "performed" (played) without authorization by the end user in a public arcade (despite the

Protecting copyright

seemingly obvious intent that a license for videogame use would entail use of the video game!).

Joint works

If two or more artists create a work with the intention that their contributions be merged into inseparable or interdependent parts of a unitary whole, the result is a joint work according to copyright law. Joint authorship must be intended at the time the work is created and implies co-creation of the piece from conception to fulfillment. Modification by a second artist of a piece by a first artist does not constitute joint authorship but is a derivative work (see Derivative Works section above).

Joint authors hold copyright as "tenants in common." Either creator can license any rights to the work, providing that the proceeds are shared equally.

Protection of creative work under copyright law is still enforced most efficiently by the contracts under which work is commissioned or licensed. Contracts should be clear about rights granted, usage, and amount of time a license is granted. Grants of rights licensing work for any use should specify what is granted and how it will be used; all other rights should be reserved to the artist or copyright holder. (For information about contracts, see Chapter 13, Standard Contracts and Business Tools.)

The importance of spelling out the usage rights the client is purchasing in the graphic artist's estimate and in the letter of confirmation cannot be overemphasized. Most legal problems between artist and client arise because the original terms and any later changes were not expressed clearly in writing. The invoice should not be the first time a client sees or hears of copyright. Clients must be equally careful to assess their usage needs in relation to their budget at the start of a project, as historically most artists adjust their fees according to the rights purchased.

In specifying rights of reproduction for digital art and design, graphic artists need to specify the number of copies permitted, the form in which they will be made, the degree of resolution, limitations on scaling up or down, and so forth. Quality control is a legitimate negotiating point that affects the artist's reputation and income. Other specified limitations usually include the number of appearances or length of time the rights are being licensed for, the market, the media, the geographic area, and the degree of exclusivity. Recent surveys show that payment may be by flat fee or royalty on either a straight percentage basis or escalating on a sliding scale. Royalties may differ for uses of the same piece in different markets. Assigning the entire copyright, all rights, or granting complete reproduction and derivative-work rights entitles the receiving party to manipulate the art or design at will. Some artists and designers are interested in granting broad rights licenses. However, many artists and designers prefer to control their work tightly and restrict image manipulation subject to their approval. Each artist or designer determines what constitutes appropriate compensation for the scope of the licensing rights granted.

Written agreements should be used to grant the right to create a derivative work from an existing image. By granting a general right to prepare a derivative work, an artist permits the client to do anything to the artwork to create something new. Therefore, specifying the resulting intended image may better protect one's rights. As with the license of any copyrighted image, intended markets, rights of reproduction, and so on granted to any derivative work should be clearly specified.

As digital markets proliferate, publishers have new types of projects in which to use art. Many of these will be derivative works, compiling text, image, and sound. An appropriate license should be agreed on that briefly describes the product and specifies that the client is licensing the right to use the art in the product described. A storyboard, outline, or comp may be attached to help explain the project.

Contracts should specify whether alteration or modification will take place, whether derivative works will be created, or if the art does not yet exist, whether the creators will collaborate equally to devise a new, original joint work with a shared copyright. Advance discussion of these issues can help avoid awkward and unpleasant situations.

A contract may specifically prohibit manipulation. One such limiting phrase is: "This work may not be digitally manipulated, altered, or scanned without specific written permission from the artist." Or: "This license does not give [Buyer] the right to produce any derivative works and [Buyer] agrees not to manipulate the image except as we have agreed in writing, even if such manipulation would not constitute a derivative work."

Without a contractual restriction, the art could be altered to the point where it no longer resembles the original piece enough to be judged a derivative work and thus would not constitute an infringement. Including a limiting phrase gives the artist the ability to prevent unauthorized manipulation or either a copyright infringement or a breach of contract.

While typefaces are not copyrightable, the software that produces them is. Owning such software usually implies a license for personal use; it cannot be lent or copied. (For more information on the ATypl Font Publishers' Antipiracy Initiative, refer to the Lettering and Type Design section in Chapter 7, Graphic Design Prices and Trade Customs.)

Electronic defense

Be aware that unauthorized uses of electronic media may be particularly difficult to monitor. While contracts are the clearest overall legal copyright protection, a preemptive line of defense may be taken electronically. For example, artwork intended for presentation but not for reproduction can be provided in a low-res form that is unsuitable for further use. Technological approaches are being continually developed to ensure protection and to monitor the appearance or alterations of a work. Encryption, or programming an invisible protective code into the body of a work, may be useful, though determined hackers can break most codes. Experts have also discussed imbedding a self-destructing key in an electronic image so that after a certain number of uses it can no longer be accessed. Digital pictures can also be labeled visibly so that notice of ownership and the terms of any license always accompany the image. Other types of "watermarking" can be as simple as imbedding a copyright notice © in an image that will be visible if reproduced.

As always, creating a paper trail and keeping good records can help prove infringement. For example, it's good business practice to keep copies of all written agreements and records of telephone conversations in which changes were discussed. Saving copies of work in stages may also help prove that an infringement has been made. And saving reference images with a record of their sources and rights agreements can protect against infringement claims by others.

Defense on the Internet

Electronic bulletin boards, Web sites, businesses, and service providers are proliferating at a truly astounding rate on the Internet, but except for some restrictions on the transmission of adult-oriented material, the only federal regulation on these electronic arenas is the Digital Millennium Copyright Act (DMCA) of 1998, which added several new sections to the copyright law. One of these, Section 512, prevents a service provider from being sued for copyright infringements carried by its service and covers four areas: e-mail communications, system caching, storage of information on systems or networks on Web sites, and browsers. The requirements imposed on service providers have important ramifications for creators in two areas: the removal or blocking of infringing material and the terms of service imposed by online providers. (For a thorough discussion of the DMCA, see that section in Chapter 2, Legal Rights and Issues.)

The first area is of particular interest to graphic artists because of the current *Kelly v. ArribaVista* case. The U.S. District Court ruled in November 1999 that photographer Les Kelly's copyright was not infringed when ArribaVista (now ditto.com) sucked his images off the Web and displayed them on its commercial search engine without his knowledge or permission; the court found that the unauthorized copying and display was "fair use." The case, which has made big waves in copyright circles and could have an enormous impact on how intellectual property may be handled on the Web, is being appealed as this book goes to press in March 2001.

Discussion of intellectual property law with regard to the Internet and the World Wide Web is ongoing but currently consists of more questions than answers. What goes online and how it is used mixes the copyright, commercial, and contractual interests of many parties. Online vendors, for example, may be more interested in getting out a lot of information to attract customers and be less motivated to monitor what happens afterwards. A publisher or original creator, though, wants to maintain control.

4 Technology Issues

Creators and publishers may sometimes be at odds. For example, freelance writers who are members of, and others supported by, the National Writers Union brought the *Tasini v. The New York Times* lawsuit in late 1993 against one database operator and five large media companies, alleging infringement of their copyrights through unauthorized reproduction of their articles on electronic databases and CD-ROMs with no additional compensation. An appeals court upheld the writers' copyright rights in a precedent-setting victory in 1999, but the case will be ultimately decided by the Supreme Court by Summer 2001. (See the Transfer of Electronic Rights section in Chapter 2, Legal Rights and Issues.)

Graphic artists have been asked to sign broad contracts agreeing that their work may appear on unlimited electronic media or in future technologies—as yet undiscovered and unnamed—as a condition of licensing a supposedly one-time right and for no additional payment. Others have received checks in payment for work performed under traditional one-time rights contracts that attempt to grant the client additional undiscussed and unremunerated rights by way of new terms stamped on the back of the check. (See the *Playboy Enterprises Inc. v. Dumas* section in Chapter 2, Legal Rights and Issues.) As the law is currently written (though yet untested), termination rights permit a graphic artist to void even the most global all-rights agreement as long as the artist retains authorship by not signing a work-for-hire agreement and if the work is registered in a timely manner (thereby providing evidence for a claim).

Strengthening copyright protections

Stock agencies can play a role in preventing and monitoring unauthorized uses of art owned by artists by using contracts stating that the image may not be manipulated without the artist's permission and that the artist must be given the first opportunity to make any desired changes. Requesting printed samples of all stock work also helps the artist monitor the image's appearance. Agencies can protect their own and their artists' interests by conducting random checks of the media to spot unauthorized uses. (See the Stock Houses section of Chapter 5, Essential Business Practices.)

However, illustrators who don't work with stock agencies need to maintain control over their intellectual property and to take advantage of secondary markets for their work. In a related industry, the American Society of Media Photographers has established a copyright licensing subsidiary, the Media Photographers Copyright Agency (MP©A), that seeks to license photography for electronic media while serving as a watchdog to protect the copyright of its members. (The subsidiary is administered through the MIRA Web site of the Copyright Clearance Center.) Some observers foresee the establishment of more copyright licensing and monitoring organizations similar to ASCAP and BMI, which oversee the use of songs and music and collect and distribute compulsory licensing fees (royalties) to their members.

The Illustrators' Partnership of America (IPA) was set up in 2000 to explore that possibility for illustrators. One of its primary goals is to help artists learn how to use new business and technological models to control and exploit their intellectual property rights and content in the electronic environment. The IPA plans to conduct research to help illustrators take advantage of emerging opportunities in electronic licensing and publication of their work.

Ethical practices

Copyrighted electronic images require the same respect as any other copyrighted images—permission for use—under federal copyright law. No one, for example, should make unauthorized or pirated copies of application software. Model releases should be obtained from any recognizable people.

However, it seems that editors and other artwork buyers have an eternal urge to crop or otherwise manipulate an image, and digital retouching makes that incredibly easy. Clear contractual terms spelling out the artist's rights and a good relationship with an editor or art director ensure that the artist will be involved throughout the editorial process so the best aesthetic results may be obtained. All changes should be discussed with the artist, and the artist should be given the first opportunity to make them or to approve changes that the art director or client would like to make. No image manipulation should take place without the artist's knowledge and permission, and any changes should be made on a duplicate copy of the art. Artists who know how to make changes electronically and who are willing to do so will have more control over their final art.

A traditional exception is for low-res images provided by sources such as stock houses. Many of these are used in presentations, with the expectation that rights to the image will be purchased if the concept is approved. In 1996 the Graphic Artists Guild spearheaded the "Ask First" campaign in response to the increase in use of sample or portfolio images in presentations without the artist's permission.

Health Issues

There is a high risk of becoming seriously injured from working on computers for extended periods of time, day in, day out. Repetitive motion disorders, an umbrella term describing a large number of repetitive strain injuries (RSI) that include carpal tunnel syndrome, are not specific to computer users but are frequently suffered by them. The Bureau of Labor Statistics notes that RSI accounted for 65 percent of all reported work-related illness in 1998. Of 494,800 newly reported work-related illnesses in private industry in 1995, RSI cases accounted for more than three-fifths of them. Repeated trauma disorders are the fastest growing category of occupational illness, with an increase of over 1,000 percent between 1982 and 1995. Injuries can occur to a graphic artist's hands, arms, wrists, shoulders, back, and vision. Headaches and chronic fatigue are also reported. A physician or clinic specializing in occupational health may be able to provide proper diagnosis and correct treatment.

While employers are responsible for creating a safe work environment, independent creators should make a safe setup a priority to avoid future disability. A number of preventive measures can reduce the risk of injury. The setup of a workstation, including desk height, chair posture, and placement of keyboard, copy stand, and monitor, are all important. Overhead lighting should be indirect and glare-reduced. Correct posture at the computer and taking frequent breaks are good ways to reduce stress and hand, wrist, arm, back, shoulder, and eye strain. A 15-minute break for each two hours is recommended by the Communications Workers of America; hourly breaks are ideal. Allowing the eyes to focus farther away than the screen distance, such as out a window, is recommended during a break, as are doing simple hand stretches.

The ergonomic quality of some hardware and furniture must be improved. For example, one stylus widely used in broadcast design is too thin for some hands to hold comfortably. Wrapping it with masking tape or foam from a hair curler has been found to help prevent RSI.

4 Technology Issues

Similarly, broadcast designers may use a foot pedal to minimize the injurious effect of constantly calling up a menu with a hand tool.

Organizations that provide publications and information on computer health issues include:

Arts, Craft and Theater Safety 181 Thompson St., #23 New York, NY 10012-2586 212.777.0062 | www.caseweb.com/acts Publishes newsletter and books about artists' health hazards and safe working conditions.

Communication Workers of America (CWA) District 1, Health and Safety Program 80 Pine St., 37th floor

New York, NY 10005 212.344.2515 | www.caseweb.com/acts Publishes "VDT Work Station Checklist" and related data sheets with complete information on safe workstation setup.

New York Committee for Occupational Safety and Health (NYCOSH)

275 Seventh Ave., 8th floor New York, NY 10001 | 212.627.3900

www.nycosh.org | nycosh@nycosh.org

NYCOSH is one of 26 COSH coalitions around the country that provide information on VDT safety and other health topics.

Occupational Safety and Health Administration (OSHA)

U.S. Department of Labor 200 Constitution Ave., N.W. Washington, DC 20210 202.693.1999 | www.osha.gov

Provides the global picture, including the graphic arts industry.

Service Employees International Union (SEIU) 1313 L St., N.W. Washington, DC 20005 202.898.3200 | www.seiu.org Publishes pamphlets on health.

The Labor Market

The employment situation is changing rapidly. When computer use was first becoming widespread over a decade ago, many companies attempted to exploit the illusory ease of working with them and refused to pay top dollar. Now many agencies and companies are hiring staff, and Web design is providing a huge area of work for graphic artists. In the process traditional distinctions between job categories are being blurred. For instance, Web programmers are becoming designers, and designers are becoming Web programmers.

Unfortunately, many things about the job market have not changed. Job titles and responsibilities are still not well defined. Classified advertisements frequently describe entry-level jobs requiring "knowledge of Quark, Photoshop & Illustrator" but offering low starting salaries that don't acknowledge the extensive schooling and ongoing training needed to acquire and maintain those skills. One classified ad in *The New York Times* advertised for a "Receptionist/Graphic Designer," certainly a prima facie case for the need for certification in the industry.

Though many employers have begun to acknowledge the high level of expertise that graphic techniques require, increased employer education is needed. A standard hierarchy of jobs recognizing required skill levels would be a beginning, though that may be difficult given the rapidly changing technology. That condition may put graphic artists seeking full-time employment at a disadvantage. Outside consultants are expected to define their roles and rates for the client, while employees have traditionally been hired to fill preestablished positions.

Temporary employment agencies

Temporary agencies, while providing work for many graphic artists in advertising agencies and large design studios, do not aid the recognition of, and compensation for, computer artists' skills. Temp agencies advertise that they can supply artists with mastery of a wide array of software applications and familiarity with many hardware systems but then pay artists only \$10 to \$20 per hour (one exception was \$26 an hour for Web design work), the same as secretarial rates, while charging the client two to three times that. On the other hand, most of the major agencies in the graphics arts sector—Aquent, Creative Assets, and Paladin offer benefits (health insurance and 401K plans after a qualifying period) and handle taxes.

For a variety of reasons, some skilled graphic artists opt to be temporary workers, hired for the duration of a specific project. These artists are often required to sign blanket contracts that ask them to release more rights of privacy and personal financial information than is relevant to the scope of their job. Some of these contracts would be considered extreme even by regular employees, who generally enjoy better compensation and benefits. This practice may have originated because companies request extremely protective contracts from other temporary workers, such as software developers, systems analysts, and other computer consultants who have access to important corporate information and financial data. However, such conditions rarely apply to a temporary graphic artist, and the same contracts should not be used. Organizing the employees of temporary agencies into unions in accord with labor laws could help standardize working conditions by establishing which skills pertain to which job titles, as well as appropriate contract language and compensation.

Other employment issues

Closely following salary in importance are issues of workplace stress, including long hours of work, unrealistic deadlines, and continual changes in a project at hand. A 14-hour workday is all too common among graphic artists in staff positions. That leads to high levels of burnout and injury. One graphic artist was hospitalized for stress after working 41 hours in three days.

The never-ending learning curve required of graphic artists working with computers is another stress. Keeping up with new software programs may necessitate expensive training programs, and upgrading hardware can be phenomenally expensive. One benefit of an in-house job is that some employers provide on-the-job training, especially if an assignment requires special competence.

However, some employers still hold the impression that working at mistaken computers takes no time, and they fail to build proofreading and correction time into the production schedule. In addition an increasing number of business people who do not have production experience work as creative managers. Too often companies, misunderstanding the technical expertise required for computer-generated work, believe that designers can be easily replaced. When faced with expensive errors and poor quality, however, many have begun to view these jobs with greater understanding and appreciation.

Signs of respect for well-trained professionals are developing, as is more understanding that the quality of a job often depends, not on the equipment being used, but on the expertise of the designer operating it. Even though similar equipment is available elsewhere, the best work is done by the best designer. Although corporations don't yet universally understand the many valuable skills graphic artists bring to a job, it is hoped that skilled graphic artists will eventually be recognized with better pay.

Organized labor in the United States would like to see American industry follow the lead of Western European countries—emphasizing high skills and rewarding them with high wages that make them competitive in the new technological era. This view stresses building a workforce with unique high-level, well-paid skills rather than lowering the U.S. worker's standard of living to that of the cheap labor in underdeveloped nations.

Communication companies of the future

Alliances of artists contributing varied creative, technological, and technical skills that provide clients with the widest possible range of services at the best possible price are being formed. A group of specialists may even form a company for the purposes of bidding on one project, then disband it when the job is

4 Technology Issues

completed and form a new "skills cluster" for the next project. Or a professional group may be assembled by the client to fulfill a project. Whether called strategic alliances, teams, skills clusters, joint ventures, or the "virtual corporation," such groupings often include designers; animation, broadcast, and multimedia specialists; page composers; and prepress and print specialists.

Strategic alliances are cost-efficient and quality-oriented. Ideally, they attract work that is closely tailored to each artist's skills and preferences and that encourages maximum creativity, flexibility, and variety in jobs. On the downside, alliances may mean less regular employment and more reliance on per-project work. Graphic artists may be pressured to hop from alliance to alliance, and indeed may prefer doing that.

There may be continued expansion of freelance jobs and more hiring to help companies maximize their use of expensive equipment purchased under the misperception that a computer can create by itself. New jobs are evolving all the time, including the Web designer, prepress specialist, digital design consultant, image-processing and image-setting expert. Some parts of the industry may incorporate graphic skills into earlier editorial stages as the creative process becomes more multimedia and team-oriented and as creation and production continue to merge. Graphic artists and production personnel may be called upon to play a larger consulting role to educate clients about new skills that are integral to the electronic age.

As the workforce changes, the nature of organizations that represent labor will have to adapt to protect workers' jobs, salaries, and health. The challenges to these organizations are great. New, largely unorganized groups of workers are emerging who urgently need their hours, wages, and working conditions represented. Through collective bargaining and legislative advocacy, unions can stay on top of these concerns to improve the economic and social conditions of professional graphic artists. Electronic technology, operated by creative personnel rather than by technicians, challenges traditional unions to identify new work disciplines. From the graphic artist's point of view, old divisions between craft and art may be an obstacle to getting the best results.

The growth of an at-home workforce, however, is a special organizing challenge. Home workers, such as piece workers in the garment and knitting trades, have historically been exploited, with protection hard to establish and monitor. But the home office has become an inevitable side effect of technology in fields ranging from graphic art to political think tanks. With technology changing so swiftly, unions must confront these changes in future collective bargaining agreements.

Computer-generated art has already spawned many new trade associations to help educate both artists and clients. Some of these are listed in Chapter 15, Resources and References.

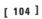

0

 $oldsymbol{\circ}$

To be successful, graphic artists must develop the business skills necessary to market and maintain their careers. As creators, graphic artists have the right to share in the economic

benefits generated by their creative product and, where possible, to seek out and generate additional opportunities. As businesspeople, securing these economic interests and rights is their responsibility.

This chapter discusses the fundamental business management issues common to all professionals in the graphic arts from preparing for the negotiation, to the negotiation process itself, to keeping track of payment schedules, to collection options when deadlines aren't met, to finding

financially rewarding ways to resell work.

Graphic artists must be able to

pinpoint and evaluate the critical terms of a job offer. Understanding contract terms, copyright basics, and customary business practices is crucial, and negotiating skillfully within these parameters can enable a graphic

artist to reach his or her business and personal goals.

For background on current copyright law, see Chapter 2, Legal Rights and Issues. Note that two parts of this chapter—Part I: Preparation and the Reuse section of Part V: Reuse and Other Markets—may apply more to illustrators than to graphic designers, though all graphic artists will benefit from reading the entire chapter.

Part I: Preparation

Graphic art is commissioned in highly competitive and specialized markets. Prices are negotiated between the buyer and the seller, and each graphic artist individually decides how to price the work. These prices usually depend upon many factors, including the use that the buyer intends to make of the art, the size and stature of the client, the client's budget, the urgency of the deadline, the complexity of the art, and the graphic artist's reputation. Both historical and current practices reveal that the factors often considered in pricing decisions vary from discipline to discipline; therefore, the information in this chapter should be supplemented by reading corresponding sections within each discipline.

Setting prices, fees, or rates

Prices, fees, or rates vary depending on the graphic artist's working arrangement. Learning how to define usage of work is critical for both illustrators and graphic designers.

Price determined by use

To encourage the free flow of ideas, copyright law vests with the creator of every artistic or literary work a bundle of rights that can be divided and sold in any number of ways (for more detailed descriptions of these rights see Chapter 2, Legal Rights and Issues). Therefore, the price of graphic art historically has been determined primarily by the extent and value of its use, or "usage." Graphic artists, like photographers, writers, and other creators, customarily sell only specific rights to the use of their creative work. The graphic artist specifies which rights of reproduction are being granted for the intended use.

Some inexperienced clients assume they are buying a product for a flat fee, with the right to reuse or manipulate the art or design however they wish. But such purchases are historically more like licensing agreements in that only the exclusive or nonexclusive right to use the work in a specific medium (such as magazine cover, point-of-purchase display, or billboard), for a limited time period, over a specific geographic area is sold, or "granted."

The basic standard of sale for a commissioned work of art is "first reproduction rights" or "one-time reproduction rights." While some clients increasingly try to obtain an overly broad grant of rights, current data indicate that reuse, more extensive use, use in additional markets, or international use should receive additional compensation. Graphic artists should consider the full potential value of their work when estimating the value of "exclusive," "unlimited," or "all-rights" agreements. Sale of the original physical art or design (including digital media) is, under copyright law, not included in the sale of reproduction rights and is normally a separate transaction.

In some cases (corporate logos, advertising, product identity), the buyer may prefer to acquire most or all rights for extended periods of time. Recent surveys report that buyers and sellers both consider additional fees for such extensive grants of rights to be usual and customary. In other cases the buyer has no need for extensive rights. One of the graphic artist's main responsibilities when negotiating transfers of rights is to identify the buyer's needs and negotiate the transfer of appropriate rights.

Manufacturing

Examples of Markets and Media

Here are examples of market categories and some of the media for which they buy art. Within each category there may be more media than space allows to be listed here.

Advertising

Book

Advertising	DOOK	wanutacturing
Animation	Anthology	Apparel
Client presentation Preproduction, comps	CD-ROM/Online	Domestics
	Educational text	Electronics
Collateral & direct mail Brochures, direct mailers, flyers, handouts, catalogs	Mass market	Food & beverage
	Trade	Footware
Display & exhibit	Electronic	Home furnishing
Magazines/magazine	Other	Jewelry
supplements Newspaper/newspaper supplements/advertorials	Specify hardcover or softcover edition, cover, jacket or interior, etc.	Novelty & retail goods Paper products, greeting cards, mugs, posters, cal- endars, giftware, other
Online World Wide Web sites; electronic publications/ periodicals	Editorial	
	Educational	Toys & games
	Audiovisual/filmstrip	Promotion
Outdoor Billboards, bus & car cards, station posters	Encyclopedia	Booklet
	Magazine	Brochure
Packaging Products, CDs, cassettes, videos, food, software	Newspaper	Calendar
	Online/database	Card
Point of sale Counter cards, shelf signs, posters	Television/cable TV	Direct mail
	Other	Poster
Poster		Press kit
Film, theater, concert,	Institutional	Sales literature
event	Annual report	Other
Presentation	Audiovisual/filmstrip/video	
Television/cable TV	Brochure	
Other	Corporate/employee publication	
	Presentation	
	Other	

Graphic artists need to know that selling extensive or all rights at prices usually paid for limited rights is like giving the buyer unpaid inventory of stock art, thereby depriving the artist (and other artists) of income from additional uses and future assignments. Clients may need to consider that paying higher prices for more rights than they will use is expensive and unnecessary. Purchasing more rights than are needed also deprives the public of access to the work, since in most cases only specific rights are ever exercised. If buyers are asking for an all-rights or work-for-hire agreement to protect themselves from competitive or embarrassing uses of the work, a limited-rights contract with exclusivity provisions can be easily drafted by the graphic artist that will both more appropriately meet the buyer's needs and more adequately remunerate the artist.

Grants of all rights should specify the category, the medium of intended use, and the title of the publication or product. Grants of rights may also specify, where appropriate, edition, number of appearances, and geographic or time limitations. For example, advertising (market category) rights in a national (region) general-interest consumer magazine (medium) for a period of one year (time). A common formula for editorial assignments is one-time North American magazine or newspaper rights. Designers may choose to limit how their work will be used—for instance, as a particular brochure and not as the basis for the client's annual report.

International uses

Determining the value of work to be used outside the United States follows the same general guidelines as with other uses. In addition to the length of time, how and where the material will be used are key. For example, selling rights to a French-language European edition of a consumer magazine includes distribution in France, Belgium, and Switzerland. A country's economic condition also plays a role. A license for distribution in Japan might be considered more valuable than one for China because a larger percentage of the population would be reached.

Royalties

Historically, graphic artists and clients have found that a good way to compensate the value an artist contributes to a project is through a royalty arrangement; this is the accepted method of payment in book publishing and all types of licensing. A royalty is the percentage of the list (retail) or wholesale price of the product that is paid to the graphic artist based on the product's sales. Royalty arrangements often include a nonrefundable advance payment to the artist in anticipation of royalties, which is paid before the product is produced and sold. Royalties are not appropriate in cases where the use of the art does not involve direct sales or where a direct sale is difficult to monitor (see Part V: Reuse and Other Markets, below).

Reuse

In most cases, illustration is commissioned for specific use, with any rights not transferred to the client reserved by the artist and available for sale. When the terms of the specified grant of rights are completed, or not exercised within a specified period of time, those rights also return to the artist and may be sold again. Subsequent uses of commissioned art, some of which are called "reuse," "licensing," and "merchandising," have grown dramatically in recent years, creating additional sources of income for artists. While many artists are concerned about the resulting drop in new commissions, a significant number of artists have take advantage of these new markets to enhance their income potential. Part V: Reuse and Other Markets in this chapter describes these opportunities.

Per-diem rates

Sometimes graphic artists are hired on a per-diem or day-rate basis. Surveys of graphic artists and clients have found this to be a perfectly acceptable work arrangement and method of compensation, provided that it accurately reflects the work required and is agreed to beforehand by both graphic artist and buyer.

Graphic artists and buyers have found it useful and effective to establish a basic day rate for the work. This, together with an estimate of the number of days needed to complete the work, art direction, consultation, and/or travel, gives both parties a starting point from which to obtain a rough total estimate. A word of caution: Some jobs look deceptively simple, and even the most experienced graphic artists and clients sometimes find that greater expenditures of time are needed than were anticipated. When negotiating an estimate, both parties often address questions concerning complexity, degree of finish, delivery time, expenses, and general responsibilities, and they agree that an estimate is just that and is not assumed to be precise.

Guild members have found that one method of estimating an appropriate per-diem rate is to first total all direct and indirect business costs, adding in a reasonable salary. Divide this total by 230 annual business days (52 weeks minus six weeks' vacation, holiday, and sick time). Then add to this figure a reasonable profit margin, which has historically ranged from 10 to 15 percent.

Per-Diem Rate Formula		
Annual rent, utilities, insur- ance, employees' salaries and benefits, advertising and promotion, outside profes- sional services, equipment, transportation, office and art supplies, business taxes, entertainment, and other business expenses:	\$	
Add a reasonable salary:	+	
Total:	\$	
Divide by 230 working business days per year:	\$	
Add a reasonable profit margin (10%–15%):	+	
Per–Diem Rate:	\$	

5 Essential Business Practices

Hourly rate formula

Whether pricing on a fee-for-use basis or by the hour, graphic artists must know what it costs them to conduct business so they know whether the fee received for a particular project amounts to profit, breaking even, or loss. Calculating the individual cost per hour of doing business enables graphic artists to evaluate their financial progress.

Guild members and other industry professionals surveyed use the following method to establish an hourly rate: First, total all direct and indirect business expenses for a year, including rent, utilities, insurance, employees' salaries and benefits, advertising and promotion, outside professional services, equipment, transportation, office and art supplies, business taxes, and entertainment. Using the actual figures in your Schedule C for IRS Form 1040 makes this easy. Include a reasonable salary that reflects current market conditions (see Chapter 6, Salaries and Trade Customs). Divide the total by 1,610, which is the number of hours worked in an average year (52 weeks minus 6 weeks' vacation, holiday, and sick time). Add to this figure a reasonable profit margin, which has historically ranged from 10 to 15 percent. The resulting hourly rate, based on a 35-hour week, covers all costs of doing business, including the graphic artist's own salary. However, most self-employed graphic artists indicate that they divide the annual overhead figure by a much smaller number of working hours to allow for time spent on such nonbillable work as writing proposals, billing, and self-promotion. A figure from 20 to 45 percent less, or roughly 900 to 1,300 hours, has been found to be more accurate and practical.

When considering a project, it is important to accurately estimate the required hours of work. Multiplying this estimate by the hourly rate demonstrates, say many graphic artists, whether the client's fee for the project will at least cover costs. If it will not, the graphic artists recommend negotiating with the client for more money, proposing a solution that will take less time, or searching with the client for another mutually agreeable alternative. Many large jobs, such as corporate design projects, require that the hours involved be used as a gauge to measure if the project is on budget.

Recent surveys indicate that design firms usually have at least two hourly rates: one for principals and one for employees. The difference is related to salary level. For example, in the graphic design field, the hourly rate for a principal is, on average, \$150 to \$250 and for studio staff \$50 to \$100.

Page-rate pricing

Some illustrators and designers working in advertising and editorial print media markets check advertising page rates as another factor in gauging fees. Advertising page rates vary according to the type and circulation of a magazine, and therefore provide a standard for measuring the extent of usage. These rates, therefore, provide a good barometer of a magazine's resources. For example, Better Homes and Gardens (ranked 5 on the Folio 500 list of magazines) had a circulation of 7.6 million copies in 1999 and received \$206,200 for each of the 1,949 pages of advertising sold. Obviously Better Homes and Gardens delivers a potential market to its advertisers that makes this cost worthwhile. Business Week (ranked 8), with a 1999 circulation base of 963,000, received \$57,400 for each of its 5,122 pages of black-and-white advertising. A page in Popular Mechanics (ranked 90), with a circulation of 1.46 million copies, costs \$52,895 for each of the 793 pages of advertising sold. A page in the regional consumer magazine New York (ranked 66), with a circulation of 438,000, costs \$28,240 for each of the 2,526 pages of advertising sold. A page in the specialty consumer magazine Scientific American (ranked 157), with a circulation of 696,000, costs \$32,200 for each of the 452 pages of advertising sold.

Magazine advertising page rates and circulation information can be found in such trade journals as the September issue of *Folio*, *Advertising Age*, and *Adweek* and in publications issued by Standard Rate & Data Service, Inc., which are available in most business libraries.

Other pricing factors

 Inflation: During periods of inflation, the change in the government's Consumer Price Index (CPI), which measures cost-ofliving fluctuations, is another factor to be considered when calculating an appropriate fee. As the costs of printing, paper, distribution, advertising page and TV rates, and other items in the communications industry rise as time passes, so may prices paid for commissioned art. Such costs are generally reviewed yearly, and any increases in the

5 Essential Business Practices

inflation rate are taken into consideration, say industry professionals. However, the CPI may also decrease, as it did in 1997, the latest date available; that year the CPI was 121.6, reflecting a 12.9 percent decrease from 1993. That may be another factor accounting for stagnant fees.

- Size of print order or ad: The reproduced size of the ad and the quantity (number) of the print order are another factor in pricing.
- Consultation: If a job requires extensive consultation, recent surveys indicate that graphic artists frequently estimate the number of hours or days required, multiply them by their individual rate, and add a consultation fee to the basic project fee. It is not uncommon, especially for a brief consultation to solve a particular problem, for the consultation fee to be substantially higher than the normal hourly rate. The nature of the project, proposed usage, unusual time demands, and any travel requirements are factors to consider when estimating a consultation fee.
- Large projects: In some markets, current data show, large orders may carry lower per-unit prices than single or smaller orders. In such cases, lower prices tend to be in keeping with standard business practices.

Billable expenses for graphic designers

Graphic designers traditionally bill clients for all expenses involved in executing an assignment, while textile designers and illustrators often absorb expenses for such things as art supplies because those costs tend to be modest. Necessary costs related to producing a job, such as model fees, prop rental, research time, production or printing, shipping, and travel expenses, are routinely billed to the client separately. These expenses, even as estimates, are generally agreed upon and set down in the original written agreement. Often a maximum amount is itemized beyond which a designer may not incur costs without the client's authorization. When graphic artists are required to advance sums on behalf of the client, surveys show that it is customary to charge a markup as a percentage of the expense to cover overhead and provide adequate cash flow. Dimensional illustration, for example, often requires substantial outlays for rental or purchase of materials and photography needed for a reproducible final. Current data indicate that markups are in the range of 15 to 25 percent, with 16.85 percent the average.

Billable expenses for computer graphics & illustration

Surveys show that graphic artists who work with computers consider that capital investment in their fees. It is important for those who rent or lease equipment or use out-of-house service bureaus to maintain strict records of all expenses in order to bill the client. Billable expenses usually include rental or leasing fees, transportation to and from the equipment, and any costs incurred in recording work as hard copy or on film or videotape. Fees paid for technical assistants, research and reference costs, and expenses for preparing raw art (from photos or line art) for digitizing camera input are usually billed as well. Other expenses, such as equipment or technology purchased to meet specific demands of the job (buying a new font or telecommunications program), are usually negotiated.

Graphic artists also usually follow the markup considerations outlined above for equipment rental, particularly when they spend time negotiating for rental time or purchasing supplies and services. Recent data show that the going billable rate for renting video animation systems, for example, averages \$400 to \$600 per hour, with \$500 to \$800 per hour for systems that create special effects. Rental fees for hardware are about 10 percent of the purchase price; for software, approximately 20 percent. Any graphic artist working with video animation systems should consider the newness of the technology and the speed with which the technology changes as part of a regular review of expenses and charges.

Freelancer as employee

Both graphic artists and clients should be aware that certain working relationships may be considered traditional employment, regardless of a "freelance" title. So-called full-time freelance positions—relationships that are steady and ongoing or that extend over a series of projects—may be considered employment under current tax or labor law. In these cases, the graphic artist may be entitled to basic employment benefits, including unemployment, workers compensation, and disability insurance. Other benefits such as medical coverage, vacation, pension, and profit sharing may also be due. Clients who do not withhold payroll taxes in these cases are flouting federal and state laws, and may face penalties equivalent to the taxes that should have been withheld. (For further discussion, see Chapter 3, Professional Issues.)

Other contractual considerations

An illustrator should consider a variety of other items, including cancellation and rejection fees, credit lines, samples, and liability for portfolios and artwork, when preparing to negotiate a contract.

Cancellation ("kill") fees

According to current and historical data, clients usually pay a graphic artist a cancellation fee if an assignment is canceled for reasons beyond the artist's control. The amount of the fee has in the past ranged from 30 to 100 percent, depending upon the degree of the work's completion. (For a more detailed discussion of such fees, see Chapter 3, Professional Issues.)

Upon cancellation all rights to the artwork, as well as possession of the original art, generally revert to the artist. Under a royalty arrangement, however, the client may demand all the originally agreed-upon rights to use of the artwork upon payment of the cancellation fee.

When determining an appropriate kill fee, many artists take into account a project's advance and any anticipated royalties. For example, suppose an illustrator completes the work for a 32-page children's picture book for which the artist received a \$5,000 advance against a 5 percent royalty, and then the job is killed. If the initial print run was to be 10,000 copies, with each book listing at \$12.95, then the anticipated royalty would have been \$6,475 (10,000 × \$12.95 × 5%). After the \$5,000 advance is subtracted, the anticipated royalty would have been \$1,475. That would be the appropriate cancellation fee.

When flat-fee projects are canceled, historical data indicate that all necessary and related expenses (such as model fees, materials, or overnight shipping fees) are paid in full.

Cancellation terms should be stipulated in writing in contracts and on confirmation forms and purchase orders. Otherwise, artists report, negotiating these fees at the time cancellation occurs makes it more difficult to protect their investment of time and resources. Artists also have found that contract language that makes payment of fees contingent upon the buyer's receipt of the artwork, not upon publication, anticipates the possibility of cancellation after acceptance and has helped ensure timely payment.

Rejection fees

According to current and historical data, clients may agree to pay the graphic artist a rejection fee if the preliminary or finished artwork is found not to be reasonably satisfactory and the assignment is terminated. The amount of the fee varies widely, historically from 20 to 100 percent, depending upon the degree of the work's completion. (For more detailed discussion of rejection fees, see Chapter 3, Professional Issues.)

By rejecting the artwork, the client has chosen not to obtain any rights to its use. Therefore, many artists refuse to permit the client to use rejected work for reproduction without a separate fee.

Credit lines

Illustrators usually incorporate their signatures into their artwork, and they are typically reproduced as part of the piece. For important pieces, especially when a letter of agreement spells out the terms of usage and payment, artists may request specific credit lines as part of the deal. For some this may mean a printed credit line with copyright notice; for others, merely the reproduction of the signature in the artwork. In some cases, as is traditional in magazines, both forms of credit may be agreed upon.

A copyright notice can be added to the credit line simply by adding © before the artist's name and the year of publication after the name—for example, © Jane Artist 2001. Such a copyright notice benefits the artist without harming the client.

Recent surveys show that some magazine photographers' contracts require that their fees be doubled if an adjacent credit line is omitted. Given the modest rates for editorial work, it is not surprising that the value of the credit line is as important as the fee. This does not yet constitute a trade practice, but it is becoming more common, and has also been adopted by some designers and illustrators.

Samples of work

It is a courtesy for clients to provide artists with examples of a finished piece as it was reproduced. This piece, often called a "tear sheet," shows the project in its completed form and can be displayed in an artist's portfolio. Even if clients purchase the copyright to artwork, artists' use of their original art in their portfolios is permissible as fair use (and is not competitive with the copyright owner's uses), except in cases of work for hire, when the client's permission must be obtained.

Liability for portfolios & original art

If an artist's portfolio is lost by an art buyer, the law of "bailments" (the holding of another's property) makes the buyer liable for the "reasonable value" of that portfolio, if the loss arose from the buyer's carelessness. If the portfolio contained original art such as drawings, paintings, or original transparencies, the amount in question could be substantial. The same potential liability exists with commissioned artwork that a client has agreed to return to the artist. A model Holding Form for use by surface and textile designers is provided in Chapter 13, Standard Contracts and Business Tools, and can be modified for use by other disciplines. The value or appraisal of originals, transparencies, and other lost items can be verified by obtaining simple written assessments from a number of the artist's clients, art directors, or vendors and then by presenting the figures to the party who lost the work or to a court. An independent appraisal by a professional appraiser is also credible. However, the full value of the work may be nearly impossible to calculate, since no one can be certain what the work will be worth over the life of the copyright, which is currently the artist's lifetime plus 50 years (see the Copyright Extension section in Chapter 2, Legal Rights and Issues). One factor that can affect a work's value is whether it is generic or specific. Generic works (a bald eagle soaring in flight) may have more potential for economic exploitation than specific works (a brand of laundry detergent). Artists may also need to prove that their work has generated additional income through transfers of rights.

There are a number of ways to minimize the risk of losing original work. First, whenever possible, artists should avoid letting original art out of their possession. Instead of submitting portfolios of finished work, it's preferable to provide transparencies, color copies, or digital files. Second, the artist should have "valuable paper" insurance that protects against the loss or damage of valuable artwork in the artist's studio, in transit, or while in the client's possession. That, however, is still not enough protection, since, as with any insurance, deductibles must be met and claims may lead to prohibitive premiums or a complete loss of coverage.

Buyers need effective systems for tracking and storing original art in their offices. They should provide a record of receipt of every portfolio and a tracking system within the organization. If possible, buyers should avoid keeping portfolios overnight and on weekends. All original art should be logged out when it is sent to any supplier, such as a color separator or a printer, and logged in when it returns. Finally, suppliers and vendors should understand that they may be held liable for any losses they cause as a result of damage to, or disappearance of, any original art.

Since absolute guarantees of protection of original art are impossible, art buyers should minimize their legal risks by purchasing suitable insurance and, more important, by instituting proper record-keeping and tracking procedures.

Part II: Negotiation

Negotiation is said to be an art, but it's really a craft that can be learned and mastered. Through negotiation each party seeks to accommodate its own needs and those of the other party. Whenever possible, an atmosphere of mutual trust and collaboration should be established so that both sides can create a win-win agreement that will satisfy their respective needs. Approaching negotiation with a "winner-take-all" attitude can do more harm than good, undermining the mutual professional respect necessary for long-standing relationships, not to mention repeat business.

Agreement is attained not merely by the exchange of concessions but by the attitudes and professional manner of the two parties conducting the negotiation. Since the terms of the final agreement may not be those initially stated by either party, the participants must use all their creative energies to develop solutions that meet their respective needs.

5 Essential Business Practices

From years of handling graphic artists' grievances with clients, the Guild has found that a common source of complaints is the failure by both sides to communicate effectively before work is started. Graphic artists and clients must know their own needs, articulate them, and take the other party's needs into account. Even if only one of the negotiators makes a conscientious effort to understand the other's point of view as well as his or her own, chances of a misunderstanding or conflict are greatly reduced.

Both graphic artist and client must have goals by which to judge a negotiation. A client, for example, must stay within the established budget and obtain appropriate artwork or graphic design. A graphic artist, like any businessperson, must earn enough to cover overhead and make a reasonable profit. The more information each party has about the other, the more effective the negotiation. Graphic artists need to know the budget for a given job and the many factors to take into account to arrive at fair pricing. They also need to have a good sense of current market forces, which is one of many reasons why this book was developed. Similarly, clients who use this book to keep abreast of current standards and contract terms are better equipped to establish more accurate budgets and to determine what rights to buy. The Guild encourages graphic artists and clients to adhere in all negotiations to the standards of the Joint Ethics Committee's Code of Fair Practice (see Chapter 1, Professional Relationships). Of course, if either graphic artists or clients find the other party does not permit them to achieve their essential goals, then the negotiation breaks down and the parties seek to fulfill their needs elsewhere.

Some graphic artists may be reluctant to ask questions or raise objections to a client's demands for fear of appearing to be difficult to work with. Guild members report, however, that as long as the discussion is carried out in an appropriately professional manner, clients appreciate graphic artists who articulate their needs, since it prevents future misunderstandings. Above all, graphic artists need to remember that clients are not "the enemy."

Preparing to negotiate

Negotiations tend to be stressful, so establishing a state of alert relaxation is very important. It is possible to relax if you are properly prepared and if you strive to make the situation as comfortable for yourself as possible. (Focus on breathing and concentrate on relaxing the muscles in your head, neck, and shoulders.)

It's also important to create a mental distance from any anxiety that may arise during a negotiation. Being objective helps one respond with agility so that the opportunity to negotiate the right job at the right price won't slip away. Though the deal at hand may seem like a "make-it-or-break-it" proposition, that is usually not the case. Most careers in the graphic arts are built upon hundreds of projects, not one.

Set your own agenda

Be prepared at the beginning of every negotiation to ask the right questions. To help yourself do that, draw up a standard agenda or checklist that outlines the topics you want to cover, and fill it out while having preliminary discussions (usually by telephone) with the potential client. Filling out this form as a routine business practice will considerably reduce stress and positively affect what you agree to in negotiations. A typical agenda includes a job description, due dates, fees, expenses, and notes on the person representing the client.

Make sure your agenda includes the most important question: "What value—monetary or otherwise—will I derive from this job?" Remember that value is not measured solely in dollars; graphic artists need to carefully consider all the benefits of doing a job, not just the fee. Sometimes exposure on a highprofile project, good portfolio samples, or flexibility on deadlines can make up for lower fees. Or taking a job may help you to establish a relationship with a new client. Some graphic artists also create three lists before entering into a negotiation: a "wish" list, which includes everything you could possibly dream of, such as a huge fee plus a royalty, your name in neon, very limited rights, and a comfortable deadline; a "nice-to-have" list, with a lower fee, more rights, and a shorter deadline; and a "bottom line" list, itemizing those things you must have, such as a "no-lower" fee, no work for hire, and a reasonable deadline. Be prepared to walk away from a job if the client can't meet your own minimums.

Research the client

Preparation is key in successful negotiation, and learning as much as you can about a potential client will help bolster your confidence. Business libraries contain valuable information about the marketplace, and a business librarian can help you locate appropriate publications. Directories for corporations and advertising agencies, such as those published by Standard Rate & Data Service, Inc., show amounts of billing, circulation, media bought, officers, and so on. Publication directories list magazines with their circulation, advertising rates, names of staff, and so forth. Subscribing to major trade magazines may also be helpful.

Magazine stands, mass transit posters, billboards, retail stores, supermarkets, and bookstores all contain valuable information that graphic artists may find useful when researching a new client. Active membership in the Graphic Artists Guild helps give visual communication professionals the extra edge they need in any job situation. Consulting with other professionals who have worked for a client may also provide valuable background information.

Identify both parties' needs

Both sides begin a negotiation by stating a set of demands based on their needs. These demands should not be confused with underlying needs, which a skilled negotiator strives to discern. For example, when the problem stated is "My company is looking for a firstclass brochure that we can produce for under \$10,000," several underlying needs are not being directly articulated. The client may actually be saying "I want top-quality work at an economical price. Can you accommodate me and make me look good, or do I have to worry that what you do may not please my boss?" Knowledgeable and skillful questioning helps determine not only what kind of brochure is required to effectively meet the client's needs, but whether some other solution might better solve the client's problem within the established parameters.

In responding to the client, a skilled negotiator communicates positive expectations about the job: "I understand your needs, and I am the best choice to solve your problems"; "I'm experienced, and I know what I'm doing"; and "I'm going to make you look good." Instead of "What is the deadline?" use a phrase like "When would you want me to deliver the layout?" From the outset, interaction that shows personal interest and regard for the client and the project is highly beneficial.

The answer to a stated problem is not always obvious. That's why it's critical to try to perceive the other person's needs. Then you will be able to respond positively to the underlying meaning of what is being said, and the negotiation can proceed harmoniously.

Dealing with common tactics

Whether intentionally or not, tactics are used during every phase of negotiation, and it's important to understand them and not take them personally. The ability to maneuver and perform is seriously hampered when egos take charge. Separating your emotional responses from calm, detached observations of an opposing party's tactics can help you defuse their effectiveness. Consider the following examples:

 Limited authority: A client's negotiator claims not to have final say on the terms of a deal. That enables the client to make rigid demands, forcing the graphic artist to offer concessions in the interests of making head way. One possible solution is to treat the project under discussion as a joint venture and recruit the other person as a newfound "partner." By emphasizing terms

5 Essential Business Practices

that create a partnership, and sharing a stake in decisions, the client's negotiator is encouraged to go to bat with the higherups to defend the graphic artist's needs and goals.

 Phony legitimacy: The negotiator states that the offer is a "standard contract" and cannot be changed. In such cases it helps to remember that contracts are working documents designed to protect both parties in an agreement. Don't feel pressured to sign standardized contracts if the terms don't protect you. Don't be afraid to strike out unfavorable sections or terms. If necessary, suggest alterations using the defense that "my attorney has instructed me not to sign contracts with these conditions" (see Chapter 13, Standard Contracts and Business Tools).

 Emotions: Anger, threats, derisive laughter, tears, or insults may seem convincing and may, in fact, be genuine, but they are tactical maneuvers. Listen carefully to the point of the message and separate it from the style of delivery. Never escalate an emotional situation. Any attempt to "roll up your sleeves and jump in" is exceedingly risky.

Special issues with phone calls & meetings

It's important to master the special skills needed to negotiate both on the phone and in face-to-face meetings. Each type of negotiation has pros and cons, though phone calls offer some advantages over in-person meetings. They provide ample opportunity to refer to written materials for support, and being in the safety and sanctity of one's own environment may bolster confidence. It's always easier to refuse someone over the phone. On the other hand, if a difficult demand has to be made, it may be easier to do it in a meeting.

Negotiating by phone also has disadvantages. It may be difficult to judge the reaction to what's being said when it's impossible to see the other person's face. And a person's attention may not be focused on what is being said; this can make it more difficult to establish the rapport and partnership so important to any successful negotiation.

Telephone dos & don'ts

As recommended above, a simple negotiation agenda or checklist should be used, outlining all the points to be covered. This helps the graphic artist keep the conversation centered on the important matters at hand and prevents the problem of forgetting important details. Some individuals go so far as to write scripts for particularly difficult situations where performing under pressure may cause confusion.

Taking notes during phone conversations is recommended highly. Graphic artists must simultaneously understand the aesthetic requirements of a project, agree on the business arrangements, and establish rapport with the individual on the phone, so all complicated details should be written down. Such notes also provide valuable reference points should a misunderstanding occur during the project.

If a discussion becomes difficult or gets bogged down, it may be best to end the call and say that you'll get back to the potential client as soon as you've had a chance to consider the project. This gives you time to consult research materials, make phone calls for more information, cool off if emotions are in play, or just have additional time in which to make a decision. In fact, some graphic artists never agree to take a job during an initial call. Rather, they take time to consider all aspects of the job in relation to their other work, and then call back after thoroughly evaluating all terms. That practice helps empower the graphic artist.

Meeting protocol

Create an environment for a meeting that puts you in as comfortable a situation as possible. If negotiating on your own turf is impossible, bring your own turf with you. Clothing should always be professional, but make sure it's also comfortable.

Any presentation or portfolio should showcase your very best work. An unusual, thoughtful, and creative presentation that is well designed goes a long way toward establishing the graphic artist's expertise—and making a sale.

Three golden rules to follow during a meeting are stop, look, and listen.

- Stop: Quiet down, breathe, and relax. Refrain from small talk unless what's being said has a purpose for the business at hand. A well-placed word here and there helps establish credibility, but giving information not asked for may i advertently provide clues that reveal the graphic artist's weaknesses or limitations.
- Look: A great deal can be learned by close attention to physical clues and the client's behavior. Office environments (wallpaper, furniture, desktops, artwork, and photographs) give clues about the client's personality. Notice if a seat is offered, if the client consults a watch constantly, or if the client is not focused on the discussion. Understanding behavioral clues and body language may give the graphic artist a substantial advantage during negotiations.
- Listen: People appreciate someone who is alert and attentive and understands what is being said. It is important to show understanding even if you don't agree with a point. It may be useful to repeat what you heard, such as, "Let me see if I understand correctly: You're saying that...." Listening effectively helps determine and address the other party's needs and expectations. Listening actively, with nods of agreement, encourages the other parties to express themselves.

There is a right and a wrong time for meetings. Recognize an opportunity and capitalize on it, but also recognize when the timing is inopportune and wait for another day. Negotiations should be avoided if the graphic artist lacks sleep, is overtired, is taking medication, is under the influence of alcohol, or has recently eaten a heavy meal. Expensive errors or bad terms may result when graphic artists are not as sharp as they should be. If the situation is uncomfortable or potentially negative, reschedule the meeting.

Deal with money last

Money should be the last item in a negotiation, for several reasons. It is the area where the majority of disagreements occur, and it is important in the early stages of a negotiation to focus on areas where it is easiest to reach an accord. Putting off a discussion of money until the end provides maximum time for a partnership to bloom.

Money should be a reflection of all the factors leading up to it. The job description, difficulty of execution, usage and reproduction rights, deadlines, and expenses all indicate how much value a particular job holds for the client. So negotiating about money before reaching agreement on these essential items is premature, and could prove to be a costly error.

Don't feel obligated to respond right away if someone starts out a negotiation with "I only have \$500, but I think you'd be great for the job." One can acknowl-

edge the figure and still bring it up later when there is more of a foundation for a working relationship on which to base requests for more money.

When the discussion finally turns to money, it is advisable, whenever possible, to get the client to make the first offer. The old game of "You say 6, I say 10, you say 7, we agree on 8" may still be played out, but it is not always necessary. Depending on how it is stated, though, a first offer is rarely a final offer, and should almost always be tested. One must weigh the risk of losing a possible working relationship by refusing to budge past a certain price. See if you can prompt a prospective client to offer a higher fee by asking if he or she can "do a little better." One well-known artist does that routinely. "Don't be afraid to ask," he advises. "If you don't ask, you won't get it." Sometimes if the client still offers a modest fee, you can negotiate an accommodation, such as reducing a license from three to two years, requesting 500 samples to mail out as your next promotion, receiving a title that looks good on your resume, or taking in-kind services like computer equipment or ad space.

Often parties establish an arbitrary limit from which they will not bend, such as "I won't pay more than \$25,000" or "I won't accept less than \$3,000." Since the figures or conditions are often selected at random, it is important to ignore such a limit until all other terms have been discussed. Don't allow an absolute to become a focal point that inhibits the imagination while coming to terms that may otherwise meet both parties' needs.

When asked for a ballpark estimate, the client will often hear only the low figure, so be careful to offer a range of figures that brackets the price in the middle. When asked in person or on the phone for a bid, graphic artists should not hesitate to withdraw and say, "I'll call you later today with a quote." This gives you time to consider your agenda and needs. It is not only practical, it's actually good business to ask for a higher price or more favorable contract terms than what one expects. Like it or not, people in business often like to feel that they've gotten a deal, and in that sense it is the graphic artist's obligation to manufacture a few concessions without harming his or her own interests.

Sometimes graphic artists are asked to bid on jobs. It is important to clarify the nature of the bid. Is the client looking for a sealed bid that will be used to compete against yourself and other graphic artists? If so, ask who the others are to make sure your work is up against comparable talent. If the client refuses to reveal who the competition is, the job may not be worth bidding on. Try to determine if the bid is an attempt to help the client structure a budget. That isn't fair. Or is it only a ballpark estimate? Does the client wish to negotiate further after you make the bid? Since a sealed bid encourages negotiation against yourself, you should clarify whether the bid is final and binding. It is unfair to ask a graphic artist to develop a competitive, sealed bid and then seek further concessions from the artist in later negotiations.

An essential element in every successful negotiation is knowing when to quit. Getting greedy when things start to go well or pushing too far could lead the other party to abandon the deal. Besides, generosity may lead to future projects and other negotiations.

The bottom line is that if you spend as much time honing your negotiation skills as you do perfecting your craft, you'll eventually start reaping monetary rewards.

What if it doesn't work

Negotiation alone cannot guarantee favorable terms. In some relationships the balance of power is so out of alignment that one party must either yield to unfavorable conditions or give up the opportunity. However, it is possible to maximize assets and protect yourself from an agreement that may be detrimental. The ability to regard a negotiation with level-headed objectivity, keeping it in perspective, provides a skilled negotiator with the attitude necessary to obtain the most favorable agreement—if that is possible. Sometimes, no matter how hard you try, you just can't make it work.

Both parties should bear in mind what their course of action will be if the negotiation ends without agreement. Artists should ask themselves: "What other jobs do I have?" and "What else will I do with my professional time if I don't take this assignment?" The client should ask, "What else can I do, or whom else can I hire, to make this project work?" Answering these questions gives both parties a realistic assessment of how much leverage they have in a negotiation. Assessing the alternatives always clarifies a negotiating position.

It's important to decide what to do if negotiations break off. As the saying goes, a bank will lend you money if you can prove you don't need it. In the same way, it's much easier to get a job if you already have one. If an artist is not busy with other jobs, the best alternative is to create a mental priority list of important and valuable projects to pursue. This helps alleviate the often ill-founded notion that the deal must be made at any cost. It's much easier to say no when there is a favorable alternative.

Remember that not every negotiation is destined to end in a deal. Two parties can "agree to disagree" amicably and part ways, with the hope of another try at a later date. Power can also be regarded as the ability to say no.

Part III: Keeping Track

Not starting to work on a job until an agreement is in writing and is signed is an essential business practice for graphic artists that cannot be underestimated. While it is possible to enforce an oral agreement, a written agreement protects both the client and the graphic artist by confirming the terms before memory fades or a misunderstanding arises. When used properly, a written agreement can be a valuable tool that helps both parties clarify their needs and reflect their concerns, specifically addressing any issues raised in negotiations. A written agreement is also evidence that both parties are professionals who treat the investment of their resources with care. Should a client refuse to pay, a written agreement protects the graphic artist's rights and offers various types of recourse, including negotiation, collection services, arbitration, and, as a last resort, a lawsuit.

The document can be as simple or as complicated as the situation requires—from an informal letter of agreement, purchase order, or invoice to a complicated contract requiring the signatures of all parties. It should name specific rights that are being transferred and describe the disposition of the original art or design, define cancellation fees, and spell out other terms. Formulating such letters and contracts, or analyzing contracts offered by clients, requires a thorough working knowledge of copyright, business law, and related terminology. Graphic artists

5 Essential Business Practices

can become familiar with these areas by carefully studying Chapter 2, Legal Rights and Issues, for copyright information; Chapter 13, Standard Contracts and Business Tools, for all types of standard contracts; and Chapter 15, Resources and References, for additional resources.

When a client uses a work-for-hire clause in a design contract or demands all rights to artwork, every effort should be made to determine the client's real needs. Often such terms were put in the contract by a lawyer trying to anticipate every possible contingency, but such terms are usually excessive and, if priced accordingly by the graphic artist, make the work too expensive for the client. Through study and practice graphic artists can learn how to rephrase contractual terms to meet their requirements and negotiate to win the client's agreement. Knowing how to do that is a valuable asset for every graphic artist.

<u>Terms</u>

Getting paid on time and in full is the just entitlement of any businessperson. Having a complete understanding of the negotiated terms and signing a written agreement help ensure timely and proper payment of fees. Though this may at times require extra effort, it will certainly pay off in the long run.

To encourage timely payment, graphic artists have historically included terms providing penalties, as allowed by law, for accounts that are past due and terms retaining rights until full payment is received (see the section on Extension of Payment Time under Collecting, below). Since job changes often alter the original terms, it is particularly important to confirm in writing any additional fees due to the graphic artist as a result of such changes. The Guild's model business forms incorporate a number of these measures and can aid graphic artists in securing their rights.

Contracts and purchase orders should contain provisions covering the following points, where applicable:

- The names of the graphic artist and client, including the name of the client's authorized buyer or commissioning party.
- A complete description of the assignment or the project.
- The fee arrangements, traditionally including fees for usage, consultations, alterations, travel time, cancellation, and reimbursement for billable expenses.

- Payment terms, including a schedule for advances, monthly service charges for late payment, expense estimates and/or maximums, and royalty percentages and terms, where applicable.
- Specifications regarding when and how the original will be returned.
- Any agreement regarding copyright notice requirements and placement of the credit line.
- The assignment of rights described in specific terms, normally naming a specific market category, medium, time period, and geographic region (see Chapter 2, Legal Rights and Issues).
- The assignment of responsibility for obtaining releases for the use of people's names and/or images for advertising or trade purposes.

Record keeping

It's a good business practice to establish a standard record-keeping system to help facilitate accurate billing, bill tracking, and fee collection and to document tax deductions. Being able to track invoices allows the graphic artist to remind buyers of outstanding obligations and to take whatever follow-up steps are necessary to obtain payment. It also provides a paper trail in the event that a disagreement or misunderstanding gets in the way of completing a project or receiving payment.

Graphic artists may find it helpful to set up a job file and/or a job ledger.

 Job file: A common method of record keeping is to set up a folder or labeled envelope for each assignment. All information and documents pertaining to the job, such as written agreements, business letters, invoices, memos, sketches, layouts, notes about phone calls or meetings, messenger and expense receipts, hours on the job, and so on, are put into this job file as they are received. The file then provides a single and complete record of all documents and decisions.

Identifying information is usually placed on the folder cover. This may include the job number, the title of the project, the buyer's name, and the delivery date. If the job is complex, the job file should be subdivided into sections to permit easy access to information. All sketches and drawings should be retained at least until payment is received.

 Job ledger: A job ledger contains standard columns for information such as the job description (job number, client, description of artwork, delivery date), rights granted (usage, status of original artwork), fees and expenses (advance or payment schedule, reimbursable expenses, sales tax, and so on), and billing information (invoice amount and date, payment due date, amount and date received, late penalties, balance due, artwork returned date). With a job ledger, an artist can determine at a glance the status of each aspect of a job. The ledger's format can vary from aprinted journal sold in stationery stores to a form specifically created by the artist.

Billing procedure

When signing a contractual arrangement, the buyer promises to make a specific payment in return for the graphic artist's grant of usage rights or sale of work. The graphic artist's invoices serve as formal communications to the buyer that payments are due; in many businesses an invoice is mandatory for the buyer to authorize a check and see that it is issued. In many instances, an invoice should accompany delivery of the finished art or design. A copy of the invoice may also be sent to the accounting department, if the business is large enough to have one, to facilitate prompt processing.

If the parties have not specified a payment due date, the generally accepted practice is payment within 30 days of delivery of the art or design. When a partial payment is due or costs are to be billed during the job, the invoice or statement should be delivered as needed. Oral requests for payment are no substitute for invoices but are additional means to use in the collection process. If cancellation or rejection occurs, the buyer should be billed immediately, according to the agreement, or if such a provision is absent, according to the standards discussed in Chapter 3, Professional Issues.

Wording of invoices should be accurate and complete to avoid payment delays. The artist's Social Security number or federal identification number should be included. Billing may be expedited by including such instructions as "Make check payable to Jan Artist or J. Artist Associates."

Sales & use taxes

States have varied policies regarding sales and use taxes (for detailed information on sales taxes, especially in California and New York, see Chapter 3, Professional Issues). In states that have sales taxes, the rate usually ranges from 3 to 9 percent, and it is levied on the sale or use of physical property within the state. A number of exemptions exist, including special rules for the sale of reproduction rights.

Generally services, including the service of transferring reproduction rights, are not subject to sales tax. Transferrals of physical property to a client (original art or mechanicals) shouldn't be taxed if they are part of a project that will later be billed to a client by an illustrator or

5 Essential Business Practices

design firm, although a resale certificate may have to be obtained. Sales tax is usually applicable for end sales or retail costs only, not for intermediate subcontracting, so an artist may have to keep forms showing that materials were intermediate and thus not taxable.

Many tax laws are unclear in relation to the graphic communications industry. In any case where graphic artists are unsure whether to collect the tax, it is safest to collect and remit it to the state sales tax bureau. If graphic artists should collect the tax but don't, they, as well as their clients, remain liable for it. But it may be difficult to collect taxes from clients whose assignments were completed without it in the past.

Checks with conditions

Some clients attempt to add terms to the contract or to change terms after the work is completed by listing conditions on the check, for example, claiming that endorsement transfers all reproduction rights and/or ownership of the original art to the payer. A 1995 U.S. Supreme Court decision (Playboy Enterprises, Inc. v. Dumas) let stand a lower court decision giving creators mixed rights when faced with additional contract terms after the work is completed (see discussion in Chapter 2, Legal Rights and Issues, and Chapter 3, Professional Issues). It has always been the Guild's opinion that endorsement of such a check does not constitute a legal contract, especially if it conflicts with the previous contract.

When confronted with checks with conditions, an artist has at least three options:

- Simply return the check and request that a new check be issued without conditions. If the conditions on the check violate a prior contract, refusal to issue a check without conditions will be a breach of contract.
- If an artist has signed a contract or sent an invoice that restricts the client's rights of use, and if the artwork has been used already,

the artist should strike out the conditions on the check and deposit it. In this case the artist should probably not sign the back of the check, but instead use a bank endorsement stamp, which eliminates the need for a signature.

If the artwork has not yet been used, the artist should notify the client in writing that he or she is striking out the conditions on the check. If the client does not respond within two weeks, the check can be safely deposited.

3. If the artist has neither signed a contract with the client nor sent an invoice restricting use, the check should be returned in order to protect all rights. Along with the check the artist should include an appropriate invoice restricting usage. Of course, the best procedure is to specify in writing which rights will be transferred before beginning the assignment.

Tracking debts

Copyright © Volker E. H. Antoni & Joel L. Hecker, Esq., 1983.

Once an invoice has been sent to the client, the graphic artist should monitor the outstanding debt until it is paid through a tracking method that is part of the record-keeping system. One simple technique is to keep a folder marked "accounts receivable." Copies of all invoices sent to clients in order of payment due date, the graphic artist's job number, or the billing date should be kept in this folder. Then the graphic artist should review the folder periodically. When payment is received, the invoice should be moved to the job file.

Graphic artists using a job ledger can determine at a glance which payments remain outstanding by referring to the "payment due date" column. When payment is received, the date is entered under "payment received date."

Continual tracking of payments also keeps information on cash flow current and allows for timely follow-up steps to collect past-due fees or other outstanding obligations.

Part IV: Collecting

Having completed and delivered an illustration or graphic design project that meets the client's specifications, it's natural to expect that payment will be made as agreed in the written document. Graphic artists who are not paid in a reasonable time will need to pursue collection of outstanding fees if they are to avoid loss of income and time. Taking routine precautions beforehand, such as clearly detailing payment and related terms in the written agreement, is the best insurance against payment problems.

Whether or not these steps have been taken, however, graphic artists who do not receive timely payment will want to implement appropriate and efficient collection strategies. Invoices tend to become more difficult to collect as they get older, so prompt action is important. The section entitled Step-by-Step Collection Strategy details all the steps graphic artists can take to collect outstanding fees. Note that it does not represent legal advice; any actions with legal ramifications should not be undertaken without consulting a qualified attorney (a list of lawyers is provided in the Consulting or Hiring a Lawyer section, below). A number of possible actions, with and without legal assistance, are discussed below.

Step-by-step collection strategy

Caution and restraint should be exercised in all communications with clients so that there is no question of harassment, which is a violation of the federal Fair Debt Collection Practices Law.

- At the completion of the project, the artist should send an invoice to the client clearly stating the amount owed by the agreed-upon due date. If appropriate, the artist can include a notation that a late payment penalty fee will be applied to all overdue balances. (Many businesses assess a late fee of 1.5 to 2 percent of outstanding balances due.)`
- 2. If the client does not make timely payment, the artist should send a follow-up invoice. A handwritten or stamped message to the effect of "Have you forgotten to send your payment? "or "Payment overdue—Please remit promptly" may help speed payment. If appropriate, the artist should include any applicable late payment penalty fee incurred to date as part of the balance due on the follow-up invoice. To help expedite payment, the artist may include a self-addressed stamped envelope or their express mail account number for the client to use in mailing back their payment.
- **3.** If the client does not make payment within 10 days of the follow-up invoice, the artist should call the client to remind them that payment is due.

Sample phone script

"Hello, Mr. Client. This is Joe Talent, at Ads & Such, and I'm calling to remind you that payment for the [name of project] that was delivered to you on [date] is now over [X] days past due. When can I expect to have payment in my hands?"

At this point the client will probably give the artist a reason for the delay, which should be listened to patiently. Hopefully it was simply an oversight and the client will agree to send payment immediately.

4. If payment is not received within 10 days of the phone call, the artist should send a "Second Notice" that payment is overdue and expected within 10 days of this notice. The Second Notice allows for possible human error or "red tape" that may have caused the delay and presents the client with another copy of the overdue invoice and a self-addressed envelope to simplify and speed payment.

Sample "second notice" letter

Dear Mr. Client:

Ten days ago I spoke with you about the outstanding balance of \$[amount] owed for the [project] Ads & Such delivered to you on [date]. You agreed to make payment within 30 days of acceptance, and now, [X days] later, you have still not settled your account.

This may be merely an oversight or your payment has crossed this letter in the mail. If there are other reasons payment has not arrived that I should be aware of, I hope you will call me immediately.

Please do not jeopardize your credit record by failing to respond to this request. If payment has been sent already, accept my thanks. If not, please send a check or money order for the \$[amount] in the enclosed return envelope no later than [date—usually 10 days from the receipt of the letter].

> Sincerely yours, Joe Talent President, Ads & Such

Enc: copy of original invoice [marked "Second Notice"] Return envelope for payment

5. If the client does not make payment within 10 days of the Second Notice, the artist can send them a "Final Notice" letter. It should say that if payment is not made within three days, the debt will be turned over to either a collection agency, the Graphic Artists Guild's Professional Practices Committee, or an attorney; see sections below for more information on these options.

Sample "final notice" letter

Dear Mr. Client:

You have repeatedly promised to make payment on your outstanding balance of \$[amount], yet your check or money order has not arrived. If it is not already in the mail, I urge you to send it today.

> Sincerely yours, Joe Talent President, Ads & Such

6. Up to this point, a number of reasonable efforts have been made and sufficient time has elapsed to allow the buyer to respond or pay the debt. The artist has also established a "paper trail" of documentation verifying the continued indebtedness and the artist's attempts to collect. If the buyer still fails to respond or pay, or acts evasively, the artist may reasonably assume that the buyer is avoiding payment intentionally. The artist must now select the next course of action from among the alternatives discussed in this section.

Prevention

The first step in any collection strategy is prevention. When dealing with a new client, be sure to ask for and check credit references. Then call the Better Business Bureau and credit-reporting agencies such as Dun & Bradstreet to verify the firm's worthiness.

Direct communication with the client to determine why payment has not been made is the next logical step. Subsequent steps depend on the client's response and the nature of the problem. In most cases graphic artists will be told of a client's cash-flow problems. In other cases the client may dispute whether monies are owed or how much. A direct discussion may clarify the problem and lead to a solution. If one discussion is not sufficient to resolve a delay, misunderstanding, or dispute, graphic artists can take advantage of the support services of a local Guild Grievance Committee (for members only) or clients may be willing to try mediation or arbitration.

If the graphic artist encounters an unreasonable or evasive client, however, more forceful measures may be required, such as engaging a collection agency, suing in small-claims court, or initiating a legal suit.

Common causes of nonpayment & strategies for dealing with them

Graphic artists usually learn why the payment has not been made during the first contact with the client. Following are some of the more common causes and suggested strategies for responding to them. (These basic negotiation concepts can be applied to other situations as well.)

- **Graphic artist's error**: Perhaps an invoice was not provided, was sent to the attention of the wrong person, was incomplete or illegible, or did not document reimbursable expenses. The artist must correct the error to expedite the payment process.
- Buyer's error: Once a project is delivered, the client may be on to the next and forget to process the check. One purpose of an invoice is to serve as a physical reminder; the client should not be expected to send the check automatically, without an invoice, and oral requests for payment are not sufficient.

If the cause of nonpayment is oversight, a new due date should be established and the client requested to follow up personally. The graphic artist should send a letter or e-mail confirming when payment will be made.

- Disputes and misunderstandings: Some disputes are caused by unintentional actions or lack of knowledge of professional standards and practices. For example, a client may make an incorrect assumption (such as assuming it's fine to delay payment when experiencing cash-flow problems) or may not be aware of appropriate professional conduct in a particular situation. Therefore the graphic artist needs to instruct the client in the proper procedure, agree on a new payment date, and write a letter or e-mail confirming the new schedule.
- Bankruptcy: If a client files for bankruptcy, there may be little a graphic artist can do except be added to the list of unsecured creditors. If the client is forced to liquidate assets to pay the creditors, a percentage of the fee may ultimately be paid to the graphic artist.

Another problem in a bankruptcy may be getting original artwork or design returned, especially if the trustee or court assumes that everything in the client's possession is an asset. Graphic artists must claim that the work belongs to them and cannot therefore be considered an asset of the bankrupt party. While New York State has passed legislation that protects the work of gallery artists if a gallery files for bankruptcy, those protections are not extended to graphic artists unless their work is similarly on exhibit.

Direct negotiation

Unless complex legal matters or large amounts of money are at issue, direct negotiation is usually the most appropriate approach. A phone call or a personal visit may be the most effective way to resolve a payment problem. A word of warning: Graphic artists should be objective and realistic at all times while conducting collection efforts. It is in the graphic artist's best interests to act professionally when dealing with the client or anyone in the client's firm.

Always refer to the written agreement when contacting the client. Wellnegotiated agreements usually foresee areas of possible dispute and specify the client's obligations and the graphic artist's rights. If necessary, remind the client of provisions in the agreement providing alternatives or penalties; they are there to provide negotiating leverage. If the reason for the payment failure is contrary to the agreement or to professional standards, the graphic artist needs to inform the client of the correct procedure. If necessary, cite the appropriate professional standards in the industry's Code of Fair Practice (see Chapter 1, Professional Relationships).

Alternatively, the artist might send a brief, businesslike letter with a copy of the original invoice attached and marked "Second Notice." Remind the client of the overdue payment and request that he or she handle it immediately. All correspondence (letters and invoices) should be sent by certified mail, return receipt requested. Copies of all correspondence and memos of discussions between the parties should be kept in the job file. Establishing a paper trail with the proper documentation may be crucial later.

At this stage the graphic artist can presume that human error or red tape was involved and that the call or letter will clear things up. These reminders often prove sufficient and forestall the need for stronger measures—until it becomes clear that nonpayment is deliberate.

Extension of payment time

Clients may claim a cash-flow problem (not having sufficient funds on hand to pay). It may be difficult to verify whether this is legitimate or an evasive maneuver. It isn't unusual for the client to blame a late payment on the company's computer; however, long intervals between programmed payments are unreasonable. Exceptions to automatic payments can be, and are, made all the time. In this case, insist that a handwritten check be authorized immediately and paid within a week.

If the cause of the delay appears legitimate and future payment will clearly be made, the graphic artist may wish to accommodate the client and grant a reasonable extension, with the new payment deadline confirmed in writing. Granting extensions should be viewed as a professional courtesy on the part of the graphic artist, not the client's right. Some graphic artists may demand a service fee, often a percentage of the outstanding balance, as compensation for the delayed payment. Graphic artists who employ this practice should make sure to stipulate it in the written agreement. This practice should be used particularly when longer extensions are granted.

Demand letter

After direct negotiation has been attempted, a client may still refuse to make payment. The client may not respond to the graphic artist's letters and calls, give unreasonable explanations, not address the issue at hand, or not make payment according to the newly negotiated terms.

As a last effort before turning to stronger alternatives, the graphic artist should send a demand letter. The basis of the graphic artist's claim should be stated briefly, with a demand for immediate payment of any outstanding balance. The demand letter should apprise the client that the graphic artist is determined to pursue his or her legal rights and further legal action will be taken unless payment is received.

Sample Demand Letter

Dear Mr. Client:

Your account is now [X months] overdue. Unless your check or money order in the amount of \$[amount] is received by [usually three days] from receipt of this letter, I will be forced to pursue other methods of collection.

You can still preserve your credit rating by calling me today to discuss payment of this invoice.

If I do not hear from you within [three days], I will be forced to turn your account over to a collection agency [or attorney or the Graphic Artists Guild Grievance Committee^[]].

Very truly yours, Joe Talent President, Ads & Such

Enc: copy of Invoice [marked "Final Notice"] Return envelope for payment

The Guild's Grievance Committee handles disputes for members only. Guild members should call their local Chapter or the National Office for information.

The Graphic Artists Guild Grievance Committee

The Graphic Artists Guild Grievance Committee provides guidance and assistance to members in good standing who need to resolve differences with clients. Guild members in need of this service should contact their local Chapter or the National Office. If a grievance cannot be resolved at the Chapter level, it may be referred to the national Grievance Committee for further action.

5 Essential Business Practices

Members may not claim the support of the Grievance Committee until the committee has reviewed the case and notified the member that the case has been accepted. The Grievance Committee may choose not to take a case if the member has begun formal litigation.

The committee reviews grievances at its earliest opportunity. If it determines that the grievance is justified, the committee contacts the member. A plan of action is recommended and appropriate support provided, ranging from direct communication with the client to testimony in court supporting the member in any follow-up litigation. It is crucial that the member participate fully and keep the committee advised of subsequent developments.

The Grievance Committee will not offer assistance in a dispute involving questionable professional conduct on a member's part, such as misrepresentation of talent, plagiarism, or any violation of the Joint Ethics Committee's Code of Fair Practice (see Chapter 1, Professional Relationships).

The following information is required when submitting a grievance (a standard grievance form is available upon request):

- **Contact information**: the member's personal and business names, addresses, phone and fax numbers, and e-mail address.
- Client information: the name of the client, the name and title of the appropriate party, and the relevant addresses and phone and fax numbers.
- The exact job description.
- Statement of grievance: the nature of the grievance, including a chronological narration of facts and the respective positions of the parties.
- Resolution attempts: the names of any agencies and persons (collection agencies or lawyers) contacted regarding the grievance and the result of such contacts.
- Copies, not originals, of relevant documents substantiating the grievance: purchase order, written agreement, invoice, correspondence, receipts, and so on.
- **Desired remedy**: a statement of what the member would consider an appropriate solution of the grievance.

Mediation & arbitration

Mediation and arbitration, based on the services of an impartial outsider, are long-established processes for settling disputes privately and expeditiously. A mediator, acting as an umpire, does everything possible to bring the parties to agreement, but he or she cannot impose a decision upon them. If the parties cannot reach an agreement, they must proceed either to arbitration or to court to resolve the dispute. An arbitrator acts as a judge, reviewing the evidence presented by both sides and then making a legally binding decision.

Submitting to mediation or arbitration is voluntary, though signing a contract with such provisions establishes the client's consent to those procedures. Should a party in the dispute not appear for arbitration, a binding decision may be reached in that party's absence.

Mediation and arbitration are speedier and far less expensive than suing in court. Their conciliatory and private atmosphere may be more appropriate for parties who have had, or would like to have, a long business relationship. These services may also be relevant if the graphic artist's monetary claim exceeds the limit of small-claims court. Arbitrators' fees, which are usually split between the parties, are relatively moderate and normally consist of a flat fee plus expenses. Either party may choose to use an attorney in arbitration proceedings, but it's not required, and such costs are borne by that party.

The American Arbitration Association is available in many cities around the country, and its services may be requested in other localities. Mediation and arbitration may also be sponsored by some volunteer arts-related lawyer groups, including Volunteer Lawyers for the Arts in New York City and California Lawyers for the Arts in San Francisco (see list under Consulting or Hiring a Lawyer below).

Collection services

If voluntary dispute resolution such as mediation or arbitration is not available or has not produced the outstanding check, commercial collection agencies will seek payment on the graphic artist's behalf. Collection agencies make escalated demands on the client through letters, phone calls, visits, and/or legal services.

Collection agency fees, in addition to routine expenses, generally range from 10 to 50 percent of the monies actually recovered, depending on the amount of money involved and how much time has lapsed since the work was first invoiced (older invoices are more difficult to collect). If the agency engages a lawyer, his or her fee is included.

Before signing an agreement with a collection agency, the graphic artist should review it carefully to determine the actions the agency will take and what it will charge. Of particular concern is dealing with an agency that may use practices that could be deemed unprofessional, since they may reflect unfavorably on the graphic artist.

Small-claims court

When all else fails, the legal system may offer a way to remedy the problem. Small-claims courts give a grievant access to the legal system while avoiding the usual encumbrances, costs, and length of a formal court proceeding; in contrast the small-claims procedure is streamlined, speedy, and available for a nominal fee. Many small-claims court cases are heard by arbitrators rather than judges. This does not prejudice one's case and may even expedite a decision.

Graphic artists may bring claims seeking a monetary judgment to small-claims court. Besides nonpayment for a completed assignment or project, other claims may include nonpayment for canceled artwork, for purchase of original art, for unauthorized reuses, or for unreturned or damaged art.

Graphic artists can handle their own cases in small-claims court with a little preparation. Information is readily available from flyers prepared by the court, how-to publications, and, perhaps best, local rules books. The court clerk, or in some localities a legal advisor, is often available to help with preparation. Small-claims forms are also known as "trespass and assumpsit" claims forms.

Each state's small-claims court has a dollar limit for what it considers a small claim. Amounts in excess of the limit require litigation in civil court. Considering the high cost of pursuing a claim through civil court, the graphic artist may decide it is more economical in the long run to reduce the claim to an amount that qualifies as a "small claim," especially if the amount in dispute is only slightly higher than the court's limit. However, this claim must be made with the understanding that the balance above the court's limit is forfeited permanently. One possible way around that is to split a larger amount into several small claims to be pursued individually—for example, if a client owes a large sum made up of payments due from several assignments.

Collecting after a judgment

Should a client fail to pay after the court has rendered its decision or affirmed an arbitration award, the law authorizes a number of collection remedies. The graphic artist gains the right, within limitations, to place a lien on the client's funds and assets. Available funds, such as bank accounts or a portion of an individual's salary, may be seized by a sheriff or marshal and turned over to the graphic artist. Similarly, the proceeds of property, such as a car, sold at public auction may be used to settle the debt.

Consulting or hiring a lawyer

A lawyer can assist in a number of ways and at different stages in the collection strategy. A lawyer may initially be able to provide enough information and advice so the graphic artist can pursue his or her own collection efforts. An initial consultation, whether in person or by phone, can confirm what the relevant law is and whether the graphic artist's position is supportable under the law. The lawyer may be able to advise about available resources, chances for successful resolution, and other legal matters.

For simple payment-due problems, a general practitioner or collection lawyer can be hired to perform services similar to that of a collection agency. The psychological effect of receiving a lawyer's letter or call often produces a quick resolution to a dispute.

When a dispute must be cleared up before payment can be made, engaging a lawyer to negotiate with the client might be helpful. The lawyer may be able to take a more forceful role on the graphic artist's behalf and may bring about a fairer and quicker settlement. A lawyer's presence and negotiation skills may also result in avoiding a lawsuit. When the problem is resolved, and if it proves advisable, a lawyer can provide a written agreement to bring complex issues to a final and binding close.

If the dispute involves the graphic artist's legal rights in, and economic control over, artwork, a lawyer specializing in art-related law should be selected. It is important that the lawyer be familiar with applicable copyright laws and trade practices, as well as the business aspects of the artist's profession. In addition, an attorney's expertise in a specific area should be verified through direct questioning and by checking references. If you think your case might actually go to trial, don't hire an attorney who has no litigation experience, no matter how great he or she may be at negotiating contracts.

The Guild offers members access to its Legal Referral Service. Members who need a lawyer's services should first contact their local Chapters for the names of attorneys in that area with expertise in a particular subject; if none is available or if additional referrals are needed, contact the Guild's National Office. Attorneys participating in the Legal Referral Service often offer reduced rates to Guild members, although any fees and expenses should be negotiated directly between the member and the attorney and are the sole responsibility of the member.

Lawyers' fees and structures vary. Some charge a flat fee, some a percentage of the monies recovered. Initial one-time consultation fees may be low. Graphic artists should discuss fees with the attorney before requesting and/or accepting advice or assistance. Graphic artists with limited income may want to take advantage of volunteer arts-related lawyer groups. Most Volunteer Lawyers for the Arts organizations place limitations on income for eligibility for assistance. Some of these groups around the country are:

California

California Lawyers for the Arts (Los Angeles area) 1641 18th St. Santa Monica, CA 90404 310.998.5590 | usercla@aol.com

California Lawyers for the Arts 926 J St., Suite 811 Sacramento, CA 95814 916.442.6210

California Lawyers for the Arts (San Francisco Bay Area) Fort Mason Center Building C, Room 255 San Francisco, CA 94123 415.775.7200 | cla@sirius.com

California Lawyers for the Arts (San Francisco area) 1212 Broadway St., Suite 834 Oakland, CA 94612 510.444.6351 | oakcal@there.net

Colorado

Colorado Lawyers for the Arts 200 Grant St., Suite B7 Denver, CO 80203 303.722.7994 | cola@artstozoo.org

Connecticut

Connecticut Volunteer Lawyers for the Arts Connecticut Commission on the Arts 1 Financial Plaza 755 Main St. Hartford, CT 06103 860.566.4770

District of Columbia

Washington Area Lawyers for the Arts 815 15th St. NW, Suite 900 Washington, DC 20005-2201 202.983.2826 | www.thewala.org

Florida

Volunteer Lawyers for the Arts/Broward ArtServe, Inc. 1350 E. Sunrise Blvd., Suite 100 Fort Lauderdale, FL 33305 954.462.9191

Georgia

Georgia Volunteer Lawyers for the Arts c/o Bureau of Cultural Affairs 675 Ponce de Leon Ave., 5th Fl. Atlanta, GA 30308 404.873.3911 | gvla@ga.freei.net

Illinois

Lawyers for the Creative Arts 213 W. Institute PI., Suite 401 Chicago, IL 60610 312.944.ARTS (2787) | agimble@gateway.net

Louisiana

Louisiana Volunteer Lawyers for the Arts c/o Arts Council of New Orleans 225 Baronne St., Suite 1712 New Orleans, LA 70112 504.523.1465

Maryland

Maryland Lawyers for the Arts 218 W. Saratoga St. Baltimore, MD 21201 410.752.1633

5 Essential Business Practices

Massachusetts

Volunteer Lawyers for the Arts of Massachusetts P.O. Box 8784 Boston, MA 02114 617.523.1764 | vla@world.std.com

Minnesota

Resources and Counseling for the Arts 308 Prince St., #270 St. Paul, MN 55101 | 651.292.4381 info@rc4arts.org | www.rc4arts.org

Missouri

St. Louis Volunteer Lawyers & Accountants for the Arts 3540 Washington, 2nd Fl. St. Louis, MO 63103 | 314.652.2410 vlaa@stlrac.org | www.vlaa.org

Kansas City Attorneys for the Arts Lathrop & Gage Attn: Don Dagenais 2345 Grand Blvd. Kansas City, MO 64108 816.474.6460 | ddagenais@lathropgage.com

New York

Volunteer Lawyers for the Arts Program Albany/Schenectady League of Arts 19 Clinton Ave. Albany, NY 12207-2221 518.449.5380 | artsleague@aol.com

Arts Council in Buffalo and Erie County 700 Main St. Buffalo, NY 14202 716.856.7520 | acbec@pce.net

Volunteer Lawyers for the Arts 1 E. 53rd St., 6th Fl. New York, NY 10022 212.319.ARTS (2787)

Ohio

Volunteer Lawyers & Accountants for the Arts c/o Cleveland Bar Association 113 St. Clair Ave. Cleveland, OH 44114-1253 216.696.3525

Toledo Volunteer Lawyers for the Arts c/o Arnold Gottlieb 608 Madison Ave., Suite 1523 Toledo, OH 43604 419.255.3344

Pennsylvania

Philadelphia Volunteer Lawyers for the Arts 251 S. 18th St. Philadelphia, PA 19103 215.545.3385

Puerto Rico

Voluntarios par las Artes Condumo El Monte Norte Apt. 518A Hato Rey, Puerto Rico 00919 787.758.3986

Rhode Island

Ocean State Lawyers for the Arts P.O. Box 19 Saunderstown, RI 02874 |401.789.5686 dspatt@artslaw.org | www.artslaw.org

Tennessee

Nashville Bar Association Lawyers Referral Services 315 Union St., Suite 800 Nashville, TN 37201 615.242.9272

Texas

Austin Lawyers & Accountants for the Arts P.O Box 2577 Austin, TX 78768 512.407.8980

Texas Accountants & Lawyers for the Arts (TALA) 1540 Sul Ross Houston, TX 77006 713.526.4876 | info@talarts.org

Utah

Utah Lawyers for the Arts 50 S. Main St., Suite 1600 Salt Lake City, UT 84144 801.482.5373

Suing in civil court

Suing in civil court or federal district court should not normally be necessary to resolve a payment or other dispute. Court should be considered as a last resort, to be used only all other options for resolving the problem have been exhausted. If big guns are brought out in a lawsuit at the beginning of a dispute, there's nothing to fall back to; but if every other alternative has been pursued without any progress, the only remaining choice is a court case, with an attorney's help.

Other cases that must be brought to civil court include monetary claims in excess of the small-claims court limit. Violation of copyright laws can be resolved only in federal court; current law requires that a work's copyright be registered with the U.S. Copyright Office before a federal case for copyright infringement can be initiated. Other nonmonetary issues, such as suing for the return of original artwork or other contractual breaches, must also be taken to civil court.

The graphic artist does not necessarily have to hire a lawyer to sue. The law allows a person to appear as his or her own lawyer; in disputes where the issue is clear, graphic artists will usually not be prejudiced by representing themselves. In disputes that do not involve large sums of money, a lawyer may be hired just to advise the graphic artist on how to prepare the case, rather than for formal representation, which will help keep legal costs down.

When a great deal of money or complex legal issues are involved, it is prudent to hire a lawyer. In such cases the fee structure and expenses should be discussed with the lawyer at the outset. An attorney will usually bill time by the hour or work for a contingency fee. Attorneys who accept a contingency (generally one third of an award or judgment, plus expenses) feel confident that the case has a good chance of winning and are willing to risk their time to pursue it. If an attorney will accept a case only by billing time, it may be a signal for the graphic artist to reevaluate the chances of winning the case or to review the amount that can realistically be expected to be recovered.

Sometimes the Graphic Artists Guild's Legal Defense Fund assists legal cases that it deems could have an industrywide impact or set important precedents for the profession cases that could affect the working lives of all graphic artists (for more information about the fund, see Chapter 14, The Graphic Artists Guild).

Part V: Reuse & Other Markets

Maximizing the income potential of artwork both enables illustrators to sustain and improve their business and provides art buyers with options for solving their needs. While reuse—the sale of additional rights to existing artwork—has long been standard practice, this market has exploded in recent years, while licensing and merchandising markets for new artwork have also grown. However, stock illustration—existing artwork whose rights are sold for other uses—is a highly controversial issue within the visual communications industry. Artists are generally wary of stock agencies that dominate the resale market and tend to undercut prices for illustration, preferring to control stock sales themselves, while graphic designers appreciate the easy access to affordable artwork that stock provides. In the best of all possible worlds, commissioned illustration and stock sales should be complementary rather than competing markets.

<u>Reuse</u>

Reuse is an opportunity available to all illustrators and an important area of income for many. The artist, authorized agent, or copyright holder sells the right to reproduce artwork originally commissioned for one specified use for a new or additional use. By trade custom, the term "stock art" in general illustration markets means copyrighted artwork for which the user negotiates a pay-per-use license or use

5 Essential Business Practices

fee. It also includes typographic alphabets (usually prepared in digital form and licensed to buyers by type houses) and typographic dingbats, usually sold as clip art.

Reuse may also be called "second rights" (though it may actually be the third, fourth, or fifteenth time the rights have been sold). In publishing they are called "subsidiary rights" and are grants of usage in addition to what the project was originally was commissioned for, such as when a chapter from a book is sold to a magazine before the book is published. In merchandising, where existing art may sell for many different uses to many different clients, grants of usage rights are called "licensing."

The selling of reuse rights represents a logical step in extending the value of artwork through the length of the copyright. Over the artist's lifetime plus 50 years, judicious control of a work's copyright and uses can generate a lot more income for an illustrator than the original rights grant. One source calculated that advertising and corporate sales of mostly photo stock accounted for 65 percent of the total use of stock art; textbook, trade, and education publishing accounted for 15 percent, with magazines and newspapers taking another 15 percent. However, the growing market for reuse fuels the debate about whether stock illustration sales reduce new commissions or harm artists by overexposing or undercontrolling the appearance of an illustration.

This debate is heightened by improvements and growth in technology. Methods of cataloging and presenting stock art have improved dramatically, thanks to advances in computers, CD-ROMs, and the Internet. Digital technology has increased compact storage, as well as enabling quicker searches, retrievals, and presentations; reduced the risk of artwork being swiped or copied; and accelerated transmission and digital delivery to platemaking or electronic end products. And technology also means that graphic artists may choose to customize existing images to meet the needs of a new client and charge fees that reflect the customized image.

Reuse may be sought by the original client, who wishes to expand the original project or use it in a new campaign. Or a prospective buyer may want to use art seen in a directory, stock catalog, or other promotional material. Some buyers may even plan a proposed project around a particular image; but if the desired image is not available, they will have to be flexible about using other work that is or commission original work. Sometimes artists envision and market a reuse; for example, an artist may propose using an existing image for a greeting card, calendar, or editorial insert.

The aesthetic is different when using existing artwork rather than commissioned illustration; the art buyer knows exactly what he or she is getting. The client's risk of being unfavorably surprised is avoided. On the other hand, an element of creativity is eliminated, as is the traditional excitement of collaboration between art director and illustrator and the thrill of creating/receiving a superlative new illustration.

The economic climate and the growth in uses of stock illustration are creating new niches for existing artwork. It is up to each artist to seek them out in order to better fulfill the artwork's potential value. Artists interested in reselling rights must make individual marketing decisions about the best avenues for reuse sales for their inventory of images.

Any discussion of reuse is predicated on an artist's control and ownership of rights. Artists who relinquish control by accepting work-forhire and all-rights conditions are forever locked out of reuse markets and other sources of potential income.

Who should handle reuse sales?

Artists, stock agencies, and artists' representatives may each claim they know the stock market best and can negotiate the most appropriate reuse fees.

Artists selling reuse

Many artists like to personally handle their own reuse sales, but there are pluses and minuses to that arrangement. On the one hand, artists have to handle all the usual record keeping connected with an illustration assignment without the excitement of creating a new image. On the other hand, a little paperwork can produce welcome additional income from an inventory of existing images.

Handling reuse sales themselves allows artists to determine the client's needs firsthand and to custom-tailor the agreement, fee, and quality of the artwork's reproduction. Knowing their own body of work, artists may come up with more options or an image better suited to the client's needs, while at the same time establishing a relationship that might result in future assignments. If a potential client contacts an artist with a possible commission but an insufficient budget, the artist can suggest reusing an existing image that conveys a similar message. Artists may feel they are best qualified to set reuse fees because of their knowledge of their work relative to the field, their reputation, and their comfort with negotiating.

To sell reuse rights personally, artists must be willing to maintain accurate records of usage rights agreements for all illustrations (see Part III: Keeping Track above); monitor sales to prevent conflicts and unauthorized usage; handle contracts, invoices, and shipping; and do all the other usual overhead of the illustration business. (In increasingly rare cases artists may also need to warehouse slides or transparencies of any artwork they do not store electronically.) Artists who maintain careful records may sell reuse rights to images that could not be handled through a stock agency (agencies often require images with completely or widely available rights). If necessary, artists may negotiate the reversion of desired reuse rights from a client.

Reuse pricing is every bit as complex as pricing for original commissioned art, and no percentage of an original commissioned fee has been set that is common to all markets. The primary criterion for setting pricing should be how the client chooses to use the work. If the client derives great value from its reuse of the work, then the artist should feel free to set a fee, commensurate with the new use, that is higher than that for the original use. Artists should also take the usual factors—size, geographicregion, exclusivity of market, time frame, and media—into consideration when setting reuse prices.

Some markets, such as greeting cards, corporate advertising, and textbooks, are known to pay 50 to 100 percent of an original commissioned rate for reuse. Others, such as editorial, usually pay a percentage of the commissioned rate. Resale rights are usually sold at less than the rate of commissioned work, though not if the artist controls the sale and determines that the new use warrants a higher rate. In most cases artists can expect to receive from 20 to 75 percent of the fee they would have charged if the work were commissioned for that use originally; the vast majority receive between 45 and 55 percent.

To maximize stock illustration sales, some artists feature images available for resale in targeted promotions or on their Web site. The only proviso on the Web is that they need to display the work in a format that is protected against unauthorized use.

Representatives selling reuse

Artists' representatives may sell reuse rights on behalf of artists as part of the normal artist-agent agreement. Reps are in a good position to negotiate reuse fees, custom-tailor reuse agreements to the clients' needs, and monitor compliance with purchase agreements. Often they are handled just like newly commissioned work: The artist usually receives 75 percent of the fee, with 25 percent going to the rep. Artists usually retain the right to refuse a sale; they also receive tear sheets of the final printed piece.

Though this type of contract has historically been standard for commissioned artwork, reps may choose to handle reuse differently from commissioned art. For example, while the usual artist-agent split of 75-25 percent is a clear advantage to the artist over the 50-50 percent split of usual stock agency agreements (see below), reps may change the percentage split to match those in stock agreements if they want their businesses to more closely resemble stock agency marketing. Artists are always free to negotiate more favorable terms.

Many reps prefer to handle reuse sales of images originally commissioned through their efforts or appearing on promotional materials carrying their name rather than have the artist or a stock house manage them. Having negotiated one-time or limited rights in the initial agreement, reps often feel they deserve the opportunity to market the rights that were reserved to the artist through their efforts. Artist-agent contracts should specify whether the rep will handle such sales and, if so, whether that is an exclusive arrangement. Artists and reps whose relationship predates the rise of the reuse market can attach a letter of agreement to their contract, detailing the new arrangements.

Artists' reps who have long-standing relationships with their artists and handled the initial agreement with the client are well positioned to market reuses that both protect the artist's reputation and avoid stepping on the original client's toes. Some reps also handle reuses of images that did not originate with them. Among the marketing techniques employed by some reps are establishing a special stock division on terms similar to those at stock agencies and developing special promotions of images judged to be particularly marketable. It may take a different kind of marketing to achieve successful, sustained reuse sales; the clients are not necessarily the same as those for commissioned work. Only the particular artists' rep can decide whether it is in his or her interest and ability to pursue stock illustration sales.

Some reps have implemented aggressive marketing and distribution of images for stock sales. For instance, a number of reps who belong to the Society of Photographer and Artist Representatives banded together in 2000 to promote the sale of stock illustration on the Web (see repstock.com). The degree to which artists' reps diverge from the business of soliciting commissioned work may influence the future direction of artist-agent agreements governing reuse sales, commissions, and other terms.

Stock agencies selling reuse

Stock illustration was introduced by stock agencies or houses that were already established as sources of stock photography; several illustration-only agencies, including international ones, have since been founded to handle stock art. An estimate of the worldwide stock art market, predominantly for photography, was \$1.6 billion per year in 2000—a huge leap from \$200 million in the mid-1990s. Of primary concern to illustrators is that stock illustration sales may, as with stock photography, reduce the demand for originally commissioned work.

Though stock illustration evolved from stock photography, the significant differences in how artwork and photography are created affect each genre's opportunities in the stock market. Photographers create many images in the course of doing business; illustrators create fewer images over their lifetime. This means that illustrators have fewer potentially incomeproducing copyrights. But the growth of the stock illustration business argues that a market exists. As demand grows, illustrators hope the market will provide them with more, and more lucrative, sources of income.

Stock agencies market images to prospective buyersthrough catalogs, directories, direct mail, CD-ROMs, the Internet, the World Wide Web, and other promotions. The artist grants the agency the right, usually exclusive (though in some cases this is negotiable), to resell selected images from the artist's existing work to specified markets for a certain length of time (usually up to five years or for the shelf life of the promotional vehicle in which the work appears) for a fee set by the agency.

A rollover clause used to be common in agency contracts, whereby artists must notify the agency within 30 days of the five-year completion to end the agreement. If such notification is not received, the contract is automatically renewed for another five years. In actual cases stock agencies stated that they would not hold artists to this stringent requirement; nonetheless, rollover contracts put the burden on the artist and make renegotiation more difficult. These days computer tracking makes it easy for agencies to notify artists of contract terminations, and some prominent agencies have taken rollover clauses out of their contracts.

The stock agency and the illustrator usually split the proceeds of whatever rights the agency sells. Interviews with major illustration stock houses indicate that the usual agency/artist splits are 50 percent each for sales inside the United States and 40-30-30 for foreign sales, with 40 percent withheld by the foreign agency.

In many contracts the artist provides electronic files of the images, a share of the cost of the agency's initial catalog featuring the images, and half the cost of any agreed-on additional promotions. The agency bears the cost of shooting any original transparencies of each illustration, filing fees, the remaining cost of the catalog, production of a CD-ROM, and maintenance of an Internet site. One unfortunate practice is that some stock agency contracts reviewed do not specify or limit the amount of advance promotional costs. Many photographers have found that these unchecked expenses can significantly reduce the value of a stock arrangement. The artist's share of costs is often deducted from future earnings, usually with a limit of 25 percent of earnings deductible in each payment period. The agency bears more of the upfront financial risk as part of its overhead.

Stock agencies usually quote reuse prices, though still negotiable, by referring to in-house charts that rely upon such factors as market, reproduction size, print run, and quantity as benchmarks. For instance, a large sale of many images may result in a low price per image, with the profit to the agency derived from search fees charged to the client for each hour the agency's staff searches their libraries.

Artists may find that fees negotiated by stock agencies are significantly lower than they would negotiate for themselves. Agencies send out periodic checks with sales reports, usually quarterly or monthly, that list the sale, the client's name, and sometimes the media in which it appeared, but not the terms of the reuse. Many artists feel the last information is vital in order to accurately calculate the income generated from each reuse. Although some agencies request tear sheets, they do not guarantee that they will send samples to the artists.

Artists under contract to a stock agency do not have the right to refuse a sale, except by indicating in the contract any off-limit markets such as pornography or cigarette and liquor advertising. Some agencies do contact artists at their discretion to discuss a proposed sale.

Some stock agencies grant clients the right to alter, tint, crop, or otherwise manipulate images; others do not. This right is usually listed in the agency's delivery memo, which states standard terms governing the client's purchase of rights, but it is usually not addressed in the artist-agency contract. Very few agencies discuss intended alterations with the artist or arrange to have the client contact the artist to discuss changes.

When a client commissions new work from an artist through a stock agency and the agency acts as agent and negotiates the fee with the client, the agency usually takes a 25 to 30 percent commission. However, when new work is commissioned through a stock agency for an illustrator who has a representative, the agency allows the rep to negotiate the price and takes a smaller finder's fee (usually 10 percent) or has the buyer contact the rep directly.

Some unrepresented illustrators do not wish to have a stock agency represent them for commissioned work. Illustrators have negotiated artist-agency contracts in which the artist handles the fee and contract negotiations directly with the client and pays the agency a 10 percent finder's fee for attracting new work rather than a full rep's commission. Some agencies do not request a finder's fee for commission referrals.

Occasional errors or abuses have occurred with agencies reporting fees received. These would be minimized if artists received a copy of the agency-client delivery memo or invoice with regularly reported sales and income, allowing

5 Essential Business Practices

them to verify prices and terms of sales. Ensuring that artists see the terms of sale and a sample of the published result would also aid in monitoring the client's compliance with the delivery memo. Some artist-agency agreements include the right to audit the agency's books by a certified public accountant.

Artists may want to ask the following questions when discussing a relationship with a stock house:

- What markets is the house strongest in?
- What portion of their sales are below [set minimum fee level]?
- How many artists are they working with?
- What are the names of artists they represent who would be willing to provide references?

Pros and cons of working with stock agencies

There is no question that artists want to maximize the income potential from a lifetime of work, leaving all such revenues to their heirs. However, there is considerable controversy in the industry about how best to do that.

Arguments in favor of artists marketing illustrations through a stock agency are:

- Agencies offer the artist the chance of generating high-volume reuse sales for little additional work on the artist's part.
- Artists have more time to create while the agency does the selling.
- The artist can pick certain images to be licensed to an agency while retaining others to market personally.
- Stock agency sales may help introduce an artist's work to new clients or new markets.
- The burden of keeping up with new technology and markets is left to the agency.
- Some agencies are expert at getting their images before buyers.

In short, the stock agency offers the possibility of additional sales for less work.

Among the arguments against artists selling reuses through stock agencies are:

- The artist does not determine or negotiate the fee for a sale.
- The artist pays a higher commission (50 percent or more) for each sale.
- The artist yields control over the integrity of the art or where it appears.
- Many stock houses are now large, impersonal corporations that seek control and rights to art that may not be in the artist's best interests.
- Increased use of stock may negatively affect the market for originally commissioned works.

For clients, stock agencies present a range of advantages and disadvantages.

Some advantages are:

- Agencies provide complete, available images that can be delivered immediately with ensured results.
- The art director saves time negotiating directly with the agency, rather than with the artist, client, and/or the designer.
- It's more economical to separate highresolution digital files for print.
- Digital catalogs offer the art director a large number of images without liability for loss of original artwork.
- Stock may serve as an introduction to an artist's work that leads to additional stock sales or commissioned assignments.

Some disadvantages are:

- Clients miss the chance to discover the artist's skills as a problem-solver and creative collaborator.
- Searching through large numbers of files is time-consuming, and the cost of the designer's time plus the use fee may exceed the price of custom art.

Trade practices & contracts for reuse sales

The artist, agent, or stock agency must be clear about which reproduction rights were transferred to the previous buyer and which are retained by the artist. It is of course illegal to sell a usage that breaches an existing contract on exclusivity of market, time frame, geographic region, and so on. It is accepted practice that an artist or agent will not sell a use that competes with another use, though the definition of competing uses may be hard to pin down. In general, a reuse should not be in the same market and time frame or for a competing client or product.

Paperwork relating to the sale of an image should always be reviewed carefully if there is any doubt as to rights previously sold. Contracts for reuse rights, whether drawn up by artists, their reps, or stock agencies, should state clearly what usage is being granted and the intended market, the size of the reproduction, the print run, the length of the agreement, and so on. Other negotiating points might include reasonable payment schedules, alteration policies, access to accounting records, receipt of copies of delivery memos, and tear sheets. (For more information on artistagent agreements, see Chapter 13, Standard Con-tracts and Business Tools.)

Artists who wish to have their stock illustration sales conducted by artists' representatives or agencies should discuss all reuse agreements and contracts carefully so all terms are fully understood and agreed upon by both parties. Artists considering prewritten contracts should remember that many points are negotiable; they may wish to consult a lawyer and/or other artists before signing a contract. Graphic Artists Guild members can discuss issues via an artist-to-artist Web forum, and a legal referral network is available that also provide these services (for more information, see Chapter 14, The Graphic Artists Guild).

Artists considering signing with a stock illustration agency or artists' rep may also want to review a copy of the firm's standard delivery memo or invoice, which states the standard terms by which a client buys rights. Information such as whether tear sheets will be provided or alterations permitted is usually located in this agreement rather than in the contract the artist signs.

Clip art & rights-free art on CD-ROMs

Grants of reuse rights in illustration sold as stock are not the same as clip art. Clip art is an image that, once acquired, comes with a grant of license for any use (though specific terms depend on the license agreement). Clip art can be any artwork that is in the public domain or camera- or computer-ready art to which all rights have been sold by the artist, with the understanding that such art may be altered, cropped, retouched, and used as often as desired. Clip art is available to the public in books and on CD-ROM. Some distributors of clip art pay the artist who creates a collection of images a royalty on sales and give them name credit.

Clip art competes with both commissioned art and stock illustration. With increased digital imaging capability, designers can create new artwork solely by combining and altering clip art, though that may not be cost-effective when one considers the designer's investment of time and effort against the cost of a commissioned illustration. On the other hand, the low cost and accessibility of clip art have created new art users, such as desktop graphics departments in small businesses, nonprofit firms, or volunteer groups. It's also possible that some independent businesspeople who might not otherwise use graphics may later choose to commission new work.

One controversial way to market an artist's entire inventory as clip art is on rights-free CD-ROM disks. Companies usually offer artists royalties on sales of the original disks but not on any additional uses since all rights are sold outright. The purchasers then get to use the work in any way they choose, including manipulating, combining, or otherwise changing the original for placement on products, in ads, or as characters in feature films.

Selling artwork on rights-free CD-ROMs gives the artist the opportunity to sell a large number

5 Essential Business Practices

of images at one time for an upfront fee and to receive royalties on sales of the CDs. However, some illustrators fear that the release of many rights-free images at low fees will flood the market with low-priced images, discouraging art buyers from purchasing original work at more desirable rates.

However, the availability of rights-free art on CDs has created new options for graphic designers, who have increased technological means of manipulating them. On the otherhand, they lose the experience of working with a knowledgeable and creative illustrator to generate new and exciting artwork custommade for their specific needs.

In the mid-1990s well-known illustrator Seymour Chwast released a sizable inventory of his work on a CD, with some restrictions for high-revenue use. He reports that its release has not limited the amount of new work he has been offered. Each disk carries a label telling the user that rights to corporate or brand identities, logos, trademarks, symbols, or other images must be negotiated separately for use on merchandise to be sold such as greeting cards or clothing. He had not established a system to monitor all uses, both legal and illegal, of his work.

The Graphic Artists Guild and other industry trade organizations concerned with artists' reprographic rights are exploring means by which such uses can be monitored and assessed.

Online sales

Reuse sales (as well as general illustration sales) on the Internet and the World Wide Web are evolving rapidly. Whereas only a handful of agencies were selling illustrations online in 1997, today the marketplace is flooded with them. For example, arttoday.com offers two reasonably priced membership plans that provide unlimited downloads (depending on the terms of the particular plan) from its vast library of images. Some online services are set up to enable the buyer to locate an image by describing it in simple language; others use keywords. Service is often free until an image is chosen.

Unauthorized reuse

Reproduction of an image without the artist's or copyright holder's permission constitutes unauthorized reuse. It involves copyright infringement, and the infringer may be liable for attorney's fees and statutory damages if pursued in court. The same may be true of unauthorized alteration of an artist's image (for more information see Chapter 2, Legal Rights and Issues, and Chapter 4, Technology Issues).

An art user who wishes to "pick up" an image from an already published source should first contact the artist to arrange for permission and payment of an appropriate usage fee. Failure to reach the artist is not sufficient excuse for unauthorized use of an image; legal due diligence (an earnest, concerted effort to obtain the necessary information) must be demonstrated.

Stories abound of artists' portfolio work being used without permission for client presentations. Digital images have made it even easier for those who engage in questionable business practices to produce "ripamatics" and include them in presentations—and artists are rarely, if ever, consulted, much less compensated. For instance, in 1995 one photographer's representative received a five-figure settlement from a major advertising agency when the photographer's portfolio was returned with the transparencies torn from the expensive matting. The agency had had the images duplicated, even though the rep had denied permission to do so. The issue surfaced again when Direct magazine reported that an artist was suing after an agency allegedly had an illustration re-created by another illustrator with only slight changes for a large direct mail campaign for a major client-with no payment to the original artist. The case stirred debate among artists' groups, agents, reps, and directory publishers about how to stem this abuse.

In addition to the obvious issue of infringement, illegal comping directly affects the work of preproduction artists, whose livelihoods depend upon assignments to create comps, storyboards, and animatics. As the practice of illegal comping persists, these artists are finding it harder to secure work. In 1996 the Graphic Artists Guild brought together more than a dozen professional organizations in the "Ask First" educational campaign to inform the industry about the harmful aspects of these practices.

Still, artists remain so fearful of electronic piracy that a new mini-industry has emerged that claims to offer digital protection for intellectual property. Some artists displaying their work via digital catalogs have begun using electronic watermarks, digital time stamping, and registries to protect their copyrights. Such methods clearly indicate ownership for protected art, as opposed to the rights-free clip art, and are available as software. All such efforts have some merit, as the Guild found when it surveyed five companies in August 1999. However, the Guild concluded that the only sure way to protect one's electronic property is by registering the work with the Copyright Office (see the Copyright section of Chapter 2, Legal Rights and Issues). "Most of these services not only downplay the importance of copyright registration," stated the article in the *Guild News*, "but, to varying degrees, mislead by implying that they provide some form of copyright protection." The article concluded that though a digital time stamp might serve as a slight deterrent to infringement, in the end a simple notice of copyright will accomplish the same purpose.

An artist, artists' rep, or stock agent who notices an unauthorized reuse will usually contact the infringer and request an appropriate fee. Other remedies include legal action, which may involve receiving damages and court fees from the user. For instance, in late 2000 celebrity photographer Michael Grecco added Corbis to the \$8.7 million suit he brought against the Sygma agency in 1998 after discovering several new unlicensed uses of his work.

Both artists and buyers should clearly specify in writing the particular rights bought or sold, including whether the client has permission to scan or alter the art electronically. While vigilance and follow-through are important, a well-written agreement is currently the best overall protection for all parties' rights.

Collectibles

Nearly every form of graphic design and illustration can be transformed into a "collectible"—any sort of theme object that buyers develop a special fondness for and seek out for purchase. Products popularly sought by collectors include dolls, plates, mini collections, steins, ornaments, pewter figurines, crystal, porcelain figurines, bronze sculpture, cold-cast resin products, music boxes, snow globes, wildlife sculpture, commemorative medallions, and functional decor. Popular subjects include Americana, animals, children, flowers, folk art, nostalgia, and sporting scenes. Production techniques have been developed that allow a panorama of artistic styles, media, and subjects to be reproduced for these markets. Licensing agreements are normally negotiated for an entire line, collection, or group of products for a particular market.

This industry is significant and offers many licensing opportunities for the creative consultant (an artist who advises but does not contribute artwork to a project), artist, or designer. Fees and royalty rates vary depending upon the company and the products marketed; typically graphic artists negotiate an advance against royalties.

Collectibles are sold through either retail outlets or direct mail. In the 1970s and 1980s, direct marketing changed the collectibles industry. A "house list" of buyers with an interest in specific themes was compiled, and once a series was started and the "first issue" became a success, buyers were solicited through

campaign brochures and advertisements in selected magazines. A collectibles series was then developed, and each subsequent "issue" was offered to the house list. A series is either limited-edition or open-ended and may develop into 30 to 40 issues. Predetermined mini-collections are also sold, composed of several items on a theme. Collectors often pay in monthly installments so payments can be kept low.

Many manufacturers and retailers have developed specialized markets; collectors clubs are popular and are established by either companies or collectors. Large companies such as Disney, Enesco, Hummel, and Lladro offer their products through retail outlets and also produce "membership-only" limited editions.

Determining markets

The collectibles industry depends on the expertise of a market team to determine public interest in a given item or subject. Current popular items include angels, teddy bears, Native Americana, nostalgia, lighthouses, cottages, folk art, children, wildlife, the millennium, and such Christmas-specific items as Santas, ornaments, and Nativities. Licensed collectibles related to a movie or celebrity or personality are perennial bestsellers, as are images of birds, cats, bears, flowers, and well-known products such as Coca-Cola® and Star Trek®.

Getting into the field

A directory of major collectibles manufacturers and artists working for them can be found in the *Collectibles Market Guide & Price Index*, published by the Collectors' Information Bureau. The index includes more than 45,000 of the most widely traded limited editions in today's collectibles market.

Graphic artists interested in getting into this field should study the types of work already commissioned by such major manufacturers as Anheuser-Busch, The Bradford Exchange, The Danbury Mint, Enesco, The Franklin Mint, The Hamilton Collection, Lenox Collections, and Reco International. Freelance work is available at all these companies, and portfolios, photographs, or examples of work should be directed to the Concept or Product Development Department.

In-house work is a good way to get experience in the field and to become familiar with the specialized requirements for such projects. However, in-house pay is often less than what a freelance graphic artist receives.

An art director will hire a freelance graphic artist who demonstrates a particular style or ability to portray the character or feeling of the projected piece. Work is often obtained by word of mouth between graphic artists who already specialize in product and collectibles design. However, companies are always looking for fresh ideas in already successful product categories and current trends that have detail, style, emotional appeal, humor, and character.

Understanding the product form is essential in this field because the limitations of the product medium, materials, and final manufacturing costs all affect the design. A graphic artist's resourcefulness in combining any limitations with creative design is often the key to a successfully marketed collectible. For example, to design porcelain figurines, the artist must consider the material's brittle nature and undercuts, which may cause problems with making the mold. These factors, as well as the need for multiple firings, make porcelains more expensive, while cold-cast resin products are less costly.

Payment & rights

Historically, graphic artists and clients have found that a good way to determine a fair price in relation to use is through a royalty arrangement, which in this market has been a percentage of total sales based on the product's wholesale price. In practice, virtually all royalties have ranged between 2 and 10 percent of the wholesale price and currently hover around 5 percent, with some on high-volume items as low as a fraction of a percent. Royalty arrangements also include a nonrefundable advance, reflecting a guarantee of coverage for expenses, which is often equal to the cost of the artwork or graphic design if it were sold outright. Creative fees depend largely on the size of company, the complexity of the design, the number of images, the audience, and so on.

Most companies attempt to impose work-for-hire contracts and retain the rights to all sketches and artwork for their concept development. The Graphic Artists Guild is unalterably opposed to work-for-hire contracts (see Chapter 2, Legal Rights and Issues).

Graphic artists who specialize in collectibles often find it helpful to have reps who can help them solicit work and negotiate contracts.

Exclusivity & competition clauses

Some collectibles contracts include exclusivity clauses, which grant the company exclusive use of the graphic artist's name and image to promote both the artist and the product series. This form of contract carries a risk: Such a clause could prohibit the graphic artist from working with any other direct-marketing companies in any capacity as either a designer or a consultant. This arrangement may also raise questions about the graphic artist's employment status; the designer may be considered a regular, if temporary, employee and may be entitled to all employee benefits (see the Employment Issues section of Chapter 3, Professional Issues).

Some contracts contain a clause whereby the graphic artist agrees not to permit any accepted artwork or design, or any work that is comparable in look or feel to the accepted work, to be used in connection with gift products, whether competitive with them or not, during the term of the agreement and for a period of one year thereafter. This grant of rights is overly broad, and the graphic artist should determine through negotiation whether the client genuinely needs it (see Part II: Negotiation, above).

Trade practices

Historically, the following trade practices have been followed by the collectibles industry.

- The intended use of commissioned or licensed work is stated clearly in a contract, purchase order, or letter of agreement, including the price and terms of sale. Uses and terms for uses other than those initially specified should be negotiated in advance when possible (see the Reuse section above).
- Fees should reflect such important factors as deadlines, job complexity, reputation and experience of a particular graphic artist, research, technique or unique quality of expression, and extraordinary or extensive use of the finished work.

3. According to current and historical data, clients usually pay the graphic artist a cancellation fee if the assignment is canceled for reasons beyond the artist's control. According to current data, the amount of the fee varies considerably, ranging from 30 to 100 percent, depending upon the degree of the work's completion. (For a more detailed discussion of such fees, see Chapter 3, Professional Issues.)

While the client usually obtains all the originally agreed-upon rights to the use of the artwork upon payment of the cancellation fee, under a royalty arrangement, all rights to the artwork, as well as possession of the original art, generally revert to the graphic artist upon cancellation.

If a job based on "documentary" work or other original art belonging to a client is canceled, payment of a time and/or labor charge is a widely accepted industry custom.

- **4.** Historically, graphic artists have received additional payment when the client requested changes that were not part of the original agreement.
- 5. Current data indicate that fees for rush work may increase the original fee by as much as 50 percent. As with all fees, the parties to the transactions must agree upon what they regard as a fair rush fee, based upon their independent judgment and the specific circumstances of their arrangement; that fee should be stated in the contract.
- **6.** Initial development costs of the design and production of the prototype are usually borne by the graphic artist. The licensee bears all other costs of developing, marketing, and selling the product.
- 7. Expenses such as travel costs, consultation time, shipping and mailing charges, and other out-of-pocket expenses should be billed to the client separately. Estimated expenses should be included in the original agreement or billed separately as they occur.
- **8.** The terms of payment should be negotiated prior to the sale, and these terms should be stated on the invoice.
- **9.** The company normally requires graphic artists to warranty that all designs are their own, are not done in collaboration with anyone else, and do not infringe upon any existing copyright, trademark, patent rights, or any similar rights of any third party.
- 10. Contracts often state specific delivery dates of preliminary and finished designs. Graphic artists may be required to deliver preliminary designs two to four weeks before the final design is due. After the finished designs are delivered, the artist should be notified promptly by the company whether or not the artwork has been accepted or rejected.
- 11. It may take up to 14 months for a piece to go from final approved stage to stores. Contracts often address this time lag and warrant that the company will, during the time of the license, manufacture, sell, distribute, and promote the products. However, if the licensed product is not offered in the store within 24 months from receipt of the artwork, the client may agree to release the unused property back to the graphic artist. If the product is not promoted, is dropped, or is overstocked, the artist may be asked to agree to

release it for sale at a discount. Although that would mean that royalties per sale paid to the artist would drop significantly, the artist will still receive the agreed-upon percentage for all sales.

- 12. The company normally submits to the graphic artist, without charge, one sample of each product for the artist's approval prior to manufacture. Some contracts provide that products are assumed approved unless the graphic artist notifies the company in writing within 10 days of the receipt of the sample.
- 13. The company normally provides two production samples free of charge no later than 30 days from the first day the item is offered for retail sale. No approval is requested or required for these production samples.
- **14.** If a contract is terminated after production, the company normally retains the right to sell any remaining inventory, but royalties are still applied to all sales and distributed to the graphic artist.
- 15. Statements showing the gross and net sale price of each licensed product are normally provided no later than 30 days after the end of each fiscal quarter. Sales are normally based on units sold and shipped at the wholesale price less any trade discounts, credits, returns, and bad debt.
- 16. Current practice indicates that, as stated in the contract, the company will normally place copyright and/or trademark registration notices on all licensed products and promotional materials. The company may, at the graphic artist's request and expense, register a copyright and trademark and/or service mark in the artist's name. This protects the artist's licensing rights but does not give the artist any right, title, or interest in or to the product.
- 17. Often collectibles gain value from the name recognition of the graphic artist who designed the product. Companies may contract to use the artist's name, photograph, likeness, signature, and/or biographical information in connection with the marketing and sale of the product. If such a request is made, the artist should stipulate that permission will be granted only with approval, per product, by the artist.
- **18.** The company is liable for any loss or damage to the designs while they are in the company's possession or in transit between the graphic artist and the company.
- **19.** Original artwork is rarely returned to graphic artists in this field. Should the artist wish to retain ownership of original artwork, this must negotiated and specifically stated in the contract.

Limited-edition prints

While original artwork may sell for thousands of dollars, lithography and serigraphy have made the collection of limited-edition prints, numbered and signed by the graphic artist, within reach of the average collector. Art for limited-edition prints may be created independently by graphic artists or under contract with a gallery or publisher. Recent survey data show that payment is made on a commission or royalty basis, and an advance is usually included. Both the advance and the

5 Essential Business Practices

ultimate payment to the artist vary, depending on, among other factors, the size of the print run, the number of colors printed, and the selling price. A typical financial arrangement for limited-edition prints is for the graphic artist to receive an advance against 50 to 67 percent of gross sales revenues, with the gallery receiving a commission of 33 to 50 percent. If the gallery or publisher is responsible for all production costs, advertising, and promotion, graphic artists traditionally receive less.

A typical edition ranges from 100 to 250 prints. Each print is usually numbered and signed by the graphic artist. The agreement has historically guaranteed the artist a certain number of proofs to use in any way he or she wishes. Artists should be aware that limited editions numbering 200 or less are granted special moral rights protections under the Visual Artists Rights Act (see Chapter 2, Legal Rights and Issues).

Marketing can make or break a limited-edition venture. Market research should be conducted prior to entering into a binding agreement, making significant outlays of money, or investing time in creating the art. The market for limited-edition prints is regulated by law in a number of states, including California, Illinois, and New York. Extensive disclosures or disclaimers may have to accompany limitededition prints sold in these states.

Trade practices for graphic artists creating limited-edition prints are the same as those for greeting card, novelty, and retail goods illustration (see Chapter 9, Illustration Prices and Trade Customs).

Licensing & merchandising

The licensing industry, which has grown from \$15 billion in North American retail sales in 1980 to \$74.15 billion in 1999 (up 4 percent from 1998), presents tremendous opportunities for graphic artists in all disciplines to generate revenue in new markets. Considering that the average royalty for all categories is about 7 percent, licensors (those granting the rights to use a work in a specific way, for a specific time, over a specific area) may realize an estimated \$5.2 billion in royalties.

Sales of licensed merchandise in 2000 were forecasted to increase 12 percent over 1999. That's more than double the percentage jump from 1998 to 1999. Music and toys/games showed the highest percentage of change from 1998 to 1999: Music was up 29 percent (attributed to Ricky Martin, Backstreet Boys, and the Spice Girls) and toys/games were up 21 percent (thanks to Poke'mon). The top percentage increases for 1999 were for trademark/brands (24 percent), entertainment/character (22 percent), fashion (18 percent), and sports (16 percent).

Product categories & property types

Whether one works as an illustrator, graphic designer, cartoonist, surface designer, or marbler, there are many possible types of products that may be used to exploit a particular work, including accessories, apparel (T-shirts, team jackets, or any apparel items containing a designer label), domestics (shower curtains or bed linens), food/beverage (boxed candy or beverage bottles), gifts/novelties (mugs, pennants, or lunch boxes), health/beauty (exercise equipment or designer fragrances), publishing (calendars or post-cards), stationery/paper products (greeting cards or gift wrap), toys/games, and video games/software. Graphic artists who create a specific work may also target a particular property type to exploit, including art (posters, figurines, commemorative plates, and other limited-edition collectibles), entertainment/character, fashion (everything from infant wear to handbags), and toys/games.

The following table, reprinted with permission of *The Licensing Letter* (© 2000 EPM Communications, Inc.), quantifies the growth of the licensing industry since 1998. Understanding where specific areas of growth occur may help graphic artists chart a marketing proposal and campaign.

1998–1999 Licensed Product Retail Sales, U.S. & Canada In billions of U.S. dollars				
Property type	1999 Retail Sales	1998 Retail Sales	% Change ′98 –′99	% All Sales ′99
Art	\$5.80	\$5.40	7	8
Celebrities/estates	\$2.00	\$2.10	-5	3
Entertainment/character	\$15.95	\$15.10	6	22
Fashion	\$13.50	\$12.85	5	18
Music	\$1.55	\$1.20	29	2
Nonprofit	\$.65	\$.75	-13	1
Publishing	\$1.35	\$1.45	-7	2
Sports	\$12.10	\$12.60	-4	16
Trademarks/brands	\$17.90	\$16.90	6	24
Toys/games	\$3.20	\$2.65	21	4
Other	\$.15	\$.15	0	0
TOTAL	\$74.15	\$71.15	4	
Product category	1999 Retail Sales	1998 Retail Sales	% Change ′98 –′99	% All Sales ′99
Accessories	\$6.50	\$6.25	4	9
Apparel	\$10.60	\$10.80	-2	14
Domestics	\$4.80	\$4.73	1	6
Electronics	\$1.00	\$1.03	-3	1
Food/beverage	\$6.90	\$6.50	6	9
Footwear	\$2.30	\$2.15	7	3
Furniture/ Home furnishings	\$1.10	\$.92	20	1
Gifts/novelties	\$6.40	\$6.25	2	9
Health/beauty	\$3.95	\$3.85	3	5
Housewares	\$2.90	\$2.70	7	4
Infant products	\$2.90	\$2.65	9	4
Music/video	\$1.50	\$1.25	20	2
Publishing	\$4.90	\$4.65	5	7
Sporting goods	\$1.90	\$2.10	-10	3
Stationery/paper	\$3.50	\$3.53	-1	5
Toys/games	\$8.75	\$8.05	9	12
Video games/software	\$4.15	\$3.70	12	6
Other	\$.10	\$.04	150	1
TOTAL	\$74.15	\$71.15	4	

➢ Numbers reflect only merchandise licensing, not licensing for advertising usage, which is growing quickly to well over half the business. ➢ ☐ Figures may not add up due to rounding.

The Licensing Letter © 2000 EPM Communications. Reprinted with permission of the publisher.

5 Essential Business Practices

Character licensing

Graphic artists who have developed a character suitable for licensing may choose to exploit it in a vast number of items, each one representing a separate license. Character licensing, which accounted for nearly \$16 billion in sales in 1999, must meet special requirements before any product can become viable as a merchandising vehicle. For example, a character must have a welldeveloped identity and personality, which entails creating an entire physical and social environment. This information is usually presented in a manuscript that potential licensees use to evaluate the potential success of a project, and it is accompanied, of course, by a number of sketches of the character.

Once a publisher or licensee has indicated an interest in a character, a "style and size guide" is prepared to ensure that the character's visual integrity is maintained in both two and three dimensions. This involves depicting the character from every possible pose, posture, and angle. A graphic artist may choose to contract with a specialist in this area.

Licensees & agents

Graphic artists who want to merchandise their works may grant a license (permission) to an entity (the licensee), which then assumes the risks of manufacture, distribution, and sales. Or, to increase their profit margin, graphic artists may assume those considerable risks themselves. They generally do better by sticking to their artwork and leaving the manufacturing and distribution of finished products to professionals in those fields.

Another option is to secure a licensing agent someone who is well connected to the network of potential licensees and who has expertise in negotiating contract terms. Licensing agents often specialize in specific product categories or property types, so it makes sense for graphic artists to contact agents with that specialty. Current data indicate that licensing agents are paid commissions of 25 to 50 percent of royalties and sometimes require a monthly retainer until a licensee is secured. (For more about working with agents, see Chapter 1, Professional Relationships.)

Whether dealing with potential licensees or with a licensing agent, graphic artists should be careful to protect their ideas by copyrighting their work and by using a nondisclosure agreement, which protects ideas that are not yet fixed in a tangible, copyrightable form. A model nondisclosure agreement is found in Chapter 13, Standard Contracts and Business Tools.

Three good sources for licensors, licensees, and licensing agents are the *North American Licensing Industry Buyers Guide, The Licensing Letter*, and the International Licensing Industry Merchandiser's Association (LIMA). (For contact information, see Chapter 15, Resources and References.)

Terms of licensing agreements

As licensor, a graphic artist or the license owner of a work grants permission to the licensee to use the art for a limited, specific purpose, for a limited, specific time, for a specific geographic area, in return for a fee or royalty. At the expiration of the license, those rights revert back to the licensor.

The image to be licensed should be described in detail. The intended uses, including the product categories or property types to be developed, should be clearly expressed in writing, as should whether the grant is exclusive or not. An exclusive grant prevents the legal exploitation of the image by anyone other than the licensee for the duration of the license. A nonexclusive license allows the licensor to permit others to exploit the work in multiple or overlapping markets. Or the license might prevent the licensor only from granting additional licenses that compete in the same market or category. For example, a licensee might insist on exclusivity in home furnishings but allow other licenses to be granted for apparel. All agreements should state clearly that all rights not specifically transferred remain the property of the licensor.

The duration of a licenses hould be clearly spelled out. Many licenses are for relatively short, fixed terms with renewal clauses tied to successful performance. This type of agreement is fair to both parties, since it provides for continued license of the art only when the graphic artist is assured of obtaining payment and the client is satisfied with the product.

The agreement should detail such conditions as breach of contract, the terms under which the contract may be terminated, insufficient sales, bankruptcy, and so on. Requirements regarding sales, production, or scheduling that provide for the best commercial exploitation of the design should be specified. If these requirements are not met, that is usually grounds to terminate the license. If a license is terminated, the graphic artist is free to license the work to others for the same or similar uses.

Industry surveys show that payment under licensing agreements is normally in the form of royalties, usually a percentage of the retail or wholesale price or a fixed amount per item sold. Royalties are usually calculated by multiplying the number of sales by the gross list or wholesale price. If the royalty is a percentage of the "net" (the amount remaining after expenses), it should be clearly spelled out in the contract how "net" is calculated.

The same surveys show that current licensing agreements most frequently include a nonrefundable advance and a nonrefundable guaranteed minimum royalty, regardless of sales. The graphic artist or license owner is entitled to periodic accounting statements with details of sales and royalties due. The artist also has the right to audit the licensee's books and records to verify the statements and to ensure that proper payment is forthcoming.

When a licensor contracts directly with a graphic artist to create artwork for someone else's licensed work, current data indicate that the work is generally done for a flat fee. For example, if the Disney Corporation contracts with an illustrator to execute artwork of its Mickey Mouse character for a new product,

Disney generally pays a flat fee for the artwork and reserves any royalties from sales for itself. On the other hand, if cartoonist Matt Groening develops new artwork of the Simpsons for a baseball cap, he as the licensor negotiates to receive a royalty on the sale of each item.

To protect their reputations, graphic artists and license owners should insist upon proper quality-control procedures to prevent inferior goods from being produced and to maximize sales potential. It is up to the artist, in consideration of the client's needs, to set those standards. If the client or manufacturer fails to meet them, the license agreement should permit the licensor to terminate the relationship. The graphic artist should also reserve the right to approve all promotional materials.

A proper copyright notice should accompany the artwork, and where possible, name credit should be given to the artist. This should be noted in the licensing agreement.

An excellent book on licensing is *Licensing Art & Design* by Caryn Leland (see the Graphic Artists Guild Bookshelf in Chapter 15, Resources and References). Model licensing agreements, reprinted with permission from the book, appear in Chapter 13, Standard Contracts and Business Tools.

5 Essential Business Practices

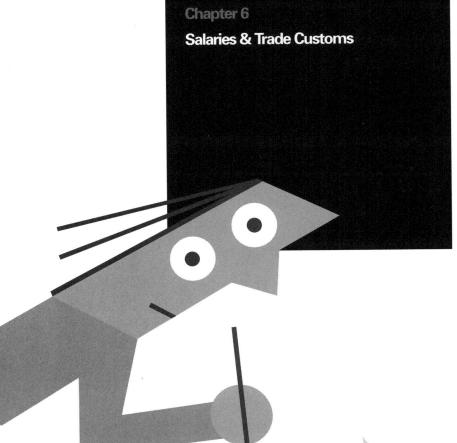

A salaried graphic artist is usually employed solely by one company. Unless the artist or designer can negotiate a written agreement that states otherwise, all art created on company time

is considered work for hire (for more information on work for hire, see Chapter 2, Legal Rights and Issues). Depending upon the responsibilities of the graphic artist and the employer, moonlighting for a competitor may be contractually or ethically prohibited; some employers may

This chapter summarizes employment conditions and salaries for graphic artists mostly graphic designers—who work on staff. Trade practices and employment conditions vary widely depending on the field. That's why it's important to consider employment conditions in addition to salary when applying

for a salaried position.

require employees to sign noncompete contracts and/or confidentiality forms. A salaried graphic artist's income is frequently limited to what the artist receives from the employer. Freelancing on the side, however, while not encouraged, may be an important source of additional revenue. Many of the disciplines overlap in salaried jobs. For instance, an art director may also produce illustrations, designs, or lettering. In fact, few salaried graphic artists specialize so rigidly that they work only in one area; the special responsibilities of a particular position dictate which talents are required.

The salary ranges listed in this chapter reflect the current market for professional graphic artists holding staff positions. The salaries are based on a traditional 35-hour week with a benefits package that includes vacation, holiday, and sick pay. For health insurance, employees are frequently required to contribute part of their premiums and to use health maintenance organizations (HMOs). Bonuses, stock options, and retirement plans are available, but these benefits usually depend upon company policy regarding salaried personnel and are often reserved for creative, supervisory, or executive functions.

Generally, larger companies, particularly those that produce a significant amount of in-house graphic art for advertising, catalogs, corporate graphics, newsletters, and packaging, hire a full-time art staff and use freelance talent to supplement it. Independent agencies or design firms may work on retainer when there is no in-house staff or when the company chooses to subcontract a specific project or an area of a large project, such as a special advertising campaign, corporate identity program, or annual and quarterly reports.

Agencies and corporations have downsized their art departments since the early 1990s, a trend that seems to favor freelancers over staff. However, these companies sometimes hire back the same individuals to work as full-time freelancers on the same projects but at a lower rate and without benefits. Even if the flat fee paid is greater than the salary previously earned, the loss of benefits—and the cost of replacing them—is significant, frequently resulting in a lower total income. This cost-cutting business practice has serious tax implications for both the employer and the graphic artist. For further discussion, refer to the Employment Issues section of Chapter 3, Professional Issues.

Graphic artists who work as full-time freelancers should be aware that the law guarantees time and a half for work in excess of 40 hours per week. And if artists provide 1,000 hours of service, they are entitled to receive all the benefits regular employees enjoy.

Employment conditions

Graphic artists should consider conditions of employment along with salary when applying for a salaried position. Among the conditions generally accepted as standard for full-time workers are:

- Policies: Many employers have written staff policies outlining how a company relates to its employees. New York State companies, for example, are required by law to notify employees "in writing or by publicly posting" about their policies on sick leave, vacations, personal leave, holidays, and hours. Other items that may be included are employee grievance procedures, causes for discipline (up to and including discharge), criteria for salary increases and promotions, and parental leave. A written staff policy reveals much about the working environment and the potential employer's attitude toward the staff.
- Benefits: All companies are required to offer such basic benefits as the minimum wage, unemployment insurance, workers compensation, and short-term disability insurance. Most companies also offer a benefit package to their employees that may include health, long-term disability, and/or life or dental insurance plans. Such benefits are at the discretion of the employer and are not currently required by law. Benefits are often related to company size, with smaller companies offering fewer benefits. Larger companies and corporations often offer pension, profit-sharing, and stock option plans, and sometimes day care facilities or child-care subsidies. An employee may qualify for a company pension depending on the plan specifications and the number of hours he or she works. Check with your employer for details.
- Job descriptions: Just as a contract between a client and a freelance artist reflects their understanding of their relationship, a written job description can define what is expected of artists during the term of their employment. The Graphic Artists Guild strongly recommends that all artists taking

a salaried position request a written job description, since it will help both employer and employee avoid assumptions and expectations that are not shared by the other party. A written description is also useful in the event a job changes significantly during the term of employment. Such changes may reflect greater responsibilities or functions, justifying a new title or greater compensation. If such changes are made, the job description should be rewritten to reflect the new title, duties, salary, benefits, and start date. It is also useful for the artist to obtain an official "offer letter" on company letterhead, stating the salary, title, start date, and benefits and signed by the hiring authority.

Performance review: A periodic (semiannual or annual) evaluation of job performance is helpful to both employer and employee. A formal review gives the employer the opportunity to discuss job performance and any changes in job description and allows employees to gauge their performance and raise questions about their job expectations. Performance reviews also allow employer and employee to suggest ways to improve the "product" or the employee's function. When handled well, job performance reviews can pinpoint potential problems and help maintain good and productive relationships between employer and employee. The results of the job performance review should be kept on file, and employees should be allowed access to their file.

While many of the above conditions of employment are not mandatory, they help both employer and employee develop and maintain good relations during the term of employment.

Salaries

Keep in mind that starting salaries are median salaries in most corporate settings. Each title has a salary range, and new employees are often hired at the low end of the range to provide room for future raises. According to *HOW* magazine's 2000 survey of salaries in the graphic design industry, average salaries for the profession are up nearly 6 percent over 1998. The average entry-level designer/production artist/Web programmer made \$30,775, compared with \$40,753 for a senior or Web designer, \$53,127 for an art or creative director, and \$66,074 for a partner/principal/owner.

Earnings gaps are a problem. It is known historically that many more men than women have been graphic designers and many more women than men have been surface designers, but it may not be as well known that men and women are not paid equally for doing the same job. According to the statistics issued in 1999 by the Women's Bureau of the U.S. Department of Labor, women workers in 1997 earned on average only 74 percent of what men earned. Overall, the median weekly earnings for women workers in 1997 were \$431 compared with \$579 for men. *HOW* magazine's 2000 survey also reflected a gap between men's and women's earnings. The average annual salary for a male designer was \$55,000, compared with \$45,288 for a female designer. However, the 2000 figure for women was up from the 1998 average of nearly \$42,000.

The issue of equal pay for equal work has received a great deal of attention from women's groups and labor organizations. The Graphic Artists Guild believes that equal pay standards should be promoted and supported. Artists with information on problems in this area are encouraged to contact the Guild.

Regional differences in pay scales are another problem area. *HOW* magazine's 2000 survey showed that designers in the Northeast reported the highest average yearly wage of \$53,308, followed by \$50,606 for their Western counterparts and \$47,993 for Southern designers, with the lowest, \$45,221, for the North Central states.

HOW magazine's 2000 survey also revealed differences in pay scales between in-house and design-firm employees. In-house designers earn on the average \$12,000 less than their design-firm counterparts. That gap has widened by \$5,000 since 1998. However, nearly three-fourths of design-firm employees are responsible for supervising junior members, while few in-house designers have to assume management responsibilities.

Design & production job categories□

□ This section was contributed by Ellie Lipetz, director of design recruitment at Cheryl Roshak Associates, which does executive recruitment in the graphic design industry.

Design and production staffs in design firms are usually ranked in the following categories (note that salaries are national averages; designers in such places as New York City, San Francisco/Los Angeles, and Seattle may add at least 20 percent to determine typical salaries in those areas):

Design staff

• Entry designer: \$30,000. 0 to 1 year experience. Learning position. Good Mac skills in Illustrator/Photoshop/Quark (not all the same level) and familiarity with Web programming/design. Supports and assists the more senior designers and works on small design projects with supervision. Detail oriented; team player; takes direction well.

- Junior designer: \$32,000 to \$35,000. 1 to 3 years experience. Growth and learning position. Good Mac skills in Illustrator/Photoshop/Quark (not all of equal strength) and experience in Web programming/design. Supports and assists the senior designers and works on aspects of some design projects with supervision. Detail oriented; team player; strong typography; takes direction well.
- Designer: \$35,000 to \$45,000. 3 to 5 years experience. Growth position. Strong Mac skills and some project management skills. Works with senior designers, art directors, or creative directors to help implement aspects of certain projects or is given smaller projects to do on own with supervision. Refines final design into final digital mechanicals. Team player; self-starting.
- Senior designer/art director: \$45,000 to \$60,000. 4 or more years experience. Management position. Strong Mac and project management skills. Able to conceptualize, design (through final digital mechanicals), art direct, and present complete projects with approval of creative director or senior art director. Works with illustrators and photographers; supervises photo shoots; goes on press. Supervises junior designers and production people. Team player; good supervisor and manager.
- Senior art director: \$55,000 to \$70,000. 6 or more years experience. Management position. Excellent Mac skills. Conceptualizes and designs with a support staff of junior designers or production artists and oversees own projects. Able to meet deadlines, hires illustrators and photographers, supervises photo shoots, and goes on press. Team player; good supervisor and manager.
- Creative/design director: \$75,000 to \$100,000 (may include equity share in firm). 8 or more years experience. Leadership position.

Excellent Mac skills. Excellent design and supervisory experience. Governs design direction of firm. Complete authority and responsibility for all departmental projects from concept to final printing and for departmental strategy, projects, staff, and departmental budgets. Guides, advises, and oversees design team and creative direction on all projects; may act as senior art director on some projects. Reviews portfolios and hires/fires staff. Excellent manager and supervisor.

Production staff

- Junior production: \$25,000 to \$30,000. 0 to 3 years experience. Learning position. Good Mac skills in Illustrator/Photoshop/Quark (not all the same level). Able to do comp production with some understanding of prepress. Takes direction from either production or design staff. Detail oriented; team player; takes direction well.
- Production: \$35,000 to \$50,000. 3 to 6 years experience. Growth position. Excellent Mac skills. Some project management skills. Able to work with minimal supervision from designer sketches on multiple projects. Able to create comps or final mechanicals for prepress (including crops, bleeds, printer spreads, formattype, style sheets, die strikes). If has design sensibility, sometimes called upon to fit copy or art, as necessary. Team player; self-starter.
- Studio manager/senior production: \$50,000 to \$70,000. 7 or more years experience. Management position. Excellent Mac skills and understanding of prepress. Must be able to be hands-on if necessary. Good organizational skills; oversees quality control of all workflow while holding deadlines. Supervises and hires/fires staff. Key liaison with studio, account executives, and outside vendors. Excellent manager and supervisor.

Staff Salaries			
Owner, partner, principal	Total compensation		
Design studio or consultancy	\$65,000-\$144,600		
Advertising agency	\$85,000-\$146,000		
Publishing house	-		
In-house design department	_		
Other	\$75,000–\$158,800		
Creative/design director	Total compensation		
Design studio or consultancy	\$69,000-\$100,000		
Advertising agency	\$65,000-\$108,000		
Publishing house	\$63,900–\$94,000		
In-house design department	\$60,000-\$100,000		
Other	\$67,000-\$108,000		
Art director	Total compensation		
Design studio or consultancy	\$47,500-\$70,000		
Advertising agency	\$42,500-\$56,500		
Publishing house	\$46,500-\$70,000		
In-house design department	\$47,000-\$70,000		
Other	\$48,000-\$75,000		
Senior designer	Total compensation		
Design studio or consultancy	\$44,000-\$65,500		
Advertising agency	\$41,300-\$72,800		
Publishing house	\$38,000-\$54,000		
In-house design department	\$42,000-\$60,000		
Other	\$44,300-\$70,000		
Designer	Total compensation		
Design studio or consultancy	\$31,000-\$41,500		
Advertising agency	\$30,000-\$40,000		
Publishing house	\$33,600-\$45,500		
In-house design department	\$31,300–\$45,000		
Other	\$35,000-\$50,500		
Print production manager	Total compensation		
Design studio or consultancy	\$40,500–\$60,000		
Advertising agency	\$38,300–\$61,900		
Publishing house	\$42,900-\$57,500		
In-house design department	\$39,500–\$66,000		
Other	\$40,000-\$65,000		

Staff Salaries continued			
Print production artist	Total compensation		
Design studio or consultancy	\$30,000-\$42,000		
Advertising agency	\$27,800-\$49,400		
Publishing house	\$25,500-\$35,000		
In-house design department	\$30,000-\$36,800		
Other	\$31,000-\$49,200		
Web developer	Total compensation		
Design studio or consultancy	\$35,000-\$70,000		
Advertising agency	-		
Publishing house			
In-house design department	\$33,000-\$67,500		
Other	\$44,000–\$66,000		
Web designer	Total compensation		
Design studio or consultancy	\$40,000-\$65,000		
Advertising agency	\$32,500-\$55,000		
Publishing house	\$21,100-\$55,000		
In-house design department	\$35,000-\$55,000		
Other	\$38,200-\$55,000		
Other Web design & production positions	Total compensation		
Web producer	\$56,500-\$79,600		
Web programmer	\$50,900-\$75,800		
Web system administrator	\$44,800-\$70,100		
Content developer	\$40,900-\$60,000		
Web media production designer	\$35,000-\$60,000		
Online community manager	\$31,500–\$75,000		
Total compensation includes wages and salary as well as other forms of cash compensation			

Total compensation includes wages and salary as well as other forms of cash compensation such as bonuses, profit sharing, incentives, and partners' portfolios.

Reprinted with permission of the American Institute of Graphic Arts and excerpted from the AIGA/Aquent Survey of Design Salaries 2000.

Trade Practices in Two Disciplines

Trade practices and employment conditions vary widely depending on the discipline. Only a few artists or cartoonists, for instance, are employed as full-time staff. Some designers work in-house in the fields of broadcast and surface/textile design. Vast differences prevail in their respective job conditions based on their particular industry.

Broadcast designers

The work of a broadcast designer involves all aspects of traditional graphic design plus the added dimensions of motion and sound. In one sense it is a combination of graphic design and filmmaking.

Broadcast designers fulfill a wide range of positions within the television industry, with the largest number of positions in local television stations. Other broadcast design positions are at cable networks, broadcast design companies, and television postproduction facilities.

The work of a broadcast designer includes just about all the designed imagery one sees on television. Some examples include the on-air look and sound of any television station or network as well as the logo, ID, lead-ins for movies, and graphics that promote shows. Most television programs begin with a title sequence designed by a broadcast designer. News and sports programs are packed with the work of broadcast designers. Almost every commercial includes some work by a broadcast designer; sometimes entire commercials are created by broadcast designers. As the medium of television extends into home video, kiosks, and even broadband Web sites, the work of broadcast designers is ever present.

In smaller station and network design departments, broadcast designers are often called upon to work in print design—particularly advertising and sales collateral—and sometimes on Web sites as well. Scenic design may also fall within a broadcast designer's scope of responsibility. At local stations this may include the design of the news set, though in larger markets scenic design is usually handed by scenic designers. Television, by the nature of its immediacy and high cost, places high demands on the broadcast designer's ability to deliver on time and on budget. The penalties for missing deadlines simply do not allow that to happen.

The most effective broadcast designers are often those who have great creative talent combined with a lot of specific skills. Because television is a technological medium, there is a strong benefit to having an affinity toward technological creative tools and techniques. Important skills beyond those of traditional graphic design include the full range of desktop computer skills, the ability to direct a live-action shoot, a working knowledge of a variety of animation techniques, video editing, compositing with systems like After Effects, Henry, Flame, and Flint, and full-on computer graphics.

Job categories

- Production artist: An expert on a particular system, such as After Effects, Henry, or Flame.
- Designer: Handles specific design assignments, like creating graphics and bumpers under supervision. Develops design solutions and follows through with implementation.
- Creative director: A manager who has creative skills, assigns work to designers, supervises their work, and screens job applicants. The creative director may also take on the role of designer on specific projects.

Surface/textile designers

Although out-of-company freelance work is the more common practice in the industry, the following trade practices are relevant to the salaried surface/textile design artist who works

6 Salaries & Trade Customs

for a design studio, manufacturer, importer, retailer, or other hiring party (for instance, converters, which used to play an important role between the mill and the buyer). Some artists may choose to be employees for temporary periods while executing specific projects. It's important that they be paid all benefits due other employees while on staff.

- Physical working conditions: Surface/textile designers should survey prospective work spaces and evaluate such aspects as lighting, ventilation, cleanliness, equipment, and supplies, among others. It is impossible to evaluate a mill's conditions for striking-off prints, for example, without paying a visit to the premises. An artist may choose to bring favorite brushes to a workplace if those provided are not adequate.
- Work practices: It is important for every surface designer to know his or her rights as an employee. Consistently working extra hours without overtime pay is illegal, unless agreed upon in advance. Some companies consider it normal practice, but in that case the designer should receive adequate compensation.

In mill work, unsafe and abusive working conditions have existed for staff employees, as well as freelancers, for years. Working through weekends or 16- to 24-hour daily shifts with no time off (leading to sleep deprivation), extended travel time, and enduring poor physical, mental, and environmental conditions at mills and print plants are common practices that should be compensated appropriately and properly. (The only benefit freelance workers receive is that they are usually paid by the hour.) According to the New York State Labor Board (NYSLB), for example, at least one halfhour lunch period in a 9 a.m. to 5 p.m. workday must be provided. (Contact the NYSLB and labor boards in other states for other information on rest periods and working conditions.) Some advances in these areas are being made with additional compensation,

guaranteed days off, overtime pay, and hiring of additional personnel to limit shift hours.

To achieve these goals, surface designers should negotiate firmly and/or organize for the purpose of collective bargaining. The Graphic Artists Guild is prepared to assist any and all staff artists to improve their working conditions in the following ways:

- Salary reviews: Ideally, employers in this field should evaluate work quality and salary advancement on an annual basis, but annual reviews are rare. Staff artists should be acquainted with the company's policies to evaluate the feasibility of negotiating merit increases, cost-of-living increases, or other improvements in hours and conditions of work.
- Temporary employee: If the employer requires the surface designer to sign a noncompetition agreement stating that she or he will not work for other companies while employed by them, the surface designer may be considered a regular, if temporary, employee and may be entitled to all employee benefits, such as health care insurance. For more information, see the Employee Issues section of Chapter 3, Professional Issues.
- Artists on per diem: Per-diem rates are usually lower than prevailing freelance prices and consequently are not beneficial to surface designers. Furthermore, per-diem surface designers do not receive fringe benefits such as medical insurance or pensions. However, hiring a per-diem surface designer for even one day requires the company to pay taxes, social security, and unemployment insurance to the government; according to government regulations, those who work per diem consistently may be automatically eligible for these fringe benefits. The Graphic Artists Guild strongly recommends that if surface designers are asked to do per-diem work, they review the ability level required and the work assigned and request commensurate payment.

- Knockoffs: A surface/textile designer should not copy or knock off a contemporary design by another artist unless that work is in the public domain; however, making knockoffs of vintage designs is commonplace. It is the special talent of the designer to be able to create a work that is original yet satisfies the fashion dictates of the season or year. Unfortunately, many employers request that designers create two or even three designs based on an original purchased from a design studio in Europe or the United States. No designer should be forced to knock off or copy designs for an employer unless the employer is willing to indemnify the artist from any actions that may arise as a result of any charges of infringement.
- Changing jobs: Staff surface designers change jobs frequently to improve salaries, win promotions, or find better working conditions. The Graphic Artists Guild advises giving employers a standard two-week notice when leaving a job. Anything less may jeopardize any severance or vacation pay due.

Job categories

 \fbox The information in this section was contributed by surface/textile designer Barbara Arlen.

- Mill worker/strikeoff artist: Up to \$35,000. Trainedto approvestrikeoffs, engravings, and films for prints; designs for dobbies and jacquards; and balanced color weights. May also coordinate solid fabrics.
- Designer/CAD designer: \$30,000 to \$60,000. Learning or growth position. Executes new versions of original designs and some original design work. Paints color combinations, repeats, and color separations or creates them with CAD (computer-assisted design). Sometimes does millwork.
- Studio head/director of CAD studio: Up to \$75,000. Management position in charge of studio personnel. Responsible for implementation of all work created in the studio, including original artwork, designs created from original artwork or antique swatches, and colorways. May help make presentations to clients and do millwork.

- Assistant stylist: Up to \$80,000. Creative and management position. Responsible for studio output or giving and receiving work from freelancers. Paints or does own CAD work. Approves lab dips and color work. Pitches patterns and sends out engravings and graphs to mills.
- Stylist/creative director: Up to \$120,000. Creative and management position. Respon-sible for all work created in the studio and by freelancers, including color work. Purchases designs and has staff make them into layouts and repeats. Supervises millwork. Travels to trade shows for design concepts. Works with clients. Creates trend boards. May do some painting or CAD work.

6 Salaries & Trade Customs

Chapter 7 Graphic Design Prices & Trade Customs **G**raphic designers use both design and production elements—including color, typography, illustration, photography, animation, and printing or programming techniques—

to organize ideas visually in order to convey a desired impact and message. In addition to exercising aesthetic judgment and project management skills, the professional graphic designer is experienced in evaluating and developing

This chapter describes the many different arenas where graphic designers apply their talent and skill. Their clients include corporations, manufacturers, nonprofits, advertising agencies, publishers, retailers, entrepreneurs, and educational institutions, encompassing all

facets of commercial, social, and cultural life.

effective communication concepts and strategies that enhance a client's image, service, or product. For a general discussion of the scope of what designers do and how they get work, review the Working with Graphic Designers section in Chapter 1, Professional Relationships. Graphic design is applied in a wide variety of visual communications, including, but not limited to, such printed materials as magazines and books, three-dimensional packaging and products, and identity systems and sales campaigns of business and industry through logos and collateral promotion, including annual reports, catalogs, brochures, press kits, and direct mail packages. The talent of graphic designers is also crucial to the broadcasting and film industries and to electronic communications industries on the World Wide Web. (For more information on this topic, see Chapter 8, Web Design and Other Digital Media Practices.)

Graphic designers generally work with or hire other graphic designers, illustrators, production artists, or photographers on either a salaried or a freelance basis. Almost all graphic designers buy and sell art. Those designers who handle many different projects within a range of industries often refer to themselves as general graphic designers.

Graphic designers may freelance or may be employed on a regular basis by a design firm or other entity as a principal or a staff designer. Traditionally, a small design firm has 1 to 9 employees; a medium-size firm has 10 to 49 employees; and a large design firm has over 50 employees. The vast majority of design firms in the United States are small or medium-size and are run by the graphic designers who are the principals or partners of the firm. Because the level of experience of a design practice, the scope of project services provided, and the overhead expenses may vary considerably, graphic design is one of the most difficult areas for which to identify pricing practices. Most design firms negotiate a flat fee, while freelancers usually bill for their time.

Median Hourly	y Freelance Rates	
Designer	\$30	
Senior designer	\$40	
Creative director/designer	\$50	
Art director	\$55	
Print production artist	\$30	
Print production manager	\$50	
Web developer	\$50	
Web designer	\$55	
Web media production designer	\$55	
Web programmer	\$65	
Content developer	\$68	

 $^{\frown}$ These figures, which are reprinted with permission from the American Institute of Graphic Arts and excerpted from the AIGA/Aquent Survey of Design Salaries 2000, are lower than those in the 9th edition of *Pricing & Ethical Guidelines*; however, they may be more accurate.

The Agreement

Since designers work with a vast array of graphic resources, it is important that all conditions and expectations be spelled out before the work begins. The following points should be considered:

- Payment: For larger projects, it is customary for one third of the payment to be made upon signing the agreement, one third upon approval of design comps, and the final third within 30 days of delivery of digital files for production.
- Rights: Most contracts include a section specifying how, when, where, and the duration for which the design will be used. The extent of use determines which rights of copyright the client needs, and may be a factor in establishing appropriate fees. Graphic designers are often entitled to credit and copyright, unless another arrangement is negotiated. Designers often contract with freelance illustrators, designers, and photographers for work on a limited-use basis for specific projects. Unless specified otherwise in writing, it is assumed that the individual creator owns the copyrights to the work, not the client or the designer. It is not uncommon, therefore, for copyrights to be held by several different contributors to a project, who may all deserve the same acknowledgment and rights on the piece or group of pieces. (For a more in-depth discussion of these and related issues, see Chapter 2, Legal Rights and Issues.) In addition to copyright concerns, all terms and conditions of working with independent creatives should be clearly outlined in

writing and reviewed prior to the commission. These standard customs are detailed in a contract, letter of agreement, or confirmation of engagement form. (See Chapter 13, Standard Contracts and Business Tools.)

- Expenses: In addition to the designer's fee, expenses reimbursed by the client typically include subcontractors' fees, digital output and file storage, photostats, supplies, travel, overnight couriers, and messenger services. Current data indicate that the markup for these services usually ranges from 15 to 25 percent, with 17.85 percent the average. The markup reimburses the designer for supervisory and handling time and helps ensure that all work is done to the designer's specifications and standards of quality. Reimbursable expenses are billed monthly, upon completion of project phases, or upon completion of the project.
- Responsibilities of the client: copywriting, providing copy on disk or in an electronic form, proofreading, and sometimes press approval.
- Consultation fees: When a graphic designer is called in by a client to advise on a project or design decision, surveys show that consultation fees are often based on an hourly rate. Consultation fees have historically ranged from \$75 to \$250 per hour.

Trade Practices

The following trade practices have been used historically and through such tradition are accepted as standard.

- 1. The intended use of the design, the price, and the terms of sale must be stated clearly in a contract, purchase order, or letter of agreement.
- The use of a design has historically influenced the price. If the design is to be fetured over an extensive geographical area or is an all-rights sale, fees are significantly

higher than when used locally, within a selected area, or for limited usage.

 Historically, designers have charged higher fees for rush work than those listed here, often adding 50 to 100 percent. A job may be considered a rush if the designer is requested to do the work on a muchabbreviated schedule.

- 4. If a design is to be used for something other than its original purpose, such as for an electronic database or on a Web site, the designer should negotiate reuse arrangements with the original commissioning party with speed, efficiency, and all due respect to the client's needs. Note that the secondary use of a design may be of greater value than the primary use. Although there is no set formula for reuse fees, recent surveys indicate that designers add a reuse fee ranging from 50 to 100 percent of the fee that would have been charged had the work been originally commissioned for the anticipated use.
- Return of original artwork, computer disks, or digital files to the designer is automatic, and should be done in a timely manner, unless otherwise negotiated. Note: This may affect sales tax requirements.
- 6. If a job is canceled through no fault of the designer, a cancellation fee is customarily charged. Depending upon the stage at which the job is terminated, the fee paid should reflect all work completed or hours spent and any out-of-pocket expenses. (See the Cancellation and Rejection Fees section in Chapter 3, Professional Issues.)
- 7. Historically, a rejection fee has been agreed upon if the assignment is terminated because the client finds the preliminary or finished work to be not reasonably satisfactory. Depending on the reason for the rejection, the rejection fee for finished work has often been equivalent to the number of hours spent on the job.
- Designers considering working on speculation assume all risks, and should take them into consideration when offered such arrangements. (See the Speculation section in Chapter 3, Professional Issues.)
- 9. The Graphic Artists Guild is unalterably opposed to the use of work-for-hire contracts, in which authorship and all rights that go with it are transferred to the commissioning party and the independent designer is treated as an employee for copy-

right purposes only. Under a work-for-hire arrangement, the independent designer receives no employee benefits and loses the right to claim authorship or to profit from future use of the work forever. (Additional information on work-for-hire contracts can be found in Chapter 2, Legal Rights and Issues.) Note: Corporate logo designs are ineligible to be done under work-for-hire contracts because they do not fit its legal definition, but all-rights transfers of such work to clients are common.

- 10. No new or additional designer or firm should be hired to work on a project after a commission begins without the original designer's knowledge and consent. The original designer may then choose, without prejudice or loss of fees owed for work completed, to resign from the account or to agree to collaborate with the new design firm.
- 11. Major revisions or alterations initiated by the client (authors alterations, or AAs) through no fault of the designer are usually billed at the designer's hourly rate. In such cases, the designer will apprise the client of anticipated billing and obtain authorization prior to executing the additional work.
- Historically, designers have been entitled to a minimum of three samples of the final piece.

Prices for design in this book are based on a survey of the United States and Canada that was reviewed by a special committee of experienced professionals organized by the Graphic Artists Guild. These figures, reflecting the responses of established professionals, are meant as a point of reference only and do not necessarily reflect such important factors as deadlines, job complexity, reputation and experience of a particular designer, research, technique or unique quality of expression, and extraordinary or extensive use of the finished design. (Refer to related material in other chapters in this book, especially Chapter 5, Essential Business Practices, and Chapter 13, Standard Contracts and Business Tools.)

Corporate Graphic Design

Corporate graphic designers specialize in business communications and identity programs, signage, internal and promotional publications, and annual reports for companies and such institutions as hospitals, universities, and museums. A team specializing in this area of design may include a principal of the firm, designer(s), production manager, copywriter, and project manager.

Since these projects often involve long-term strategic research and development, corporate designers are frequently brought in at the earliest planning stages. Many corporate design offices work on retainer and also act as design consultants in peripheral areas in addition to their main projects.

Project proposals

The project begins once a client accepts the design proposal outlining the scope of the project, its budget, schedule, and the terms under which it will be executed. Historically, design projects are often quoted and billed by phase, with an initial fee representing 10 to 33 percent of total estimated fees and reimbursable expenses. With new clients and Web site projects, some designers request as much as a 50 percent initiation fee upfront to ensure that they will be paid if the project is canceled in midstream.

Phase 1. Planning: This phase is concerned with gathering information and establishing design criteria. It often requires spending a great deal of time with the client to define the needs, objectives, and problems to be solved.

Phase 2. Concept development: After the designer and client have reached an agreement concerning the basic program, visual solutions are pursued that meet the stated objectives. This phase results in a presentation showing only those ideas that the design team feels are viable, appropriate, and meet the prescribed criteria.

Phase 3. Design development: At this stage, the design team refines the accepted design, which may include general format, typography, color, other elements, and the assignment of illustration and/or photography. A final presentation may be made to the client explaining the refined applications. Any changes in budget and/or schedule are agreed upon at this point.

Phase 4. Design implementation: Decisions on all related art direction, including commissioned illustrations and photography, typography, copywriting, layouts or digital files, and all other elements, are final at this point. Designer errors or printer errors (PEs) are not billable after this point, but all AAs are. The client may make changes in files or on press only through the designer. Conversely, the designer may execute design alterations either in files or on press only with the client's final approval.

Phase 5. Production: Depending on the end product(s) a design firm or designer has been commissioned to produce, this phase may be a matter of going on press, supervising the fabrication or manufacturing of products, or launching a Web site. Supervision is the key to this phase, since achieving the designer's vision depends on the precision and quality attained in this final step. After the end product is approved, the project is considered billable. Traditionally, costs related to production or printing are the responsibility of the client.

Comparative Fees for Corporate Graphic Design

Corporate identity design				
Client annual revenues	Comprehensive branding/ID ¹	Comprehensive Internet Web site ²	Logo design projects ³	Stationery systems ⁴
Over \$500 million	\$65,000-\$110,000	\$125,000-\$200,000	\$40,000-\$70,000	\$20,000-\$30,000
\$100-\$500 million	\$55,000-\$85,000	\$75,000-\$150,000	\$30,000-\$60,000	\$15,000-\$25,000
\$50-\$100 million	\$45,000-\$75,000	\$60,000-\$110,000	\$25,000-\$50,000	\$10,000-\$20,000
\$10-\$50 million	\$35,000-\$60,000	\$40,000–\$70,000	\$15,000-\$25,00	\$8,000–\$15,000
\$1–\$10 million	\$25,000-\$40,000	\$30,000-\$50,000	\$10,000-\$20,000	\$5,000-\$10,000
Under \$1 million	\$15,000-\$30,000	\$20,000-\$35,000	\$5,000-\$12,000	\$3,000-\$6,000

¹ Usual and customary fees for comprehensive research, consultation, and design audit; design of an integrated identity system including links to divisions and affiliates; presentation of three to six schematics, final applications to business papers and other corporate formats, and implementation guidelines.

² Usual and customary fees for research and design of all visual aspects and elements of Web site look and feel; organization and architecture of corporate Web site, including site map, informational hierarchy and relationships, supervision of illustration, photography, and animation, coordination with programmers and information architects.

³ Usual and customary fees for research and application of primary logo identity to all corporate materials including advertising, business papers, signage, and in-house publications; presentation of three to six schematics, final applications to stationery; implementation guidelines.

⁴ Usual and customary fees for research and design of letterhead, envelope, and business card only; presentation of up to three comprehensive layouts showing format.

Limited corporate projects

Client annual revenues	Annual reports ⁵	Newsletters ⁶	National brand products ⁷
Over \$500 million	\$25,000-\$85,000	\$12,000-\$22,000	\$40,000-\$80,000
\$100-\$500 million	\$20,000-\$75,000	\$10,000-\$20,000	\$30,000-\$75,000
\$50-\$100 million	\$15,000-\$60,000	\$7,000-\$17,000	\$25,000-\$60,000
\$10-\$50 million	\$13,000–\$50,000	\$4,000–\$12,000	\$20,000-\$50,000
\$1–\$10 million	\$15,000-\$40,000	\$2,000-\$10,000	\$15,000-\$40,000
Under \$1 million	\$15,000-\$30,000	\$2,000-\$10,000	\$5,000-\$20,000

5 Research and design of 32-page report (8 pages of financial data and 24 pages of text); presentation of up to three comprehensive layouts showing format; supervision of illustration and photography.

6 Research and design of 12-page, two-color newsletter, presentation of up to three comprehensive layouts showing format, supervision of illustration and photography.

⁷ Research and design of an integrated branding system for the launch of a new brand product showing applications to packaging, labeling, and advertising and collateral. Includes presentation of up to three comprehensive layouts showing format, and supervision of illustration and photography.

Billing

Billing expenses and fees are handled in a number of ways. During the first phase, the designer may arrange to bill on an hourly or project basis. If clients prefer to be billed on a project basis, they usually establish an acceptable limit ("cap") on the total amount. However, the designer needs to clearly spell out that the client cannot request endless revisions without additional compensation.

Comparative Fees f	or Corporate Gra	phic Design continued	
0	ther identity campa	aigns	
	Political ⁸	Recording artist ⁹	
World tour	-	\$20,000-\$50,000	
National campaign or tour	\$10,000-\$35,000	\$10,000-\$30,000	
Statewide campaign	\$7,000-\$20,000	_	
Local campaign or engagement	\$1,000-\$10,000	\$1,000-\$10,000	
0			

⁸ Design of a complete marketing program to apply concept and logo to posters, bumper stickers, buttons, direct mail, outdoor advertising, banners, podium placards, and other collateral.

⁹ Design of a consistent visual identity to include recording cover(s), print and newspaper advertising, security badges, crew ID cards, point-of-sale displays, merchandising material (team jackets, T-shirts, souvenir books, and posters).

Restaurants/Sports teams Restaurants¹⁰ Sports team¹¹ Major franchise \$40,000-\$90,000 \$60,000-\$110,000 Regional franchise \$20,000-\$50,000 \$45,000-\$75,000 Four star \$12,000-\$25,000 Two star \$4,000-\$7,500

10 Research, design, and presentation of up to three logo concepts and application to signage, business papers, and in-house collateral (menus, placemats, tent cards, napkins, matches, etc.).

11 Design and presentation of up to three logo concepts and application to uniforms, outerwear, pennants, banners, merchandising, souvenir books, and other collateral. Based on concept, three to five layouts, comprehensive, supervision of illustration and photography, and final art for each component. Does not include fabrication, supervision of execution, and other production expenses that may be billed separately.

Recent surveys indicate that expenses are usually billed with markups included (except for costs incurred for client-approved travel). Sales tax is rarely included in expense estimates and is usually billed periodically or at the end of the project along with AAs, which are billed at a predetermined hourly rate.

The printing or manufacturing part of the project may be billed by the studio or directly to the client, depending on the particular designer's practice. The printer and all other professionals working with the designer are accountable to the designer and are ethically bound to follow the designer's direction while working on the project, regardless of who pays the printer. This becomes a matter of practicality as well, since the designer is orchestrating many elements and must control them all to ensure consistency.

The pricing ranges in the chart do not constitute specific prices for particular jobs. The buyer and seller are free to negotiate, with each designer independently deciding how to price the work, after taking all factors into account.

Corporate identity

The objective of a properly executed corporate identity program is the accurate visual presentation of an organization's unique personality. The client's initial focus may be on the development of a new "mark" or logo, but a complex procedure involving several phases and a wide range of expertise is required to furnish a full-fledged, professionally executed corporate identity program.

A typical three-phase program includes the following:

Phase 1. Orientation: This phase of the program is concerned with gathering information and establishing design image criteria. A significant sampling of visual materials is collected and evaluated, and interviews are conducted with various relevant audiences. Communication objectives, a plan of action, and a nomenclature (hierarchy and system of language to be used within the identity system) are established.

Phase 2. Design development: In this creative phase, design ideas for the mark, logo, or other primary identification device are developed. Applications to stationery and signage must also be provided to demonstrate the specific advantages of each design. Recommendations are also made regarding color schemes and secondary typography. The design selection process should be made according to the approved image criteria, not based on individual taste or subjective preference.

Phase 3. Implementation: This phase of the program is unquestionably the most important. Sufficient application formats must be developed to visually demonstrate the nature of the corporate identification system. Guidelines (usually in the form of a graphics standards manual) establish the management-endorsed design policy and implementation procedures. Rules governing proper usage of the program's design elements, formats, templates, and nomenclature are presented, including reproduction materials for graphics and color guidelines.

Finally, organizations that want to make the most effective use of a visual corporate identity program either contract for a long-term consulting agreement with the design firm or establish a properly administered in-house communications department, or a combination of both.

Branding Design

Branding products or services became the rage in the late 1990s. In this increasingly consumerdriven society, designers are asked to create distinctive visual images or campaigns to identify a particular brand or commodity. Often a sense of differentiation or exoticism is evoked by a brand campaign to captivate the consumer.

Thanks to rapidly changing communication technologies, branding is also a response to the proliferation of information anywhere, anytime, in any form. A unique and identifiable look associated with a certain product makes its design—including advertising, packaging, and direct mail promotion—more important than ever before.

Designers use the usual tools of form, colors, textures, graphics, typestyles, and other imagery to evoke emotions connecting a consumer to a brand so the consumer will continue to buy it. Designers who specialize as brand identity consultants may need to have a special understanding of the universal emotional, psychological, and visceral meanings of color, shape, and form. Armed with that expertise, brand designers are showing that well-defined, well-designed brand imagery can produce big dividends for many commodities.

Advertising & Promotion Design

Advertising designers must have a sophisticated knowledge of marketing, sales, and advertising print production in addition to design skills. Because they have expertise in a variety of disciplines, they can successfully coordinate a company's visual identity with its marketing. Consequently, more and more of these designers are being asked by clients to replace advertising agencies. In these cases, designers often apply for agency status to be eligible for the "agency discount" when placing advertising with magazines and newspapers.

Advertising agency fees are usually tied to the total advertising budget, historically a 15 to 20 percent commission for creative work and media placement. However, in today's competitive marketplace, many clients attempt to lower this fee if their advertising budget is large enough to be leverage for more favorable terms.

It is common practice for several agencies to pitch the client (known as the "account") on speculation, presenting ideas for their upcoming advertising campaign. The investment and risks involved are usually accepted by advertising agencies because of the tremendous ongoing rewards that may be reaped from media placement, should the agency win the account. However, graphic designers, who do not enjoy these rewards, must assess these speculative risks much more critically. Since ideas are a designer's stock in trade, many in the industry believe it is not good to "give ideas away" by working on spec.

The designer's role is to work as part of a creative team comprised of a copywriter, an account executive, and/or a public relations professional. When the designer is working as part of a team, the proposal presented to the client usually includes a strategy as well as a design solution. Because a client's investment in advertising is often sizable and therefore risky, agencies frequently limit the designer's creative input, despite the potential benefits of the designer's expertise to the client. Sometimes designers may only be asked to provide concepts or to give a presentation for a campaign, which the client's in-house art department will then execute. Although that means the designers will not be able to charge a full fee for such service, they should charge as much of a full fee as possible.

The designer agrees to work with an advertising agency for at least the length of the entire advertising campaign, a long-term rather than project-based relationship. Traditionally, fees of most graphic design firms have been based on hourly or per-project estimates, and designers have not enjoyed a percentage of the ongoing revenue generated from a successful campaign. However, many

Comparative Fees for Advertising & Promotion Design

Usual and customary fees based upon concept and design of:

- 1. Campaign using three to five different sizes and shapes employing the elements of photography or illustration, headline, subhead, body copy, and company logo or sign-off.
- 2. Presentation of three to five layouts, two revisions, and a final comprehensive for each component indicated and supervision of art and photography.
- 3. Reasonable deadline and production schedule.

4. Unlimited use within the specified media for one year from date of first placement.

Advertisii	ig campaigns		
National	Regional	Local	
\$11,000-\$25,000	\$8,000-\$20,000	\$5,000-\$10,000	
\$45,000-\$80,000	\$25,000-\$45,000	\$18,000-\$30,000	
Consume	er magazines		
Spread	Full page	1/2 page	1/4 page
<i>Digest, People)</i> \$6,000–\$12,000	\$4,500–\$9,500	\$3,000–\$7,200	\$2,000-\$5,000
orker, Atlantic Moi \$4,000–\$8,000	nthly) \$3,000–\$7,000	\$2,500–\$6,000	\$1,500-\$3,000
Scientific America \$5,500–\$10,000	an) \$5,000–\$9,000	\$3,000–\$6,500	\$2,000-\$4,000
Busines	s magazines		
Spread	Full page	1/2 page	1/4 page
<i>usiness Week)</i> \$8,000–\$17,000	\$6,000–\$14,000	\$3,500-\$7,000	\$3,000-\$5,000
<i>Record)</i> \$6,000–\$11,000	\$4,500–\$8,500	\$3,000–\$5,000	\$2,500-\$4,000
ene, Hospitals) \$4,500–\$7,500	\$3,500–\$7,000	\$2,500-\$5,000	\$2,000-\$3,500
Advertorials (i	nserts or outser	ts)	
Spread	Full page	1/2 page	1/4 page
general business \$9,000–\$20,000	\$4,000-\$10,000	\$3,500-\$8,500	\$2,500-\$5,000
tutional, profession \$6,000–\$12,000	nal \$3,000–\$6,500	\$2,500-\$6,000	\$2,000–\$4,000
New	snaners		
Insert		1/2 page	1/4 page
irculation over 250	,000	\$3,000-\$7,000	\$2,000-\$4,000
n of 100,000–250,0 \$8,000–\$12,000	00 \$4,000–\$10,000	\$2,000-\$4,000	\$1,750-\$4,250
under 100,000 \$6,000–\$10,000	\$3,000-\$8,000	\$1,750-\$3,750	\$1,500-\$3,000
φ0,000 φ10,000			
	National \$11,000-\$25,000 \$45,000-\$80,000 Consume Spread Digest, People) \$6,000-\$12,000 Yorker, Atlantic Mon \$4,000-\$8,000 , Scientific America \$5,500-\$10,000 Business Spread Business Week) \$8,000-\$17,000 Record) \$6,000-\$11,000 ene, Hospitals) \$4,500-\$7,500 Advertorials (i Spread , general business \$9,000-\$20,000 tutional, profession \$6,000-\$12,000 New Insert irculation over 250 \$10,000-\$15,000 n of 100,000-250,0 \$8,000-\$12,000 Under 100,000	National Regional \$11,000-\$25,000 \$8,000-\$20,000 \$45,000-\$80,000 \$25,000-\$45,000 Consumer magazines Spread Full page Digest, People) \$6,000-\$12,000 \$4,500-\$9,500 %orker, Atlantic Monthly) \$4,000-\$8,000 \$3,000-\$7,000 %orker, Atlantic Monthly) \$4,000-\$8,000 \$3,000-\$7,000 %cientific American) \$5,500-\$10,000 \$5,000-\$9,000 Business magazines Spread Full page Business magazines \$9,000 \$6,000-\$14,000 Record) \$6,000-\$11,000 \$4,500-\$8,500 \$6,000-\$11,000 \$4,500-\$8,500 ene, Hospitals) \$4,500-\$7,000 \$4,500-\$7,500 \$3,500-\$7,000 Advertorials (inserts or outser Spread Spread Full page , general business \$9,000-\$10,000 \$10,000-\$12,000 \$4,000-\$10,000 tutional, professional \$6,000-\$12,000 \$10,000-\$15,000 \$5,000-\$12,000 \$10,000-\$15,000 \$5,000-\$12,000 \$8,000-\$12,00	\$11,000-\$25,000 \$8,000-\$20,000 \$5,000-\$10,000 \$45,000-\$80,000 \$25,000-\$45,000 \$18,000-\$30,000 Consumer magazines Spread Full page 1/2 page Digest, People) \$6,000-\$12,000 \$4,500-\$9,500 \$3,000-\$7,200 \$6,000-\$12,000 \$3,000-\$7,000 \$2,500-\$6,000 /corker, Atlantic Monthly) \$4,000-\$8,000 \$3,000-\$7,000 \$2,500-\$6,000 .Scientific American) \$5,500-\$10,000 \$5,000-\$9,000 \$3,000-\$6,500 .Scientific American) \$5,000-\$9,000 \$3,000-\$6,500 .Scientific American) \$5,000-\$9,000 \$3,000-\$6,500 .Scientific American) \$5,000-\$9,000 \$3,000-\$6,500 .Scientific American) \$5,000-\$10,000 \$3,000-\$6,500 .Scientific American) \$5,000-\$11,000 \$3,500-\$7,000 .Scientific American) \$6,000-\$11,000 \$3,500-\$5,000 .Scientific American) \$6,000-\$11,000 \$3,500-\$5,000 .Scientific American) \$4,500-\$6,500 \$2,500-\$6,000 .general business \$9,000-\$20,000 \$4,000-\$10,000 \$3,500-\$8,500 .general business \$2,500-\$6,0

alternative arrangements are possible. For example, the designer may handle only the creative work and not the placement. Historically, in this case some designers have charged 10 percent of the total advertising budget for the duration of the campaign. The designer may also negotiate a retainer. Or the designer may be hired to create only a single ad and in that case negotiate a price based on the type of placement. For instance, surveys indicate that a full-color, full-page advertisement in *Rolling Stone* magazine usually commands a higher fee than a small black-and-white ad in a limited-run trade publication. (For more information, see Chapter 5, Essential Business Practices.)

Graphic designers who specialize in advertising and promotion design often handle posters, billboards, and press kits in addition to the design and placement of magazine and newspaper advertising. Since they hire other graphic artists on a freelance basis and purchase art and photography on behalf of their clients, they must have a good working knowledge of advertising illustration and photography, including the trade customs that govern both fields.

Compa	rative Fees for	Outdoor Adver	tising			
Billboard						
Client annual revenues	National	Regional	Local			
Over \$500 million	\$6,000–\$15,000	\$3,500-\$12,000	\$3,000-\$9,000			
\$100–\$500 million	\$5,000-\$12,000	\$3,000-\$10,000	\$2,500-\$8,000			
\$50–\$100 million	\$4,000-\$10,000	\$2,500-\$8,000	\$2,000-\$7,000			
\$1–\$50 million	\$3,000–\$9,000	\$2,000-\$7,000	\$1,500-\$6,000			
Under \$1 million	\$2,000-\$8,000	\$1,500-\$6,000	\$1,000-\$5,000			
	Bus & t	ransit				
Client annual revenues	National	Regional	Local			
Over \$500 million	\$9,000-\$20,000	\$7,000–\$16,000	\$5,000–\$8,000			
\$100–\$500 million	\$8,000–\$17,000	\$6,000-\$14,000	\$4,000-\$7,500			
\$50–\$100 million	\$7,000–\$15,000	\$5,000-\$12,000	\$3,000–\$7,000			
\$10–\$50 million	\$6,000–\$14,000	\$4,000-\$10,000	\$2,000-\$6,500			
\$1–\$10 million	\$5,000-\$12,000	\$3,000-\$8,000	\$1,500-\$5,500			
Under \$1 million	\$4,000-\$10,000	\$2,000-\$6,000	\$1,000-\$3,500			
	Station p	oosters				
Client annual revenues	×	Regional	Local			
Over \$500 million		\$8,000-\$16,000	\$4,000-\$8,000			
\$100–\$500 million		\$7,000-\$14,000	\$3,500-\$7,000			
\$50–\$100 million		\$6,000-\$12,000	\$3,000-\$6,000			
\$10–\$50 million		\$5,000-\$10,000	\$2,000-\$5,000			
\$1–\$10 million		\$2,000-\$7,500	\$1,000-\$3,500			
Under \$1 million		\$1,000-\$5,000	\$500-\$2,500			

The price ranges in the chart on page 174 assume limited use of advertising design with up to five insertions within a specified media for one year. Surveys indicate that unlimited usage within the same media generally increases fees by up to 75 percent; unlimited use in any media increases fees by up to 90 percent; and a complete transfer of copyrights increases fees by up to 175 percent. All reimbursable out-of-pocket expenses incurred, including digital file preparation and/or service bureau output, are billed separately.

The price ranges in the charts above do not constitute specific prices for particular jobs. The buyer and seller are free to negotiate, with each designer independently deciding how to price the work, after taking all factors into account.

Collateral Design

Graphic designers who specialize in collateral material do packaging, brochures, catalogs, press kits, and direct mail packages. While clients generally retain advertising agencies to handle major campaigns for products and/or services, they often commission or retain a design firm to furnish these pieces.

Like advertising designers whose work is targeted to elicit a specific response, collateral designers must have a sophisticated awareness of advertising, marketing, and sales. They often receive art and photography from the client, so

	Direct ma	il package [⊂]
Client annual revenues	Complex	Simple (1- or 2-color)
Over \$500 million	\$8,000-\$27,000	\$6,000-\$20,000
\$100–\$500 million	\$7,000-\$22,000	\$5,000-\$15,000
\$50–\$100 million	\$6,000-\$18,000	\$4,000-\$12,000
\$10-\$50 million	\$5,000-\$14,000	\$3,000-\$9,000
\$1–\$10 million	\$4,000-\$12,000	\$2,000-\$7,000
Under \$1 million	\$2,000-\$10,000	\$1,000-\$5,000
	Press or r	nedia kit ^{©©}
Client annual revenues	Complex	Simple (1- or 2-color)
Over \$500 million	\$6,000-\$26,000	\$3,500-\$18,000
\$100–\$500 million	\$5,000-\$22,000	\$2,500-\$14,000
\$50–\$100 million	\$4,000-\$17,000	\$2,000-\$12,000
\$10–\$50 million	\$3,000-\$14,000	\$1,700-\$10,000
\$1–\$10 million	\$2,000-\$12,000	\$1,200-\$8,000
Under \$1 million	\$1,500-\$10,000	\$1,000-\$8,000

7 Graphic Design Prices & Trade Customs

Comparative Fees for Collateral Material/Promotion continued						
Product & service catalog (12 pages at 81/2" x 11")						
Client annual revenues	Complex	Simple (1- or 2-color)				
Over \$500 million	\$8,000-\$30,000	\$5,000-\$23,000				
\$100–\$500 million	\$5,000-\$28,000	\$2,500-\$19,000				
\$50-\$100 million	\$5,000-\$25,000	\$2,500-\$16,000				
\$10–\$50 million	\$5,000-\$20,000	\$2,000-\$14,000				
\$1–\$10 million	\$3,000-\$18,000	\$1,500-\$11,000				
Under \$1 million	\$2,000-\$15,000	\$1,500-\$8,000				
	Brochure design (2 or more colors)				
Client annual revenues	16 pages, 8 1/2" x 11"	8 pages, 8 1/2" x 11"	6 panels, 4 ["] x 9"			
Over \$500 million	\$10,000-\$35,000	\$8,000-\$30,000	\$5,000-\$23,000			
\$100-\$500 million	\$8,000-\$30,000	\$7,500-\$27,000	\$3,500-\$20,000			
\$50–\$100 million	\$8,000-\$25,000	\$7,500-\$25,000	\$3,500-\$15,500			
\$10–\$50 million	\$5,000-\$20,000	\$5,000-\$15,000	\$3,500-\$13,000			
\$1–\$10 million	\$3,000-\$15,000	\$2,000-\$12,000	\$1,000-\$10,000			
Under \$1 million	\$2,500-\$15,000	\$1,000-\$10,000	\$500-\$5,000			
	Brochure desi	gn (one color)				
Client annual revenues	16 pages, 8 1/2" x 11"	8 pages, 8 1/2" x 11"	6 panels, 4" x 9"			
Over \$500 million	\$6,000-\$20,000	\$5,000-\$15,000	\$4,000-\$10,000			
\$100–\$500 million	\$5,000-\$16,500	\$4,000-\$13,000	\$3,000-\$8,500			
\$50–\$100 million	\$5,000-\$12,000	\$4,000-\$10,000	\$2,000-\$7,000			
\$10–\$50 million	\$4,000-\$11,000	\$2,000-\$8,200	\$1,500-\$6,000			
\$1–\$10 million	\$3,000–\$8,600	\$2,000-\$6,000	\$1,250-\$4,000			
Under \$1 million	\$2,000-\$10,400	\$1,500-\$6,500	\$750-\$3,000			

Design of a basic package including outer envelope, personalized letter, brochure, reply card, and return envelope.
 Design of a basic kit including cover or folder, letterhead for text, and formatting for other insert material.

it is important to know how the rights to those visuals are transferred. If additional rights are needed, their transfer should be negotiated before the design or production stages. Graphic designers traditionally sell specific uses to the client—for example, first-time print runs.

The price ranges in the chart above do not constitute specific prices for particular jobs. The buyer and seller are free to negotiate, with each artist independently deciding how to price the work, after taking all factors into account.

Comparative Fees for Package Design

Based on concept and design, presentation of three to five layouts, finished comp, supervision of illustration or photography, and final art. Does not include any reimbursable or out-of-pocket expenses, such as service bureau output or production expenses, which may be billed separately.

	General	Specialized consumer	Consumer test run
Apparel	\$10,000-\$30,000	\$15,000-\$35,000	\$6,000-\$8,000
Domestics	\$10,000-\$25,000	\$15,000-\$30,000	\$4,000-\$7,000
Electronics	\$10,000-\$20,000	\$10,000-\$20,000	\$6,000-\$10,000
Food/beverages	\$15,000-\$30,000	\$15,000-\$30,000	\$10,000-\$20,000
Footwear	\$10,000-\$25,000	\$10,000-\$25,000	\$2,000-\$6,000
Gifts/novelties	\$10,000-\$20,000	\$10,000-\$20,000	\$5,000-\$10,000
Home furnishings	\$12,000-\$25,000	\$12,000-\$25,000	\$5,000-\$10,000
Housewares	\$6,000-\$15,000	\$10,000-\$20,000	\$3,000-\$8,000
Toys/games	\$12,000-\$25,000	\$12,000-\$25,000	\$6,000-\$12,000
	Music/F	ilm/Video [⊡]	
	Major distribution	Limited distribution	Re-released propert
Pop/rock	\$5,000-\$10,000	\$1,500-\$7,500	\$1,500-\$2,500
Classical/jazz	\$5,000-\$10,000	\$1,500-\$7,500	\$1,200-\$2,400
Major studio release	\$5,000-\$14,000	\$4,000-\$10,000	\$2,000-\$5,000
Independent release	\$2,500-\$8,000	\$1,000-\$5,000	\$750-\$3,000
Documentary/foreign	\$3,000-\$8,500	\$1,200-\$6,000	\$1,000-\$3,500
TV/Cable production	\$3,500-\$10,000	\$2,500-\$7,500	\$1,500-\$4,000
	Software/D	igital games	
	Major distribution	Limited distribution	Re-released propert
Business software	\$20,000-\$30,000	\$5,000-\$12,000	\$7,000–\$8,500
Educational software	\$15,000-\$30,000	\$5,000-\$10,000	\$5,000-\$7,500
Computer/video games	\$15,000-\$25,000	\$6,000-\$12,000	\$7,000-\$10,000

□ Based on concept and design of enclosure, jewel case, and liner notes (where applicable) for compact discs, audiocassettes, or similar media. Presentation of three to five layouts, finished comp, supervision of illustration or photography, and final art. Does not include any reimbursable or out-of-pocket expenses, such as service bureau output or production expenses, which may be billed separately.
□ Based on concept and design of box enclosure, media label, and manual cover. Presentation of three to five layouts, finished comp, supervision of illustration or photography, and final art. Does not include any reimbursable or out-of pocket expenses, such as service bureau output or production expenses, which may be billed separately.

Publication Design

Publication designers create the formats and look of magazines or tabloid newspapers. These have an editorial point of view and often contain advertising.

Most publication design is executed by designers on the publisher's staff. Independent offices may produce magazines and/or tabloids, but they are not the norm in this field. However, there are many freelance or independent publication designers who may be hired to design the format for a new magazine or tabloid; redesign an existing magazine or a special issue, section, or feature within a magazine; or develop a magazine prototype used by an editorial team to pitch a new magazine either in-house or to a publishing company. (Designers are rarely called upon to design or redesign a spread of a magazine.) Frequently, freelance or independent designers continue on as consultants for periodic oversight either on retainer or for a fee based on an estimated number of hours per issue. As "consulting art director" the person may work with one or more staff associate art directors, assistant art directors, and/or designers and production artists.

At the planning stage for each issue of the publication, the key editorial staff (most often the editor-in-chief, section editors, and key writers for the issue) meet with the art director and appropriate staff to hold a story and cover conference. During this session, the strategy for several issues is mapped out, with a major focus on the current issue. A direction is established, and concepts may be determined at this time. Then the art director commissions art for the issue within yearly budget constraints. That may involve locating new creative talent (illustrators and photographers) whose styles are appropriate for the new design. Since the editors assume authority for the publication, they have approval over dummies and storyboards. The publisher most often has final approval over the entire package, and revisions are frequently required.

Freelance designers who are commissioned to work on publications are often expected to sign all-rights or work-for-hire contracts. Designers may choose to weigh all their options before undertaking assignments on that basis. (For more information, see the Work for Hire section in Chapter 2, Legal Rights and Issues.)

Because logos are the anchors of most magazines, they are the anchors of most magazine design work. Consequently, fees for magazine design are front-loaded toward logo design since its development takes place at the beginning of the project. If logo design is not required (an existing magazine wishes a new design without changing its logo), then the design fee is weighted more toward cover design.

Standard procedure is to bill the design and development fee in segments, no matter what the size or cost of the job. For larger projects, it is usual for one third of the payment to be made upon signing the agreement, one third upon approval of design comprehensives, and the final third within 30 days of delivery of electronic files or printed pieces. For smaller projects, one half is customary at the outset, with the balance due upon submission of final layouts. Billable expenses and production charges are invoiced regularly (usually weekly or monthly) to help the designer manage out-of-pocket expenses.

Comparative Fees for Publication Design

Creative design fees depend largely on the complexity of the assignment, the number of pages, circulation, production needs and schedules, the client's budget, the design team, deadlines, and printing schedules. Experienced designers work collaboratively with editors/publishers in establishing creative and workable design solutions for a publication. The following data are based on normal conditions and do not reflect any reimbursable or out-of-pocket expenses.

	Con	sumer magazine
Startup		-
Circulation	General-interest	Special-interest
Over 1 million	\$50,000-\$100,000	\$30,000-\$70,000
500,000 to 1 million	\$50,000-\$100,000	\$20,000-\$60,000
100,000 to 500,000	\$30,000-\$90,000	\$15,000-\$50,000
50,000 to 100,000	\$20,000-\$50,000	\$10,000-\$25,000
Less than 50,000	\$10,000-\$35,000	\$7,500-\$20,000
Redesign of existing form	nat	
Circulation	General-interest	Special-interest
Over 1 million	\$40,000-\$80,000	\$25,000-\$50,000
500,000 to 1 million	\$35,000-\$75,000	\$20,000-\$50,000
100,000 to 500,000	\$30,000-\$70,000	\$15,000-\$45,000
50,000 to 100,000	\$20,000-\$45,000	\$12,000-\$25,000
Less than 50,000	\$7,500-\$15,000	\$7,500-\$15,000
Layout and execution of Circulation	existing design General–interest	Special-interest
Over 1 million	\$20,000-\$35,000	\$20,000-\$30,000
500,000 to 1 million	\$20,000-\$35,000	\$15,000-\$25,000
100,000 to 500,000	\$15,000-\$30,000	\$10,000-\$20,000
50,000 to 100,000	\$15,000-\$30,000	\$10,000-\$20,000
Less than 50,000	\$5,000-\$15,000	\$5,000-\$10,000
	_	
Startup	ħ	rade magazine
Circulation	General-interest	Special-interest
Over 1 million	\$20,000-\$75,000	\$20,000–\$60,000
500,000 to 1 million	\$15,000-\$75,000	\$15,000-\$50,000
100,000 to 500,000	\$10,000-\$60,000	\$10,000–\$35,000
50,000 to 100,000	\$10,000-\$50,000	\$7,500-\$25,000
Less than 50,000	\$10,000-\$30,000	\$7,500-\$20,000
Redesign of existing form	General-interest	Special-interest
Over 1 million	\$25,000-\$70,000	\$20,000-\$50,000
500,000 to 1 million	\$25,000-\$70,000	\$20,000-\$50,000
	\$20,000-\$60,000	\$10,000-\$30,000
100,000 to 500,000		
50,000 to 100,000	\$15,000-\$50,000 \$10,000 \$25,000	\$7,500-\$20,000 \$7,500 \$15,000
Less than 50,000	\$10,000-\$25,000	\$7,500–\$15,000

	Trade	magazine continu	led	
Layout & execution of ex		anaguzine continu	ivu	
Circulation	General-interest	Special-interest		
Over 1 million	\$20,000-\$40,000	\$15,000-\$30,000		
500,000 to 1 million	\$20,000-\$40,000	\$15,000-\$30,000		
100,000 to 500,000	\$15,000-\$30,000	\$10,000-\$20,000		
50,000 to 100,000	\$15,000-\$30,000	\$7,500-\$15,000		
Less than 50,000	\$10,000-\$20,000	\$7,500-\$15,000		
	Co	rporate/In-house		
Startup	00	porate/in-nouse		
Circulation	4/C 64–page magazine	1/C 64–page magazine	4/C 12–page tabloid/newsletter	1/C 12–page tabloid/newsletter
Over 100,000	\$20,000-\$60,000	\$15,000-\$35,000	\$5,000-\$20,000	\$3,000-\$15,000
50,000 to 100,000	\$20,000-\$60,000	\$15,000-\$35,000	\$5,000-\$15,000	\$2,500-\$12,000
25,000 to 50,000	\$15,000-\$40,000	\$10,000-\$30,000	\$3,000-\$10,000	\$2,500-\$7,500
Under 25,000	\$15,000-\$30,000	\$7,500-\$20,000	\$3,000-\$10,000	\$2,500-\$7,500
Redesign of existing form	at			
Circulation	4/C 64–page magazine	1/C 64–page magazine	4/C 12–page tabloid/newsletter	1/C 12–page tabloid/newsletter
Over 100,000	\$15,000-\$30,000	\$10,000-\$20,000	\$7,500-\$15,000	\$5,000-\$10,000
50,000 to 100,000	\$15,000-\$30,000	\$10,000-\$20,000	\$5,000-\$12,000	\$5,000-\$10,000
25,000 to 50,000	\$12,000-\$25,000	\$7,500-\$15,000	\$4,000–\$8,000	\$3,000–\$6,500
Under 25,000	\$12,000-\$22,000	\$7,500-\$12,000	\$3,000-\$6,500	\$3,000-\$5,000
Layout and execution of e	existing design			
Circulation	4/C 64–page magazine	1/C 64–page magazine	4/C 12–page tabloid/newsletter	1/C 12–page tabloid/newsletter
Over 100,000	\$12,000-\$25,000	\$8,000–\$18,000	\$7,500-\$15,000	-
50,000 to 100,000	\$12,000-\$25,000	\$8,000–\$18,000	\$5,000-\$12,000	\$4,000–\$8,000
25,000 to 50,000	\$10,000-\$20,000	\$7,500-\$15,000	\$4,000–\$7,500	\$2,500-\$6,000
Under 25,000	\$10,000-\$20,000	\$6,000-\$10,000	\$3,000–\$6,000	\$2,000-\$4,000
	Specia	al one-time projec	ts	
Circulation	Special issue	Section design		
Over 1 million	\$12,500-\$25,000	\$7,500-\$15,000		
500,000 to 1 million	\$10,000-\$20,000	\$5,000-\$10,000		
100,000 to 500,000	\$10,000-\$20,000	\$5,000-\$10,000		
50,000 to 100,000	\$7,500-\$15,000	\$3,500–\$6,000		
Less than 50,000	\$7,500-\$15,000	\$3,500-\$6,000		

Fees for editorial design vary as widely as the magazines themselves. The complexity of the work involved is always an element. Some of the other factors affecting price are the magazine's audience (consumer, trade, or corporate/ in-house), size (number of pages), numerical and geographical circulation, production values and capacity (black-and-white versus color printing methods), whether the publisher is an individual or small or large corporation, the size and stature of the designer or design firm, and the urgency of the schedule. The lower end of the fee range is appropriate for a redesign that only requires the designer to create one or two cover designs and a few inside spreads. If the client requires a full-blown dummy issue to demonstrate every possible variation that might occur in the magazine, a proportionately higher fee is customarily charged. Another factor when determining fees is whether the freelance design team has to provide written guidelines and electronic templates for the in-house art department to use.

With such factors in mind, current surveys indicate the fee for designing a small-circulation black-and-white consumer magazine, based on concept and design, logo development, rough and comprehensive layouts, and client consultation, ranges from \$10,000 to 35,000. Production of digital files and all reimbursable/out-of-pocket expenses incurred to produce sketches, comps, and files are billed separately.

The price ranges in the chart on pages 180–181 do not constitute specific prices for particular jobs. The buyer and seller are free to negotiate, with each designer independently deciding how to price the work, after taking all factors into account.

Book Jacket or Cover Design

Book jacket designers create the look of the jacket or cover of a book, or of a series of books, using the graphic elements of typography, illustration, photography, and/or specially designed letterforms.

After accepting the job, the designer is given a brief synopsis of the book and a marketing and sales strategy. The purchase order (PO) or contract usually reflects terms (deadlines and credit) and fees, which are agreed upon in writing by the publisher's art director and the designer.

Copyright and credit for the designer should be agreed upon before work begins. When credit is given, it usually appears on the back flap or on the back of the cover, though it occasionally appears on the copyright page. If other creative elements (illustration or lettering) appear on the cover, they should be credited as well. If the publisher is preparing the flaps of the jacket or the back cover where the copyright will appear, all credits should be noted on the digital proof or in the file but outside the reproduction area. When the rest of the jacket or cover is set in type, the credits should then be added; otherwise, they may be overlooked. Book jacket designers should specify on the invoice that the artwork is prepared only for the named edition and title.

Many designers usually sell one-time reproduction rights; however, current practice varies. With some unscrupulous publishers, artists may find their work appearing on the paperback edition years after a hardcover jacket was issued without receiving additional

Comparative Fees for Book Jacket Design

Usual and customary fees for a typical two- or three-color project entailing concept, design and presentation of finished front cover and spine. Includes supervision of illustration/photography, presentation of concept layout(s), and a final comprehensive. Does not include billable expenses. Rights licensed for use on first edition only.

		Hardcover		
	One/first concept	Additional concepts (per sketch)	Wraparound (% of fee)	Voluntary termination (% of fee)
Mass market	\$2,000-\$3,500	\$700-\$1,000	20%	25%
Major trade	\$2,000-\$2,500	\$700-\$1,000	25%	25%
Minor trade	\$1,000-\$2,000	\$650-\$1,000	25%	25%
Textbook	\$1,000-\$2,000	\$500-\$800	25%	25%
Young adult	\$1,000-\$2,000	\$500-\$1,000	10%	10%
		Paperback		
	One/first concept	Additional concepts (per sketch)	Wraparound (% of fee)	Voluntary termination (% of fee)
Mass market	\$1,500-\$3,500	\$750-\$1,500	20%	50%
Major trade	\$1,000-\$3,500	\$750-\$1,500	25%	33%
Minor trade	\$1,000-\$3,500	\$750-\$1,500	30%	50%
Textbook	\$750-\$2,200	\$550-\$1,200	20%	33%
Young adult	\$1,000-\$2,500	\$750-\$1,500	100%	50%

payment; reputable publishers pay for additional paperback rights. Designers should clarify this provision in a written agreement with the publisher, as well as any additional payments for use of the art by another domestic publisher, by book clubs or foreign publishers, or by film, television, or other media.

The right of the client to make additional use of the finished art is usually limited to advertising and promoting the original edition for which the contract was signed. If any other rights are negotiated, a statement of those rights should appear on the designer's bill if they are not reflected in writing at the time they are negotiated. The bill should also state that all other rights are reserved by the designer and that original art should be returned to the designer. The designer may prepare anywhere from one to three sketches or comps for presentation, though most publishers require only one initial comp. Sometimes the designer provides a black-and-white or color printout of a design, and another one or two variations may be requested. If more than three comps are required, industry sources indicate that it is customary for an additional fee to be paid.

Generally, the comp is as close as possible in appearance to the finished piece. Such tight comps often entail expenses. Historically, all out-of-pocket expenses in the sketch stage are billable to the client. Today, for instance, high-quality color prints (for example, an Iris print or a fiery) used in most comps are billable directly to the client. Unfortunately, the nature of publishing leads to a high rate of rejection of comp presentations. Current industry practices indicate that this risk is accepted by designers and publishers, who agree to a rejection fee, reflecting the amount of work completed at the time of the project's termination. Recent data indicate that the usual rejection fee is one half the agreed-upon design fee for an accepted job. Any incurred expenses also are paid.

Once the comp is approved, the designer executes or commissions the illustration, lettering, or other graphic elements used in the finished art. Production costs for necessities such as, but not necessarily limited to, photographic processing, type, and digital output are generally billed by the designer over and above the design fee. Such costs are directly assumed by the client. Current data indicate that markups and handling fees for outside services are in the range of 15 to 25 percent. These are applied to cover expenses incurred (for type or hard-copy output) when the publisher does not pick them up directly.

The price ranges in the chart on page 183 do not constitute specific prices for particular jobs. The buyer and seller are free to negotiate, with each artist independently deciding how to price the work, after taking all factors into account.

Book Design

Book designers develop the style and visual flow of a book's interior by using the graphic elements of typography, illustration, and photography. The function of book designers ranges from highly creative to purely mechanical.

Basic design fee

Historically, a basic fee has included an initial consultation with the publisher, packager (firm that sells a finished book to a publisher), or other contractor to discuss the project; analysis of the manuscript or designing representative sample pages; preparation of layouts or manuscript markup; and presentation of completed design (also called layouts). When sample pages are prepared by a typesetter (composition house or compositor), the basic fee also includes "specing" (writing specifications or codes on the sample manuscript) and reviewing the sample pages after they have been set. The designer is entitled to a higher fee if type composition or page layout is part of the job.

If a publisher requests minor changes in the design, revisions are included in the basic design fee. If major changes are requested, the design fee may have to be renegotiated, or changes may be billed at the designer's hourly rate.

The prices in the chart below are based on the preparation of as many layouts as the designer feels are necessary to show major design elements. When the client wishes to see highly detailed layouts, a higher fee is usually charged. Any additional considerations (such as the use of two or more colors) are usually reflected in a higher fee.

Before the designer can tackle the creative aspects of the job, it is necessary for someone—either the publisher or the designer—to analyze the project and prepare a design brief, also known as a design survey or design extract.

Comparative Fees for Book Design

Usual and customary fees for consultation with publisher, preparation of design brief, two to three concepts showing layout of major design elements—including composition order, checking of galleys, page proofs, and dummying. Includes supervision of illustration/photography. Does not include billable expenses.

	Maa	o mortest/trade		
		s market/trade	Simple	CD-ROM
Mass market	\$10,000-\$17,500	\$8,000-\$12,000	\$5,000-\$10,000	\$5,000-\$10,000
Major trade	\$15,000-\$25,000	\$7,500-\$15,000	\$6,000-\$13,500	\$15,000-\$30,000
Each additional trade in series (% of fee)	55%–85%	50%–75%	50%–75%	0%–55%
Young adult	\$6,000–\$10,000	\$1,850-\$3,500	\$1,300-\$2,500	\$3,250-\$5,000
Each additional trade in series (% of fee)	66%–95%	50%	40%-55%	50%
		Textbook		
	Complex	Average	Simple	CD-ROM
College text	\$6,500-\$13,500	\$4,000–\$6,500	\$3,000-\$5,000	\$3,500-\$5,000
Each additional trade in series (% of fee)	55%-85%	5%–55%	5%–55%	50%
EI–Hi text	\$5,000-\$9,000	\$3,000-\$5,000	\$2,000-\$3,500	\$4,000–\$4,750
Each additional trade in series (% of fee)	66%–95%	50%	50%	50%

Complex" designs require special treatment for each page, two-color basic texts, or other books of greater complexity than average format. C + Average" includes front matter, part opening, chapter opening, and text comprising three to six levels of heads, tabular matter, extracts, footnotes, and simple back matter. C + Simple" includes title page, chapter opening, double spread of text, and spreads for front matter.

The design brief

The design brief includes a copy of the manuscript and/or a selection of representative copy for sample pages and a summary of all typographic problems, elements, and code or key marks; the compositor's name, method of composition, and available typefaces; and a description of the proposed physical characteristics of the book (trim size, page length, number of columns, gutter widths, number of colors, if more than one). The publisher should also indicate whether any particular visual style is desired. The designer's pricing is based on the publisher's preparation of the design brief. When the designer's assignment includes this responsibility, it is usually reflected in a higher fee.

<u>Design</u>

After the fee is agreed upon, the designer prepares layouts for the title page, table of contents, chapter openings, and double-page spreads of the text that include most or all typographic elements and a sample treatment of illustrations or photographs. These examples are needed for the publisher to evaluate and approve the design and are used as a guide in production. Designers may provide a "composition order" (comp order) for a typesetter that details all type specifications based on the layouts; sometimes publishers prepare the comp order based on the designer's written specifications.

Since the publisher often has established ideas of what a comp order should include and look like, the designer should request the publisher's guidelines, if available, and/or sample comp orders. When written specs are not required by the publisher, designers may mark up all or part of the manuscript, which may include a bibliography, index, and other front and back matter.

Publishers may use in-house or a compositor's production facilities to take the book from layouts to page makeup. In those cases the designer will be required to check the first set of page proofs to make sure the compositor has followed all design specifications. Other publishers may give designers electronic files of type and art and have them make up the pages electronically.

Special layout fee

Technologies that generate output-ready digital files or film are the standard for production. (For an in-depth discussion of this topic, refer to the Production Artist section later in this chapter and to the Wave of the Future section in Chapter 4, Technology Issues.) However, a few publishers continue to use traditional production methods, and current data show that a mechanical fee of \$25 to \$50 per hour is paid to cover the preparation of mechanical boards, finished art for ornaments, maps, and other specialties, and final corrections made by the publisher.

Extra charges

Supervision or art direction of an art program, including hiring and coordinating illustrators or photographers, extra conference time, trips to the publisher, and time spent doing other production work, is billed at an hourly design rate. The cost of specially commissioned work and other supplies is traditionally a billable expense.

Book design categories

Some unusual projects or books for small presses may not fit into the following categories. In such cases, designers traditionally use their hourly rates as the basis for a fee. If the design is to be used for a series of books, a reuse fee should be negotiated.

Trade books

• Simple: A straightforward book such as a novel or short book of poetry. Design includes a layout showing a title page, a chapter opening, a spread of text,

and spreads of front matter. Simple books are generally done in-house but may be given to a freelance designer if the publisher is small and does not have an in-house design department.

- Average: General nonfiction, poetry, or drama books, anthologies, or illustrated books designed on a grid system. Design may include front matter (half title, title, copyright, dedication, acknowledgments, preface, contents, list of illustrations, introduction, ad card), part opening, chapter opening, text with three to six levels of heads, tabular matter, illustrations and/or photographs, extracts, footnotes, and simple back matter such as bibliography and index. The design, excluding the front matter, is set in sample pages for the publisher and approved before the complete manuscript is typeset.
- Complex: Workbooks, catalogs, and elaborate art or picture books that require special treatment of each page or more complex printing techniques. This category also includes books with two or more colors, cookbooks, and other books of greater complexity than the previous category.

Current data indicate that designers of all three types of trade book projects bill publishers a flat fee. In addition to complexity, page count is a criterion for determining fees. For complex designs, a separate page makeup fee is often billed hourly. The current range for a complex book design project is \$10,000 to \$25,000.

Textbooks

- Simple: These are mostly straight text with up to three levels of heads, simple tables, and/or art.
- Average: These have up to six levels of heads, tables and/or charts, extracts, footnotes, and illustrations, diagrams, and/or photographs laid out on a grid system.
- Complex: These are usually foreign language texts, two-, three-, or four-color texts, complicated workbooks, catalogs, or illustrated books that require special treatment of each page.

Current data indicate that designers of all three types of textbook projects bill publishers a flat fee. In addition to complexity, page count is a criterion for determining fees. Design fees for complex textbooks currently range from \$6,500 to \$13,500.

The price ranges in the chart do not constitute specific prices for particular jobs. The buyer and seller are free to negotiate, with each designer independently deciding how to price the work, after taking all factors into account.

Book Packaging Design

Occasionally a writer and book designer collaborate to create a "package" that is then sold to a publisher. Such a package includes completely finished digital files, relieving the publisher of any production responsibilities. Generally, this way of working is most common when the idea for the book originates with the writer or designer who wishes to maintain control over the book.

Lettering & Typeface Design

Lettering or typography is used for both text and headlines in all areas of the communications industry: advertising and promotion, corporate identity, packaging, and publishing. Many lettering artists also offer graphic design services.

The computer has had a major impact on lettering, since any graphic designer can now manipulate and customize fonts on a computer. However, some designers still specialize in the field of lettering, creating all kinds of unique headlines used in magazines, books, packaging, and movies. Some do the many aspects of lettering entirely by hand, although increasingly lettering designers draw sketches manually and then complete the work digitally. Letters may be drawn first and then refined; they may be outlined and then filled in; they may begin with an already drawn form or typeface and then be altered, either manually on paper or digitally after the work is scanned into a computer; or they may begin on a computer and then be customized.

The work of lettering artists is similar to that of illustrators. Upon agreement on the terms and fee for the project, a letterer prepares a sketch or sketches of possible solutions to a specific problem. Upon acceptance of the sketches or comp, finished art is prepared for reproduction. Sometimes, however, the client may wish to digitize the work in-house, so the letterer may be responsible only for the sketches; the artist should be properly compensated upon delivery of the work.

Historically, artists have received one half of the total fee upon delivery of sketches. (Increasingly, more time is spent on sketches and less on completing the digital finish.) "Buyouts" (all-rights transfers) currently cost up to 50 percent or more above the original price of the art. In packaging design, fees depend on, among other factors, whether the client hired the artist directly, which is unusual, or a design/ad agency hired the artist, which is more common. In the latter case, the fee is usually significantly less, reflecting in-house input into the design and the agency's reluctance to part with any more of the client's fee for services than is absolutely necessary.

Calligraphy

Traditionally, calligraphic letters are formed with a broad-edged pen or a brush. Packaging, invitations, award certificates, illuminated scrolls, and hand-addressed envelopes are some of the uses for which calligraphy may be commissioned, in addition to its use in headlines in magazines, books, and movies. While no longer widely used in business applications, calligraphy is often prized today as a craft or art form.

Many factors affect the pricing of calligraphy, including the size of the original art, the amount of design and its complexity, intended uses and distribution, time allowed to complete the project (rush or over a holiday), and the surface upon which the work will be executed, as well as the materials involved (for example, matte or glossy paper, glass or metal, use of gold leaf). While many surveyed calligraphers price envelope addressing by the line or standard three lines (name, street address, and city-state address), they have found that fees for certificates and illuminated scrolls are much more difficult to gauge because of the varying amount of design and color work that may be involved. All factors must always be taken into account when pricing each job.

Comparative Fees for Lettering & Calligraphy

Usual and customary creative fees. Reimbursable expenses not included.

Roughs		ling [_]	
Distribution	Masthead	Film/video	Recording/cover
National	\$1,000-\$2,500	\$1,000-\$2,500	\$500-\$1,500
Regional	\$1,000-\$1,500	\$1,000-\$1,500	\$500-\$1,500
Local	\$750-\$1,000	\$750-\$1,000	\$500-\$1,000
Corporate or in-house	\$500\$1,000	\$500-\$1,000	\$500–\$1,000
Corporate or in-house Finished work Distribution	\$500–\$1,000 Masthead	\$500-\$1,000 Film/video	\$500–\$1,000 Recording/cover
Finished work			
Finished work Distribution	Masthead	Film/video	Recording/cover
Finished work Distribution National	Masthead \$1,000–\$4,700	Film/video \$1,500-\$5,500	Recording/cover \$1,500–\$2,700

Headlines□				
Distribution	Complex	Simple		
Consumer/wide	\$1,000-\$2,000	\$600–\$1,200		
Trade/medium	\$750-\$1,500	\$500-\$1,500		
Special interest/narrow	\$750-\$1,200	\$500-\$1,000		
Corporate or in-house	\$500-\$1,000	\$300–\$750		

🗁 Headlines for a specific article: one comp, one finish on books, magazines, brochures, shopping bags, etc.

Hardcover book jacket⊂

Distribution	Complex	Average	Simple	
Mass market	\$1,000-\$2,500	\$750-\$2,000	\$600-\$1,500	
Major trade	\$1,000-\$2,000	\$600-\$1,500	\$500-\$1,500	
Minor trade	\$750-\$2,000	\$500-\$1,500	\$400-\$1,000	
Textbook	\$650-\$1,500	\$500-\$1,000	\$400-\$750	
Young adult	\$600–\$1,200	\$500-\$1,000	\$400-\$750	

🗁 Lettering used as a design solution component. One-time rights only for the specific edition: one comp, one finish.

Paperback cover			
Distribution	Complex	Average	Simple
Mass market	\$1,000-\$1,800	\$750-\$1,400	\$550-\$1,200
Major trade	\$700-\$1,500	\$600-\$1,200	\$500-\$1,000
Minor trade	\$600-\$1,000	\$500-\$1,000	\$400-\$800
Textbook	\$600-\$1,000	\$500-\$1,000	\$400-\$600
Young adult	\$600-\$1,000	\$500-\$1,000	\$400-\$600

🗁 Lettering used as a design solution component. One-time rights only for the specific edition: one comp, one finish.

continued...

Comparative	Fees	for	Lettering	8	Calligraphy	continued
-------------	------	-----	-----------	---	-------------	-----------

	Cert	ificates	
	Complex	Average	Simple
Design and fill-in	\$250-\$400	\$100-\$300	\$50-\$200
Preprinted/name only	\$45-\$50	\$25-\$35	\$4-\$25
Name and date	\$25-\$45	\$25–\$40	\$7–\$30
Additional line	\$25-\$45	\$15-\$35	\$3-\$25
Additional gold capitals	\$55-\$100	\$45-\$50	\$3–\$40

➢ All reimbursable and out-of-pocket expenses incurred, including custom color mixing, file preparation, service bureau output, or production of mechanicals, are billed separately.

	M	lenus	
	Complex	Average	Simple
Lettering only	\$300	\$250	\$200
Lettering & design (one-color)	\$400	\$350-\$5,000	\$300-\$1,000
Lettering & design (full-color)	\$600–\$1,800	\$100-\$450	\$400–\$1,200

Stationery				
Complex	Average	Simple		
\$350-\$1,500	\$200-\$1,100	\$175-\$1,000		
\$500-\$1,700	\$475–\$1,400	\$250-\$1,200		
\$300-\$1,000	\$150-\$700	\$75-\$550		
	Complex \$350-\$1,500 \$500-\$1,700	Complex Average \$350-\$1,500 \$200-\$1,100 \$500-\$1,700 \$475-\$1,400	ComplexAverageSimple\$350-\$1,500\$200-\$1,100\$175-\$1,000\$500-\$1,700\$475-\$1,400\$250-\$1,200	

Business card

	Complex	Average	Simple
Corporation	\$225-\$850	\$150-\$700	\$80-\$600
Small business	\$225-\$1,400	\$200-\$1,000	\$100-\$1,000
Individual	\$130-\$700	\$80-\$700	\$10-\$580

Social/personal				
	Complex	Average	Simple	
Monogram	\$600	\$400	\$300	
Name only	\$300	\$250	\$200	
Name & address	\$350-\$1,500	\$275-\$1,000	\$250-\$800	
Envelope/return address	\$150	\$125	\$100	

<u>Ketubot</u>

Ketubot (plural of the Hebrew word *ketubah*) are illustrated or illuminated Jewish marriage contracts. They fall into two different categories: prints and originals. Prints require that the lettering artist fill in the spaces provided in English, Hebrew, or both. An original requires lettering a blank surface (usually parchment or paper) and possibly adding decoration. Decorations range from simple to elaborate and may include color and gold. Prices for an original *ketubah* vary widely depending on the length of the text and the use of decorative elements.

<u>Typeface design</u>

Typographic symbols are among the most fundamental tools of graphic communication. Thousands of typefaces exist today, giving graphic designers the ability to depict the feeling, mood, tone, and very essence of a message through type.

Computer-generated typeface design is used extensively today. Digital manipulation of type enables designers to explore visual options more easily than ever before. The downside of computer-generated typography is that if the person operating the computer has not been schooled in good design, the final product can be a disaster.

	Flat fee	Advance on royalties	Percentage of royalty
Manufacturer, complex $^{\square}$	\$5,000-\$10,000	\$1,250-\$5,000	25%
Manufacturer, simple	\$2,500-\$7,500	\$1,000-\$1,500	25%
Magazine, complex	\$2,500-\$12,000	-	_
Magazine, simple	\$1,000-\$9,500	_	_

Type classification is based on the following factors:

- Families are clusters of related type designs that bear the names of their parent typefaces. They vary only in style (width, stance, or special treatment) and/or weight (bold, regular, light, italic).
- Fonts include the complete set of characters in a single typeface: alphanumerics (letters and numbers), ligatures or kerning sets (letter combinations), punctution marks, alternate characters (special initial caps), and special symbols (foreign or mathematical symbols and accent marks).
- **Display faces** differ from text faces in that they are used only for headlines or callouts rather than text.

Typeface design for text faces involves creating the alphabet (upper- and lowercase letters), numbers, ligatures, punctuation, and alternate and special characters. Creating or styling complete families of fonts (or portions thereof) often requires up to eight sets of finished drawings, including styles (roman and italic), weights (normal, condensed, bold), upper- and lowercase letters, and very often alternative sets (small caps, lining and old-style numbers—numbers with ascenders and descenders that correspond to the varying heights of lowercase letters), alternate characters, and ligatures or kerning sets (that show proper spacing between individual letters).

Type designers may also offer clients services that were once provided by type foundries: modification of spacing metrics, creation of custom kerning, expansion of existing character sets, and coding for specialized language uses. These services are priced according to the client's intended use and vary widely.

The price ranges in the chart on page 191 do not constitute specific prices for particular jobs. The buyer and seller are free to negotiate, with each artist independently deciding how to price the work, after taking all factors into account.

Retouching & Photo Illustration

Retouchers are graphic artists who alter, enhance, or add to a photograph. This is done either manually, by applying bleach, dyes, gouache, or transparent watercolor to the photograph or transparency/chrome with a paintbrush or airbrush, or electronically, using special software. The resulting image usually appears untouched. This "invisible art" requires a highly skilled hand and eye to be successful. Therefore, the retoucher most often specializes in one area of retouching and concentrates on the skills and technical knowledge of that area.

Current technology allows electronic scanning and manipulation of images, including color correction, cloning a subject, distorting or enhancing an image, and preserving an image, as in the restoration of old photos. Specialists in this new discipline of photo illustration are experts in manipulating and altering photographs and other images to better meet a client's needs. As clients become more aware of the computer's creative capacities, designers will have to expand their skills inventory to meet client needs. Also, as these technologies become more widely available, scanning and output fees will continue to drop. (For a more detailed discussion, see Chapter 4, Technology Issues.)

Photo illustration is a powerful tool that can have dramatic consequences. For instance, the public response to an artist's photo illustration of O. J. Simpson that appeared on the cover of *Time* magazine raised ethical questions about the role of photo illustration in journalism and whether such works should be clearly labeled so as not to possibly mislead the public.

	Advertising	
	Flat fee	Hourly rate
National/general consumer	\$1,200-\$11,000	\$60-\$145
Regional/trade	\$750-\$4,000	\$50-\$115
World Wide Web	\$900-\$7,000	\$60-\$120
	Editorial	
	Flat fee	Hourly rate
National/general consumer	\$350-\$6,000	\$40-\$160
Regional/trade	\$100-\$4,500	\$45-\$130
World Wide Web	\$600-\$4,000	\$50-\$125
	Corporate	
	Flat fee	Hourly rate
National/large corporation	\$700-\$11,000	\$55–\$135
Regional/small corporation	\$500-\$8,000	\$60-\$120
World Wide Web	\$700-\$4,000	\$65-\$125
Excludes scanning		

<u>Computers versus handwork</u>

Retouching electronically is faster than working manually since it dispenses with the intermediate step of a dye transfer or copy negative and the re-creation of a facsimile of the original artwork. Perhaps one of its greatest advantages is that it saves one or two generations of artwork, which is critical in stringent quality-oriented or time-sensitive jobs. It can also do very subtle things such as define individual hairs in a hairdo, remove crow's feet, or create subtleties in skin tones. However, basic drawing and painting skills—light and shadow, the direction of reflected light, and shading an object to render enhanced "invisible" shadows—are still needed.

Electronic retouching is also more compatible with the mechanics of the prepress process since it integrates color management—the calibration of color from what the scanner sees to what the monitor displays to what the output device finally produces (print or transparency). With manual retouching, a compromise adjustment mechanism (a profile) must be used to compensate for each device and keep control of consistency.

The primary drawback of digital retouching is the artist's loss of control. With the airbrush, paintbrush, pencil, or pen in the artist's hand, results are immediate. A secondary drawback is that the artist is looking at a screen that has projected light, rather than a photo that has reflected light.

Pricing

When pricing a traditional retouching project, the artist must take many factors into account:

- Surface: Most high-quality color work is done on transparencies or dye transfers. The dyes used must be the same as those on the actual print so the scanner cannot tell which parts have been altered. The dyes also allow the artist to combine different images and retouch the seams to make a single image. Because C-prints (reproductions made from negatives) are able to show extreme detail, they are often used for presentations. One limitation is that they can only be painted with airbrush opaques. C-prints require up to seven hours to retouch, including drying.
- **Dye transfer**: This process creates richer, sharper images and is extremely dependable for printers to reproduce, as are chromes. Dye transfers may require 30 hours or more to retouch, since a test print, an adjustment, another test print, and finally the retouching are needed.
- Brush, pencil, dyes, bleaching, etching, and airbrush techniques: These are used on all surfaces. In black-and-white retouching, high-quality photographic prints are most commonly used. Because C-prints are made from negatives, they are less saturated in color but have sharper definition. R-prints, softer and more saturated in color, are made from transparencies. Upscale markets, such as the cosmetics industry, often prefer R-prints, though C-prints are more economical to produce.
- **Complexity**: Retouching and photo illustration can run the gamut in changes to the photo from simply adding a few highlights to actually creating realistic hand-wrought backgrounds, shapes, or figures or stripping two or more photos together to create a montage.
- Expenses: According to recent surveys, typography, photography, props, and other out-of-pocket expenses are generally billed as additional expenses. Artists also should take into consideration the initial cost of hardware and software.
- Overtime: Retouching, by its nature, should not be a last-minute project. It's important to know how retouchers charge for less-than-optimal time requirements. Normal timing for an average project is three days. Overtime rates for less than three days' turnaround are as follows: two days, 50 percent more; one day (rush job), 100 percent more. If the job requires evening, weekend, or holiday time, a 100 percent overtime charge may be added.
- Rights: Unlike other graphic artists, retouchers always work on an existing piece of art and are not usually entitled to copyright or reuse fees. The fee that they charge represents the total income from that project, unlike other artists who may benefit from future uses of a work. On the other hand, photo illustrators are creators who, like other artists, control all the rights to their creation.

Environmental Graphic Design

Environmental graphic designers plan, design, and specify sign systems (signage) and other forms of visual communication in the built and natural environment. The field can be broken down into several areas: information and interpretation; direction and orientation; identification, ornamentation, and regulation.

Environmental graphic design deals primarily with guiding people through complex spaces such as cities, buildings, and parks. It includes the science of "wayfinding," an industry term referring to the design and implementation of directional systems that use such design elements as sculptural or architectural features and such aids as color coding and graphic symbols.

Environmental graphic designers come predominantly from the fields of graphic, product, and landscape design and architecture. They work closely with architects, real estate developers, and individual clients on projects that vary widely in scale and size. Consequently, environmental graphic designers may have extensive knowledge of building design and construction, among other areas, including the design possibilities and limitations of materials and how they react to weather; how distance affects the visibility of fonts; basic shop practices, including routing, bending, and cutting; legal requirements for signage; Braille, tactile letters, and audio wayfinding systems to enhance accessibility for individuals with disabilities; and project management.

An environmental graphic design team often includes a principal of the firm, a project designer, and assistant designers. Since these projects frequently involve long-term research and development, environmental graphic designers are often brought in at the earliest stages. In addition, many environmental graphic design offices work on retainer and act as design consultants in peripheral areas in addition to their main projects.

Comparative Fees for Environmental Graphic Design				
Commercia	l real estate			
	Comprehensive signage			
Corporate campus	\$7,500-\$60,000			
Class "A" office building	\$4,000-\$25,000			
Class "B" office building	\$2,000-\$35,000			
Loft building	\$2,750-\$10,000			
Warehouse / light manufacturing	\$3,500-\$9,000			
Parking garage	\$2,500-\$7,000			
Based on research and design of all exterior	and interior signage systems, evoluting tenant			

Based on research and design of all exterior and interior signage systems, excluding tenant signage (if applicable). Includes presentation of three concepts showing format, comprehensive layouts, up to two revisions and final art. Does not include any reimbursable or out-of-pocket expenses such as service bureau output or production expenses, which may be billed separately. Project budgets may be as high as \$200,000 and sometimes reach \$1 million, according to the industry trade press. Current data indicate that a large, internally illuminated exterior signage system may cost \$30,000 or more, including the cost of fabricating the sign and the designer's fees and expenses.

Artists seeking employment in environmental graphic design should try to apprentice either with someone already working in the field or in the graphics department of an architectural firm. They must be able to read working drawings and understand architectural scale. Useful study also includes architectural drafting, computer-aided design, corporate identity and information systems design, packaging, mathematics, psychology, fine art, literature, and cultural history.

Specific professional and government codes regulate and guide the way a sign must be designed and where it must be located. Consequently, environmental graphic designers are required to know and follow standards established by the American Institute of Architects (AIA), the Construction Specifications Institute (CSI), and the Society of Environmental Graphic Designers (SEGD), as well as local zoning laws, municipal sign ordinances, state and local building codes, fire codes, and other government regulations. A significant example of such regulations was created with the passage in 1991 of the Americans with Disability Act (ADA), which affects the interior and exterior signs of all public facilities in the entire country. Passage of the ADA called for the removal of all architectural and communications barriers to those with special needs, which caused the cost of signage to almost double. ADA Accessibility Guidelines are available from the U.S. Department of Justice (voice: 800.514.0301; TTY: 800.514.0383; Internet: www.usdoj.gov/crt/ada/adahom1.htm).

The Graphic Artists Guild Foundation and the National Endowment for the Arts have published the "Disability Access Symbols Project," a graphics package that is available digitally and as hard copy. The project collected and standardized a graphic vocabulary of 12 symbols indicating accessibility, such as wheelchair access for mobility-challenged people, audio description services for visually challenged people, and listening devices for the hard of hearing. The symbols may be used in signage, floor plans, and other materials promoting the accessibility of places, events, or programs.

Project proposals

The project begins once a client accepts a design proposal, which outlines the scope of the project, the services to be provided, the project's budget, schedule, and the terms under which it will be executed. Historically, most environmental graphic design projects have been quoted and billed by phase, with an initiating fee representing 10 to 30 percent of total fees and reimbursable expenses.

Phase 1. Programming: Concerned with gathering information and establishing design criteria, this phase often requires spending a great deal of time with the client or on site to define the needs and problems that are to be solved.

Phase 2. Schematic design: After the designer and client have reached an agreement concerning the basic program, visual solutions are pursued that solve the stated problems. Much of this

phase involves concept development, which results in a presentation showing only those ideas that the design team feels are viable, appropriate, and meet the prescribed criteria.

Phase 3. Design development: At this stage, the design team refines the accepted design, and a final presentation is made, explaining the applications. Once the client and designer have chosen a definite direction, any changes in budget and/or schedules are also agreed upon.

Phase 4. Contract documentation: Decisions are final at this point. The project is fully documented for implementation, which includes preparing working drawings, specifications, and reproducible artwork, where appropriate. Any changes made by the client after this point are billable as additional work, although designer errors are not.

Phase 5. Production: Depending on the end product(s) a studio has been commissioned to produce, this phase may involve quality checking and coordination of product manufacturing. Supervision is key to this phase, since so much depends on the precision and quality achieved in this final step. After the end product is approved, the project is considered billable. The designer normally retains the right to execute any design alterations, corrections, and fabrication.

Billing

Billing expenses and fees may be handled in a number of ways. During the first phase, the designer may arrange to bill for a lump sum or on an hourly or project basis. If clients prefer to be billed on a project basis, the client usually establishes an acceptable cap on the total amount billed. However, the designer must make it clear that the client is not entitled to unlimited revisions.

Recent surveys indicate that expenses for work done directly with clients are usually billed with markups, including costs incurred for clientapproved travel. However, work for architects does not usually include a markup. Sales tax, if applicable, is usually not included in estimates but is billed periodically or at the end of the project along with client alterations, which are billed at a predetermined hourly rate.

The final fabrication and installation of the project is normally handled by a contract between the client and the fabricator. However, the fabricator is accountable to the designer and is ethically bound to follow the designer's direction while working on the project, regardless of who is invoiced. This, of course, becomes a matter of practicality, since the designer is orchestrating many elements and must control them all to ensure consistency.

The pricing ranges in the chart on page 195 do not constitute specific prices for particular jobs. Depending on the practice of the studio principals, the printing or manufacturing part of the project may be billed directly to the client. The buyer and seller are free to negotiate, with each designer independently deciding how to price the work, after taking all factors into account.

Exhibit & Display Design

Exhibit and interior display design are growing specialties. The field includes permanent installation work in natural history and art museums, science and technology education centers, and travel and tourism information centers as well as temporary exhibit and promotional venues such as trade shows, conventions, conferences, other special events, and window and interior displays in retail stores and boutiques. Many companies are solely devoted to the unique design, production, and logistical problems related to these assignments.

	Corpora	te, large company [□]	
	1,000-2,500 sq ft	3,000–5,000 sq ft	6,000 + sq ft
Simple	\$5,000-\$15,000	\$10,000-\$25,000	\$20,000-\$50,000
Complex	\$10,000-\$30,000	\$20,000-\$50,000	\$30,000-\$100,000
	Corpora	te, small company [□]	4
	1,000–2,500 sq ft	3,000–5,000 sq ft	6,000 + sq ft
Simple	\$4,000-\$10,000	\$5,000-\$20,000	\$10,000-\$40,000
Complex	\$7,500-\$20,000	\$10,000-\$40,000	\$15,000-\$80,000
	La	rge museum [⊡]	
5	1,000–2,500 sq ft	3,000–5,000 sq ft	6,000 + sq ft
Simple	\$5,000-\$15,000	\$10,000-\$25,000	\$20,000-\$50,000
Complex	\$10,000-\$30,000	\$15,000-\$50,000	\$20,000-\$100,000
	Sn	nall museum	
	1,000–2,500 sq ft	3,000–5,000 sq ft	6,000 + sq ft
Simple	\$3,500-\$15,000	\$7,000-\$20,000	\$10,000-\$40,000
Complex	\$6,000-\$20,000	\$4,000-\$30,000	\$12,000-\$70,000
	Trad	e show exhibit	
	200 sq ft	1,000 sq ft	2,500 + sq ft
Large company	\$3,000-\$6,000	\$5,000-\$15,000	\$10,000-\$50,000
Small company	\$2,000-\$5,000	\$5,000-\$20,000	\$10,000-\$40,000
	Retail v	vindow displays	
Department store	window display	\$2,000-\$3,500	
Department store	interior display	\$1,500-\$2,500	
Boutique window	display	\$750-\$2,000	
Boutique interior	display	\$300-\$1,500	

➢ Based on research, consultation, and design of exhibit, including all structural forms and organization of illustrative, photographic, and editorial material; presentation of up to three layouts showing format; and final art. Supervision of execution and billable expenses are billed separately. "Simple" refers to basic panel or case displays; "complex" refers to architectural work, reconstruction, large 3-D features, e tensive detailing.
➢ Based on research, consultation, and design of exhibit covering 2,500 square feet (except for window and interior displays, which are obviously smaller), including all structural forms and organization of illustrative, photographic, and editorial material; presentation of up to three layouts, up to two revisions, and final plans and rendering. Supervision of execution and billable expenses are billed separately.

Developing permanent installations whose main purpose is to educate rather than promote or sell is one example of this type of interpretive design. Exhibit designers work closely with an architect or planning firm to customize the space to meet the project's particular communications needs. Exhibit designers may have other specialists on staff or consult with graphic designers, signage experts, lighting designers, photography and film output vendors, and illustrators. These jobs are generally estimated on a project basis by the design firm. The permanence of the display is often a factor in negotiating prices.

7 Graphic Design Prices & Trade Customs

It is critical for the exhibit designer to establish a scope of work before negotiating a contract. The scope of work should identify the approximate size (square footage) of the exhibit; all likely elements such as cases/ objects, graphics, vignettes, audiovisual, or computer components; and who will be responsible for what input, including research, curating, scriptwriting, architectural and engineering services, new illustration or photography, photo research, obtaining objects and negotiating loans, and construction supervision. If the client is an established museum, it will likely provide the majority of these functions. However, an increasing number of organizations, new to doing exhibitions, may want the designer to assemble a team to perform all such functions.

As organizations weigh the actual cost of realizing their needs, they may also hire exhibit designers to do feasibility studies to determine the scope of work for a prospective project. A feasibility study includes doing a site survey of existing conditions, developing a narrative or story line, locating sources of images and information, and assembling a firm description of, and bid on, the project so the prospective client may seriously consider what they can afford to spend. The only proviso for the exhibit designer is to make sure to do the study under a separate contract and not as part of the potential project, in case the client decides to cancel it as a result of the study.

In trade show exhibit design, a client usually has a group of specialists-an "exhibitsgroup"-design the traveling exhibition, taking into consideration the detailed and specific needs of the design message, the need to customize the exhibit from venue to venue, and the unique traveling and setup/takedown requirements. Freelance artists are often hired to fulfill particular graphic design needs such as typography, photography, illustration, and overall creative direction. Printed collateral materials are often needed at the show sites and are prepared in parallel with the overall exhibition design. When pricing these assignments, the artist-designer should consider not only the specific nature of the

usage but also that such shows have a limited calendar life of a year or two. Advertising and institutional pricing guidelines should be the starting points for negotiating prices, with the understanding that exhibit usages are not as extensive as those for advertising and broadcast.

Project proposals follow the phases outlined for environmental graphic design. Fees for exhibit projects are usually negotiated with a "not to exceed" figure. They generally range from 15 to 25 percent of the total project budget, with 20 percent the most common figure. As in other types of design involving construction, change orders are customary as the scope of work evolves. Expenses are generally added to the negotiated fees. Specific contract terms may depend on the client, so determining the client's needs and establishing a collegial working relationship are important from the start.

For window and interior displays in retail stores and boutiques that change on a monthly or more frequent schedule, designers usually work on a per-project basis, though many have contracts for a specified period of time or number of projects. While there are no industry standards for this specialty, certain conditions generally prevail. Designers customarily present sketches or drawings on spec for a proposed project. However, the price of the sketches, generally between \$200 and \$300, may be figured into the overall budget, which includes the cost of materials (a 50 percent deposit is standard for materials). Display designers are responsible for providing all materials, props, and backgrounds to be used in displays (except permanent fixtures such as manneguins). Unless otherwise specified, these become their property (except permanent fixtures), even if they were specially built or purchased for a specific project. Designers may subsequently rent or sell these materials, though not to a competing retail outlet unless they are significantly altered first. Designers are responsible for the durability of all displays; any repairs due to weak or faulty construction are expected at no additional charge.

Broadcast Design

The demands of television, which is in 98 percent of American homes, presents unique challenges to broadcast designers. Their work is visible in all sports, news, music, and network programming. It includes creating the look for an entire show, channel, or network with opening graphics and bumpers (shorter clips of an opening animation that identifies a broadcast).

The development of computer graphics has greatly expanded the design, art direction, and execution of television graphics and animations. This capability now requires broadcast designers to keep up with hardware and software capabilities, enabling them to combine live-action direction with synthetic imagery. In many cases, it places the designer in the role of a producer/director, making him or her responsible for coordinating a crew, combining all video and audio production elements, and supervising the project through postproduction.

For on-air functions, broadcast designers are required to be illustrators, animators, and type designers. They must be knowledgeable about animation techniques and, on occasion, prepare and shoot animation on both film and tape. Knowledge of both stand photography (a computerized tabletop machine that permits zooms, pans, and other special effects) and remote still photography (filming that occurs outside of the plant or studio) is essential.

Broadcast designers are also responsible for devising off-air collateral—everything from small-space program-listing ads to full-page newspaper ads for print media, as well as trade publication ads, booklets, brochures, invitations, posters, and other material. In that capacity they double as corporate designers, coordinating everything from the on-air look to the application of identity logos/marks from stationery, memo pads, and sales promotion materials to new vehicle or even helicopter markings.

Scenic design may be another area of responsibility. It requires understanding construction techniques, materials, and paints, and an awareness of staging, furnishing, lighting, spatial relationships, and camera angles.

Art directors in this field must be skilled managers, proficient in organization, budgeting, purchasing, directing a staff, and working with upper management. Obviously, not all these skills apply to every individual or situation; each design staff is built around personal duties and strengths. Nevertheless, a broad spectrum of roles for designers exists in the broadcast medium, especially with the proliferation of cable channels with specialty programming. (For more discussion, see the Broadcast Designers section in Chapter 6, Salaries and Trade Customs.)

Greeting Card & Novelty Design

Greeting card and novelty design is often handled by graphic designers, surface designers, and illustrators, although some artists specialize in this field. Opportunities abound to have art or design published on greeting cards as well as holiday decorations, posters, magnets, mugs, T-shirts, stationery, and gift or boutique-type products.

Comparative Fees for Display, Novelty, & Merchandise Design

Based on concept, three to five layouts, comprehensive, supervision of illustration and photography, and final art for each component. Does not include fabrication, supervision of execution, and other production expenses that may be billed separately.

	Extensive use	Limited use	
Banners	\$3,000-\$6,000	\$2,000-\$5,000	
Counter cards	\$2,000-\$5,000	\$1,000-\$3,500	
Counter display	\$4,000–\$6,000	\$3,000-\$4,000	
Posters	\$4,000-\$7,000	\$3,000-\$6,000	
Shopping bags	\$4,000-\$6,000	\$3,000-\$6,000	
	Mercha	ndising	
	Flat fee	Advance	Percentage of royalty
Calendars	\$2,000-\$10,000	\$2,000-\$5,000	6%
Consumer stationery	\$500-\$2,000	\$400-\$800	6%
Gift wrap (no repeat)	\$800-\$1,400	\$200-\$400	6%
Gift wrap (repeat)	\$800-\$2,000	\$200-\$400	6%
Greeting cards	\$400-\$1,000	\$250-\$500	3%-8%
Kitchen products	\$900-\$1,600	\$250-\$500	4%–10%
Mugs	\$250-\$800	\$200-\$400	4%–10%
Paper products	\$500-\$1,000	\$250-\$500	4%–6%
T-shirts	\$250-\$1,500	\$250-\$500	4%-6%

The stationery and gift industries have grown extremely competitive in the last few years. For example, more than 7.4 billion greeting cards are purchased by American consumers each year, generating a projected \$7 billion in U.S. retail sales. Though there are more than 1,600 greeting card publishers in America, the big three—Hallmark, American Greetings, and Gibson—together comprise more than 85 percent of the market. Approximately half of all card designs are created by freelance artists and designers.

Since manufacturing materials, resources, and requirements for production of various items often limit their display and design, research into those factors can be an important aspect of such assignments. The resourcefulness of graphic artists in combining these limits with creative design is often key to a successfully marketed novelty item.

Some specialists in the stationery and gift industry develop their own designs and attempt to license their work to manufacturers on a speculative basis to maximize their income potential. This gives artists the ability to have their designs appear on many products and to collect revenue from a variety of sources. Naturally, not all designs can make the transition from card to mug to paper plate, but many of them do, making them profitable ventures for their creators.

Although there are no fixed rates in this industry, most companies pay between \$300 and \$500, depending on complexity, or they pay an advance of \$200 to \$250 against a royalty of 4 to 6 percent of gross sales. Determining what rights are being acquired is critical. Twenty years ago most companies automatically bought all rights to a design, even if they only produced greeting cards. They even kept the original art. This practice, viewed by many artists as unfair, has been changing over the years.

If a project is killed, either because the artist didn't execute the assignment in a satisfactory fashion or because the client changed its mind about the project, the artist should receive a kill fee. If the artist does the requested assignment but the project doesn't move forward, a general kill fee is half the flat fee arrangement or all of a royalty advance (since there will be no royalties). If the artist does the assignment but the design was found lacking, one quarter to one third of the agreed-upon price may be more appropriate. (For more discussion of kill fees, see the Cancellation and Rejection Fees section of Chapter 3, Professional Issues.)

Licensing

The Graphic Artists Guild recommends that artists retain the rights to their work. It is preferable to license the right to use a design for a certain product (a greeting card, for example), for a certain time period (three years), and for a certain territory (North America). Then the artist has the right to license the same design in North America for a different product—perhaps a magnet or a mug—or to license the rights for the same product in Asia, Australia, or somewhere else in the world. This practice enables the artist to earn more than a few hundred dollars for a design.

Artists can license their work on a flat-fee or a royalty basis. There is nothing wrong with accepting a flat fee upfront. Royalties can be tricky; even if the design sells well, the artist doesn't get paid additional money until the advance is paid off, which can take more than a year. Some companies, especially start-up concerns, may not have an effective system in place to distribute the product, which may negatively affect any royalties earned. To determine if a royalty fee is profitable, it's best to ask how many pieces the client plans to produce for their initial and ensuing press runs. Then evaluate the options, and strike the best deal.

Commissioning procedures

Most companies send the artist a commissioning form that spells out all the details of what they want. Many companies also include a contract with it so there is no misunderstanding about what rights they wish to acquire. The commissioning form should have the due date for the sketches, color comps, and finished art. Many companies include prices for the sketches separately from the finished art. Then if the project is terminated after the sketch stage, the artist knows how much he or she will be paid. If a company communicates clearly what is expected and the sketches don't reflect those requirements, the firm expects the artist to try again at no additional charge. If, however, the company changes its mind about what is wanted, then it should expect to pay for the artist to rework the sketch.

Contracts

If the company does not send a commissioning form and contract specifying what is wanted and what rights it wishes to acquire, or if the artist wishes to improve contract terms, it is best to send the firm a letter of agreement or contract before beginning work on the project. **7** Graphic Design Prices & Trade Customs

Some of the variables in a contract include:

- Property: Design(s).
- **Products:** What the company plans to produce or manufacture using the designs.
- **Territory**: Where the company can sell the products. Many companies sell worldwide and therefore need to obtain worldwide rights to the design.
- Term: Length of time the company is allowed to manufacture products with this particular design. The average greeting card has a shelf life of three years, but companies usually ask for a five-year term and often an extension term (an additional time period of one to three years).
- Renewal fee: Percentage of the original compensation to be paid to the artist if the company wishes to continue to use the design for an additional period. In a flat-fee contract, the artist needs an additional incentive to allow the company to continue to produce the design; otherwise, the artist could relicense that design elsewhere. In a royalty contract, a renewal fee clause is unnecessary because the artist is being compensated by additional royalties. Renewal fee rates generally range from 30 to 100 percent of the original agreed-upon price.

Two other items are important to include in the contract.

- Samples: Companies customarily give artists a number of samples in the quantity in which their product is sold. For example, greeting cards are usually sold in either dozens or half dozens, so the artist ordinarily receives 6 or 12 samples. Mugs and other gift products are sold individually or in lots of two or three, so the artist receives fewer samples. If more samples are needed as useful giveaways, it's best to request more or even work for a lower fee in return for additional samples.
- Credit: Some companies are happy to give designers credit; others are not. It's easy to give the artist credit on greeting cards. On stationery or a beach towel, it's much more difficult. But always ask; it may lead to more work or assignments from other clients.

The price ranges in the chart on page 201 do not constitute specific prices for particular jobs. The buyer and seller are free to negotiate, with each artist independently deciding how to price the work, after taking all factors into account. (Refer to related material in other chapters in this book, especially the Greeting Cards section in Chapter 9, Illustration Prices and Trade Customs.)

Chart & Map Design

Chart and map designers rely upon their pictorial abilities as illustrators to solve a client's specific problems. Though related, there is a difference between "map design" and traditional cartography. Map design generally involves editing, combining, and restyling data from preexisting maps. Cartography includes these tasks but also requires independent confirmation and correction of data on existing maps. Both map design and cartography require an understanding of projections (reproductions of spatial objects such as the earth upon flat or curved surfaces) and their significant implications, but it is more useful in the latter discipline.

The chart or map designer frequently works from raw data based on the client's research, often beginning with a projection supplied by the client. However, map designers often find it necessary to do additional research to supplement what is provided, and digital geographic information systems go a long way toward aiding the work of the chart or map designer. Chart design ranges from the whimsical and highly illustrative to the scientific and highly technical. On the editorial end, the map or chart designer is treated much like a traditional illustrator. The designer is asked to provide artwork to fit a prescribed space, and prices for such work are comparable to pricing for illustration in similar markets. Current data indicate that larger works of map and chart design usually command higher fees than traditional illustration, especially when they are highly complex, requiring considerable detail and accuracy. (For more information, see Chapter 9, Illustration Prices and Trade Customs.)

Other uses include advertising and collateral, corporate literature, and technical publications. Often the designer is treated as an integral part of the project by the project directors and art directors working on it. This involvement can include page layout; determination of style, size, content, and color; and even the printing method. Historically, the greater the designer's involvement in a project, the larger the fees. In these circumstances, it is generally recognized that map and chart design is not illustration per se, and projects are more often priced on a fee-plus-expenses basis. Billable expenses include everything required: reference materials (topographical maps), the time it takes to do research, messengers, miscellaneous art supplies, typography, and digital service bureau output.

The map or chart designer's responsibilities usually include a tight sketch in color with all typography in position; one revision, if necessary; and finished artwork. Finished artwork can be in almost any form, including black-and-white illustration, full-color artwork for separation, page layouts, artwork on disk or film, or any combination.

The price ranges in the chart do not constitute specific prices for particular jobs. The buyer and seller are free to negotiate, with each designer independently deciding how to price the work, after taking all factors into account.

Comparative Fees for Chart & Map Design

Usual and customary fees based upon client consultation, research, presentation of tight color sketch and typography in position, one revision, and finished art. Ranges reflect varied uses.

Client annual revenues			
Over \$500 million	\$2,500-\$3,500		
\$100–\$500 million	\$2,000-\$2,500		
\$50–\$100 million	\$1,800-\$2,200		
\$10–\$50 million	\$1,500-\$2,000		
\$1–\$10 million	\$1,000-\$1,500		
Under \$1 million	\$1,000-\$1,200		

Production Artist

The role and responsibilities, as well as the mode of work, of the production artist have changed drastically with the introduction of electronic technology into the graphic workplace. Before computers, production artists were responsible for quickly and precisely combining type and art as directed by the designer's specifications and preparing the final forms, called mechanicals, based on a knowledge of printing, to go to the camera operator. To accommodate the limits of the print medium, many details, including the kind of overlay used on the keyline to the way the ink sat on the paper, had to be understood and considered in the construction of the mechanicals.

With the advent of computers, typographers, strippers, camera personnel, and others involved in lithographic processes were replaced by computer operators and service bureaus. The latter are companies that translate digital files directly to film or other necessary hardcopy output. As a result, designers are now expected to be skilled production artists. Once the designer and client have agreed upon the final design, the production artist begins preparing the art for the printer. The production artist provides the link between the conceptual design and the tangible result, between the graphic designer and the printer. The essential elements a production artist handles include graphic files, software, fonts, 7 Graphic Design Prices & Trade Customs

color matching, instructions to the printer for resolution, screens, and trapping, and other service bureau and printer's guidelines.

To ensure the integrity of the final product, the production artist's responsibilities include using appropriate tools (hardware and software); conveying to designers the expense of producing their design electronically and giving designers options to be more costeffective; maintaining the integrity of all the design elements; and completing the work by the deadline. Production artists must be detailoriented and keep current on technological changes in computing and printing. The scope of knowledge that a production artist must have includes design, printing processes conventional and electronic—and constantly changing computer capabilities.

Where does the production artist's responsibility end and the service bureau/printer's begin? Production artists can save designers significant costs if they are skilled in areas where printers traditionally have expertise, such as high-end scanning, photo retouching, imposition, and trapping. If a production artist is able to assume one or more of these responsibilities, the person should be appropriately compensated for providing such service.

Production artists are able to provide certain skills and services based on their level of expertise and training. For example, a production artist working at a printer or service bureau has skills and responsibilities that are different from a production artist working at a design firm. Therefore, fees are determined in part by the level of services provided.

Pricing

The complexity of the job determines the production artist's level of pricing. Some factors production artists should take into account include:

 Level of complexity in preparing electronic files (a four-page newsletter compared with a 100-page catalog).

- Scanning (low-end, high-end).
- Tint building.
- Clipping paths.
- Page layout (simple to complex).
- File conversions (Mac to PC or PC to Mac).
- On-site or off-site work.
- Last-minute decisions/rush jobs.
- Preparation of all paperwork: specifications for printer, composite laser proof (marked up), laser-proof separations, folding dummy (a model of how a finished piece will fold).
- Production of rough color proof versus high-quality color proof.

The price ranges in the chart do not constitute specific prices for particular jobs. The buyer and seller are free to negotiate, with each production artist independently deciding how to price the work, taking all factors into account.

Hourly Rates for Production				
s, mechanicals, or reflight/prepress				
Hourly rate				
\$35-\$95				
\$40-\$100				
\$40-\$105				
\$50-\$225				

Web Design & Other Digital Media Practices

The Internet and online media services, such as AOL, Prodigy, and WebTV, as well as digital media products, such as touch-screen kiosks, software titles, and video games, are the fastest-

in the world today. Forrester Research, a leading industry research firm, reports that U.S. online purchases hit \$20 billion in 1999, accounting for 7 percent of all retail sales. It projects that U.S. consumers will spend

growing commercial markets

This chapter focuses on the newest design frontier: creating an ever-expanding array of digital media, including Web sites, computer games, and software programs. Because the language used to describe digital media is also new, a glossary is provided at the end of the chapter.

\$184 billion online by 2004. Forrester also predicts that online ad spending will rise to \$33 billion by 2004, with an 18 percent loss of revenues in newspaper/print media and direct marketing. With this burgeoning growth comes a never-ending need for fresh content videos, photos, illustrations, multimedia presentations, and animations—to keep people clicking away. Digital media and Web designers stand at the forefront of this field: creating the content for those new markets. These creators work for a wide range of industries, including entertainment, publishing, marketing, education, commerce, and training.

Since the technological means of protecting copyright and reuse are being developed simultaneously with the digital market, and since trade practices for traditional media may not always apply, this chapter offers some of the terms and protective mechanisms that artists themselves are developing in response to this new market. No doubt design and business practices in this new arena will continue to change as rapidly as the industry. (See the Glossary at the end of the chapter for new terms.)

Ready for the Internet & New Media?

Although many clients casually interchange the concepts and challenges of design between print and new media, the functional and production methods of the two are profoundly different. (For helpful books and Web sites, see Chapter 15, Resources and References.)

The digital workspace that has evolved using print programs such as Adobe PageMaker, InDesign, and QuarkXPress came directly from traditional typesetting and printing (using much the same vocabulary, measuring systems, and printing terms). By contrast, the methodologies, computer languages, and production processes employed on the Internet are being created by multinational computer programming consortiums such as the W3C and by large software companies such as Microsoft and America Online, which owns Netscape. A basic knowledge of such computer languages as HTML, DHTML, CSS, and XML is strongly advised if one wishes to know what is possible in the creation of Web design.

If you are thinking of making the jump into new media design, it might be helpful to ask yourself a few simple questions. Do you:

- Have the right computer hardware, software, and Internet connection? If not, are you prepared to purchase what's needed?
- Know what makes a Web page work? Do you want to (or can you afford to) take the time to learn these hands-on skills, or would you rather art direct on a per-project basis? If you choose the latter, do you know what can and cannot be accomplished within the given project or medium? What if you create a design only to be told later, "That can't be done," or "It isn't practical given the bandwidth"?
- Have experience in organizing and managing the teams of consultants frequently required to produce large sites/projects in a timely manner? Do you need to subcontract with skilled Web or multimedia programmers? Do you know where to find them?
- Know how to find a good Internet service provider (ISP), optimize graphics and animations for the Web, and put them on a remote Web server?
- Know where to go if you need help?

If you answer yes to these important questions, you are well on your way to becoming involved with Web design and digital content creation. But traditional concerns and guideposts are still important, including:

- The need for clear communication and contracts between clients and creators.
- An understanding of copyright protection.
- The basic essential of respectful treatment by clients in the face of pressing deadlines. Such practices provide the basis for a successful enterprise, whether it's a 12-month Web site contract or designing a set of characters for a new video game.

The Digital Marketplace

While many digital content providers are extensions of traditional print publishers, media companies, corporations, and advertising agencies, the digital marketplace is increasingly crowded with startup companies called "dot.coms." The scope of interests and professions that these providers represent is truly diverse. Commercial transactions such as banking and shopping are being handled online. Advertisers can publish whole catalogs on a CD-ROM or Web site, and these must be updated as stock is depleted or added, with the demand for images to illustrate new products providing steady work for freelance artists. Software designers are creating programs that will allow prospective real estate clients and home builders to view simulated living space and property without ever leaving the realtor's or builder's office.

Industrial applications include setting up a network of personal computers so that people in remote places can communicate and work together. Training and retraining of personnel is another use. For instance, the Defense Department is the largest user of digital media within the federal government; all its training programs in most branches of the military service are conducted with digital media.

Joint research projects, development efforts, and diagnostics are now less constrained by time or distance. For example, hospitals and doctors use digital technology to send image data of medical samples to distant labs for diagnosis.

Corporate communications and public relations departments in large companies hire digital media professionals to design presentations for product introductions, technical training, management development, trade shows, motivational sales meetings, and meetings of the board or shareholders. Designers incorporate charts, graphs, photography, film, computer graphics, and video, and they sometimes enhance their work with sound effects and music. Of course, designers must respect and therefore purchase appropriate licenses for materials they have not created or confirm that they are in the public domain. (See the Copyright section in Chapter 2, Legal Rights and Issues.)

Great emphasis is being placed on the development of preschool and elementary education programs. Much of this work is called "edutainment," educational material presented in an entertaining format, such as a numbers game that teaches children math or an adventure game that features historic characters or events. Museums and zoos, for example, exploit digital media to enhance visitors' experiences.

Reference materials like encyclopedias are compressed, and video, animation, and sound added to the text, graphics, and photos. The resulting CD-ROMs are equipped with search engines that help define the subject of interest, pinpoint its location, and cross-reference it with other material on the disk. Development budgets for such reference projects can range from \$100,000 to as high as \$1 million, with project teams consisting of from 20 to more than 100 people.

Comparative Fees for Audi	ovisual/Multimedia Design
Usual and customary fees based upon a typic and supervision of illustration/photography ar three to five layouts, a final comprehensive, and	al project that entails concept, design, layout, ad limited animated elements. Presentation of d execution of finished art.
Business pr	esentations
	Per slide/frame
Single projectors	\$300–\$600
Multiple projectors	\$250-\$500
Educational p	presentations
Single projectors	\$250–\$500
Multiple projectors	\$250–\$500
Storyboards	\$75–\$100
Courseware (25 screens, per screen)	\$250
Legal pres	sentations
Single projectors	\$250-\$500
Multiple projectors	\$325–\$700
Anim	ation
	Per second
Industrial	\$65–\$140
WWW (large client)	\$325–\$700
WWW (small client)	\$250-\$625

Web Site Design

Mounting a Web site can be like posting a handbill in Times Square. It's a real challenge to get noticed. With thousands of sites coming online each week-each more elaborate than the next-the pressure to grab someone's attention and effectively communicate a message with good graphic design and good illustration is intense.

However, graphic design is just the tip of the Internet iceberg. Designers, marketing managers, and clients must carefully examine and map out the overall information structure, presentation, and delivery mode of any site. In fact, many Web designers call themselves "information architects" or "interface designers." Similar to architects of three-dimensional space, designers may need to coordinate a team of specialists, including illustrators, photographers, copywriters, animators, multimedia experts, and computer programmers.

The life force behind an increasing number of complex Web sites is the programming and code. If the designer is responsible only for developing the visual interface, not for the programming, it is essential that the designer have a clearly structured relationship with a trusted programmer. Designers are advised to define the ownership rights of the program code (some are in

the public domain; some are proprietary) in all contractual arrangements with the programmer who creates it from a variety of computer languages. The programmer will want to retain rights to it; that ownership should be considered in light of the client's needs, including whether the programmer is able to maintain the code indefinitely. For highly complex Web sites or those central to the client's mission, the source code is sometimes provided to the customer with limited-usage rights.

Before proposing how a Web site will work, the project manager must coordinate with the development team, including designers, programmers, and animators, the many detailed tasks involved in making the site work. The designer is expected to provide the programmer with all the interactivity objectives and details. The programmer, in turn, is responsible for producing Alpha and Beta site testing versions, and may also be responsible for providing the documentation necessary to implement the work. Thorough advance planning is necessary because, once programming has begun, any changes to the program or to the artistic elements will incur high charges.

<u>The proposal</u>

A design proposal with estimated fees and anticipated expenses is usually presented to the client before work begins. The proposal is a general agreement that details many of the following factors:

- Project objectives and requirements.
- Project team members who have clearly delineated responsibilities.
- Project time frame.
- Intended use of the work.
- Technical constraints and exclusions.
- Art phases and nature of all deliverables.
- Terms of payment.

In addition, designers frequently prepare language explaining relationships with subcontractors (such as animators or programmers), detailed design specifications (outlining requirements and deliverables for both the client and the designer, milestones for review, and accountability factors), billing procedures, and contract terms. (Refer to the Developing a Design Proposal section in Chapter 1, Professional Relationships.) The number or complexity of the templates required as well as the format in which they are needed (static, Quark/Photoshop, or HTML) should also be outlined in the proposal.

It is customary for proposals to be submitted to clients as a complimentary service, although any fees and expenses accrued thereafter on a client's behalf and with the client's consent are billable. If the client accepts the proposal, the terms and conditions expressed in writing are confirmed with the signatures of the client, programmer, and designer. Frequently, a deposit payment is also requested before work begins. Once a client accepts the design proposal and any appropriate deposits have been received, actual work begins.

Contract terms

Many components of contracts for illustration and design also apply to digital media. The Trade Practices sections in Chapter 7, Graphic Design Prices and Trade Customs, and Chapter 9, Illustration Prices and Trade Customs, as well as the model contracts in Chapter 13, Standard Contracts and Business Tools, give in-depth descriptions of contracts by type of work provided. However, it's important to note terms specific to digital media.

 Deliverables: Interim or final products. Many contracts do not describe these in sufficient detail, leaving both graphic artist and client in peril of miscommunication and dissatisfaction during the contract and, even worse, with the results. Creating an in-depth specification sheet and flowchart help the designer avoid major headaches.

A full and clear description includes the size and scope of the work, using appropriate measurements (such as time, file size, number of screens or pages, complexity of linking and navigational elements, segment of programming source code, site assets); intermediate review timetables and the deliverables required at those stages; the technical needs of the product such as medium, electronic file format, style guides; copyright ownership of the deliverables; modules that conform to the function specifications; and the review schedule, the kinds and types of revisions included in the fee, and the terms of acceptance.

- Expenses: It is widespread industry practice for the client to reimburse direct and indirect expenses, as specified in the contract. If precise amounts are not known at the time of signing, they are estimated, and the client should be given the option to approve any costs in excess of those projected in the original agreement. Direct costs include commissioning new or leasing existing images, hiring voice talent, and signing run-time licenses. Other expenses include travel, research materials, postage and delivery charges, photocopying, and media costs (such as recordable CDs and Zip disks). For designers who bill hourly, capital investment needs to be considered when establishing fees. (See the Hourly Rate Formula section in Chapter 5, Essential Business Practices.)
- Kill and cancellation fees: A negotiated kill fee in most markets of the graphic communications industries usually reflects the amount of work completed.
- Payment terms: Depending on the length of the project, fees may be paid in
 a lump sum within a set period (30 days) after completion or at periodic
 intervals when there are longer deadlines. These are often tied to reviews of
 deliverables, but if there is only one review, payment may be divided into three
 increments: one third on signing the contract, one third upon review, and the
 last third upon completion. Some design firms even request 50 percent of the
 payment upfront to cover hiring freelance programmers and coders.
- Schedule: While the timing of deliverables is an important contract commitment, all digital media projects require specific time frames, including those without tangible deliverables: for example, provision of services. Contracts that include schedules should include contingency provisions to be met in the event deadlines are missed by either designer or client.

• **Copyright:** For a full discussion of copyright issues, see Chapter 2, Legal Rights and Issues, and Chapter 4, Technology Issues.

One specific copyright concern related to digital media is ownership of the rights to deliverables. Obviously, the creator should ensure that the necessary rights to all work used to create the final product are purchased or confirmed to be in the public domain. Digital media creators often negotiate for the copyright to the final deliverable; if this proves difficult, creators then attempt to retain rights to intermediate deliverables.

- Noncompete clauses: These contract provisions restrict an artist from creating work perceived to be in competition with a particular client. Noncompete clauses are therefore troublesome for creators, as they limit their potential client base. Clients, however, have legitimate concerns that work resembling theirs will appear in the same market at an overlapping time. A compromise may be a stipulation that the artist will not create work that is in conflict with the client's. If it appears difficult to eliminate a noncompete clause, traditional limitations appropriate to the project may be negotiated, such as time limits, geography, or usage. On occasion, designers also propose clauses that offer the client the right to refuse new product ideas before they are offered to other clients.
- Credit: Appropriate attribution and publicizing of credit can enhance a designer's reputation and ability to get work, and is therefore an important point of negotiation. For instance, production studios have taken the initiative in negotiating them with clients. As in film, video, and television, there are often many creators, and credit may be difficult to negotiate initially. As creators' work and reputations grow, however, this should become easier. Credit options may include the creation of a colophon/credit page, a link to the designer's site or e-mail address, or an embedded comment in the HTML code like "Another cool site by The Designer."
- Demonstration rights: These are essential for self-promotion. However, clients
 may be wary of preempting launch publicity or revealing work to possible
 competitors. Compromises may have to be negotiated, such as the right to
 show limited portions or unlimited rights after the product is released.
- Liability: Liability raises a range of concerns. Usually the client is responsible for obtaining permissions for any materials, including code and software, submitted to the designer. Similarly, the designer is usually responsible for obtaining necessary clearances for all subcontracted work (illustration or photography), unless the client assumes that responsibility. The designer should also define to what extent the Web site will be compatible with existing technologies, software, and platforms and to what extent each party is responsible for the smooth operation of the Web site. For instance, subcontracted programmers are responsible for the functionality and legality of their code (they must define all copyright terms relating to their code with the client) and any bugs or incompatibilities. It should be clearly spelled out that any lack of projected hits, sales, or awards are not the designer's responsibility. The designer should also have the right to reuse code at a later date.

Pricing

Applying traditional print pricing guidelines to digital media is difficult, if not impossible. The traditional criteria of size, placement, or number of insertions don't apply to artwork used in digital media, where the end user often determines the sequence, timing, and repetitions of the work. Geographic distribution remains relevant for some digital media markets such as games, kiosks, pointof-purchase displays, and training programs, though the global nature of the Internet makes locale moot for Web site design.

Recent research indicates that designers are transferring rights only for known delivery media, which are specifically listed in the contract. Some payments are made as flat fees; others are treated as an advance against a royalty based on total distribution. Some companies have even been known to allocate royalties to the freelancers they have hired for particular jobs.

Recent survey data indicate that royalty payments, when applicable, vary dramatically depending on the type of product, the relationship of the creator to the product, and the economics of how the product is going to be created and distributed. These variables may include independent distributors, overhead, unit production costs, and what portion of the overall work the designer contributed. Since the market is still in flux, royalty rates vary dramatically.

The principle of value-based pricing (keying prices to the work's role in the client's success) is as valid in the digital world as in other media. Generally, the wider and greater the benefit or viewing of the Web site, the higher the value to the client. This may be gauged in relation to projected sales or to the client's track record on previous or similar projects.

Some designers estimate the hours the job should take as an additional gauge of a job's worth. Fees for meeting time, which may be charged at a lowerthan-usual hourly rate, are usually added. Occasionally a client prefers to set a fixed price for a project. At such times, an accepted industry practice is for designers to increase fees to accommodate unexpected changes, rush work, and overages that can occur during the course of a job.

Making flowcharts and simple storyboards can help the designer assess the scope of the Web design project and serve as an early catalog of the amount of graphics required. Web designers often determine file names and sizes on these charts before beginning design concepts. On occasion, a designer may negotiate payment for a sample to determine the time and therefore the scope of the project. Creating a development site based on the mandatory design specifications created for any smooth-running Web project, with a basic skeleton and outline, is another possibility. Such a site allows the client to review and make changes while the content is easy to manipulate.

Designers should be aware that although Web server software collects data about how many "hits," or visits, a page gets, that number can easily be manipulated. That makes using the number of hits for pricing a highly risky process at best. Also, Web pages are often changed constantly; some graphics may be on the site for only a few weeks or months, while others remain constant.

	ternet Service Providers/Por	als/Search Engines)	
imited rights transfer assu	ımed.		
	Major service	Smaller service	
lmage map	\$500-\$6,000	_	
Banner	\$375–\$2,225	-	
Spot	\$300-\$900	\$200-\$700	
lcon/button	\$150–\$900	\$125-\$600	
	World Wide W	eb [©]	
Advertising			
Image map	Large company/many hits \$350–\$5,200	Small company/few hits	
Animated banner	φ550-φ5,200 _	\$100-\$2,000 \$125-\$1.000	
Banner	- \$400-\$4,500	\$125-\$1,000 \$200-\$1,000	
Animated spot	\$400-\$4,500		
	- #25 #2.000	\$150-\$700	
Spot	\$25-\$2,000	\$200-\$700	
lcon/buttons	\$150–\$500	\$125–\$500	
Corporate			
	Large company/many hits	Small company/few hits	
lmage map	\$1,500-\$4,000	\$1,000-\$3,000	
Billboard	\$1,200-\$2,000	\$750-\$1,500	
Spot	\$500-\$1,200	\$400–\$1,000	
lcon/buttons	\$250-\$500	\$200–\$500	
Editorial			
	Large company/many hits	Small company/few hits	
mage map	\$1,500-\$4,000	\$800–\$1,500	
Billboard	\$1,200-\$2,000	\$500-\$1,000	
Spot	\$300-\$1,000	\$250-\$1,000	
lcon/buttons	\$150-\$500	\$125-\$250	
ndividual/personal			
	Large company/many hits	Small company/few hits	
Spot	_	\$300–\$500	

	A desertising (Desertising	-
	Advertising/Promotion	n Small company/limited distribution
Splash screen	\$1,500-\$3,000	\$1,000-\$2,500
Full screen	\$1,000-\$2,000	\$700-\$1,875
Half screen	\$750-\$1,500	\$500-\$1,000
lcon/button	\$350-\$500	\$250-\$400
	Consumer/General inter	est
Splash screen	\$1,500-\$3,000	\$1,000-\$2,000
Full screen	\$1,000-\$2,000	\$750-\$1,500
Half screen	\$750-\$1,500	\$500-\$1,000
lcon/button	\$200-\$400	\$150–\$300
	Business/Special intere	est
Splash screen	\$1,500-\$3,000	\$1,000-\$2,000
Full screen	\$1,000-\$2,000	\$750-\$1,500
Half screen	\$750-\$1,500	\$500-\$1,000
lcon/button	\$250-\$500	\$200–\$400
	Educational/Children	
Splash screen	\$600-\$1,200	\$500-\$1,000
Full screen	\$400–\$900	\$300–\$700
Half screen	\$250-\$600	\$150-\$500
lcon/button	\$150-\$350	\$100-\$400
Storyboards (per screen)	\$400	\$150
	Entertainment/Games	5
Splash screen	\$1,500-\$3,000	\$1,000-\$2,000
Full screen	\$1,000-\$2,000	\$750-\$1,000
Half screen	\$500-\$1,000	\$400-\$700
lcon/button	\$250-\$600	\$150-\$400
Storyboards (per screen)	\$400	\$400
	Catalog	
Splash screen	\$1,500-\$2,500	\$1,000–\$2,000
Full screen	\$1,000-\$2,000	\$700-\$1,500
Half screen	\$700-\$1,500	\$300-\$700
lcon/button	\$200–\$500	\$150-\$350

Comparative Fees for Digital & Electronic: CDs, WWW, Games, Software

Offline media (CD-ROM, CD-Interactive, other portable media)

Usual and customary creative fees for a typical project that entails concepts, design, layout, supervision of illustration and/or photography and animated elements for "offline" products (CD-ROM, CD-Interactive, other portable media). Creative design fees are dependent on the complexity of assignments, the client's size and budget, number of screens (pages), pressings, production needs, deadlines and rights transferred. Assumes first English language publication rights; excludes reimbursable expenses.

	International	National	Limited	Bundled with print media
Advertising/ promotion	\$30,000-\$75,000	\$25,000–\$60,000	\$15,000-\$40,000	\$20,000-\$40,000
Games	\$200,000-\$400,000	\$100,000-\$200,000	\$40,000-\$100,000	-
Children/ educational	\$50,000-\$100,000	\$40,000-\$80,000	\$20,000-\$40,000	\$10,000-\$20,000
Product catalog	\$50,000-\$100,000	\$40,000-\$80,000	\$25,000-\$50,000	\$25,000-\$50,000
Consumer/ general interest	\$30,000-\$60,000	\$40,000-\$80,000	\$15,000-\$30,000	\$20,000-\$50,000
Business/ special interest	\$30,000-\$60,000	\$25,000-\$50,000	\$12,000-\$25,000	\$12,000-\$25,000

Online media (Internet Web site, online service providers[—] & major portals[—])

.

. . .

Usual and customary creative fees for a typical project that entails concept, site map organization, design of home page and secondary pages under main headings, supervision/direction of illustration/photography and limited animated and audio elements. This assumes some knowledge of current programming applications. Creative design fees depend on the complexity of assignments, the client's size and budget, number of screens (pages), production needs and schedules, deadlines, and rights transferred. Assumes transfer/license of electronic rights for two years, and excludes reimbursable expenses.

Advertising & pro	omotion			
Client annual revenues	Web site campaign	E-commerce catalog	Splash pages (per page)	Banners, Buttons, Flash animations
Over \$500 million	\$120,000-\$225,000	\$100,000-\$160,000	\$6,000-\$12,000	\$5,000-\$7,000
\$100–\$500 million	\$80,000-\$160,000	\$100,000-\$120,000	\$6,000-\$11,000	\$4,000–\$6,000
\$50–\$100 million	\$75,000-\$150,000	\$60,000-\$100,000	\$5,000-\$8,000	\$3,000-\$5,000
\$10–\$50 million	\$50,000-\$110,000	\$45,000–\$80,000	\$3,000–\$6,000	\$2,000-\$3,000
\$1–\$10 million	\$30,000-\$60,000	\$30,000–\$60,000	\$2,000-\$4,000	\$1,000-\$3,000
Under \$1 million	\$15,000-\$35,000	\$15,000-\$40,000	\$1,000-\$3,000	\$500-\$2,000

C Examples of online service providers are America On-Line and Excite! C Examples of portals are Yahoo!, Microsoft Network, and other search engines. C Refers to design of banners that appear on multiple sites.

continued...

	01	nline media contin	ued	
Corporate, educa	tional, public relations			
Client annual revenues	Entire Web site	Splash pages (per page)	Full screen	Additional pages (per page)
Over \$500 million	\$160,000-\$360,000	\$10,000-\$20,000	\$4,000–\$8,000	\$2,000–\$4,000
\$100–\$500 million	\$125,000-\$275,000	\$8,000-\$14,000	\$4,000-\$7,000	\$2,000–\$4,000
\$50–\$100 million	\$100,000-\$200,000	\$5,000-\$10,000	\$3,000-\$5,000	\$1,000–\$3,000
\$10–\$50 million	\$50,000-\$100,000	\$4,000–\$9,000	\$2,000-\$4,000	\$1,000–\$2,000
\$1–\$10 million	\$25,000-\$50,000	\$2,000–\$4,000	\$2,000–\$3,000	\$1,000–\$2,000
Under \$1 million	\$15,000-\$40,000	\$2,000-\$3,000	\$2,000–\$3,000	\$500-\$1,000

Additional Fees for Illustration Used in Electronic Media

	Percentage of original fee
Stock sale of existing art	50%–100%
Rush fee	30%–175%
Unlimited use for 1 year	100%–250%
Work for hire (transfer of legal authorship)	35%–700%

Project team

Since it's almost impossible for one person to successfully perform all phases of good product development in a reasonable period of time, most digital media projects require a number of skilled workers who function as a creative team. The designer is the creator of the product's vision (what the product is supposed to be) and determines what features will and won't be included. The designer strongly influences the work of programmers, artists, and sound technicians, but, as with the best art directors in other markets and product categories, the designer allows craftspeople to carry out their work as independently as necessary.

Both creators and clients should guard against micromanaging the project. Clients should review all materials received at agreed-upon intervals from the creator and give a detailed list of comments and suggestions for revision at specific deadlines. As in other fields, changes are easiest to implement if they are made before production of the finished work. Designers surveyed report treating such changes after production as author's alterations and charging fees accordingly.

Questions to ask when designing a Web site

As part of developing a proposal, the designer should ask the client a number of questions to determine the client's goals, the level of client sophistication, and work-flow issues.

Goals

- What is the client's business and how will the client's Web site advance it? What message is the Web site supposed to convey?
- Who is the primary audience for the Web site? The primary age group of the audience? Their professions, disciplines, and interests? (Designers should warn clients that if the target is a broad-based, international audience, with potentially slow modems, old browsers, or expensive service, this may limit the design options.)
- What are the secondary goals of the Web site? Is this an informational site or an avenue for Internet-based marketing or revenue?
- What subjects, in order of priority, does the client want to cover on the Web site? Have the client define at least five separate areas of subject matter and state what's unique about their business.

Online education

- Does the client understand the difference between the Web and an online e-mail service such as American Online? The answer to this question is an indicator of the client's overall Web knowledge. If the client does not understand the difference, the designer may want to factor in time for basic Internet education.
- Does the client require a Web hosting account and/or dial-up access? How many users? What user privileges would the client like?
- Is the account only for e-mail or does the price quoted allow for server space to host a Web site? How many megabytes of server space?
- If the client already has an Internet account, is it with a true Internet service provider (ISP) or with an online service such as America Online? If the account is with an online service rather than a true ISP, extra costs or special arrangements may be needed to host the Web site.

Planning

• Who will give final approval of the project? If someone other than the client's team will have final approval, then the designer needs to make sure that person has Internet access and understands the Web.

- What domain name would the client like? For example, www.yourwebsite.com? www.yourwebsite.org? www.yourwebsite.net? What are two or three alternative domain names in case the first choice is already taken?
- Are the client's source materials in electronic form, and if so, does the designer need to handle file conversions? The designer may need to educate the client about how to submit materials in as consistent and compatible formats as possible. If necessary, the designer should provide the client with a variety of options and be prepared to do conversions.
- Does the site require advanced functionality, such as database functionality (Access, Filemaker Pro, Microsoft SQL, Oracle Server)? Does the site need to be coded in a special language such as Microsoft ASP or Allaire's Cold Fusion?
- Are there requirements for e-commerce, such as the ability to process credit card transactions, development of Shopping Cart strategies, survey forms, advanced configurator sales selectors, online games and interactive demonstrations, online chat and message boards?
- Is the site to be hosted in-house or with another provider? If in-house, the client's information services department should be included in the planning meetings.

Design

- Is the Web site to be designed from scratch, or is it a makeover of an existing site? If a makeover, does the client want any additions?
- What look and feel would the client like for the Web site? The client should show the designer examples of Web sites, magazines, publications, or artistic works they like. Does the client have a specific genre, culture, or style in mind?
- Are there any collateral marketing materials (brochures, publications, corporate identity programs, or posters), preproduction sketches, or media (CD-ROMs, video games, records, or tapes) that the Web site should be consistent with?
- Does the client desire graphics interactivity and/or multimedia (also involving content development and site mapping)? These typically include JavaScript rollovers and effects, animated GIFs, Quicktime or AVI movies, sound files, PDF downloads, Macromedia Flash animations, and interactivity.
- Does the client need a new logo or new collateral marketing materials and media to be consistent with the new Web site? If so, these design services should be quoted *in addition to* and *not* as part of the Web site proposal.
- Does the designer wish to negotiate a credit link that targets his or her home URL or e-mail?

Follow-up

 Does the client have the staff to respond to e-mail? If not, the designer may need to explain that the client may develop a bad reputation in the online world if people don't receive immediate responses.

 Does the client plan to have in-house site maintenance, or does the client want the designer to do it? Designers considering site maintenance arrangements should look carefully at the ability of their own organization to do at least biweekly or monthly changes.

Copyright

From the moment a Web site is launched, it can fall prey to illegal copying or element downloading. The information or graphics can be downloaded freely by anyone who wants them. Though graphics appear as very-low-resolution images, they can easily be reused. In fact, VRML object models that are entirely text-based can be copied, resized, reapplied, and remorphed into new VRML pages.

New software technology enables designers to imbed invisible comments (digital watermarks) and numeric signatures in the file's binary data. While that offers minimal protection, it still doesn't prevent copying or swiping. The best way to legally protect graphics on the Web is to clearly spell out any permitted uses of the images and the text on the site. (For more about copyright in the digital environment, see the Digital Millennium Copyright Act section in Chapter 2, Legal Rights and Issues.)

American copyright and libel law is being applied to Internet content, but enforcement in the global Internet environment is extremely difficult. If a designer sees one of his or her graphics on someone else's page (the most frequent offense), common practice is to send an e-mail and ask the person to take it down, as Web etiquette requires. Most frequently, the individual didn't realize it was illegal to use other people's graphics. However, if the user copied the graphic artist's work without permission and refuses to remove it, that's blatantly illegal and could be grounds for a legal suit.

It is common to use a button or graphic from a target, or linked, page as a graphic pointer. Since linkages may increase the chances of capturing a customer, Web content providers generally allow this specific use. However, some users set up "link-jacking," pointing to a resource on another server but not actually copying it, which raises other intricate legal and ethical issues.

Beware of worms or search robots. Bitmap worms are programs that scan the Web for graphics, collecting them into icon and so-called clip art collections and then presenting them on a different site as so-called public domain art. There are a variety of ways to protect artwork or graphics on the Web. One is to place special text on the server warning worms to stay away and prohibiting link-jacking. If the graphic artist knows of a particular worm, he or she can program the server to deny it access to the site. The graphic artist can also check hit reports to see who is snooping around the site; if one visitor downloads 2 megs of images, that's a good sign something illegal has been going on.

Protecting and enforcing one's legal rights in the digital world is easier said than done. Designers and artists are encouraged to register their sites/images with the U.S. Copyright Office (for information on registration procedures, see Chapter 2, Legal Rights and Issues).

Computer Games

The computer games industry is decades old, dating from the first appearance of Pong and Apple and Tandy computers. There are four different markets: arcade, console (Nintendo/Sega), PC/Mac, and online. Future prospects are expansive: The next frontier is online games with hundreds of players involved simultaneously in real time. (The computer games industry is changing so rapidly that it's difficult to stay on top of the business. The following is a general overview.)

> Development costs vary, depending on the platform, scope, and scale of the title, and the amount of chrome desired. A PC CD-ROM game can have a budget of \$250,000 to \$1 million; a video game may range from \$500,000 to \$2 million or more. Game development budgets can range from \$1 million to \$2 million, with promotional budgets twice that amount. Independent developers must generally seek out investors if they ever hope to see their game on the market. Many developers choose to license their product to a publisher or, particularly in PC games, make their products available through shareware. Projects often take 12 to 18 months to complete. Video game developers almost always seek outside investors and avoid shareware introductions.

> Most publishers prefer freelancers to be part of a team responsible for the whole project, rather than subcontracting with individual freelancers. A competent development team needs designers, programmers, artists (of varying skills and depending on the title), and sound technicians. Specialists like Sprite and Voxel animators, 3-D modelers, texture, skin, and mesh designers, and cinematic and digital rotoscoping designers may also be needed. A project manager is valuable if the team is larger than five or six people. A good team of well-rounded generalists is also valuable, since they are invariably more efficient, find the most attractive answers, and get the product done faster. If that is not practical, it may be best to break up the basic disciplines into subdisciplines to get the expertise needed for a particular product. For example, a text- or dialogue-heavy game with a designer unfamiliar in that area needs a scriptwriter. A game with lots of animation and with artists unfamiliar with animation work will need an animation specialist.

> It is unwise for a designer to "type" games too strongly, as good games are built of various design elements. The trick is to determine which design features work harmoniously together. Successful designers either make inspired guesses based on personal taste or reuse formulas that have proved successful in the past, with some modifications. The most common categories are action, sports, adventure, role-playing, simulation, strategy, card games, and educational.

Royalties

Industry practice indicates that teams usually get a significant advance on royalties, paid in pieces as milestones are reached. Royalties are commonly a percentage of the publisher's sales; recent data show that they are usually in the 10 to 20 percent range, with high-end amounts going to aggressive and/or famous designers/developers. Returns are subtracted from royalties, and since returns can occur up to 12 months after sale, it's not uncommon for bad games to show negative royalties at some point. Savvy artists anticipate this eventuality by ensuring that the advance is nonrefundable. The advance is sometimes recoupable from future royalties due the developer; it is subtracted from royalty payments until the publisher has been repaid. Care should be taken to determine whether the contract requires the advance to be refunded if sales of the product are not large enough to earn it back. It is to the developer's advantage to secure only nonrefundable advances. Developers with a proven track record are most often able to negotiate nonrecoupable advances. Very few publishers include cancellation or kill fees in their contracts.

Some designer/developers ask for royalty guarantees. In this scenario, the publisher guarantees to the designer/developers that royalties from sales will reach at least a specified figure of dollars or units. However, about the only time a publisher will consider this is when the designer/developer has a finished product (with small or no advance) and he or she can evaluate reasonably whether the product can achieve the specified sales level.

Some titles involve advances of less than \$25,000, while others are in the \$1 million to \$2 million range. A modest PC title includes a \$250,000 to \$500,000 advance, while a big PC title is about \$600,000 to \$1.2 million in advances. Due to steep graphic expenses, good console action games tend to cost about 50 percent more. Publishers usually try to keep advances to a minimum so that developers and designers share in the product's risks—and its rewards if sales are strong.

Rights

For a computer game, publishers prefer to buy all rights, worldwide, on all platforms, and often insist on total copyright transfer or at least joint rights. As with all markets and products, designers and developers stand to gain the most by retaining their rights as creators. Sometimes it's only for limited platforms, since few publishers handle all platforms well. Sometimes it's only for a limited part of the world, especially if the publisher is able to cover only some continents. Be sure to clarify that "all Web Design & Other Digital Media Practices

rights" refers to all computer entertainment rights on the specified platforms and in specified parts of the world. Online rights are usually another platform, but since they're closely related to personal computers, publishers usually insist on online rights as well.

Savvy artists will retain ancillary rights such as character licensing of toys, games, cartoons, and movies. While publishers may attempt to buy these for the same initial fee, artists and developers should consider including veto rights or rights of first refusal as well as additional compensation.

The only licensing in the computer game business is the application of a general entertainment title license (usually a book, toy, or movie title) to a game. (For more information on licensing and merchandising opportunities, see the Reuse and Other Markets section in Chapter 5, Essential Business Practices.)

<u>Credit</u>

Traditionally, credits appear onscreen and in the game manual. However, some publishers skimp so much on the game manual that the onscreen location is the only one. Credits on the box are uncommon.

Contracts

Provisions such as indemnity, noncompete or conflict, and exclusivity clauses are included in some contracts, but the most common is the right of first refusal on future products in general or on future products with any relation to the product developed.

Agents

Some developers use agents, and current surveys indicate that their fees are 10 to 20 percent. However, the percentage may be higher if an agent specializes in individual designers, since the agent may have to find a team of programmers, artists, and/or sound technicians to work with the designer.

Software Programs

Software programs include productivity, entertainment, education, and utilities. Though many associate games with software, designers and developers distinguish between the two genres. (The software program development industry is changing so rapidly that it's practically impossible to keep up with the business. The following is a general overview.)

Publishers may do complete development in-house or occasionally pull together creators into project teams for individual titles; in some instances, they contact an independent production studio. Budgets for software titles range from \$200,000 to \$700,000; if the product is a reference title, the budget can go as high as \$1 million. Financing is normally provided through entertainment companies, book publishers, and software companies, although private investors will sometimes provide seed money for a designer to create a prototype that can be taken to a publisher, who may then provide the remaining development funds.

The advance is normally designed to help fund the development of the title and reflects the anticipated earnings of the product. It rarely exceeds the royalty due on the sales generated by the product's first printing. Similar to book publishing advances, the advance is sometimes recoupable from the future royalties due the developer and is subtracted from royalty payments until the publisher has been repaid. Be sure to determine whether the contract requires the advance to be refunded if sales of the product are not great enough to earn it back. It is to the developer's advantage to secure nonrefundable advances only. Developers with a proven track record are most often able to negotiate nonrecoupable advances.

Other Digital Markets

Other growing digital, multi-, and interactive media markets include, but are not limited to, kiosks and point-of-information/purchase displays, laptop-based presentations, and computer-based training. The primary concern for graphic artists seeking work in these fields is becoming comfortable with the digital tools—and with the limitations of onscreen production such as fewer dpi than print, fewer color options, and smaller file size options. (The many applications of digital media are exploding so rapidly that it is practically impossible to keep up with the business. The following is a general overview.)

A kiosk is a freestanding computer system used to access information and advice, typically through a series of interactive menus and a touch screen. Kiosks are used in malls, banks (automated teller machines), museums, airports or train and bus stations, exhibit booths at trade shows, and libraries. Another form of kiosk is the point-of-purchase (POP) or information display used to promote or provide information on products such as books, music, cosmetics, automotive parts, and even personalized greeting cards and children's books. Most kiosks are bilingual, giving the user a choice of English or some other foreign language such as Spanish or Russian, and have a video/audio interface that leads the user to the desired result, be it a purchase, a destination, or a banking transaction.

Laptop-based presentations are in great demand for trade shows and marketing. The portability of these computers, coupled with their increasing memory, speed, and the skill of designers working in the media, provide ever-more sophisticated presentation capabilities.

Computer-based training programs save clients from flying in staff to a central location for skills or information upgrades. The programs make individual or small-group trainings at separate locations exceedingly cost-effective.

A training project is generally contracted to a multimedia production company, which functions much as a video production firm. These firms, often listed under "Multimedia" in the phone book, contract for artists, voice talent, programmers, and other specialists on an as-needed basis. However, the teams rarely work closely together. The production company assigns and manages the tasks and coordinates the final product. Some larger clients have attempted to contract work themselves, though reportedly with limited success. The length of project work varies—sometimes as short as four to five days, other times as long as a year. Occasionally such projects as computer-based training programs may last for several years.

Glossary

applications: A software program that performs a specific task such as page layout, word processing, or illustration.

binary: A system with only two possible states: on or off, 1 or 0, high or low.

bitmap: Image created when coloration is added to pixels onscreen; the file that gives instructions for coloration.

CGI (Common Gateway Interface): A standard for running external programs from a World Wide Web HTTP server. CGI specifies how to pass arguments to the executing program as part of the HTTP request. It also defines a set of environment variables.

chrome: Amount and quality of graphics, animation, sound effects, interactivity, and so on.

CSS: Powerful method for formatting text styles on Web site pages by having selected parts of a page reference master CSS style sheets. Note that visual implementations of CSS still vary between Microsoft Internet Explorer and Netscape Navigator

DHTML (Dynamic HTML): An extension of HTML giving greater control over the layout of page elements and the ability to have Web pages that change and interact with the user without having to communicate with the server. DHTML was created by Microsoft and can be viewed in Internet Explorer 4.0 and Netscape Communicator 4.0, but Microsoft and Netscape disagree on how DHTML should be implemented. The Document Object Model Group of the World Wide Web Consortium is developing standards for DHTML (www.w3c.org/DOM/).

digital: Representation of an electronic signal by a set of discrete numerical values, most commonly in binary form.

file conversions: Changing one kind of file to another, usually from one platform to another; for example, from a file for a D0S-compatible PC to a file for a Macintosh.

HTML (HyperText Markup Language): Markup language used to structure text and multimedia documents and to set up hyperlinks between documents; used extensively on the World Wide Web.

home page: Usually the first page of an organization or individual's Web site.

interactive: Describes productions and services that enable users to choose commands that directly influence the direction or outcome of their experience.

interface: The point where hardware, software, and user connect; the physical (electrical or mechanical) connection between elements of computer hardware.

Internet: A network of computers connected by telephone lines. First created by the U.S. Department of Defense to send information, particularly in the event of a war that destroyed one or more terminals. The Internet is now a "network of networks" with companies that provide access for a fee to anyone with appropriate equipment.

Internet service provider (ISP): Company that provides a hookup to the Internet. All vary in kind and level of service: some provide direct access; others provide added services such as news, chat rooms, downloadable software sections, and entertainment.

Java: A trademark used for a programming language designed to develop applications, especially ones for the Internet, that can operate on different platforms.

JavaScript: Netscape's simple cross-platform World Wide Web scripting language, only very vaguely related to Java. JavaScript is intimately tied to the World Wide Web and currently runs in only three environments: as a server-side scripting language, as an embedded language in server-parsed HTML, and as an embedded language run in browsers. JavaScript should not be confused with Java, and is a Netscape, not a Sun, trademark.

link: A connection between one area and another. A primary feature of interactive products is the ability of users to explore linked materials.

pixel: The smallest lighted segment on a computer monitor's screen; the smallest segment of color in a digital image file.

platform: A set of hardware components, operating system, and delivery media that provides specific functions and capabilities for the production or playback of digital programming.

productivity tools: Software applications used by business professionals such as word processors, databases, and spreadsheets. Usually character-based, they allow users to organize and manipulate text and numbers in various ways.

search engine: A Web page that allows Web users to enter their own homepage information and URL in a database; also allows Internet users to search for specific URLs from a database list using the needed homepage information as a search criteria. **server**: An Internet computer established by ISPs to respond to information requests from other computers on the network.

SGML (Standard Generalized Markup Language): A standardized markup language used to describe the logical structure of a computer document.

shareware: Software that users may test without initial payment. However, if use is continued, a fee must be paid.

site: All the Web pages that branch from a homepage.

URL (Uniform Resource Locator): An address for a file or location on the Internet.

utilities: Programs designed to improve, repair, or enhance a user's computer system or a specific computer program.

VRML (Virtual Reality Modeling Language): A draft specification for the design and implementation of a platform-independent language for virtual reality scene description. VRML 1.0 was released on May 26, 1995.

virtual reality (VR): The use of computer hardware (visual displays and tracking and mobility devices) in conjunction with special software programs to produce an experience that immerses the user in a highly interactive environment.

World Wide Web (WWW): The part of the Internet made up of the collective Web sites that are often linked to various other sites to create a "web" of information. The Web is different from e-mail and newsgroups.

XML (eXtensible Markup Language): A metalanguage written in SGML that allows one to design a markup language; allows for the easy interchange of documents on the World Wide Web.

Thanks to Tad Crawford for use of pricing perspectives from his Legal Guide for the Visual Artist, 4th ed., Allworth Press, 1999.

Chapter 9 Illustration Prices & Trade Customs

RA

101

S

D

1

During the Depression years, illustrators such as Harrison Fisher, Neysa McMein, and Norman Rockwell received \$2,500 to \$3,000 to create the cover art for *Cosmopolitan, McCall's,* and

The Saturday Evening Post. For an interior color page, artists were paid about \$1,200. For advertising, an automobile manufacturer or a cigarette This chapter details the different markets where illustrators, mainly independent contractors, sell their artwork. The accepted trade practices that govern the buying and selling of artwork are provided for each market.

maker paid up to \$5,000 for an illustration.

In 1935, advertisers spent \$130 million on magazine advertising and \$140 million on newspaper advertising. In 1950, advertisers spent about \$450 million on 68,300 pages of magazine advertising. Illustrators were getting about \$1,200 for a color editorial page of illustration and \$2,000 to \$5,000 for advertising. In 1975, advertising spending had tripled, to about \$1.36 billion on 80,000 pages of magazine advertising. Total circulation was up to 249 million, nearly double the 1950 figure. Illustrators were getting about \$1,500 for a color editorial page and \$3,500 for advertising. By 1985, magazine advertising revenue totaled \$4.92 billion, reflecting 153,000 ad pages. Payment for full-page color editorial illustrations was down to \$1,300, and a page of advertising still earned about \$5,000.

By 1999, advertising revenue exceeded \$15.5 billion, covering more than 255,000 advertising pages. Circulation was over 400 million. However, illustrators were still getting between \$500 and \$2,000 for a color editorial page and between \$2,000 and \$6,000 for a page of advertising. In 1935, artists could buy land and a house with one advertising assignment. Today, the taxes for that house might just be covered.

INSPIRATIO

Historical Overview

Outlets and usage have mushroomed over the past 70 years, yet reimbursement has not. At the same time that the demand for art of all kinds is escalating—as an essential component of sales, persuasion, and education—there is less and less respect for its practitioners. Working conditions are becoming more onerous. Not only is the artist expected to jump to fulfill quicker turnaround times, but there is also an epidemic of inappropriate requests for uncompensated rights.

This historical overview is not intended to drive contemporary artists to cut their mouse cords in despair. Rather it is intended to encourage illustrators and designers to evaluate the true worth of their work and seek it aggressively. The growth of demand—and of new markets on the Internet and in other digital and interactive media—suggests that a permanent downward slide is not inevitable. The value of intellectual property has ballooned as markets have gone global. United States copyright and information-related industries account for more than 5 percent of the gross national product and return a trade surplus of more than \$1 billion per year. Since 1977 the copyright industries' share of the gross domestic product has grown more than twice as fast as the rest of the economy and employment in copyright industries more than doubled, increasing nearly three times as fast as the annual rate of the whole economy.

At the same time that artists are making persistent, concerted efforts to educate clients about the true value of what they do, more clients are learning that customers are less convinced by or receptive to clip art. It behooves—and benefits—clients to see artists as partners in creating their message, while treating artists with the respect and rewards their work deserves.

Overview

Illustrators are graphic artists who create artwork for any number of different markets. Most illustrators are freelancers (independent contractors) who maintain their own studios and work for a variety of clients, as compared with salaried staff artists working for one employer. Some fields in which illustrators are usually hired as staff include animation, comic books, greeting cards, and clip art production houses. While some freelance illustrators hire representatives or agents who promote their work to art buyers, many do their own promotion and marketing. (For a thorough discussion of artist's representatives, see Chapter 1, Professional Relationships.)

Illustrators use a variety of traditional and new techniques and tools, including pen and ink, airbrush, acrylic and oil painting, watercolor, collage, multidimensional structures, and computers. Most have a signature style, while some are sought for their versatility. Illustrators are responsible for knowing the technical requirements of color separation and printing, including trapping and other production technologies, that are necessary to maintain the quality of the final printed piece (see Chapter 4, Technology Issues).

Original or specially commissioned illustration is sold primarily on the basis of usage and reproduction rights, but other factors are important (see Chapter 5, Essential Business Practices). Original artwork, unless sold separately, usually remains the property of the illustrator.

Usage rights are generally sold according to the client's needs. Other uses for a work may be sold to other clients as long as they are noncompetitive or do not compromise the commissioning client's market. Clients that manage their businesses well only buy rights particular to the project, as it is uneconomical to pay for additional rights that are not needed and that will not be used.

The data reported in all the charts in this chapter reflect usual and customary fees based upon presentation of three to five sketches, completion of finished art within a reasonable deadline, and unlimited use within the specified media, if applicable, for one year from date of first placement (unless specified otherwise). Current data indicate that, where applicable, an additional 25 percent is added for each color overlay in addition to black. Reimbursable and out-of-pocket expenses are billed separately.

Advertising Illustration

Illustrators are hired to provide visuals for products or services for specific advertising needs. The illustrator's first contact in this market is usually an art buyer, who receives and solicits portfolios and often, especially in the larger agencies, remains the primary conduit for the flow of work. For creative guidance, however, illustrators usually work with art directors, account executives, copywriters, and heads of the agency's creative group. The terms and fee for the art are normally negotiated with the agency's art buyer or art director by the illustrator or the artist's representative.

Premium prices for illustration are paid in the advertising field, where the highest degree of professionalism and performance is expected from artists working within unusually strict time demands. Advertising illustration prices are negotiated strictly on a use basis, with extra pay added for the sale of residual or all rights, complexity of style, or extra-tight deadlines.

Advertisements are usually thought of in terms of the number of times they run. Therefore, sale of usage rights may refer to limited or unlimited use in a specific media and geographic area within a specified time period; for example, they may be "limited to one to five insertions in consumer magazines in the United States for one year." The media, distribution area, and time period for which advertising rights are being sold should be clearly defined and the price agreed upon before the project starts.

Agencies expect illustrators to work in a specific style represented in their portfolios and to follow a sketch supplied by the agency and approved by the client. However, changes and last-minute alterations are not uncommon, since many advertisements are created by committee and illustrators may need to please several people of varying opinions. Many illustrators set fees that include a finite number and type of alterations, such as reasonable revision." Additional, "one especially significant, changes necessitate additional charges. However, artists tend to be flexible, giving valued and responsible clients some leeway.

Trade practices

The following trade practices have been used historically, and through such tradition are accepted as standard:

- **1**. The intended use of the art must be stated clearly in a contract, purchase order, or letter of agreement stating the price and terms of sale.
- Artists normally sell rights to one to five insertions of their artwork within a given medium and a given market for one year from date of first use, unless otherwise stated.
- 3. The artwork cannot be altered in any way, except for what occurs during the normal printing process, without the written consent of the artist. Since it is very easy to alter art electronically these days, the client should inform the artist if he or she wishes to alter the artwork and then do so only with the permission and supervision of the illustrator. Anything less is a violation of professional good faith and ethical practice.
- 4. Return of original artwork "unaltered and undamaged except for normal use and wear" to the artist is automatic unless otherwise negotiated. The advertising agency must be responsible for the art while it is in its possession; the artist should place a value on the artwork to cover loss or damage.
- 5. If artwork is to be used for something other than its original purpose, such as for an electronic database or a Web site, that price is usually negotiated as soon as possible. Note that the secondary use of an illustration may be of greater value than the primary use. Although there is no set formula for reuse fees, current surveys indicate that artists add a reuse fee ranging from 50 to 100 percent of the fee that would have been charged had the illustration been commissioned for the new use.
- **6.** Illustrators should negotiate reuse arrangements with the original commissioning party with speed, efficiency, and all due respect to the client's position.

- 7. Historically, artists have charged higher fees for rush work than those listed here, often by an additional 25 to 75 percent
- 8. If the illustrator satisfies the client's requirements and the finished work is still not used, full compensation should be made. However, historically, if a job is canceled after the work is begun, through no fault of the artist, a cancellation or kill fee is often provided. Depending upon the stage at which the job is terminated, the fee must cover all work done, including research time, sketches, billable expenses, and compensation for lost opportunities resulting from the artist's refusing other offers in order to make time available for the commission. In addition, clients who put commissions on hold or withhold approval for commissions for longer than 30 days should secure the assignment by paying a deposit up front.
- 9. Historically, a rejection fee has been agreed upon if the assignment is terminated because the preliminary or finished work is found to be not reasonably satisfactory and steps to correct the problem have been exhausted. The rejection fee for finished work often has been over 50 percent of the full price, depending upon the reason for rejection and the complexity of the job. When the job is rejected at the sketch stage, current surveys indicate the customary fee is 20 to 50 percent of the original price. This fee may be less for quick, rough sketches and more for highly rendered, time-consuming work.
- 10. Artists considering working on speculation assume all risks, and should evaluate them carefully when offered such arrangements. For a thorough discussion of the risks, see the Speculation section in Chapter 3, Professional Issues.
- 11. The Graphic Artists Guild is unalterably opposed to the use of work-for-hire contracts, in which authorship and all rights that go with it are transferred to the commissioning party and the independent artist is treated as an employee for copyright purposes only. The independent artist receives no employee benefits and loses the right to claim authorship or to profit from future use of the work forever. In the Guild's view, advertising is not eligible to be work for hire, as it does not fall under any of the eligible categories defined in the law. Additional information on work for hire can be found in Chapter 2, Legal Rights and Issues.
- 12. Customary and usual out-of-pocket expenses such as props, costumes, model fees, travel costs, production costs, shipping, picture reference, and consultation time are billed to the client separately. An expense estimate is usually included in the original written agreement or as an amendment to the agreement.

All prices for illustration in this book are based on a survey of the United States and Canada that was reviewed by a special committee of experienced professionals through the Graphic Artists Guild. These figures, reflecting the responses of established professionals, are meant as a point of reference only and do not necessarily reflect such important factors as deadlines; job complexity; reputation and experience of a particular illustrator; research; technique or unique quality of expression; and extraordinary or extensive use of the finished art. (See related material in other sections of this book, especially in Chapter 5, Essential Business Practices, and Chapter 13, Standard Contracts and Business Tools.)

The price ranges in the following charts do not reflect any of the above considerations and do not constitute specific prices for particular jobs. The buyer and seller are free to negotiate, with each artist independently deciding how to price the work, after taking all factors into account.

Comparative	Fees	for	Advertising	Illustration
-------------	------	-----	-------------	--------------

		Color
	B/W or 1 color	
	r's Digest, People) or nat	\$3,000-\$6,500
Spread	\$2,000-\$4,000	\$2,000-\$6,000
Full page	\$1,500-\$2,500	
Half page	\$1,000-\$2,000	\$1,500-\$3,000
Quarter page	\$750-\$1,500	\$1,000-\$2,000
Spot	\$500-\$1,000	\$750-\$1,500
		hly) or medium circulation
Spread	\$2,000-\$3,000	\$2,500-\$5,000
Full page	\$1,500-\$2,500	\$2,000-\$4,000
Half page	\$1,000-\$2,000	\$1,000-\$2,500
Quarter page	\$500-\$1,200	\$750-\$1,500
Spot	\$400-\$1,000	\$600-\$1,200
Single-interest (Fly Fish	ing, Scientific American) or small circulation
Spread	\$1,500-\$2,000	\$2,000–\$3,000
Full page	\$1,000-\$2,000	\$1,000-\$2,000
Half page	\$600-\$1,200	\$750-\$2,000
Quarter page	\$500-\$750	\$500-\$1,500
Spot	\$250-\$750	\$300–\$800
		Color
Advertorials (inserts/outsert	ts)	Color
Advertorials (inserts/outsert	ts) B/W or 1 color	Color tional circulation \$2,000–\$6,000
Advertorials (inserts/outsert	B/W or 1 color er's Digest, People) or na	Color tional circulation \$2,000–\$6,000 \$2,000–\$6,000
Advertorials (inserts/outsert General-interest <i>(Reade</i> Opener/cover	B/W or 1 color er's Digest, People) or na \$1,500–\$2,000	Color tional circulation \$2,000–\$6,000
Advertorials (inserts/outsert General-interest (<i>Reade</i> Opener/cover Spread	B/W or 1 color er's Digest, People) or na \$1,500–\$2,000 \$1,500–\$2,000	Color tional circulation \$2,000–\$6,000 \$2,000–\$6,000
Advertorials (inserts/outsert General-interest <i>(Reade</i> Opener/cover Spread Full page	B/W or 1 color er's Digest, People) or na \$1,500–\$2,000 \$1,500–\$2,000 \$750–\$1,500	Color tional circulation \$2,000–\$6,000 \$2,000–\$6,000 \$1,500–\$3,000
Advertorials (inserts/outsert General-interest (<i>Reade</i> Opener/cover Spread Full page Half page Quarter page Spot	B/W or 1 color er's Digest, People) or na \$1,500–\$2,000 \$1,500–\$2,000 \$750–\$1,500 \$500–\$1,000 \$500–\$1,000 \$300–\$750	Color tional circulation \$2,000-\$6,000 \$1,500-\$6,000 \$1,500-\$3,000 \$1,000-\$2,000 \$750-\$1,500 \$500-\$1,000
Advertorials (inserts/outsert General-interest (<i>Reade</i> Opener/cover Spread Full page Half page Quarter page Spot	B/W or 1 color er's Digest, People) or na \$1,500–\$2,000 \$1,500–\$2,000 \$750–\$1,500 \$500–\$1,000 \$500–\$1,000 \$300–\$750	Color tional circulation \$2,000-\$6,000 \$1,500-\$3,000 \$1,000-\$2,000 \$750-\$1,500 \$500-\$1,000 *500-\$1,000
Advertorials (inserts/outsert General-interest (<i>Reade</i> Opener/cover Spread Full page Half page Quarter page Spot	B/W or 1 color er's Digest, People) or na \$1,500–\$2,000 \$1,500–\$2,000 \$750–\$1,500 \$500–\$1,000 \$500–\$1,000 \$300–\$750	Color tional circulation \$2,000-\$6,000 \$1,500-\$6,000 \$1,500-\$3,000 \$1,000-\$2,000 \$750-\$1,500 \$500-\$1,000
Advertorials (inserts/outserf General-interest (Reade Opener/cover Spread Full page Half page Quarter page Spot Special-interest (The Ne	B/W or 1 color er's Digest, People) or na \$1,500–\$2,000 \$1,500–\$2,000 \$750–\$1,500 \$500–\$1,000 \$500–\$1,000 \$300–\$750 ew Yorker, Atlantic Mont	Color tional circulation \$2,000-\$6,000 \$1,500-\$3,000 \$1,000-\$2,000 \$750-\$1,500 \$500-\$1,000 *500-\$1,000
Advertorials (inserts/outserf General-interest (<i>Reade</i> Opener/cover Spread Full page Half page Quarter page Spot Special-interest (<i>The No</i> Opener/cover	B/W or 1 color er's Digest, People) or na \$1,500-\$2,000 \$1,500-\$2,000 \$750-\$1,500 \$500-\$1,000 \$500-\$1,000 \$300-\$750 ew Yorker, Atlantic Mont \$1,200-\$2,000	Color tional circulation \$2,000–\$6,000 \$1,500–\$3,000 \$1,000–\$2,000 \$750–\$1,500 \$500–\$1,000 * <i>hly)</i> or medium circulation \$1,800–\$4,500
Advertorials (inserts/outserf General-interest (Reade Opener/cover Spread Full page Half page Quarter page Spot Special-interest (The No Opener/cover Spread	B/W or 1 color er's Digest, People) or na \$1,500-\$2,000 \$1,500-\$2,000 \$750-\$1,500 \$500-\$1,000 \$500-\$1,000 \$300-\$750 ew Yorker, Atlantic Mont \$1,200-\$2,000 \$1,000-\$2,000	Color tional circulation \$2,000-\$6,000 \$2,000-\$6,000 \$1,500-\$3,000 \$1,000-\$2,000 \$750-\$1,500 \$500-\$1,500 \$500-\$1,000 thly) or medium circulation \$1,800-\$4,500 \$1,800-\$3,500
Advertorials (inserts/outsert General-interest (Reade Opener/cover Spread Full page Half page Quarter page Spot Special-interest (The No Opener/cover Spread Full page	B/W or 1 color er's Digest, People) or na \$1,500-\$2,000 \$1,500-\$2,000 \$750-\$1,500 \$500-\$1,000 \$500-\$1,000 \$300-\$750 ew Yorker, Atlantic Mont \$1,200-\$2,000 \$1,000-\$2,000	Color tional circulation \$2,000-\$6,000 \$1,500-\$3,000 \$1,000-\$2,000 \$750-\$1,500 \$500-\$1,000 \$750-\$1,000 \$1,800-\$4,500 \$1,800-\$3,500 \$1,200-\$2,500
Advertorials (inserts/outserf General-interest (Reade Opener/cover Spread Full page Half page Quarter page Spot Special-interest (The No Opener/cover Spread Full page Half page	B/W or 1 color er's Digest, People) or na \$1,500-\$2,000 \$750-\$1,500 \$500-\$1,000 \$500-\$1,000 \$300-\$750 ew Yorker, Atlantic Mont \$1,200-\$2,000 \$1,000-\$2,000 \$1,000-\$2,000 \$750-\$1,000	Color tional circulation \$2,000-\$6,000 \$1,500-\$3,000 \$1,000-\$2,000 \$750-\$1,500 \$500-\$1,000 \$500-\$1,000 \$1,800-\$4,500 \$1,800-\$3,500 \$1,200-\$2,500 \$1,000-\$2,000
Advertorials (inserts/outserf General-interest (<i>Reade</i> Opener/cover Spread Full page Quarter page Spot Special-interest (<i>The No</i> Opener/cover Spread Full page Half page Quarter page Spot	B/W or 1 color er's Digest, People) or na \$1,500-\$2,000 \$1,500-\$2,000 \$750-\$1,500 \$500-\$1,000 \$300-\$750 ew Yorker, Atlantic Mont \$1,200-\$2,000 \$1,000-\$2,000 \$1,000-\$2,000 \$750-\$1,000 \$500-\$750	Color tional circulation \$2,000-\$6,000 \$1,500-\$3,000 \$1,500-\$3,000 \$750-\$1,500 \$500-\$1,000 \$500-\$1,000 \$1,800-\$4,500 \$1,800-\$3,500 \$1,200-\$2,500 \$1,000-\$2,000 \$500-\$1,000 \$350-\$750
Advertorials (inserts/outserf General-interest (<i>Reade</i> Opener/cover Spread Full page Quarter page Spot Special-interest (<i>The No</i> Opener/cover Spread Full page Half page Quarter page Spot	B/W or 1 color er's Digest, People) or na \$1,500-\$2,000 \$1,500-\$2,000 \$750-\$1,500 \$500-\$1,000 \$500-\$1,000 \$300-\$750 ew Yorker, Atlantic Mont \$1,200-\$2,000 \$1,000-\$2,000 \$1,000-\$2,000 \$1,000-\$2,000 \$250-\$1,000 \$250-\$1,000 \$250-\$2,000	Color tional circulation \$2,000-\$6,000 \$1,500-\$3,000 \$1,500-\$3,000 \$750-\$1,500 \$500-\$1,000 \$500-\$1,000 \$1,800-\$4,500 \$1,800-\$3,500 \$1,200-\$2,500 \$1,000-\$2,000 \$500-\$1,000 \$350-\$750
Advertorials (inserts/outserf General-interest (Reade Opener/cover Spread Full page Half page Quarter page Spot Special-interest (The No Opener/cover Spread Full page Half page Quarter page Spot Single-interest (Fly Fish	B/W or 1 color er's Digest, People) or na \$1,500-\$2,000 \$1,500-\$2,000 \$750-\$1,500 \$500-\$1,000 \$300-\$750 ew Yorker, Atlantic Mont \$1,200-\$2,000 \$1,000-\$2,000 \$1,000-\$2,000 \$500-\$750 \$250-\$500 aning, Scientific American	Color tional circulation \$2,000-\$6,000 \$1,500-\$3,000 \$1,000-\$2,000 \$750-\$1,500 \$500-\$1,000 \$500-\$1,000 \$1,800-\$4,500 \$1,800-\$3,500 \$1,200-\$2,500 \$1,000-\$2,000 \$500-\$1,000 \$350-\$750
Advertorials (inserts/outserf General-interest (Reade Opener/cover Spread Full page Half page Quarter page Spot Special-interest (The No Opener/cover Spread Full page Half page Quarter page Spot Single-interest (Fly Fish Opener/cover	B/W or 1 color er's Digest, People) or na \$1,500-\$2,000 \$750-\$1,500 \$500-\$1,000 \$500-\$1,000 \$300-\$750 ew Yorker, Atlantic Mont \$1,200-\$2,000 \$1,000-\$2,000 \$1,000-\$2,000 \$500-\$750 \$250-\$500 ning, Scientific American \$1,000-\$1,500	Color tional circulation \$2,000-\$6,000 \$1,500-\$3,000 \$1,000-\$2,000 \$750-\$1,500 \$500-\$1,000 \$500-\$1,000 \$1,800-\$4,500 \$1,800-\$3,500 \$1,200-\$2,500 \$1,200-\$2,500 \$1,000-\$2,500 \$350-\$750 c) or small circulation \$1,500-\$3,500
Advertorials (inserts/outserf General-interest (Reade Opener/cover Spread Full page Half page Quarter page Spot Special-interest (The No Opener/cover Spread Full page Half page Quarter page Spot Single-interest (Fly Fish Opener/cover Spread	B/W or 1 color er's Digest, People) or na \$1,500-\$2,000 \$1,500-\$2,000 \$750-\$1,500 \$500-\$1,000 \$300-\$750 ew Yorker, Atlantic Mont \$1,200-\$2,000 \$1,000-\$2,000 \$1,000-\$2,000 \$1,000-\$2,000 \$1,000-\$2,000 \$1,000-\$2,000 \$1,000-\$2,000 \$1,000-\$2,000 \$1,000-\$2,000 \$1,000-\$2,000 \$750-\$1,000 \$250-\$500 ning, Scientific American \$1,000-\$1,500 \$750-\$1,200	Color tional circulation \$2,000-\$6,000 \$2,000-\$6,000 \$1,500-\$3,000 \$1,500-\$3,000 \$750-\$1,500 \$500-\$1,000 \$500-\$1,000 \$1,800-\$4,500 \$1,800-\$4,500 \$1,800-\$2,500 \$1,200-\$2,500 \$1,000-\$2,000 \$500-\$1,000 \$350-\$750 c) or small circulation \$1,500-\$3,500 \$1,000-\$3,500

Business magazines [□]			
	B/W or 1 color	Color	
General (<i>Business Wee</i>	<i>k, Fortune, Forbes)</i> or la	rge circulation	
Spread	\$2,000-\$4,000	\$3,000-\$5,500	
Full page	\$1,500-\$3,000	\$2,000-\$4,000	
Half page	\$1,000-\$2,000	\$1,500-\$3,000	
Quarter page	\$750-\$1,700	\$1,000-\$2,000	
Spot	\$500-\$1,200	\$750-\$1,200	
Trade <i>(Convene, Institu</i>	<i>tional Hospitals)</i> or med	ium circulation	
Spread	\$1,500-\$2,500	\$2,500-\$5,500	
Full page	\$1,000-\$2,000	\$1,500-\$3,000	
Half page	\$750-\$1,500	\$1,000-\$2,500	
Quarter page	\$500-\$1,200	\$750-\$2,000	
Spot	\$500-\$1,000	\$500-\$1,500	
Professional (Architectu	<i>iral Record)</i> or small circ	ulation	
Spread	\$1,000-\$2,500	\$2,000-\$4,000	
Full page	\$1,000-\$2,000	\$1,500-\$3,000	
Half page	\$750-\$1,500	\$1,000-\$2,000	
Quarter page	\$500-\$1,000	\$750-\$1,500	
Spot	\$500-\$1,000	\$500-\$1,000	
General (Business Wee	B/W or 1 color k, Fortune, Forbes) or la	Color ge circulation	
Opener/cover	\$1,000-\$1,500	\$3,000–\$6,000	
Spread	\$750-\$1,200	\$2,000-\$4,500	
Full page	\$500-\$1,000	\$1,500-\$3,500	
Half page	\$300-\$750	\$1,000-\$2,500	
Quarter page	\$300-\$750	\$750-\$2,000	
Spot	-	\$500–\$1,000	
Frade (Convene, Institut	<i>tional Hospitals)</i> or medi	um circulation	
Opener/cover	\$1,500-\$3,000	\$1,500-\$4,000	
Spread	\$1,000-\$2,000	\$1,000-\$3,500	
Full page	\$750-\$1,000	\$750-\$3,000	
Half page	\$500-\$1,000	\$500-\$2,000	
Quarter page	\$250-\$500	\$250–\$1,000	
Spot	\$250-\$500	\$200–\$750	
Professional (Architectu	<i>Iral Record)</i> or small circ	ulation	
Opener/cover	\$1,000-\$1,500	\$2,000-\$3,500	
Spread	\$500-\$1,000	\$2,000–\$3,000	
Full page	\$300-\$800	\$1,500-\$2,500	
	\$250-\$600	\$1,000-\$2,000	
Half page	+		
Half page Quarter page	\$250-\$500	\$500-\$1,000	

[235]

Comparative Fees for Advertising Illustration continued				
Newspapers				
	B/W or 1 color	Color		
National or major metro				
Spread	\$2,500-\$3,500	\$2,500-\$6,500		
Full page	\$1,200-\$3,500	\$1,500-\$4,500		
Half page	\$1,000-\$2,500	\$1,000-\$3,000		
Quarter page	\$750-\$2,000	\$1,000-\$2,000		
Spot	\$500-\$1,500	\$500-\$1,500		
Midsize metro				
Spread	\$1,500-\$3,000	\$2,000-\$5,000		
Full page	\$1,000-\$2,500	\$1,500-\$4,000		
Half page	\$750-\$2,000	\$1,000-\$2,500		
Quarter page	\$500-\$1,500	\$750-\$1,750		
Spot	\$500-\$1,000	\$500-\$1,000		
Small metro				
Spread	\$1,000-\$2,000	\$1,500-\$3,500		
Full page	\$750-\$1,750	\$1,000-\$2,500		
Half page	\$500-\$1,500	\$1,000-\$1,750		
Quarter page	\$350-\$1,000	\$1,000-\$1,500		
Spot	\$300-\$750	\$500-\$800		
Weekly				
Spread	\$1,000-\$2,000	\$1,000-\$2,000		
Full page	\$500-\$1,500	\$750-\$1,750		
Half page	\$500-\$1,000	\$500-\$1,500		
Quarter page	\$300-\$750	\$500-\$1,000		
Spot	\$200-\$550	\$350-\$700		
Magazine Supplements				
	B/W or 1 Color	Color		
National or major metro				
Spread	\$2,000-\$3,500	\$2,000-\$5,500		
Full page	\$1,500-\$2,750	\$1,500-\$3,500		
Half page	\$1,000-\$2,000	\$1,000-\$3,000		
Quarter page	\$750-\$1,500	\$1,000-\$2,000		
Spot	\$500-\$1,000	\$750-\$1,500		
Midsize metro				
Spread	\$1,500-\$3,000	\$1,700-\$4,500		
Full page	\$1,000-\$2,500	\$1,500-\$3,500		
Half page	\$750-\$1,750	\$800-\$2,500		
Quarter page	\$500-\$1,200	\$750-\$1,750		
Spot	\$500-\$1,000	\$500-\$1,200		

	Newspape	rs continued	
Magazine Supplements cont			
	B/W or 1 color	Color	
Small metro			
Spread	\$1,200-\$2,000	\$1,200-\$4,000	
Full page	\$750-\$2,000	\$1,000-\$2,500	
Half page	\$500-\$1,500	\$600-\$1,700	
Quarter page	\$500-\$1,000	\$750-\$1,200	
Spot	\$350-\$750	\$500-\$1,000	
Weekly			
Spread	\$1,000-\$1,700	\$1,000-\$3,000	
Full page	\$500-\$1,500	\$500-\$1,750	
Half page	\$500-\$1,000	-	
Quarter page	\$400-\$800	\$300-\$1,000	
Spot	\$300-\$600	\$250-\$750	
Advertorials (inserts/outsert	s)		
	B/W or 1 color	Color	
National or major metro			
Opener/cover	\$1,200-\$1,600	\$2,000-\$4,500	
Spread	\$1,000-\$1,500	\$1,200-\$4,000	
Full page	\$750-\$1,200	-	
Half page	\$600-\$1,000	\$600-\$1,000	
Quarter page	\$300-\$1,000	\$400-\$750	
Spot	\$200-\$500	\$200-\$500	
Midsize metro			
Opener/cover	-	\$1,000-\$2,000	
Spread	\$750-\$1,250	\$1,000-\$1,750	
Full page	\$500-\$1,000	-	
Half page	\$400-\$750	\$500-\$1,000	
Quarter page	\$200-\$500	\$300-\$600	
Spot	\$200-\$400	\$300-\$600	
Small metro			
Opener/cover	\$600-\$1,000	\$600-\$1,000	
Spread	\$750-\$1,000	-	
Full page	\$300-\$750	\$300-\$600	
Half page	\$250-\$500	\$300-\$600	
Quarter page	\$200-\$500	\$200-\$500	
Spot	\$150-\$500	\$200-\$400	
Weekly			
Opener/cover	\$500-\$1,000	\$500-\$1,000	
Spread	\$500-\$1,200	\$500-\$1,000	
Full page	\$400-\$1,000	\$400-\$1,000	
Half page	\$250-\$750	\$250-\$750	
Quarter page	\$150-\$400	\$150-\$400	
Spot	\$150-\$400	\$150-\$400	

continued...

Product and Service Catalog			
	B/W or 1 color	Color	
Over 100,000 print run			
Cover	\$1,500-\$3,000	\$2,500-\$5,500	
Full page	\$1,000-\$2,200	\$1,500-\$4,000	
Half page	\$750-\$1,500	\$1,000-\$2,500	
Quarter page	\$500-\$1,200	\$750-\$1,500	
Spot	\$300-\$850	\$500-\$1,000	
10,000 to 100,000 print ru	ı		
Cover	\$1,200-\$2,500	\$2,200-\$3,700	
Full page	\$1,000-\$2,000	\$1,500-\$2,700	
Half page	\$650-\$1,200	\$750-\$2,000	
Quarter page	\$500-\$1,000	\$600-\$1,000	
Spot	\$250-\$700	\$400-\$750	
Under 10,000 print run			
Cover	\$1,000-\$2,000	\$1,300-\$2,500	
Full page	\$600-\$1,400	\$1,000-\$2,000	
Half page	\$400-\$1,000	\$650-\$1,500	
Quarter page	\$250-\$750	\$500-\$800	
Spot	\$150-\$600	\$300–\$600	
Press or Media Kit			
	B/W or 1 color	Color	х. Х
Extensive use			
Cover	\$1,500-\$4,000	\$2,500-\$5,000	
Full page	\$1,500-\$2,500	\$2,000-\$4,000	
Half page	\$1,000-\$2,000	\$1,500-\$3,000	
Quarter page	\$750-\$1,000	\$1,000-\$2,300	
Spot	\$500-\$800	\$600-\$1,200	
Limited use			
Cover	\$1,200-\$3,000	\$2,000-\$4000	
Full page	\$1,200-\$2,000	\$1,200-\$3,200	
Half page	\$750-\$1,300	\$1,000-\$2,300	
Quarter page	\$600-\$1,000	\$600-\$1,600	

Comparati	ve Fees for Adve	rtising Illustration continued
	Collatera	continued
Brochures (81/2"x 11" or 6" x 9")		
	B/W or 1 color	Color
Over 100,000 print run		
Cover	\$1,000-\$2,500	\$2,000-\$5,000
Full page	\$850-\$2,000	\$1,500–\$4,000
Half page	\$650-\$1,400	\$1,000–\$2,500
Quarter page	\$500-\$1,000	\$800-\$1,500
Spot	\$400-\$850	\$500-\$1,000
10,000 to 100,000 print run		
Cover	\$1,000-\$2,000	\$2,000-\$4,000
Full page	\$700-\$1,800	\$1,500-\$3,000
Half page	\$500-\$1,200	\$750-\$2,000
Quarter page	\$500-\$850	\$600–\$800
Spot	\$400-\$700	\$400-\$800
Under 10,000 print run		
Cover	\$600-\$1,500	\$1,500-\$3,000
Full page	\$500-\$1,400	\$1,000-\$2,200
Half page	\$400-\$1,000	\$600-\$1,600
Quarter page	\$250-\$800	\$500-\$800
Spot	\$250-\$600	\$300–\$700
Adslick/Flyer		
Over 100,000 print run	B/W or 1 Color	Color
Cover	\$1,000-\$2,200	\$2,000-\$4,000
Full page	\$850-\$2,000	\$1,500-\$4,000
Half page	\$650-\$1,500	\$1,000-\$2,400
Quarter page	\$500-\$1,200	\$700-\$2,000
Spot	\$300-\$850	\$400-\$1,500
10,000 to 100,000 print run		+···· +·/···
Cover	\$850-\$2,000	\$1,500-\$3,000
Full page	\$600-\$1,800	\$1,200-\$3,000
Half page	\$500-\$1,400	\$750-\$2,000
Quarter page	\$400-\$1,000	\$500-\$1,500
Spot	\$300-\$850	\$300-\$1,200
Under 10,000 print run		+ • • • • • •
Cover	\$700-\$1,600	\$1,000-\$2,500
Full page	\$500-\$1,400	\$500-\$2,000
Half page	\$500-\$1,200	\$400-\$1,500
Quarter page	\$300-\$900	\$300-\$1,200
Spot	\$200-\$750	\$300-\$800
		nued

	Collatoral	continued
Direct Response Mailers	Collateral	continued
	B/W or 1 Color	Color
Over 100,000 print run	-,	
Cover	\$1,200-\$2,000	\$2,500-\$3,300
Full page	\$1,000-\$2,000	\$2,000-\$2,600
Half page	\$750-\$1,500	\$1,400-\$2,200
Quarter page	\$500-\$1,000	\$1,000-\$1,500
Spot	\$400-\$850	\$700-\$1,000
10,000 to 100,000 print r	un	
Cover	\$1,000-\$2,000	\$2,000-\$2,600
Full page	\$800-\$2,000	\$1,500-\$2,500
Half page	\$600-\$1,250	\$1,000-\$1,200
Quarter page	\$500-\$1,000	\$800-\$1,200
Spot	\$400-\$700	\$500–\$75
Under 10,000 print run		
Cover	\$750-\$1,500	\$1,500-\$2,200
Full page	\$500-\$1,500	\$1,000-\$2,000
Half page	\$400-\$1,000	\$800-\$1,500
Quarter page	\$300-\$800	\$600-\$1,000
Spot	\$300-\$600	\$300-\$1,100
	Displays	& exhibits
Large Client		
	B/W or 1 color	Color
One year trade show lice	ense	
Walls	\$750-\$3,000	\$1,500–\$8,500
Banners	\$1,500–\$3,000	-
Booth surfaces	-	\$1,750–\$5,000
Poster	-	\$2,000-\$4,000
Floor display	-	\$1,000-\$3,500
Tabletop	\$750-\$1,750	\$1,000-\$3,000
Single trade show		
Walls	\$500-\$2,500	\$1,500-\$7,000
Banners	\$750-\$2,500	\$1,500-\$3,000
Booth surfaces	-	\$1,000-\$3,500
Poster	\$1,500-\$2,500	\$2,000-\$5,500
Floor display	\$1,000-\$2,200	\$1,000-\$3,000
Tabletop	\$750-\$1,500	\$750-\$2,500

	Displays & ex	hibits continued
Small Client	. ,	
	B/W or 1 color	Color
One year trade show lice		
Walls	\$500-\$2,500	\$1,200-\$7,000
Banners	\$1,000-\$2,200	\$1,000-\$3,200
Booth surfaces	-	\$1,750-\$3,200
Poster	\$1,000–\$1,750	\$1,000-\$5,000
Floor display	\$500-\$2,000	\$500-\$2,000
Tabletop	\$500-\$1,500	\$750–\$2,000
Single trade show		
Walls	\$150-\$2,000	\$500–\$3,500
Banners	\$500-\$1,750	\$750-\$3,000
Booth surfaces	-	\$750-\$2,500
Poster	\$750-\$1,500	\$1,000-\$3,000
Floor display	\$300-\$1,500	\$500-\$2,000
Tabletop	\$500-\$1,000	\$500-\$1,500
Interior display Window display	\$1,200–\$2,500 -	- \$1,000-\$2,500
Point of Sale		
Extensive use	B/W or 1 color	Color
Floor display	\$400-\$2,800	\$1,000–\$6,000
	\$800-\$4,500	\$0,000 \$5,000
Posters	\$600-\$4,500	\$2,000-\$5,000
Posters Shopping bags	\$1,000-\$4,500	\$2,500-\$5,000 \$2,500-\$3,500
Shopping bags	\$1,000-\$4,500	\$2,500-\$3,500
Shopping bags Banners	\$1,000–\$4,500 \$300–\$2,500	\$2,500-\$3,500 \$800-\$4,000
Shopping bags Banners Counter display	\$1,000–\$4,500 \$300–\$2,500 \$400–\$4,300	\$2,500-\$3,500 \$800-\$4,000 \$1,500-\$5,000
Shopping bags Banners Counter display Shelf sign	\$1,000–\$4,500 \$300–\$2,500 \$400–\$4,300 \$300–\$1,500	\$2,500-\$3,500 \$800-\$4,000 \$1,500-\$5,000 \$500-\$2,000
Shopping bags Banners Counter display Shelf sign Counter card Limited use	\$1,000-\$4,500 \$300-\$2,500 \$400-\$4,300 \$300-\$1,500 \$530-\$2,200	\$2,500-\$3,500 \$800-\$4,000 \$1,500-\$5,000 \$500-\$2,000 \$1,000-\$3,000
Shopping bags Banners Counter display Shelf sign Counter card Limited use floor display	\$1,000-\$4,500 \$300-\$2,500 \$400-\$4,300 \$300-\$1,500 \$530-\$2,200 \$200-\$2,100	\$2,500-\$3,500 \$800-\$4,000 \$1,500-\$5,000 \$500-\$2,000 \$1,000-\$3,000 \$800-\$3,000
Shopping bags Banners Counter display Shelf sign Counter card Limited use floor display Posters	\$1,000-\$4,500 \$300-\$2,500 \$400-\$4,300 \$300-\$1,500 \$530-\$2,200 \$200-\$2,100 \$500-\$3,000	\$2,500-\$3,500 \$800-\$4,000 \$1,500-\$5,000 \$500-\$2,000 \$1,000-\$3,000 \$800-\$3,000 \$1,000-\$4,000
Shopping bags Banners Counter display Shelf sign Counter card Limited use floor display Posters Shopping bags	\$1,000-\$4,500 \$300-\$2,500 \$400-\$4,300 \$300-\$1,500 \$530-\$2,200 \$200-\$2,100 \$500-\$3,000 \$800-\$3,700	\$2,500-\$3,500 \$800-\$4,000 \$1,500-\$5,000 \$500-\$2,000 \$1,000-\$3,000 \$800-\$3,000 \$1,000-\$4,000 \$1,400-\$3,000
Shopping bags Banners Counter display Shelf sign Counter card Limited use floor display Posters Shopping bags Banners	\$1,000-\$4,500 \$300-\$2,500 \$400-\$4,300 \$300-\$1,500 \$530-\$2,200 \$200-\$2,100 \$500-\$3,000 \$800-\$3,700 \$200-\$1,800	\$2,500-\$3,500 \$800-\$4,000 \$1,500-\$5,000 \$500-\$2,000 \$1,000-\$3,000 \$800-\$3,000 \$1,000-\$4,000 \$1,400-\$3,000 \$500-\$2,500

continued...

Comparativ		
	Outo	loor
Bus, Car, & Transit Cars		
	B/W or 1 color	Color
Major campaign	¢0.000 ¢10.000	¢2 500 \$10 000
Large ad	\$2,000-\$10,000	\$2,500-\$10,000 \$2,000-\$7,000
Medium ad	\$1,500-\$7,000 \$1,000-\$5,000	\$2,000-\$7,000 \$1,500-\$5,000
Small ad	\$1,000-\$5,000	φ1,500-φ5,000
Regional campaign	¢1 500 ¢5 000	\$2,000-\$6,000
Large ad	\$1,500-\$5,000	
Medium ad	\$1,000-\$4,000	\$1,500-\$4,500
Small ad	\$500–\$3,000	\$1,000–\$4,000
Local campaign	¢1 000 ¢4 000	\$1,500-\$6,000
Large ad	\$1,000-\$4,000 \$750-\$2,000	\$1,000-\$2,700
Medium ad		\$600-\$2,000
Small ad	\$500-\$1,000	
that an additional 15% to 25% is	a were reported in 2000, i added for each color ove	igures are from 1997 edition.
that an additional 15% to 25% is Station/Kiosk Poster	added for each color ove \$2,000-\$3,500	igures are from 1997 edition. CC Current data indicate rlay in addition to black, and 25% for 3-D or extensions. \$2,500-\$5,500
that an additional 15% to 25% is Station/Kiosk Poster Major campaign	added for each color ove	rlay in addition to black, and 25% for 3-D or extensions.
that an additional 15% to 25% is Station/Kiosk Poster	added for each color ove \$2,000–\$3,500	rlay in addition to black, and 25% for 3-D or extensions. \$2,500–\$5,500
that an additional 15% to 25% is Station/Kiosk Poster Major campaign Regional campaign	added for each color ove \$2,000-\$3,500 \$1,500-\$3,000	rlay in addition to black, and 25% for 3-D or extensions. \$2,500–\$5,500 \$2,000–\$4,000
that an additional 15% to 25% is Station/Kiosk Poster Major campaign Regional campaign Local campaign	added for each color ove \$2,000-\$3,500 \$1,500-\$3,000	rlay in addition to black, and 25% for 3-D or extensions. \$2,500–\$5,500 \$2,000–\$4,000
that an additional 15% to 25% is Station/Kiosk Poster Major campaign Regional campaign Local campaign Outdoor Billboards (color)	added for each color ove \$2,000-\$3,500 \$1,500-\$3,000	rlay in addition to black, and 25% for 3-D or extensions. \$2,500–\$5,500 \$2,000–\$4,000
that an additional 15% to 25% is Station/Kiosk Poster Major campaign Regional campaign Local campaign Outdoor Billboards (color) Major national/regional	added for each color ove \$2,000–\$3,500 \$1,500–\$3,000 \$800–\$2,500	rlay in addition to black, and 25% for 3-D or extensions. \$2,500–\$5,500 \$2,000–\$4,000
that an additional 15% to 25% is Station/Kiosk Poster Major campaign Regional campaign Local campaign Outdoor Billboards (color) Major national/regional Over 40 installations	added for each color ove \$2,000-\$3,500 \$1,500-\$3,000 \$800-\$2,500 \$5,500-\$10,000	rlay in addition to black, and 25% for 3-D or extensions. \$2,500–\$5,500 \$2,000–\$4,000
that an additional 15% to 25% is Station/Kiosk Poster Major campaign Regional campaign Local campaign Outdoor Billboards (color) Major national/regional Over 40 installations 10–40 installations	added for each color ove \$2,000-\$3,500 \$1,500-\$3,000 \$800-\$2,500 \$5,500-\$10,000 \$4,500-\$8,500 \$2,500-\$8,000	rlay in addition to black, and 25% for 3-D or extensions. \$2,500–\$5,500 \$2,000–\$4,000
that an additional 15% to 25% is Station/Kiosk Poster Major campaign Regional campaign Local campaign Outdoor Billboards (color) Major national/regional Over 40 installations 10–40 installations 1–10 installations	added for each color ove \$2,000-\$3,500 \$1,500-\$3,000 \$800-\$2,500 \$5,500-\$10,000 \$4,500-\$8,500 \$2,500-\$8,000	rlay in addition to black, and 25% for 3-D or extensions. \$2,500–\$5,500 \$2,000–\$4,000
that an additional 15% to 25% is Station/Kiosk Poster Major campaign Regional campaign Local campaign Outdoor Billboards (color) Major national/regional Over 40 installations 10–40 installations 1–10 installations \$500 million to \$100 million	added for each color ove \$2,000-\$3,500 \$1,500-\$3,000 \$800-\$2,500 \$5,500-\$10,000 \$4,500-\$8,500 \$2,500-\$8,000 n	rlay in addition to black, and 25% for 3-D or extensions. \$2,500–\$5,500 \$2,000–\$4,000
that an additional 15% to 25% is Station/Kiosk Poster Major campaign Regional campaign Local campaign Outdoor Billboards (color) Major national/regional Over 40 installations 10–40 installations 1–10 installations \$500 million to \$100 million Over 40 installations	added for each color ove \$2,000-\$3,500 \$1,500-\$3,000 \$800-\$2,500 \$5,500-\$10,000 \$4,500-\$8,500 \$2,500-\$8,000 n \$5,000-\$9,000	rlay in addition to black, and 25% for 3-D or extensions. \$2,500–\$5,500 \$2,000–\$4,000
that an additional 15% to 25% is Station/Kiosk Poster Major campaign Regional campaign Local campaign Outdoor Billboards (color) Major national/regional Over 40 installations 10–40 installations \$500 million to \$100 million Over 40 installations \$500 million to \$100 million Over 40 installations	added for each color ove \$2,000-\$3,500 \$1,500-\$3,000 \$800-\$2,500 \$5,500-\$10,000 \$4,500-\$8,500 \$2,500-\$8,000 n \$5,000-\$9,000 \$4,000-\$8,000	rlay in addition to black, and 25% for 3-D or extensions. \$2,500–\$5,500 \$2,000–\$4,000
that an additional 15% to 25% is Station/Kiosk Poster Major campaign Regional campaign Local campaign Outdoor Billboards (color) Major national/regional Over 40 installations 10–40 installations \$500 million to \$100 million Over 40 installations 10–40 installations 10–40 installations	added for each color ove \$2,000-\$3,500 \$1,500-\$3,000 \$800-\$2,500 \$5,500-\$10,000 \$4,500-\$8,500 \$2,500-\$8,000 n \$5,000-\$9,000 \$4,000-\$8,000	rlay in addition to black, and 25% for 3-D or extensions. \$2,500–\$5,500 \$2,000–\$4,000
that an additional 15% to 25% is Station/Kiosk Poster Major campaign Regional campaign Local campaign Outdoor Billboards (color) Major national/regional Over 40 installations 10–40 installations \$500 million to \$100 million Over 40 installations 10–40 installations 10–40 installations 10–40 installations	added for each color ove \$2,000-\$3,500 \$1,500-\$3,000 \$800-\$2,500 \$5,500-\$10,000 \$4,500-\$8,500 \$2,500-\$8,000 \$5,000-\$9,000 \$4,000-\$8,000 \$2,300-\$8,000	rlay in addition to black, and 25% for 3-D or extensions. \$2,500–\$5,500 \$2,000–\$4,000

Comparative I	ees for Advertisin	ng Illustration con	tinued
A	nimated television	commercials	
	Complex	Simple	
Original design/development (30 sec.)	\$18,000-\$50,000	\$10,000-\$18,000	
Licensing of character (30 sec.)	\$12,000-\$25,000	\$7,500–\$15,000	
Styling of key frames (15 sec.)	\$10,000-\$20,000	\$5,000-\$11,000	
Styling of key frames (30 sec.)	\$25,000-\$40,000	\$15,000-\$30,000	
TV (per frame)	\$130-\$225	\$100-\$175	
	Motion picture p	oosters	
Major production (over \$5 milli	on)		
Produced poster	\$5,000-\$15,000		
Finished art unused	\$4,000-\$10,000		
Comp sketch only	\$500-\$4,000		
Limited production (under \$5 m	nillion)		
Produced poster	\$3,500-\$13,000		
Finished art unused	\$2,500-\$6,000		
Comp sketch only	\$400-\$3,500		
	Theater & event	posters	
	1 color	2–3 color	4 color
Large production			
Complex	\$1,000-\$2,500	\$2,000-\$5,000	\$3,000-\$8,000
Simple	\$750-\$1,500	\$1,000-\$2,500	\$1,500-\$5,000
Small production			
Complex	\$750-\$1,500	\$1,000-\$2,500	\$1,500-\$4,000
Simple	\$500-\$1,000	\$750-\$1,700	\$1,000-\$3,000

Additional Usage Fees for Advertis	ing Illustration
	Percentage of original fee
Sale of original art	15%–60%
Stock sale of existing art	40%-100%
Rush fee	25%-75%
Each color overlay in addition to black	20%–30%
Unlimited use in print media only; no time or geographical limits	60%–200%
Unlimited use, any media (including digital), for 1 year	40%–175%
Total copyright transfer (excluding original art)	100%–250%
Work-for-hire (transfer of legal authorship)	100%–275%

Preproduction (Comps, Animatics, Storyboards, TV & Audiovisual) Illustration

Artists who specialize in preproduction art service the advertising, television, and motion picture industries and usually are called upon to produce high-caliber professional work within tight deadlines. Although some artists tend to specialize, nearly all are engaged in three areas of preproduction art: comps (common abbreviation for "comprehensives"), storyboards, and animatics.

Comps are visual renderings of proposed advertisements and other printed promotional materials, usually consisting of a "visual" (a rendering of the illustration or photo to be used in the finished piece), headlines, and body text.

A storyboard is a visual presentation of a proposed television commercial, program, or feature film, using sequential frames. They are sometimes drawn on a telepad, which is a preprinted matrix with frames that are usually 23/4" x 33/4", although some agencies supply their own telepads in larger formats. In advertising, storyboards are generally used in-house (within an agency) to present the concept of the proposed commercial to the client. An important component of preproduction artwork in advertising is the "key" frame, a large single frame used with other frames to establish the overall mood or to portray the highlight or key moment of the commercial. The key frame must be given extra attention-and compensation-since it carries most of the narrative burden.

Storyboard renderings for feature films or television are used by producers to envision creative concepts and to evaluate a concept's visual qualities and continuity. Used most often as a reference to an accompanying script, the storyboards and text are filmed as a "photoplay," a critical element in determining a property's value as entertainment and as a visual production. Storyboards are the visual blueprint producers rely upon to budget and help avoid cost overruns. Artist fees for television or feature-film storyboards have historically been based on the production's budget and its intended distribution. Fees for high-budget productions, which usually require more complex storyboard renderings, generally have been higher than fees for low-budget productions. The break point between low- and high-budget television productions has been \$500,000, or for feature films, \$5 million.

Storyboards for motion picture and television features are generally blackand-white and emphasize camera angles and moves. Because a greater number of frames are generally produced for feature-length storyboards, the rendering style the most in demand is quick, clean, and realistic. Artists who do storyboards for motion picture and television features must work more closely with other members of the creative team than is customary in advertising preproduction. And it is not unusual for artists to scout locations or work on location.

An animatic is a limited-animation video using camera movements, a select number of drawings, some animation, and a sound track. An animatic is usually produced to test a proposed "spot" or TV commercial. The need for animatics has increased due to the demand for test marketing by advertisers. An animatic must "score" well on such things as audience recall to go into full production.

Video storyboards are also used frequently in other markets as well, especially motion pictures for television, because of the wider availability of relatively inexpensive video equipment. Video storyboards use only storyboard art (no moving parts), and movement is achieved with simple camera moves. Often a tighter style than normal is required, which many artists have used to explain fees that are approximately 25 percent higher than for regular storyboards.

Artists must know ahead of time whether film or videotape will be used, since each has its own special requirements. A good grasp of current TV commercial, film, and music-video styles is crucial to success in this field. Preproduction artists generally receive taped copies of their work from production houses so they can compile a reel of sample commercials for their portfolios.

Fees in this field historically have depended upon job complexity, including factors such as the degree of finish required, the number of subjects in a given frame, the type of background required, and the tightness of the deadline. In pricing animatics, one background illustration and one to one-and-one-half cut-out figures comprise one frame. Two figures and their moving parts can constitute one frame when backgrounds are used for several scenes.

Some agencies, production companies, producers, and individuals may request that artists sign nondisclosure or noncompete agreements to protect trade secrets and creative properties for specified periods. These conditions may restrict an artist's opportunities for future work; this is a factor that should be seriously considered when negotiating fees. Some agencies also request that artists work in-house, and that should be taken into account when establishing a fee. Rush work is traditionally billed at an average of 70 percent over the regular fee, but it ranges from 50 to 100 percent. Hourly rates, although rarely used, have ranged from \$75 to \$150 per hour. Flat per-frame rates more accurately reflect all the factors involved in the job, although hourly rates may be appropriate for consultation time if the artist participates in the design of the scene or sequences.

In some cases, a per-diem rate of \$600 to \$650 may be paid, when the artist works on site for extended periods. Be aware that these conditions may open an artist to reclassification as an employee rather than as an independent contractor; that may put the client and the artist at risk, depending on how the client treats the artist. If an artist does not serve any other clients, on-site work may endanger an artist's home office deduction. (See the Employment Issues section in Chapter 3, Professional Issues.)

A growing trend in large city markets is for advertising agencies to have exclusive contracts with artist's representatives and preproduction art studios in exchange for lower fees but more or less steady work. Artists who are not represented by a designated studio cannot work with a particular ad agency, regardless of past affiliations with art directors. Exclusive ad agency/studio contracts therefore force artists to work with a particular representative, thereby forfeiting a percentage of their income and jeopardizing the artist's status as an independent contractor. The consequent reduction in competition among studios and artists raises concerns about restraint-of-trade issues.

Another factor affecting ad agency practices is cost consultants: Many ad agency clients are retaining the services of consultants who control agency expenditures and seek to fix suppliers' fees. Artist suppliers are rarely able to negotiate directly with these cost consultants, but must work through the agencies. That puts pressure on artists to marshal a firm negotiating stance with agencies in order to maintain industry standards.

Trade practices

The following trade practices have been used historically, and through such tradition are accepted as standard:

- The intended use of the art must be stated clearly in a contract, purchase order, or letter of agreement stating the price and terms of sale.
- Return of original artwork to the artist is not automatic unless otherwise negotiated.
- Artists have historically sold all rights for preproduction work. Since this work is very product-specific (campaigns are often confidential, and the media used—say, markers—are fugitive, or impermanent), frames are almost never reusable. Higher

fees for this work have compensated for the loss of rights, though many art directors will return artwork for an artist's self-promotional use.

4. If artwork is to be used for anything other than its original purpose, such as for an electronic database or a Web site, the price is usually negotiated as soon as possible. Note that the secondary use of an illustration may be of greater value than the primary use. Although there is no set formula for reuse fees, current surveys indicate that artists add a reuse fee ranging from 20 to 100 percent of the fee that would have been charged had the illustration been commissioned for the new use.

9 Illustration Prices & Trade Customs

- Illustrators should negotiate reuse arrangements with the original commissioning party with speed, efficiency, and all due respect to the client's position.
- Historically, artists have charged higher fees for rush work than those listed here, often by an additional 50 to 100 percent.
- 7. If the artist satisfies the client's requirements and the finished work is still not used, full compensation should be made. However, historically, if a job is canceled after the work is begun, through no fault of the artist, a cancellation or kill fee is often provided. Depending upon the stage at which the job is terminated, the fee must cover all work done, including research time, sketches, billable expenses, and compensation for lost opportunities resulting from the artist's refusing other offers in order to make time available for the commission. In addition, clients who put commissions on hold or withhold approval for commissions for longer than 30 days should secure the assignment by paying a deposit up front.
- 8. Historically, a rejection fee has been agreed upon if the assignment is terminated because the preliminary or finished work is found to be not reasonably satisfactory and steps to correct the problem have been exhausted. The rejection fee for finished work often has been over 50 percent of the full price, depending upon the reason for rejection and the complexity of the job. When the job is rejected at the sketch stage, current surveys indicate the customary fee is 20 to 50 percent of the original price. This fee may be less for quick, rough sketches and more for highly rendered, time-consuming work.
- **9.** Artists considering working on speculation assume all risks, and should evaluate them carefully when offered such arrangements (for a thorough discussion of the risks, see the Speculation section in Chapter 3, Professional Issues).

- 10. The Graphic Artists Guild is unalterably opposed to the use of work-for-hire contracts, in which authorship and all rights that go with it are transferred to the commissioning party and the independent artist is treated as an employee for copyright purposes only. The independent artist receives no employee benefits and loses the right to claim authorship or to profit from future use of the work forever. Additional information on work for hire can be found in Chapter 2, Legal Rights and Issues.
- 11. Customary and usual expenses such as props, costumes, model fees, travel costs, production costs, and consultation time are billed to the client separately. An expense estimate should be included in the original written agreement or as an amendment to the agreement.

All prices for illustration in this book are based on a survey of the United States and Canada that was reviewed by a special committee of experienced professionals through the Graphic Artists Guild. These figures, reflecting the responses of established professionals, are meant as a point of reference only and do not necessarily reflect such important factors as deadlines, job complexity, reputation and experience of a particular illustrator, research, technique or unique quality of expression, and extraordinary or extensive use of the finished art. (See related material in other sections of this book, especially in Chapter 5, Essential Business Practices, and Chapter 13, Standard Contracts and Business Tools.)

The price ranges in the following chart do not reflect any of the above considerations and do not constitute specific prices for particular jobs. The buyer and seller are free to negotiate, with each artist independently deciding how to price the work, after taking all factors into account.

	Advertising	comps	
	Line	Tone	
Major campaign			
Spread	\$150-\$1,200	_	
Full page	\$150-\$800	\$175-\$1,200	
Minor campaign			
Spread	\$150-\$900	_	
Full page	\$100-\$550	\$200-\$500	
TV a	advertising test mark	eting (30-sec. spot)	
Animatics			
	Per frame		
5" x 7" (8" x 10" bleed)	\$75-\$275		
8" x 10" (11" x 14" bleed)	\$150-\$400		
Storyboards			
	Line	Tone	
Miniboards (1 ["] x 11/2")	-	\$25-\$125	
Telepads (21/4" x 31/4")	\$50-\$75	\$50-\$90	
4" × 5"	\$50-\$75	\$75-\$125	
5" x 7"	\$75-\$100	\$100-\$175	
8" x 10" key frame	\$125-\$200	\$150-\$300	
9" x 12" key frame	\$150-\$250	\$200-\$400	
Те	levision programmir	g (per frame)	
	Line	Tone	
Major production (over \$5 m	nillion budget)		
4" × 5"	\$40-\$70	\$50-\$85	
5" × 7"	\$50\$90	\$75-\$125	
Concept/key frame	\$100-\$120	\$150-\$300	
Minor production (under \$5	million budget)		
4" x 5"	\$25-\$65	\$35–\$80	
5" × 7"	\$85	\$100	
Concept/key frame	\$100	\$120-\$500	
	Film storyboards (p	per frame)	
	Line	Tone	
Major production (over \$5 m	nillion budget)		
2" × 5"	\$40	\$75	
4" × 10"	\$150	\$225	
8" × 20"	\$300	\$400	
Limited production (under \$	5 million budget)		
2" × 5"	\$35	\$60	
4" × 10"	\$80	\$110	
8"× 20"	\$200	\$300	

Onscreen Artwork in Motion Pictures, Television, & Video

The section Onscreen Artwork in Motion Pictures, Television, & Video is copyright © 2000 Greg Victoroff, Esq., and used with permission.

Producers of audiovisual works, including motion pictures or television or video programs, generally must obtain a license to use illustrations, drawings, paintings, or other two- or three-dimensional works of graphic or visual art as recognizable set decorations or props.

Licenses permitting the use of art in connection with a specific program, movie, or video can be obtained from either the artist or the artist's representative or gallery. According to recent survey responses, reuse fees or additional royalties are usually not paid for reruns of commercial television programs or when motion pictures are released on video or shown on commercial television.

Public broadcasting companies must pay royalties fixed by the Librarian of Congress for use of published pictorial and visual works in public television programs. Lower royalties are paid for "background" uses (less than full screen or lasting less than 3 seconds); higher royalties are required for "featured" uses (full screen for 3 seconds or more).

In the same surveys, license fees were generally set as either a flat fee or a rental fee, with more paid for a major use (3 seconds or more, full frame, or close-up) than for a minor use. License fees are also paid for background uses (less than 3 seconds or less than half of the work shown on screen). However, if the average lay observer cannot even discern the work in the background, the use may be considered "incidental" or "fair use," not requiring any payment or permission.

Surveys also reveal that flat fees for using art in a full-length feature motion picture, nationally broadcast video, television program, or commercial range from \$2,000 to \$10,000 for a major use and from \$1,000 to \$4,000 for a minor use. Rental fees range from 10 to 25 percent of the retail price of the art for each week (or part of a week) the art is used by the production company. Retroactive licenses in the above ranges are paid when art is inadvertently used without permission, and a reasonable sum is added (up to 100 percent or more of the license fee) if the services of an attorney are required.

Trade practices for artists creating on-screen artwork in motion pictures, television, and video follow the same general protocols as other areas of illustration.

	Flat fee
Major use (full frame or close-up, more than 10 sec.)	\$2,000-\$10,000
Minor use (2 to 10 sec.)	\$1,000-\$4,000
Additional usage fees for entertainment illustration	
	Percentage of original fee
Sale of original art	50%-200%
Unlimited use, any media (including digital), for 1 year	60%-180%
Total copyright transfer (excluding original art)	100%-200%

Corporate & Institutional Illustration

An illustrator creating corporate or institutional illustration works with a graphic designer, art director, or in-house personnel such as writers, advertising/marketing managers, or communication service directors to create visuals for annual reports, in-house publications, and other material targeted to internal or specific audiences. The assignment is generally editorial, and the illustrator is often called upon to determine the concept and design of the art. In annual reports particularly, illustrations are "think pieces" that contribute substantially to enhancing the corporation's or institution's public image.

Clients include both Fortune 500 and smaller companies as well as educational institutions, government agencies, and not-for-profit groups and associations that organize for purposes other than private profit. However, this does not mean not-for-profit organizations operate at a deficit; some, in fact, such as AARP, with 32.5 million members, have enormous resources. Other examples of not-for-profits include trade associations and business leagues, hospitals and health-service organizations, professional membership societies, trade unions, philanthropies, museums and other arts groups, and charitable and educational organizations. Whether a client is for-profit or not-for-profit, pricing varies according to its size and resources.

Annual reports

An annual report—the yearly fiscal report by a corporation to its stockholders and the financial community—is an important way a company promotes itself. Designers of annual reports often seek thoughtful, provocative illustration to offset the written and financial material while projecting the company's public image powerfully and effectively.

Fees for illustration have historically been based on the size of the corporation and the nature of the annual report and have usually been negotiated on a one-time-use basis only. When dealing with large assignments in this area, artists should be prepared to set a fee for selling original art, since annual report clients frequently make such requests.

Corporate calendars

Prices for illustrations for company calendars can vary greatly and usually depend upon the size of the company, the complexity of the subject, and the intended use. Calendars designed only for internal use generally pay less than calendars distributed to consumers for promotion or sale.

Trade practices

The following trade practices have been used historically, and through such tradition are accepted as standard:

- The intended use of the art must be stated clearly in a contract, purchase order, or letter of agreement stating the price and terms of sale.
- 2. The artwork cannot be altered in any way, except for what occurs during the normal printing process, without the written consent of the artist. Since it is very easy to alter art electronically these days, the client should inform the artist if he or she wishes to alter the artwork and then do so only with the permission and supervision of the illustrator. Anything less is a violation of professional good faith and ethical practice.
- **3.** Return of original artwork to the artist is automatic unless otherwise negotiated.
- **4.** Artists normally sell only first reproduction rights unless otherwise stated.
- 5. If artwork is to be used for other than its original purpose, such as for an electronic database or a Web site, the price is usually negotiated as soon as possible. Note that the secondary use of an illustration may be of greater value than the primary use. Although there is no set formula for reuse fees, current surveys indicate that artists add a reuse fee ranging from 50 to 100 percent of the fee that would have been charged had the illustration been commissioned for the new use.

9 Illustration Prices & Trade Customs

- Illustrators should negotiate reuse arrangements with the original commissioning party with speed, efficiency, and all due respect to the client's position.
- Historically, artists have charged higher fees for rush work than those listed here, often by an additional 20 to 150 percent.
- 8. If the illustrator satisfies the client's requirements and the finished work is still not used, full compensation should be made. However, historically, if a job is canceled after the work is begun, through no fault of the artist, a cancellation or kill fee is often provided. Depending upon the stage at which the job is terminated, the fee must cover all work done, including research time, sketches, billable expenses, and compensation for lost opportunities resulting from the artist's refusing other offers in order to make time available for the commission. In addition, clients who put commissions on hold or withhold approval for commissions for longer than 30 days should secure the assignment by paying a deposit upfront.
- 9. Historically, a rejection fee has been agreed upon if the assignment is terminated because the preliminary or finished work is found to be not reasonably satisfactory and steps to correct the problem have been exhausted. The rejection fee for finished work has often been over 50 percent of the full price, depending upon the reason for rejection and the complexity of the job. When the job is rejected at the sketch stage, current surveys indicate the customary fee is 20 to 50 percent of the original price. This fee may be less for quick, rough sketches and more for highly rendered, time-consuming work.
- Artists considering working on speculation assume all risks, and should evaluate them carefully when offered such arrangements. For a thorough discussion of the risks, see the Speculation section in Chapter 3, Professional Issues.

- 11. The Graphic Artists Guild is unalterably opposed to the use of work-for-hire contracts, in which authorship and all rights that go with it are transferred to the commissioning party and the independent artist is treated as an employee for copyright purposes only. The independent artist receives no employee benefits and loses the right to claim authorship or to profit from future use of the work forever. Additional information on work for hire can be found in Chapter 2, Legal Rights and Issues.
- 12. Customary and usual expenses such as unusual props, costumes, model fees, travel costs, production costs, and consultation time should be billed to the client separately. An expense estimate should be included in the original written agreement or as an amendment to the agreement.

All prices for illustration in this book are based on a survey of the United States and Canada that was reviewed by a special committee of experienced professionals through the Graphic Artists Guild. These figures, reflecting the responses of established professionals, are meant as a point of reference only and do not necessarily reflect such important factors as deadlines, job complexity, reputation and experience of a particular illustrator, research, technique or unique quality of expression, and extraordinary or extensive use of the finished art. (See related material in other sections of this book, especially in Chapter 5, Essential Business Practices, and Chapter 13, Standard Contracts and Business Tools.)

The price ranges in the following charts do not reflect any of the above considerations and do not constitute specific prices for particular jobs. The buyer and seller are free to negotiate, with each artist independently deciding how to price the artwork after taking all factors into account.

A	In-house news	letters	
	B/W or 1 Color	Color	
Large corporation or larg	e print run		
Cover	\$1,000-\$3,500	\$2000-\$5,700	
Full page	\$800-\$2,800	\$1000–\$4,000	
Half page	\$500-\$2,000	\$700-\$2,500	
Quarter page	\$250-\$1,250	\$400–\$1,800	
Spot	\$200-\$750	\$250-\$1,000	
Medium corporation or m	nedium print run		
Cover	\$700-\$2,400	\$1,300-\$3,300	
Full page	\$600-\$2,000	\$900-\$2,500	
Half page	\$400-\$1,800	\$500-\$2,000	
Quarter page	\$200-\$900	\$300-\$1,500	
Spot	\$150-\$600	\$200–\$1,000	
Small or nonprofit corpor	ration or organization or sn	all print run	
Cover	\$650-\$2,200	\$900-\$2,400	
Full page	\$500-\$1,000	\$600-\$2,000	
Half page	\$250-\$800	\$300-\$1,000	
Quarter page	\$150-\$600	\$200–\$750	
Spot	\$75-\$500	\$100-\$500	
	Annual repo		
	B/W or 1 Color	Color	
Large corporation or larg			
Cover	\$1,900-\$4,600	\$2,500-\$6,750	
Full page	\$1,200-\$5,000	\$1,500-\$6,000	
Half page	\$750-\$2,500	\$1,000-\$4,000	
Quarter page	\$500-\$2,250	\$750-\$2,500	
Spot	\$300-\$1,500	\$500-\$2,000	
Medium corporation or m		\$1,000 \$1,000	
Cover	\$1,750-\$4,100	\$1,900-\$4,900	
Full page	\$750-\$2,500	\$1,500-\$4,000	
Half page	\$500-\$2,000	\$1,000-\$2,500	
Quarter page	\$300-\$1,750	\$500-\$2,250	
Spot	\$150-\$1,000	\$350-\$2,000	
	ration or limited distribution		
Cover	\$1,100-\$2,600	\$1,550-\$3,650	
Full page	\$750-\$3,000	\$1,000-\$2,500	
Half page	\$500-\$2,500	\$750-\$1,100	
Quarter page	\$250-\$1,000	\$400-\$900	
Spot	\$125-\$800	\$200-\$600	

➢ Since no significant new data were reported in 2000, figures are from the 1997 edition, with the exception of "cover," where they are from the 1994 edition. Current data indicate that an additional 20% to 25% is added for each color overlay in addition to black.

9 Illustration Prices & Trade Customs

Cor	porate magazines & other uses	
Business-to-customer magazines	s (Ambassador In-Flight)	
Cover	\$3,500	
Spread	\$2,000-\$3,000	
Full page	\$1,500-\$2,000	
Half page	\$800-\$1,000	
Quarter page	\$300-\$1,000	
Spot	\$400-\$1,800	
Special event invitations	\$500-\$2,500	
Web site use (nonadvertising)		
Page	\$500-\$2,000	
Quarter page	\$500-\$1,200	
Spot	\$200–\$400	
Artwork for corporate logos		
Major corporation	\$4,000-\$15,500	
Small corporation	\$700-\$4,000	

	Percentage of original fee
Sale of original art	75%-200%
Stock sale of existing art	50%-100%
Rush fee	25%-100%
Each color overlay in addition to black	25%
Jnlimited use in print media only, no time or Jeographical limits	80%–150%
Jnlimited use, any media (including digital), or 1 year	60%-125%
Fotal copyright transfer (excluding original art)	115%-250%
Nork-for-hire (transfer of legal authorship)	150%-250%

Book Publishing

The publishing business has undergone tremendous growth and change in the last 15 years. Most well-known publishing houses have been acquired by multinational conglomerates here and abroad, and many smaller houses have been either eliminated or incorporated as imprints. A worldwide jump in paper prices in the early 1990s increased the pressure on publishers' bottom lines, though paper prices have now stabilized. A few giant bookstore chains, which often negotiate heavy discounts, dominate the industry, and a growing percentage of bookselling is now handled electronically. Both these factors are causing the demise of independent bookstores.

The use of book packagers has grown in recent years, particularly for novelty books, such as pop-up books and book-and-craft-kit combinations. These independent suppliers take over some or all of the function of preparing a book for publishers. Often they initiate a project, find writers and illustrators, arrange for whatever extras may be involved, and strike a deal with a publisher, usually supplying a set number of bound books at a set price. When a book has been conceived by the packager rather than the publisher, the artist will be asked to sign a contract with the packager rather than the publisher, even before the packager has contracted for the project with a publisher.

Book jackets

Book jacket illustration or design is the second most important ingredient in the promotion and sales of a book, superseded only by the fame and success of the author. Pricing illustration in the book publishing market is complex, so all the factors involved need serious attention. Romance, science fiction, and other genre paperback covers can command higher fees than some hardcover jackets, especially when the projected audience is very large. Artists who design and illustrate jackets may approach their work differently from other graphic artists. (See the Book Jacket Design section in Chapter 7, Graphic Design Prices and Trade Customs.)

Historically, illustrators who are specially selected for occasional cover assignments receive higher fees than illustrators who specialize only in book jackets. In addition, artists recognized for their painterly, highly realistic, or dramatic studies have commanded much higher fees than those whose styles are more graphic and design-oriented. Although this practice is prevalent in the entire illustration field, it is particularly so in publishing.

Some paperback publishers give very specific instructions on assignments, sometimes including the art director's rough notes from a cover conference. If an illustrator is required to read a lengthy manuscript in search of illustrative material and then produce sketches subject to approval by editors, this factor is traditionally taken into account when negotiating the fee.

Other factors that have historically prompted additional fees and that have been negotiated before the assignment is confirmed include changes in approach and direction after sketches are completed, requiring new sketches; additional promotional uses above and beyond what is common trade practice (using the art separately from the cover without the title or author's name); and extremely tight color comps done for sales meetings and catalogs.

Another way illustrators can earn additional fees is to license a cover illustration for use on foreign editions of a book. This type of secondary rights usage is growing; however, fees vary widely from country to country and use to use, with few standards and generally very low fees. The artist should establish his or her own optimal fees for such rights and not just accept what is offered. Breaking down the fee into amounts for each use (both hardback and paperback, for instance) and stipulating a particular length of time for the sale, with an option to renew, are ways to boost fees and maximize the artist's income.

While domestic book club rights are usually included in the original hardcover fee, audiocassette covers and CD-ROMs, a growing market, are negotiated as separate subsidiary rights. All other residual rights, especially movie and television rights, are reserved by the artist. Transfer of those and all other rights is negotiated by the artist and the client

Jackets for mass-market & trade books

Mass-market books have large print runs and appeal to a wide audience. They include bestsellers, mysteries, thrillers, gothics, fantasy, science fiction, historical novels, and modern romance novels. Trade books include poetry, serious fiction, biography, how-to books, and more scholarly works that appeal to a special audience. When pricing work in these areas, the size of the print run is traditionally taken into account.

Because of their larger print runs and higher gross sales, mass-market books historically generate higher fees. But illustrators who want to break into this market should know that the fee structure is based on the star system, with illustrators of best-sellers able to command fees far above the average. For instance, fees charged by one prominent illustrator with 25 years' experience and many best-sellers to his credit start at \$7,500 for a front cover and \$8,000 for a wraparound. Of course, if a particular artist is requested by a best-selling author, then even higher fees can be easily negotiated. Being regarded as the "clincher" who can help boost sales of the book gives the artist considerable leverage.

A hardcover assignment might also include paperback rights, for which an additional 50 percent of the original fee is customarily charged. On occasion the fee for a book with a very large paperback print run may amount to an additional 100 percent of the original fee, or possibly more.

	Front Cover	ardcover Wraparound	
Mass market	\$2,000-\$3,500	\$2,500-\$5,000	
Major trade	\$1,500-\$3,000	\$1,500–\$4,000	
Minor trade	\$700-\$2,000	\$1,000-\$3,000	
Textbook	\$900-\$2,000	\$1,200-\$2,600	
Young adult/chapter	\$700-\$2,600	\$900-\$3,200	
	Pa	aperback [⊖]	
	Front Cover	Wraparound	
Mass market	\$1,800-\$3,300	\$2,200-\$4,000	
Major trade	\$1,200-\$2,500	\$2,000-\$3,500	
Minor trade	\$600-\$1,800	\$1,000-\$2,500	
Textbook	\$800-\$1,800	\$900-\$3,200	
Young adult/chapter	\$500-\$2,300	\$700-\$3,000	

☐ Mass-market books appeal to a large audience and are sold in other stores in addition to major retail bookstores. Trade books are mostly hardcover and are sold almost entirely in retail bookstores.

	t Illustration
	Percentage of original fee
Sale of original art	100%
Stock sale of existing art	40%–90%
Rush fee	20%–35%
Foreign or world publication rights	40%-140%
Unlimited use, any media (including digital), for 1 year	50%-150%
Total copyright transfer (excluding original art)	175%–225%
Subsidiary rights sales	Royalty (percentage of list price)
Development and accepted	5%-50%
Percentage of receipts	10%–50%
Foreign publisher, translation, or English-language edition	10/0-30/0
	10%-70%

Book interiors

Illustrations have long been recognized as an important ingredient in the editorial and marketing value of a book. Book illustrators work with editors, art directors, book designers, or book packagers to create anything from simple instructional line drawings to full-color-spread illustrations for textbooks, picture books, children's and young adult books, novelty books, and special reprints of classics, among other trade genres. The importance of illustration to a specific book may be significant or limited, depending on needs determined by the publisher.

Outside of children's books, it is exceedingly rare for royalties to be paid for book illustration. (If such an opportunity arises, check the Children's Book Illustrations section below for details on an appropriate contract.) A one-time flat fee is usually paid for interior illustrations for all other books.

Book packagers often offer illustrators either a flat fee or a 10 percent royalty. This royalty is not figured on the book's list price, as with some publishers' contracts, but on what the packager will receive from the publisher for the finished books ("base selling price"). Since publishers generally set a book's retail price at four to five times the cost of its production, illustrators should be aware that 10 percent of the base selling price amounts to a 2 to 2.5 percent royalty of the list price.

Publishers generally allot 10 percent (or 5 percent, in the case of mass-market material) of list price for author's and illustrator's royalties. When a publisher uses a packager to produce a book, that 10 percent may be absorbed by the publisher or may be paid to the packager in addition to the base selling price. Sometimes that share is paid to a licenser in exchange for the right to publish

a book about a popular property (cartoon characters, for instance) and a packager is hired to create the book. In some cases, particularly where the project originated with the author-artist, all or some of those list-price royalties may be paid to the artist. It is the publisher's choice to do so; the packager is not likely to promise an artist any of the publisher's royalties.

Thus, the compensation offered to artists who work through packagers is generally at a lower rate than work that comes directly from publishers. However, two factors may somewhat mitigate this difference. Because a packager's contract with a publisher will involve the sale of a predetermined number of books, paid upfront, the packager will pay the artist's royalty on the full print run before publication. If a second printing is ordered, royalties on that print run will again be paid in full, rather than if and when the books are sold. This arrangement brings payment to the artist somewhat sooner than the standard publisher's contract. Rights to reuse the artwork (in other editions or promotions, for example) are often considered when negotiating the advance or the fee.

Other factors affecting advances and fees in this complex area include the type of book and the importance of the author, the artist's reputation and record of commercial success, the size of the print order, and the length of time estimated for the total project.

Historically, illustrators have gotten partial payments for long projects. For example, one third of the total fee is customarily paid upon approval of sketches, one third upon delivery of half of the finished art, and the remainder within 30 days of delivery of the finished art. Some artists report payments of 50 percent for sketches and 50 percent for final art.

Adult hardcover			
	B/W or 1 Color	Color	
ajor publisher or large	distribution		
Spread	\$1,000-\$2,000	\$1,200-\$2,500	
Full page	\$500-\$1,000	\$800-\$2,000	
Half page	\$400-\$1,000	\$500-\$1,000	
Quarter page	\$150-\$700	\$300-\$700	
Spot	\$100-\$400	\$200-\$500	
nor publisher or limite	d distribution		
Spread	\$500-\$1,000	\$1,000-\$2,000	
Full page	\$250-\$700	\$600-\$1,000	
Half page	\$200-\$500	\$400-\$700	
Quarter page	\$100-\$300	\$200-\$500	
Spot	\$100-\$200	\$200-\$400	

Your	g adult (ages 8–12), ind		
Major publisher or large o	B/W or 1 Color	Color	
	\$700-\$1,200	\$1,000–\$1,800	
Spread	\$500-\$800	\$600-\$1,000	
Full page	\$300-\$600	\$350-\$700	
Half page	\$200-\$400	\$250-\$500	
Quarter page	\$100-\$300	\$150-\$450	
Spot		φ100 φ 1 00	
Minor publisher or limite	\$500-\$1,000	\$700-\$1,000	
Spread	\$350-\$600	\$350-\$700	
Full page	\$200-\$400	\$350-\$500	
Half page		\$200-\$350	
Quarter page	\$100-\$300 \$100 \$200	\$100-\$250	
Spot	\$100–\$200	φ100-φ200	
	Textbook/Edu	ıcational	
	B/W or 1 Color	Color	
College textbooks			
Spread	\$600-\$1,200	\$800-\$1,700	
Full page	\$400-\$850	\$600-\$1,200	
Half page	\$300–\$550	\$350-\$750	
Quarter page	\$150-\$350	\$250-\$450	
Spot	\$100-\$250	\$100–\$300	
Elementary through high			
Spread	\$400-\$1,000	\$1,000-\$1,500	
Full page	\$300–\$800	\$700-\$1,000	
Half page	\$200-\$500	\$350-\$750	
Quarter page	\$150-\$400	\$250-\$400	
Spot	\$100-\$250	\$100-\$350	
Juvenile workbooks			
Spread	\$400-\$900	\$700-\$1,200	
Full page	\$250-\$750	\$350-\$800	
Half page	\$200-\$500	\$300-\$500	
Quarter page	\$100-\$300	\$150–\$400	
Spot	\$75-\$200	\$75-\$250	

Additional Fees for Book Interior Illustration		
	Percentage of original fee	
Sale of original art	50%-80%	
Stock sale of existing art for use in books	30%-40%	
Each color overlay in addition to black	20%–40%	
Foreign or world publication rights	30%-100%	
Work-for-hire (transfer of legal authorship)	50%-275%	

Children's books

The illustrator's contribution to a children's book can range widely, from the entire contents of a wordless picture book to a jacket illustration for a young adult novel. For pricing purposes, the possibilities usually fall into two categories: a flat fee, for books in which the illustrator's contribution is usually substantially less than the author's, or a royalty contract, in which the contributions of author and illustrator are comparable or in which the illustrator is also the author.

Packagers often pay only a flat fee, but most publishers will negotiate a royalty reflecting the percentage of art versus text. The artist's share can range from 2 to 5 percent, depending upon the reputation of the artist versus the author.

Publishers' flat-fee contracts tend to ask for all possible rights to the art in return for a one-time fee. However, illustrators should negotiate to retain the rights or negotiate additional payment for additional uses, such as the sale of paperback rights. Holding nonbook or merchandising rights is particularly vital; otherwise, illustrators will not be able to keep the rights to a copyrighted character.

Chapter books for ages 8 to 12 and young adult books for children over 12 have historically been illustrated for a flat fee. A typical flat-fee book contract commissions a full-color wraparound jacket. From 1 to 14 black-and-white interior illustrations of various sizes may be included in a chapter book.

One category of children's books—the juvenile workbook—is handled quite differently from others. Workbooks are assigned through brokers or publishers' agents, representing many illustrators working in varied styles, who have historically established pricing for each book with the publisher. Budgets for workbooks vary considerably, depending on the size of the publisher, locality, publication schedules, and experience of the artist. Illustrator fees for these projects may also vary considerably, and it's always preferable to work directly with the publisher. Workbooks are usually priced per page, per half page, or per spot. Although fees are traditionally quite low, an entire workbook can add up to a considerable amount of work. Artists who are able to produce this kind of artwork quickly may find this field quite lucrative and feel secure knowing that months of work lie ahead. However, to meet increasingly rushed publishing deadlines, a book with a considerable amount of illustration may be divided up among several illustrators.

	Illustrations only	Illustrations & text
Picture books (32 pages)		
Advance	\$5,500-\$8,500	\$8,000-\$12,500
Royalty (% of list price)	5%-6%	8%–10%
Sales point (when royalty escalation takes effect)	30,000–70,000	10,000–20,000
Royalty escalation (% to which royalty increases after sales point is reached)	6%–15%	6%–10%
Use bev	ond original hardcov	er edition
	-	Royalty (percentage of list price)
Publisher's direct sales		2.5%–10% of net sales
Remainder sales		2.5%-10% of net sales
Canadian sales		3%–10% of net sales
Publisher's own paperback e	dition	2.5%-6%
	Subsidiary rights sale	es
Percentage of receipts		25%–50%
Foreign publisher, translatior or English-language edition	٦,	25%-80% of net sales
First serial, dramatic TV, motion picture		25%–85% of net sales
Domestic reprint, paperback, book club, digest, anthology or serial, merchandising, audio/visual, sound recordin		25%–65% of net sales

Royalty contracts

An advance against royalties is paid for most children's picture books, storybooks, and middle-grade readers. If the author and the artist are not the same, a full royalty on the book's list price is commonly split 50-50 between the two creators. (The author and artist each receive 25 percent, with the publisher retaining the other 50 percent.) The royalty and the amount of the advance are based on the illustrator's reputation, experience, and the publisher's budget. The advance is designed to reflect the anticipated earnings of the book, and will rarely exceed the royalty due on the sales of the book's entire first printing. Frequently, 50 percent of the advance is paid on signing the contract and the remaining 50 percent is paid on delivery of the artwork. Or advances may be paid in thirds on signing, on delivery of rough sketches, and on delivery of the finished art. (All the artist's out-of-pocket expenses should be paid in addition to the advance.) An appropriate advance will be earned back within two (and up to ten) years after publication. If the advance is earned back after only three months of release, either the advance was too low or the book was an unanticipated good seller.

It is to the illustrator's advantage to obtain as large an advance as possible, since it may not be earned back by sales, or it may take considerable time before any royalties are actually paid. If an advance is earned back very quickly (within the first six-month royalty period), it is a sign that a higher advance would have been more appropriate, a point to consider when negotiating future contracts.

It is customary for a nonrefundable advance to be paid against royalties; it is to the illustrator's advantage to secure only nonrefundable advances. Artists should scrutinize contracts to make sure that the advance does not have to be refunded if a sufficient number of books is not sold to earn it back. The publisher's right to reject the art should be clearly defined and limited in the contract, and any changes requested by the publisher should be defined as "reasonable." If the artist has submitted pencil drawings that were approved and has not deviated from them in creating the finished art, the artist should be paid the complete advance for the time spent—even if the art is rejected.

Royalty contracts are complicated and vary from publisher to publisher. "Boilerplate" authors' contracts rarely are written with artists in mind, and they can be difficult to comprehend. The Graphic Artists Guild strongly recommends that an attorney or agent with a track record in publishing children's books review any contract if it contains terms about which the illustrator is uncertain, especially if it is the artist's first book contract. Even publishers' boilerplate contracts are not carved in stone, and can be amended if the changes are agreeable to both parties. Among those sections of a royalty contract that are often negotiated are the lists of the royalty percentages for the publisher's uses of the work ("publisher's direct") and for the sale of subsidiary rights. In the chart of comparative fees for children's book illustration, see the royalties for uses beyond the original hardcover edition.

The basic provisions of a children's book royalty contract, in addition to the amount of the advance and division of royalties, have historically been:

- Grant of rights: The illustrator grants to the publisher the right to use the art as specified within the contract.
- Alterations: The art cannot be altered in any way by the publisher, except as part of the normal printing process, without the written consent of the artist. (It is all too easy to alter art electronically, but that should not be allowed.)
- Delivery: Sets deadlines for finished art and sometimes for rough sketches. Often this clause has also specified what payments are due the artist if the project is canceled or rejected (see the Cancellation and Rejection Fees section in Chapter 3, Professional Issues).
- Warranty: This states that the illustrator has not infringed copyrights or broken any other laws in granting rights to the publiser.
- Indemnity: The illustrator shares the cost of defending any lawsuit brought over the art. An artist who is found to have broken the terms of the warranty bears the entire cost of the lawsuit and any damages that may result. The indemnity provision might present more risk than the illustrator is willing to accept, but without an attorney it is difficult to counter this provision effectively. An illustrator should request to be indemnified by the publisher for any suits arising from a request on the publisher's part, such as making a character look like a famous person.
- **Copyright**: The publisher agrees to register the copyright to the work in the artist's name.
- Agreement to publish: The book will be published within a specific period of time, usually 18 months from receipt of finished art. If the publisher fails to do so, the rights should revert back to the artist (reversion rights).

Additional points to consider are:

- Paperback advance: If an advance against royalties is to be paid for the original publisher's paperback edition, that has historically been negotiated at the time of the original contract. The royalty rate is usually less than for the hardcover edition.
- Escalation: For trade books, royalties totaling 10 percent (for author and illustrator combined) have historically often been raised to 12.5 percent after sales reach 20,000 copies. Though mass-market books have usually had lower royalty rates, these have also been raised based on sales.
- Deescalation: Some publisher's contracts have historically stipulated that royalty rates may decrease dramatically under two conditions: when high discounts are given to distributors or other buyers, or when book sales from a low-quantity reprint are slow. Not all publishers include these clauses in their contracts; it is in the artist's interest to strike them, or at least to try to negotiate better terms.

Traditionally there has been some justification for the illustrator accepting lower royalty for a book whose sales are vastly increased by a high discount negotiated between the publisher and booksellers, such as bookstore chains. It also has been common practice for the royalty to decline incrementally once discounts pass 50 percent. It is less favorable for the artist to accept the terms offered by some publishers whereby any discount above, say, 50 percent produces royalties figured not on the book's list price but on the "amount received"-the wholesale price-which immediately reduces the royalty rate by at least half.

Illustrators have found it desirable to ensure that this deep discount is given only for "special sales" and is not part of the publisher's normal trade practice. The latter could mean that the publisher is using these discounts to gain sales at the expense of the artist and/or author. Be aware that as giant retail and bookstore chains' domination of the book market has grown, deep discounts have as well. Deep discounts are also customary in sales through book fairs and the publisher's own book club. The artist should try to limit or eliminate all special sales. The artist's royalty payments will decline when books are discounted and the backlist is diminished.

By accepting a decrease in royalty for a slow-selling reprint, the illustrator may give the publisher incentive to keep the book in print. But the terms of the decrease should have limitations. For instance, the book should have been in print at least two years, be in a reprint edition of 2,500 or fewer copies, and have sales of less than 500 copies in one royalty period. Under these conditions, the royalty might drop to 75 or even 50 percent of the original rate.

A foreign-language edition to be sold domestically also may be published with a lower royalty rate, as it is costlier to produce than a simple reprint and may have limited sales potential. Terms may be set, however, to escalate to a normal royalty rate if sales exceed low expectations.

Subsidiary sales: Income derived from the publisher's selling any rights to a third party are divided between publisher and artist and/or author, depending on whether the rights involve art, text, or both. The percentage earned by the illustrator for each type of use is variable and is determined by negotiation. The possible use of a character in a greeting card or poster, for example, can be a valuable source of additional income for the artist. The relatively new area of electronic rights, either as a subsidiary right or as income derived from the publisher's own electronic products, is still ambiguous, and developments are changing constantly. Some publishing contracts leave the category unresolved, stating specifically that

9 Illustration Prices & Trade Customs

terms for electronic rights will be agreed upon mutually when and if the need arises. If that is not possible, then the artist should limit those rights to three to five years, with an automatic reversion to the artist whether or not they are used by that time. (For a more detailed discussion of these concerns, see Chapter 4, Technology Issues.)

- Author's copies: Publishers' contracts usually provide 10 free copies to the author, but 20 free copies are often negotiated. Most publishers offer the artist a 40 to 50 percent discount off the list price on purchases of their book. Some publishers will pay royalties on these sales; others (ungenerously) do not.
- Schedule of statements and payments: This defines when and how accounting will be made. Normally, a royalty period is six months, with the appropriate royalty payment made four months and one day after the period closes. A useful clause found in many contracts allows access by the artist or a designated accountant to examine the publisher's books and records. If, in a given royalty period, errors of 5 percent or more are found in the publisher's favor, the publisher will correct the underpayment and pay the cost of the examination up to the amount of the error. If an audit costs more than the error, the artist must pay the difference.
- Pass-through clause: This takes effect when the illustrator's share of a subsidiary sale exceeds \$1,000. The publisher will then send payment within 30 days of receipt rather than holding it until the semi-annual royalty reporting date.
- Remaindering: If the book is to be remaindered (sold at a huge discount, often at the end of a print run), the publisher should notify the illustrator, and allow him or her to buy any number of copies at the remaindered price.
- Return of artwork: Since the art remains the property of the artist, it should be returned "unaltered and undamaged except for normal use and wear" after publication, if

not sooner. Since publishers must be responsible for the art while it is in their possession, a value should be placed on the cover and inside illustrations in the event of possible loss, damage, or negligence by the publisher. (With children's book art now in demand by galleries and museums, a lost or damaged piece will deny the artist a possible sale of original art.)

Termination of agreement: This states that
if a work is not, or will not be, available in
any edition in the United States, it is out
of print. At that time, the illustrator may
request in writing that all rights return to
the artist. The publisher usually has six
months to declare an intent to reprint and
a reasonable amount of time in which to
issue a new edition. Failing this, the agreement is terminated, and all rights return to
the artist.

In some boilerplate contracts, "out-of-print" is defined too narrowly, or the time allowed the publisher is unreasonably long. Some contracts also grant the illustrator the right to purchase any existing film, plates, or die stamps within 30 days after termination.

- Quality control: Occasionally a provision is added to contracts that allows the illustrator to consult on the design of the book and to view bluelines, color separations, and proofs while corrections can still be made. However, a good working relationship and an informal agreement with the art director is probably as good a guarantee of this actually occurring.
- Revisions without the artist's consent: A clause prohibiting that is good insurance for protecting the integrity of the work.

Many of these contractual points may not add up to much money for any one book, or even a lifetime of books. But illustrators can effectively manage their careers only if they retain control over their work. Therefore it makes sense to negotiate the best possible contract, not merely the best possible advance.

Trade practices

The following trade practices have been used historically, and through such tradition are accepted as standard:

- **1.** The intended use of the art must be stated clearly in a contract, purchase order, or letter of agreement stating the price and terms of sale.
- 2. The artwork cannot be altered in any way, except for what occurs during the normal printing process, without the written consent of the artist. Since it is very easy to alter art electronically these days, the publisher should inform the artist if he or she wishes to alter the artwork and then do so only with the permission and supervision of the illustrator. Anything less is a violation of professional good faith and ethical practice.
- 3. Return of original artwork to the artist is automatic unless otherwise negotiated.
- 4. Artists normally sell only first reproduction rights unless otherwise stated.
- 5. If the artwork is to be used for other than its original purpose, such as for an electronic database or a Web site, the price is usually negotiated as soon as possible. Note that the secondary use of an illustration may be of greater value than the primary use. While publishers frequently offer work-for-hire contracts in this market, artists may negotiate terms for secondary use. Although there is no set formula for reuse fees, current surveys indicate that artists add a reuse fee ranging from 50 to 100 percent of the fee that would have been charged had the illustration been commissioned for the new use.
- 6. Illustrators should negotiate reuse arrangements with the original commissioning party with speed, efficiency, and all due respect to the client's position.
- **7.** Historically, artists have charged higher fees for rush work than those listed here, often by an additional 20 to 100 percent.
- **8.** When satisfactory art has been produced but the publisher, for whatever reason, decides not to use it, the full payment customarily goes to the artist, and rights to the unused work are not transferred to the publisher.
- 9. If the illustrator satisfies the client's requirements and the finished work is still not used, full compensation should be made. However, historically, if a job is canceled after the work is begun, through no fault of the artist, a cancellation or kill fee is often provided. Depending upon the stage at which the job is terminated, the fee must cover all work done, including research time, sketches, billable expenses, and compensation for lost opportunities resulting from the artist's refusing other offers in order to make time available for the commission. In addition, clients who put commissions on hold or withhold approval for commissions for longer than 30 days should secure the assignment by paying a deposit upfront.
- 10. Historically, a rejection fee has been agreed upon if the assignment is terminated because the preliminary or finished work is found to be not reasonably satisfactory and steps to correct the problem have been exhausted. The rejection fee for finished work has often been over 50 percent of the full price, depending upon the reason for rejection and the complexity

of the job. When the job is rejected at the sketch stage, current surveys indicate that a customary fee is 20 to 50 percent of the original price. This fee may be less for quick, rough sketches and more for highly rendered, time-consuming work.

- **11.** Artists considering working on speculation assume all risks, and should evaluate them carefully when offered such arrangements. For a thorough discussion of the risks, see the Speculation section in Chapter 3, Professional Issues.
- 12. The Graphic Artists Guild is unalterably opposed to the use of work-for-hire contracts, in which authorship and all rights that go with it are transferred to the commissioning party and the independent artist is treated as an employee for copyright purposes only. The independent artist receives no employee benefits and loses the right to claim authorship or to profit from future use of the work forever. Additional information on work for hire can be found in Chapter 2, Legal Rights and Issues.
- 13. Customary and usual expenses such as unusual props, costumes, model fees, travel costs, production costs, and consultation time should be billed to the client separately. An expense estimate should be included in the original written agreement or as an amendment to the agreement.

All prices for illustration in this book are based on a survey of the United States and Canada that was reviewed by a special committee of experienced professionals through the Graphic Artists Guild. These figures, reflecting the responses of established professionals, are meant as a point of reference only and do not necessarily reflect such important factors as deadlines, job complexity, reputation and experience of a particular illustrator, research, technique or unique quality of expression, and extraordinary or extensive use of the finished art. (See related material in other sections of this book, especially Chapter 5, Essential Business Practices, and Chapter 13, Standard Contracts and Business Tools.)

The price ranges in the chart above do not reflect any of the above considerations and do not constitute specific prices for particular jobs. The buyer and seller are free to negotiate, with each artist independently deciding how to price the work, after taking all factors into account.

Editorial Illustration

Editorial illustrators are commissioned by art directors and editors of consumer and trade magazines and newspapers to illustrate specific stories, covers, columns, or other editorial material in print or electronic media. Usually the art director, editor, and illustrator discuss the slant and intended literary and graphic impact of a piece before the artist prepares sketches. Often illustrators prepare several sketches that explore a range of approaches to the problem. Editorial art is often commissioned under tight deadlines, especially for news publications and weekly magazines and newspapers.

Some editorial illustrators have encountered an unethical problem now that all work is handled digitally: Some unscrupulous art directors and editors have digitally altered the illustrator's work without permission. Be sure to stipulate in any written agreement that artwork may not be cropped or altered in any way without first obtaining the artist's permission.

Magazines

Fees for editorial assignments have historically been tied to the magazine's circulation and geographic distribution, which in turn determine its advertising rates and therefore its income. Magazines are divided into categories, with figures of circulation and readership the most accepted criteria for establishing the appropriate category. Occasionally the magazine's readership can influence the level of quality of the publication and fees paid for artwork; for example, fees may be higher from The New Yorker magazine, which historically has had a higher income demographic than similar circulation magazines. Circulation and distribution information is usually available from advertising and subscription departments of magazines.

Several categories of consumer magazines are described in the chart. However, magazines don't always fall neatly into one category. For example, *Time*, *Reader's Digest*, and *Family Circle* are high-circulation general-interest consumer magazines. *Forbes* is a general business magazine, which, though distributed nationally, falls into the regional or medium category because of its comparatively lower circulation of nearly 800,000 copies. It is, however, a highly successful publication that ranked number 18 in the 1999 *Folio: 500*, with 1998 revenues of more than \$242 million, reflecting 4,734 advertising pages sold at \$40,720 per black-and-white page (an increase over 1992 when it was ranked number 20). *Popular Mechanics*, ranked number 84 in the 1999 *Folio: 500*, with 1998 revenues of \$75.4 million, is also distributed nationally but is considered a single-interest magazine. *New York* magazine, ranked number 64 in the 1999 *Folio: 500*, is a special-interest magazine serving a predominantly local readership, but because it enjoyed 1998 revenues of nearly \$92.7 million, it is large enough for the regional or medium category.

Spread illustrations occupy two facing pages. If a spread illustration occupies only one half of each page, one historical basis for fee negotiation has been to add the partial page rate. However, if only the title or very little text is used on the spread, it could be interpreted as a full-spread illustration. In these cases, discretion should be used.

Spot illustrations are usually one column in width and simple in matter. Judging the complexity of the assignment may help determine if a spot rate is appropriate. Although quarter-page illustrations are not spots, some magazines (particularly those with lower budgets) make no distinction between the two. In recent years art directors have tended to call any illustration that is less than half a page a spot illustration. This practice fails to accurately describe the commissioned illustration and undermines established trade practices to the artist's detriment.

Comparative Fees for Magazine Editorial Illustration				
	Consumer ma	agazines		
	B/W or 1 Color	Color		
General-interest (Reader's	Digest, People) or natior	al circulation		
Cover	-	\$3,500-\$4,000		
Spread	-	\$1,700-\$3,200		
Full page	-	\$1,100-\$2,500		
Half page	\$475-\$1,000	\$1,000-\$1,600		
Quarter page	\$400-\$600	\$600-\$1,100		
Spot	\$300-\$600	\$300-\$700		

	Consumer magazi	nes continued	
	B/W or 1 Color	Color	
Special-interest <i>(Atlantic I</i> Cover	Nonthly, The New Yorker,		
Spread	_	\$1,600-\$3,500	
Full page	-	\$1,500-\$2,300	
	-	\$1,000-\$1,700	
Half page Quarter page	\$475-\$1,000	\$600-\$1,000	
	\$300-\$600	\$400-\$700	
Spot	\$200-\$500	\$300-\$600	
Cover	American, Fly Fishing) or –	small circulation \$1,000–\$2,000	
Spread	-	\$800-\$2,000	
Full page	\$650-\$900	\$550-\$1,500	
Half page	\$325–\$650	\$450-\$1,000	
Quarter page	\$200-\$500	\$300-\$600	
Spot	\$125–\$350	\$200-\$400	
	Pusiness mes		
	Business mag B/W or 1 Color	Color	
General (Business Week) (0000	
Cover	-	\$1,000–\$4,000	
Spread	-	\$1,000-\$4,000	
Full page	-	\$850-\$2,000	
Half page	\$600-\$1,000	\$500-\$1,200	
Quarter page	\$400-\$750	\$400-\$1,000	
Spot	\$200-\$650	\$300-\$600	
rade (Chain Store Age), in Architectural Record), or s	nstitutional <i>(Hospitals),</i> pr small circulation	ofessional	
Cover	-	\$750-\$2,500	
Spread	-	\$750-\$2,500	
Full page	\$450-\$1,500	\$550-\$1,500	
Half page	\$300-\$1,000	\$350-\$1,000	
Quarter page	\$150-\$750	\$250-\$750	
Quarter page	** ***	\$150-\$500	
Spot	\$100–\$400	\$100-\$000	
Spot	urnals		
Spot esearch and academic jo Cover		\$800-\$2,500	
Spot Spot Cover Spread	urnals \$800–\$2,000 –	\$800–\$2,500 \$800–\$2,000	
Spot Research and academic jo Cover Spread Full page	urnals \$800–\$2,000 – \$400–\$1,500	\$800–\$2,500 \$800–\$2,000 \$500–\$1,500	
Spot Spot Cover Spread	urnals \$800–\$2,000 –	\$800–\$2,500 \$800–\$2,000	

Additional Fees for Magazine Editorial Illustration		
Sale of original art	Percentage of original fee 150%–200%	
Royalties per 1,000 reprints	15%–30%	
Royalties per photocopy	5%-10%	
Stock sale of existing art	70%–100%	
Rush fee	70%–125%	
Each color overlay in addition to black	50%	
Unlimited use in print media only, no time or geographical limits	150%–250%	
Unlimited use, any media (including digital), for 1 year	40%-225%	
Total copyright transfer (excluding original art)	175%–250%	
Work-for-hire (transfer of legal authorship)	275%–375%	

<u>Newspapers</u>

For pricing purposes some city newspapers, such as *The New York Times* and *The Washington Post*, are considered large-circulation national publications. They carry national and international news and are distributed both nationally and internationally. Medium-circulation newspapers are generally regional in nature, sell outside the city where they are published, often carry national news, and publish four-color supplements and weekend magazines. Local newspapers, naturally, have the lowest circulation. However, even in this category the size of readership varies widely and historically has been taken into account when determining fees. It is worth noting that this is one of the lowest-paying fields of illustration and is valued, especially for new and emerging talent, as a tradeoff for providing exposure and published portfolio pieces.

Trade practices

The following trade practices have been used historically, and through such tradition are accepted as standard:

- 1. The intended use of the art must be stated clearly in a contract, purchase order, or letter of agreement stating the price and terms of sale.
- 2. The artwork cannot be altered in any way, except for what occurs during the normal printing process, without the written consent of the artist. Since it is very easy to alter art electronically these days, the art director or editor should inform the artist if he or she wishes to alter the artwork and then do so only with the permission and supervision of the illustrator. Anything less is a violation of professional good faith and ethical practice.

- 3. Return of original artwork to the artist is automatic unless otherwise negotiated.
- 4. Artists normally sell only first reproduction rights unless otherwise stated.
- 5. If the artwork is to be used for other than its original purpose, such as on an electronic database or a Web site, a separate price is usually discussed and negotiated as soon as possible. Note that the secondary use of an illustration may be of greater value than the primary use. Although there is no set formula for reuse fees, current surveys indicate that artists add a reuse fee ranging from 50 to 100 percent of the fee that would have been charged had the illustration been commissioned for the new use.
- 6. Illustrators should negotiate reuse arrangements with the original commissioning party with speed, efficiency, and all due respect to the client's position.
- **7.** Historically, artists have charged higher fees for rush work than those listed here, often by an additional 20 to 150 percent.
- 8. If the illustrator satisfies the client's requirements and the finished work is still not used, full compensation should be made. However, historically, if a job is canceled after the work is begun, through no fault of the artist, a cancellation or kill fee is often charged. Depending upon the stage at which the job is terminated, the fee has to cover all work done, including research time, sketches, billable expenses, and compensation for lost opportunities resulting from the artist's refusing other offers in order to make time available for the commission. In addition, clients who put commissions on hold or withhold approval for commissions for longer than 30 days should secure the assignment by paying a deposit.
- 9. Historically, clients have paid a rejection fee if the assignment is terminated because the preliminary or finished work is found to be not reasonably satisfactory. The rejection fee for finished work has often been over 50 percent and up to 100 percent (if the finish matches the sketch) of the full price, depending upon the reason for rejection and the complexity of the job. When the job is rejected at the sketch stage, current surveys indicate that the customary fee is 20 to 50 percent of the original price. This fee may be less for quick, rough sketches and more for highly rendered, time-consuming work.
- 10. Artists considering working on speculation assume all risks, and should evaluate them carefully when offered such arrangements. For a thorough discussion of the risks, see the Speculation section in Chapter 3, Professional Issues.
- 11. The Graphic Artists Guild is unalterably opposed to the use of work-for-hire contracts, in which authorship and all rights that go with it are transferred to the commissioning party and the independent artist is treated as an employee for copyright purposes only. The independent artist receives no employee benefits and loses the right to claim authorship or to profit from future use of the work forever. Additional information on work for hire can be found in Chapter 2, Legal Rights and Issues.
- 12. Customary and usual expenses such as unusual props, costumes, model fees, travel costs, production costs, and consultation time should be billed to the client separately. An expense estimate should be included in the original written agreement or as an amendment to the agreement.

All prices for illustration in this book are based on a survey of the United States and Canada that was reviewed by a special committee of experienced professionals through the Graphic Artists Guild. These figures, reflecting the responses of established professionals, are meant as a point of reference only and do not necessarily reflect such important factors as deadlines, job complexity, reputation and experience of a particular illustrator, research, technique or unique quality of expression, and extraordinary or extensive use of the finished art. (See related material in other sections of this book, especially in Chapter 5, Essential Business Practices, and Chapter 13, Standard Contracts and Business Tools.)

The price ranges in the chart below do not reflect any of the above considerations and do not constitute specific prices for particular jobs. The buyer and seller are free to negotiate, with each artist independently deciding how to price the work, after taking all factors into account.

	B/W or 1 Color	Color
National, large metro, o	r large circulation	
Section cover	\$600-\$2,000	\$800-\$3,000
Full page	\$500-\$1,500	\$600-\$2,000
Half page	\$300-\$1,000	\$750-\$1,500
Quarter page	\$200-\$700	\$550-\$1,200
Spot	\$300-\$600	\$400-\$900
vidsize to small metro,	or medium to small circ	ulation
Section cover	\$500-\$1,500	\$750-\$2,000
Full page	\$300-\$1,000	\$500-\$1,500
Half page	\$300-\$750	\$300-\$1,000
Quarter page	\$125-\$500	\$300-\$750
Spot	\$100-\$400	\$150-\$500
-		
Section cover	\$600-\$3,000	\$700-\$4,000
Section cover Spread	\$600–\$3,000 \$500–\$2,000	\$650-\$3,000
Section cover Spread Full page	\$600–\$3,000 \$500–\$2,000 \$500–\$1,500	\$650–\$3,000 \$500–\$2,000
Section cover Spread Full page Half page	\$600-\$3,000 \$500-\$2,000 \$500-\$1,500 \$400-\$1,000	\$650-\$3,000 \$500-\$2,000 \$300-\$1,500
Section cover Spread Full page	\$600–\$3,000 \$500–\$2,000 \$500–\$1,500	\$650-\$3,000 \$500-\$2,000 \$300-\$1,500 \$300-\$1,000
Section cover Spread Full page Half page	\$600-\$3,000 \$500-\$2,000 \$500-\$1,500 \$400-\$1,000	\$650-\$3,000 \$500-\$2,000 \$300-\$1,500
Section cover Spread Full page Half page Quarter page Spot	\$600-\$3,000 \$500-\$2,000 \$500-\$1,500 \$400-\$1,000 \$300-\$850	\$650-\$3,000 \$500-\$2,000 \$300-\$1,500 \$300-\$1,000 \$200-\$750
Section cover Spread Full page Half page Quarter page Spot	\$600-\$3,000 \$500-\$2,000 \$500-\$1,500 \$400-\$1,000 \$300-\$850 \$250-\$650	\$650-\$3,000 \$500-\$2,000 \$300-\$1,500 \$300-\$1,000 \$200-\$750
Section cover Spread Full page Half page Quarter page Spot	\$600-\$3,000 \$500-\$2,000 \$500-\$1,500 \$400-\$1,000 \$300-\$850 \$250-\$650 or medium to small circ	\$650-\$3,000 \$500-\$2,000 \$300-\$1,500 \$300-\$1,000 \$200-\$750 ulation
Section cover Spread Full page Half page Quarter page Spot Midsize to small metro, Section cover	\$600-\$3,000 \$500-\$2,000 \$500-\$1,500 \$400-\$1,000 \$300-\$850 \$250-\$650 or medium to small circ \$500-\$2,000	\$650-\$3,000 \$500-\$2,000 \$300-\$1,500 \$300-\$1,000 \$200-\$750 ulation \$550-\$2,500
Section cover Spread Full page Half page Quarter page Spot Midsize to small metro, Section cover Spread	\$600-\$3,000 \$500-\$2,000 \$500-\$1,500 \$400-\$1,000 \$300-\$850 \$250-\$650 or medium to small circ \$500-\$2,000 \$450-\$2,000	\$650-\$3,000 \$500-\$2,000 \$300-\$1,500 \$200-\$750 ulation \$550-\$2,500 \$550-\$2,500
Spread Full page Half page Quarter page Spot Midsize to small metro, Section cover Spread Full page	\$600-\$3,000 \$500-\$2,000 \$500-\$1,500 \$400-\$1,000 \$300-\$850 \$250-\$650 or medium to small circ \$500-\$2,000 \$450-\$2,000 \$350-\$1,500	\$650-\$3,000 \$500-\$2,000 \$300-\$1,500 \$300-\$1,000 \$200-\$750 ulation \$550-\$2,500 \$350-\$2,500 \$350-\$2,000

Package Illustration

The demand for engaging, forceful, and highly creative packaging for recordings has attracted the best of talented editorial and advertising illustrators, who in turn have created a new art form. Many record album covers have become collector's items. Several books have been published on record album cover art, and there's an ongoing market in collecting and selling them.

With the advent of the smaller-format CD and cassette during the 1980s, overall graphic presentation and type design have come to rival record cover artwork in importance. Though the original long box gave artists some large-scale opportunities, these have been phased out in favor of small boxes, which retailers prefer because they can display more CDs.

Commissions for recording cover illustration can be lucrative, and artists should request advances on royalties. Based on current data, however, fees vary widely, depending on the recording artist, the particular label and recording company, and the desirability and fame of the illustrator.

With the growth of independent record companies specializing in specific genres, there are many modest-budget, total-package assignments (including illustration, type treatment, and overall design) for diligent creators willing to search for them in many locations around the country. Fees for complex recording packages have gone higher than \$10,000. This kind of assignment, however, requires many meetings, sketches, and changes.

Most recording companies have subsidiary labels, featuring various recording artists and types of music. The minor labels of major recording companies are usually reserved for less commercial records and re-releases of previous recordings. According to current survey data, recent mergers and acquisitions in the recording industry (Sony-Columbia, BMG-RCA, Turner-Time Warner) have all but eliminated any discernible differences in fees based on geographic location. In all cases, only record company publication rights are transferred, and the original art is returned to the artist. Tie-in poster rights are sometimes included.

It is common in the music packaging market for the musicians, their management, or the project's producers to purchase the original art. The artist should be prepared with a dollar amount in case this happens. Possible tie-ins with videotape/disk marketing should also be kept in mind when considering an appropriate fee for the image.

One illustrator who has worked extensively with major recording companies advises artists working in the field to employ a lawyer experienced in the entertainment industry to negotiate contracts for them. Otherwise, the artist may be unknowingly ripped off through various tricks and maneuverings. It is also in the artist's best interests for the contract to contain a clause clearly spelling out that additions and alterations will lead to extra charges.

Trade practices

The following trade practices have been used historically, and through such tradition are accepted as standard:

- The intended use of the art must be stated clearly in a contract, purchase order, or letter of agreement stating the price and terms of sale.
- 2. The artwork cannot be altered in any way, except for what occurs during the normal printing process, without the written consent of the artist. Since it is very easy to alter art electronically these days, the client should inform the artist if he or she wishes to alter the artwork and then do so only with the permission and supervision of the illustrator. Anything less is a violation of professional good faith and ethical practice.
- **3.** Return of original artwork to the artist is automatic unless otherwise negotiated.
- **4.** Artists normally sell only first reproduction rights unless otherwise stated.
- 5. If the artwork is to be used for other than its original purpose, such as for an electronic database or a Web site, the price is usually negotiated as soon as possible. Note that the

secondary use of an illustration may be of greater value than the primary use. Although there is no set formula for reuse fees, current surveys indicate that artists add a reuse fee ranging from 50 to 100 percent of the fee that would have been charged had the illustration been commissioned for the new use.

- Illustrators should negotiate reuse arrangements with the original commissioning party with speed, efficiency, and all due respect to the client's position.
- Historically, artists have charged higher fees for rush work than those listed here, often by an additional 20 to 150 percent.
- 8. If the illustrator satisfies the client's requirements and the finished work is still not used, full compensation should be made. However, historically, if a job is canceled after the work is begun, through no fault of the artist, a cancellation or kill fee is often provided. Depending upon the stage at which the job is terminated, the fee must cover all work done, including research time, sketches, billable expenses, and compensation for lost opportunities resulting from the artist's refusing other offers in order to make time available for the commission. In addition, clients who put commissions on hold or withhold approval for commissions for longer than 30 days should secure the assignment by paying a deposit upfront.
- 9. Historically, a rejection fee has been agreed upon if the assignment is terminated because the preliminary or finished work is found not to be reasonably satisfactory and steps to correct the problem have been exhausted. The rejection fee for finished work has often been over 50 percent and up to 100 percent (if the finish matches the sketch) of the full price, depending upon the reason for rejection and the complexity of the job. When the job is rejected at the sketch stage, current surveys indicate that the customary fee is 20 to 50 percent. This fee may be less for quick, rough sketches and more for highly rendered, time-consuming work.

- Artists considering working on speculation assume all risks, and should evaluate them carefully when offered such arrangements. For a thorough discussion of the risks, see the Speculation section in Chapter 3, Professional Issues.
- 11. The Graphic Artists Guild is unalterably opposed to the use of work-for-hire contracts, in which authorship and all rights that go with it are transferred to the commissioning party and the independent artist is treated as an employee for copyright purposes only. The independent artist receives no employee benefits and loses the right to claim authorship or to profit from future use of the work forever. Additional information on work for hire can be found in Chapter 2, Legal Rights and Issues.
- 12. Customary and usual expenses such as unusual props, costumes, model fees, travel costs, production costs, consultation time, and so on should be billed to the client separately. An expense estimate should be included in the original written agreement or as an amendment to the agreement.

All prices for illustration in this book are based on a survey of the United States and Canada that was reviewed by a special committee of experienced professionals through the Graphic Artists Guild. These figures, reflecting the responses of established professionals, are meant as a point of reference only and do not necessarily reflect such important factors as deadlines, job complexity, reputation and experience of a particular illustrator, research, technique or unique quality of expression, and extraordinary or extensive use of the finished art. (See related material in other sections of this book, especially in Chapter 5, Essential Business Practices, and Chapter 13, Standard Contracts and Business Tools.)

The price ranges in the charts below do not reflect any of the above considerations and do not constitute specific prices for particular jobs. The buyer and seller are free to negotiate, with each artist independently deciding how to price the work, after taking all factors into account.

	Music recordin	gs [—]	
Major studio or distribution	Popular & rock	Classical & jazz	Other
Major studio or distribution	\$1,300-\$5,000	\$1,000-\$3,000	\$500-\$3,500
Small studio or distribution	\$1,300-\$3,000	\$1,000-\$3,000	\$500-\$2,000
Rereleased recording	\$1,300–\$1,500	\$1,000–\$3,000	\$500-\$2,000
	Videos		
	Special-/single-interest	General-interest	
Major studio or distribution	\$1,000–\$3,500	\$1,500-\$3,000	
Small studio or distribution	\$500-\$1,000	\$1,000-\$2,000	
Rereleased recording	\$500-\$1,000	\$1,000-\$2,000	
	Software 1		
	Test run	Limited distribution	National distribution
Business software	\$1,000-\$2,000	\$1,500-\$3,500	\$3,000-\$7,000
Educational software	\$1,000-\$1,500	\$2,000-\$3,000	\$3,000-\$4,000
Video games software	\$1,500-\$2,000	\$2,500-\$3,500	\$2,500-\$4,500
	Retail products		
	Test run	Limited distribution	National distribution
Apparel	-	-	\$300-\$4,700
Electronics	-	\$3,000	-
Food/beverages	\$300-\$3,000	\$500-\$5,000	\$1,500-\$4,000
Footwear	-	\$1,000	
Furniture/home furnishings	-	\$1,200	-
Gifts/novelties	\$1,200	-	_
Health/beauty aids	\$400-\$1,000	\$500-\$3,500	\$1,500-\$5,500
Housewares	\$400	\$1,500-\$2,000	\$2,500
nfant products	-	-	\$750-\$2,000
Sporting goods	\$500	\$500	\$500
Stationery	\$500	\$500	\$500
Toys/games	\$1,000-\$4,500	\$1,000	\$1,000-\$7,500
√ideo games/software	\$2,500	\$2,500-\$3,500	\$2,000-\$4,500
Other (cards, labels, pet food)	\$4,000	\$1,200-\$2,500	\$3,000-\$9,000

C Since no significant new data were reported in 2000, figures are from the 1997 edition. C One piece of art used on CD and cassettes. C T Test run and limited distribution products usually have a short shelf life; national distribution indicates an extended shelf life.

Additional Fees for Packaging Illustration		
	Percentage of original fee	
Sale of original art	75%–125%	
Stock sale of existing art	25%-100%	
Rush fee	10%–115%	
Total copyright transfer (excluding original art)	100%-350%	
Work-for-hire (transfer of legal authorship)	50%-725%	

Fashion Illustration

Fashion illustrators are graphic artists who specialize in drawing clothed figures and accessories in a specific style or "look" for use by retailers, advertising, graphic design studios, corporations/manufacturers, and in editorials for magazines and newspapers. Sometimes fashion illustrators are required to create an illustration with only a photo or croquis (working sketch) of the garment for reference; the illustrator must invent the drape of the garment on a model, the light source, or even the garment itself.

Although the advertising market for apparel and accessory illustration has declined in recent years, illustrations are still being commissioned for work with a fashion theme in the growing beauty and cosmetic areas, as well as in the development of crossover markets that are well suited to an illustrative style. Such illustration is generally used as comp or finished art for magazine or newspaper editorial, print advertising, storyboards, television/video, packaging, display, collateral material, and product development or test presentations. Internet displays and sales venues are relatively new markets.

Current data indicate that factors determining fees include the type and extent of usage, market (such as corporate, advertising, or editorial), size and prestige of account, volume of work, the illustrator's experience and desirability, job complexity, and deadlines.

Most apparel illustration is paid on a per-figure basis, with an additional charge for backgrounds. When more than three figures are shown (4 to 10), a group rate can be charged at a lower rate, usually 80 to 90 percent of an artist's singlefigure rate. In volume work (considered any amount over 10 figures), such as catalog, brochure, or instructional use, the per-figure price is negotiated at a volume rate, usually 75 percent of an artist's single-figure rate. Accessory illustration is generally paid on a per-item basis. With the exception of specialized work, accessory illustration rates are generally 50 to 75 percent of an artist's per-figure prices. When more than three items are shown, additional items can be charged at a lower unit price.

The price ranges in the chart reflect current data based on surveys of fees for women's, men's, and children's fashion, beauty, and cosmetic illustration. These ranges do not reflect complexity of style and fees for highly rendered and photographic styles of illustration, which, data indicate, command a 50 percent premium over the high ranges in all categories.

Trade practices

The following trade practices have been used historically, and through such tradition are accepted as standard:

- The intended use of the art must be stated clearly in a contract, purchase order, or letter of agreement stating the price and terms of sale.
- 2. The artwork cannot be altered in any way, except for what occurs during the normal printing process, without the written consent of the artist. Since it is very easy to alter art electronically these days, the client should inform the artist if he or she wishes to alter the artwork and then do so only with the permission and supervision of the illustrator. Anything less is a violation of professional good faith and ethical practice.
- **3.** Return of original artwork to the artist is automatic unless otherwise negotiated.
- **4.** Artists normally sell first reproduction rights unless otherwise stated.
- Current data indicate that additional uses of artwork in the same (or other) media entails additional fees ranging from 20 to 100 percent of the standard initial fee for the same medium usage.
- 6. If the artwork is to be used for other than its original purpose, the price is usually negotiated as soon as possible. Note that the secondary use of an illustration may be of greater value than the primary use. Although there is no set formula for reuse fees, current surveys indicate that artists add a reuse fee ranging from 20 to 100 percent of the fee that would have been charged had the illustration been commissioned for the new use.
- Illustrators should negotiate reuse arrangements with the original commissioning party with speed, efficiency, and all due respect to the client's position.
- If a client wishes to purchase all reproduction rights *or* original artwork, current data indicate that a typical charge is 100 percent

of the assignment price or higher, depending on the value of the original art for the individual artist. And the artist retains the copyright.

- 9. If a client wishes to purchase all reproduction rights and original artwork, current data indicate that a typical charge is 200 percent of the assignment price or higher, depending on the value of the original art for the individual artist. And the artist retains the copyright.
- Historically, artists have charged higher fees for rush work than those listed here, often by an additional 20 to 150 percent.
- All corrections/revisions should be made in the preliminary sketch stage. All client changes, particularly in finished art, historically require an additional charge; the amount depends on the amount and complexity of the change.
- 12. If the illustrator satisfies the client's requirements and the finished work is still not used, full compensation should be made. However, historically, if a job is canceled after the work is begun, through no fault of the artist, a cancellation or kill fee is often provided. Depending upon the stage at which the job is terminated, the fee must cover all work done, including research time, sketches, billable expenses, and compensation for lost opportunities resulting from the artist's refusing other offers in order to make time available for the commission. Current data indicate that these fees are calculated as follows: prior to finish-in-progress, 50 percent; finished art-in-progress, 70 percent; after completion of finished art, 100 percent. In addition, clients who put commissions on hold or withhold approval for commissions for longer than 30 days should secure the assignment by paying a deposit upfront.
- 13. Historically, a rejection fee has been agreed upon if the assignment is terminated because the preliminary or finished work is found not to be reasonably satisfactory and steps to correct the problem have been exhausted. The rejection fee for finished

work often has been over 50 percent of the full price, depending upon the reason for rejection and the complexity of the job. When the job is rejected at the sketch stage, current surveys indicate that the customary fee is 20 to 50 percent of the original price. This fee may be less for quick, rough sketches and more for highly rendered, time-consuming work.

- 14. Artists considering working on speculation assume all risks, and should evaluate them carefully when offered such arrangements. For a thorough discussion of the risks, see the Speculation section in Chapter 3, Professional Issues.
- 15. The Graphic Artists Guild is unalterably opposed to the use of work-for-hire contracts, in which authorship and all rights that go with it are transferred to the commissioning party and the independent artist is treated as an employee for copyright purposes only. The independent artist receives no employee benefits and loses the right to claim authorship or to profit from future use of the work forever. Advertising is not eligible to be work for hire, as it does not fall under any of the eligible categories defined in the law. Additional information on work for hire can be found in Chapter 2, Legal Rights and Issues.

16. Customary and usual expenses such as unusual props, costumes, model fees, travel costs, production costs, and consultation time should be billed to the client separately. An expense estimate should be included in the original written agreement or as an amendment to the agreement.

All prices for illustration in this book are based on a survey of the United States and Canada that was reviewed by a special committee of experienced professionals through the Graphic Artists Guild. These figures, reflecting the responses of established professionals, are meant as a point of reference only and do not necessarily reflect such important factors as deadlines, job complexity, reputation and experience of a particular illustrator, research, technique or unique quality of expression, and extraordinary or extensive use of the finished art. (See related material in other sections of this book, especially in Chapter 5, Essential Business Practices, and Chapter 13, Standard Contracts and Business Tools.)

The price ranges in the following chart do not reflect any of the above considerations and do not constitute specific prices for particular jobs. The buyer and seller are free to negotiate, with each artist independently deciding how to price the work, after taking all factors into account.

Direct mail brochures			
	B/W	Color	
Print run over 100,000 or la	rge circulation		
Cover	\$1,500-\$5,000	\$1,800-\$5,000	
Figure*	\$1,000	\$1,700	
Spot/quarter page	\$500-\$1,500	\$500-\$2,500	
Print run 10,000 to 100,000	or medium circulation		
Cover	\$850-\$4,000	\$1,000-\$4,000	
Figure*	\$750	\$1,400	
Spot/quarter page	\$350-\$2,000	\$400-\$2,500	
Print run under 10,000 or si	mall circulation		
Cover	\$500-\$2,000	\$500-\$3,000	
Figure*	\$350	\$900	
Spot/quarter page	\$350-\$1,000	\$500-\$1,500	

[276]

for Collateral & Direct Mail continued			
	Instructional b	ooklets	
	B/W	Color	
Print run over 100,000 or la	arge circulation		
Cover	\$2,000-\$2,500	\$2,000-\$3,500	
Figure*	\$800	\$1,400	
Spot/quarter page	\$500-\$750	\$500-\$1,000	
Print run 10,000 to 100,000	or medium circulation		
Cover	\$1,000-\$2,000	\$2,000-\$3,000	
Figure*	\$450	\$900	
Spot/quarter page	\$400-\$750	\$500-\$1,000	
Print run under 10,000 or s			
Cover	\$1,000-\$2,000	\$1,000-\$2,000	
Figure*	\$275	\$550	
Spot/quarter page	\$250-\$500	\$300-\$500	
·	Retail catal	ogs	
D	B/W	Color	
Print run over 100,000 or la			
Cover	\$1,500-\$4,000	\$2,000-\$5,000	
Figure*	\$800	\$1,300	
Spot/quarter page	\$500-\$700	\$500-\$1,000	
Print run 10,000 to 100,000			
Cover	\$1,300-\$3,000	\$1,750-\$4,000	
Figure*	\$550	\$900	
Spot/quarter page	\$250-\$500	\$300–\$500	
Print run under 10,000 or sr			
Cover	\$800-\$2,000	\$800–\$3,000	
Figure*	\$350	\$600	
Spot/quarter page	\$175–\$500	\$300-\$500	
	Trade catal	ogs	
Drint num and the sea	B/W	Color	
Print run over 100,000 or la			
Cover	\$2,000-\$4,000	\$2,000-\$5,000	
Figure*	\$800	\$1,400	
Spot/quarter page	\$500-\$1,000	\$500-\$1,500	
Print run 10,000 to 100,000			
Cover	\$2,000-\$3,000	\$2,000-\$4,000	
Figure*	\$4,500	\$9,000	
Spot/quarter page	\$250-\$500	\$500-\$1,500	
Print run under 10,000 or sr	nall circulation		
Cover	\$2,000	\$2,000-\$2,500	
Figure*	\$350	\$600	
Spot/quarter page	\$150-\$500	\$200-\$500	

Other		
	B/W	Color
Hang tag/labels	\$750-\$800	\$1,000-\$2,000
Patterns	\$150	\$250-\$375
Store fixtures (per piece)	\$1,000	\$1,500-\$2,500
T-shirt apparel		
Flat fee	\$500-\$1,000	\$500-\$1,500
Advance	\$250	\$500–\$750
Royalty	2%–10%	5%–15%
Showroom/presentation boa	ards	
Figure	\$150-\$300	\$250-\$500
Flat	\$30-\$50	\$50–\$100
Line sheets/price list*		
Figure	\$50	\$100–\$125
Flat	\$20	\$50
Retail buying service/mat se	ervice*	
Figure	\$100	-
Flat	\$10	-

Enco for Eachier /Decuty Illustration

advertising illustration are included in the general advertising chart above, and comparable fees for fashion/beauty editorial illustration are included in the general editorial chart above.

Greeting Cards, Novelties, & Retail Goods Illustration

The greeting card and paper novelty fields have grown more competitive after a boom in the 1980s. New greeting card companies and fresh card lines constantly enter-and leave-the industry, while the largest card publishers continue to hold the lion's share of the market. Since success or failure in this business is based largely on the public's buying habits, greeting card designs lend themselves particularly well to royalty or licensing arrangements.

Artwork for retail products such as novelty merchandising, apparel, china, giftware, toys, and other manufactured items is traditionally purchased through licensing agreements. Calendars and posters for retail sale may also use licensing or royalty agreements. For more information about uses of this type of illustration, see the Greeting Card and Novelty Design section in Chapter 7, Graphic Design Prices and Trade Customs, the Royalties and Licensing section in Chapter 5, Essential Business Practices, and the Book Publishing section above.

Greeting cards

Sales of greeting cards in such mass-market outlets as supermarkets showed tremendous growth over the last decade, which highlights the benefits of royalty agreements. New market niches, such as cards for Hispanics, working women, and seniors, have been introduced, with anticipated sales growth during the next decade.

Although the major companies publish mostly cards developed by staff artists, they do commission or buy some outside work. The rest of the industry, however, depends heavily on freelance illustration and design. Freelancers

9 Illustration Prices & Trade Customs

create inventory of their own designs for sale to producers/manufacturers rather than rely on specially commissioned works and usually develop a different style for different clients in order to minimize competition.

Designs, mostly created in full color, generally fall into everyday or seasonal lines. Everyday cards include birthday, anniversary, get well, friendship, juvenile, religious/inspirational, congratulations, sympathy, and other such sentiments. Christmas cards comprise the vast majority of seasonal greetings, making up more than one third of all cards sold and as much as 50 to 100 percent of some card companies' offerings. Other seasonal cards include Valentine's Day, Easter, Mother's and Father's Day, Hanukkah, and other holidays. Current survey data indicate that special effects, such as embossed, die-cut, or pop-up cards, command larger fees.

Artists whose cards sell well may propose that the company commission them to develop an entire line of cards, which involves from 20 to 36 stylistically similar cards with a variety of greetings. In cases where an artist's cards become top sellers and the style is strongly identified with the company, the value of the artist's work to the company is recognized with equity and other compensation. Exclusive arrangements providing royalties are negotiated on occasion; artists are advised, however, to develop a solid relationship with the client before considering such an agreement.

Greeting card designs are sold either on an advance against royalty basis or for a flat fee (artists should not do revisions on a proposed design before reaching agreement on payment and terms). According to current survey data, the royalty is usually a percentage of the wholesale price. In most cases a nonrefundable advance is paid in anticipation of royalties. This reflects the fact that production and distribution schedules require a year to 18 months before a design reaches the marketplace. Royalties and licensing are discussed further in Chapter 5, Essential Business Practices.

Many greeting card companies purchase greeting card rights only, with the artists

retaining all other rights. Limited rights are appropriate, since most cards, particularly holiday greetings, are marketed for only one year.

Retail products

A wide array of designs and illustrations are in demand for T-shirts, towels, mugs, tote bags, and other such novelty items. Whether a design or illustration is specifically developed by the artist for marketing as a product, or a design or illustration is sold as a spin-off of a nationally known character, it is usually done under a licensing agreement.

In such agreements an artist, designer, or owner of rights to artwork permits ("licenses") another party to use the art for a limited specific purpose, for a specified time, in a specified territory, in return for a fee or royalty. For a detailed discussion of licensing, see Chapter 5, Essential Business Practices. An excellent book on the subject is *Licensing Art and Design* by Caryn Leland, published by Allworth Press (see The Graphic Artists Guild's Bookshelf in Chapter 15, Resources and References). Model licensing agreements, reprinted with permission of the author, appear in Chapter 13, Standard Contracts and Business Tools.

Trade practices

The following trade practices have been used historically, and through such tradition are accepted as standard:

- The intended use of the art must be stated clearly in a contract, purchase order, or letter of agreement stating the price and terms of sale.
- 2. The artwork cannot be altered in any way, except for what occurs during the normal printing process, without the written consent of the artist. Since it is very easy to alter art electronically these days, the client should inform the artist if he or she wishes to alter the artwork and then do so only with the permission and supervision of the illustrator. Anything less is a violation of professional good faith and ethical practice.

- **3.** Return of original artwork to the artist is automatic unless otherwise negotiated.
- 4. Artists normally sell only first reproduction rights unless otherwise stated.
- 5. If the artwork is to be used for other than its original purpose, such as on an electronic database or a Web site, the price is usually negotiated as soon as possible. Note that the secondary use of an illustration may be of greater value than the primary use. Although there is no set formula for reuse fees, current surveys indicate that artists add a reuse fee ranging from 20 to 100 percent of the fee that would have been charged had the illustration been commissioned for the new use.
- Illustrators should negotiate reuse arrangements with the original commissioning party with speed, efficiency, and all due respect to the client's position.
- Historically, artists have charged higher fees for rush work than those listed here, often by an additional 20 to 150 percent.
- 8. If the illustrator satisfies the client's requirements and the finished work is still not used, full compensation should be made. However, historically, if a job is canceled after the work is begun, through no fault of the artist, a cancellation or kill fee is often provided. Depending upon the stage at which the job is terminated, the fee must cover all work done, including research time, sketches, billable expenses, and compensation for lost opportunities resulting from the artist's refusing other offers in order to make time available for the commission. In addition, clients who put commissions on hold or withhold approval for commissions for longer than 30 days should secure the assignment by paying a deposit upfront.
- Historically, a rejection fee has been agreed upon if the assignment is terminated because the preliminary or finished work is found to be not reasonably satisfactory

and steps to correct the problem have been exhausted. The rejection fee for finished work has often been over 50 percent of the full price, depending upon the reason for rejection and the complexity of the job. When the job is rejected at the sketch stage, current surveys indicate that the customary fee is 20 to 50 percent of the original price. This fee may be less for quick, rough sketches and more for highly rendered, time-consuming work.

- Artists considering working on speculation assume all risks, and should evaluate them carefully when offered such arrangements. For a thorough discussion of the risks, see the Speculation section in Chapter 3, Professional Issues.
- 11. The Graphic Artists Guild is unalterably opposed to the use of work-for-hire contracts, in which authorship and all rights that go with it are transferred to the commissioning party and the independent artist is treated as an employee for copyright purposes only. The independent artist receives no employee benefits and loses the right to claim authorship or to profit from future use of the work forever. Additional information on work for hire can be found in Chapter 2, Legal Rights and Issues.
- 12. Customary and usual expenses such as unusual props, costumes, model fees, travel costs, production costs, and consultation time should be billed to the client separately. An expense estimate should be included in the original written agreement or as an amendment to the agreement.

All prices for illustration in this book are based on a survey of the United States and Canada that was reviewed by a special committee of experienced professionals through the Graphic Artists Guild. These figures, reflecting the responses of established professionals, are meant as a point of reference only and do not necessarily reflect such important factors as deadlines, job complexity, reputation and

9 Illustration Prices & Trade Customs

experience of a particular illustrator, research, technique or unique quality of expression, and extraordinary or extensive use of the finished art. (See related material in other sections of this book, especially in Chapter 5, Essential Business Practices, and Chapter 13, Standard Contracts and Business Tools.)

The price ranges in the chart do not reflect any of the above considerations and do not constitute specific prices for particular jobs. The buyer and seller are free to negotiate, with each artist independently deciding how to price the work, after taking all factors into account.

Comparative Assume limited license of 3 years	Fees for Merchan for indicated use.	dising & Retai	I Illustration $^{\Box}$
	Color greet	ing cards	
	Flat fee	Advance	Royalty percentage
Original design	\$300-\$750	\$200-\$750	4%–10%
Licensing of character	-	\$500-\$2,000	4%-6%
op-up or specialty cards	\$1,000-\$4,000	\$350-\$600	5%
	Color po	osters	
Original design	\$1,500-\$6,000	\$500-\$1,500	5%–50%
Licensed artwork	\$1,000-\$5,000	\$750-\$1,500	8%–14%
	Color cal	endars	
12 illustrations and cover	\$3,600-\$14,000	\$1,200-\$7,000	5%–10%
Advance as percent of projected sales	10%–33%	5%–10%	
	Display/novelty	products	
Driginal design	\$1,500-\$2,500	\$700-\$1,000	3%–5%
Licensed artwork	\$1,000-\$1,500	\$500-\$800	5%–10%
	Shopping	g bags	
Limited use	\$500-\$3,500		
Extensive use	\$5,000		
	Domestic proc	lucts	- -
Original design	\$700-\$800	\$500-\$3,000	5%-10%
icensed artwork	\$1,000–\$4,000	\$500-\$2,000	10%
	Paper produc	tsāāāāā	
Original design	\$700-\$3,000	\$500-\$2,000	5%-10%
Licensed artwork	\$500-\$2,000	\$300-\$1,000	6%–10%

on the wholesale price of the item. Advances and royalties may vary wilely depending on the client and the distribution. Current data indicate that 25 percent is added for each color overlay in addition to black. T-shirts, gifts, caps, mugs, game boards, key chains, etc. Wallpaper, tablecloths, napkins, fabrics, window treatment.

Medical Illustration

Medical illustration is one of the most demanding and highly technical areas of the graphic arts. Medical illustrators are specially trained graphic artists who combine scientific knowledge of the human body with a mastery of graphic techniques to create accurate medical and health illustrations. The work of a medical illustrator ranges from highly realistic, anatomically precise pieces emphasizing instructional content to imaginative and conceptual pieces emphasizing subjective impact.

Accuracy of content and effectiveness of visual presentation are equally essential in this field. Many medical illustrators hold master's degrees from one of the five medical schools, accredited through the American Medical Association (AMA), that offer training in the field. Formal medical studies include gross anatomy, physiology, embryology, pathology, neuroanatomy, and surgery, as well as commercial art techniques, television, photography, and computer graphics. Medical illustrators may be certified by the Association of Medical Illustrators (AMI) through written examination and portfolio review. Certification is maintained and renewed every five years through an organized continuing-education program.

While many medical illustrators still work with a wide variety of traditional rendering techniques, including pen and ink, watercolor, airbrush, and acrylics, a growing number of illustrators now work partially or exclusively on the computer. Many have even moved into three-dimensional animation, where they can depict how things work at the microscopic level. Some medical illustrators specialize in the design and construction of anatomical models, exhibits, and prosthetics or in techniques for film, video, and interactive media. A growing market for medical illustration is in the legal field, where medical illustration is commissioned specifically for use in courtroom proceedings to clarify complex medical or scientific information for judges and juries.

Because of their extensive background in science and medicine, medical illustrators often work directly with clients, editors, and art directors in the conceptual development of projects.

Trade practices

The following trade practices have been used historically, and through such tradition are accepted as standard:

- **1.** The intended use of the art must be stated clearly in a contract, purchase order, or letter of agreement stating the price and terms of sale.
- 2. The artwork cannot be altered in any way, except for what occurs during the normal printing process, without the written consent of the artist. Since it is very easy to alter art electronically these days, the client should inform the artist if he or she wishes to alter the artwork and then do so only with the permission and supervision of the illustrator. Anything less is a violation of professional good faith and ethical practice.

- 3. Return of original artwork to the artist is automatic unless otherwise negotiated.
- **4.** Artists normally sell only first reproduction rights unless otherwise stated. Additional rights are traditionally licensed on a one-time basis, with separate payment for each and every use.
- 5. If the artwork is to be used for other than its original purpose, such as on an electronic database or a Web site, the price is usually negotiated as soon as possible. Note that the secondary use of an illustration may be of greater value than the primary use. Although there is no set formula for reuse fees, current surveys indicate that artists add a reuse fee ranging from 20 to 100 percent of the fee that would have been charged had the illustration been commissioned for the new use.
- 6. Illustrators should negotiate reuse arrangements with the original commissioning party with speed, efficiency, and all due respect to the client's position.
- **7.** Historically, artists have charged higher fees for rush work than those listed here, often by an additional 50 percent.
- 8. If the illustrator satisfies the client's requirements and the finished work is still not used, full compensation should be made. However, historically, if a job is canceled after the work is begun, through no fault of the artist, a cancellation or kill fee is often provided. Depending upon the stage at which the job is terminated, the fee must cover all work done, including research time, sketches, billable expenses, and compensation for lost opportunities resulting from the artist's refusing other offers in order to make time available for the commission.
- 9. Historically, a rejection fee has been agreed upon if the assignment is terminated because the preliminary or finished work is found to be not reasonably satisfactory and steps to correct the problem have been exhausted. The rejection fee for finished work has often been over 50 percent of the full price, depending upon the reason for rejection and the complexity of the job. When the job is rejected at the sketch stage, current surveys indicate the customary fee is 20 to 50 percent of the original price. This fee may be less for quick, rough sketches and more for highly rendered, time-consuming work.
- 10. Artists considering working on speculation assume all risks, and should evaluate them carefully when offered such arrangements. For a thorough discussion of the risks, see the Speculation section in Chapter 3, Professional Issues.
- 11. The Graphic Artists Guild is unalterably opposed to the use of work-for-hire contracts, in which authorship and all rights that go with it are transferred to the commissioning party and the independent artist is treated as an employee for copyright purposes only. The ind pendent artist receives no employee benefits and loses the right to claim authorship or to profit from future use of the work forever. Additional information on work for hire can be found in Chapter 2, Legal Rights and Issues.

12. Customary and usual expenses such as shipping fees, travel costs, consultation time, and other unusual expenses should be billed to the client separately. An expense estimate should be included in the original written agreement or as an amendment to the agreement.

Pricing information in this section is based on a broad survey of medical illustrators in cooperation with the Graphic Artists Guild and the Association of Medical Illustrators. The price ranges are meant as points of reference from which both buyer and seller are free to negotiate, taking into account usage, copyright, complexity, research, and the artist's experience, skill, and reputation. They do not necessarily reflect such important factors as deadlines, job complexity, research, technique or unique quality of expression, and extraordinary or extensive use of the finished art. (See related material in other sections of this book, especially in Chapter 5, Essential Business Practices, and Chapter 13, Standard Contracts and Business Tools.)

The price ranges in the charts below do not reflect any of the above considerations and do not constitute specific prices for particular jobs. The buyer and seller are free to negotiate, with each artist independently deciding how to price the work, after taking all factors into account.

Advertising			
	Sketches/Comps	Line	Tone/Color
Conceptual			
Spread	\$400-\$2,500	\$2,250-\$3,500	\$1,500-\$6,500
Full page	\$400-\$2,000	\$1,250-\$2,000	\$1,200-\$4,000
Spot	\$200-\$700	\$700-\$1,500	\$500-\$2,000
Anatomical and surgical			
Spread	\$575–\$1,500	\$2,500-\$4,500	\$2,000-\$7,000
Full page	\$275-\$1,200	\$2,000-\$3,700	\$1,500-\$5,000
Spot	\$150-\$800	\$800-\$1,500	\$400-\$2,100
Product			
Spread	\$650-\$2,000	\$2,800-\$6,000	\$1,500-\$7,500
Full page	-	\$2,200-\$4,500	\$800-\$6,000
Spot	\$200-\$800	\$900-\$2,000	\$800-\$3,000
Poster			
Simple	\$550-\$1,500	-	\$900-\$7,000
Moderate	\$500-\$2,250	_	\$2,000-\$8,500
Complex	\$700-\$3,500	_	\$1,500-\$14,500

Comparative Fees for Medical/Natural Science Illustration

	Presenta	ition	
	Line	Tone/Color	
Conceptual			
Spread	-	\$1,500-\$2,500	
Full page	\$600-\$900	\$700-\$1,500	
Spot	\$200-\$500	\$350-\$850	
Anatomical and surgical			
Spread	\$675-\$3,300	\$1,200-\$3,500	
Full page	\$500-\$2,000	\$650-\$2,000	
Spot	\$75-\$900	\$300-\$900	
Product			
Spread	-	\$1,500-\$3,000	
Full page	-	\$700-\$1,500	
Spot	-	\$425-\$900	
Cons	ultation/Research	/Expert testimony	
	Hourly rate	/ Expert testimony	
ducational institutions	\$45-\$75		
egal	\$75-\$115		
	<i><i><i></i></i></i>		
	Editorial		
	Line	Tone/Color	
rofessional publications/medi	cal journals		
Cover	-	\$1,200-\$2,000	
Spread	-	\$1,200-\$2,000	
Full page	\$400-\$1,000	\$750-\$1,500	
Spot	-	\$325-\$800	
consumer publications (books,	health and science		
Cover	-	\$1,250-\$3,000	
Spread	-	\$1,000-\$2,500	
Full page	\$300-\$1,500	\$700-\$1,500	
Spot	\$200-\$500	\$350-\$800	
	Simple	Moderate	Complex
nstructional texts (college, me		extbooks, patient educat	
	\$100-\$275	\$300-\$600	\$350-\$1,000
ledical/Scientific/Legal exhibit	s (usually 30" x 40")		
Computer animation	\$5,000–\$8,000		\$10,000-\$20,000
Each image (per panel)	\$500-\$600		\$600-\$1,200
Overlays	\$75-\$200		\$250-\$500
Construction of models for me	dical use		
Model construction	\$5,000-\$10,000		\$10,000+
Hourly rate	\$100-\$200		
lourly rate for consultation (bi	lled in addition to fe	e), excluding expenses	\$100-\$200
Day rate for testimony			\$1,000-\$2,500

Additional Fees for Medical/Natural Science Illustration		
	Percentage of original fee	
Sale of original art	50%-250%	
Stock sale of existing art	50%-75%	
Rush fee	30%–75%	
Unlimited use in print media only; no time or geographical limits	75%-300%	
Unlimited use, any media (including digital), for 1 year	95%–200%	
Total copyright transfer (excluding original art)	100%–400%	

Scientific (Biological) Illustration

Scientific illustrators create accurate and detailed images of scientific subjects, including anthropology, astronomy, botany, cartography, geology, paleontology, and zoology, often working directly with scientists and designers to illustrate books and journals or to create exhibits and educational materials for universities, research centers, state and federal government departments, museums, zoos, botanical gardens, and aquaria. Natural science illustration is increasingly expanding into all areas of graphic communications and commercial applications, such as special-interest magazines, environmental design, merchandise and package illustration, advertising, computer graphics, and audiovisuals.

Scientific illustrators must be versatile in more than one technique or medium, using everything from traditional pencils and paints to digital media; often they must be skilled in using optical equipment and precision measuring devices. A thorough understanding of the subject matter is required. The illustrator must pictorially reconstruct an entire object from incomplete specimens or conceptualize an informed interpretation. Specimens must be correctly delineated to show proportion, coloration, anatomical structures, and other diagnostic features. Scientific illustrations are judged for their accuracy, readability, and beauty.

Scientific illustrators who create works for books and journals report that workfor-hire contracts are unfortunately all too common in the field. Because more and more works are computer generated, the illustrator's function is frequently viewed as mere data entry, and although their work is integral to the scientific data provided, illustrators are often not even credited. To protect illustrators' rights in this field, and because it may take years for the work to be accepted for publication, practitioners recommend pricing work high for first (and probably only) use, requesting payment upon submission of the work, and providing scanned images rather than original artwork.

In additional to intended usage and rights transferred, the factors found in Guild research that affect pricing in this field include research and consultation time, travel, reference materials, and complexity of project.

Trade practices

The following trade practices have been used historically, and through such tradition are accepted as standard:

- 1. The intended use of the art must be stated clearly in a contract, purchase order, or letter of agreement stating the price and terms of sale.
- 2. The artwork cannot be altered in any way, except for what occurs during the normal printing process, without the written consent of the artist. Since it is very easy to alter art electronically these days, the client should inform the artist if he or she wishes to alter the artwork and then do so only with the permission and supervision of the illustrator. Anything less is a violation of professional good faith and ethical practice.
- 3. Return of original artwork to the artist is automatic unless otherwise negotiated.
- 4. Artists normally sell only first reproduction rights unless otherwise stated.
- 5. If the artwork is to be used for other than its original purpose, such as a database or Web site, the price is usually negotiated as soon as possible. Note that the secondary use of an illustration may be of greater value than the primary use. Although there is no set formula for reuse fees, current surveys indicate that artists add a reuse fee ranging from 20 to 100 percent of the fee that would have been charged had the illustration been commissioned for the new use.
- Illustrators should negotiate reuse arrangements with the original commissioning party with speed, efficiency, and all due respect to the client's position.
- 7. Historically, artists have charged higher fees for rush work than those listed here, often by an additional 20 to 150 percent.
- 8. If the illustrator satisfies the client's requirements and the finished work is still not used, full compensation should be made. However, historically, if a job is canceled after the work is begun, through no fault of the artist, a cancellation or kill fee is often provided. Depending upon the stage at which the job is terminated, the fee must cover all work done, including research time, sketches, billable expenses, and compensation for lost opportunities resulting from the artist's refusing other offers in order to make time available for the commission. In addition, clients who put commissions on hold or withhold approval for commissions for longer than 30 days should secure the assignment by paying a deposit upfront.
- 9. Historically, a rejection fee has been agreed upon if the assignment is terminated because the preliminary or finished work is found to be not reasonably satisfactory and steps to correct the problem have been exhausted. The rejection fee for finished work has often been over 50 percent of the full price, depending upon the reason for rejection and the complexity of the job. When the job is rejected at the sketch stage, current surveys indicate that the customary fee is 20 to 50 percent of the original price. This fee may be less for quick, rough sketches and more for highly rendered, time-consuming work.
- **10.** Artists considering working on speculation assume all risks, and should evaluate them carefully when offered such arrangements. For a thorough discussion of the risks, see the Speculation section in Chapter 3, Professional Issues.

- 11. The Graphic Artists Guild is unalterably opposed to the use of work-for-hire contracts, in which authorship and all rights that go with it are transferred to the commissioning party and the independent artist is treated as an employee for copyright purposes only. The independent artist receives no employee benefits and loses the right to claim authorship or to profit from future use of the work forever. Additional information on work for hire can be found in Chapter 2, Legal Rights and Issues.
- 12. Customary and usual expenses such as shipping fees, travel costs, consultation time, and other unusual expenses should be billed to the client separately. An expense estimate should be included in the original written agreement or as an amendment to the agreement.

Technical Illustration

Technical Illustrations create highly accurate renderings of machinery, charts, instruments, scientific subjects (such as biological studies, geological formations, and chemical reactions), space technology, cartography (maps), or virtually any subject that requires precision interpretation in illustration. Technical illustrators often work directly with a scientist, engineer, or technician to achieve the most explicit and accurate visualization of the subject and/or information.

Technical illustration is used in all areas of graphics communication in this age of high technology. Some of the areas most commonly requiring this specialized art are annual reports, special- or single-interest magazines, industrial publications, packaging, advertising, corporate, editorial, computer graphics, and audiovisuals.

These artists may work in a variety of media ink, wash, airbrush, pencil, watercolor, gouache, and computers—and are often trained in mechanical drafting, mathematics, diagrams, blueprints, and production.

In addition to intended usage and rights transferred, the factors found in Guild research that affect pricing in this field include research and consultation time, travel, reference materials, and complexity of project.

Trade practices

The following trade practices have been used historically, and through such tradition are accepted as standard:

1. The intended use of the art must be stated clearly in a contract, purchase order, or letter of agreement stating the price and terms of sale.

- 2. The artwork cannot be altered in any way, except for what occurs during the normal printing process, without the written consent of the artist. Since it is very easy to alter art electronically these days, the client should inform the artist if he or she wishes to alter the artwork and then do so only with the permission and supervision of the illustrator. Anything less is a violation of professional good faith and ethical practice.
- Return of original artwork to the artist is automatic unless otherwise negotiated.
- Artists normally sell only first reproduction rights unless otherwise stated.
- 5. If the artwork is to be used for other than its original purpose, such as an electronic database or a Web site, the price is usually negotiated as soon as possible. Note that the secondary use of an illustration may be of greater value than the primary use. Although there is no set formula for reuse fees, current surveys indicate that artists add a reuse fee ranging from 20 to 100 percent of the fee that would have been charged had the illustration been commissioned for the new use.

- **6.** Illustrators should negotiate reuse arrangements with the original commissioning party with speed, efficiency, and all due respect to the client's position.
- Historically, artists have charged higher fees for rush work than those listed here, often by an additional 20 to 150 percent.
- 8. If the illustrator satisfies the client's requirements and the finished work is still not used, full compensation should be made. However, historically, if a job is canceled after the work is begun, through no fault of the artist, a cancellation or kill fee is often provided. Depending upon the stage at which the job is terminated, the fee must cover all work done, including research time, sketches, billable expenses, and compensation for lost opportunities resulting from the artist's refusing other offers in order to make time available for the commission. In addition, clients who put commissions on hold or withhold approval for commissions for longer than 30 days should secure the assignment by paying a deposit upfront.
- 9. Historically, a rejection fee has been agreed upon if the assignment is terminated because the preliminary or finished work is found to be not reasonably satisfactory and steps to correct the problem have been exhausted. The rejection fee for finished work often has been over 50 percent of the full price, depending upon the reason for rejection and the complexity of the job. When the job is rejected at the sketch stage, current surveys indicate that the customary fee is 20 to 50 percent of the original price. This fee may be less for quick, rough sketches and more for highly rendered, time-consuming work.
- 10. Artists considering working on speculation assume all risks, and should evaluate them carefully when offered such arrangements. For a thorough discussion of the risks, see the Speculation section in Chapter 3, Professional Issues.

- 11. The Graphic Artists Guild is unalterably opposed to the use of work-for-hire contracts, in which authorship and all rights that go with it are transferred to the commissioning party and the independent artist is treated as an employee for copyright purposes only. The independent artist receives no employee benefits and loses the right to claim authorship or to profit from future use of the work forever. Additional information on work for hire can be found in Chapter 2, Legal Rights and Issues.
- 12. Customary and usual expenses such as shipping fees, travel costs, consultation time, and other unusual expenses should be billed to the client separately. An expense estimate should be included in the original written agreement or as an amendment to the agreement.

All prices for illustration in this book are based on a survey of the United States and Canada that was reviewed by a special committee of experienced professionals through the Graphic Artists Guild. These figures, reflecting the responses of established professionals, are meant as a point of reference only and do not necessarily reflect such important factors as deadlines, job complexity, reputation and experience of a particular illustrator, research, technique or unique quality of expression, and extraordinary or extensive use of the finished art. (See related material in other sections of this book, especially in Chapter 5, Essential Business Practices, and Chapter 13, Standard Contracts and Business Tools.)

The price ranges in the following charts do not necessarily reflect any of the above considerations and do not constitute specific prices for particular jobs. The buyer and seller are free to negotiate, with each artist independently deciding how to price the work, after taking all factors into account.

	Advertising	
	Line	Tone/Color
General-interest <i>(Reader's Digest, F</i>		agazines
Spread	\$2,000-\$2,500	\$2,500-\$5,000
Full page	\$1,500-\$2,000	\$2,000-\$4,000
Half page	\$1,000-\$1,500	\$1,500-\$3,000
Spot/quarter page	\$500-\$1,000	\$750-\$1,500
Special-interest (The New Yorker, A		ulation magazines
Spread	\$2,000-\$3,500	\$2,500-\$5,000
Full page	\$1,500-\$2,500	\$2,000-\$3,500
Half page	\$1,000-\$1,500	\$1,500-\$2,500
Spot/quarter page	\$250-\$1,000	\$500-\$1,500
Single-interest (Scientific American	, Golf Digest) or small circulation	on magazines
Spread	\$1,500-\$2,500	\$2,000-\$3,500
Full page	\$800-\$1,500	\$1,500-\$3,000
Half page	\$400-\$1,000	\$1,000-\$2,000
Spot/quarter page	\$250-\$750	\$350-\$1,000
National newspapers or suppleme	ntal newspaper magazines	
Section cover	\$1,500-\$2,500	\$2,000-\$3,500
Spread	\$1,000-\$2,000	\$1,500-\$2,500
Full page	\$750-\$1,500	\$1,000-\$2,000
Half page	\$500-\$1,000	\$500-\$1,500
Spot/quarter page	\$250-\$750	\$350-\$1,000
	Editorial publications	
	Line	Tone/Color
Vlagazines		¢1 750 ¢5 000
Cover	-	\$1,750-\$5,000
Spread		\$1,500-\$4,000
Full page	\$350-\$2,000	\$1,000-\$3,500
Half page	\$250-\$1,000	\$500-\$2,000
Spot/quarter page	\$125–\$500	\$250-\$1,000
Newspapers		#4 000 #0 000
Section cover	\$500-\$2,000	\$1,200-\$3,000
Spread	\$750-\$2,000	\$1,000-\$2,500
Full page	\$500-\$1,500	\$700-\$2,000
Half page	\$250-\$1,000	\$350-\$1,500
Spot/quarter page	\$200-\$700	\$250-\$1,000
Books		
Full page	\$250-\$1,000	\$400-\$1,500
Half page	\$175–\$750	\$250-\$1,000

Comparative Fees for Technical Illustration $^{\Box}$

9 Illustration Prices & Trade Customs

Co	rporate clients	
	Line	Tone/Color
mployee Publications Cover		
	\$1,000-\$2,000	\$1,500-\$3,500
Spread	\$1,000-\$1,500	\$1,500-\$2,500
Full page	\$500-\$1,000	\$1,000-\$2,000
Half page	\$350-\$800	\$500-\$1,000
Spot/quarter page	\$200-\$500	\$250-\$750
struction Manuals		
Cover	\$500-\$1,300	\$800-\$2,000
Spread	\$800-\$1,000	\$1,500-\$2,500
Full page	\$250-\$750	\$900-\$1,500
Half page	\$150-\$500	\$600-\$1,000
Spot/quarter page	\$100-\$300	\$250-\$750
ollateral/Direct Response		
Cover	\$1,000-\$2,500	\$1,500-\$3,500
Spread	\$1,000-\$2,500	\$1,500-\$3,500
Full page	\$500-\$1,500	\$1,000-\$2,000
Half page	\$250-\$1,000	\$500-\$1,500
Spot/quarter page	\$100-\$500	\$250-\$750
esentations		
Color flip charts	-	\$750-\$1,000
Trade show exhibits	-	\$750-\$2,500
N	oncorporate	
tructional Manuals	Line	Tone/Color
Cover	\$450-\$2,000	\$800-\$2,500
Spread	\$550-\$2,500	\$1,000-\$3,000
Full page	\$200-\$1,500	\$500-\$2,000
Half page	\$150-\$1,000	\$250-\$1,200
ot/quarter page	\$50-\$750	\$100-\$1,000
ruction on packaging (flat fee)	τος φίος	
ta sheets (per hour)*		\$350-\$800
duct user and service manuals (per hour	.) *	\$50-\$100
	1	\$50-\$100

➢ Since no significant new data were reported in 2000, figures are from the 1997 edition. An asterisk (*) indicates where data differed significantly in 2000.

Additional Fees for Technical Illustration		
	Percentage of original fee	
Sale of original art	75%–150%	
Stock sale of existing art	35%-150%	
Rush fee	15%–120%	
Unlimited use in print media only; no time or geographical limits	20%–300%	

Architectural/Interior Illustration

Architectural/interior illustrators (also known as renderers or perspectivists) are hired by an architect, designer, or real estate developer to create accurate representations (sketches, drawings, or paintings) of exterior or interior design projects. The original illustration itself is often sold for design presentation purposes, but the copyright and the reproduction rights are usually retained by the artist. Increasingly, artists are providing their drawings to clients on a temporary "use basis," with eventual return of the original.

Illustrators are also commissioned by real estate developers and/or their advertising agencies to create art for promotional purposes. Advertising and promotional reproduction rights are negotiated separately from the sale or primary use of the original art, and surveys indicate that the intended uses for the work will affect the fee. (For more information, see Advertising Illustration above.) When the artist is asked to provide renderings to be used by the client in a design competition, the artist may be asked to provide them at a lower fee. In this speculative arrangement the artist will usually negotiate that additional compensation or a bonus is due if the client wins the competition. The amount of the bonus depends on the size of the original discount and the value of the contract the client will secure from winning the competition.

The finished art is in the form of one or a combination of several media: watercolor, colored pencil, marker, gouache, pen and ink, airbrush, pastel, and/or digital. Many illustrators are taking advantage of computer-aided design (CAD) programs in ways that range from preliminary perspective layouts to complete final renderings. Not only are they extremely useful for their speed and accuracy, but they also allow the artist to quickly choose views that serve the client's needs.

Architectural/interior artists are hired for their unique illustrative styles and their accuracy in depicting the building, space, color, and/or materials. They usually have a background in architectural, interior, or industrial design and have chosen this specialized field after part-time or freelance experience in the business. As a result of these unique qualifications, they are often hired to work in a client's office on a rendering project while the design is in progress. There it is customary for the renderer to bill hourly (from \$100 to \$250 per hour), plus expenses. Illustrators often work from a variety of reference materials, depending on the end use and the level of detail required by the client, ranging from rough schematic design sketches with verbal descriptions to completely detailed working drawings.

Recent surveys show that factors involved in pricing include the complexity of the design project (which depends upon the views and amount of detail required), the number of images, the media to be used, and the amount of time required for travel and consultation for the project.

	Sketch	perspectives	
	+/- 11" x 17"	+/- 16" x 24"	+/- 20" x 30"
Marker	\$500-\$1,000	\$800-\$1,700	\$1,000-\$2,000
Pencil	\$500-\$1,000	\$700-\$1,500	\$1,000-\$2,000
Watercolor	\$800-\$1,800	\$1,000-\$2,200	\$1,500-\$3,000
Pen and ink	\$500-\$1,000	\$700-\$1,500	\$1,000-\$2,000
Computer-generated	Low-res \$750–\$1,500	Medium-res \$750–\$1,500	High-res \$1,000–\$2,500
	Formal i	llustrations	
N.4	+/- 11" x 17"	+/- 16" x 24"	+/- 20" x 30"
Marker	\$750-\$1,700	\$1,000-\$2,000	\$1,500-\$3,000
Pencil	\$1,100–\$1,800	\$1,500-\$3,000	\$1,500-\$4,000
Watercolor	\$2,000-\$3,800	\$3,000-\$4,800	\$3,500-\$5,600
Pen and ink	\$1,100-\$1,800	\$1,500-\$3,000	\$2,000-\$4,000
Airbrush	_	_	\$2,000-\$3,500
Computer-generated	Low-res \$2,000–\$3,000	Medium-res	High-res
eenipater generated	\$2,000-\$3,000	\$2,000–\$3,200	\$2,800–\$4,300
		ation illustrations	
Marker	+/- 11" x 17"	+/- 16" x 24"	+/- 20" x 30"
Pencil	\$1,000-\$2,500	\$1,500-\$3,000	\$2,000-\$3,500
	\$1,500-\$2,600	\$2,000-\$3,500	\$2,500-\$5,000
Watercolor	\$2,000-\$4,000	\$4,000-\$6,000	\$4,500-\$7,000
Pen and ink	\$1,300-\$2,000	\$1,800-\$3,200	\$2,500-\$4,000
Airbrush	\$1,700-\$3,500	\$2,300-\$4,700	\$3,000-\$5,0000
Computer-generated	Low-res \$2,500–\$4,000	Medium-res \$3,000–\$4,400	High-res \$3,500–\$5,500
	Hourly fees fo	r in-house projects	
	Per hour		
Drafting	\$35–\$90		
Computer-aided design	\$60-\$130		
Rendering	\$50-\$200		
Study models	\$50-\$120		

cityscapes, aerial views, fully illustrated exteriors or interiors, etc.

Trade practices

The following trade practices have been used historically, and through such tradition are accepted as standard:

- The intended use of the art must be clearly stated in a contract, purchase order, or letter of agreement stating the price and terms of sale.
- 2. The artwork cannot be altered in any way, except for what occurs during the normal printing process, without the written consent of the artist. Since it is very easy to alter art electronically these days, the client should inform the artist if he or she wishes to alter the artwork and then do so only with the permission and supervision of the illustrator. Anything less is a violation of professional good faith and ethical practice.
- **3.** Return of original artwork to the artist is automatic unless otherwise negotiated.
- Artists normally sell only first reproduction rights unless otherwise stated.
- 5. If the artwork is to be used for other than its original purpose, such as on an electronic database or a Web site, the price is usually negotiated as soon as possible. Note that the secondary use of an illustration may be of greater value than the primary use. Although there is no set formula for reuse fees, current surveys indicate that artists add a reuse fee ranging from 20 to 100 percent of the fee that would have been charged had the illustration been commissioned for the new use.
- 6. Illustrators should negotiate reuse arrangements with the original commissioning party with speed, efficiency, and all due respect to the client's position.
- Historically, artists have charged higher fees for rush work than those listed here, often by an additional 20 to 150 percent.
- A client may request that the artist enter into a nondisclosure agreement that would prevent the artist from showing or publishing (for self-promotion) the artwork for a specific

period of time. Any conditions limiting an artist's ability to exploit artwork are factors in negotiating fees.Nondisclosure agreements should always be in writing.

- 9. If the illustrator satisfies the client's requirements and the finished work is still not used, full compensation should be made. However, historically, if a job is canceled after the work is begun, through no fault of the artist, a cancellation or kill fee is often provided. Depending upon the stage at which the job is terminated, the fee must cover all work done, including research time, sketches, billable expenses, and compensation for lost opportunities resulting from the artist's refusing other offers in order to make time available for the commission. In addition, clients who put commissions on hold or withhold approval for commissions for longer than 30 days should secure the assignment by paying a deposit upfront.
- 10. Historically, a rejection fee has been agreed upon if the assignment is terminated because the preliminary or finished work is found to be not reasonably satisfactory and steps to correct the problem have been exhausted. The rejection fee for finished work often has been over 50 percent of the full price, depending upon the reason for rejection and the complexity of the job. When the job is rejected at the sketch stage, current surveys indicate that the customary fee is 20 to 50 percent of the original price. This fee may be less for quick, rough sketches and more for highly rendered, timeconsuming work.
- Artists considering working on speculation assume all risks, and should evaluate them carefully when offered such arrangements. For a thorough discussion of the risks, see the Speculation section in Chapter 3, Professional Issues.
- 12. The Graphic Artists Guild is unalterably opposed to the use of work-for-hire contracts, in which authorship and all rights that go with it are transferred to the

9 Illustration Prices & Trade Customs

commissioning party and the independent artist is treated as an employee for copyright purposes only. The independent artist receives no employee benefits and loses the right to claim authorship or to profit from future use of the work forever. Additional information on work for hire can be found in Chapter 2, Legal Rights and Issues.

13. Travel costs, shipping fees, production costs, consultation time, and other unusual expenses are normally billed separately to the client. An expense estimate should be included in the original written agreement or as an amendment to the agreement.

All prices for illustration in this book are based on a survey of the United States and Canada that was reviewed by a special committee of experienced professionals through the Graphic Artists Guild. These figures, reflecting the responses of established professionals, are meant as a point of reference only and do not necessarily reflect such important factors as deadlines, job complexity, reputation and experience of a particular illustrator, research, technique or unique quality of expression, and extraordinary or extensive use of the finished art. (See related material in other sections of this book, especially in Chapter 5, Essential Business Practices, and Chapter 13, Standard Contracts and Business Tools.)

The price ranges in the chart above do not reflect any of the above considerations and do not constitute specific prices for particular jobs. The buyer and seller are free to negotiate, with each artist independently deciding how to price the work, after taking all factors into account.

Dimensional (3-D) Illustration

Dimensional illustration includes, but is not limited to, paper, soft, or relief sculpture; paper/photo collage; assemblage; plastic, wood, and/or metal fabrications; clay imagery; food sculpture; fabric/stitchery; and other types of mixed media. Dimensional illustrators create original three-dimensional (3-D) artwork, varying from low-relief collage to sculptural assemblage, that is generally shown from one vantage point. This genre includes traditional illustrators, model makers, paper sculptors, and fabric artists whose work is created for a wide range of uses in the same markets as that of other illustrators, predominantly in advertising and editorial. Some dimensional illustrators also seek work in related markets, such as architectural models, window displays, museum exhibits, convention display booths, prototypes for toys and giftware, sculpture for building interiors, food styling, animation, and sets, props, costumes, and puppets for TV commercials and performances.

Any 3-D illustration to be used in print must have two images: the original dimensional artwork and a photograph (transparency or slide) or digital image to be submitted for reproduction. Typically, the client buys one-time usage rights.

Photographing the artwork

Because many dimensional illustrators like to maintain control over the entire process, they choose to photograph their own work. In addition to making the final image, they may take preliminary photos, often Polaroids, to establish camera angles or to submit as sketches or comps. Another advantage is that the artwork may be constructed without regard to permanence or the need for transportation or reassembly. Dimensional illustrators thereby eliminate the expense of hiring a photographer and scheduling such services under deadline pressure, along with any possible confusion over copyright. However, the 3-D illustrator who so chooses is obligated to make a considerable investment in equipment and supplies and in mastering the techniques needed to produce suitable high-quality reproductions. Dimensional illustrators who opt to use the services of a professional photographer must consider copyright issues carefully. As the creator of the original work, 3-D illustrators implicitly grant authorization to create a two-dimensional (2-D) derivative of their work. Frequently, however, once artwork is photographed for use, it is difficult for 3-D illustrators to control uses and distributions or even obtain copies of their work. This situation can occur under the most ordinary arrangements: when the client hires both the artist and the photographer, when the photographer hires the artist, and even when the artist hires the photographer.

Fortunately, most art directors and photographers function under the assumption that the final photographic image does not belong to either the dimensional illustrator or the photographer, but to both. The reasons for this are logical: The photo could not have been created without the dimensional illustration and is therefore a derived image. In the well-known case of *Rogers v. Koons*, photographer Art Rogers successfully sued sculptor Jeff Koons for producing unauthorized life-size dimensional derivatives of Rogers' photograph. Earlier cases, in which sculptors who sued photographers were vindicated, provided precedents for Rogers' suit. Therefore photographers should not assume ownership and full rights to an image when that image is derived fully from a dimensional illustrator's work. In most relationships involving model makers, a photographer or client who wants to assume all rights to the work and the derivative photograph will offer to buy out the artist for a fee significantly higher than that offered for first rights. It is sound practice, as always, to ascertain in advance what rights the client and the photographer want.

The best protection dimensional illustrators have is a written agreement; only a simple letter to the other party is needed to confirm basic terms. Dimensional illustrators should consider the following:

- When the client hires both the illustrator and the photographer:
 - ••• License: Specify the precise scope of the license granted to the client for use of the illustration and its photographic reproductions.
 - ••• Assignments: Limit the client's agreements with all third parties (including the photographer) for use of any reproductions of the illustration, photographic and otherwise.
 - •••• **Rights reserved**: Obtain permission to make unfettered use of the photograph (a transparency is preferable so additional reproductions can be made).
 - ••• **Credit**: Require the client and the photographer to provide a specific credit to the artist whenever the photograph is used (Photography © 2000 John Photographer, Artwork © 2000 Jane Artist).
 - ••• Pricing: Take into account the number of images to be made when setting a fee.
- When a dimensional illustrator is retained by the photographer:
 - •••• License: Specify the rights you are granting to the photographer and the photographer's permitted uses of the photograph depicting your work.

- •••• Authorship: Retain the copyright in the illustration and, if possible, share joint copyright in the photograph.
- ••• **Rights reserved:** Specify that you may use your illustration freely and without restriction (including having it rephotographed by another photographer).
- ··· Credit: Specify the credit that the photograph must carry.
- ••• Access: Obtain rights to use the photograph and to obtain a transparency or copy of the negative.
- ••• **Pricing**: Specify compensation for the initial use; take into account the number of images to be made when setting a fee.
- When a dimensional illustrator hires the photographer:
 - •••• Grant of rights: Specify the rights you are granting the photographer and limit the photographer's exercise of copyright in the photograph.
 - ··· Permission: Specify the anticipated use of the photograph.
 - ··· Credit: Specify the credit used at all times with the photograph.
 - ••• Access: If you are free to reproduce the photograph without using the photographer's services, obtain a negative or a transparency that can be duplicated.
 - ••• Pricing: Take into account the number of images to be made when setting a fee.

Pricing

Pricing ultimately depends on the client's intended use. Typically, as with 2-D illustration, clients buy one-time publication rights. Artwork created for or permanent exhibit or for broadcast media is priced relative to those markets.

Recent Guild surveys show that several factors specifically affecting pricing for dimensional illustration should be considered when negotiating with a client. In today's cost-cutting atmosphere, 3-D illustrators are often asked to price their work on a scale similar to that for 2-D art (work painted, drawn, or bitmapped on a flat surface). However, because the 3-D illustrator offers the client greater potential for use (since the lighting and perspective can be varied when photographing it), because photographing the artwork requires an extra process and expense, because the materials and techniques needed to create the piece may require a considerable investment on the artist's part, and because of the complexity of 3-D versus 2-D art, it is not readily comparable to 2-D art. Another consideration when estimating a fee is how many different photographic images may be needed for a variety of different uses. If cost is a primary concern to the client, dimensional illustrators frequently offer options, such as simplifying the artwork or, if possible, creating a smaller original.

Often 3-D pieces may be used to promote the client's product in a public place: a shop window or a counter display. Generally, a 3-D display is more valuable to a client than a flat picture because of the greater range of ways to exploit the work. (For example, see Packaging Illustration above.)

Added costs

In addition to photography costs, the materials used to build a 3-D project can be much more expensive than the traditional art supplies used in 2-D illustration. Model-making materials used in miniature sets or architectural models, real objects used in assemblages, rare fabrics used in fabric collages, and casting resins for molded sculpture can add significantly to the cost of a job. It is up to the individual artist to determine if expenses for materials will be included in the original creator's fee or billed separately. If included, the artist should consider unforeseen circumstances that might lead to additional expenses and include an allowance for changes.

Few clients like surprises, so it is advisable to estimate costs as closely as possible at the time of the agreement. Clients should be made aware of the potential for additional expenditures for supplies and be alerted in advance when photographic expenses and materials will be billed separately. It is good practice, when billing separately, to submit receipts and/or an itemized list with the invoice.

Projects requiring support services (mold making, vacuum forming, plating, engraving, or foundry casting) can increase expenses significantly. The client should be fully informed of any such anticipated expenses, which, again, can be billed separately or reflected in the artist's creative fee.

Model makers in particular need to maintain large facilities and extensive equipment to produce their work—often not just a single piece of sculpture but a complete setting. And they may need to hire extra help for especially detailed or large projects. If the deadline is short, the model maker may not only have to hire help but also have to refuse other valuable work in order to serve the client's needs. The client should be aware that giving the artist sufficient time to complete the project is an important factor in controlling costs. Because the model maker's overhead is higher than that for the typical 2-D illustrator, these added expenses are generally reflected in model makers' fees. A client requesting a piece of sculpture that has been cast from a living model, molded on a vacuum-forming unit, and "gold" plated should expect to pay a considerably higher price than for digitally produced flat art.

Trade practices

The following trade practices have been used historically, and through such tradition are accepted as standard:

 The intended use of the art must be stated clearly in a contract, purchase order, or letter of agreement stating the price and terms of sale. This contract should be signed by both parties before the artist starts the work. The agreement should state the usage rights; for example, "For one-time, nonexclusive, English-language, North American print rights only, in one hardcover edition, to be published by XXX, entitled 'YYY.' All additional requests for usage by [client] or any other publication, except as specified above, are to be referred to [name of artist] to determine the appropriate reprint fee."

- 2. The artwork (photograph of the 3-D art) cannot be altered in any way, except for what occurs during the normal printing process, without the written consent of the artist. Since it is very easy to alter art electronically these days, the client should inform the artist if he or she wishes to alter the artwork and then do so only with the permission and supervision of the illustrator. Anything less is a violation of professional good faith and ethical practice.
- **3.** Return of original artwork to the graphic artist is automatic unless otherwise negotiated. If the client wishes to display the artwork, dimensional illustrators have reportedly charged fees ranging from 100 to 200 percent, in addition to the base one-time use price. The display usage should be agreed upon in the initial purchase order.
- 4. The terms of payment should be negotiated prior to the sale and these terms should be stated on the invoice, including provisions for late payment. As they largely reflect the graphic artist's labor, invoices should be made payable upon receipt.
- 5. An advance payment, termed a "material advance," may be requested for large projects.
- 6. Guild surveys show that additional payment is routinely paid to an artist when (a) the client requests artwork changes that were not part of the original agreement, and (b) sales taxes must be collected on all artwork, except when original work is returned to the dimensional illustrator.
- 7. Terms of joint authorship and ownership of the photographic image should be accepted by all parties (the dimensional illustrator, the photographer, and, where applicable, the client) and stated in the agreement. The Guild's survey data indicate that a dimensional illustrator who allows the copyright to become the property of the photographer receives substantially higher compensation than for work with shared copyright.
- 8. Historically, artists have charged higher fees for rush work than those listed here, often by an additional 20 to 150 percent.
- 9. If the illustrator satisfies the client's requirements and the finished work is still not used, full compensation should be made. However, historically, if a job is canceled after the work is begun, through no fault of the artist, a cancellation or kill fee is often provided. Depending upon the stage at which the job is terminated, the fee must cover all work done, including research time, sketches, billable expenses, and compensation for lost opportunities resulting from the artist's refusing other offers in order to make time available for the commission. Ownership of all artwork and copyright is retained by the artist. If a job based on "documentary" work or other original art belonging to a client is canceled, recent surveys reveal that payment of a time and/or labor charge is common.

- 10. Historically, a rejection fee has been agreed upon if the assignment is terminated because the preliminary or finished work is found to be not reasonably satisfactory and steps to correct the problem have been exhausted. The rejection fee for finished work has often been over 50 percent of the full price, depending upon the reason for rejection and the complexity of the job. When the job is rejected at the sketch stage, current surveys indicate that the customary fee is 20 to 50 percent of the original price. This fee may be less for quick, rough sketches and more for any time-consuming work.
- **11.** Artists considering working on speculation assume all risks, and should evaluate them carefully when offered such arrangements. For a thorough discussion of the risks, see the Speculation section in Chapter 3, Professional Issues.
- 12. The Graphic Artists Guild is unalterably opposed to the use of work-for-hire contracts, in which authorship and all rights that go with it are transferred to the commissioning party and the independent artist is treated as an employee for copyright purposes only. Besides, sculpture is not eligible to be work for hire, as it does not fall under any of the eligible categories defined in the law. Additional information on work for hire can be found in Chapter 2, Legal Rights and Issues.
- 13. Customary and usual expenses, such as travel costs, consultation time, shipping and mailing charges, and other out-of-pocket expenses for materials (film, model-making supplies, casting resins, and fabric) as well as fees for production services not performed by the dimensional illustrator (such as vacuum forming), outside services such as photography and processing, model fees, and additional production staff are usually billed to the client separately as they occur. An expense estimate, which states that the estimate is subject to amendment, can be included in the original written agreement with the client.

Marbling (Marbled Printing)

Marblers are artists who create unique contact prints by floating paints and inks on a liquid size, manipulating the colors with special combs and tools to form designs, and applying paper, fabric, or other materials to pick up the design. Although no two pieces of marbling are exactly alike, mastery of technical variables can enable a marbler to produce designs that are quite similar to each other or to centuries-old patterns. Many marblers concentrate on creating images based on classical designs that are traditionally used to decorate covers or endpapers of hand-bound books. Other artists produce more contemporary images with oils, watercolors, or Japanese suminagashi marbling specialties.

The immense popularity of marbling (or marblizing) accompanying a renaissance of this long-neglected art has heightened the demand for marbled images. Marbled designs are sought by ad agencies, graphic designers, magazine and book publishers, and clothing, home furnishing, stationery, and various other manufacturers for reproduction on everything from promotional brochures and package design to backdrops for television spots. Because the expense of operating a marbling business is similar to that incurred by other graphic artists, and because the marbler's creations enhance the value of the client's product or service, recent survey data indicate that marblers are routinely paid reproduction fees. Most marblers protect their copyrights by registering their designs with the Library of Congress and by stamping a copyright notice that includes their name, address, and phone number on the back of papers offered for sale in art supply and paper stores. Because many papers are cut after purchase, some artists stamp their work in several places so that even small sections of their work can be identified. Despite these precautions, some users wrongfully assume that purchasing a marbled paper authorizes them to reproduce the design. For this reason, marblers must vigilantly protect their work against copyright infringement.

Recent Guild research has found that factors affecting the pricing of custom work most often include setup and actual printing time; complexity of design; when different, specific coloring is desired; number of samples required; altering pattern scale; matching ink specifications; and cost of materials.

Usual and customary considerations of fees for reproduction rights may include consultation time, intended use, extent of use (border, full page, spread), length of time for the specified use, and the number of rights purchased.

Trade practices

The following trade practices have been used historically, and through such tradition are accepted as standard:

- The intended use of the art must be stated clearly in a contract, purchase order, or letter of agreement stating the price and terms of sale.
- 2. The artwork cannot be altered in any way, except for what occurs during the normal printing process, without the written consent of the artist. Since it is very easy to alter art electronically these days, the client should inform the artist if he or she wishes to alter the artwork and then do so only with the permission and supervision of the illustrator. Anything less is a violation of professional good faith and ethical practice.
- Return of original artwork to the artist is automatic unless otherwise negotiated. Clients are usually expected to make their selection of marbled papers for use within 14 days.
- Samples of the finished product are customarily sent to the marbler upon completion; this is usually specified in the contract.

- **5.** Artists normally sell only first reproduction rights unless otherwise stated.
- 6. Fees for custom work are normally charged separately from any reproduction rights sold. Current data indicate that higher fees are charged for creating an unusually large number of custom samples. Additional payments are routinely made by the client for changes or alterations requested after the original assignment is agreed upon.
- Surveys show that fees for multiples of a marbled pattern(s) are often discounted below the per-pattern fee.
- 8. Payment is expected upon delivery of the assignment, not upon its publication.
- 9. If the artwork is to be used for other than its original purpose, the price is usually negotiated as soon as possible. Note that the secondary use of an illustration may be of greater value than the primary use. Although there is no set formula for reuse fees, current surveys indicate that artists add a reuse fee ranging from 20 to 100 percent of the fee that would have been charged had the illustration been commissioned for the new use.

- 10. illustrators should negotiate reuse arrangements with the original commissioning party with speed, efficiency, and all due respect to the client's position.
- **11**. Historically, artists have charged higher fees for rush work than those listed here, often by an additional 20 to 150 percent.
- 12. If the illustrator satisfies the client's requirements and the finished work is still not used, full compensation should be made. However, historically, if a job is canceled after the work is begun, through no fault of the artist, a cancellation or kill fee is often provided. If a custom job is canceled, current data indicate that 100 percent of the fee is expected. Cancellation fees for reproduction rights after the contract is signed but prior to execution of finished art have been found to be 50 percent of the negotiated fee.
- 13. Historically, a rejection fee has been agreed upon if the assignment is terminated because the preliminary or finished work is found to be not reasonably satisfactory and steps to correct the problem have been exhausted. The rejection fee for finished work has often been more than 50 percent of the full price, depending upon the reason for rejection and the complexity of the job. When the job is rejected at the sketch stage, current surveys indicate that the customary

fee is 20 to 50 percent of the original price. This fee may be less for quick, rough sketches and more for highly rendered, time-consuming work.

- 14. Artists considering working on speculation assume all risks, and should evaluate them carefully when offered such arrangements. For a thorough discussion of the risks, see the Speculation section in Chapter 3, Professional Issues. However, the creation of work initiated by a marbler for presentation and sale is commonly accepted in the textile and greeting card industries. Recent surveys have found that it is also standard practice to obtain a written guarantee of payment for creating any new work specifically requested by clients.
- 15. The Graphic Artists Guild is unalterably opposed to the use of work-for-hire contracts, in which authorship and all rights that go with it are transferred to the commissioning party and the independent artist is treated as an employee for copyright purposes only. The independent artist receives no employee benefits and loses the right to claim authorship or to profit from future use of the work forever. Additional information on work for hire can be found in Chapter 2, Legal Rights and Issues.

Postage Stamp Illustration

There are several markets for stamp illustration, including the United States Postal Service (USPS), the United Nations, European nations, and small-country stamp producers. Stamps are often offered to collectors; the USPS has a very active branch that caters specifically to philatelists (people who collect and study postage stamps and postmarked materials such as first-day-of-is-sue envelopes, postcards, and stamps canceled by a specific post office). Sometimes the debut of a postage stamp will be accompanied by a media campaign, as with the release of the Elvis Presley stamp, where the public was asked to vote on which of two images (the young Elvis or the old Elvis) would be produced.

United States stamp program

The commission to do a stamp can come from the USPS directly or from one of the many designers who work with the Postal Service. U.S. postage stamp illustrations are normally priced per image. The contract usually calls for the artist to produce up to three sketches per image, which are priced at \$1,000, regardless of whether the project is completed by the USPS. The normal fee total per final stamp image is \$3,000. The USPS demands that artists do commissions on a work-for-hire basis, relinquishing both copyright and original artwork for the one-time fee.

If the stamp is a popular issue, the artist may be asked to sign open or a limited edition series for sale to collectors, though only one or two stamps per year are offered with artists' signatures. The artist may be asked to sign from 5,000 to 20,000 uncut sheets. An uncut sheet consists of six sets of usually 20 stamps per "pane" (a stamp sheet normally purchased from the post office), which is the way the stamps come off the printer's press before they are cut for retail sale. The fee paid to the artist for signing the uncut sheets ranges from \$1 to \$4 per signature, depending on the edition and the number of sheets being signed.

Because the USPS insists on retaining the copyright and artwork, it perpetuates the worst possible business terms (work for hire) for artists. In addition, work-for-hire terms allow the USPS has to license stamp images to for-profit companies to produce spin-offs like mugs or T-shirts—with the USPS collecting all the profits. However, a few artists have been able to negotiate control over secondary rights, and the use of Warner Bros. cartoon characters could only have been negotiated through some sort of licensing arrangement. Although the artist cannot sign the image created for the stamp, he or she may be attributed as the creator on materials printed about the stamp.

In 1997 the Guild initiated a campaign to make the USPS change its artistunfriendly practices. Finally, in 1999 the Guild was invited to a meeting with the creative director of stamp development at the USPS where a number of issues were discussed, including credit and recognition, compensation and authorship rights, and third-party licensing. The USPS agreed to publicize artists' and designers' names in press releases, program yearbooks, USA Philatelic catalogs and newsletters, and stamp sheets (depending on subject matter). The Guild stressed that the USPS's use of artwork does not fall into any of the nine categories outlined in the Copyright Act as appropriate uses of work for hire (for a thorough discussion of this topic, see Chapter 2, Legal Rights and Issues). The Guild requested that the USPS purchase only those rights needed to satisfy its intended and anticipated uses, with the artist or designer reserving all other rights, and that the ownership of original artwork be handled as a separate negotiation and transaction. As of March 2001 when this book was published, the USPS was still reviewing the issues the Guild raised.

Comparable Fees for Postage Stamp Illustration $^\square$		
	Per image	Additional images
United States	\$3,000	\$3,000
Small country	\$300-\$1,700	\$300-\$1,700
United Nations	\$1,000-2,000	\$1,000-\$2,000
Additional fee for sale of original art	\$300-\$2,000	
	Per signature	
Additional fee for signing limited numbers of stamp sheets to sell as collector's items	\$1–\$4	
🗁 Since no significant new data	were reported in 2000, figu	rres are from the 1997 edition.

United Nations stamp program

The United Nations maintains a stamp program through the United Nations Postal Administration (UNPA). Fees average \$2,000 for a single image, \$1,000 each for multiple images, with a maximum fee of \$12,000 for a series. The UN usually retains the copyright, but the artwork belongs to the artist. The UN seeks out artists from around the world to maintain a global profile.

European stamp programs

European stamp programs pay \$2,500 to \$5,000 per stamp image. Each country offers slightly different rights belonging to the artist, but the contracts are unfortunately quite similar to those used in the United States. Some European countries—Great Britain, for example—require stamp illustrators to be citizens of the country for which the stamp will be produced.

Small-country stamp programs

Small countries that have stamp programs pay an average of \$500 per stamp image. The work is usually created through an ad agency. The agency usually insists on owning the rights and copyright, but the artist sometimes retains ownership of the artwork.

9 Illustration Prices & Trade Customs

I

Chapter 10

Cartooning Prices & Trade Customs

Cartoonists create single- or multipanel cartoons, comic strips, or comic books, and may specialize in types of cartoons that range from a gag (a visual joke with the punch line in the caption) This chapter discusses the many markets availto editorial, political, or adult able for both staff and freelance cartoonists. subject matter, among other While the market is highly competitive, topics. Cartoons look as though especially for newspaper syndication, and the they are easy to create because demand for comic books is decreasing, new they are relatively simple opportunities are opening up in electronic in style, but in fact creating publishing and alternative comic books. cartoons is a highly demanding

specialization that usually requires a long apprenticeship.

Most cartoonists are freelancers, though staff cartoonists also work at newspapers, magazines, advertising agencies, greeting card publishers, television and motion picture studios, videotape production houses, and commercial art studios. Cartoons are also sought by editors and art directors for books, training materials, in-house publications, novelty items, and posters. Although the field has historically been dominated by men, the number of published works by women is on the rise.

Magazine Cartooning

The magazine cartoon is probably the most popular of the graphic arts; media surveys invariably place cartoons among readers' first preferences. Magazine or gag cartoons are created by freelance cartoonists who usually conceive the idea, draw the cartoon, and then offer it for sale to appropriate magazines. Magazine cartoonists bring a unique blend of writing and drawing skills to every piece. A magazine cartoon must be staged as graphic theater that instantly communicates a situation and characters. A good cartoon says it faster and with more impact than a paragraph of descriptive words and, most important, makes you laugh. (If a cartoonist works with a writer, often called a "gagman," he or she gets 25 percent of the fee paid by the publication. Future payments for reprints are usually worked out between the writer and artist, especially if the artist and the writer work together on a regular basis.)

The pricing of freestanding magazine cartoons is different from that of other forms of illustration. They are purchased as a complete editorial element, similar to a freelance feature article, at fixed rates determined by each publication. A handful of magazines (such as *The New Yorker*) give additional compensation to those cartoonist contributors who are closely identified with that particular magazine. In those instances the cartoonist may have a contract providing an annual signature fee, bonuses, and, in a few cases, fringe benefits in return for first look at the cartoons.

Among the factors affecting prices for magazine cartoons are whether the cartoon is black-and-white or color; the size of reproduction; the magazine's geographical distribution, circulation, impact, and influence; the importance of cartoons as a regular editorial element; the extent of the rights being purchased; and the national reputation of the cartoonist. Since the list is composed of objective and subjective factors, and the mix in each case is different, rates vary considerably. Because many cartoonists and humorous illustrators work in overlapping markets, readers should also refer to Chapter 9, Illustration Prices and Trade Customs, for related topics.

The fees in the chart are meant as a point of reference only and do not necessarily reflect such important factors as deadlines, job complexity, the reputation and experience of a particular cartoonist, research, technique, the unique quality of expression, and extraordinary or extensive use of the finished cartoon. The buyer and seller are free to negotiate, taking into account all the factors involved. Representative fees for specific categories of cartoons were collected from the responses of established professionals who have worked for the publications, directly from the publications themselves, or from current resource directories such as The Artists' Market; see Chapter 15, Resources and References, for more information.

Submitting art

Unless a cartoonist is under contract to a magazine, submission of art is normally done on a speculative basis, which means the artist assumes all risks with no promise of payment unless the work is bought. It is important to have an organized plan of attack. Artists should review cartoons found in their targeted publication and submit work that reflects that style. It's helpful to check first with a magazine to find out if it is still looking at unsolicited material. The Cartoonists Association provides members with constantly updated lists of magazines actively looking for cartoons as well as the rates they pay.

Consumer mag	azines	
	B/W	Color
New Yorker	\$575	Negotiable
Modern Maturity	\$500	+
Better Homes & Gardens	\$400	\$400
National Enquirer	\$300	-
First for Women	\$150	-
Saturday Evening Post	\$125	-
L.A. Weekly	\$120-\$200	-
Ms.	\$100 ^{——}	-
Trade magaz	ines	
	B/W	Color
Troika Magazine	\$250	-
Drink Magazine	\$200-\$350	_
Business Law Today	\$150 ^{——}	-
American Legion Magazine	\$150	-
Heartland USA	\$150	-
Sales & Marketing Management Magazine	\$150	-
Medical Economics	\$120	-
Management Review	\$100	\$200
The Artist's Magazine	\$65	-
Writer's Digest	\$50-\$85	_
Bartender Magazine	\$5	\$100
Racquetball Magazine	\$50	-
The Witness	\$50	-
Bulletin of the Atomic Scientists	\$35-\$150	-
Cat Fancy	\$35	-
Videomaker Magazine	\$30-\$200	\$200-\$800
The Presbyterian Record	\$25\$50	_
Chess Life	\$25	\$40
Popular Electronics	\$25	_

➢ Data taken from 2000 survey and supplemented with data from 2000 Artist's & Graphic Designer's Market. ➢ Minimum. ➢ ➢ More for color. ➢ ➢ Will negotiate.

Most publications will send a copy of their submission guidelines if they receive a self-addressed stamped envelope, while others may charge a small fee. Following are guidelines for submissions:

- Send no more than 10 or 12 single- or multipanel cartoons to a magazine at one time. Each cartoon should fill the center of an 81/2" x 11" sheet.
- Send good-quality photocopies. Do not send originals!
- Never send the same cartoon to more than one U.S. publisher at a time. However, multiple submissions of cartoons are acceptable to many European and other overseas publishers.
- Label the back of each cartoon with your name, address, phone number/fax, and e-mail address. For personal inventory control, discreetly number each piece.
- Send a short letter and concise resume stating where your work has appeared in the past.
- To have cartoons returned, include a self-addressed stamped envelope.
- Keep good records about who was sent what when.

See Chapter 13, Standard Contracts and Business Tools, for a sample artwork inventory form.

Trade practices

In the ideal relationship between cartoon buyer and seller, the following trade practices would be accepted as standard. Unfortunately, in the real world many transactions don't go smoothly, and the artist must be prepared to make allowances when problems arise. It is up to artists to act in their self-interest and even be prepared to lose a sale if conditions do not meet their expectations.

- 1. Payment is due on acceptance of the work, net 30 days, never on publication.
- 2. Artists normally sell only first reproduction rights unless otherwise stated.
- **3.** Under copyright law, cartoonists retain copyright ownership of all work they create. Copyright can be transferred only in writing.
- **4.** Purchasers should make selections promptly (within two to four weeks) and promptly return cartoons not purchased.
- 5. Return of original artwork to the artist is expected unless otherwise negotiated.
- 6. The Graphic Artists Guild is unalterably opposed to the use of work-for-hire contracts, in which authorship and all rights that go with it are transferred to the commissioning party and the independent artist is treated as an employee for copyright purposes only. The independent artist receives no employee benefits and loses the right to claim authorship or to profit from future use of the work forever. In any event, cartoons created by the initiative of the artist are ineligible to be work for hire.
- 7. Terms of sale should be specified in writing in a contract or on the invoice.

Editorial Cartooning

Editorial cartoonists are usually salaried staff artists on individual daily newspapers. Salaries vary greatly with the circulation and status of the paper and the reputation and experience of the cartoonist. Three factors combine to make editorial cartooning probably the most competitive subspecialty in all cartooning: (1) the number of newspapers, especially major dailies, is shrinking; (2) there are ever-increasing budget constraints at the remaining papers; and (3) syndicated editorial cartoons are very high quality (often created by Pulitzer Prize–winning cartoonists) and relatively cheap (in comparison with employing a staff cartoonist).

Some editorial cartoonists are syndicated nationally while on staff with a base paper. Usually the papers require that they do two locally oriented cartoons per week, while the syndicates want at least three cartoons a week relating to national issues. As with comic strips, the earnings received by editorial cartoonists from syndication depend on the terms of their particular contracts and the number and size of the newspapers buying their work (see the Newspaper Syndication section below).

Although editorial cartoonists are generally paid less than illustrators in other markets, the job is salaried and provides both fringe benefits and more stability than freelancing. Some editorial cartoonists can make up the disparity in income by selling reprints. Other advantages afforded editorial cartoonists are that they often have significant creative freedom, exposure, and name recognition by being published in a widely circulated newspaper.

Sometimes freelance cartoonists sell their work to major daily newspaper op-ed pages or to weekly newsmagazines. Rates vary, but they are generally based on the location (leisure or advertising section) of the work, the column width of the piece, whether the drawing is an original or a reprint, and the reputation of the artist, with well-known artists generally sought for large commissions such as covers. Freelance editorial cartoonists without national recognition are rarely even considered. (Artists should check with individual papers regarding their interest in freelance contributions before sending work.)

Newspaper Syndication

Many freelance cartoonists develop comic strips, panels, or editorial cartoons for the seven major national and international syndicates (see pages 313–314) that edit, print, package, market, and distribute them to newspapers throughout the world. Since the number of newspapers using syndicated material is limited, the field is highly competitive. Few new strips are introduced in any given year by the seven major syndicates (perhaps two to four per syndicate), and sales of these new features are usually limited to the somewhat rare instance of an existing feature being dropped. The more numerous smaller syndicates typically offer better contract terms but provide fewer services and much less sales support. The last alternative, self-syndication, is particularly difficult because the newspapers prefer to buy comics from the dependable syndicates that screen and manage the artists. (The Cartoonists Association provides members with constantly updated lists of newspapers actively looking for cartoons as well as the rates they pay.) Because of the intense competition to get syndicated, it is very tempting for cartoonists whose strips or panels are accepted by a major syndicate to sign the first contract offered.

Syndicate submission guidelines are available on the company's Web site or may be obtained by sending a request with a self-addressed stamped envelope. The following are generally accepted guidelines for syndicate submissions:

- Syndicates prefer to be contacted by mail only.
- Submit a presentation kit that includes a "character sheet" (drawings of all characters, their names, and perhaps a descriptive paragraph). Include five or six finished strips and enough pencil roughs to complete publication for a month (both dailies and Sundays).
- It is customary practice to send the same strip submission package to all syndicates at the same time. Acceptance by more than one may add to the artist's negotiation leverage.

When a cartoonist sells a strip, it is very tempting to sign the first contract offered. Instead, cartoonists owe it to themselves to prepare to negotiate contracts as well as they can and to understand all terms thoroughly. (A free, in-depth analysis of syndicate contracts and the syndication business is available at www.stus.com/thesis.htm.) There is no substitute for knowledgeable legal counsel in contract negotiations. A lawyer with expertise in cartooning, visual arts, copyright, and/or literary property contracts is recommended.

Foremost among the terms that are changing in the field are the monetary split between the syndicate and the artist, ownership of the feature, and the length of the contract. The split for newly syndicated cartoonists is still fixed at the customary 50/50, but it is more common for artists renewing their contracts to achieve a better split, such as 60/40 or even higher. A few artists are winning a percentage of gross rather than net receipts.

Syndicates routinely used to demand copyright ownership of the feature, and a few still start negotiations requesting it. But artists benefit so much economically and artistically from retaining ownership that over the last decade it has become standard for artists to win this point in negotiations. However, artists must be alert to the many contract terms syndicates are promoting to undercut the value of the artists' copyright. For example, most syndicates demand a right of first refusal for renewals, and some major syndicates are even requiring that they be paid their income split for some period of time *after* termination of the contract.

Contracts for newly syndicated artists that used to run for 20-year terms are being negotiated with much shorter renewal dates (5 to 7 years) that are conditional on the syndicate achieving satisfactory sales of the feature. Such flexibility created by ownership of the feature and periodic renegotiations benefits the cartoonist, whose bargaining leverage may increase considerably over the contract period if the work is successful and who may therefore be able to negotiate better terms upon renewal. Depending on the other contract terms and the attitude of the syndicate (which varies considerably), the initial contract term plus a fairly easy-to-achieve renewal can be expected to last for a combined 10 to 15 years (3,650 to 5,475 cartoons), so artists should not sign syndicate contracts unless the business deal is acceptable for the long term.

A number of well-known cartoonists have negotiated or renegotiated contracts with major syndicates on terms more favorable to the artist, such as shorter contracts, better income splits, guaranteed minimums, signing bonuses, and allowing the cartoonist to own and manage their licensing rights. Cartoonists who are offered a syndicate contract should keep these terms in mind.

Syndicated cartoonists' earnings are based on the number of newspapers carrying their strips or panels, as well as the circulation levels of the papers. This does not mean, however, that syndicates use standardized contracts.Syndicate contracts are complicated and vary considerably among the major firms. So, too, do the capabilities of the syndicates' sales forces and licensing departments.

10 Cartooning Prices & Trade Customs

Other negotiated terms include the artist's share of merchandising income; quality control over products or animated versions of the feature; the editorial role of the syndicate; what expenses the syndicate may legitimately deduct before the income split; a role for the artist in securing merchandising and licensing contracts (with the best solution being that the syndicate has the right to sell the strip only to newspapers and periodicals, with the artist retaining all other rights); and the ability to leave an unsatisfactory contract relationship. All terms of a contract are negotiable.

When a syndicate offers a contract for a particular strip, that indicates serious interest. The syndicate will probably be willing to negotiate, however reluctantly. And if one syndicate recognizes that a strip is marketable, chances are good that other syndicates will too. Therefore it may be worth walking away from an unsatisfactory contract offer to seek another syndicate as your partner. Artists must remember that this is a contract for thousands of cartoons over a significant portion of their careers, so the business arrangement must be at least minimally satisfactory.

Progressive changes in syndicated contract terms reflect the decision of individual cartoonists to fight for more control of their creations and the increasing importance of character licensing in today's markets. In their contracts, savvy artists stipulate that the syndicate has the right to sell the strip only to newspapers and periodicals, with the artist retaining all other rights, including book rights. Cartoonists who sharpen their negotiating skills can protect their income and art for the future rather than churn out work for 20 years under unfavorable terms negotiated when the artist was a relative beginner.

Syndicated cartoonists typically make between \$20,000 and \$150,000 per year, depending on the number of newspapers that subscribe to the strip and how many products are made from the licensing of characters. Of course, a handful of superstar cartoonists can make hundreds of thousands and even millions of dollars each year. Aspiring cartoonists should also recognize that more than 50 percent and as high as 70 percent of newly launched syndicated cartoons fail and are canceled within the first five years, resulting in very little income for the artist.

A listing of major and smaller syndicates is below. The listing is updated annually in July in the *Directory of Syndicated Services* published by *Editor & Publisher*. (For an order form, write to Editor & Publisher, 11 W. 19th St., New York, NY 10011.) Other sources of information include *Cartoonist Profiles* magazine or a local library.

North American Comic Syndicates

Major syndicates

Creators Syndicate, Inc. 5777 West Century Blvd., Suite 700 Los Angeles, CA 90045 310.337.7003 | www.creators.com

King Features Syndicate (Cowles, North America) 235 East 45th St. New York, NY 10017 212.455.4000 | www.kingfeatures.com

Los Angeles Times Syndicate 218 S. Spring St. Los Angeles, CA 90012 213.237.7987 | www.lats.com

Tribune Media Services, Inc. 435 N. Michigan Ave., Suite 1500 Chicago, IL 60611 312.222.4444 | 800.254.6535 www.tms.tribune.com

United Media (United Feature Syndicate & Newspaper Enterprise Association) 200 Madison Ave. New York, NY 10016 212.293.8500 | www.unitedmedia.com

Universal Press Syndicate 4520 Main St., Suite 700 Kansas City, MO 64111 816.932.6600 | www.uexpress.com

Washington Post Writers Group 1150 15th St., NW Washington, DC 20071-9200 202.334.6375 | www.postwritersgroup.com

Small syndicates with limited distribution

Cartoonists & Writers Syndicate 67 Riverside Dr., Suite 1D New York, NY 10024 212.227.8666 | 212.362.9256 www.cartoonweb.com

Copley News Service 123 Camino de la Reina, Suite E-250 P.O. Box 120190 San Diego, CA 92108 619.293.1818 | www.copleynews.com

Crain News Service 1400 Woodbridge Ave. Detroit, MI 48207 313.446.0485 | www.crain.com

Future Features Syndicate 1923 Wickham Rd., Suite 117 Melbourne, FL 32935 | www.futurefeatures.com iSyndicate, Inc. 650 Delancy St., Suite 312 San Francisco, CA 94107 415.896.1900 | www.isyndicate.com

The New York Times News Service/Syndicate 122 East 42nd St., 14 Fl. New York, NY 10164-2463 212.499.3300 | www.nytsyn.com

ParadigmTSA P.O. Box 111732 Stamford, CT 06911-1732 877.888.PTSA | www.paradigm-tsa.com

Singer Media Corp. SeaView Business Park 1030 Calle Crodillero, Suite 106 San Clemente, CA 92673 949.498.7227 | singer@deltanet.com

Electronic Publishing

Electronic publishing is the new frontier in cartooning. Online syndication of print cartoons, as well as online-only syndication of cartoons, is rapidly expanding the market for syndicated cartoon material. Innovations such as animated editorial cartoons have also been introduced. While it is yet to be fully realized, there is real income potential here, once the systems for charging and collecting are developed. The details of successful business models are still being worked out, but one encouraging trend is the development of online syndicates, such as iSyndicate, that sell to new markets and hire new cartoonists.

Many online purchasers of cartoon rights offer very different business terms in their contracts than traditional print syndicates. Artists should consider very carefully the specific rights they grant and how those rights are likely to be used in the electronic world. Like many publishers today, syndicates are attempting to retain electronic publication rights, and artists should consider this carefully when negotiating fees. This area is relatively new and uncharted, so artists should make every effort to retain their rights. For more information on copyright and the Internet, see Chapter 2, Legal Rights and Issues, and Chapter 4, Technology Issues.

Comic Books

Though there are more than 600 individual comic book titles on the market today, publishers have seen sales of comic books drop significantly since the mid-1990s. For example, in 1993 *Batman* was selling 300,000 units monthly; in 1996 the number had fallen to approximately 75,000. Many of DC's and Marvel's titles hover around 20,000 in sales, which just reaches the break-even point of 17,000 to 28,000 for color production. Only four or five titles have sales in excess of 250,000; these include *Gen 13, Spawn, Spiderman*, and *X-MEN*. It's increasingly rare to see a book with what used to be considered healthy sales. *Heavy Metal*, at the height of its popularity, sold 300,000 copies. Industry experts suggest a range of causes for the drop: high cover prices and increasing emphasis on specialty comic book stores, which are less plentiful and accessible than newsstands. About 95 to 98 percent of comic books sold today can be purchased only in comic book shops.

Licensing prospects in TV, movies, video games, toys, and consumer products have emerged as the driving factor in determining if a comic book series will be continued. Sales rates that would have seemed low or of marginal profitability in the past are accepted today because of fear that discontinuation would affect licensing possibilities. For further information, see the Licensing and Merchandising section below and the Reuse and Other Markets section of Chapter 5, Essential Business Practices.

Publishing comic books, which are cinematic in style, often mimics film production. Writers conceive a story and develop a script or plot, often indicating specific views of the action to be portrayed. Some companies use a style where scene descriptions and full dialogue are given just like a screenplay. Others do not indicate panel breaks, or even specify the number of panels, and may or may not indicate page breaks, giving the artist much more freedom in which to make a graphic statement.

Each monthly comic book (averaging 22 pages of story, with another 10 pages of ads and letters) is produced in 21 days to meet distribution deadlines. Such high-pressure working conditions mean that comic books are mass-produced in assembly-line fashion. (Some contracts used in the industry may contain a clause that penalizes the artist if deadlines are not met.) Publishers divide the production among people with special skills who complete a specific component in the process and then pass the work on to the next stage of production.

Specialists in comic books generally include writers, pencil artists (pencilers), lettering artists (letterers), ink artists (inkers), and coloring artists (colorists). The editor generally assumes a tracking role, guiding the work along the path from freelancer to freelancer, hoping to meet the company's deadlines and, on rare occasions, also serving as art director. The trend in at least the last decade shows a greater number of comic book artists who write, draw, and ink their own stories, but even for such specialists, the rigors of the three-week deadline require severe discipline.

When comic books are created traditionally, pencilers lay out the action from the typewritten script and finish the art on bristol board. The penciled board is passed on to the letterer, who letters the balloon text in ink and inks the balloon and panel borders. The board goes next to the inker, who inks the figures and backgrounds on each panel. (Background artists, if used, are usually subcontractors, assistants, or interns.) After the boards are reduced to $6" \times 9"$ or $81/2" \times 11"$ Strathmore paper, they are passed on to the colorist, who hand-colors and color-codes the photocopies of all 22 pages of the book. The boards and coded reductions are then sent to the separator, and finally the colored photocopies are sent to the printer for manufacture.

With the introduction of new technologies, the process of hand-coloring and color-coding guides on Strathmore paper may soon be obsolete; both DC Comics and Marvel have begun to switch to computer-colored comics. Color artists are still needed to do the computer coloring, but due to the necessary learning curve and the cost of the equipment (a Mac capable of doing the job may cost as much as \$8,000 to \$12,000, including monitor, scanner, keyboard, software, and color printer), a more sizable initial investment is needed to become a colorist than in

the past. Many colorists hand in their work on disk, which is then "edited" at the publishing company before being sent to a separator for creation of the final film. Font programs capable of approximating a letterer's handwriting are replacing hand-letterers; at least three companies are now using pen fonts based on real comic book hand-lettering.

Freelance artists working in this industry are expected to meet minimum production quotas. They report being paid a page rate set by the publisher for each page completed. Page rates vary according to the specialization. Contract artists at many of the companies still enjoy all the benefits of being salaried employees, including medical and dental insurance. However, with the downturn in the industry, many contracted freelancers are being asked to contribute toward their medical and dental insurance.

Since comic books are paid on the piecework system, the faster an artist works, the more he or she will earn. However, to meet production deadlines, artists are expected to complete a minimum number of pages in each production cycle. Letterers, for example, are expected to complete at least 66 pages over three weeks but strive to complete 10 pages per day, five days a week. Many artists must work 10 hours a day, six days a week, to make a living wage. Comic book publishers generally pay artists a lower page rate for reprinting an original publication.

As in other genres, the more popular an artist or writer, the higher the company's projected sales. Therefore all aspects of compensation, including royalties, are open to negotiation.

If a comic book's net domestic sales exceed 75,000 copies, a royalty on the excess is usually paid to the writer, penciler (or other layout artist), and inker; recently some companies have been paying royalties at 40,000 copies. Royalties are graduated according to the degree of creative input and the number of sales but generally range from 2 to 5 percent of the cover price. Those artists who perform more than one function receive a larger royalty; if more creators are involved in a project, they all share the royalties. However, the general downturn in sales has made the payment of royalties almost moot, as few titles reach the 75,000 mark.

Freelance agreements with the major comic book publishers provide for the return of original art. The artist(s) may assign, sell, or transfer ownership only of the physical original. Since several artists work on a given piece, ownership of the original art must be negotiated; normally only the penciler and inker receive original artwork, though a hand-painted piece is given to the colorist. However, the artists do not retain any of the copyrights to the work, as the contracts usually contain a work-for-hire clause, which transfers legal authorship and all rights to the publisher. For more information about work for hire, see Chapter 2, Legal Rights and Issues.

In the Graphic Artists Guild's view, however, comic books are not a collective work as defined in the Copyright Act of 1978. Therefore, comic books are not eligible to be work for hire, and freelance artists working in the comic book industry may actually be conventional employees, not independent contractors. While this means that all work created by them is work for hire, it also entitles the artists to at least the minimum benefits and entitlements afforded to any conventional employee, including unemployment, disability, and workers compensation insurance and the right to organize for the purpose of collective bargaining. For more information on employment issues, refer to Chapter 3, Professional Issues.

0	riginal publication
Writers (plot and script)	\$75–\$120
Painted art	\$150–\$350
Layouts/breakdowns	\$35-\$100
Pencil art	\$55–\$200
Background art	\$10-\$25
Ink art	\$45-\$150
Lettering	\$18–\$35
Lettering on overlay	\$20-\$35
Coloring art	\$20-\$35

Alternative comic books

Alternative comics, while not new, became very hot in the late 1990s. That's part of the trend viewing the comic book medium as an art form for creative expression rather than as an assembly-line business marketed to the major comic book publishers. The scarcity of wellpaying work is partly responsible for artists doing comic books as a labor of love. Also, comicbookshave become more highly regarded intellectually in recent years, with many art directors counted as fans, so that a small self-published book may serve an artist as a portfolio or promotion piece.

Usually the artist is also the writer of the stories and frequently acts as the publisher and distributor. Or creator-owned art may be done speculatively and submitted to publishers on a freelance basis similar to gag cartoons. Many times these stories are bought by small presses at a low page rate, such as \$50 a page.

Or they may be contributed gratis to smaller presses that can't afford to pay but give artists the opportunity to have their work in print and circulation. The major advantage of working this way for artists who feel strongly about their work is being able to maintain full control of the content and the copyrights.

Trade practices

The following trade practices for comic book art have been used historically, and through such traditions are accepted as standard.

- The intended use of the art must be stated clearly in a contract, purchase order, or letter of agreement stating the price and terms of sale.
- 2. Artists normally sell first North American reproduction rights only unless otherwise stated. Ancillary rights (TV, movie, European distribution, paper or hardback printing, or

character licensing) are negotiable and are often shared by the publisher and the artist for a fixed period of up to five years, at which time the full rights revert to the artist.

- 3. If the artwork is to be used for other than its original purpose, the price is usually negotiated as soon as possible. The secondary use of the art may be of greater value than the primary use. Although there is no set formula for reuse fees, current surveys indicate that artists add a reuse fee ranging from 25 to 75 percent of the fee that would have been charged had the art been originally commissioned for the anticipated usage. Artists should negotiate reuse arrangements with the original commissioning party with speed, efficiency, and all due respect to the client's position.
- 4. Deadlines for delivery of finished art and rough sketches should be outlined in the contract. The clause should also specify what payments are due to the artist in the event the project is canceled or rejected. For negotiable fee suggestions, see the sections describing kill and rejections fees in Chapter 9, Illustration Prices and Trade Customs.
- 5. The artist warranties that the art is original and does not infringe on the copyrights of others and that the artist has the authority to grant rights to the publisher.
- 6. An artist can request to be indemnified by the publisher for any suits arising from the use of the art by the publisher that might infringe on the rights of others and also against any suits arising from a request on the publisher's part, such as making a character look like a famous person or existing image.
- 7. In the case of creator-owned art (versus work for hire), the publisher agrees to copyright the work in the artist's name.
- For non-work-for-hire contracts, revisions without the artist's consent are unacceptable; artists should be consulted to protect the integrity of their work.
- Fees should be established to be paid to the artist in the event artwork is lost or dam-

aged due to the publisher's negligence.

- 10. The publisher agrees to publish the book within a specific period of time, and upon failure to do so, the rights revert back to the artist (sometimes called reversion rights).
- 11. Royalties are graduated according to the degree of creative input and the number of sales but generally range from 2 to 5 percent of the cover price. Royalties are paid on a quarterly basis, at which time the artist receives a statement of sales.
- 12. Return of original artwork to the artist is automatic unless otherwise negotiated. The artwork is often divided between the artists working on the project (primarily the penciler and inker). Most artists view original artwork as a subsidiary income, selling it either directly to collectors or through an agent.
- Publishers usually provide the artist with 10 free copies of the book, but 20 to 50 copies are often negotiated. Most publishers offer the artist a 40 to 50 percent discount off the list price on purchases of the book.
- 14. Artists considering working on speculation often assume all risks and should take these into consideration when offered such arrangements; for details, see the Speculation section in Chapter 3, Professional Issues.
- 15. Although work-for-hire contracts dominate this field, the Graphic Artists Guild is unalterably opposed to their use because authorship and all rights that go with it are transferred to the commissioning party and the independent artist is treated as an employee for copyright purposes only. The independent artist receives no employee benefits and loses the right to claim authorship or to profit from future use of the work forever. Furthermore, comic books are not eligible to be work for hire, as they do not fall under any of the eligible categories defined in copyright law. Additional information on work for hire can be found in Chapter 2, Legal Rights and Issues.

Original Cartoon Books or Collections

In addition to collections of the published work of one or more cartoonists, there has been a recent trend toward publishing books of original cartoon works.

Book contracts vary as much as syndication contracts, so it is advisable to consult a qualified literary agent or lawyer. Historically, standard contract terms have included an advance against royalties at the contract signing. Current data indicate that a first-time cartoonist-author may expect an advance ranging from as low as \$1,000 for reprints to \$10,000, with a royalty ranging from 4 to 10 percent. For further information, refer to the Newspaper Syndication section earlier in this chapter and to the Children's Book Illustrations section in Chapter 9, Illustration Prices and Trade Customs.

Reprints

Although revenues from advertising and subscriptions have increased significantly over the last 20 years, magazines have not proportionately increased payments to cartoonists and other artists. To make a viable income, cartoonists try to sell drawings repeatedly to secondary periodicals for use either in merchandising (T-shirts or coffee mugs) or in books as part of an anthology, a textbook, or a collection, which in turn will usually generate more reprints. Reprint sales can be made in the United States and in countries throughout the world. For further information, see the Reuse and Other Markets section of Chapter 5, Essential Business Practices.

Surveyed artists have sold black-and-white reprints to *Time* for upwards of \$200 and to *Forbes* for \$300, but every publication has its own criteria for establishing a fee. Obviously some drawings will generate additional fees and others will not. On a rare occasion, one will turn out to be immensely popular and more than cover the meager earnings from the others.

Artists should be sure to specify the terms of the sale in writing in a contract or on the invoice. For example, if the work is to appear in traditional print media, such as in a textbook, the following should be included:

For one-time, nonexclusive, English language, North American print rights only, in one hardcover edition, to be published by [name of publisher], entitled [title of publication]. All additional requests for usage by your organization or any other publication, except as specified above, are to be referred to [name of artist] to determine the appropriate reprint fee.

Trade practices allow for additional printings of the same edition without additional fees, but any change in the content of a book or in the arrangements of its elements would constitute a new edition that would be considered an additional use. If the publisher wishes to purchase electronic publishing rights, which allow for the easy manipulation and arrangement of materials, the cartoonist should limit the license to use the work for a specific period of time, such as a year, after which any additional or continued rights would be renegotiated. Of course, no changes should be made to a work without the artist's approval and supervision.

Comparative Fees for Cartoon Reprints				
	Textbooks			
Cover	\$750-\$1,200			
Interior	\$250-\$400			
	Hardcover books			
Cover	\$750-\$1,200			
Interior	\$250-\$400			
	Paperback books			
Cover	\$750-\$1,200			
Interior	\$250-\$400			
	Cartoon anthologies			
Cover	\$750-\$1,200			
Interior	\$250-\$400			
The fees list The smaller fee is sold, the fee is hig	ificant new data were reported in 2000, figures are from the 1997 edition ed are per edition, unless stated otherwise; all languages; no electronic rights for domestic rights only, the larger fee for world rights. If electronic rights are her and for a specified time. The Fee is per run. If the book is reprinted in middered a second run.			

Licensing & Merchandising

According to *Licensing Letter*, entertainment/character licensing and merchandising accounted for \$15.1 billion in North American sales in 1998 (a 6 percent decrease from \$16.1 billion in 1997), which accounted for 21 percent of all licensed products that year. When characters such as Dilbert, The Simpsons, Snoopy, or TeleTubbies are licensed for a range of products from toys and apparel to designer sheets and stationery, their creators stand to earn considerable additional income if they retain all or a significant percentage of the subsidiary rights in the property. In fact, for a few select properties, income from licensing can earn much more than sales of the original character to newspapers and television broadcasters. For less successful properties, even very limited supplemental income may make the crucial difference in making a project sustainable.

It is sometimes assumed that only nationally known syndicate characters are sought by licensing agents or manufacturers. With the tremendous growth in this area, however, there are now possibilities for cartoonists to develop characters specifically for product use. Cartoonists interested in pursuing this potentially lucrative application of their work should consult an attorney specializing in this field to ensure adequate copyright protection before presenting work to licensers or manufacturers. Trade shows for character licensing and merchandising are held several times a year around the country. They provide a place for creators, licensers, syndicates, and manufacturers to explore business opportunities. (To obtain a list of shows, contact the International Licensing Industry Merchandisers Association at www.licensing.org/Public/06trade.html.) For an extensive discussion of these opportunities, consult the Reuse and Other Markets section of Chapter 5, Essential Business Practices.

O Character animation as entertainment-such as flip books-started long before motion picture film was produced in the late 19th century. Film animation was introduced in 1900 and was effectively This chapter discusses the growing number adapted for industrial uses in of jobs involving animation. Thanks to the com-1917 and for commercial uses in puter, animated special effects are increasingly 1921. It has since been adapted used in a wide range of applications—everything for educational uses as well. from TV commercials to biomedical research In recent years, computers have and simulator rides in theme parks. enabled animation artists, who are skilled at creating the illusion of movement, to create

images never before seen outside the imagination.

Today there is a huge demand for computer animation and effects. Applications for animation span varied fields and interests such as biomedical research, scientific and educational films, litigation arts (forensic animation), television titles and station IDs, feature films and visual effects in motion pictures, interactive games, CD-ROM books, virtual-reality software, simulator rides for theme parks, spot sequences created for broadband Internet, and much more. An estimated 20 percent of all TV commercials use animated sequences. Animated films figure prominently in the lists of the top box office–earning films of all time.

Animation is also in demand as an art form. Independent animated films, in a broad spectrum of styles and with their own markets and distribution channels, are usually shown at film festivals or competitions that showcase the artist's work. Independent filmmakers often create production companies to solicit development funds, which can range from \$5,000 to over \$100,000.

Animation companies are growing, and movie studios and game companies are creating computer animation divisions. As more and more interactive services are put online, there will be an even greater demand for designers, animators, directors, and programmers.

Traditional animators once worked with line drawings that were inked and then painted onto cels (celluloids, or cellulose acetate sheets) with watercolor or gouache. The process was difficult, time-consuming, and expensive. Often several animators were assigned to specific characters, backgrounds, or other segments of a project. The end result was almost always a team effort by a number of artists, each with his or her own area of expertise. Computer animation has increased the level of sophistication, as in such recent mass-market successes as *Toy Story 2*.

To be successful in today's market, an animator must have an in-depth understanding of real-life movement, traditional and computer animation techniques, and technical film details, including timing, staging, texture mapping, lighting, squashing and stretching, and easing in and out. Animation artists may also work as illustrators, cartoonists, and designers for film. Though occasionally cartoonists or illustrators who supply artwork may want to try animating it, most are satisfied with seeing their drawings animated by someone else.

Computer Animation

High-quality computer animation used to require access to sophisticated and expensive equipment, such as silicon graphics computers, but with recent technological advances, broadcast-quality output (used primarily for TV commercials and video games) is readily available, though by no means inexpensive. Graphics software now available off the shelf is designed to run on different platforms, including Silicon Graphics (SGI), Sun MicroSystems, PCs using Windows NT, Apple Macintoshes, and Commodore Amigas. The software used includes Alias/Wavefront and Soft Image. Most large motion picture studios work with Maya.

The technology is changing so quickly that cutting-edge techniques used today can be outdated almost before a project is completed, so a significant part of a computer animator's job is keeping current with the evolution of animation technology (see also Chapter 8, Web Design and Other Digital Media Practices). However, many cutting-edge animation studios prefer to hire artists who have traditional animation skills in addition to computer training and experience. Having a solid background in all types of animation techniques can only enhance an artist's chances for employment.

2-D & 3-D computer animation

Computer animation done in 2-D is used for cartoons and some special effects. A particularly startling example is "morphing," which uses a highly advanced fade-in/fade-out program to distort images, giving them the appearance of changing seamlessly from one state to another.

3-D animation uses modeling and/or digitizing to create objects that not only have shape and dimension but also can be viewed from any angle. With the help of a complex rendering program, the artist can project the object onto a screen or into a virtual environment. Then 2-D texture maps (a surface pattern like wallpaper) are often applied to the 3-D image to give it a realistic surface. Computer-generated imagery (CGI)—images created digitally using a software program—is commonly used in 3-D computer graphics when doing special effects. Architectural animation allows artists to create realistic simulations of environments, which clients can "walk through" even though they have not yet been built. An efficient design tool, it helps the architect avoid expensive construction mistakes by making alterations before work begins.

Artists who create storyboards for commercials and movie effects sequences are able to enhance the impact of their storyboards with programs like Elastic Reality, which allows them to create simple movement and effects with still images.

Motion picture computer animation is the highest echelon of the field. Perhaps the most famous of all animation houses today are George Lucas's Industrial Light and Magic (ILM) and Steven Jobs's Pixar. These studios write a great deal of their own software because so much of what they produce is unprecedented in the industry.

Comp	uter Animation, Fee	per Second
	2–dimensional	3-dimensional
Advertising	\$500-\$1,000	-
Broadcast	\$600-\$1,200	-
Corporate	\$200-\$600	\$500-\$1,000
Educational	\$150-\$500	_
Industrial	\$200-\$600	-
Web, large client	\$200-\$600	\$400-\$1,000
Web, small client	\$150-\$500	\$250-\$600

Other Forms of Animation

Clay figures (claymation), puppets, and any other 3-D objects can also be used to narrate a story. Puppet animation often requires the artist to create movie sets to scale that depict the story line and can be filmed from many angles. Many 3-D claymation animators have also moved into 3-D computer graphics illustration because of their skill at perceiving movement and form in 3-D space. Aardmann Studio in London and Will Vinton's studio in Washington State are the better-known practitioners of this technique.

Animation Is Multicultural

Many animated features are sold internationally and dubbed in any number of foreign languages. So much of animation is based on action, movement, and physical humor that it works well in many different cultures and can be easily dubbed when necessary. Artists must anticipate international markets for their work and need to pay particular attention to such details as avoiding written words or signs in the background that are needed to understand the story. Writers must be aware of expressions in the dialogue, such as slang or colloquialisms, that may be difficult to translate.

Careers in Animation

Animation artists generally work for a studio, but some members of the animators' union, the Motion Picture Screen Cartoonists (MPSC) of the International Alliance of Theatrical Stage Employees (IATSE), work freelance. (Various locals of the union are located in different cities; for instance, Local 839 is in Los Angeles and Local 843 is in Orlando.) There are also nonunion animation artists, but most artists employed by animation studios are covered by the collective bargaining agreements negotiated by MPSC. Some of the big-name studios that MPSC has negotiated contracts with are Hanna-Barbera Productions, Marvel, Universal Cartoon Studios, UPA Pictures, Walt Disney Pictures and Television, and Warner Bros. Animation.

Animation studios

Almost all animation is created by a team in a studio. The team consists, among others, of:

- Producer: Hires the team, locates investors, manages expenses, handles distribution, and is responsible for the overall development of the film.
- Writer: Identifies the subject of the film, defines the characters, and develops the story line and dialogue.
- Character developer: Makes models based on the designer's concepts (often supplied by an advertising agency when the product is a television commercial).
- Visual development artist: Provides early inspirational work to help define the look and style of the film and visualize more

complex shots. The artist must be facile in both traditional skills and current software like Photoshop. Some larger motion picture studios may hire a sculptor to create clay maquettes of characters for visual reference for traditional animators and for digitizing purposes. Many vis-dev artists later move into the art direction/production designer roles.

 Art director: Oversees the creation of the project's visual style, supervises visual development artists in the preproduction phase, and in consultation with the director oversees the color-modeling process down the line to color timing the film prints. Some projects hire a separate production design supervisor so the art director can focus on color and lighting.

- **11** Animation Prices & Trade Customs
- Storyboard/layout artist: Creates storyboard representing the scope of the film's action, breaking the story down into specific scenes and showing the film's sequential development in proper scale. (In feature animation, the storyboard artist is separate from the layout artist.)
- Layout artist: Creates the environment or background layout (exterior and interior spaces) in which animated characters function. The category is divided into three parts: character, cleanup, and background layout.
- Background artist: Paints/color-styles the background layout. This job is now done both with traditional tools and digitally.
- Color stylist: Chooses colors for the characters; works in conjunction with the art director and background artist.
- Director: Responsible for the overall coordination of all animated characters within a project. All elements must work together, including layouts, storyboards, and voice talent. Although there may be some interaction with the "environment" (background), the director is usually concerned only with the actions of the characters, timing, and supervision of the project.
- Animator: Creates "roughs," thumbnail sketches, and models of the characters depicting their range of movement, key poses, expressions, and emotions.

- Assistant animator (inbetweener): Prepares drawings to fill the intervals between key poses or frames. Inbetweeners also refine the sketches, clean and tighten up lines, and darken shadows.
- Inker/opaquer: Creates the outline of each character based on a scanned sketch and then paints in the character. (These functions are separated in traditional animation, with the inker outlining a character on an acetate sheet and the opaquer painting in the character on the opposite side.) Almost all of this work is now done on computer, except for some gallery cels created for collectors.
- Checker: Checks that all the cels, layers, exposure sheets, bar sheets, and backgrounds are executed, marked, and registered prior to filming; checks camera mechanics.
- Camera operator/scene planner/film tranfer technician: Films the movie. In motion picture productions a scene planner, formerly a traditional camera operator, digitally refines the more sophisticated camera movements to accent the action. The film transfer technician oversees the transfer of digital images to film stock. (As the technology of digital projection develops, film transfer may prove to be a transitory role.)
- Film editor: Cuts together the pieces of exposed film, matching the images to the sound track. Prepares the footage for duplication and printing.

Job Markets

The job market for animation is varied, highly competitive, and rapidly growing. Over a quarter of a million artists are working in the field, three quarters of whom are male. Aspiring animators must have a good knowledge of the industry in general and, more specifically, the target employer's place within that industry.

The majority of work continues to be in advertising, specifically in 30-second commercial spots, but forecasters predict a continued market for animated feature films. Many large production houses have entry-level positions for animation assistants or inbetweeners, and it is not uncommon to later become an animator and, eventually, a director. TV commercial work usually lasts a few weeks to a few months, while television series projects can take from several months to three years to produce. Artists working in this area must think continually about lining up their next job because layoffs are common when a project ends. In showing work, portfolios of storyboards, backgrounds, model sheets, and similar items are useful. Artists seeking entry-level positions should include examples of basic artistic skills, especially life drawing. Almost every employer has a printed summary of portfolio requirements. It pays for artists to do some research into what kind of images a company has used in the past and then make sure their portfolios reflect both their strengths and the company's focus. To show the true nature of their ability to animate movement, animation artists can often submit samples of their work on a film reel or videocassette.

Computer animation companies look for three types of employees: artists to do animation, visual development, storyboards, and design; technical directors/technicians who support the artists by doing modeling, lighting, and working specialized software to, say, create fur on animals; and engineers for technical support and maintenance. Many traditionally trained animators are being hired by computer companies to do drawings on paper that are then scanned into the computer. Technical operators and directors take over at this point to complete the project. College graduates with a background in computers who do not draw well often become technical directors. Special skills are needed on almost every computer project, and the average artist rarely possesses the technical background to create new effects and other special elements.

Trained computer animators will find positions with film and video production studios, special effects production houses, television stations, and video game producers. Companies are seeking artists with experience in ball-and-socket puppets, set and model building (creating highly realistic miniatures used in special effects), armatures, mold making, and costume design for puppets.

Though it may be difficult to win, artists should try to include a clause in their contract that gives them the right to show any work they create under contract for self-promotion. Rarely will an artist have the time to create a demo reel of his or her most current techniques and accomplishments, so retaining the right to show already produced work can be a tremendous advantage. The standard industry practice toward samples is currently a "don't ask, don't tell" approach, but if a studio's proprietary work appears on your Web site, you're asking for trouble.

Salaries

According to the MPSC, going rates for animation artists have increased dramatically in the past decade, and despite corporate pressure to reduce production costs, the momentum is not likely to be reversed. Trends suggest that the data in the chart may not adequately reflect these rapidly rising pay rates.

One of the more comprehensive directories of animation companies in the United States is published by *Animation* magazine. Some cities have regional directories covering film, video, and computer production companies. Trade magazines and newsletters also carry job listings. A listing of services and organizations useful to animators can be found in the *International Motion Picture Almanac*.

Pricing

A key factor affecting pricing is whether one is working freelance or on staff. If the animation artist is freelancing, pricing is affected by the animation's category. That is determined by how much movement there is, the intricacy of the movement, and how intricate the drawings must be. Pricing is set before work is begun.

A good method of determining freelance fees for animation is to look at the union wage scale for the same type of work. MPSC Local 839, IATSE, maintains a Web site at www.primenet.com/mpsc839 or www.awn.com/mpsc839. The site includes detailed information on their latest collective bargaining agreement, including wage scales, hours of employment, working conditions, and general employment practices found in the industry. The contract provides for several levels of experience; more senior artists (known as journeymen) enjoy a higher wage scale than those artists who have been in the business for less than a year or two.

The examples of minimum rates in the chart were supplied by the MPSC Local 839, IATSE, and represent the anonymous poll of its members taken in July 2000. For staff salaries see Chapter 6, Salaries and Trade Customs. Review the MPSC Web site for the latest contract provisions and wage scales.

Minimum Weekly Salary Rates for Television $^{\square}$		
	Features	
Theatrical script First draft Second draft	\$90,000 \$6,500 \$5,000	
Direct-to-video script	\$15,000	
Storyboards, per page	\$350	
Т	V storyboards	
1 to 8 minutes	\$1,100	
11 to 22 minutes	\$5,000	
30 minutes, per page Per act Per 30 minutes	\$200 \$5,400 \$2,500	

➢ Source: Motion Picture Screen Cartoonists, Local 839, IATSE, Member Unit-Rate Survey, Staff (Salaried) Positions, July 2000. All salaries represent the union-negotiated pay scales for journeymen for the contract effective through July 31, 1999 (still negotiating latest contract as of February 2001). All salaries are computed on a 40-hour week, and all numbers were rounded off to the nearest dollar.

Weekly	Salaries	of	Animation	Artists
--------	-----------------	----	-----------	---------------------

Classification	Journey minimum	Minimum reported	Median average	Maximum reported
Producer	\$1,391	\$2,200	\$3,850	\$6,000
Director	\$1,391	\$875	\$2,800	\$12,019
Assistant director	\$1,134	\$1,094	\$1,700	\$2,500
Staff writer	\$1,210	\$2,000	\$3,280	\$4,200
Sheet timer	\$1,134	\$1,323	\$1,500	\$2,205
Production board	\$1,391	\$837	\$1,800	\$3,146
Story sketch	\$1,082	\$1,250	\$2,570	\$3,600
Art director	\$1,391	\$1,649	\$2,625	\$4,420
Visual development	\$1,210	\$813	\$2,350	\$3,300
Color key/stylist	\$1,029	\$813	\$1,378	\$1,946
Model designer	\$1,210	\$906	\$1,525	\$2,000
Character layout	\$1,210	\$1,100	\$1,465	\$2,500
Key assistant layout	\$1,157	\$1,795	\$1,875	\$2,000
Assistant layout	\$1,029	\$1,028	\$1,225	\$1,450
CGI animator/modeller	\$1,210	\$1,120	\$1,938	\$4,000
CGI technical director	\$1,210	\$1,263	\$2,014	\$2,709
CGI 3-D compositor	\$1,157	\$1,720	\$2,067	\$3,160
CGI opaquer	\$847	\$822	\$900	\$1,350
CGI scanner	\$847	\$838	\$850	\$1,350
Background painter	\$1,210	\$1,400	\$2,000	\$5,077
Assistant background	\$1,029	\$1,125	\$1,200	\$1,200
Supervising animator	\$1,391	\$1,937	\$3,609	\$8,447
Character animator	\$1,210	\$961	\$2,120	\$4,000
Effects animator	\$1,210	\$836	\$2,025	\$4,200
Animating assistant	\$1,028	\$928	\$1,012	\$1,115
Lead key assistant animator	\$1,157	\$1,135	\$2,900	\$5,200
Animation character assistant	\$1,029	\$1,100	\$1,550	\$2,100
Breakdown	\$898	\$897	\$1,075	\$1,290
Inbetweener	\$863	\$862	\$900	\$1,025
Animation checker	\$1,029	\$1,029	\$1,300	\$2,350
Inker	\$854	\$847	\$875	\$950
Final checker	\$884	\$1,250	\$1,300	\$1,325

Source: Motion Picture Screen Cartoonists, Local 839, IATSE, Member Salary Survey, July 2000. All salaries are computed on a 40-hour week, and all numbers are rounded off to the nearest dollar. The listing of "Journey minimum" shows the union minimums for the various job categories, though not all people working in those jobs are under Local 839 jurisdiction. Co Some of the minimums may be for people working at union shops at less than journey level. Co the "median average" represents the middle rate when the results were listed in order from lowest to highest. The numbers should be viewed in the context of the minimums and maximums reported.

11 Animation Prices & Trade Customs

I

Chapter 12

Surface Design Prices & Trade Customs **S**urface and textile designers create repeating and nonrepeating patterns, illustrations, and woven or knitted designs to be used for fashion apparel, home furnishings, and giftware, paper,

and other retail products. This work is created during a preproduction stage for use by textile mills, clothing and home furnishings manufacturers, converters, and retail product development departThis chapter describes designs created primarily for fabrics and paper. Once laboriously painted by hand, surface designs are now mostly computer generated. Computer use has accelerated the entire production process—from design creation to retail sale.

ments. Surface and textile designers create individual designs or groups of designs with new colorations to sell or license for a specific use or combination of uses. For instance, they may be commissioned to create an entire line of designs for use on sheets, pillowcases, comforters, pillows, wall hangings, and other products for the home. Or they may design a woven pattern, knitted fabric, or printed imagery. Trends in surface and textile designs are extremely important, especially in the apparel industry. Traditionally the American garment industry was based on the European market, with American designers studying the European trade shows to identify trends and, where possible, purchase designs for the upcoming season. However, that has changed drastically in the last ten years, given the rise of computer technology, which has effectively dissolved borders in the industry. Whereas once Europe set and led design trends, nowadays the marketplace has become receptive to global design influences, with American design playing an increasingly important role. Today the global marketplace drives trends. Manufacturers who are able to respond quickly to "what's selling" are changing the "Europe-first" character of the marketplace. Though a number of European studios have sold work in America for years, now European studios must compete for European business with American studios. Frequently, when American trends are recycled in the European market, they return to the United States with a fresh twist the following year.

Forecasting a particular season's color line or color look (a color palette that may apply to a company's whole line or to a particular design being worked on) is a vital part of trend setting in surface and textile design. A color line or color look can be set by a forecast group, design studio, individual artist, or myriad trade fairs that everyone related to the business or their representatives attends. Different color charts are made up and sold to customers. The process is like a selffulfilling prophecy, since no one is going to pay high fees and then ignore the advice. However, anyone in the field who has been following color lines for a long time is often able to predict with amazing accuracy when everyone will tire of a particular color look and switch to a new one.

Designs consist of original artwork executed in a variety of techniques on paper or fabric or produced as computer printouts. Designs for the apparel industry are presented in the form of croquis—a design concept or sketch, not normally in repeat—for purchase by a textile or garment manufacturer. Designs for the home furnishings industry are generally presented in repeat (the customer may develop the design further to meet its own specifications).

Surface and textile designers work either as independent contractors or in studios. Studio employees include designers, art directors, and salespeople. Often a studio becomes associated with a particular "look," which is largely determined by the art director or principal. Some studios work through a representative or agent to sell their artwork in a particular market.

Surface/textile designers often work as problem solvers, conceptualizing solutions to a client's specific needs. Factors that may determine a designer's fee include a track record of success, the complexity of the design relative to the rendering technique and the number of colors used, the transfer of copyright and/or usage rights, time spent researching and rendering the design, and the designer's advertising or selvage credit.

Computer-Aided Design Changing the Industry

The introduction of computer-aided design (CAD) has had as profound an effect on surface and textile design as it has on many other fields of graphic art. Internet connections now make it possible for an individual or corporation to work worldwide in a matter of seconds, and manufacturing is becoming both more digital and more global. Many time-consuming jobs, such as drawing, painting, or weaving elaborate, intricate imagery by hand, have been virtually eliminated, and the entire process—from design creation to retail sale—has been significantly simplified and speeded up.

Formerly, a stylist in the home furnishings industry had to gather trends and other relevant information from any number of trade sources and deliver them with written and verbal instructions to an artist, who then spent many hours or days creating a visual image based on the stylist's instructions. After the image was reviewed, revisions were frequently needed, and the entire piece might have to be started over from scratch. Finally, a layout and color line were agreed upon, the art was created as a repeat, and color ways (up to six color variations in which a design is rendered) were produced. The process had a particularly long timeline if the design was a large format or decorative area. Then the artwork was given to a sales representative, who sold it to a manufacturer. The final production process was often time-consuming, depending on whether the manufacturer used screen printing or engraving.

Working digitally cuts out many laborious procedures. Now a stylist points the artist to Web sites and databases, or the CAD artist researches them independently and creates original artwork. Revisions are done instantly. Repeats are virtual, and cloning can be done in minutes, rather than the days required when they were painted. Color lines are chosen and matched to swatches or to the Pantone color system online. All the pre- and postproduction information about the sample is entered into a database, which makes for easy referral if further revisions, color palettes, or coordinate designs are needed. Color printouts on paper or fabric are available immediately, so the art director no longer needs to make mill visits. Fabric that is printed digitally can go directly to the sample room to be sewn, eliminating costly, time-consuming mill runs, which often necessitated trips overseas. A sample garment can be photographed digitally and displayed on a Web site. Orders, including different sizes and colors, require a much shorter sales cycle. And with the sales cycle reduced, much more customization of a garment can be accommodated in relatively little time. The CAD designer has now done the job in significantly less time than it may have taken five different sets of hands and complex machinery to do.

The many software programs, both proprietary and off-the-shelf, that drive CAD are becoming more and more complex and sophisticated, and the designer who knows how to use such CAD packages is increasingly sought out in the digital marketplace. It is important for anyone wishing to enter the field today to become proficient in using Adobe Photoshop and Illustrator as well as the latest software.

Jobs available for someone with CAD experience are varied and include both in-house and freelance positions. For example, during a rush a freelancer might be hired as a studio artist to paint a rough design, scan it, and refine it on-screen. Though CAD designers are generally pushing salaries higher in the industry, salaries or rates can vary widely, particularly in the apparel market.

Types of Surface & Textile Design

Surface design is a design that is applied to a surface through printing. Textile design refers to the creation of fabric—woven and knit. But a print design may also be applied to a woven or knit fabric. Some knit and woven designs can be done on paper and transferred to fabric. In the case of knits the CAD program sets the pattern, and it becomes part of the knit. In the case of wovens (usually jacquards) the pictorial design is an integral part of the weave. Sometimes a print is superimposed on the patterned knit or woven, and sometimes it's printed on plain cloth. Most CAD software have programs, both proprietary and off-the-shelf packages supplied by companies working with textile requirements, that can turn any design sketch or squiggle into a knitwear or woven design. All complexities of knits and wovens are programmed, and therefore even designers without a knit or woven background can create knits or wovens.

Each of the three basic types of design—woven, knitted, and printed—has its own methods of working. Trade practices are essentially the same throughout the industry.

Woven textiles

Our ancestors stopped wearing animal skins and palm fronds when they discovered how to weave materials. The ancient Egyptians were famous for their cotton goods, as were the Chinese for their silk garments. Since then, a huge variety of fabrics, using a wide range of materials, have been created by interlacing two sets of yarns—a warp and a weft—on a loom. The patterns created can be very simple or extremely complex and require expert knowledge of weave structure. Color, texture, and density of the fabric are also necessary design decisions.

The woven design industry has become highly computerized, and it is essential for anyone in the field to be computer literate. Woven designs can be visualized on a computer screen or by weaving an actual sample on a handloom (though that term is deceptive because most handlooms are computerized today). Given the predominance of CAD-designed wovens, it may seem surprising that the market for hand-painted woven colorways (stripes, plaids, or checks have traditionally been painted because of the fineness of the pattern) has not been taken over by the computer printout. The demand is still high because clients find they get a clearer idea of the end product's appearance with finely applied opaque gouache paint on paper than with a printout.

Despite the predominance of CAD in production, hand-weavers have not been replaced by CAD designers. Design development work is widely available, particularly in the contract furnishing market. And specialists are still needed to create jacquard designs—woven fabrics that often start out as painted designs (geometrics, florals, scenics) and are then transposed by a knowledgeable weaver into a loom pattern.

Most studios specializing in woven fabrics have a designer or stylist or both. If the studio has its own loom, a sample weaver, also known as a hand-weaver, will execute the designer's or stylist's directions. Between the designer/stylist and the sample weaver there may be many levels and titles, depending on the amount of responsibility the weaver is given and his or her ability and experience. The designer and the weaver may be the same person in a small studio. Some studios may not have their own looms and may farm out the work to independent contractors.

Knitted textiles

Knitting yarn or thread into fabric on a machine is based on the same principle as knitting by hand—loops of material are interlocked horizontally and vertically so they make a continuous fabric. Different combinations of loops create different knit structures.

Knit designers develop stitch structures and color combinations for four seasons. They either work as staff designers for knitware companies, which have their own showrooms, or work as independent contractors through studios that act as brokers and take swatches on consignment. Buyers purchase knit designs from the studios and produce their own original knitted garments. Though the design process is increasingly computerized, speeding up the entire cycle, enough handwork is still required that CAD does not yet dominate the design phase of the business.

Before computers, a knit pattern was programmed on punch cards, which directed a knitting machine to reproduce it. Today knits are increasingly produced by CAD programs, just like woven textiles. Though large companies tend to dominate the production end of the business, with the bulk of manufacturing handled abroad, most rely on design work created here. That leaves the field, driven by the American market, wide open for independent knit designers who choose to pursue their own artistic vision.

Embroidery, the most popular of current embellishment techniques, is often used on knits. Just think of the many different logos embroidered on knitted designer golf shirts. The introduction of high-speed multihead computerized embroidery machines in the late 1970s opened up the industry just when hand-embroidered jeans became popular, and knit designers have taken advantage of the new opportunities to include embroidery in their designs. Knit designers may find it helpful to have a basic understanding of embroidery stitches, or to consult a specialist, in order to successfully incorporate the work in their designs.

12 Surface Design Prices & Trade Customs

Printed textiles

The one field that has not been affected by CAD—and probably won't be—is printed textiles. Because each design is a unique, creation, which is silk-screened or transferprinted onto a fabric, original designs are hand-painted with acrylics, watercolors, or pastels or are created by direct transfer or with collage. The designer picks the medium to suit the design, always keeping in mind that the technique has to be compatible with the way the fabric will be printed. Traditionally, print designers working in the fashion or home furnishings market sell the copyright to their work to the manufacturer.

Designers who create prints for the fashion market must research trends, often based on European sources. For inspiration they may visit trade shows, museums, libraries, secondhand bookstores, or retail shops or hire the services of trend watchers. One designer said he picked up ideas while walking down the street; once he was inspired by tile in a restaurant bathroom.

Studios that design prints for the fashion market create four seasonal collections a year, often devising as many as 250 designs or color variations a month to sell to textile or garment manufacturers. Designers execute the imagery under the supervision of an art director or stylist. The latest trend in this specialty is that converters (middlemen who shuttle between the textile manufacturer and the garment manufacturer) are being phased out as garment manufacturers assume more direct control over their merchandise.

Licensing & Royalties

A license is an agreement through which a graphic artist who owns the reproduction rights to a piece of art or design permits another party, usually a client, to use the art or design for a limited, specific purpose, for a specified time, and throughout a specific geographic area in return for a fee or royalty. For example, imagery may be licensed to one party for wall coverings and to others for paper goods, dinnerware, or barware. At the expiration of the license, the right to use the design reverts to the graphic artist or designer unless another contract is negotiated. (More thorough discussions of licensing can be found in Chapter 2, Legal Rights and Issues, and Chapter 5, Essential Business Practices. Model licensing agreements appear in Chapter 13, Standard Contracts and Business Tools. *Licensing Art & Design* by Caryn Leland, listed in Chapter 15, Resources and References, is available through the Graphic Artists Guild Bookshelf.) In the surface and textile design industries, licensing agreements are normally negotiated for an entire line, collection, or group of products for a particular market. A licensing agreement for domestics, for example, would include designs for a number of entire "beds" (sheets, pillowcases, duvet and/or bedspread, ruffle, shams, and so on). A license for bath products would include a shower curtain, mat, and towels of various sizes. Although licenses are sometimes granted for a single product, such as a shower curtain or beach towel, that is an unusual practice. Of course, any design can be licensed in the apparel market, though that is rare because designs have such a short life in that volatile marketplace.

Graphic artists and clients have found that the best way to determine a fair price in relation to use is through a royalty arrangement. In this market that is a percentage of total sales paid to the designer based on the product's wholesale price. In practice, royalties have ranged between 2 and 10 percent of the wholesale price and currently hover around 5 percent, with some as low as a fraction of a percent on high-volume items. Royalty arrangements have also included a nonrefundable advance payment to the artist in anticipation of royalties, paid before the product is sold. At minimum, many designers negotiate advances to cover their expenses. Often advances are equal to the price of the artwork if it were sold outright.

Comparative Advances & Royalties for Surface Design			
Advances & royalties for department stores/specialty shops $^\square$			
Advance royalty Percentage of		Percentage of royalty	
Domestics (per bed)	\$5,000	5%	
Home decorative (per program)	\$5,000	5%	
Tabletop products (per program)	\$3,000	5%	
Tableware	\$1,500	5%	
Bath products	\$5,000-\$10,000	5%	
Kitchen products	\$3,000	5%	
Novelty/retail	\$750	5%	

 \simeq Royalty percentages reflect arrangements with department stores and are based on wholesale price. For mass distribution (chains and discount stores) percentages may be 2 points less.

Hourly Fees &	Day Rates for Surf	ace Design [—]
Queita anali	Hourly	Day rate
Onsite work Offpremises work	\$40-\$100 \$45-\$140	\$200-\$600 \$200-\$1,100
Mill work	_	\$150-\$600

➢ Includes color separations, hand and machine knits, and hand-painted fabrics for the apparel and home decorative markets.
➢ ➢ Based on an eight-hour day; expenses for travel are generally billed in addition to the day rate.
➢ ➢ ➢ No significant new data reported in 2000. Figures are from 1997 edition.

12 Surface Design Prices & Trade Customs

Co	mparative Fees f	or Surface/Textile Design ⁽¹⁾
	Appare	I (flat fees)□□
Textiles		
	Complex design, multiple colors	Simple design, few colors
Corner	\$250	\$100
Concept	\$500	\$225
Croquis	\$350-\$675	\$200-\$375
Design in repeat	\$450-\$1,500	\$450-\$1,000
Tracing repeat layout	\$150-\$450	\$150-\$250
Colorways	\$150-\$300	\$100-\$200
Repeats	\$1,000	\$400
Painted Wovens		
	Complex design, multiple colors	Simple design, few colors
Stripe	\$200	\$40
Design in repeat	\$400	\$100
Colorways	\$150-\$300	\$100-\$200
		nestics
	Complex design, multiple colors	Simple design, few colors
Sheets	\$2,000	\$900
Pillow slips (engineered)	\$700	\$300
Duvet/covers	\$2,000	\$900
9" repeat	\$1,000	\$65
18" repeat	\$1,300	\$800
36" repeat	\$2,000	\$1,000
	Scarves & h Complex design,	andkerchiefs C C C Simple design,
	multiple colors	few colors
Concepts	\$1,000	\$750
Design	\$2,400	\$500
	Tableton	products
	Complex design,	Simple design,
Tablecloths	multiple colors	few colors
	\$750-\$2,000 \$500	\$350-\$600 \$200 \$250
Napkins Placemats		\$200-\$350 \$250
	\$450-\$1,000	\$250
Chinaware	\$1,500	\$1,500
	C	ontinued

Kitc	hen products (designe	d, engineered or in re	peat)
	Complex design, multiple colors	Simple design, few colors	
Potholders/ oven mitts	\$500	\$250	
Towels	\$600	\$350	
	Home decorati	ve products	
	Wallcovering/curtain	Drapery/upholstery	Rug/carpet
Corner	\$150-\$550	\$375	-
Croquis	\$800-\$2,000	\$800	-
Design in repeat	\$1,000-\$2,000	\$1,400-\$2,500	\$2,000
Tracing repeat ayout	\$250-\$500	\$250-\$500	-
Colorways	\$175-\$1,000	\$175-\$1,000	\$250-\$750
Repeats for home decora	tive products		
9" repeat	\$750-\$2,000		
18" repeat	\$1,000-\$2,000		
36" repeat	\$1,250-\$2,500		
	Bath pr	oducts	
	Concept/croquis	Design, engineered or in repeat	Colorway
Shower curtain	\$500-\$1,200	\$900-\$2,000	\$175-250
Towels (guest, wash, hand)	\$200-\$350	\$450-\$500	-
Towels (bath)	\$300-\$350	\$750-\$900	-
Towels (beach)	\$650	\$1,200-1,600	\$300-\$400
	Retail & nove	Ity products	
	Concept	Design	Complete design
T-shirts (engineered)	\$150-\$250	\$250-\$1,000	\$250-\$1,400
Greeting cards	\$125-\$250	\$400-\$500	_
Giftwrap (in repeat)	\$225-\$350	\$400-\$500	\$400-\$1,200

➢ No significant new data reported in 2000. Figures are from 1997 edition. ➢ Fees are for each design; ranges reflect design complexity. ➢ Fees are for each design; ranges reflect design complexity, size, and number of colors.

Working with Representatives

Surface and textile designers frequently use representatives or agents who have the legal right to act on behalf of the designers they represent only in the ways agreed to by both parties. A model Surface/Textile Designer-Agent Agreement is in Chapter 13, Standard Contracts and Business Tools, and a complete discussion of the artist/representative relationship is in Chapter 1, Professional Relationships.

Trade Practices

Historically, the following trade practices have guided the industry; they are particularly relevant to freelance surface and textile designers. The Graphic Artists Guild strongly recommends confirming all agreements in writing. Designers should be sure to read any agreement carefully and should consider the benefits of restricting the sale of rights to specific markets only. (For detailed information on negotiating and model contract provisions, see Chapter 3, Professional Issues; Chapter 5, Essential Business Practices; and the surface design business and legal forms in Chapter 13, Standard Contracts and Business Tools.)

1. Speculation: Speculative ventures, whether in financial markets or in the visual communications industries, are fraught with risk. Individuals who choose this course risk loss of capital and all expenses. Designers who accept speculative assignments (whether directly from a client or by entering a contest or competition) risk losing fees, expenses, and the potential opportunity to pursue other, rewarding assignments. In some circumstances, all the risks are placed on the designer, with the client or contest holder assuming none. For example, some buyers will decide only upon completion of finished art whether or not to purchase it. Each designer should make an independent decision about acceptance of speculative assignments based upon a careful evaluation of the risks and benefits of accepting them and of the designer's particular circumstances.

Many surface/textile designers, choosing to act as entrepreneurs, create their own designs and try to exploit them in a variety of ways. For example, if a designer's work for the domestics markets is accepted by a manufacturer who agrees to pay an advance against a royalty on sales, the designer and the manufacturer are sharing the risk in their mutual investment. The compensation to both parties is speculative, meaning both are dependent on the sale of the product.

Current data indicate that the vast majority of designers who create works on assignment or commission do receive payment for their work. (To help ensure that, see the Estimate and Confirmation Form in Chapter 13, Standard Contracts and Business Tools.)

2. Billing for a sale: When a sale is made, a receipt or invoice is presented by the designer that states the terms of the sale and is signed by the client. The terms of payment should be negotiated prior to the sale, and these terms should be stated on the invoice. Because invoices largely reflect the designer's labor, they should be made payable upon receipt. However, companies often take 30 days to pay invoices. If payment is legitimately delayed, the designer may wish to accommodate the buyer and grant a reasonable payment extension, but the new payment deadline should be in writing. Any transfer of copyright or usage rights should be contingent upon full payment of the designer's invoice.

Granting extensions should be viewed as a professional courtesy on the part of the designer, not the buyer's right. Some designers may demand a late fee—usually a percentage of the outstanding balance—as compensation for a delay in payment. Designers who employ this practice usually notify their clients of the policy in writing before any work is accepted. This practice should be used particularly when longer extensions are granted.

3. Cancellation (kill) fees: According to current and historical data, clients usually pay the designer a cancellation fee if the assignment is canceled for reasons beyond the designer's control. The amount of the fee varies considerably, ranging from 30 to 100 percent, depending upon the percentage of work completed. (A detailed discussion of kill fees is in Chapter 3, Professional Issues.)

Unless otherwise agreed to, the client usually obtains all the originally agreedupon rights to the use of the artwork upon payment of the cancellation fee. Under a royalty arrangement, however, all rights to the artwork, as well as possession of the original art, generally revert to the designer upon cancellation.

If a job based on documentary work or other original art belonging to a client is canceled, payment of a time and/or labor charge is a widely accepted industry custom.

4. Client responsibilities: Historically, designers have received additional payment when the client requests changes in the artwork that were not part of the original agreement or when the client orders corners (beginnings of designs presented for client approval—usually the upper left-hand corner rendered in the style, technique, color, and materials proposed for the finished design) that were not developed into purchased sketches. Sales taxes, if due in accordance with state laws, must be collected on all artwork.

- 5. Credit to designer: In acknowledgment of the creative work they provide, many designers receive credit and their copyright notice printed on the selvedge of the fabric or on the product, if other than fabric.
- 6 Expenses: Expenses such as travel costs, consultation time, shipping and mailing charges, and other out-of-pocket expenses should be billed to the client separately. Estimated expenses should be included in the original agreement or billed separately as they occur.
- 7. Holding work: The practice of holding work is pertinent only to noncommissioned speculative work. Although previous experience with a client who wishes to hold work prior to purchasing it has generally been the guide for allowing this practice, designers should be aware that by consenting to an extended holding period they run the risk that the work may be damaged or lost. Most stylists and design directors have the authority to purchase artwork on the spot, and they should be encouraged to do so. When that is impossible, a maximum holding period of three days is permitted by some designers, but most limit this time to several hours or one day, and only upon signing of a written holding form. Longer periods are impractical due to the perishable nature of fashion items that are valid for a limited time. However, with more standard or classic works, some designers may consider allowing clients to hold them for several weeks in consideration of a "leasing fee," which will then be applied against a purchase price.
- 8. Knockoffs: A surface/textile designer should not copy, or "knock off," a design by another artist unless that work is in the public domain. Special talent or insight allows a contemporary designer to create a work that is highly prized and satisfies the fashion dictates of the season or year. Designers who are knowingly hired to create a knockoff should request that the client indemnify them from any legal action that may arise from such work.

- 9. Quantity orders: Each surface design is individual in nature, and its creation is labor intensive, a factor in pricing that in the view of many designers is not diminished by the quantity of designs ordered. Nevertheless, each designer should decide independently how to price his or her work.
- 10. Return of original artwork: Original artwork is rarely returned to textile designers. One reason is that the reproduction process mutilates the work to the point where it is rendered useless. Surface designers could negotiate obtaining samples of their printed designs or other finished products for display and portfolio use.
- 11. Rush work: Current data indicate that expedited or rush work may increase the original fee by 50 percent. As with all fees, the parties to the transaction must agree upon what they regard, based upon their independent judgment and the specificcircumstances of their arrangement, as a fair rush fee.
- 12. Uses and limitations: The intended use of commissioned or licensed work is generally stated clearly in a contract, purchase order, invoice, or letter of agreement stating the price and terms of sale. If the design is sold specifically for sheets and pillowcases, the surface designer may, upon agreement with the client, sell the same design in other markets, such as for toweling, boutique items, or stationery.

Should a client who has commissioned work decide to use the design for products other than those originally stated in the contract (for example, selecting a border originally designed for a top sheet to use on a towel), the designer should be offered the first opportunity to redesign the artwork to fit the required format of the new product. Current and historical data indicate that additional compensation is generally paid for such extended uses. However, if no specific limits on usage were stated in the original contract

12 Surface Design Prices & Trade Customs

and changes do not have to be made to the artwork to render it usable for a new product, it is quite possible that the designer may not be offered additional payment for the use of the design in a new format.

Specific uses, and terms for uses other than those initially specified, should be negotiated in advance whenever possible. There are times that the secondary use of the art or design may be of greater value than its primary use. Therefore, there is no set formula for reuse fees.

Fees for surface design, reflecting responses to a survey of established professionals in the United States and Canada, are meant as a point of reference only and do not necessarily reflect such important factors as deadlines, research, job complexity, technique or unique quality of expression, extraordinary or extensive use of the finished art, and reputation and experience of a particular surface designer. Nor do the ranges constitute specific prices for particular jobs. The buyer and seller are free to negotiate, with each artist independently deciding how to price the work, after taking all the factors into account. (Refer to related material in other chapters of this book, especially Chapter 5, Essential Business Practices, and Chapter 13, Standard Contracts and Business Tools.)

Chapter 13 Standard Contracts & Business Tools

The professional landscape of the graphic artist has changed dramatically over the last 10 years. New media, new technology, growing competition in the workplace,

and the consolidation of publishing venues have all placed new demands on artists and on the companies who hire them. While clients routinely ask for more rights, often without additional compensation, artists struggle to retain control and to bolster the value of

This chapter describes why contracts are needed to define and protect all kinds of business relationships. Seven different types of contracts are explained, and contract terms are defined in a Glossary and discussed in detail. Also included is advice on what to do when things go wrong. Sample contracts are provided for various graphic assignments.

their work. Increasingly, the business side of the graphic

arts is defined by contracts.

At first glance, contracts may inspire dread, yet they can make business much easier. When the basic concepts are understood, contracts can protect both the artist and the client. And contracts can provide a common working language by which each job can proceed. With a little time and patience, graphic artists can learn not only how to read clients' contracts, but also how to structure their own agreements that best represent their interests.

Why Have Contracts?

There are always two sides to every assignment. Clients may assume they own more rights than the artist's fee dictates or that a kill fee represents 25 percent of the agreed-upon price. The graphic artist may expect a check immediately upon delivery, while the client pays 30 days or more after publication. To avoid confusion and misunderstanding, a well-written contract defines the working relationship of the client and the artist, the use of the finished work, and how any changes in the scope of the project are handled.

Most contracts provide:

- A definition of the project or assignment.
- · Limitations on the use of the work.
- Terms for such professional issues as payment and artist's credit.
- Protection in the event of a dispute.

The primary rule to remember when reading a contract is that the person or business that drafts the contract is concerned with rights and controls that are advantageous to their business. Their objective is to get the other party to agree to the protections laid out in the document. As independent contractors, artists should make every effort to present their own contracts. This may not always be possible, so having a clear understanding of contract language is important.

Graphic artists have the same advantages as clients when they read contracts. Although the legal language may seem daunting at first, every clause contains basic principles and concerns regarding the specific assignment and affecting general studio policy. With a little common sense and a glossary (see the Glossary before the contracts in this chapter), artists can learn to understand and negotiate many legal documents.

How do contracts protect?

A contract is an agreement, whether oral or written, that defines the obligations and responsibilities of each party. One party makes an offer, usually with terms benefiting that party. The second party considers the offer and negotiates terms to reflect their needs. Ideally, each party should benefit equally from the contract. Once both parties agree to its terms and sign the contract, it is legally binding.

In written contracts, obligations are defined in paragraphs (clauses), and all terms within a contract are potentially subject to negotiation before the agreement is finalized. Clauses in graphic arts contracts typically set business standards for such things as payment and kill fees, number of roughs or comps, alterations, licensing and copyright transfers, and dispute resolution.

Contract clauses also provide limitations against unauthorized uses of the finished work. Each party is notified that certain behavior is expected and that a breach of that behavior can result in legal proceedings. At times the language may appear harsh, but the intent is to protect the signers from potential misunderstandings as the job proceeds.

It is important to understand and agree to terms before starting a job. Should an artist start a job after seeing a client's contract but without signing it, it can be argued that the artist has accepted the terms and the contract is binding. By making sure all terms are agreed upon before starting, the graphic artist enjoys the protections of a binding contract.

Agreements that are straightforward, clearly written, and customized to the project and its use provide a positive game plan for both client and artist. The content should reflect the best interests of all parties, or at least an agreeable compromise. One-sided documents requiring a signature without possibility of negotiation are not to the advantage of either party.

Seven Basic Types of Contracts

Contracts can be as simple as a oral agreement or as complex as a multipage document. Regardless of the scope of the project, a written contract is always advisable. Seldom will one boilerplate contract be appropriate for every job, so flexibility and customization are key to drawing up contracts. Here are some of the more common types of contracts, ranging from the most simple to the more complex.

Oral agreement

While written agreements are always preferred, circumstances do not always allow for them. Thus, many jobs are assigned over the phone, where usually just the bare essentials are discussed: what work is needed, the timeline for the work, where the work will be used, how it will be reproduced, and the compensation for the work. The graphic artist orally accepts the client's terms over the phone or in person with a simple handshake. This type of agreement is legal and binding. However, if a dispute arises over the terms of the agreement, proving what was actually intended can be difficult. Often, one party's memory may contradict another's, and there is no set rule to determine what evidence will be allowed for review by the courts. If there are no witnesses or documents to prove the specific terms of the agreement, then either side could prevail.

If a graphic artist has built a long-standing relationship with a client, an oral agreement may be adequate. However, before accepting an oral agreement, certain things should be considered: Whom you are dealing with the direct owner of the business or a representative of the owner? Who will be accountable if there is a dispute in the agreement? Are you willing to take a risk with this person?

Letter of agreement or engagement

If an assignment is initiated by an oral agreement as described above, the artist will have more legal protection if he or she finalizes the deal with a one-page document defining the project. Called a "letter of agreement," this document can be very simple and should include a project description, what is due, when it's due, usage and ownership rights, kill fees, and so on. It is advisable to have a standard letter of agreement on file in your computer, which you can then tailor to the project and fax to the client if time is limited.

Purchase order

Historically, companies have used purchase orders (POs) to assign work to contributors or to track a job from assignment to payment. POs often resemble invoice forms, with a tracking number and a statement of the assignment and terms, which often appears in small print on the back or the bottom of the order. Many POs now function as contracts, including assignment of rights and more general terms, and require the graphic artist's signature before the job starts or before the artist's invoice can be processed for payment.

Purchase orders, however, can present a problem for the graphic artist. Because they are often generalized boilerplate documents, automatically sent out by buyers with each assignment, they don't clearly state the expectations and obligations of both parties for a specific assignment. Should a dispute in terms arise, graphic artists run the risk of not being as protected as they would be with a custom contract. If there are unacceptable terms on a PO,the artist should cross them out using the addendum procedure outlined later in this chapter.

Working contract

This document is what everyone knows and recognizes as a contract, complete with legalisms and clauses. Regardless of its length, a working contract can be written in either clear and concise language or convoluted and confusing terminology. Either way, artists are often intimidated by the initial look of a contract and for this reason do not properly review it before signing. It cannot be stressed enough how important it is to be fully aware of the meaning of each and every clause in a contract before signing it. If read with patience, even the most confusing contract can be understood.

Traditionally, detailed working contracts are usually used for more complex jobs that require periodic payments or royalties, such as books or other major commissions. However, as the electronic marketplace grows and the nature of corporate business changes, graphic artists must expect to deal with clients' growing demands for greater rights and control over projects. Increasingly, longer, more complicated contracts are used for such seemingly simple jobs as editorial assignments, which in the past were covered by simple letters of agreement.

One strategy for coping with such client demands is for graphic artists to create their own working contract that reflects their studio policy and basic business standards. That contract can then be customized to suit a particular project. However, artists should be prepared to deal with client contracts—always considering a contract a first offer to be negotiated. A client's contract, when properly negotiated, protects both parties equally.

Postproject contract

Terms in small type at the bottom or on the back of a graphic artist's invoice, on the back of a client's check, or even on a purchase order sent from the client after receiving the artist's invoice are all examples of postproject contracts. However, the legality of such after-the-fact documents is questionable and subject to varying interpretation in the courts. Usually they do not require two signatures, which erodes their authority as agreements between two parties.

Using postproject contracts is not a smart business strategy for either artist or client. It's always best to promote open communication by using standard contracts and letter of agreements that can be easily customized, offered for discussion, and signed before the job begins. That way the job proceeds with all terms and expectations understood and agreed to by both parties. The time and expense invested in preparing them is minimal compared with the legal costs that may result if a dispute arises.

Invoices

Invoice contracts are sometimes used by graphic artists and artists' representatives who do not want to alarm or intimidate clients with lengthy contracts. As with POs, the terms are usually preprinted and not specific to the assignment at hand. It's important to point out that invoice contracts provide little legal protection, as no signatures are involved. To be legally binding, such forms must conform to an oral or written agreement made before the work was started.

Checks

Check contracts are the trickiest. Sometimes an artist may receive a check for services rendered, but the check is not for the full, agreed-upon amount. If a check states "payment in full" and the artist endorses and cashes it, that could possibly be considered acceptance of the lower amount for all the services rendered. In the 1995 federal case of *Playboy Enterprises, Inc. v. Dumas,* the court decided that payment in this form is not legal unless the check restates a "prior agreement, either explicit or implied, made before the creation of the work." (For a more detailed discussion of this case, see Chapter 2, Legal Rights and Issues.)

It is very important to note that in New York State, this type of activity is legal and is considered payment in full. This could possibly hurt the artist. Before cashing any check that is for less than the agreed-upon amount, it is *always* advisable for the artist to verify that the check was not sent in lieu of the full amount.

Boilerplate contract

A boilerplate contract is one with generic or formulaic language (standard terminology). There are two definitions of a boilerplate contract. One is a document used as a general template for a wide range of projects, whose clauses and elements are altered to fit a particular project before the contract is offered. As a matter of studio policy, graphic artists should design their own boilerplate letters of agreement and working contracts for ongoing use. Then the graphic artist has a contract base that can be customized as needed for each assignment.

Although never clearly labeled as such, a boilerplate contract can also be a multiple-use contract, designed to cover a wide variety of projects with no attempt at customization. Multiple-use contracts, provided by both large and small companies, can be recognized by their obvious generalized clauses, especially in the assignment of rights and licensing. They *must* be carefully reviewed and negotiated because they typically request many more concessions than are realistic for the project at hand.

To deal effectively with noncustomized boilerplates, graphic artists need to establish their own studio policy (see the Using Contracts section below) that defines general terms and expectations for various assignments. This sets a business standard that the graphic artist can work from when negotiating all contracts, but especially boilerplates with generalized clauses.

Retainer agreement

Although retainer agreements are most often used by attorneys and accountants, they are also used with increasing frequency by graphic designers and sometimes by illustrators.

When signing a retainer agreement, the graphic artist agrees to work for the client for a specific amount of time over a given period or on a particular project for a fee paid according to an agreed-upon schedule. Often the schedule includes an upfront payment, which reduces the graphic artist's risk; otherwise the designer is virtually extending credit to a possibly unknown client. The payment also guarantees the designer's availability for the duration of the project.

Retainers may take several forms:

- Annual retainer: Payment schedules vary, but the client usually agrees to pay a substantial fee upfront—30 percent is recommended—and the graphic artist guarantees to be available to work for the client as needed. The agreement may include a specific number of hours or days devoted to the client's needs, with additional time billed as used. Payment for time not used is forfeited, or can be accumulated throughout the year as credit.
- Project-based retainer: This also involves a substantial fee upfront—30 percent is recommended—to retain the graphic artist's services as a one-time deposit against

future billings. Hourly rates are set, and the client is kept informed of the hours being billed against the retainer. After the retainer hours are used, regular hourly billing continues. If the fee is not completely used, the remaining amount may or may not be refundable.

3. Service retainer: This agreement covers longer-term commitments of six months or a year, with payments made in monthly installments. Design services are billed against this retainer, which is very similar to a level billing program where annual project fees are set with a client, who pays the fees in equal installments.

The service retainer is different from the more traditional annual retainer, which is usually based on hourly billing. The problem with hourly billing is that the client may lose control over costs—especially if the clock keeps ticking. In a project-based agreement, both sides know exactly what will change hands. The advantages to the graphic artist of working on retainer are guarantees of long-term designer/client relationships, multiple projects, and a steady cash flow. Among the disadvantages are clients calling too often about minor issues and expecting priority over nonretainer clients. Clients may also question that they are getting all the service they are paying for. A retainer relationship may sometimes limit the graphic artist's ability to compete for other assignments.

Among the advantages of retainers to the client are cost savings, since retainer work is usually done at a 10 to 15 percent discount. (Additional billing hours may or may not be discounted.) Having a graphic artist on retainer means having on hand an individual who is fully aware of the company's needs and products, and being given preferential treatment by that individual—two benefits that are increasingly valued in this age of tight deadlines.

What a Contract Should Include

Contracts in the visual communications industries usually cover four issues: copyright use, payment, legal, and working relationship.

Copyright use issues

In the graphic arts, the value of a particular work of art or design depends on *its use*. An illustration used for a small local magazine has one value; the same illustration used in a worldwide advertising campaign is worth far more. A logo designed for a local mom-and-pop store has much less value than a logo used by a global corporation. Use determines price. (For more on use and value, see the Copyright section in Chapter 2, Legal Rights and Issues.)

Under copyright law, any exclusive use of a design or artwork licensed by a client must be transferred in writing. To avoid any future dispute between client and artist, it is always best to clearly specify which uses are agreed upon in a written contract. As important as it is to specify where and how a work is going to be used, it is just as important to stipulate where it cannot be used. A contract should describe in detail exactly where, how, and how long a work can be used, including the following issues:

• **Type of medium/product type**: Where will the finished work appear: solely in a magazine, in a newspaper ad, on a Web site, on a CD cover, or on a billboard? Or in multiple media? In the age of multimedia it is extremely important to be specific about each medium where the work will be used, since each use helps define the final value of the work.

- Category of use: What is the intent of the use: advertising, editorial, corporate, institutional, book? To understand the difference in value between a single magazine page and a multimarket campaign, it may help to study the many charts detailing survey results that appear in preceding chapters of this book.
- Geographic area of use: How widely will the work be used: North America, Europe, worldwide, on planets yet to be discovered? As the span of the marketplace increases, so does the work's exposure, which can increase its present and future value.
- **Duration of use**: How long will the work be used: one time, one year, for two editions? Limitations on duration of use allow graphic artists to control the exposure of their work and to receive fair market value in each venue where their work appears.
- All-rights terms: Such clauses allow clients unlimited use of a work, including in multiple markets and in any way the client may see fit. All-rights clauses (also called buyouts, which is a misleading term and one to be avoided) are often used for logos, in advertising, or in other areas where a design appears so frequently that keeping track of usage is impossible. An artist agreeing to all-rights terms should always consider appropriate compensation.
- Ownership of original art: Who retains the original? Giving a client the right to artwork or to a design for a specified use or a particular period of time is different from selling the client the physical artwork or sending the client an electronic file. The sale of original art is often a secondary market for graphic artists and is, by law, a transaction separate from the transfer or sale of reproduction rights.
- Licensing third parties: Many clients specify the right to resell or transfer their agreed-upon rights to others. That can be for resale purposes or to allow the worktoflowthrough normal channels of manufacture and distribution. However, transferring the right to license to a client may effectively remove the artist's control over the work and divert any potential resale revenue from the artist.
- Exclusivity: Who has the right to license, use, or resell the artwork? "Exclusivity" means that only the client can use the art for the agreed-upon purposes for the time specified and that the artist or designer cannot resell the art to, or adapt it for, any other person or concern within the same medium, category of use, or type of product for the time period stipulated in the contract. "Nonexclusive rights" means that while the client can use the art for the agreed purposes, the artist can also resell the work to other clients for other uses.

Many contracts, especially editorial ones, may combine exclusive and nonexclusive terms. For example, a magazine may ask for exclusive terms for 60 days from the date of publication. After 60 days, the contract stipulates nonexclusive terms, allowing the magazine to continue to use the image while the artist is free to resell the work to other clients. Nonexclusive rights can extend the use and value of artwork to clients; the artist should consider this added value when determining the price of the work. • Work for hire: A work-for-hire clause assigns authorship of art or design to the client. The graphic artist hands over all rights to the client, including copyright, all preliminary concepts, and even the original. By signing a work-for-hire contract an artist becomes in effect an employee of the client for copyright purposes only, but with none of the benefits or compensation usually associated with employment. Note that the contract must specifically include the words "work for hire" or "work made for hire" to qualify as such. (For a thorough discussion of work for hire, see Chapter 2, Legal Rights and Issues.)

Payment issues

How much will be paid for a particular use or design? When is payment due? Are there penalties if it is not paid on time? All these issues fall under this category.

- Fee/estimate: What is the monetary value of the final work? A variety of factors are used to estimate and set fees: media and geographic areas in which the work will appear, frequency of use, and allocation of a variety of rights.
- Additional expenses: If the contract is part of an estimate, how much is estimated for expenses? If outside vendors are used, who will pay their costs and when? Are delivery fees and media, such as disks, paid for by the client or the graphic artist? Will the client be notified if expenses rise over the original estimate by a certain percentage? When is payment for the expenses, carried by the graphic artist, due from the client? Will those expenses be marked up?
- Kill/cancellation fees: If a project is canceled for reasons beyond the control
 of the graphic artist, the project is considered "killed." Typical charges for
 services rendered can be 25 to 50 percent if the work is killed during the
 initial sketch stage, 50 percent if killed after completion of the sketch stage,
 and 100 percent if killed after the final design is completed.

"Rejection" is used when an assignment is canceled due to client dissatisfaction. Perhaps the final art deviates from the agreed-upon sketch or the style is different from the artist's portfolio or samples shown to obtain the job. Common cancellation fees are one-third of the total fee if canceled before completion of final art, and 50 to 100 percent after the final artwork is completed.

Determining whether a job is killed or rejected may become a matter of common sense and negotiation. Both the graphic artist and the client need to realistically evaluate the causes for terminating the project and negotiate payment accordingly. Contracts should provide a clear directive that the client, in killing or canceling the project, gives up any agreed-upon copyright transfer. Any future use is subject to renegotiation.

 Payment schedule: When are payments due? For large projects, payment is often divided into scheduled segments, called "progress payments": a percentage upon signing, a percentage due after approval of the initial designs, the remainder upon delivery of the final work, plus expenses. Smaller jobs may simply require payment at delivery or net 30 days after delivery of the artwork. As with any schedule, specific deadlines can be crucial, and the graphic artist should consider whether the final payment plan is realistic. There is a big difference between 30 days after receipt of the invoice and 30 days after first use, which may be delayed for many reasons beyond the artist's control.

- Late-payment fees: When is a payment late and subject to penalties? After 30 days? Some artists charge a penalty fee (such as 1 1/2 percent of the total) due every month that the balance is in arrears. As an incentive for timely payment, some artists offer clients a small discount (such as 2 percent) if payment is received within a short period of time after the invoice date (say, 15 days).
- Client alterations: Any changes requested by the client that are integral to the original assignment are usually considered part of the process and not client (or author's) alterations. When changes go beyond the original, agreedupon scope of a project, they are billable over and above the agreed-upon price. These changes can be billed by the hour (the artist's hourly rate is often stipulated in the contract) or by an addition fee agreed upon at the time of the change.

If the nature of the assignment changes in the middle of the work, the graphic artist may assume that the client is liable for an additional fee and increased expenses. It's important to specify such expectations in the initial contract. It is also important to discuss the change in the original assignment with the client so there is no misunderstanding at the time of completion and billing.

- Taxes: What taxes are due, and who pays them? Some taxes to consider are state sales tax and transfer taxes. (See the Sales Tax section in Chapter 3, Professional Issues.)
- **Default/legal fees:** How will the matter be settled should the client not pay the bill? If there is a dispute regarding rights or use, who will cover the expenses incurred in the resolution of the dispute? (See the Remedies section under Legal Issues, below.)

Legal issues

Clauses in this category define responsibilities over such legal issues as questions of ownership, libel, and seeking recourse in disputes.

• Warranty: A warranty is an assurance by the creator that the work is original and unique, created solely by the artist or designer for the buyer. It protects the buyer from legal action based on the art or design supplied to them by the graphic artist.

A warranty may also guarantee that the graphic artist holds the exclusive rights to the artwork or design, and has the authority to sell the agreed-upon rights, and that no one else may claim these rights. Typical warranties of this type may state that "to the best of the artist's knowledge," the artist has not infringed on any person's copyright in creating the artwork.

Some buyers want to be assured that nothing in a work is considered "obscene" or "indecent." This may be a matter of personal taste that is beyond the artist's control. However, if a client is adamant about certain issues, this language ("no explicit sexual references") should be clearly stated in the wording of the contract.

 Indemnity: Indemnity is a common clause in practically all contracts that seeks to exempt or protect the client and/or the graphic artist from damages or liability in actions brought by third parties. Should someone other than the client or graphic artist sue one of the parties, this clause protects the other from also being brought into the lawsuit. Similarly, graphic artists should insert wording into any contract that will protect them if a client causes the work to be subject to any litigation.

An indemnity clause should be negotiated based on the scale and scope of the work. A typical indemnification clause reads: "Artist holds client harmless from and against any and all judgments and related costs and expenses arising out of, or concerning artist's rights in, the material provided."

- **Remedies:** Remedy clauses map out agreed-upon courses of action by which a disagreement or breach of contract can be resolved. Solutions in remedy clauses include negotiation, mediation, arbitration, and in-court action. Several points need to be considered:
 - Types of remedies: Will the claim be taken to an arbitrator or mediator agreed upon by both parties or appointed by only one party, or will the dispute be settled in court? (It's important to note the difference between arbitration and mediation. Arbitration by a neutral party results in a binding decision, enforced by a court. In mediation, an impartial mediator seeks to facilitate an agreement between the two parties. A mediator can be appointed by a judge or another third party, such as an arts mediation service, but the resolution is binding upon the parties only if the parties agree to it in writing.) Does agreement to use arbitration or mediation waive all rights to otherwise pursue additional settlement in court? (It may or may not; see the When Things Go Wrong section below.)
 - •••• Geographic area: Where will resolution of the dispute be pursued? Individual cities, counties, and states all have different laws and codes that govern and affect a final ruling in a dispute. If the client and the graphic artist do business in different locales, then a remedy clause needs to specify where arbitration or court action will take place.
 - •••• Legal expenses: Who will pay legal costs, such as lawyers and research, should a dispute arise? Clients often try to establish that the graphic artist bears full financial responsibility regarding expenses incurred in the settlement of a dispute. This responsibility often extends beyond the client/graphic artist relationship to actions by third parties who feel the work has somehow infringed on their rights. (See the Indemnity section above.)
 - •••• Cure provision: A cure provision is a clause in the contract that gives an infringing party a certain amount of time to "fix" a mistake before any legal action is taken. Such a provision is necessary for both parties because often circumstances beyond anyone's control create situations adverse to the agreement; for example, late delivery of supplies by a third party could cause the graphic artist to be late in handing in an assignment. The typical cure provision gives a party approximately 30 days to cure the breach.

Working relationship issues

This category describes areas in a contract that define the basic working elements of a project: the function and facets of the job, what's expected and when, who approves the work, and so on. Here is a standard list for any assignment:

- **Project description**: The project description is one of the main considerations in setting compensation for the work. Be sure to include the project name, a thorough description of the project, uses, and copyright transfers. Both parties benefit when the scope of the project is described in as much detail as possible.
- Work stages and scheduling: What is expected at the various stages and when: pencil roughs, color comps, camera-ready mechanical? What is the responsibility of each party at each stage? How many ideas will be presented in the initial stages, and how many revisions are reasonable under the stated fee schedule? Is there a penalty for missed deadlines? Number of revisions, scheduled sign-offs, and time allowed for turnarounds are important considerations governing the work. Both graphic artist and client should strive to set realistic expectations for each stage.
- Approval process: Who accepts and approves the work and when? How long does the client have to review and sign off on concepts, comps, or final art without upsetting the final delivery date? The contract may include language that specifies a monetary penalty for missed deadlines, especially at the final deliverable stage.
- Final artwork and return of originals: What form should the final deliverable work take: reflective art, transparency, electronic transmission? Is final art to be hand-delivered, mailed, express-mailed, or e-mailed? When should the artist expect the original artwork to be returned? What would be appropriate compensation in the event of damage or loss of the original? Does the artist receive tearsheets or finished samples? Delivery and care of the artwork as well as samples of the printed work are all concerns that should be governed by the contract.

Using Contracts

The more proactive artists are in managing their business, the less intimidated they are by unreasonable situations. However, by its nature all creative work, which straddles the line between the personal and the practical, is not the average business transaction. The following three suggestions enable a graphic artist to adopt a proactive stance.

Create a boilerplate contract

Start by drafting a basic studio contract based on the ones in this book. Study contracts sent by clients and incorporate appropriate clauses into your boilerplate. Also compare notes with other professionals in the field about what clauses should be included. (For detailed examples, review the Graphic Artists Guild's *Contract Monitor*—www.gag.org/contracts/ contracts.html—on a regular basis.)

Save the new contract as a template in your computer. Then customize the contract by changing, adding, or removing clauses to suit a particular job and print it out on studio letterhead. By designing your contract to look as professional as possible, you project businesslike authority, and your contract will be taken more seriously.

Follow the same procedure to draft your own letter of agreement for less complicated jobs, and store it for future use.

Establish a studio policy

Being proactive means anticipating the needs of your business as well as your client before an assignment comes in. Setting a studio policy eliminates possible problems and conflicts before they arise.

Using an established policy depersonalizes the process of negotiation. Policies can be quoted whenever something unpleasant arises, such as: "Our policy is no returns without receipt." So it's not the artist saying "no"; it's the studio saying "no." In reality the artist and the artist's business are one and the same, but clients often find it harder to question a business policy than to badger an individual.

As a businessperson, it's easy to establish a list of policies that support your work. Prepare a written statement, and then practice quoting the studio policy out loud. Try saying: "I'm sorry, but we have a studio policy of not signing workfor-hire contracts." With practice the phrase will sound natural and convincing.

In addition to establishing priorities, studio policies help pinpoint difficult or problem clients. Should a job sound confusing or the client undependable, the artist can simply say, "This job sounds terrific. Let me send you our standard letter of agreement so that you're aware of our studio policy. When you're ready, just sign and return the letter, and I'll get started on the work." The letter communicates to the client the terms under which you will and won't consider a job.

Here are several helpful studio policies:

- Do not ever work on projects without a signed agreement.
- Do not accept work-for-hire terms.
- Do not accept all-rights terms (or buyouts).
- Do not do work on spec.

- Refuse contracts that deny the artist the opportunity to negotiate terms.
- · Establish a studio minimum for work.
- Do not quote estimates on the spot; allow time for reflection.

Here's another policy to consider: Practice not signing a contract the moment it comes in. No matter how exciting the prospect of the job, set aside an hour to read over the contract with the understanding that any agreement must benefit both parties, not just one.

Working with clients' contracts

When a client says, "I have a contract to fax you," don't automatically assume it's unfavorable to you. But don't assume it has your best interests at heart either. Every contract offers an opportunity to work out an agreement. Tell the client you're looking forward to seeing the contract. Then follow these simple steps:

- Get acquainted: Make a copy of the contract. Then read through it carefully without interruption, using a pen to make notes and a highlighter to mark problem areas.
- Isolate problem areas: After the first read-through, pause and read through it again, noting any areas you don't understand and repetitive clauses. Occasionally a client's legal department may try to establish a right in several clauses spread throughout a document or sneak a clause under an inappropriate heading. Write additional notes in the margin.
- Compare notes: Does the contract reflect what the client said when assigning the job? Is the client saying one thing and the contract another? Does the contract ask for more rights or terms than was initially discussed? Does the stated fee support what the contract is requesting? If not, make notes about the items that are beyond the scope of the assignment and estimate what is needed to cover the additional work.
- Start the rewrite process: Methodically cross out sentences and rewrite passages that are unreasonable. (Remember that negotiation

13 Standard Contracts & Business Tools

is a two-way street.) Be aware of the client's concerns as well as your own. Although the client may have submitted a contract that deals only with its needs, it is important to alter the contract so it reflects a reasonable agreement. An invaluable skill in client negotiations is to understand both sides of the transaction and work in good faith toward a common understanding. The goal is for both parties to sign an agreement that supports an ongoing working relationship. Keep that in mind during the rewrite.

- Alter the original: Now copy your changes neatly onto the original contract, using a ruler and a thin black pen (do not use a wide felt marker that will completely obliterate the original). Put your initials in the margin next to each change. Should changes to a clause be so extensive that an addendum is required, cross out the entire clause and write "See addendum" next to the section. Compile all the addenda on a separate sheet; title each one with the clause number, the name of the clause, and the word "Addendum" so the client can easily locate the original clause in the contract. For instance: "Section 4. Grant of License Addendum," followed by the rewritten clause. Then attach the addenda to the contract.
- Send it to the client: Fax or mail the altered contract with a cover letter thanking the client for sending it. Be sure to alert the client to any alterations by stating something like: "Please note that I have made substantial changes in the contract sent. The changes occur in Sections 3, 5, and 8. Please feel free to contact me should you have any questions regarding these changes." Then conclude with an encouraging word and a polite request: "I am looking forward to starting the project as soon as I receive the signed contract."
- Prepare for a reaction: Arriving at an appropriate contract often involves a series of back-and-forth compromises. Expect questions about the reasoning behind the revisions and deletions. Be prepared to explain patiently why the alterations were made. If the client insists on a deleted clause, try to negotiate a higher fee or another trade to compensate. As in all business transactions, but especially phone conversations, remain calm, businesslike, and personally removed from the issues.

Determine, in advance, what the bottom line is, and be prepared to turn down the job if that is not met. It's helpful to remember that not all negotiations result in projects.

Negotiation

When negotiating a contract, it is necessary to be as professional as possible and strive for a win-win solution. (If needed, review the Negotiation section in Chapter 5, Essential Business Practices.) Set up standard points you want to cover or an agenda that outlines topics to be covered and refer to it whenever negotiating, particularly over the phone. Whether a project is interesting purely for the money, because it's a valuable showcase, or because it will help establish a working relationship with a new client, having a standard agenda may influence what you agree to during negotiations.

In addition, you may want to develop a "position paper" with several questions that you need to have answered in any negotiation: (1) What value—monetary or otherwise—will I derive from this job? (2) Is that enough to cover my time and expenses? (3) What is the price I'd like for the job? (4) What is the price I'm willing to accept? (5) What is the price I won't go below? (6) Can I afford not to do the job? (7) What will I do instead if I turn it down?

The majority of art directors and creative service personnel who commission art and design have little or no understanding of contracts and copyright. They are too busy juggling a number of important creative projects in unusually hectic, high-pressure surroundings, and like artists, most of them would prefer to spend their time in creative pursuits rather than administering legal details. So if the artist has a clear understanding of how to suggest contract amendments and put them into writing, that will help avoid problems.

Keep thorough written records of every negotiation, including your initial checklist containing a job description, due dates, fees, and expenses, notes on the person representing the client, records of follow-up meetings and phone calls, hours on the job, sketches or layouts, contracts, invoices, all e-mail correspondence, memos, and business letters. This is the "job packet" that provides a paper trail in the event that a disagreement or misunderstanding gets in the way of completing the project and receiving payment.

When clients try to use work-for-hire clauses in contracts or demand all rights to artwork, every effort should be made to determine the client's real needs. Often such terms were put in a contract by a zealous lawyer trying to anticipate every possible contingency. But such terms usually are excessive and, if priced accordingly, make the work too expensive.

Money should be the last item in a negotiation, for several reasons. It is the area where the majority of disagreements occur, and it is important in the earliest stages of a negotiation to focus on areas in which it is easiest to reach agreement. In this way a partnership is given time to bloom. Also, money should only be a reflection of all the factors that lead up to it. The job description, usage and reproduction rights, deadline, expenses, difficulty of execution, all define how much value a particular job holds for the client. So negotiating about money before reaching agreement on other items is premature and can be a costly error.

When discussing money, it is advisable, whenever possible, to outline all the factors that go into the project, then try to get the client to make the first offer. The old game of "You say 6, I say 10, you say 7, I say 9, we agree on 8" may be played out but may not be necessary. Depending on how it is stated, a first offer is rarely a final offer and should almost always be tested. Once again, the artist must weigh the risk of losing a possible working relationship by refusing to budge past a certain price. But in the end you set your bottom line.

Often parties may establish an arbitrary limit from which they will not bend, such as "I won't pay more than \$5,000" or "I won't accept less than \$3,000." Since the figures or conditions are often selected at random in the first place, it may be important to ignore such a limit, if possible. Focusing on an absolute may inhibit the imagination required to establish terms that meet both parties' needs.

Tactical problems may occur, especially if emotions become involved, so try to stay calm, cool, and collected at all times, even if the client isn't. If the person you're negotiating with claims not to have the final say on terms, then talk about the project as a joint venture and solicit the person as your newfound "partner." Hopefully that will inspire the person to go to bat with his or her boss to defend your needs. If a contract states that it is a "standard contract" and cannot be changed, remember that contracts are working documents that should protect both parties. Don't agree to sign a standard contract if it doesn't protect you. Don't be afraid to strike out unfavorable sections or terms. If necessary, the defense "My attorney has instructed me not to sign contracts with these conditions" may be used to suggest alterations.

Don't ever feel obligated to respond right away, especially if a client starts out a negotiation with "I only have \$500, but I think you'd be great for the job." One can acknowledge the figure and still find creative ways to ask for more money. For instance, try selling the client usage of an existing piece of art (stock). (See the Reuse and Other Markets section in Chapter 5, Essential Business Practices.)

It's always best to tell the client you'll call back shortly after you've had a chance to think about the project. Then take time to review the terms and note any points you want to change. If a project has many variables, you might consider talking it over with an associate or consult a Guild hotline (see the Member Benefits and Services section in Chapter 14, The Graphic Artists Guild).

It is important to note that negotiation itself cannot lead to a good contract in every situation. There are some relationships where the balance of power is so out of alignment that one party must either yield to unfavorable conditions or give up the opportunity. However, it is possible to maximize assets and protect yourself from an agreement that may be detrimental to you.

Remember that not every negotiation is destined to end in a deal. Two parties can "agree to disagree" amicably and part ways in hopes of another try at a later date. The ability to regard negotiation with levelheaded objectivity, keeping it in perspective, gives a skilled negotiator the attitude necessary to obtain the most favorable agreement.

Before Calling a Lawyer

Though many contracts may appear incomprehensible at first glance, the more contracts you read, the more you will understand. In most circumstances, calling a lawyer is not necessary. For smaller projects the cost could easily be more than the assignment fee! Sometimes, especially in the beginning, you just need a little help with a particular clause. Here are some less expensive ways to come to terms with contracts.

- Network: Call fellow graphic artists, talk openly about contracts, and ask their opinions. Establish a network or support group with other artists in your field to share information about contracts and companies. Join graphic artist chat boards on the Internet. Two excellent examples are the ispot (www.ispot.org) and the Graphic Artists Guild (www.gag.org).
- Find a coach: Seek experienced graphicartists as business mentors. A free lunch in exchange for advice can help short-circuit future business headaches. If you are a Guild member, call your chapter's Contract Point Person. Although they are not lawyers, Point People can often answer simple questions,

provide coaching through a difficult negotiation, or suggest other resources.

 Read and grow wiser: In addition to this book, many books educate artists about contracts and business matters (see those listed in Chapter 15, Resources and References). In this digital age, the Internet has many sites that provide business support to graphic artists; a number of them are hosted by artists. Publications such as the Guild's e-mail newsletter, *The Contract Monitor*, explain common clauses, offer negotiating tips, and alert subscribers to unreasonable companies. To subscribe, go to the Guild's Web site (www.gag.org/contracts/ contracts.html) and follow the easy instructions.

When to Call a Lawyer

When writing or negotiating a contract, there are times when you should consult a lawyer:

- · For large and/or complicated projects involving complex royalty or licensing issues.
- For projects requiring lengthy schedules and/or penalties.
- For licensing work in multinational markets.

When things go wrong

At the other end of the legal spectrum is the question of what to do when things go wrong after a contract is signed. The fact that the contract exists at all is usually a great deterrent to a violation of terms, but when an agreed-upon clause is violated, it becomes a breach of contract.

There are many ways to address a breach, most of them without incurring great expense. No matter what method you use, once you know things are going wrong, it's essential to maintain a thorough paper trail to document your side of the case.

Establish a paper trail

- Keep copies of all letters sent to the client.
- Refresh your memory as to key conversations and oral agreements before, during, and after the job was completed. Write them down for further reference.
- Keep a record of all telephone calls made regarding the dispute, including the date and year of the call. Take notes about the content of each call, the people involved in the conversation, and what was agreed/not agreed to. If necessary, follow up each conversation with a brief letter recording your understanding of the conversation. That allows clients to respond if they feel the facts are inaccurate. Keep the telephone log as a separate file, and do not write on the contract.
- Set up specific dates when you expect an agreed-upon action to be taken. Send all correspondence by certified mail, return receipt requested, and file the receipt with a copy of the letter for future reference.
- Keep a folder with all receipts, notes, and papers regarding the problem.

A word of etiquette: As in negotiating, strive to keep all correspondence and discussions calm, businesslike, and at arm's length. Shouting or threats only serve to limit communication, harden positions, and drag out the negotiation process. Showing clients that you mean business and are methodical can be much more effective than acting in a way that will alienate them. Help the client solve the problem by offering reasonable solutions. Your goal is to encourage the client to work with you to find a solution.

No solution?

There will, however, be times when the client has no intention of solving the problem. Just like any businessperson, the graphic artist has a wide range of available options, depending on the scope or severity of the problem. The following list of actions is scaled from minor to major breaches of a contract.

- Write to the offending client, asking for a remedy to the problem: Mention the contract as a tool you plan to use to prove your point, if needed, in court. Spell out specifics. This is your first brick when laying a foundation for action if going to court.
- Negotiate one-on-one: Try to avoid potential expensive arbitration or legal fees by offering to sit down and negotiate a resolution. Even in extreme circumstances, it is always better to attempt to negotiate before heading down the legal road. (Review the Negotiation section in Chapter 5, Essential Business Practices.)
- Mediation: Mediation is an informal method of resolving disputes. It is a more aggressive style of negotiation in which an impartial third party is brought in to facilitate the discussion between the disputing parties. If the parties are able to resolve their differences with the mediator's assistance, the resolution is written up as a Memorandum of Agreement, which is then signed by both parties and the mediator. Such a memorandum constitutes an enforceable contract between the parties. The Volunteer Lawyers for the Arts provide low-cost or free mediation services for artists, with fees based on a sliding scale. (For a list, see the Collecting section of Chapter 5, Essential Business Practices.)
- Arbitration: Arbitration is similar to mediation except that the proceedings are more formal and the resolution is handed down to the parties by the arbitrator, rather than arrived at by the parties themselves. The arbitrator's rulings are legally binding upon both parties, and arbitration rulings usually cannot be appealed.

Many associations offer arbitration, including:

··· The American Arbitration Association (212.484.4000).

··· The American Bar Association Dispute Resolution Program (202.331.2258).

- ··· Judicate (800.631.9900).
- Consider small-claims court: If the breach is payment-related and the fee is within the allowable range, then small-claims court is often an inexpensive way to recover damages. States vary as to maximum amounts allowed in small-claims cases. Many books exist to help you wind your way through small-claims court, including the excellent self-help legal publications from Nolo Press. (See Chapter 15, References and Resources.)
- **Call arts organizations for referrals**: Check with local arts organizations for legal groups that specialize in the arts, such as Volunteer Lawyers for the Arts and other nonprofit organizations. Often these organizations can also refer you to local mediators and arbitrators.
- Join a professional organization: If you are a member of the Graphic Artists Guild, for instance, you can contact your chapter's Contract Point Person. That volunteer has a wealth of local references, such as Guild-sanctioned lawyers, and can suggest useful negotiating tactics.

Just the Beginning

Although this chapter by no means prepares you to take the bar, you should now feel more confident in reading, negotiating, and even drafting simple contracts for your business. By making these business practices an important part of your studio policy, you'll be protecting your business and minimizing disputes. And you will project a professionalism that clients appreciate.

A variety of contracts and business forms follow a glossary of important legal terms. If you have access to the Internet, you can also download these forms from the Graphic Artists Guild Web site (www.gag.org/contracts/contracts.html).

Glossary

all-media rights: The media that convey your art or design can take many forms. In print media the final work is printed on a press in the form of a book or magazine. In electronic media the work goes out in digital form, such as a CD or multimedia presentation. Television, radio, and Internet are examples of other media. Each one of these areas is valuable and worth compensation to the graphic artist. Contracts that ask for all-media rights are, in essence, asking you to allow the buyer to distribute your work in all media (often they include the clause "now known or invented in the future").

all-rights contract: More and more publishers are doing away with contracts that allow the graphic artist who created the work to have any connection with it after he or she accepts an initial payment for it. Artists are being required to give up "all rights," meaning they give up any and all interest in, and control over, any future use of the image and are specifically prohibited from reselling the artwork. In some cases, the artist even agrees to give up the boards or computer files with which the image was created!

While "all-rights" can mean different things to different publishers, under a typical all-rights contract, the publisher pays a fee (usually a single payment) and purchases the right to use and reuse the piece, in any medium, any number of times, forever. The publisher is therefore free to sell and make money from the work without any additional compensation to the creator.

All-rights contracts, as bad as they are, are distinct from work-for-hire contracts, which strip away not only the graphic artist's rights but also the graphic artist's authorship. The buyer becomes the author under the law. Under an all-rights contract the artist still retains a statutory termination right. (See **perpetuity** and **termination rights**.) Thus the all-rights contract is always better than the **work-for-hire contract**.

assigning (transferring): Term commonly used for reselling or relicensing signed-over rights to artwork. Assignment clauses usually appear in contracts under a section at the end that reads: "Assignment of rights/delegation of duties." Duties are generally specific to the contracting parties, but assignments can be transferred. For instance, an illustrator cannot delegate his or her duty to create an illustration, because it is a personal duty based upon a personal vision and drawing style. In exchange for doing the drawing, the illustrator has the right to get paid, though the illustrator can assign this right to someone else if he or she wishes. The client has the duty to pay and thereby gains certain rights to the work. If the client wishes to assign its rights in the art to a third party, that may be permissible as long as the contract clearly states that the rights assigned are no greater than those the client would have had. (See also sublicensing rights.) The difficulty arises if the client tries to delegate its duty to pay to another party that has no direct obligation to the illustrator. Sometimes a client that is about to be bought by another specifies that the successor company will hold the rights that it has purchased. However, there is no real reason for the company to specify this since a successor company routinely acquires the original company's assets.

blanket contract: A blanket agreement is a contract kept on file by the publishing firm covering all future (and sometimes past) assignments. For example, Meredith Corporation, publisher of many *Better Homes and Gardens* specialty magazines, requires its contributing graphic artists to sign a blanket contract. These contracts require special vigilance by the graphic artist because, in addition to the current job, their language controls all future jobs, including reprints. A graphic artist should be able to renegotiate a reprint rather than sign away that right for nothing.

cancellation fee: Payment made when the artworksatisfiestheclient'sstated requirements, but the client decides, for reasons outside the artist's control, not to use it. For example, the artwork was intended to accompany an article that has been killed, or unforeseen space limitations don't leave enough room for artwork. The issue of copyright, however, does not go away just because a project has been canceled. The client still obtains all the originally agreed-upon rights to the use of the artwork upon payment of the fee, unless there is a written agreement that the rights revert to the artist if the project is canceled. See also kill fee.

confidentiality: In addition to the standard confidentiality clause found in many contracts, prohibiting disclosure of company secrets and information concerning the job, confidentiality clauses are now being drafted to prevent discussion of the contract terms. This addition makes it harder for graphic artists to publicize unfair client terms within the graphic arts community, though they are free to discuss terms before signing a contract.

A typical confidentiality clause reads: "[Artist/-Licensor] may, during the course of providing his or her services hereunder or in relation to this Agreement, have access to, and acquire knowledge regarding, materials, data, systems, and other information of or with respect to [client] which may not be accessible or known to the general public. Any knowledge acquired by [artist/licensor] from such materials... shall not be used, published or divulged by Licensor to any person, firm...." Here's the new language: "Licensor specifically agrees that the foregoing confidentiality obligation applies to the terms of this Agreement and any information disclosed to [artist/licensor] in any document provided to [artist/licensor] by [the company]."

There are two ways to view this new language: (1) The client feels public disclosure of the terms may give the competition unfair advantage. (2) The contract terms are so unfair that the client would prefer no one other than the graphic artist have knowledge of them for the sake of its public relations. Therefore, the graphic artist should read each contract carefully, discuss the terms within the community (and with a lawyer, if necessary), and sign a contract only when he or she feels clear about the terms of the job and its fairness to his or her business.

electronic rights: Many publishers are attempting to gain electronic publication rights, in addition to other rights, and graphic artists should make every effort to retain them. Publishers' demands to repurpose work in online and digital media without additional compensation is a growing problem for all creators, and graphic artists should consider this carefully, especially when negotiating fees.

exclusive use: No one except the purchaser may use the image in the same manner (category, media, product, territory, term or duration of use) specified in the contract. According to copyright law, exclusive uses must be transferred in writing.

kill fee: Payment by the client to the graphic artist when the client does not use a commissioned work. Kill fee is a general term that covers two types of payments: cancellation fee and rejection fee. Graphic artists generally negotiate a kill fee as a percentage of the agreed-upon fee for the finished piece: from 20 to 100 percent, depending on the stage of completion of the artwork at the time the project is killed. If the contract does not mention a kill fee, there is no guarantee that one will be paid. **license**: The right to sell or rent artwork or design for a specific use and period of time. It is in the graphic artist's interests to license use of their work, rather than sign **all-rights** or **work-for-hire** contracts. Also see **sublicensing rights**.

moral rights: Personal rights of creators in their original (not reproduced) works, regardless of the sale or transfer of copyrights, specifically: right of identification of authorship; right of approval, restriction, or limitation on use or subsequent modifications. The moral rights provision of the copyright law, the Visual Artists Rights Act, clearly does not apply to reproductions of artwork, but only to alterations of originals, such as gallery works and murals.

no assertion of rights clause: The following clause should be included in every graphic artist's contract: "NO ASSERTION OF RIGHTS: It is expressly understood and agreed that, except for the licenses granted [client] under this Agreement, as between Originator and [client], all right, title, and interest in and to Licensed Digital Files vests solely and exclusively in Originator." This clarifies that the rights licensed to the client are only the ones specified in the contract and that the artist retains all other rights. Think of this clause as the graphic artist's Bill of Rights (it's like the final item in the real Bill of Rights!).

nonexclusive use: The purchaser, along with the graphic artist, is allowed to reuse (and perhaps resell, depending on the specific language) the workinspecified regions and situations. Although nonexclusive clauses often include grants that do not fit anywhere else, they are usually broad gray areas that need to be specified and clarified to avoid future conflicts of interest.

ownership of artwork: Standard industry practice assumes that the graphic artist owns the original work even if rights of reproduction are transferred. Or he or she can sell the original and still keep rights of reproduction. Copyright law clearly states that the copyright is separate and distinct from the material work in which it is embodied. perpetuity: Term, meaning "forever," that is increasingly used in contracts because publishers intend to mount an assault on the termination provision in the 1978 copyright law. (According to the law, the graphic artist retains the statutory right of authorship [if he or she has not signed a work-for-hire contract] and his or her termination right [or "recapture right"] regardless of the terms of the contract. This means that even if a graphic artist signs a contract with a perpetuity clause, he or she or any heirs should be able to terminate it after 35 years. However, the termination provision, since it kicks in after 35 years, cannot be tested until 2013.) To be on the safe side, it is recommended that graphic artists negotiate rights for a limited time period.

rejection fee: Payment made when the artwork does not satisfy the client's stated requirements. For example, the artwork unexpectedly deviates from the artist's traditional style, or the final artwork is not consistent with the preliminary sketches or roughs accepted by the client. When this happens, the causes are, in theory at least, within the artist's control. See also **kill fee**.

return of artwork: It is standard industry practice that when the client uses original artwork during the project, the client is responsible to return the artwork undamaged to the graphic artist.

right to modify (alterations): The purchaser of rights to artwork for inclusion in a collective work holds the copyright only in the collective work, not in the underlying contribution (the art) itself. Since altered artwork is a derivative work of an original, if the artist does not grant the right to create a derivative work, the client has no right to alter the image. Any alterations to artwork (which could be defined as "cropping and sizing") should not be made without consultation with the initial illustrator, and he or she should be allowed the first option to make alterations, whenever possible. If alterations are required after acceptance of artwork, payment is charged in addition to the original amount.

13 Standard Contracts & Business Tools

sublicensing rights: Some companies are asking for the right to "sublicense to third parties any of the rights granted to the publisher." They want to resell the artwork to another, in either exclusive or nonexclusive areas, for profit while giving the graphic artist nothing. However, the graphic artist can demand a percentage of the fee received for sublicensing and still be free to sell the image elsewhere.

Because the issue is complicated, it is recommended that the right to license artwork to a third party not be included in a contract unless the basic elements of the third-party license are spelled out: the third party should be under the same copyright limitations as any other client and the artist should receive the same fees as any other client.

termination rights: These rights involve two things: the termination right provided in the copyright law (discussed under **perpetuity**) and placing a termination right in a contract. For instance, most contracts with agents have a termination clause, which governs the basis on which the parties can dissolve the relationship and defines the period of time after dissolution during which the agent can continue to either rep the artist or receive payment for jobs the agent has gotten the artist.

warranty/indemnification clause: In it a graphic artist guarantees that the work created will not violate the copyright of any party; usually mention of legal fees (covered by the

graphic artist in case of copyright infringement) is included. Such a clause can be beneficial or disastrous, depending upon very subtle differences in phrasing. For instance, a graphic artist can ameliorate the warranty of noninfringement by adding that the work does not infringe "to the best of the artist's knowledge and belief." This means that if the graphic artist doesn't know about a similar work, he or she is not liable for the similarity. If possible, do not sign an indemnity clause that requires the graphic artist to hold the client harmless (pay the attorney's fees and damages) if he or she cannot have input into the defense. Do not sign it if it covers "all actions arising from the artwork" since frivolous suits can lead to bankruptcy. If the clause says "all judgments arising from the artwork," the graphic artist is limited to actual lost cases. It's best to limit indemnity to copyright infringement and avoid inclusion of trade dress.

work-for-hire contract: The phrase "work for hire," or similar expressions such as "done-for-hire" or "for-hire," signifies that the commissioning party is the owner of the copyright of the artwork (as if the commissioning party had, in fact, been the artist). Work-for-hire contracts strip the graphic artist not only of rights but also of authorship; the buyer becomes the author under the law. The Graphic Artists Guild is unalterably opposed to work-for-hire contracts. See also all-rights contract.

Contract Forms

The following pages contain the standard Graphic Artists Guild contract forms. It should be noted that while these forms are as comprehensive as possible, some terms may not be suited to a given assignment; but they can be used as starting points for your own customized contacts. However, legal language is written to be precise, and simplification of contact terms into "plain English" or deletion of contract terms altogether may leave the artist exposed to misinterpretation and misunderstanding of important aspects of an agreement.

All-Purpose Illustrator's Letter of Agreement

This letter of agreement is a model, which should be amended to fit the artist's particular circumstances. Remove all language in italics before using this form.

FRONT

Illustrator's Letterhead

то

Commissioned by

Date

Job/Invoice Number

Shipping Number

Illustrator's Tax ID (Social Security) Number

THIS AGREEMENT MUST BE SIGNED AND RETURNED BEFORE ARTIST CAN SCHEDULE OR BEGIN THIS JOB.

Project title (if any)

Client's purchase order number (if available)

DESCRIPTION

Subject matter Size Color or black & white

Media

Any relevant production information

DUE DATES

Sketch	Final

COPYRIGHT USAGE

Rights transferred

Duration of usage

Limitations on media in which used (print rights only, no electronic usage)

Limitations on number of insertions (if appropriate)

Limitations on geographical use (North American, English editions)

Owner of original art (only if different from Credits below)

Fee for rights granted

1. Reservation of Rights

All rights not expressly granted above are retained by the Artist, including any electronic rights or usage and including, but not limited to, all rights in sketches, comps, or other preliminary materials. Any use additional to that expressly granted above requires arrangement for payment of a separate fee.

2. Revisions

(A) Preliminary Work/Sketches: Artist agrees to submit _________ *linsert studio standard*] rough sketches and/or ________ *linsert studio standard*] finished sketches for Client's approval. Additional fees will be charged to Client for revisions made after such sketches and for all revisions that reflect a new direction for the assignment or new conceptual input. (B) Finished Art: Client agrees to pay Artist an additional fee, to be negotiated separately, for changes requested to final art where Client asked Artist to proceed directly to final art. No additional fee shall be billed for changes required to bring final artwork up to original specifications or assignment description. Client agrees to offer Artist the first opportunity to make any changes to final artwork.

3. Cancellation and Kill Fees

Cancellation ("kill") fees are due based on the amount of work completed. Fifty percent (50%) of the final fee is due within 30 days of notification that for any reason the job is canceled or postponed before the final stage. One hundred percent (100%) of the total fee is due despite cancellation or postponement of the job if the art has been completed. Upon cancellation or kill, all rights to the art revert to the Artist, and all original art must be returned, including sketches, comps, or other preliminary materials.

4. Credits and Copies

A credit line suitable to the design of the page will be used. Client agrees to pay an additional 50% of the total fee, excluding expenses, for failure to include credit line. Credit line is required independent of Artist's signature, which shall be included at Artist's discretion unless otherwise agreed in writing above. Client agrees to provide Artist with *[insert studio standard]* sample copies of any printed material.

5. Payment

Payment for finished work is due upon acceptance, net 30 days. The Client's right to use the work is conditioned upon receipt of payment within 30 days of acceptance and upon Client's compliance with the terms of this agreement. A 11/2% monthly service charge will be billed against late payment.

6. Original Art

Original art remains the property of the Artist unless expressed otherwise in the agreement. Client is responsible for return of original art in undamaged condition within 30 days of first reproduction.

7. Additional Expenses

If Client does not provide a courier/shipping number in the space provided above, shipping charges will be added to the final invoice. Client agrees to reimburse Artist for the following expenses:

Messengers	Models	
Props	Travel	
Telephone	Proofs	
Transport disks	Transparencies	
Film output	Other	

8. Permissions and Releases

The Client agrees to indemnify and hold the Artist harmless against any and all claims, costs, and expenses, including attorney's fees, due to materials included in the Work at the request of the Client for which no copyright permission or privacy release was requested or for which uses exceed the uses allowed pursuant to a permission or release.

9. Miscellany

This Agreement shall be binding upon the parties, their heirs, successors, assigns, and personal representatives. This Agreement constitutes the entire understanding of the parties. Its terms can be modified only by an instrument in writing signed by both parties, except that the Client may authorize expenses or revisions orally. No terms attached to any check for payment under this Agreement can modify the Agreement except under an independent instrument in writing signed by both parties. Any dispute regarding this agreement shall be arbitrated in *[your city and state]* under the rules of the American Arbitration Association and the laws of *[state of arbitration]*. A waiver of a breach of any of the provisions of this Agreement shall not be construed as a continuing waiver of other breaches of the same or other provisions. This Agreement shall be governed by the laws of the State of *[name of your state]* and courts of such State shall have exclusive jurisdiction and venue.

Consented and agreed to

Artist's signature/date

Authorized signature/date

Buyer's name and title

Accounts payable contact name/phone

Remove all language in italics before using this form.

FRONT

Art Buyer's Letterhead

то

Commissioned by

Date

Purchase Order Number

Job Number

ASSIGNMENT DESCRIPTION (Indicate any preliminary presentations required by the buyer.)

Delivery date	
Fee	

BUYER SHALL REIMBURSE ARTIST FOR THE FOLLOWING EXPENSES

Messengers	Models	Props
Travel	Telephone	Proofs
Transport disks	Transparencies	Film output
Other		
RIGHTS TRANSFERRED. BUYER PURCHASES THE FOLLOWING EXCLUSIVE RIGHTS FOR USAGE:		
Title or Product (name)		

Category or Use (advertising, corporate, promotional, editorial, etc.)

Medium of Use (consumer or trade magazine, annual report, TV, book, etc.)

Edition (if book) (hardcover, mass-market paperback, quality paperback, etc.)

Geographic Area (if applicable)

Time Period (if applicable)

Artist reserves any usage rights not expressly transferred. Any usage beyond that granted to buyer herein shall require the payment of a mutually agreed-upon additional fee. Any transfer of rights is conditional upon receipt of full payment.

1. Time for Payment

All invoices shall be paid within 30 days of receipt. The grant of any license or right of copyright is conditioned on receipt of full payment.

2. Default in Payment

The Buyer shall assume responsibility for all collection of legal fees necessitated by default in payment.

3. Changes

Buyer shall make additional payments for changes requested in original assignment. However, no additional payment shall be made for changes required to conform to the original assignment description. The Buyer shall offer the Artist first opportunity to make any changes.

4. Expenses

Buyer shall reimburse Artist for all expenses arising from this assignment, including the payment of any sales taxes due on this assignment. Buyer's approval shall be obtained for any increases in fees or expenses that exceed the original estimate by 10% or more.

5. Cancellation

In the event of cancellation of this assignment, ownership of all copyrights and the original artwork shall be retained by the Artist, and a cancellation fee for work completed, based on the contract price and expenses already incurred, shall be paid by the Buyer.

6. Ownership of Artwork

The Artist retains ownership of all original artwork, whether preliminary or final, and the Buyer shall return such artwork within 30 days of use.

7. Credit Lines

The Buyer shall give Artist and any other creators a credit line with any editorial usage. If similar credit lines are to be given with other types of usage, it must be so indicated here:

[] If this box is checked, the credit line shall be in the form: © 200_____.

8. Releases

Buyer shall indemnify Artist against all claims and expenses, including reasonable attorney's fees, due to uses for which no release was requested in writing or for uses which exceed authority granted by a release.

9. Modifications

Modification of the Agreement must be written, except that the invoice may include, and Buyer shall pay, fees or expenses that were orally authorized in order to progress promptly with the work.

10. Warranty of Originality

The Artist warrants and represents that, to the best of his/her knowledge, the work assigned hereunder is original and has not been previously published, or that consent to use has been obtained on an unlimited basis; that all work or portions thereof obtained through the undersigned from third parties is original or, if previously published, that consent to use has been obtained on an unlimited basis; that the Artist has full authority to make this agreement; and that the work prepared by the Artist does not contain any scandalous. libelous, or unlawful matter. This warranty does not extend to any uses that the Buyer or others may make of the Artist's product that may infringe on the rights of others. Buyer expressly agrees that it will hold the Artist harmless for all liability caused by the Buyer's use of the Artist's product to the extent such use infringes on the rights of others.

11. Limitation of Liability

Buyer agrees that it shall not hold the Artist or his/her agents or employees liable for any incidental or consequential damages that arise from the Artist's failure to perform any aspect of the Project in a timely manner, regardless of whether such failure was caused by intentional or negligent acts or omissions of the Artist or third party.

12. Dispute Resolution

Any disputes in excess of \$______ (maximum limit for small-claims court) arising out of this Agreement shall be submitted to binding arbitration by a mutually agreed-upon arbitrator pursuant to the rules of the American Arbitration Association. The Arbitrator's award shall be final, and judgment may be entered in any court having jurisdiction thereof. The Buyer shall pay all arbitration and court costs, reasonable attorney's fees, and legal interest on any award of judgment in favor of the Artist.

13. Acceptance of Terms

The signature of both parties shall evidence acceptance of these terms.

Consented and agreed to

Artist's signature/date

Authorized signature/date

Buyer's name and title

Artist-Agent Agreement

Remove all language in italics before using this form.

FRONT

Artist's Letterhead

Agreement, this day of

, 200 , between

(hereinafter referred to as the "Artist"), residing at

and

(hereinafter referred to as the "Agent"), residing at

Whereas, the Artist is an established artist of proven talents; and

Whereas, the Artist wishes to have an agent represent him or her in marketing certain rights enumerated herein; and

Whereas, the Agent is capable of marketing the artwork produced by the Artist; and

Whereas, the Agent wishes to represent the Artist;

Now, therefore, in consideration of the foregoing premises and the mutual covenants hereinafter set forth and other valuable consideration, the parties hereto agree as follows:

1. Agency

The Artist appoints the Agent to act as his or her [non-] exclusive representative: (A) in the following geographical area:

(B) for the markets listed here (specify publishing, advertising, etc.):

.

The Agent agrees to use his or her best efforts in submitting the Artist's work for the purpose of securing assignment for the Artist. The Agent shall negotiate the terms of any assignment that is offered, but the Artist shall have the right to reject any assignment if he or she finds the terms thereof unacceptable.

2. Promotion

The Artist shall provide the Agent with such samples of work as are from time to time necessary for the purpose of securing assignments. These samples shall remain the property of the Artist and be returned within 30 days of termination of this Agreement. The Agent shall take reasonable efforts to protect the work from loss or damage, but shall be liable for such loss or damage only if caused by the Agent's negligence. Promotional expenses, including but not limited to promotional mailings and paid advertising, shall be paid _____% by the Agent and ____% by the Artist. The Agent shall bear the expenses of shipping, insurance, and similar marketing expenses.

3. Term

This Agreement shall take effect on the _____ day of _____, 200____, and remain in full force and effect for a term of one year, unless terminated as provided in Paragraph 9.

4. Commissions

The Agent shall be entitled to the following commissions: (A) On assignments secured by the Agent during the term of this Agreement, 25% of the billing. (B) On house accounts, 10% of the billing. For purposes of this Agreement, house accounts are defined as accounts obtained by the Artist at any time or obtained by another agent representing the Artist prior to the commencement of this Agreement and are listed in Schedule A attached to this Agreement. It is understood by both parties that no commission shall be paid on assignments rejected by the Artist or for which the Artist fails to receive payment, regardless of the reason payment is not made. Further, no commissions shall be payable in either (A) or (B) above for any part of the billing that is due to expenses incurred by the Artists in performing the assignment, whether or not such expenses are reimbursed by the Client. In the event that a flat fee is paid by the Client, it shall be reduced by the amount of expenses incurred by the Artist in performing the assignment, and the Agent's commission shall be payable only on the fee as reduced for expenses.

5. Billing

The [] Artist [] Agent shall be responsible for all billings.

6. Payments

The party responsible for billing (the "Billing Party") agrees to hold all funds due to the other party as trust funds in an account separate from the Billing Party's funds prior to making payment to the other party. The Billing Party shall make all payments due within 10 days of receipt of any fees covered by this Agreement. Late payments shall be accompanied by interest calculated at the rate of % per month thereafter.

7. Accountings

The Billing Party shall send copies of invoices to the other party when rendered. If requested, that party shall also provide the other party with semiannual accountings showing all assignments for the period, the Clients' names, the fees paid, expenses incurred by the Artist, the dates of payment, the amounts on which the Agent's commissions are to be calculated, and the sums due less those amounts already paid.

8. Inspection of the Books and Records

The Billing Party responsible shall keep the books and records with respect to commissions due at his or her place of business and permit the other party to inspect these books and records during normal business hours on the giving of reasonable notice.

9. Termination

This Agreement may be terminated by either party by giving 30 days written notice to the other party. If the Artist receives assignments after the termination date from Clients originally obtained by the Agent during the term of this Agreement, the commission specified in Paragraph 4(A) shall be payable to the Agent under the following circumstances. If the Agent has represented the Artist for 6 months or less, the Agent shall receive a commission on such assignments received by the Artist within 90 days of the date of termination. This period shall increase by 30 days for each additional 6 months that the Agent has represented the Artist, but in no event shall such period exceed 180 days.

10. Assignment

This Agreement shall not be assigned by either of the parties hereto. It shall be binding on and inure to the benefit of the successors, administrators, executors, or heirs of the Agent and Artist.

11. Arbitration

Any disputes in excess of \$_____ (maximum limit for small-claims court) arising out of this Agreement shall be submitted to binding arbitration before a mutually agreed-upon arbitrator pursuant to the rules of the American Arbitration Association. The Arbitrator's award shall be final and judgment may be entered in

any court having jurisdiction thereof. The Agent shall pay all arbitration and court costs, reasonable attorney's fees, and legal interest on any award of judgment in favor of the Artist.

12. Notices

All notices shall be given to the parties at their respective addresses set forth above.

13. Independent Contractor Status

Both parties agree that the Agent is acting as an independent contractor. This Agreement is not an employment agreement, nor does it constitute a joint venture or partnership between the Artist and Agent.

14. Amendments and Merger

All amendments to this Agreement must be written. This Agreement incorporates the entire understanding of the parties.

15. Governing Law

This Agreement shall be governed by the laws of the State of _____.

In witness whereof, the parties have signed this Agreement as of the date set forth above.

SCHEDULE A: HOUSE ACCOUNTS

Date	
1. name and address of Client	
2.	
_3.	
_4	
5.	
_6	
7.	
8.	
9.	
10.	
11.	
12.	
Artist	Agent

Artwork Inventory Form

Remove all language in italics before using this form.

Artist's Letterhead

ID#
Final or Rough
Name of Publication
Date Sent
Date Accepted
Date Final Due (if applicable)
Fee Negotiated
Date Rejected
Date Artwork Returned

Computer-Generated Art Job Order Form

Remove all language in italics before using this form.

-		0	N I	-
r	ĸ	О	IN	

Illustrator's Letterhead

то	Date
	Commissioned by
	Purchase Order Number
	Job Number
	For Use in Issue Date
DEFINITION/TYPE OF ASSIGNMENT/NATU	RE OF MARKET
Additional Uses (promotional, packaging, etc.)	
Number of Screens or Images Still Frame (s	single frame, multiple frame)
Sector Length Per Screen Maxim	num Preferred Minimum
Copy to Read (The Artist is not responsible for any co	opy other than what appears below; be sure copy is spelled and titled correctly
Disk(s) may be used only for the purposes st Disk(s) may not be copied without the Artist's p	tated below. All other use(s) and modification(s) is (are) prohibited permission and must be returned after use.
Disk(s) may not be copied without the Artist's p	tated below. All other use(s) and modification(s) is (are) prohibited permission and must be returned after use.
RIGHTS TRANSFERRED	permission and must be returned after use.
RIGHTS TRANSFERRED Any transfer of rights is conditional upon recei	permission and must be returned after use.
RIGHTS TRANSFERRED Any transfer of rights is conditional upon recei Type of Use (game program, advertising, etc.)	permission and must be returned after use. pt of full payment.
Disk(s) may not be copied without the Artist's p RIGHTS TRANSFERRED Any transfer of rights is conditional upon recei Type of Use (game program, advertising, etc.) Medium of Use (floppy, documentation, package	permission and must be returned after use. pt of full payment.
Disk(s) may not be copied without the Artist's p RIGHTS TRANSFERRED Any transfer of rights is conditional upon recei Type of Use (game program, advertising, etc.) Medium of Use (floppy, documentation, packag Distribution/Geographical Area (method of dis	permission and must be returned after use. pt of full payment. ging, promotion, etc.) stribution, electronically downloaded, floppy disk, store distribution)
Disk(s) may not be copied without the Artist's p RIGHTS TRANSFERRED Any transfer of rights is conditional upon recein Type of Use (game program, advertising, etc.) Medium of Use (floppy, documentation, package Distribution/Geographical Area (method of dis Time/Number of Printings (one-time use, etc.)	permission and must be returned after use. pt of full payment. ging, promotion, etc.) stribution, electronically downloaded, floppy disk, store distribution)
Disk(s) may not be copied without the Artist's p RIGHTS TRANSFERRED Any transfer of rights is conditional upon recei Type of Use (game program, advertising, etc.) Medium of Use (floppy, documentation, packag Distribution/Geographical Area (method of dis Time/Number of Printings (one-time use, etc.) System Applications (for use on specific mach	permission and must be returned after use. pt of full payment. ging, promotion, etc.) stribution, electronically downloaded, floppy disk, store distribution)
Disk(s) may not be copied without the Artist's p RIGHTS TRANSFERRED Any transfer of rights is conditional upon recein Type of Use (game program, advertising, etc.) Medium of Use (floppy, documentation, package Distribution/Geographical Area (method of dis Distribution/Geographical Area (method of dis Time/Number of Printings (one-time use, etc.) System Applications (for use on specific macher PRODUCTION SCHEDULE	permission and must be returned after use. pt of full payment. ging, promotion, etc.) stribution, electronically downloaded, floppy disk, store distribution) stribution, electronically downloaded, floppy disk, store distribution)
Disk(s) may not be copied without the Artist's p RIGHTS TRANSFERRED Any transfer of rights is conditional upon recein Type of Use (game program, advertising, etc.) Medium of Use (floppy, documentation, package Distribution/Geographical Area (method of dis Distribution/Geographical Area (method of dis Time/Number of Printings (one-time use, etc.) System Applications (for use on specific mach PRODUCTION SCHEDULE Eirst Showing	permission and must be returned after use. pt of full payment. ging, promotion, etc.) stribution, electronically downloaded, floppy disk, store distribution) stribution, electronically downloaded, floppy disk, store distribution)
Disk(s) may not be copied without the Artist's p RIGHTS TRANSFERRED Any transfer of rights is conditional upon recein Type of Use (game program, advertising, etc.) Medium of Use (floppy, documentation, package Distribution/Geographical Area (method of dis 	permission and must be returned after use. pt of full payment. ging. promotion, etc.) stribution, electronically downloaded, floppy disk, store distribution) stribution, electronically downloaded, floppy disk, store distribution) stribution, electronically downloaded, floppy disk, store distribution)
Disk(s) may not be copied without the Artist's p RIGHTS TRANSFERRED Any transfer of rights is conditional upon recein Type of Use (game program, advertising, etc.) Medium of Use (floppy, documentation, package Distribution/Geographical Area (method of dis Time/Number of Printings (one-time use, etc.)	permission and must be returned after use. pt of full payment. ging, promotion, etc.) stribution, electronically downloaded, floppy disk, store distribution) stribution, electronically downloaded, floppy disk, store distribution) stribution, electronically downloaded, floppy disk, store distribution)

1. Time for Payment

All invoices are payable within 30 days of receipt. A 11/2% monthly service charge is payable on all overdue balances. The grant of any license or right of copyright is conditioned on receipt of full payment.

2. Default in Payment

The Client shall assume responsibility for all collection of legal fees necessitated by default in payment.

3. Estimates

If this form is used for an estimate or assignment confirmation, the fees and expenses shown are minimum estimates only. Final fees and expenses shall be shown when invoice is rendered. The Client's approval shall be obtained for any increases in fees or expenses that exceed the original estimate by 10% or more.

4. Expenses

The Client shall reimburse the Artist for all expenses arising from this assignment, including the payment of any sales taxes due on this assignment and shall advance \$______ to the Artist for payment of said expenses.

5. Artist's Guarantee for Program Use

The Artist guarantees to notify the Client of any licensing and/or permissions required for art generating/driving programs to be used.

6. Changes

The Client shall be responsible for making additional payments for changes requested by the Client in original assignment. However, no additional payment shall be made for changes required to conform to the original assignment description. The Client shall offer the Artist the first opportunity to make any changes.

7. Cancellation

In the event of cancellation of this assignment, ownership of all copyrights and the original artwork shall be retained by the Artist, and a cancellation fee for work completed, based on the contract price and expenses already incurred, shall be paid by the Client.

8. Ownership and Return of Artwork

The Artist retains ownership of all original artwork, whether preliminary or final. The Client waives the right to challenge the validity of the Artist's ownership of the art subject to this agreement because of any change or evolution of the law and will return all artwork within 30 days of use.

9. Copy-Protection

The Client must copy-protect all final art that is the subject of this agreement against duplication or alteration.

10. Credit Lines

The Artist shall be given credit in (**a**) floppy disk, (**b**) documentation, (**c**) packaging, (d) Artist's mark on art.

[] If this box is checked, the Artist shall receive copyright notice in this form: © 200____.

11. Alterations

Any electronic alteration of original art (color shift, mirroring, flopping, combination cut and paste, deletion) creating additional art is prohibited without the express permission of the artist. The artist will be given first opportunity to make any alterations required. Unauthorized alterations shall constitute additional use and will be billed accordingly.

12. Other Operating Systems Conversions

The Artist shall be given first option at compiling the work for operating systems beyond the original use.

13. Unauthorized Use and Program Licenses

The Client will indemnify the Artist against all claims and expenses arising from uses for which the Client does not have rights to or authority to use. The Client will be responsible for payment of any special licensing or royalty fees resulting from the use of graphics programs that require such payments.

14. Warranty of Originality

The Artist warrants and represents that, to the best of his/her knowledge, the work assigned hereunder is original and has not been previously published, or that consent to use has been obtained on an unlimited basis; that all work or portions thereof obtained through the undersigned from third parties is original or, if previously published, that consent to use has been obtained on an unlimited basis; that the Artist has full authority to make this agreement; and that the work prepared by the Artist does not contain any scandalous, libelous, or unlawful matter. This warranty does not extend to any uses that the Client or others may make of the Artist's product that may infringe on the rights of others. Client expressly agrees that it will hold the Artist harmless for all liability caused by the Client's use of the Artist's product to the extent such use infringes on the rights of others.

15. Limitation of Liability

Client agrees that it shall not hold the Artist or his/ her agents or employees liable for any incidental or consequential damages that arise from the Artist's failure to perform any aspect of the Project in a timely manner, regardless of whether such failure was caused by intentional or negligent acts or omissions of the Artist or a third party.

16. Dispute Resolution

Any disputes in excess of \$______ (maximum limit for small-claims court) arising out of this Agreement shall be submitted to binding arbitration before a mutually agreed-upon arbitrator pursuant to the rules of the American Arbitration Association. The Arbitrator's award shall be final, and judgment may be entered in any court having jurisdiction thereof. The Client shall pay all arbitration and court costs, reasonable attorney's fees, and legal interest on any award of judgment in favor of the Artist.

17. Acceptance of Terms

The signature of both parties shall evidence acceptance of these terms.

Consented and agreed to

Artist's signature/date

Authorized signature/date

Client's name and title

Computer-Generated Art Invoice

This invoice form is a sample of a possible contract for computer-generated art. Artists should view this as a model and amend it to fit their situations and the needs of their Client, based on a negotiated agreement. Remove all language in italics before using this form.

FRONT		
Illustrator's Letterhead	1	

то

Date

Authorized Buyer

<u>Client's Job Number</u> For Use in Issue

Artist's Job Number

Date

Minimum

DEFINITION/TYPE OF ASSIGNMENT/NATURE OF MARKET

Additional Uses (promotional, packaging, etc.)

Number of Screens or Images Still Frame (single frame, multiple frame)

Sector Length Per Screen Maximum Preferred

Copy to Read (The Artist is not responsible for any copy other than what appears below; be sure copy is spelled and titled correctly.)

Disk(s) may be used only for the purposes stated below. All other use(s) and modification(s) is (are) prohibited. Disk(s) may not be copied without the Artist's permission and must be returned after use.

RIGHTS TRANSFERRED

Any transfer of rights is conditional upon receipt of full payment.

Type of Use (game program, advertising, etc.)

Medium of Use (floppy, documentation, packaging, promotion, etc.)

Distribution/Geographical Area (method of distribution, electronically downloaded, floppy disk, store distribution)

Time/Number of Printings (one-time use, etc.)

System Applications (for use on specific machine, or compiled into other operation languages)

ITEMIZED EXPENSES (other billable items)

Client's Alterations

Sale of Original Art

Miscellaneous

Subtotal

Sales Tax

Payments on Account

Balance Due

Original artwork, including sketches and any other preliminary materials, remains the property of the Artist unless purchased by payment of a separate fee subject to terms appearing herein.

continued...

1. Time for Payment

All invoices are payable within 30 days of receipt. A 11/2% monthly service charge is payable on all overdue balances. The grant of any license or right of copyright is conditioned on receipt of full payment.

2. Default in Payment

The Client shall assume responsibility for all collection of legal fees necessitated by default in payment.

3. Expenses

The Client shall reimburse the Artist for all expenses arising from this assignment, including the payment of any sales taxes due on this assignment.

4. Artist's Guarantee for Program Use

The Artist guarantees to notify the Client of any licensing and/or permissions required for art generating/driving programs to be used.

5. Ownership and Return of Artwork

The Artist retains ownership of all original artwork, whether preliminary or final. The Client waives the right to challenge the validity of the Artist's ownership of the art subject to this agreement because of any change or evolution of the law, and will return all artwork within 30 days of use.

6. Copy-Protection

The Client must copy-protect all final art that is the subject of this agreement against duplication or alteration.

7. Credit Lines

The Artist shall be given credit in: (a) floppy disk, (b) documentation, (c) packaging, (d) Artist's mark on art.

[] If this box is checked, the Artist shall receive copyright notice in this form: © 200______.

8. Other Operating Systems Conversions

The Artist shall be given first option at compiling the work for operating systems beyond the original use.

9. Alterations

Any electronic alteration of original art (color shift, mirroring, flopping, combination cut and paste, deletion) creating additional art is prohibited without the express permission of the Artist. The Artist will be given first opportunity to make any alterations required. Unauthorized alterations shall constitute additional use and will be billed accordingly.

10. Unauthorized Use and Program Licenses

The Client will indemnify the Artist against all claims and expenses arising from uses for which the Client does not have rights to or authority to use. The Client will be responsible for payment of any special licensing or royalty fees resulting from the use of graphics programs that require such payments.

11. Arbitration

Any disputes in excess of \$______ (maximum limit for small-claims court) arising out of this Agreement shall be submitted to binding arbitration before a mutually agreed-upon arbitrator pursuant to the rules of the American Arbitration Association. The Arbitrator's award shall be final, and judgment may be entered in any court having jurisdiction thereof. The Client shall pay all arbitration and court costs, reasonable attorney's fees, and legal interest on any award of judgment in favor of the Artist.

12. Acceptance of Terms

The signature of both parties shall evidence acceptance of these terms.

Consented and agreed to

Artist's signature/date

Authorized signature/date

Buyers's name and title

Remove all language in italics before using this form ..

F	R	0	N	Т

Designer's Letterhead

то

Date

Commissioned by

Purchase Order Number

Job Number

DESCRIPTION OF ASSIGNMENT

Primary Use

Additional Uses

Number of Screens or Images Still Frame (single frame, multiple frame)

Sector Length Per Screen

Minimum

Description of Materials to Be Supplied by Client

Date Due

Disk(s) may be used only for the purposes stated below. All other use(s) and modification(s) is (are) prohibited. Disk(s) may not be copied without the Developer's permission and must be returned after use.

Maximum Preferred

RIGHTS TRANSFERRED

Any transfer of rights is conditional upon receipt of full payment.

Distribution/Geographical Area

System Applications (for use on specific machine, or compiled into other operation languages)

PRODUCTION SCHEDULE (Including milestones, dates due, and appropriate fees.)

Milestone	Due Date	Payment upon Acceptance
Contract Signing		\$
Delivery of Web Site Design		\$
Delivery of Beta Version		\$
Delivery of Final Version (includes return of source materials to Client)		\$
Acceptance of Final Version		\$
Total		\$
	r a bonus of payable to th red to the Client prior to (c	ne Developer in the event an acceptable date).

continued...

1. Time for Payment

Each milestone is payable upon the Client's acceptance of the Deliverables. All invoices are payable within 30 days of receipt. A 11/2% monthly service charge is payable on all overdue balances. The grant of any license or right of copyright is conditioned on receipt of full payment.

2. Default in Payment

The Client shall assume responsibility for all collection of legal fees necessitated by default in payment.

3. Estimates

If this form is used for an estimate or assignment confirmation, the fees and expenses shown are minimum estimates only. Final fees and expenses shall be shown when invoice is rendered. The Client's approval shall be obtained for any increases in fees or expenses shall be shown when invoice is rendered. The Client's approval shall be obtained for any increases in fees or expenses that exceed the original estimate by 10% or more.

4. Expenses

The Client shall reimburse the developer for all expenses arising from this assignment, including payment on any sales taxes due on this assignment and shall advance to the Developer for payment of said expenses.

5. Internet Access

Access to Internet will be provided by a separate Internet Service Provider (ISP) to be contracted by the Client and who will not be party to this agreement.

6. Progress Reports

The Developer shall contact or meet with the Client on a mutually acceptable schedule to report all tasks completed, problems encountered, and recommended changes relating to the Development and testing of the Web site. The Developer shall inform the Client promptly by telephone upon discovery of any event or problem that may significantly delay the development of the work.

7. Developer's Guarantee for Program Use

The Developer guarantees to notify the Client of any licensing and/or permissions required for art generating/driving programs to be used.

8. Changes

The Client shall be responsible for making additional payments for changes requested by the Client in original assignment. However, no additional payment shall be made for changes required to conform to the original assignment description. The Client shall offer the Developer the first opportunity to make any changes.

9. Testing and Acceptance Procedures

The Developer will make every good-faith effort to thoroughly test all deliverables and make all necessary corrections as a result of such testing prior to handing over the deliverables to the Client. Upon receipt of the deliverables, the Client shall either accept the deliverable and make the milestone payment set forth or provide the Developer with written notice of any corrections to be made and a suggested date for completion, which should be mutually acceptable to both the Developer and the Client. The developer shall designate _______ (name) and the Client shall designate _______ (name) as the only designated persons who will send and accept all

deliverables, and receive and make all communications between the Developer and the Client. Neither party shall have any obligation to consider for approval or respond to materials submitted other than through the designated person listed above. Each party has the right to change its designated person upon _____ day(s) notice to the other.

10. Web Site Maintenance

The Developer agrees to provide the Client with reasonable technical support and assistance to maintain and update the Web site on the Internet during the Warranty Period of (dates) at no cost to the Client. Such assistance shall not exceed hours per calendar month. After the expiration of the Warranty Period, the developer agrees to provide the Client with reasonable technical support and assistance to maintain and update the Web site on the Internet for an annual fee for a period of years after the last of \$ day of the Warranty Period, payable 30 days prior to the commencement date of each year of the Maintenance Period. Such maintenance shall include correcting any errors or any failure of the Web site to conform to the specifications. Maintenance shall not include the development of enhancements to the originally contracted project.

11. Enhancements

Under the maintenance agreement, if the Client wishes to modify the Web site, the Developer shall be given first option to provide a bid to perform such enhancements.

12. Confidential Information

The Developer acknowledges and agrees that the source materials and technical and marketing plans or other sensitive business information, including all materials containing said information, that are supplied by the Client to the Developer or developed by the Developer in the course of developing the Web site are to be considered confidential information. Information shall not be considered confidential if it is already publicly known through no act of the Developer.

13. Return of Source Information

Upon the Client's acceptance of the Final Version, or upon the cancellation of the project, the Developer shall provide the Client with all copies and originals of the source materials provided by the Developer.

14. Cancellation

In the event of cancellation of this assignment, ownership of all copyrights and any original artwork shall be retained by the Developer, and a cancellation fee for work completed, based on the pro-rated portion of the next payment and expenses already incurred, shall be paid by the Client.

15. Ownership of Copyright

Client acknowledges and agrees that the Developer retains all rights of copyright in the subject material.

16. Ownership and Return of Artwork

The Developer retains ownership of all original artwork, in any media, including digital files, whether preliminary or final. The Client waives the right to challenge the validity of the Developer's ownership of the art subject to this agreement because of any change or evolution of the law and will return all artwork within 30 days of use.

17. Ownership of Engine

The Developer retains ownership of all engines that are created by Developer for used in the production of the product unless those engines are provided by the Client.

18. Copy-Protection

The Client must copy-protect all final art that is the subject of this agreement against duplication or alteration.

19. Credit Lines

The Developer shall be given credit in (a) floppy disk, (b) documentation (c) packaging (d) Developer's mark on art.

[] If this box is checked, the Developer shall receive copyright notice in this form: © 200_____.

20. Alterations

Any electronic alteration of original art (color shift, mirroring, flopping, combination cut and paste, deletion) creating additional art is prohibited without the express permission of the Developer. The Developer will be given first opportunity to make any alterations required. Unauthorized alterations shall constitute additional use and will be billed accordingly.

21. Other Operating Systems Conversion

The Developer shall be given first option at compiling the work for operating systems beyond the original use.

22. Unauthorized Use and Program Licenses

The Client will indemnify the Developer against all claims and expenses arising from uses for which the Client does not have rights to or authority to use. The Client will be responsible for payment of any special licensing or royalty fees resulting from the use of graphic programs that require such payments.

23. Warranty of Originality

The Developer warrants and represents that, to the best of his/her knowledge, the work assigned hereunder is original and has not been previously published or that consent to use has been obtained on an unlimited basis; that all work or portions thereof obtained through the undersigned from third parties is original or, if previously published, that consent to use has been obtained on an unlimited basis; that the Developer has full authority to make this agreement; and that the work prepared by the Developer does not contain any scandalous, libelous, or unlawful matter. This warranty does not extend to any uses that the Client or others may make of the Developer's product that may infringe on the rights of others. Client expressly agrees that it will hold the Developer harmless for all liability caused by the Client's use of the Developer's product to the extent such use infringes on the rights of others.

24. Limitation of Liability

Client agrees that it shall not hold the Developer or his/her agents or employees liable for any incidental or consequential damages that arise from the Developer's failure to perform any aspect of the project in a timely manner, regardless of whether such failure was caused by intentional or negligent acts or omissions of the Developer or a third party. Furthermore, the Developer disclaims all implied warranties, including the warranty of merchantability and fitness for a particular use.

25. Dispute Resolution

Any disputes in excess of \$______ (maximum limit for small-claims court) arising out of this Agreement shall be submitted to binding arbitration before a mutually agreed-upon arbitrator pursuant to the rules of the American Arbitration Association. The Arbitrator's award shall be final, and judgment may be entered in any court having jurisdiction thereof. The Client shall pay all arbitration and court costs, reasonable attorney's fees, and legal interest on any award of judgment in favor of the Developer.

26. Acceptance of Terms

The signature of both parties shall evidence acceptance of these terms.

Consented and agreed to

Developer's signature/date

Authorized signature/date

Client's name and title

Graphic Designer's Estimate & Confirmation Form

Remove all language in italics before using this form.

Commissioned by Assignment Number Client's Purchase Order Number Assignment Number Delivery Date (predicated on receipt of all materials to be supplied by Client) Materials Supplied by Assignment Number Fee FEE PAYMENT SCHEDULE ESTIMATED EXPENSES Client's hall reimburse the Designer for all expenses. Expense amounts are estimates only. Illustration Printing. (If brokered by Designer) Photography Client's Alterations Models & Props Toll Telephone Calls Materials & Supplies Transportation & Travel Messengers Shipping & Insurance Copies Other Expenses Subtotal Sales Tax Total Total Fite or Product (name) Category of Use (advertising, corporate, promotional, editorial, etc.) Medium of Use (consumer or trade magazine, annual report, TV, book, etc.) Edition (if book) (hardcover, mass-market paperback, quality paperback, etc.)		FRONT	
Commissioned by Assignment Number Client's Purchase Order Number Assignment DescRiPTION Delivery Date (predicated on receipt of all materials to be supplied by Client) Materials Supplied by Assignment Number Fee Fee Fee Fee Fee Fee Fee Fee Fee F	Designer's Letterhead		
Commissioned by Assignment Number Client's Purchase Order Number Assignment DescRiPTION Delivery Date (predicated on receipt of all materials to be supplied by Client) Materials Supplied by Assignment Number Fee Fee Fee Fee Fee Fee Fee Fee Fee F			
Commissioned by Assignment Number Client's Purchase Order Number Assignment DescRiPTION Delivery Date (predicated on receipt of all materials to be supplied by Client) Materials Supplied by Assignment Number Fee Fee Fee Fee Fee Fee Fee Fee Fee F		Dete	
Assignment Number Client's Purchase Order Number ASSIGNMENT DESCRIPTION Delivery Date (predicated on receipt of all materials to be supplied by Client) Materials Supplied by Assignment Number Fee FEE PAYMENT SCHEDULE FEE PAYMENT SCHEDULE ESTIMATED EXPENSES Client shall reimburse the Designer for all expenses. Expense amounts are estimates only. Illustration Printing (<i>lf brokered by Designer</i>) Photography Client's Alterations Models & Props Toll Telephone Calls Materials & Supplies Transportation & Travel Messengers Copies Subtotal Sales Tax Total RIGHTS TRANSFERED The Designer transfers to the Client the following exclusive rights of usage: Title or Product (name) Category of Use (advertising, corporate, promotional, editorial, etc.) Medium of Use (consumer or trade magazine, annual report, TV book, etc.) Edition (if book) (hardcover, mass-market paperback, quality paperback, etc.)	то		
Client's Purchase Order Number ASSIGNMENT DESCRIPTION Delivery Date (predicated on receipt of all materials to be supplied by Client) Materials Supplied by Assignment Number Fee Fee FEE PAYMENT SCHEDULE FEE PAYMENT SCHEDULE ESTIMATED EXPENSES Client shall reimburse the Designer for all expenses. Expense amounts are estimates only. Illustration Printing (ff brokered by Designer) Photography Client's Alterations Models & Props Toll Telephone Calls Materials & Supplies Transportation & Travel Messengers Shipping & Insurance Copies Other Expenses Subtotal Sales Tax Total Sales Tax Total Category of Use (advertising, corporate, promotional, editorial, etc.) Medium of Use (consumer or trade magazine, annual report, TV book, etc.) Edition (if book) (hardcover, mass-market paperback, quality paperback, etc.)			
ASSIGNMENT DESCRIPTION Delivery Date (predicated on receipt of all materials to be supplied by Client) Materials Supplied by Assignment Number Fee FEE PAYMENT SCHEDULE FEE PAYMENT SCHEDULE FEE PAYM			
Delivery Date (predicated on receipt of all materials to be supplied by Client) Materials Supplied by Assignment Number Fee FEE PAYMENT SCHEDULE ESTIMATED EXPENSES Client shall reimburse the Designer for all expenses. Expense amounts are estimates only. Illustration Printing (if brokered by Designer) Photography Client's Alterations Models & Props Toll Telephone Calls Materials & Supplies Transportation & Travel Messengers Shipping & Insurance Copies Other Expenses Subtotal Sales Tax Total Total RIGHTS TRANSFERRED The Designer transfers to the Client the following exclusive rights of usage: Title or Product (name) Category of Use (edvertising, corporate, promotional, editorial, etc.) Medium of Use (consumer or trade magazine, annual report, TV, book, etc.) Edition (if book) (hardcover, mass-market paperback, etc.)		Client's Purchase Order Number	
Materials Supplied by Assignment Number Fee FEE PAYMENT SCHEDULE ESTIMATED EXPENSES Client shall reimburse the Designer for all expenses. Expense amounts are estimates only. Illustration Printing (if brokered by Designer) Photography Client's Alterations Models & Props Toll Telephone Calls Materials & Supplies Transportation & Travel Messengers Shipping & Insurance Copies Other Expenses Subtotal Sales Tax Total Sales Tax Total Category of Use (advertising, corporate, promotional, editorial, etc.) Medium of Use (consumer or trade magazine, annual report, TV, book, etc.) Edition (if book) (hardcover, mass-market paperback, quality paperback, etc.)	ASSIGNMENT DESCRIPTION		
Materials Supplied by Assignment Number Fee FEE PAYMENT SCHEDULE ESTIMATED EXPENSES Client shall reimburse the Designer for all expenses. Expense amounts are estimates only. Illustration Printing (if brokered by Designer) Photography Client's Alterations Models & Props Toll Telephone Calls Materials & Supplies Transportation & Travel Messengers Shipping & Insurance Copies Other Expenses Subtotal Sales Tax Total Sales Tax Total Category of Use (advertising, corporate, promotional, editorial, etc.) Medium of Use (consumer or trade magazine, annual report, TV, book, etc.) Edition (if book) (hardcover, mass-market paperback, etc.)	Delivery Date (predicated on receipt of all m	aterials to be supplied by Client)	
Assignment Number Fee FEE PAYMENT SCHEDULE			
FEE PAYMENT SCHEDULE ESTIMATED EXPENSES Client shall reimburse the Designer for all expenses. Expense amounts are estimates only. Illustration Printing (if brokered by Designer) Photography Client's Alterations Models & Props Toll Telephone Calls Materials & Supplies Transportation & Travel Messengers Shipping & Insurance Copies Other Expenses Subtotal Sales Tax Total Total Product (name) Category of Use (advertising, corporate, promotional, editorial, etc.) Medium of Use (consumer or trade magazine, annual report, TV, book, etc.) Edition (if book) (hardcover, mass-market paperback, quality paperback, etc.)			
ESTIMATED EXPENSES Client shall reimburse the Designer for all expenses. Expense amounts are estimates only. Illustration Photography Client's Alterations Models & Props Toll Telephone Calls Materials & Supplies Transportation & Travel Messengers Shipping & Insurance Copies Other Expenses Subtotal Sales Tax Total Total			
ESTIMATED EXPENSES Client shall reimburse the Designer for all expenses. Expense amounts are estimates only. Illustration Printing <i>(if brokered by Designer)</i> Photography Client's Alterations Models & Props Toll Telephone Calls Materials & Supplies Transportation & Travel Messengers Shipping & Insurance Copies Other Expenses Subtotal Sales Tax Total Total RIGHTS TRANSFERRED The Designer transfers to the Client the following exclusive rights of usage: Title or Product <i>(name)</i> Category of Use <i>(advertising, corporate, promotional, editorial, etc.)</i> Medium of Use <i>(consumer or trade magazine, annual report, TV, book, etc.)</i> Edition (if book) <i>(hardcover, mass-market paperback, quality paperback, etc.)</i>			
Client shall reimburse the Designer for all expenses. Expense amounts are estimates only. Illustration Printing (if brokered by Designer) Photography Client's Alterations Models & Props Toll Telephone Calls Materials & Supplies Transportation & Travel Messengers Shipping & Insurance Copies Other Expenses Subtotal Sales Tax Total Total RIGHTS TRANSFERRED The Designer transfers to the Client the following exclusive rights of usage: Title or Product (name) Category of Use (advertising, corporate, promotional, editorial, etc.) Medium of Use (consumer or trade magazine, annual report, TV, book, etc.) Edition (if book) (hardcover, mass-market paperback, quality paperback, etc.)	FEE PAYMENT SCHEDULE		
Client shall reimburse the Designer for all expenses. Expense amounts are estimates only. Illustration Printing (if brokered by Designer) Photography Client's Alterations Models & Props Toll Telephone Calls Materials & Supplies Transportation & Travel Messengers Shipping & Insurance Copies Other Expenses Subtotal Sales Tax Total Total RIGHTS TRANSFERRED The Designer transfers to the Client the following exclusive rights of usage: Title or Product (name) Category of Use (advertising, corporate, promotional, editorial, etc.) Medium of Use (consumer or trade magazine, annual report, TV, book, etc.) Edition (if book) (hardcover, mass-market paperback, quality paperback, etc.)			
Client shall reimburse the Designer for all expenses. Expense amounts are estimates only. Illustration Printing (if brokered by Designer) Photography Client's Alterations Models & Props Toll Telephone Calls Materials & Supplies Transportation & Travel Messengers Shipping & Insurance Copies Other Expenses Subtotal Sales Tax Total Total RIGHTS TRANSFERRED The Designer transfers to the Client the following exclusive rights of usage: Title or Product (name) Category of Use (advertising, corporate, promotional, editorial, etc.) Medium of Use (consumer or trade magazine, annual report, TV, book, etc.) Edition (if book) (hardcover, mass-market paperback, quality paperback, etc.)			
Client shall reimburse the Designer for all expenses. Expense amounts are estimates only. Illustration Printing (if brokered by Designer) Photography Client's Alterations Models & Props Toll Telephone Calls Materials & Supplies Transportation & Travel Messengers Shipping & Insurance Copies Other Expenses Subtotal Sales Tax Total Total RIGHTS TRANSFERRED The Designer transfers to the Client the following exclusive rights of usage: Title or Product (name) Category of Use (advertising, corporate, promotional, editorial, etc.) Medium of Use (consumer or trade magazine, annual report, TV, book, etc.) Edition (if book) (hardcover, mass-market paperback, quality paperback, etc.)	ESTIMATED EXPENSES		
Photography Client's Alterations Models & Props Toll Telephone Calls Materials & Supplies Transportation & Travel Messengers Shipping & Insurance Copies Other Expenses Subtotal Sales Tax Total Total RIGHTS TRANSFERRED The Designer transfers to the Client the following exclusive rights of usage: Title or Product (name) Category of Use (advertising, corporate, promotional, editorial, etc.) Medium of Use (consumer or trade magazine, annual report, TV, book, etc.) Edition (if book) (hardcover, mass-market paperback, quality paperback, etc.)		xpenses. Expense amounts are estimates only.	
Photography Client's Alterations Models & Props Toll Telephone Calls Materials & Supplies Transportation & Travel Messengers Shipping & Insurance Copies Other Expenses Subtotal Sales Tax Total Total RIGHTS TRANSFERRED The Designer transfers to the Client the following exclusive rights of usage: Title or Product (name) Category of Use (advertising, corporate, promotional, editorial, etc.) Medium of Use (consumer or trade magazine, annual report, TV, book, etc.) Edition (if book) (hardcover, mass-market paperback, quality paperback, etc.)	Illustration	Printing (if brokered by Designer)	
Models & Props Toll Telephone Calls Materials & Supplies Transportation & Travel Messengers Shipping & Insurance Copies Other Expenses Subtotal Sales Tax Total Total RIGHTS TRANSFERRED The Designer transfers to the Client the following exclusive rights of usage: Title or Product (name) Category of Use (advertising, corporate, promotional, editorial, etc.) Medium of Use (consumer or trade magazine, annual report, TV, book, etc.) Edition (if book) (hardcover, mass-market paperback, quality paperback, etc.)			
Materials & Supplies Transportation & Travel Messengers Shipping & Insurance Copies Other Expenses Subtotal Sales Tax Total Total RIGHTS TRANSFERRED The Designer transfers to the Client the following exclusive rights of usage: Title or Product (name) Category of Use (advertising, corporate, promotional, editorial, etc.) Medium of Use (consumer or trade magazine, annual report, TV, book, etc.) Edition (if book) (hardcover, mass-market paperback, quality paperback, etc.)			
Messengers Shipping & Insurance Copies Other Expenses Subtotal Sales Tax Total Total RIGHTS TRANSFERRED The Designer transfers to the Client the following exclusive rights of usage: Title or Product (name) Category of Use (advertising, corporate, promotional, editorial, etc.) Medium of Use (consumer or trade magazine, annual report, TV, book, etc.) Edition (if book) (hardcover, mass-market paperback, quality paperback, etc.)			
Copies Other Expenses Subtotal Sales Tax Total Total RIGHTS TRANSFERRED The Designer transfers to the Client the following exclusive rights of usage: Title or Product (name) Category of Use (advertising, corporate, promotional, editorial, etc.) Medium of Use (consumer or trade magazine, annual report, TV, book, etc.) Edition (if book) (hardcover, mass-market paperback, quality paperback, etc.)			
Subtotal Sales Tax Total RIGHTS TRANSFERRED The Designer transfers to the Client the following exclusive rights of usage: Title or Product (name) Category of Use (advertising, corporate, promotional, editorial, etc.) Medium of Use (consumer or trade magazine, annual report, TV, book, etc.) Edition (if book) (hardcover, mass-market paperback, quality paperback, etc.)			
Sales Tax Total RIGHTS TRANSFERRED The Designer transfers to the Client the following exclusive rights of usage: Title or Product (name) Category of Use (advertising, corporate, promotional, editorial, etc.) Medium of Use (consumer or trade magazine, annual report, TV, book, etc.) Edition (if book) (hardcover, mass-market paperback, quality paperback, etc.)			
Total RIGHTS TRANSFERRED The Designer transfers to the Client the following exclusive rights of usage: Title or Product (name) Category of Use (advertising, corporate, promotional, editorial, etc.) Medium of Use (consumer or trade magazine, annual report, TV, book, etc.) Edition (if book) (hardcover, mass-market paperback, quality paperback, etc.)			
RIGHTS TRANSFERRED The Designer transfers to the Client the following exclusive rights of usage: Title or Product (name) Category of Use (advertising, corporate, promotional, editorial, etc.) Medium of Use (consumer or trade magazine, annual report, TV, book, etc.) Edition (if book) (hardcover, mass-market paperback, quality paperback, etc.)			
The Designer transfers to the Client the following exclusive rights of usage: Title or Product (name) Category of Use (advertising, corporate, promotional, editorial, etc.) Medium of Use (consumer or trade magazine, annual report, TV, book, etc.) Edition (if book) (hardcover, mass-market paperback, quality paperback, etc.)		Total	
The Designer transfers to the Client the following exclusive rights of usage: Title or Product (name) Category of Use (advertising, corporate, promotional, editorial, etc.) Medium of Use (consumer or trade magazine, annual report, TV, book, etc.) Edition (if book) (hardcover, mass-market paperback, quality paperback, etc.)			
Category of Use (advertising, corporate, promotional, editorial, etc.) Medium of Use (consumer or trade magazine, annual report, TV, book, etc.) Edition (if book) (hardcover, mass-market paperback, quality paperback, etc.)		owing exclusive rights of usage:	
Category of Use (advertising, corporate, promotional, editorial, etc.) Medium of Use (consumer or trade magazine, annual report, TV, book, etc.) Edition (if book) (hardcover, mass-market paperback, quality paperback, etc.)	Title or Product (name)		
Medium of Use (consumer or trade magazine, annual report, TV, book, etc.) Edition (if book) (hardcover, mass-market paperback, quality paperback, etc.)		omotional, editorial, etc.)	
Edition (if book) (hardcover, mass-market paperback, quality paperback, etc.)			
	Geographic Area (if applicable)		

Any usage rights not exclusively transferred are reserved to the Designer. Usage beyond that granted to the Client herein shall require payment of a mutually agreed-upon additional fee subject to all terms. Any transfer of rights is conditional upon receipt of full payment.

1. Time for Payment

All invoices are payable within 30 days of receipt. A 11/2% monthly service charge is payable on all overdue balances. The grant of any license or right of copyright is conditioned on receipt of full payment.

2. Default in Payment

The Client shall assume responsibility for all collection of legal fees necessitated by default in payment.

3. Estimates

The fees and expenses shown are minimum estimates only. Final fees and expenses shall be shown when invoice is rendered. The Client's approval shall be obtained for any increases in fees or expenses that exceed the original estimate by 10% or more.

4. Changes

The Client shall be responsible for making additional payments for changes requested by the Client in original assignment. However, no additional payment shall be made for changes required to conform to the original assignment description. The Client shall offer the Designer the first opportunity to make any changes.

5. Expenses

The Client shall reimburse the Designer for all expenses arising from this assignment, including the payment of any sales taxes due on this assignment, and shall advance \$_______ to the Designer for payment of said expenses.

6. Cancellation

In the event of cancellation of this assignment, ownership of all copyrights and the original artwork shall be retained by the Designer, and a cancellation fee for work completed, based on the contract price and expenses already incurred, shall be paid by the Client.

7. Ownership and Return of Artwork

The Designer retains ownership of all original artwork, whether preliminary or final, and the Client shall return such artwork within 30 days of use unless indicated otherwise below:

8. Credit Lines

The Designer and any other creators shall receive a credit line with any editorial usage. If similar credit lines are to be given with other types of usage, it must be so indicated here:

9. Releases

The Client shall indemnify the Designer against all claims and expenses, including reasonable attorney's fees, due to uses for which no release was requested in writing or for uses that exceed authority granted by a release.

Consented and agreed to

Designer's signature/date

Authorized signature/date

Client's name and title

10. Modifications

Modification of the Agreement must be written, except that the invoice may include, and the Client shall pay, fees or expenses that were orally authorized in order to progress promptly with the work.

11. Uniform Commercial Code

The above terms incorporate Article 2 of the Uniform Commercial Code.

12. Code of Fair Practice

The Client and the Designer agree to comply with the provisions of the Code of Fair Practice (which is in the Ethical Standards section of Chapter 1, Professional Relationships).

13. Warranty of Originality

The Designer warrants and represents that, to the best of his/her knowledge, the work assigned hereunder is original and has not been previously published, or that consent to use has been obtained on an unlimited basis; that all work or portions thereof obtained through the undersigned from third parties is original or, if previously published, that consent to use has been obtained on an unlimited basis; that the Designer has full authority to make this agreement; and that the work prepared by the Designer does not contain any scandalous, libelous, or unlawful matter. This warranty does not extend to any uses that the Client or others may make of the Designer's product that may infringe on the rights of others. Client expressly agrees that it will hold the Designer harmless for all liability caused by the Client's use of the Designer's product to the extent such use infringes on the rights of others.

14. Limitation of Liability

Client agrees that it shall not hold the Designer or his/her agents or employees liable for any incidental or consequential damages that arise from the Designer's failure to perform any aspect of the Project in a timely manner, regardless of whether such failure was caused by intentional or negligent acts or omissions of the Designer or a third party.

15. Dispute Resolution

Any disputes in excess of \$______ (maximum limit for small-claims court) arising out of this Agreement shall be submitted to binding arbitration before a mutually agreed-upon arbitrator pursuant to the rules of the American Arbitration Association. The Arbitrator's award shall be final, and judgment may be entered in any court having jurisdiction thereof. The Client shall pay all arbitration and court costs, reasonable attorney's fees, and legal interest on any award of judgment in favor of the Designer.

16. Acceptance of Terms

The signature of both parties shall evidence acceptance of these terms.

Remove all language in italics before using this form.

Designer's	Letterhead
то	Date Commissioned by Assignment Number Invoice Number Client's Purchase Order Number
ASSIGNMENT DESCRIPTION	
FEE PAYMENT SCHEDULE	
ITEMIZED EXPENSES (OTHER BILLABLE EXPENSES)	· · · · · · · · · · · · · · · · · · ·
Illustration	Printing (if brokered by Designer)
Photography	Client's Alterations
Models & Props	Toll Telephone Calls
Materials & Supplies	Transportation & Travel
Messengers	Shipping & Insurance
Copies	Other Expenses
	Subtotal
	Sales Tax
	Total

FRONT

RIGHTS TRANSFERRED

The Designer transfers to the Client the following exclusive rights of usage.

Title or Product (name)

Category of Use (advertising, corporate, promotional, editorial, etc.)

Medium of Use (consumer or trade magazine, annual report, TV, book, etc.)

Edition (if book) (hardcover, mass-market paperback, quality paperback, etc.)

Geographic Area (if applicable)

Time Period (if applicable)

Any usage rights not exclusively transferred are reserved to the Designer. Usage beyond that granted to the Client herein shall require payment of a mutually agreed-upon additional fee subject to all terms. Any transfer of right is conditional upon receipt of full payment.

1. Time for Payment

All invoices are payable within 30 days of receipt. A 11/2% monthly service charge is payable on all overdue balances. The grant of any license or right of copyright is conditioned on receipt of full payment.

2. Default in Payment

The Client shall assume responsibility for all collection of legal fees necessitated by default in payment.

3. Expenses

The Client shall reimburse the Designer for all expenses arising from this assignment, including the payment of any sales taxes due on this assignment.

4. Changes

The Client shall be responsible for making additional payments for changes requested by the Client in original assignment. However, no additional payment shall be made for changes required to conform to the original assignment description. The Client shall offer the Designer the first opportunity to make any changes.

5. Cancellation

In the event of cancellation of this assignment, ownership of all copyrights and the original artwork shall be retained by the Designer, and a cancellation fee for work completed, based on the contract price and expenses already incurred, shall be paid by the Client.

6. Ownership and Return of Artwork

The Designer retains ownership of all original artwork, whether preliminary or final, and the Client shall return such artwork within 30 days of use unless indicated otherwise below:

7. Credit Lines

The Designer and any other creators shall receive a credit line with any editorial usage. If similar credit lines are to be given with other types of usage, it must be so indicated here:

8. Releases

The Client shall indemnify the Designer against all claims and expenses, including reasonable attorney's fees, due to uses for which no release was requested in writing or for uses that exceed authority granted by a release.

9. Modifications

Modification of the Agreement must be written, except that the invoice may include, and the Client shall pay, fees or expenses that were orally authorized in order to progress promptly with the work.

10. Uniform Commercial Code

The above terms incorporate Article 2 of the Uniform Commercial Code.

11. Code of Fair Practice

The Client and the Designer agree to comply with the provisions of the Code of Fair Practice (which is in the Ethical Standards section of Chapter 1, Professional Relationships).

12. Warranty of Originality

The Designer warrants and represents that, to the best of his/her knowledge, the work assigned hereunder is original and has not been previously published, or that consent to use has been obtained on an unlimited basis; that all work or portions thereof obtained through the undersigned from third parties is original or, if previously published, that the consent to use has been obtained on an unlimited basis; that the Designer has full authority to make this agreement; and that the work prepared by the Designer does not contain any scandalous, libelous, or unlawful matter. This warranty does not extend to any uses that the Client or others may make of the Designer's product that may infringe on the rights of others. Client expressly agrees that it will hold the Designer harmless for all liability caused by the Client's use of the Designer's product to the extent such use infringes on the rights of others.

13. Limitation of Liability

Client agrees that it shall not hold the Designer or his/her agents or employees liable for any incidental or consequential damages that arise from the Designer's failure to perform any aspect of the Project in a timely manner, regardless of whether such failure was caused by intentional or negligent acts or omissions of the Designer or a third party.

14. Dispute Resolution

Any disputes in excess of \$______ (maximum limit for small-claims court) arising out of this Agreement shall be submitted to binding arbitration before a mutually agreed-upon arbitrator pursuant to the rules of the American Arbitration Association. The Arbitrator's award shall be final, and judgment may be entered in any court having jurisdiction thereof. The Client shall pay all arbitration and court costs, reasonable attorney's fees, and legal interest on any award of judgment in favor of the Designer.

Illustrator's Estimate & Confirmation Form

Remove all language in italics before using this form.

FRONT

Illustrator's Letterhead

то	Date	·
	Commissioned by	
	Illustrator's Job Number	
	Client's Job Number	
ASSIGNMENT DESCRIPTION		
DELIVERY SCHEDULE		
FEE PAYMENT SCHEDULE		
ESTIMATED EXPENSES (OTHER BILLABLE ITEMS)		
Toll Telephone Calls	Shipping & Insurance	
Transit & Travel	Client's Alterations	
Messengers	Other Expenses	
Cancellation Fee (percentage of fee)	Before Sketches	After Sketches
	After Finish	
Sale of Original Art		
RIGHTS TRANSFERRED Any usage rights not exclusively transferred are rese Client herein shall require payment of a mutually agre For use in magazines and newspapers, first North Ame	ed-upon additional fee subjec	t to all terms.
For all other uses, the Client acquires only the following	ng rights:	
Title or Product (name)		
Category of Use (advertising, corporate, promotional, ed	itorial, etc.)	
Medium of Use (consumer or trade magazine, annual re	port, TV, book, etc.)	
Geographic Area (if applicable)		
Time Period (if applicable)		
Number of Uses (if applicable)		
Other (if applicable)		

Original artwork, including sketches and any other preliminary material, remains the property of the Illustrator unless purchased by a payment of a separate fee. Any transfer of rights is conditional upon receipt of full payment.

1. Time for Payment

Payment is due within 30 days of receipt of invoice. A 11/2% monthly service charge will be billed for late payment. Any advances or partial payments shall be indicated under Payment Schedule on front.

2. Default in Payment

The Client shall assume responsibility for all collection of legal fees necessitated by default in payment.

3. Grant of Rights

The grant of reproduction rights is conditioned on receipt of full payment.

4. Expenses

The Client shall reimburse the Illustrator for all expenses arising from the assignment.

5. Estimates

The fees and expenses shown are minimum estimates only. Final fees and expenses shall be shown when invoice is rendered. The Client's approval shall be obtained for any increases in fees or expenses that exceed the original estimate by 10% or more.

6. Sales Tax

The Client shall be responsible for the payment of sales tax, if any such tax is due.

7. Cancellation

In the event of cancellation or breach by the Client, the Illustrator shall retain ownership of all rights of copyright and the original artwork, including sketches and any other preliminary materials. The Client shall pay the Illustrator according to the following schedule: 50% of original fee if canceled after preliminary sketches are completed, 100% if canceled after completion of finished art.

8. Alterations

Alteration to artwork shall not be made without consulting the initial Illustrator, and the Illustrator shall be allowed the first option to make alterations when possible. After acceptance of artwork, if alterations are required, a payment shall be charged over the original amount.

9. Revisions

Revisions not due to the fault of the Illustrator shall be billed separately.

10. Credit Lines

On any contribution for magazine or book use, the Illustrator shall receive name credit in print. If name credit is to be given with other types of use, it must be specified here:

[] If this box is checked, the Illustrator shall receive copyright notice adjacent to the work in the form: © 200____.

Consented and agreed to

Illustrator's signature/date

Authorized signature/date

Client's name and title

11. Return of Artwork

The Client assumes responsibility for the return of the artwork in undamaged condition within 30 days of first reproduction.

12. Loss or Damage to Artwork

The value of lost or damaged artwork is placed at no less than \$_____ per piece.

13. Unauthorized Use

The Client will indemnify the Illustrator against all claims and expenses, including reasonable attorney's fees, arising from uses for which no release was requested in writing or for uses exceeding the authority granted by a release.

14. Warranty of Originality

The Illustrator warrants and represents that, to the best of his/her knowledge, the work assigned hereunder is original and has not been previously published, or that consent to use has been obtained on an unlimited basis; that all work or portions thereof obtained through the undersigned from third parties is original or, if previously published, that consent to use has been obtained on an unlimited basis; that the Illustrator has full authority to make this agreement; and that the work prepared by the Illustrator does not contain any scandalous, libelous, or unlawful matter. This warranty does not extend to any uses that the Client or others may make of the Artist's product that may infringe on the rights of others. Client expressly agrees that it will hold the Illustrator harmless for all liability caused by the Client's use of the Illustrator's product to the extent such use infringes on the rights of others.

15. Limitation of Liability

Client agrees that it shall not hold the Illustrator or his/her agents or employees liable for any incidental or consequential damages that arise from the Illustrator's failure to perform any aspect of the Project in a timely manner, regardless of whether such failure was caused by intentional or negligent acts or omissions of the Illustrator or a third party.

16. Dispute Resolution

Any disputes in excess of \$______ (maximum limit for small-claims court) arising out of this Agreement shall be submitted to binding arbitration before a mutually agreed-upon arbitrator pursuant to the rules of the American Arbitration Association. The Arbitrator's award shall be final, and judgment may be entered in any court having jurisdiction thereof. The Client shall pay all arbitration and court costs, reasonable attorney's fees, and legal interest on any award of judgment in favor of the Illustrator.

17. Acceptance of Terms

The signature of both parties shall evidence acceptance of these terms.

Illustrator's Invoice

Remove all language in italics before using this form.

			0		-
- 1	FI	К	Ο	IN	

Illustrator's Letterhead

Date

Commissioned by Illustrator's Job Number Client's Job Number

ASSIGNMENT DESCRIPTION

FEE PAYMENT SCHEDULE

ITEMIZED EXPENSES (OTHER BILLABLE ITEMS)

Toll Telephone Calls	
Transportation & Travel	
Messengers	
Shipping & Insurance	

Client's Alterations
Sale of Original Art
Cancellation Fee
Miscellaneous
Subtotal
Sales Tax
Payments on Account
Balance Due

RIGHTS TRANSFERRED

Any usage rights not exclusively transferred are reserved to the Illustrator. Usage beyond that granted to the Client herein shall require payment of a mutually agreed-upon additional fee subject to all terms.

For use in magazines and newspapers, first North American reproduction rights unless specified otherwise here:

For all other uses, the Client acquires only the following rights:

Title or Product (name)

Category of Use (advertising, corporate, promotional, editorial, etc.)

Medium of Use (consumer or trade magazine, annual report, TV, book, etc.)

Geographic Area (if applicable)

Time Period (if applicable)

Number of Uses (if applicable)

Other (if applicable)

Original artwork, including sketches and any other preliminary materials, remains the property of the Illustrator unless purchased by payment of a separate fee subject to all terms. Any transfer of rights is conditional upon receipt of full payment.

TERMS

1. Time for Payment

Payment is due within 30 days of receipt of invoice. A 11/2% monthly service charge will be billed for late payment.

2. Default in Payment

The Client shall assume responsibility for all collection of legal fees necessitated by default in payment.

3. Expenses

The Client shall reimburse the Illustrator for all expenses arising from the assignment.

4. Sales Tax

The Client shall be responsible for the payment of sales tax, if any such tax is due.

5. Grant of Rights

The grant of reproduction rights is conditioned on receipt of payment.

6. Credit Lines

On any contribution for magazine or book use, the Illustrator shall receive name credit in print. If name credit is to be given with other types of use, it must be specified here:

[] If this box is checked, the Illustrator shall receive copyright notice adjacent to the work in the form:

© 200

7. Additional Limitations

If the Illustrator and the Client have agreed to additional limitations as to either the duration or geographical extent of the permitted use, specify here:

8. Return of Artwork

The Client assumes responsibility for the return of the artwork in undamaged condition within 30 days of first reproduction.

9. Loss or Damage to Artwork

The value of lost or damaged artwork is placed at no less than \$_____ per piece.

10. Alterations

Alteration to artwork shall not be made without consulting the initial Illustrator, and the Illustrator shall be

allowed the first option to make alterations when possible. After acceptance of artwork, if alterations are required, a payment shall be charged over the original amount.

11. Unauthorized Use

The Client will indemnify the Illustrator against all claims and expenses, including reasonable attorney's fees, arising from uses for which no release was requested in writing or for uses that exceed the authority granted by a release.

12. Warranty of Originality

The Illustrator warrants and represents that, to the best of his/her knowledge, the work assigned hereunder is original and has not been previously published, or that consent to use has been obtained on an unlimited basis; that all work or portions thereof obtained through the undersigned from third parties is original or, if previously published, that consent to use has been obtained on an unlimited basis; that the Illustrator has full authority to make this agreement; and that the work prepared by the Illustrator does not contain any scandalous, libelous, or unlawful matter. This warranty does not extend to any uses that the Client or others may make of the Illustrator's product that may infringe on the rights of others. Client expressly agrees that it will hold the Illustrator harmless for all liability caused by the Client's use of the Illustrator's product to the extent such use infringes on the rights of others.

13. Limitation of Liability

Client agrees that it shall not hold the Illustrator or his/her agents or employees liable for any incidental or consequential damages that arise from the Illustrator's failure to perform any aspect of the Project in a timely manner, regardless of whether such failure was caused by intentional or negligent acts or omissions of the Illustrator or a third party.

14. Dispute Resolution

Any disputes in excess of \$______ (maximum limit for small-claims court) arising out of this Agreement shall be submitted to binding arbitration before a mutually agreed-upon arbitrator pursuant to the rules of the American Arbitration Association. The Arbitrator's award shall be final, and judgment may be entered in any court having jurisdiction thereof. The Client shall pay all arbitration and court costs, reasonable attorney's fees, and legal interest on any award of judgment in favor of the Illustrator.

Illustrator's Release Form for Models

Illustrator's Letterhead

In consideration of	dollars <u>(\$</u>), receipt of which is acknowledged,
l,, d	lo hereby give	, his or
her assigns, licenses, and legal representativ	es the irrevocable	right to use my name (or any fictional name),
picture, portrait, or photograph in all forms a	and media and in a	all manners, including composite or distorted
representations, for advertising, trade, or a	ny other lawful p	ourposes, and I waive any right to inspect or
approve the finished version(s), including	written copy tha	at may be created in connection therewith.
I am of full age.* I have read this release and	d am fully familiar	with its contents.
Witness		
Model		
Address		
Address		
Date	, 200	
	n na shekara ka shekara	
CONSENT (if applicable)		
I am the parent or guardian of the minor name I approve the foregoing and waive any rights		the legal authority to execute the above release.

Witness	
Parent or Guardian	
Address	
Address	
Date	. 200

*Delete this sentence if the subject is a minor. The parent or guardian must then sign the consent.

Reproduced with permission from Business and Legal Forms for Illustrators by Tad Crawford (Allworth Press).

Licensing Agreement (Short Form)

Remove all language in italics before using this form.

FRONT

Licensor's Letterhead

1	(The "Licensor")
hereby grants to	_(the "Licensee")
a nonexclusive license to use the image	
(the "Im	age") created and
owned by Licensor on ("Licensed Products") and to distribute
and sell these Licensed Products in	(territory)
for a term of years commencing	200,
in accordance with the terms and conditions of	of this Agreement.

2. Licensor shall retain all copyrights in and to the Image. Licensee shall identify the Licensor as the artist on the Licensed Products and shall reproduce thereon the following copyright notice: © 200

3. Licensee agrees to pay the Licensor a nonrefundable _%) percent of the net sales of the rovalty of (Licensed Products. "Net Sales" as used herein shall mean sales to customers less prepaid freight and credits for lawful and customary volume rebates, actual returns, and allowances. Royalties shall be deemed to accrue when the Licensed Products are sold, shipped, or invoiced, whichever first occurs.

4. Licensee shall pay Licensor a nonrefundable advance in the upon signing of this Agreement. Licensee amount of \$ further agrees to pay Licensor a guaranteed nonrefundable minimum royalty of \$_____ every month.

5. Royalty payments shall be paid on the first day of each month commencing , 200___, and Licensee shall furnish Licensor with monthly statements of account showing the kinds and quantities of all Licensed Products sold, the prices received therefor, and all deductions for freight, volume rebates, returns, and allowances. The first royalty statement shall be sent on . 200

6. Licensor shall have the right to terminate this Agreement upon 30 days' notice if Licensee fails to make any payment required of it and does not cure this default within said 30 days. whereupon all rights granted herein shall revert immediately to the Licensor.

7. Licensee agrees to keep complete and accurate books and records relating to the sale of the Licensed Products. Licensor shall have the right to inspect Licensee's books and records concerning sales of the Licensed Products upon prior written notice.

8. Licensee shall give Licensor, free of charge, (number) samples of each of the Licensed Products for Licensor's personal use. Licensor shall have the right to purchase additional samples of the Licensed Products at the Licensee's manufacturing cost. "Manufacturing cost" shall be per Licensed Product. \$

9. Licensor shall have the right to approve the quality of the reproduction of the Image on the Licensed Products and on any approved advertising or promotional materials and Licensor shall not unreasonably withhold approval.

10. Licensee shall use its best efforts to promote, distribute, and sell the Licensed Products, and said Products shall be of the highest commercial quality.

11. All rights not specifically transferred by this Agreement are reserved to the Licensor. Any transfer of rights is conditional upon receipt of full payment.

12. The Licensee shall hold the Licensor harmless from and against any loss, expense, or damage occasioned by any claim, demand, suit, or recovery against the Licensor arising out of the use of the Image.

13. Nothing herein shall be construed to constitute the parties hereto joint ventures, nor shall any similar relationship be deemed to exist between them. This Agreement shall not be assigned in whole or in part without the prior written consent of the Licensor.

14. This Agreement shall be construed in accordance with the laws of (state); Licensee consents to jurisdiction of the courts of (state).

15. All notices, demands, payments, royalty payments and statements shall be sent to the Licensor at the following address: and to the Licensee at:

16. Any disputes arising out of this Agreement shall be submitted to binding arbitration before a mutually agreed-upon arbitrator pursuant to the rules of the American Arbitration Association in the city of . The Arbitrator's award shall be final, and judgment may be entered in any court having jurisdiction thereof. The Licensee shall pay all arbitration and court costs, reasonable attorney's fees, and legal interest on any award of judgment in favor of the Licensor.

17. This Agreement constitutes the entire agreement between the parties hereto and shall not be modified, amended, or changed in any way except by written agreement signed by both parties hereto. This Agreement shall be binding upon and shall inure to the benefit of the parties, their successors, and assigns.

In witness whereof, the parties have executed this Licensing Agreement on the day		_, 200
Licensee (company name)	JIE RA	
By (name, position)		
Licensor	31510	
© Caryn Leland 1990	MEMBER	

Remove all language in italics before using this form.

FRONT

Licensor's Letterhead

1. Grant of License

Agreement made this day of _	, 200
between	(the "Licensor"),
having an address at	
	(address), and
	(the "Licensee"),
located at	

(address), whereby

Licensor grants to Licensee a license to use the designs listed on the attached Schedules A and B (the "Designs") in accordance with the terms and conditions of this Agreement and only for the production, sale, advertising, and promotion of certain articles (the "Licensed Products") described in Schedule A for the Term and in the Territory set forth in said Schedule. Licensee shall have the right to affix the Trademarks: ______ and _____

on or to the Licensed Products and on packaging, advertising, and promotional materials sold, used, or distributed in connection with the Licensed Products.

2. Licensor's Representation and Credits

A. Licensor warrants that Licensor has the right to grant to the Licensee all of the rights conveyed in this Agreement. The Licensee shall have no right, license, or permission except as herein expressly granted. All rights not specifically transferred by the Agreement are reserved to the Licensor.

B. The Licensee prominently shall display and identify the Licensor as the designer on each Licensed Product and on all packaging, advertising, and display and in all publicity therefor and shall have reproduced thereon (or on an approved tag or label) the following notices: "© (Licensor's name), 200___. All rights reserved." The Licensed Products shall be marketed under the name

for									.The
	shall	not	be	co-joined	with	any	third	party's	name

name shall not be co-joined with any third party's name without the Licensor's express written permission.

C. The Licensee shall have the right to use the Licensor's name, portrait, or picture, in a dignified manner consistent with the Licensor's reputation, in advertising or other promotional materials associated with the sale of the Licensed Products.

3. Royalties and Statements of Account

A. Licensee agrees to pay Licensor a nonrefundable royalty of ______(____%) of the net sales of all of the Licensed Products incorporating and embodying the Designs. "Net sales" is defined as sales direct to customers less prepaid freight and credits for lawful and customary volume rebates, actual returns, and allowances; the aggregate of said deductions and credits shall not exceed 3% of accrued royalties in any year. No costs incurred in the manufacture, sale, distribution, or exploitation of the Licensed Products shall be deducted from any royalties due to Licensor. Royalties shall be deemed to accrue when the Licensed Products are sold, shipped, or invoiced, whichever first occurs. **B.** Royalty payments for all sales shall be due on the 15th day after the end of each calendar quarter. At that time and regardless if any Licensed Products were sold during the preceding time period, Licensee shall furnish Licensor an itemized statement categorized by Design, showing the kinds and quantities of all Licensed Products sold and the prices received therefor, and all deductions for freight, volume rebates, returns, and allowances. The first royalty statement shall commence on: ______ 200_.

C. If Licensor has not received the royalty payment as required by the foregoing paragraph 3B within 21 days following the end of each calendar quarter, a monthly service charge of 11/2% shall accrue thereon and become due and owing from the date on which such royalty payment became due and owing.

4. Advances and Minimum Royalties

A. In each year of this Agreement, Licensee agrees to pay Licensor a Guaranteed Minimum Royalty in the amount of \$______, of which \$______ shall be deemed a Nonrefundable Advance against royalties. The difference, if any, between the Advance and the Guaranteed Minimum Royalty shall be divided equally and paid quarterly over the term of this Agreement commencing with the quarter beginning ______ 200_.

B. The Nonrefundable Advance shall be paid on the signing of this agreement. No part of the Guaranteed Minimum Royalty or the Nonrefundable Advance shall be repayable to Licensee.

C. On signing of this Agreement, Licensee shall pay Licensor a nonrefundable design fee in the amount of \$_____ per Design. This fee shall not be applied against royalties.

D. Licensor has the right to terminate this Agreement upon the giving of 30 days' notice to Licensee if the Licensee fails to pay any portion of the Guaranteed Minimum Royalty when due.

5. Books and Records

Licensee agrees to keep complete and accurate books and records relating to the sale and other distribution of each of the Licensed Products. Licensor or its representative shall have the right to inspect Licensee's books and records relating to the sales of the Licensed Products upon 30 days' prior written notice. Any discrepancies over 5% between the royalties received and the royalties due will be subject to the royalty payment set forth herein and paid immediately. If the audit discloses such an underpayment of 10% or more, Licensee shall reimburse the Licensor for all the costs of said audit.

6. Quality of Licensed Products, Approval, and Advertising

A. Licensee agrees that the Licensed Products shall be of the highest standard and quality and of such style and appearance as to be best suited to their exploitation to the best advantage and to the protection and enhancement of the Licensed Products and the good will pertaining thereto. The Licensed Products shall be manufactured, sold, and distributed in accordance with all applicable national, state, and local laws.

B. In order to ensure that the development, manufacture, appearance, quality, and distribution of each Licensed Product is consonant with the Licensor's good will associated with its reputation, copyrights, and trademark, Licensor shall have the right to approve, in advance, the quality of the Licensed Products (including, without limitation, concepts and preliminary prototypes, layouts, or camera-ready art prior to production of first sample and revised production sample, if any) and all agreements. No part of the Guaranteed Minimum Royalty or the Nonrefundable Advance shall be repayable to Licensee.

C. On signing this agreement, Licensee shall be responsible for delivering all items requiring prior approval pursuant to Paragraph 6B without cost to the Licensor. Licensor agrees not to withhold approval unreasonably.

D. Licensee shall not release or distribute any Licensed Product without securing each of the prior approvals provided for in Paragraph 6B. Licensee shall not depart from any approval secured in accordance with Paragraph 6B without Licensor's prior written consent.

E. Licensee agrees to expend at least _____% percent of anticipated gross sales of the Licensed Products annually to promote and advertise sales of the Licensed Products.

7. Nonexclusive Rights

Nothing in this Agreement shall be construed to prevent Licensor from granting other licenses for the use of the Designs or from utilizing the Designs in any manner whatsoever, except that the Licensor shall not grant other Licenses for the use of the Designs in connection with the sale of the Licensed Products in the Territory to which this License extends during the term of this Agreement.

8. Nonacquisition of Rights

The Licensee's use of the Designs and Trademarks shall inure to the benefit of the Licensor. If Licensee acquires any trade rights, trademarks, equities, titles, or other rights in and to the Designs or in the Trademark, by operation of law, usage, or otherwise during the term of this Agreement or any extension thereof, Licensee shall forthwith upon the expiration of this Agreement or any extension thereof or sooner termination, assign and transfer the same to Licensor without any consideration of the than the consideration of this Agreement.

9. Licensee's Representations

The License warrants and represents that during the term of this License and for any time thereafter, it, or any of its affiliated, associated, or subsidiary companies will not copy, imitate, or authorize the imitation or copying of the Designs, Trade names, and Trademarks, or any distinctive feature of the foregoing or other designs submitted to the Licensee by Licensor. Without prejudice to any other remedies the Licensor may have, royalties as provided herein shall accrue and be paid by Licensee on all items embodying and incorporating imitated or copied Designs.

10. Registrations and Infringements

A. The Licensor has the right but not the obligation to obtain, at its own cost, appropriate copyright, trademark, and patent protection for the Designs and the Trademarks. At Licensor's request and at Licensee's sole cost and expense, Licensee shall make all necessary and appropriate registrations to protect the copyrights, trademarks, and patents in and to the Licensed Products and the advertising, promotional, and packaging material in the Territory in which the Licensed Products are sold. Copies of all applications shall be submitted for approval to Licensor prior to filing. The Licensee and Licensor agree to cooperate with each other to assist in the filing of said registrations.

B. Licensee shall not at any time apply for or abet any third party to apply for copyright, trademark, or patent protection that would affect Licensor's ownership of any rights in the Designs or the Trademarks.

C. Licensee shall notify Licensor in writing immediately upon discovery of any infringements or imitations by others of the Designs, Trade names, or Trademarks. Licensor in its sole discretion may bring any suit, action, or proceeding Licensor deems appropriate to protect Licensor's rights in the Designs, Trade names, and Trademarks, including, without limitation, for copyright and trademark infringement and for unfair competition.

If for any reason Licensor does not institute any such suit or take any such action or proceeding, upon written notice to the Licensor, Licensee may institute such appropriate suit, action, or proceeding in Licensee's and Licensor's names. In any event, Licensee and Licensor shall cooperate fully with each other in the prosecution of such suit, action, or proceeding. Licensor reserves the right, at Licensor's cost and expense, to join in any pending suit, action, or proceeding.

The instituting party shall pay all costs and expenses, including legal fees, incurred by the instituting party. All recoveries and awards, including settlements received, after payments of costs and legal fees, shall be divided 75% percent to the instituting party and 25% percent to the other party

11. Indemnification and Insurance

A. The Licensee hereby agrees to indemnify and hold the Licensor harmless against all liability, cost, loss, expense (including reasonable attorney's fees), or damages paid, incurred, or occasioned by any claim, demand, suit, settlement, or recovery against the Licensor, without limitation, arising out of the breach or claim of breach of this Agreement; the use of the Designs by it or any third party the manufacture, distribution, and sale of the Licensed Products; and for any alleged defects in the Licensed Products. Licensee hereby consents to submit to the personal jurisdiction of any court, tribunal, or forum in which an action or proceeding is brought involving a claim to which this foregoing indemnification shall apply.

B. Licensee shall obtain at its sole cost and expense product liability insurance in an amount providing sufficient and adequate coverage, but not less than \$1 million combined single limit coverage protecting the Licensor against any claims or lawsuits arising from alleged defects in the Licensed Product.

12. Grounds for and Consequences of Termination

A. Licensor shall have the right to terminate this Agreement by written notice, and all the rights granted to the Licensee shall revert forthwith to the Licensor and all royalties or other payments shall become due and payable immediately if:

i. Licensee fails to comply with or fulfill any of the terms or conditions of this Agreement;

continued...

ii. The Licensed Products have not been offered or made available for sale by Licensee _____ months from the date hereof;

iii. Licensee ceases to manufacture and sell the Licensed Products in commercially reasonable quantities; or

iv. The Licensee is adjudicated a bankrupt, makes an assignment for the benefit of creditors, or liquidates its business.

B. Licensee, as quickly as possible, but in no event later than 30 days after such termination, shall submit to Licensor the statements required in Paragraph 3 for all sales and distributions through the date of termination. Licensor shall have the right to conduct an actual inventory on the date of termination or thereafter to verify the accuracy of said statements.

C. In the event of termination, all payments theretofore made to the Licensor shall belong to the Licensor without prejudice to any other remedies the Licensor may have.

13. Sell-off Right

Provided Licensee is not in default of any term or condition of this Agreement, Licensee shall have the right for a period of ______ months from the expiration of this Agreement or any extension thereof to sell inventory on hand subject to the terms and conditions of this Agreement, including the payment of royalties and guaranteed minimum royalties on sales that continue during this additional period.

14. Purchase at Cost

A. Licensor shall have the right to purchase from Licensee, at Licensee's manufacturing cost, such number of Licensed Products as Licensor may specify in writing to Licensee, but not to exceed ______ for any Licensed Product. For purposes of this Paragraph, "manufacturing cost" shall mean \$_____ per Licensed Product. Any amounts due to Licensee pursuant to this Paragraph shall not be deducted from any royalties, including any minimum royalties, owed to Licensor. B. Licensee agrees to give the Licensor, without charge, ______ each of the Licensed Products.

15. Miscellaneous Provisions

A. Nothing herein shall be construed to constitute the parties hereto partners or joint ventures, nor shall any similar relationship be deemed to exist between them.

B. The rights herein granted are personal to the Licensee and shall not be transferred or assigned, in whole or in part, without the prior written consent of the Licensor.

C. No waiver of any condition or covenant of this Agreement by either party hereto shall be deemed to imply or constitute a further waiver by such party of the same or any other condition. This Agreement shall be binding upon and shall inure to the benefit of the parties, their successors, and assigns.

D. Whatever claim Licensor may have against Licensee hereunder for royalties or for damages shall become a first lien upon all of the items produced under this Agreement in the possession or under the control of the Licensee upon the expiration or termination of this Agreement.

E. This Agreement shall be construed in accordance with the laws of ______. The Licensee hereby consents to submit to the personal jurisdiction of the ______ Court, _____ County, and Federal Court of the District ______ for all purposes in connection with this Agreement.

F. All notices and demands shall be sent in writing by certified mail, return receipt requested, at the addresses above first written; royalty statements, payments, and samples of Licensed Products and related materials shall be sent by regular mail.

G. This Agreement constitutes the entire agreement between the parties hereto and shall not be modified, amended, or changed in any way except by written agreement signed by both parties hereto. Licensee shall not assign this Agreement.

In witness whereof, the parties have executed this Licensing Agreement as of the date first set forth above.

Licensee (company name)

By (name, position)

Licensor

© Caryn Leland 1990

FRONT

Magazine's Letterhead

This letter is to serve as our contract for you to create certain illustrations for us under the terms described herein

1. Job Description

We, the Magazine, retain you, the Illustrator, to create - illustration(s) described as follows (indicate if sketches are required:

to be delivered to the Magazine by _ 200____ for publication in our magazine titled ___

2. Grant of Rights

The Illustrator hereby agrees to transfer to the Magazine first North American magazine rights in the illustration(s). All rights not expressly transferred to the Magazine hereunder are reserved to the Illustrator.

3. Price

The Magazine agrees to pay the Illustrator the following purchase price: \$ in full consideration for the Illustrator's grant of rights to the Magazine. Any transfer of rights is conditional upon receipt of full payment.

4. Changes

The Illustrator shall be given the first option to make any changes in the work that the Magazine may deem necessary. However, no additional compensation shall be paid unless such changes are necessitated by error on the Magazine's part, in which case a new contract between us shall be entered into on mutually agreeable terms to cover changes to be done by the Illustrator.

5. Cancellation

If, prior to the Illustrator's completion of finishes, the Magazine cancels the assignment, either because the illustrations are unsatisfactory to the Magazine or for

any other reason, the Magazine agrees to pay the Illustrator a cancellation fee of 50% of the purchase price. If, after the Illustrator's completion of finishes, the Magazine cancels the assignment, the Magazine agrees to pay 50% of the purchase price if cancellation is due to the illustrations not being reasonably satisfactory and 100% of the purchase price if cancellation is due to any other cause. In the event of cancellation, the Illustrator shall retain ownership of all artwork and rights of copyright, but the Illustrator agrees to show the Magazine the artwork if the Magazine so requests so that the Magazine may make its own evaluation as to the degree of completion of the artwork.

6. Copyright Notice and Authorship Credit

Copyright notice shall appear in the Illustrator's name with the contribution. The Illustrator shall have the right to receive authorship credit for the illustration and to have such credit removed if the Illustrator so desires due to changes made by the Magazine that are unsatisfactory to the Illustrator.

7. Payments

Payment shall be made within 30 days of the billing date.

8. Ownership of Artwork

The Illustrator shall retain ownership of all original artwork and the Magazine shall return such artwork within 30 days of publication.

9. Acceptance of Terms

To Constitute this a binding agreement between us, please sign both copies of this letter beneath the words "consented and agreed to" and return one copy to the Magazine for its files.

Consented and agreed to
Artist's signature/date
Magazine
Authorized signature/date
Name and title

Nondisclosure Agreement for Submitting Ideas

FRONT

Illustrator's or Designer's Letterhead

Agreement, entered into as of this day of,	200, between
(hereinafter referred to as the "Illustrator" or "Designer"), located	at
and	(hereinafter referred to as the "Recipient")
located at	

Whereas, the Illustrator (or Designer) has developed certain valuable information, concepts, ideas, or designs, which the Illustrator (or Designer) deems confidential (hereinafter referred to as the "Information"); and

Whereas, the Recipient is in the business of using such Information for its projects and wishes to review the Information; and

Whereas, the Illustrator (or Designer) wishes to disclose this Information to the Recipient; and

Whereas, the Recipient is willing not to disclose this Information, as provided in this Agreement;

Now, therefore, in consideration of the foregoing premises and the mutual covenants hereinafter set forth and other valuable considerations, the parties hereto agree as follows:

1. Disclosure

Illustrator (or Designer) shall disclose to the Recipient the Information, which concerns

2. Purpose

Recipient agrees that this disclosure is only for the purpose of the Recipient's evaluation to determine its interest in the commercial exploitation of the Information.

3. Limitation on Use

Recipient agrees not to manufacture, sell, deal in, or otherwise use or appropriate the disclosed Information in any way whatsoever, including but not limited to adaptation, imitation, redesign, or modification. Nothing contained in this Agreement shall be deemed to give Recipient any rights whatsoever in and to the Information.

4. Confidentiality

Recipient understands and agrees that the unauthorized disclosure of the Information by the Recipient to others would irreparably damage the Illustrator (or Designer). As consideration and in return for the disclosure of this Information, the Recipient shall keep secret and hold in confidence all such Information and treat the Information as if it were the Recipient's own property by not disclosing it to any person or entity.

5. Good-Faith Negotiations

If, on the basis of the evaluation of the Information, Recipient wishes to pursue the exploitation thereof, Recipient agrees to enter into good-faith negotiations to arrive at a mutually satisfactory agreement for these purposes. Until and unless such an agreement is entered into, this nondisclosure Agreement shall remain in force.

6. Miscellany

This Agreement shall be binding upon and shall inure to the benefit of the parties and their respective legal representatives, successors, and assigns.

© Tad Crawford 1990

In witness whereof, the parties have signed this Agreement as of the date first set forth above.

Illustrator (or Designer)

Recipient

Company name

Bу

Authorized signatory, title

Surface/Textile Designer–Agent Agreement

Introduction

The Surface/Textile Designer–Agent Agreement seeks to clarify Designer-Agent relationships by providing a written understanding to which both parties can refer. Its terms can be modified to meet the special needs of either Designer or Agent. The Agreement has been drafted with a minimum of legal jargon, but this in no way changes its legal validity.

The Agreement balances the needs of both Designer and Agent. The agency in Paragraph 1 is limited to a particular market. In the market the Agent has exclusive rights to act as an agent, but the Designer remains free to sell in that market also (except to accounts secured by the Agent). Because both Agent and Designer will be selling in the same market, the Designer may want to provide the Agent with a list of clients previously obtained by the Designer and keep this list up-to-date.

If the Agent desires greater exclusivity, such as covering more markets, the Designer may want to require that the Agent exercise best efforts (although it is difficult to prove best efforts have not been exercised) and perhaps promise a minimum level of sales. If the level is not met, the Agreement would terminate.

Paragraph 2 seeks to protect the Designer against loss or damage to his or her artwork, in part by requiring the Agent to execute with the client contracts that protect the designs.

Paragraph 3 sets forth the duration of the Agreement. A short term is usually wise, since a Designer and Agent who are working well together can simply extend the term by mutual agreement in order to continue their relationship. Also, as time goes on, the Designer may be in a better position to negotiate with the Agent. The term of the Agreement has less importance, however, when either party can terminate the agency relationship on 30 days' notice as Paragraph 10 provides.

The minimum base prices in Paragraph 4 ensure the Designer a minimum remuneration. Flexibility in pricing requires that the Designer and Agent consult one another in those cases in which a particular sale justifies a price higher than the base price. The Designer can suggest that the Agent follow the Graphic Artists Guild's Pricing and Ethical Guidelines to establish the minimum base price.

The Agent's rate of commission in Paragraph 5 is left blank so the parties can establish an acceptable rate. If the Designer is not paid for doing an assignment, the Agent will have no right to receive a commission. Nor are commissions payable on the amount of expenses incurred by the Designer for work done on assignment. Discounts given by the Agent on volume sales of the work of many designers shall be paid out of the Agent's commission.

Paragraph 6 covers the Agent's obligations when commissioned work is obtained for the Designer. Of particular importance are the terms of the order form secured by the Agent from the client. The Agent should use the order form developed by the Graphic Artists Guild or a form incorporating similar terms.

Holding of designs by clients can present a problem, which Paragraph 7 seeks to resolve by establishing a maximum holding time of five working days. Again, the Agent should use the holding form developed by the Graphic Artists Guild or a form with similar terms.

In Paragraph 8 the Agent assumes responsibility for billing and pursuing payments that are not made promptly. The reason for keeping any single billing under the maximum allowed for suit in small-claims court is to make it easier to collect if a lawsuit is necessary. The Agent should use the invoice form of the Graphic Artists Guild or a form with similar provisions.

Paragraph 9 allows the Designer to inspect the Agent's books to ensure that proper payments are being made.

Termination is permitted on giving 30 days' written notice to the other party. Paragraph 10 distinguishes between sales made or assignments obtained prior to termination (on which the Agent must be paid a commission, even if the work is executed and payment received after the termination date) and those after termination (on which no commission is payable). Within 30 days' notice of termination, all designs must be returned to the Designer.

Paragraph 11 provides that the Agreement cannot be assigned by either party since the relationship between Designer and Agent is a personal one.

In Paragraph 12, arbitration is provided for disputes in excess of the maximum limit for suits in small-claims court. For amounts within the small-claims limit, it is probably easier to simply sue rather than seek arbitration.

The manner of giving notice to the parties is described in Paragraph 13.

Paragraph 14 affirms that both Designer and Agent are independent contractors, which avoids certain tax and liability issues that might arise from the other legal relationships mentioned.

This Agreement is the entire understanding of the parties and can be amended only in writing. In stating this, Paragraph 15 points out the general rule that a written contract should always be amended in writing that is signed by both parties.

Paragraph 16 leaves room for the parties to add any optional provisions that they consider necessary. Some of the optional provisions that might be agreed to appear below.

Paragraph 17 sets forth the state whose law will govern the Agreement. This is usually the law of the state in which both parties reside or, if one party is out of state, in which the bulk of the business will be transacted.

Finally, paragraph 18 defines what constitutes acceptance of the contract terms.

Optional provisions

Additional provisions could be used to govern certain aspects of the Designer-Agent relationship. Such provisions might include:

- The scope of the agency set forth in Paragraph 1 is limited to the following geographic area: ______.
- Despite any provisions of Paragraph 1 to the contrary, this agency shall be nonexclusive and the Designer shall have the right to use other Agents without any obligation to pay commissions under this Agreement.
- The Agent agrees to represent no more than _____ (number) designers.
- The Agent agrees not to represent conflicting hands, such hands being designers who work in a similar style to that of the Designer.
- The Agent agrees to have no designers as salaried employees.
- The Agent agrees not to sell designs from his or her own collection of designs while representing the Designer.
- The Agent agrees to employ _____ (number) full time and _____ (number) part-time salespeople.
- The Agent agrees that the Designer's name shall appear on all artwork by the Designer that is included in the Agent's portfolio.

- The Agent agrees to seek royalties for the Designer in the following situations:
- The Agent agrees to hold all funds due to the Designer as trust funds in an account separate from funds of the Agent prior to making payment to the Designer pursuant to Paragraph 8 hereof.
- The Agent agrees to enter into a written contract with each client that shall include the following provision:

Credit Line for Designer: The designer shall have the right to receive authorship credit for his or her design and to have such credit removed in the event changes made by the client are unsatisfactory to the designer. Such authorship credit shall appear as follows on the selvage of the fabric:

☐ If this box is checked, such authorship credit shall also accompany any advertising for the fabric:______

Copyright Notice for Designer: Copyright notice shall appear in the Designer's name on the selvage of the fabric, the form of notice being as follows: © 200_____

The placement and affixation of the notice shall comply with the regulations issued by the Register of Copyrights. The grant of rights in this design is expressly conditioned on copyright notice appearing in the Designer's name.

☐ If this box is checked, such copyright notice shall also accompany any advertising for the fabric.

FRONT

Designer's Letterhead

Agreement, this	_ day of	, 200, between _	
(hereinafter referred to a	s the "Designe	r"), residing at:	
		and	(hereinafter referred to as the "Agent"),
residing at:			

Whereas, the Designer is a professional surface/textile designer; and

Whereas, the Designer wishes to have an Agent represent him or her in marketing certain rights enumerated herein; and

Whereas, the Agent is capable of marketing the artwork produced by the Designer; and

Whereas, the Agent wishes to represent the Designer;

Now, therefore, in consideration of the foregoing premises and the mutual covenants hereinafter set forth and other valuable consideration, the parties hereto agree as follows:

1. Agency

The Designer appoints the Agent to act as his or her representative for:

Sale of surface/textile designs in apparel market,

Sale of surface/textile designs in home furnishing market,

Securing of service work in apparel market. Service work is defined to include repeats and colorings on designs originated by the Designer or other designers,

Securing of service work in home furnishing market
 Other______

The Agent agrees to use his/her best efforts in submitting the Designer's artwork for the purpose of making sales or securing assignments for the Designer. For the purposes of this Agreement, the term artwork shall be defined to include designs, repeats, colorings, and any other product of the Designer's effort. The Agent shall negotiate the terms of any assignment that is offered, but the Designer shall have the right to reject any assignment if he or she finds the terms unacceptable. Nothing contained herein shall prevent the Designer from making sales or securing work for his or her own account without liability for commissions except for accounts that have been secured for the Designer by the Agent. This limitation extends only for the period of time that the Agent represents the Designer. Further, the Designer agrees, when selling his or her artwork or taking orders, not to accept a price that is below the price structure of his or her Agent.

After a period of ______ months, the Designer may remove his or her unsold artwork form the Agent's portfolio to do with as the Designer wishes.

2. Artwork and Risk of Loss, Theft, or Damage

All artwork submitted to the Agent for sale or for the purpose of securing work shall remain the property of the Designer. The Agent shall issue a receipt to the Designer for all artwork that the Designer submits to the Agent. If artwork is lost, stolen, or damaged while in the Agent's possession due to the Agent's failure to exercise reasonable care, the Agent will be held liable for the value of the artwork. Proof of any loss, theft, or damage must be furnished by the Agent to the Designer upon request. When selling artwork, taking an order, or allowing a client to hold artwork for consideration, the Agent agrees to use invoice, order, or holding forms that provide that the client is responsible for loss, theft, or damage to artwork while being held by the client, and to require the client's signature on such forms. The Agent agrees to enforce these provisions, including taking legal action as necessary. If the Agent undertakes legal action, any recovery shall first be used to reimburse the amount of attorney's fees and other expenses incurred and the balance of the recovery shall be divided between Agent and Designer in the respective percentages set forth in Paragraph 5. If the Agent chooses not to require the client to be responsible as described herein, then the Agent agrees to assume these responsibilities. If the Agent receives insurance proceeds due to loss, theft, or damage of artwork while in the Agent's or client's possession, the Designer shall receive no less than that portion of the proceeds that have been paid for the Designer's artwork.

3. Term

This Agreement shall take effect on the _____ day of _____, 200_, and remain in full force and effect for a term of one year, unless terminated as provided in Paragraph 10.

4. Prices

At this time the minimum base prices charged to clients by the Agent are as follows:

Sketch (apparel market)

Repeat (apparel market)

Colorings (apparel market)

Sketch (home furnishing market)

Repeat (home furnishing market)

Colorings (home furnishing market)

Other

The Agent agrees that these prices are minimum prices only and shall be increased whenever possible (i.e., when the work is a rush job or becomes larger or more complicated than is usual.) The Agent also agrees to try to raise the base price to keep pace with the rate of inflation.

The Agent shall obtain the Designer's written consent prior to entering into any contract for payment by royalty.

No discounts shall be offered to clients by the Agent without first consulting the Designer.

When leaving a design with the Agent for possible sale, the Designer shall agree with the Agent as to the price to be charged if the design should bring more than the Agent's base price.

5. Agent's Commissions

The rate of commission for all artwork shall be ______. It is mutually agreed by both parties that no commissions shall be paid on assignments rejected by the Designer or for which the Designer does not receive payment, regardless of the reasons payment is not made.

On commissioned originals and service work, expenses incurred in the execution of a job, such as phone calls, shipping, etc., shall be billed to the client in addition to the fee. No Agent's commission shall be paid on these amounts. In the event that a flat fee is paid by the client, it shall be reduced by the amount of expenses incurred by the Designer in performing the assignment, and the Agent's commission shall be payable only on the fee as reduced for expenses. It is mutually agreed that if the Agent offers a client a discount on a large group of designs including work of other designers, then that discount will come out of the Agent's commission since the Agent is the party who benefits from this volume.

6. Commissioned Work

Commissioned work refers to all artwork done on a nonspeculative basis. The Agent shall provide the Designer with a copy of the completed order form that the client has signed. The order form shall set forth the responsibilities of the client in ordering and purchasing artwork. To this the Agent shall add the date by which the artwork must be completed and any additional instructions that the Agent feels are necessary to complete the job to the client's satisfaction. The Agent will sign these instructions. Any changes in the original instructions must be in writing, signed by the Agent, and contain a revised completion date.

It is mutually agreed that all commissioned work generated by the Designer's work shall be offered first to the Designer. The Designer has the right to refuse such work.

The Agent agrees to use the order confirmation form of the Graphic Artists Guild, or a form that protects the interests of the Designer in the same manner as that form. The order form shall provide that the Designer will be paid for all changes of original instructions arising through no fault of the Designer. The order form shall also provide that if a job is canceled through no fault of the Designer, a labor fee shall be paid by the client based on the amount of work already done and the artwork will remain the property of the Designer. In a case in which the job being canceled is based on artwork that belongs to the client, such as a repeat or coloring, a labor fee will be charged as outlined above and the artwork will be destroyed. If the artwork is already completed in a satisfactory manner at the time the job is canceled, the client must pay the full fee.

7. Holding Policy

In the event that a client wishes to hold the Designer's work for consideration, the Agent shall establish a maximum holding time with the client. This holding time shall not exceed 5 working days. Any other arrangements must first be discussed with the Designer. The Agent agrees to use the holding form of the Graphic Artists Guild, or a form that protects the interests of the Designer in the same manner as that form. All holding forms shall be available for the Designer to see at any time.

8. Billings and Payments

The Agent shall be responsible for all billings. The Agent agrees to use the invoice form of the Graphic Artists Guild, or a form that protects the interests of the Designer in the same manner as that form. The Agent agrees to provide the Designer with a copy of all bills to clients pertaining to the work of the Designer. The Designer will provide the Agent with a bill for his or her work for the particular job. The Designer's bill shall be paid by the Agent within 1 week after the delivery of artwork or, if the Agent finds it necessary, within 10 working days after receipt of payment from the client. The terms of all bills issued by the Agent shall require payment within 30 calendar days or less. If the client does not pay within that time, the Agent must immediately pursue payment and, upon request, inform the Designer that this has been done. The Agent agrees to take all necessary steps to collect payment, including taking legal action if necessary. If either the Agent or Designer undertakes legal action, any recovery shall first be used to reimburse the amount of attorney's fees and other expenses incurred and the balance of the recovery shall be divided between the Agent and Designer in the respective percentages set forth in Paragraph 5. The Agent agrees, whenever possible, to bill in such a way that no single bill exceeds the maximum that can be sued for in small-claims court.

continued...

Under no circumstances shall the Agent withhold payment to the Designer after the Agent has been paid. Late payments by the Agent to the Designer shall be accompanied by interest calculated at the rate of 11/2% monthly.

9. Inspection of the Books and Records

The Designer shall have the right to inspect the Agent's books and records with respect to proceeds due the Designer. The Agent shall keep the books and records at the Agent's place of business and the Designer may make such inspection during normal business hours on the giving of reasonable notice.

10. Termination

This Agreement may be terminated by either party by giving 30 days' written notice by registered mail to the other party. All artwork executed by the Designer not sold by the Agent must be returned to the Designer within these 30 days. In the event of termination, the Agent shall receive commissions for all sales made or assignments obtained by the Agent prior to the termination date, regardless of when payment is received. No commissions shall be payable for sales made or assignments obtained by the Designer after the termination date.

11. Assignment

This Agreement shall not be assigned by either of the parties hereto. It shall be binding on and inure to the benefit of the successors, administrators, executors, or heirs of the Agent and Designer.

12. Arbitration

Any disputes in excess of \$_____ (maximum limit for small-claims court) arising out of this Agreement shall be submitted to binding arbitration before a mutually agreed-upon arbitrator pursuant to the rules of the American Arbitration Association. The Arbitrator's award shall be final and judgment may be entered in any court having jurisdiction thereof. The Agent shall pay all arbitration and court costs, reasonable attorney's fees, and legal interest on any award of judgment in favor of the Designer.

13. Notices

All notices shall be given to the parties at their respective addresses set forth above.

14. Independent Contractor Status

Both parties agree that the Agent is acting as an independent contractor. This Agreement is not an employment agreement, nor does it constitute a joint venture or partnership between the Designer and Agent.

15. Amendments and Merger

All amendments to this Agreement must be written. This Agreement incorporates the entire understanding of the parties.

16. Other Provisions

17. Governing Law

This Agreement shall be governed by the laws of the State of ______.

18. Acceptance of Terms

The signature of both parties shall evidence acceptance of these terms.

In witness whereof, the parties have signed this Agreement as of the date set forth above.

Designer

Agent

Surface/Textile Designer's Estimate and Confirmation Form

FR	ONT
Designer's	s Letterhead
то	Date
	Pattern Number
	Due Date
ESTIMATED PRICES	
Sketch	
Repeat	
Colorings	
Corners	
Tracings	
Other	
DESCRIPTION OF ARTWORK	
Repeat	
Size	
Colors	
Type of Printing	
1/2 Drop Yes	□ No
SPECIAL COMMENTS	
conti	inued

TERMS

1. Time for Payment

Because the major portion of the above work represents labor, all invoices are payable 15 days net. A 11/2% monthly service charge is payable on all unpaid balances after this period. The grant of textile usage rights is conditioned on receipt of payment.

2. Default of Payment

The Client shall assume responsibility for all collection of legal fees necessitated by default in payment.

3. Estimated Prices

Prices shown above are minimum estimates only. Final prices shall be shown in invoice.

4. Payment for Changes

Client shall be responsible for making additional payments for changes requested by Client in original assignment.

5. Expenses

Client shall be responsible for payment of all extra expenses rising from assignment, including but not limited to mailings, messengers, shipping charges, and shipping insurance.

6. Sales Tax

Client shall assume responsibility for all sales taxes due on this assignment.

7. Cancellation Fees

Work canceled by the client while in progress shall be compensated for on the basis of work completed at the time of cancellation and assumes that the Designer retains the project, whatever its stage of completion. Upon cancellation, all rights, publication and other, revert to the Designer. Where Designer creates corners that are not developed into purchased sketches, a labor fee will be charged, and ownership of all copyrights and artwork is retained by the Designer.

8. Insuring Artwork

The client agrees when shipping artwork to provide insurance covering the fair market value of the artwork.

9. Uniform Commercial Code

The above terms incorporate Article 2 of the Uniform Commercial Code.

10. Warranty of Originality

The Designer warrants and represents that to the best of his/her knowledge, the work assigned hereunder is original and has not been previously published, or that consent to use has been obtained through the undersigned from third parties is original or, if previously published, that the consent to use has been obtained on an unlimited basis; that the Designer has full authority to make this agreement; and that the work prepared by the Designer does not contain any scandalous, libelous, or unlawful matter. This warranty does not extend to any uses that the Client or others may make of the Designer's product that may infringe on the rights of others. Client expressly agrees that it will hold the Designer harmless for all liability caused by the Client's use of the Designer's product to the extent such use infringes on rights of others.

11. Limitation of Liability

Client agrees that it shall not hold the Designer or his/her agents or employees liable for any incidental or consequential damages that arise from the Designer's failure to perform any aspect of the Project in a timely manner, regardless of whether such failure was caused by intentional or negligent acts or omissions of the Designer or a third party.

12. Dispute Resolution

Any disputes in excess of \$______ (maximum limit for small-claims court) arising out of this Agreement shall be submitted to binding arbitration before a mutually agreed-upon arbitrator pursuant to the rules of the American Arbitration Association. The Arbitrator's award shall be final, and judgment may be entered in any court having jurisdiction thereof. The Client shall pay all arbitration and court costs, reasonable attorney's fees, and legal interest on any award of judgment in favor of the Surface/Textile Designer.

13. Acceptance of Terms

Consented and agreed to
Designer's signature/date
Authorized signature/date
Client name and title

Designer's Letterhead		
то	Date Pattern number	
NUMBER OF DESIGNS HELD		
	Sketch	
Design	Number of designs held	
	Sketch	
Design	Number of designs held	
	Sketch	
Design	Number of designs held	
	Sketch	
Design	Number of designs held	
	Sketch	
Design	Number of designs held	
	Sketch	
Design		

The submitted designs are original and protected under the copyright laws of the United States, Title 17 United States Code. These designs are submitted to you in confidence and on the following terms:

1. Ownership and Copyrights

You agree not to copy, photograph, or modify directly or indirectly any of the materials held by you, nor permit any third party to do any of the foregoing. All artwork and photographs developed from these designs, including the copyrights therein, remain my property and must be returned to me unless the designs are purchased by you. Any transfer of rights is conditional upon receipt of full payment.

2. Responsibility for Artwork

You agree to assume responsibility for loss, theft, or any damage to the designs while they are being held by you. It is agreed that the fair market value for each design is the price specified above.

3. Holding of Artwork

You agree to hold these designs for a period not to exceed ______ working days from the above date. Any holding of artwork beyond that period shall constitute a binding sale at the price specified above. You further agree not to allow any third party to hold designs unless specifically approved by me.

4. Arbitration

Any disputes in excess of \$ ______ (maximum limit for small-claims court) arising out of this Agreement shall be submitted to binding arbitration before a mutually agreed-upon arbitrator pursuant to the rules of the American Arbitration Association. The Arbitrator's award shall be final, and judgment may be entered in any court having jurisdiction thereof. The party holding the designs shall pay all arbitration and court costs, reasonable attorney's fees, and legal interest on any award of judgment in favor of the Surface/ Textile Designer.

5. Uniform Commercial Code

The above terms incorporate Article 2 of the Uniform Commercial Code.

6. Acceptance of Terms

Consented and agreed to	
Designer's signature/date	
Authorized signature/date	
Client's name and title	GUILD

	Designer's	Letterhead
то		Date Invoice Number Purchase Order Number Stylist Designer
		Pattern Number Price Subtotal
		Subtotal Sales Tax Payments on Account Balance Due

TERMS

1. Receipt of Artwork

Client acknowledges receipt of the artwork specified above.

2. Time for Payment

Because the major portion of the above work represents labor, all invoices are payable 15 days net. The grant of textile usage rights is conditioned on receipt of payment. A 1 1/2% monthly service charge is payable on unpaid balance after expiration of period for payment.

3. Default in Payment

The Client shall assume responsibility for all collection of legal fees necessitated by default in payment.

4. Adjustments to Invoice

Client agrees to request any adjustments of accounts, terms, or other invoice data within 10 days of receipt of the invoice.

5. Uniform Commercial Code

These terms incorporate Article 2 of the Uniform Commercial Code.

6. Dispute Resolution

Any disputes in excess of \$_____ (maximum limit for small-claims court) arising out of this Agreement shall be submitted to binding arbitration before a mutually agreed-upon arbitrator pursuant to the rules of the American Arbitration Association. The Arbitrator's award shall be final, and judgment may be entered in any court having jurisdiction thereof. The Client shall pay all arbitration and court costs, reasonable attorney's fees, and legal interest on any award of judgment in favor of the Designer.

7. Acceptance of Terms

Consented and agreed to	Å
Designer's signature/date	
Authorized signature/date	
Client's name and title	GULD

Web Site Design & Maintenance Order Form

This job order form is a sample of a possible contract for Web site development and maintenance. Since the field is changing very rapidly, artists should view this as a model and amend it to fit their particular circumstances. Remove all language in italics before using this form.

Developer's Letterhead		
то	Date	
	Commissioned by	
	Purchase Order Number	
	Job Number	
DESCRIPTION OF ASSIGNMENT		
Primary Use		
	he page is a frame page, the number of frames per page)	
Pixel Length per Screen Ma	aximum Preferred Minimum	
Description of Materials to Be Supplied	by Client	
Date Due		

RIGHTS TRANSFERRED

The material on the disk can be used only for the purposes stated below. All other use(s) and modification(s) is (are) prohibited. The material on the disk may not be copied without the Developer's permission and must be returned after use. Any transfer of rights is conditional upon receipt of full payment.

SYSTEM APPLICATIONS

(For use on specific machine or compiled into other operation languages)

PRODUCTION SCHEDULE (Including milestones, dates due, and appropriate fees.)

Milestone	Due Date	Payment upon Acceptance
Contract Signing		\$
Delivery of Web Site Design		\$
Delivery of Beta Version		\$
Delivery of Final Version (includes return of source materials to Client)		<u>\$</u>
Acceptance of Final Version		\$
Total		\$
Bonus: Client agrees to pay Develope	er a bonus of	navable to the Developer in the event an accent-

Bonus: Client agrees to pay Developer a bonus of ______ payable to the Developer in the event an acceptable Final Version of the Web site is delivered to the Client prior to ______ (date).

continued...

TERMS

1. Time for Payment

Payment is due at each milestone upon the Client's acceptance of the Deliverables. All invoices are payable within 30 days of receipt. A 11/2% monthly service charge is payable on all overdue balances. The grant of any license or right of copyright is conditioned on receipt of full payment.

2. Default in Payment

The Client shall assume responsibility for all collection of legal fees necessitated by default in payment.

3. Estimates

If this form is used for an estimate or assignment confirmation, the fees and expenses shown are minimum estimates only. Final fees and expenses shall be shown when invoice is rendered. The Client's approval shall be obtained for any increases in fees or expenses that exceed the original estimate by 10% or more.

4. Expenses

The Client shall reimburse the Developer for all expenses arising from this assignment, including the payment of any sales taxes due on this assignment, and shall advance \$______ to the Developer for payment of said expenses.

5. Internet Access

Access to Internet will be provided by a separate Internet Service Provider (ISP) to be contracted by the Client and who will not be party to this agreement.

6. Progress Reports

The Developer shall contact or meet with the Client on a mutually acceptable schedule to report all tasks completed, problems encountered, and recommended changes relating to the development and testing of the Web site. The Developer shall inform the Client promptly by telephone upon discovery of any event or problem that may delay the development of the work significantly.

7. Developer's Guarantee for Program Use

The Developer guarantees to notify the Client of any licensing and/or permissions required for artgenerating/driving programs to be used.

8. Changes

The Client shall be responsible for making additional payments for changes in original assignment requested by the Client. However, no additional payment shall be made for changes required to conform to the original assignment description. The Client shall offer the Developer the first opportunity to make any changes.

9. Testing and Acceptance Procedures

The Developer will make every good-faith effort to test all deliverables thoroughly and make all necessary corrections as a result of such testing prior to handing over the deliverables to the Client. Upon receipt of the deliverables, the Client shall either accept the deliverable and make the milestone payment set forth herein or provide the Developer with written notice of any corrections to be made and a suggested date for completion, which should be mutually acceptable to both the Developer and the Client. The Developer shall designate ______ (name)

and the Client shall designate

(name) as the only designated persons who will send and accept all deliverables and receive and make all communications between the Developer and the Client. Neither party shall have any obligation to consider for approval or respond to materials submitted other than through the designated persons listed above. Each party has the right to change its designated person upon ______ day(s) notice to the other.

10. Web Site Maintenance

The Developer agrees to provide the Client with reasonable technical support and assistance to maintain and update the Web site on the Internet during the Warranty Period of (dates) at no cost to the Client. Such assistance shall not exceed _____ hours per calendar month. After the expiration of the Warranty Period, the Developer agrees to provide the Client with reasonable technical support and assistance to maintain and update the Web site on the Internet for an annual fee of \$____ for a period of vears after the last day of the Warranty Period payable 30 days prior to the commencement date of each year of the Maintenance Period. Such maintenance shall include correcting any errors or any failure of the Web site to conform to the specifications. Maintenance shall not include the development of enhancements to the originally contracted project.

11. Enhancements

Under the maintenance agreement, if the Client wishes to modify the Web site, the Developer shall be given first option to provide a bid to perform such enhancements.

12. Confidential Information

The Developer acknowledges and agrees that the source materials and technical and marketing plans or other sensitive business information, as specified by the Client, including all materials containing said information, that are supplied by the Client to the Developer or developed by the Developer in the course of developing the Web site are to be considered confidential information. Information shall not be considered confidential if it is already publicly known through no act of the Developer.

13. Return of Source Information

Upon the Client's acceptance of the Final Version, or upon the cancellation of the project, the Developer shall provide the Client with all copies and originals of the source materials provided to the Developer.

14. Ownership of Copyright

Client acknowledges and agrees that Developer retains all rights to copyright in the subject material.

15. Ownership and Return of Artwork

The Developer retains ownership of all original artwork, in any media, including digital files, whether preliminary or final. The Client waives the right to challenge the validity of the Developer's ownership of the art subject to this agreement because of any change or evolution of the law and will return all artwork within 30 days of use.

16. Cancellation

In the event of cancellation of this assignment, ownership of all copyrights and any original artwork shall be retained by the Developer, and a cancellation fee for work completed, based on the prorated portion of the next payment and expenses already incurred, shall be paid by the Client.

17. Copy-Protection

The Client must copy-protect all final art that is the subject of this agreement against duplication or alteration.

18. Credit Lines

The Developer shall be given credit on: (a) floppy disk, (b) documentation, (c) packaging, (d) Developer's mark on art.

□ If this box is checked, the Developer shall receive copyright notice in this form: © 200_____.

19. Alterations

Any electronic alteration of original art (color shift, mirroring, flopping, combination cut and paste, deletion) creating additional art is prohibited without the express permission of the developer. The Developer will be given first opportunity to make any alterations required. Unauthorized alterations shall constitute additional use and will be billed accordingly.

20. Other Operating Systems Conversions

The Developer shall be given first option at compiling the work for operating systems beyond t he original use.

21. Unauthorized Use and Program Licenses

The Client will indemnify the Developer against all claims and expenses arising from uses for which the Client does not have rights to or authority to use. The Client will be responsible for payment of any special licensing or royalty fees resulting from the use of graphics programs that require such payments.

22. Warranty of Originality

The Developer warrants and represents that, to the best of his/her knowledge, the work assigned hereunder is original and has not been previously published, or that consent to use has been obtained on an unlimited basis: that all work or portions thereof obtained through the undersigned from third parties is original or, if previously published, that consent to use has been obtained on an unlimited basis; that the Developer has full authority to make this agreement; and that the work prepared by the Developer does not contain any scandalous, libelous, or unlawful matter. This warranty does not extend to any uses that the Client or others may make of the Developer's product that may infringe on the rights of others. CLIENT EXPRESSLY AGREES THAT IT WILL HOLD THE DEVELOPER HARMLESS FOR ALL LIABILITY CAUSED BY THE CLIENT'S USE OF THE DEVELOPER'S PRODUCT TO THE EXTENT SUCH USE INFRINGES ON THE RIGHTS OF OTHERS.

23. Limitation of Liability

Client agrees that it shall not hold the Developer or his/her agents or employees liable for any incidental or consequential damages that arise from the Developer's failure to perform any aspect of the Project in a timely manner, regardless of whether such failure was caused by intentional or negligent acts or omissions of the Developer or a third party. Furthermore, the Developer disclaims all implied warranties, including the warranty of merchantability and fitness for a particular use.

24. Dispute Resolution

Any disputes in excess of \$______ (maximum limit for small-claims court) arising out of this Agreement shall be submitted to final binding arbitration before a mutually agreed-upon arbitrator pursuant to the rules of the American Arbitration Association. The Arbitrator's award shall be final, and judgment may be entered in any court having jurisdiction thereof. The Client shall pay all arbitration and court costs, reasonable attorney's fees, and legal interest on any award of judgment in favor of the Developer.

25. Acceptance of Terms

Consented and agreed to	
Developer's signature/date	
Authorized signature/date	
Client's name and title	

The mission of the Graphic Artists Guild is to promote and protect the economic interests of its members. It is committed to improving conditions for all

creators of graphic art and to raising standards for the entire industry. The Guild's vision for the future would be that, through the work of the Guild

· Graphic artists are recog-

compensated for their work.

all graphic artists are established. Buyers of art and

This chapter describes the Graphic Artists Guild's mission and its vision for the visual communications industry as well as the Guild's history and accomplishments over the past three decades. The many services nized, respected, and fairly and benefits that come with Guild member-Baseline fee levels that protect ship are also detailed.

design recognize the value of graphic art to their businesses, and their relationships with graphic artists are fair and ethical.

- The Guild is recognized widely as the leading organization working on behalf of graphic artists. Through its large, active, and involved membership, the Guild has substantial impact on legislative issues and in the global marketplace.
- Because of Guild programs and services, its members enjoy recognition, prosperity, and security.

Long-Range Goals

Financial and professional respect

To ensure that our members are recognized financially and professionally for the value they provide.

Education and research

To educate graphic artists and their clients about ethical and fair business practices.

To educate graphic artists about emerging trends and technologies having an impact on the industry.

Valued benefits

To offer programs and services that anticipate and respond to the needs of our members, helping them prosper and enhancing their health and security.

Legislative

To advocate for the interests of our members in the legislative, judicial, and regulatory arenas.

Organizational development

To be responsible trustees for our members by building an organization that works proactively on their behalf.

The methods used to accomplish these goals correspond to our members' needs. For instance, 1995 marked the first time in the Guild's more than 30-year history that it negotiated its first bona fide collective bargaining agreement on behalf of graphic designers employed as staff; a subsequent agreement, with significant pay raises and improved benefits, was signed in 1999. For the vast majority of our members who work for themselves, we work hard to help them improve the skills necessary to compete more effectively in today's volatile markets. This book, for example, helps artists, designers, and clients manage their businesses better. Noted illustrator Marshall Arisman, Guild member since 1982, says that if the Guild's *Pricing & Ethical Guidelines* were the only thing the Guild ever accomplished, it alone would justify its existence.

History of the Guild

<u>1967</u>

 Independent national Guild and local Guild branch (Chapter) organized in Detroit, with initial membership of 113, who signed charter on Nov. 2, 1967. Graphic Artists Guild Constitution patterned after that of the Screen Actors Guild.

<u>1968</u>

- Organizing of Guild Chapters initiated in Cleveland, Chicago, New York, and San Francisco.
- First issue of a Graphic Artists Guild newsletter, *To Date*, published in Feb. 1968.
- First annual Guild Art Show in Detroit.

14 The Graphic Artists Guild

<u>1970</u>

- New York branch (Chapter) charter signed March 7, 1970.
- Detroit Guild Chapter calls strike against Campbell Ewald, an automotive industry advertising agency with ties to Chevrolet/-General Motors.

<u> 1971-72</u>

- Detroit Guild strike against Campbell Ewald proves unsuccessful due to lack of solidarity among local area artists and pressure from some Detroit art studios.
- National Guild office in Detroit declines rapidly after failure of strike, while other chapters continue to build and function independently.

<u>1972</u>

 New York Chapter becomes de facto national Guild headquarters, leading efforts to organize Guild Chapters in other cities.

<u> 1973</u>

- First edition of the Graphic Artists Guild's Handbook: Pricing & Ethical Guidelines published as a 20-page booklet.
- First publication of *Flash*, forerunner of current national *Guild News* newsletter.

<u>1974</u>

 Illustrators Guild founded after group of independent illustrators successfully negotiate higher page rates with Children's Television Workshop, publishers of Sesame Street magazine.

<u>1975</u>

- Formation of Professional Practices Committee to help Guild members resolve disputes with clients.
- Second edition of the Graphic Artists Guild's *Handbook: Pricing & Ethical Guidelines* published as a 40-page booklet.

<u>1976</u>

- First publication of the Graphic Artists Guild's *Talent Directory* (now known as the *Directory of Illustration*), the first sourcebook to serve the needs of illustrators.
- Illustrators Guild merges with Graphic Artists Guild.
- Major medical coverage added to benefits program.
- Guild stages its first business seminars for graphic artists: "How to Run Your Own Business" and "Artists & Agents."

<u>1978</u>

- Graphic Artists for Self-Preservation (GASP) merges with Graphic Artists Guild.
- National Guild office organized in New York.
- New York Chapter becomes a cosponsor of the independent Joint Ethics Committee (JEC) to promote the industry's oldest ethical arbitration for industry practitioners.
- Atlanta Chapter chartered.
- Creative Designers Guild merges with Graphic Artists Guild.
- Favorable decision obtained from Copyright Royalty Tribunal that raises fees and improves reporting procedures for 260 PBS stations regarding use of previously published art for broadcasting.
- Guild publishes *Visual Artists Guide to the New Copyright Law* by Tad Crawford.

<u>1979</u>

- First National Board of Directors elected.
- Third edition of the Graphic Artists Guild Handbook: Pricing & Ethical Guidelines published as a 48-page booklet.
- Second edition of the Graphic Artists Guild *Directory of Illustration* published as a 156-page book.
- Textile Designers Guild merges with Graphic Artists Guild.

- Long-term legislative drive initiated that targets federal copyright and tax laws and promotes model legislation to establish legal rights for artists at federal and state levels.
- Model business forms drafted for various graphic art disciplines.
- Negotiation with a number of publishers results in their withdrawal of work-for-hire contracts.

<u>1980</u>

- First National Board Convention.
- Boston Chapter chartered.
- Good Works (no-fee job referral program) initiated.
- Class begins at Graphic Artists Guild's Business School, geared towards professionals and taught by professionals.
- Guild assists a group of textile designers in obtaining a National Labor Relations Board investigation and in filing an unfair labor practices complaint against Print-a Pattern after the designers were terminated subsequent to seeking to negotiate an employment contract. The designers were able to obtain unemployment insurance and entered into a private settlement regarding monies due.
- Favorable ruling from IRS provides Guild with nonprofit status as a labor organization, which allows flexibility and broader activities as a professional association beyond those of purely educational or philanthropic associations.
- Guild publishes *Protecting Your Heirs and Creative Work* by Tad Crawford.
- Guild assists in formation of Children's Book Artists & Author Association (CBAAA).

<u>1981</u>

 Professional Education Program started by New York Chapter.

- Oregon passes an artists' fair practices law (Sects. 359.350-359.365 of Rev. Stat.), based on the Guild's model law.
- Guild's 1981-82 *Directory of Illustration* (3rd ed.) is published as a 272-page book, becoming the largest reference book of its kind in the United States at the time.

<u>1982</u>

- Indiana Chapter chartered.
- Fourth edition of the Graphic Artist Guild's *Handbook: Pricing & Ethical Guidelines* published as a 136-page book.
- Guild succeeds in passing California's artists' fair practices law (Sect. 988 of Civil Code).
- Assistance provided in the formation of the National Writers Union.
- Responding to Guild opposition, IRS withdraws proposed rule that would have disallowed a home-studio deduction where artist has a primary source of income at another location and from other type of work.
- Guild forms the Copyright Justice Coalition, an alliance of creators' groups, including photographers and writers, to lobby for work-for-hire reform in U.S. Congress.
 Forty-two organizations join coalition efforts, the largest creators' advocacy coalition in history.
- Graphic Artists Guild Foundation organized and receives National Endowment for the Arts (NEA) grant for study.
- New York Chapter succeeds in passage of New York State artists' fair practices law (Sects. 1401 & 1403 of Arts & Cult. Affairs Law) and artists' authorship rights law (Art. 12-J of Gen. Bus. Law).

<u>1984</u>

- Cartoonist Guild merges with Graphic Artists Guild.
- Fifth edition of the Graphic Artists Guild's *Handbook: Pricing & Ethical Guidelines* published as a 194-page book.

- Fourth edition of the Graphic Artists Guild *Directory of Illustration* published.
- Testimony is presented before the Democratic National Platform Committee on professional issues.
- Guild proposed a Copyright Justice Act to reform work-for-hire provision of the copyright law by eliminating instances in which artists lose rights and benefits as creators of their work.

<u>1985</u>

- Guild Foundation drafts ethical guidelines for contests and competitions.
- Boston Chapter succeeds in passage of state's Arts Preservation Act.
- Formation of Giolito Communications Center, a specialized reference library operated by the Guild Foundation.
- National Legal Referral Network established.
- Traveling education workshops established.

<u>1986</u>

- Contract terms renegotiated with Children's Television Workshop concerning low pay and work-for-hire issues.
- Testimony presented before Congressional Office of Technology Assessment regarding impact of technology on the profession.
- Guild members testify before U.S. Congress in support of Berne Convention (international copyright agreement concerning moral rights).

<u>1987</u>

- At-Large Chapter organized to provide unaffiliated members with National Board representation.
- National Professional Practices (currently called Grievance) Committee organized.
- Sixth edition of the Graphic Artists Guild's Handbook: Pricing & Ethical Guidelines published as a 208-page book.

 Coalition of Designers merges with Graphic Artists Guild.

<u>1988</u>

- Albany Chapter chartered.
- Guild spearheads formation of Artists for Tax Equity (AFTE) coalition to confront intended application of uniform tax capitalization requirements to all artists and designers. Coalition grows to 75 organizations representing nearly 1 million artists and designers.
- Fifth edition of the Guild's *Directory of Illustration* released in 9" × 12" format and begins annual publication thereafter.

<u>1989</u>

- Guild's leadership helps AFTE win necessary exemption from uniform tax capitalization for all artists and graphic designers through a "technical correction" to the tax law.
- Guild, through the Copyright Justice Coalition, helps convince the Supreme Court to decide in favor of sculptor James Earl Reid in the landmark decision that virtually ends work for hire for freelancers in the absence of a written agreement.
- Testimony presented on work-for-hire abuses to Senate Judiciary's Subcommittee on Patents, Copyrights, and Trademarks.

<u>1990</u>

- Atlanta Chapter helps win protection for artists in Georgia, requiring printers to obtain written authorization of copyright clearance for all print orders over \$1,000.
- Guild, together with the AIGA (American Institute of Graphic Arts) and the SEGD (Society of Environmental Graphic Designers), begins working to clarify sales tax collection guidelines for illustrators and graphic designers in New York State.

1991

- Expanded and updated 7th edition of the Graphic Artists Guild's Handbook: Pricing & Ethical Guidelines published as a 240page book. Three printings bring the total number of copies in circulation to 53,000.
- Guild takes leadership role in addressing health-care crisis for artists and designers, formally endorsing universal health-care legislation in Congress. Steps are taken to organize Artists United for Universal Health, a coalition of arts and artists organizations dedicated to this goal.

1992

- Guidelines for the Interpretation of Sales Tax Requirements for Graphic Designers and Illustrators, formulated by the Guild, AIGA, and SEGD, are approved by New York State Department of Taxation.
- Guild organizes "Eye to Eye," its first national conference and trade show, celebrating 25 years of advancing the interests of creators.

<u>1993</u>

- Chicago Chapter chartered.
- National Labor Relations Board certifies the Guild as the exclusive bargaining agent for the graphic artists employed at Thirteen/WNET (Educational Broadcasting Corporation), a publicly funded television station in New York City.
- Immigration and Naturalization Service relies upon the Guild to provide references for foreign artists seeking temporary work visas.
- Guild Foundation produces an awardwinning set of disability access symbols, Disability Access Symbols Project: Promoting Accessible Places and Programs, produced with the support and technical assistance of the NEA's Office for Special Constituencies. The Disability Access Symbols Project (available in both disk and hard-copy formats) was distributed to hundreds of government and nonprofit organizations.

<u>1994</u>

- Seattle's Society of Professional Graphic Artists, founded in the 1950s, merges with the Guild as the SPGA/Seattle Chapter.
- Eighth edition of the Graphic Artists Guild's Handbook: Pricing & Ethical Guidelines is published. Updated in design, organization, and information, it has grown to nearly 300 pages, with an initial printing of approximately 30,000 copies.
- Guild and ASMP back widow of illustrator Patrick Nagel in copyright ownership lawsuit against *Playboy* (*Dumas vs. Playboy*), concerning after-the-fact work-for-hire contracts stamped on the back of artist's payment checks. (See Chapter 2, Legal Rights and Issues.)

<u>1995</u>

- Northern California Chapter chartered.
- Guild takes proactive lead on electronic rights issues, organizing "Clients vs. Creators: The Struggle Over E-Rights," an industry roundtable featuring Bruce Lehman, U.S. Commissioner of Patents and Trademarks.
- Guild successfully negotiates its first collective bargaining agreement with Thirteen/WNET on behalf of the staff designers it represents, improving hours, pay, and other working conditions.

1996

- Guild organizes coalition of 16 industry organizations and launches "Ask First," a copyright awareness campaign intended to end unauthorized use of images for client presentations.
- Guild reaches understanding with American Society of Media Photographers (ASMP), National Writers Union (NWU), and Copyright Clearance Center (CCC) to establish digital licensing agency.
- Guild reaches agreement with Kopinor, the Norwegian reprographic rights organization, to accept distribution of royalties attributed to U.S. illustrators and designers.

14 The Graphic Artists Guild

- Guild adopts its first strategic plan to adapt to changing industry conditions.
- Guild's World Wide Web site on the Internet is activated: www.gag.org.

<u>1997</u>

- Portland, Oregon, Chapter chartered.
- The Graphic Artists Guild Legal Defense Fund founded.
- Ninth edition of the Graphic Artists Guild's Handbook: Pricing & Ethical Guidelines is published, with 313 pages. More than 70,000 copies sold.

1998

- Southern California Chapter chartered.
- Thirty Years of Raising Standards published, a compendium of Guild history, archival material, and information about the Guild's mission and services.
- First Walter Hortens Distinguished Service Award (to be given annually) presented to illustrator Milton Glaser for his "unswerving devotion to the issues confronting the profession and for focusing wide public attention on those issues" (specifically his public stand against the Chrysler Corporation's preemptive editorial policy).
- First Lifetime Achievement Award presented to Simms Taback for more than 20 years of service to the Guild.
- Guild launches Contract Monitor, an electronic newsletter analyzing industry contracts.
- Guild opposes projected raises in copyright fees and launches copyright registration campaign.
- Revised Code of Ethical Practice adopted.

<u>1999</u>

 After a nearly 20-year search for an appropriate union, Guild membership votes by three-to-one margin to affiliate with the United Auto Workers, creating UAW Local 3030.

- Guild negotiates its second collective bargaining agreement with Thirteen/WNET on behalf of the staff designers it represents, improving pay and working conditions.
- 1999 Walter Hortens Distinguished Service Awards: graphic designer and writer DK Holland wins Professional Practices Award; Robert Kanes, art director of *PCWorld*, wins Outstanding Client Award; and Marybeth Peters, U.S. Register of Copyrights, is given a Special Award for the Advancement of Creators' Rights.
- Copyright rate hike contained to \$30 rather than \$45 due to Guild lobbying efforts, among others.
- The Guild Legal Defense Fund supports two potentially groundbreaking cases: photographer Leslie Kelly's case against Arriba Soft Corporation and the lawsuit by 18 medical illustrators against Advanstar Communications, Inc. (*Teri J. McDermott, et al. v. Advanstar Communications, Inc.*).
- First president from the West Coast elected: illustrator Jonathan Combs of the SPGA/-Seattle Chapter.
- The Campaign for Illustration (C4I) is initiated to preserve the economic wellbeing of illustrators, to help artists defend and control their rights, and to make the illustration community a truly cohesive business and creative force. Its three components are education, action, and community.

<u>2000</u>

- 2000 Walter Hortens Distinguished Service Awards: illustrator Brad Holland wins Professional Practices Award; Steven Heller, art director of *The New York Times Book Review*, wins Outstanding Client Award; and Jonathan Tasini, president of the National Writers Union and lead plaintiff in the groundbreaking electronic rights lawsuit *Tasini, et al. v. The New York Times, et al.*, is given a Special Award for the Advancement of Creators' Rights.
- Philadelphia and DC/Baltimore Chapters chartered.

Taking Action

The Graphic Artists Guild is a national organization whose headquarters are located in New York City. Local Chapters of the Guild exist in Albany, New York; Atlanta, Georgia; Boston, Massachusetts; Chicago, Illinois; DC/Baltimore, Maryland; Indianapolis, Indiana; Los Angeles, California; New York; Philadelphia, Pennsylvania; Portland, Oregon; San Francisco, California; and Seattle, Washington. An At-Large Chapter serves those individuals who do not reside in or near a geographic Chapter.

Unlike other graphic arts organizations dedicated to promoting "excellence in graphic design" or "advancing illustration," the Guild is mandated by its constitution "to advance and extend the economic and social interest of [our] members" and to "promote and maintain high professional standards of ethics and practice and to secure the conformance of all buyers, users, sellers, and employers to established standards."

Foremost among the Guild's activities is the ongoing effort to educate members and nonmembers alike about the business of being a graphic artist. Both nationally and at the Chapter level, the Guild organizes programs on negotiation and pricing strategies, tax issues, self-promotion, time management, and other essential business skills that are not, by and large, taught in art schools. The Guild provides a means for experienced artists to share their understanding of the advertising, publishing, and corporate markets with young artists and a way for artists at every level to share concerns and information. In fact, many artists join the Guild for the information and networking it offers and are drawn into other activities as well.

The bottom line, though, is work—the more the better. The Guild wants to help members get not only jobs but good jobs that recognize the valuable contributions of graphic artists financially and otherwise. One way is through the Graphic Artists Guild *Directory of Illustration* (published annually by Serbin Communications), whose purpose is to make it easier for advertising agencies, marketing executives, art directors, and design firms to find the right artist for the right assignment. Artists find it one of the best advertising values around.

The New York Chapter offers the national *Jobline News*, a weekly newsletter listing job opportunities in all areas of the graphic arts, ranging from freelance and part-time to long-term and full-time staff positions. (Job offerings are not limited to the New York area.) The Guild does not guarantee job placement nor does it act as an agent or a representative. The service, available by mail, fax, and e-mail, merely provides an inside track to job opportunities. Clients can list opportunities in the *Jobline News* free of charge by contacting the Guild office by phone, fax, mail, or e-mail and completing a classified advertisement that includes the job description and contact information. Members, nonmembers, and students pay a modest yearly fee to subscribe.

Guild Chapters in Boston, Chicago, New York, Northern California, and Seattle hold annual illustration trade shows where the work of illustrators is viewed by a steady stream of art buyers from a wide range of venues who come to survey the available talent. But the Guild doesn't just help artist members cope with the market as it is. When the market stacks the deck unfairly against artists, the Guild is determined to do something about it, whether through education, legislative advocacy, or direct intervention. Guild members have established a strong track record of successful lobbying on behalf of artists in state, federal, and regulatory venues, developing trail-blazing publications on professional practices and pricing strategies, and establishing educational seminars and group health, life, and disability insurance plans.

Through lobbying, the Guild has helped strengthen copyright laws, ease the tax burden on freelancers, and gotten the graphic artist's point of view heard in the national health-care debate. The National Grievance Committee helps members resolve grievances, which in turn helps reinforce industry standards. Since knowledge is power, especially in the communication industries, the Guild makes special efforts to keep our members informed through newsletters, programs, and events.

Active membership in the Graphic Artists Guild is the best way to ensure the advancement of creators' interests and equitable professional conditions for all. Today most graphic artists join the Guild to act together to protect their professional integrity and their art by sharing information, discussing problems in the industry, and working to improve the profession. Guild members work together, communicating with each other to take advantage of the experiences of the group, on contract issues, pricing, and artists' rights legislation.

The Campaign for Illustration

One example of taking action is the Graphic Artists Guild's Campaign for Illustration (C4I), which was initiated in 1999 to support, preserve, and promote the positive role that illustrators play in the creative life of this country and to recover the ground illustrators have lost in the recent past. C4I was designed to help illustrators fight for their rights as a unified force on three major fronts: education, action, and community.

- Education: Everyone who works with illustration, including artists, clients, educators, and students, needs to be better informed about the many issues affecting the industry. A variety of activities are being planned to address each constituent group. For instance, ads for the Campaign Against Royalty-Free Images are being run in trade magazines to inform artists about the various problems related to this type of work.
- Action: A range of activities are planned, from helping artists promote and sell their own stock to promoting legislation that would allow artists to bargain collectively.
- **Community**: The goal is to create large, unified blocks of illustrators who are informed about the issues and willing to work together to bring about change. Only by working together will illustrators be able to turn the tide in their favor.

To learn more about C4I, contact the National Office of the Graphic Artists Guild or the Guild's Web site, www.gag.org.

Member Benefits and Services

The needs and concerns of members dictate all the Guild projects, benefits, and services. In addition to national programs, each Chapter of the Guild organizes its own programs to serve the needs of its region. When an issue is recognized as a concern that extends beyond any one Chapter, it is often referred to the National Board for assessment and possible action or, in the case of successful events, implementation in all Chapters.

World Wide Web site

The Guild's Web site—www.gag.org—features a portfolio area for all disciplines, Chapter homepages highlighting events and programs, news briefs, and links to related organizations. *Contract Monitor*, an electronic newsletter that analyzes industry contracts, alerts readers to contract problems and tracks the relationship between graphic artists and publishers.

Artist-to-Artist Web Forum

Artist-to-Artist Web Forum is part of the Guild's Web site. This service is open to Guild members and nonmembers who have questions about professional issues, such as pricing, contracts, or negotiating. Guild members who are seasoned professionals share their experience and know-how. Discussion topics often target problems in the field.

National & local newsletters

The Guild News, a national communication vehicle, is published bimonthly and distributed to members, art supply stores, and teaching institutions with art and design programs. It features a wide variety of issues affecting graphic artists and how they work. It also provides updated information on programs, legislative initiatives, legal issues, hotline tips, book reviews, event calendars, and other items of national and local interest. Submission of articles and artwork from members is welcome (subject to the editor's discretion). Chapters are encouraged to submit pages detailing their activities. Subscriptions are available for \$12 per year for nonmembers (contact the National Office for further information).

Most Chapters publish their own monthly or quarterly newsletters, covering issues of regional interest, announcing meetings and programs, and reporting on members' activities.

The Graphic Artists Guild Directory of Illustration

Published by Serbin Communications and sponsored by the Graphic Artists Guild, this advertising directory for illustrators offers discounted rates for Guild members and has a free distribution to more than 251,000 art directors and buyers around the world. For more information or to reserve pages in the *Directory of Illustraton*, contact Serbin Communications at 800.876.6425.

Professional education programs

Whether it's promoting the business of art or updating the many skills needed to compete effectively in the market, the Guild offers events throughout the year on topics of special interest. Some may be discipline-specific (related to graphic design, illustration, surface/textile design, multimedia, cartooning, or computer design); others appeal to the broad spectrum of Guild members (such topics as negotiation, marketing, self-promotion, and financial planning). Members receive announcements for general and disciplinespecific meetings from individual Chapters and through the national Guild News.

Another component of the program is curriculum development for art schools, in which teachers who are Guild members share information about professional practices on the undergraduate level. The Guild also sponsors courses and workshops in cooperation with art schools, undergraduate art departments, and related organizations.

14 The Graphic Artists Guild

<u>Professional practices moni-</u> toring & dispute resolution

The national organization monitors problems that occur throughout the industry and tracks member complaints on issues concerning standards, practices, and pricing. Most Chapters offer grievance procedures for members who have contractual or professional disputes with clients. These Chapter committees help resolve disputes through informal contact with the client. If the dispute is not resolved through local committee assistance, the artist may submit the case to the National Grievance Committee. The national committee reviews grievances, makes recommendations for further action, communicates with the client, and may also provide support letters and expert witnesses for court cases.

Legal Referral Network

Because independent contractors often face legal questions particular to their type of business, the Guild has a referral system listing attorneys and accountants around the country who have been selected because of their familiarity with artists' issues and, in some cases, their willingness to work with our members for reduced fees. Network attorneys are available in Albany, New York; Atlanta, Georgia; Boston, Massachusetts; Chicago, Illinois; Indianapolis, Indiana; Los Angeles, California; Miami, Florida; New York City; Portland, Oregon; San Francisco, California; and Washington, D.C. (referrals may not be available in other areas of the country).

<u>Insurance</u>

The Guild provides members with access to health, life, and disability insurance coverage. Through its longtime relationship with the companies offering these plans, the Guild is

National Board of Directors

able to refer members to insurance professionals who can evaluate their special needs and design customized protection packages.

Artist locator service

The Guild's National Office receives dozens of calls each week from potential clients who have seen an artist's work but don't know how to locate the artist. Then artist members are contacted by the Guild on behalf of the prospective client. (Note that addresses and phone numbers of members are confidential and are not available to callers unless specifically instructed otherwise by the member.)

Discounts

Through various agreements, the Guild offers members discounts on such useful services as art and office supplies, overnight delivery services, long-distance phone calls, and car rentals (call the National Office for details). Discounts are also available on most popular talent directories and sourcebooks, as well as books and trade publications. Many Chapters have developed discount programs with suppliers in their areas so that local members can receive from 5 to 20 percent off art supplies and services.

<u>Meetings & networks</u>

Regular membership meetings are hosted by most Guild Chapters. Programs on such issues as negotiating, pricing, resource sharing, or selfpromotion are highlighted. Members are able to confer directly with peers on business issues, keep updated on the latest developments in the field, and socialize. Some Chapters also offer monthly get-togethers for members of a particular discipline (such as children's book illustrators or cartoonists).

The National Board of Directors, which has oversight responsibility for the organization, consists of elected artist members. Each local Chapter has representatives on the National Board. The full board meets at least twice a year to establish goals and priorities, share information on program development, and approve the organization's budget.

The Graphic Artists Guild Foundation

The Graphic Artists Guild Foundation was formed in 1983 to "foster, promote, and advance greater knowledge, appreciation, and understanding of the graphic arts...including the presentation and creation of the graphic arts; activities designed to promote, aid, and advance the study of existing works, and to promote the creation, presentation, and dissemination of new works; to sponsor workshops, training sessions, symposia, lectures, and other educational endeavors." Further, the Foundation's constitution states among its goals that it is "to help monitor and establish rules governing industry practices and to contribute to modifying these when necessary."

The Foundation receives grants and donations to conduct studies that will benefit the industry, the public, and the arts in general. For instance, it undertook a two-year study, partially sponsored by the NEA, of art-related contests and competitions. The study assessed the nature of contests and competitions and developed a set of ethical guidelines and standards for these events.

In 1993, with the support and assistance of the NEA's Office for Special Constituencies, the Foundation developed the Disability Access Symbols Project: Promoting Accessible Places and Programs. These 12 graphic symbols assist the communications needs of design firms, agencies, not-for-profits, and other entities who need to show that programs and services are accessible to people with mobility, sight, or hearing impairments. To achieve standardization, the symbols and accompanying text were reviewed by more than 15 organizations representing people with various disabilities in connection with the design community. The symbols are available on

floppy disks (DOS or Mac) and as reproducible slicks. Please call 800.500.2672 for more information.

The Foundation also administers the Giolito Communication Center, a reference library containing more than 1,000 books and periodicals on subjects related to the graphic communications field, an industry talent directory archive, and a wide assortment of graphic software programs. The center also provides a Mac workstation available for use at a nominal fee when reservations are made in advance.

The Graphic Artists Guild Foundation provides an avenue for tax-deductible donations and bequests to advance the interests of artists. Donations, which are deductible to the fullest extent allowed by law, can be sent to the Foundation c/o the Graphic Artists Guild. Please make checks payable to the Graphic Artists Guild Foundation. Call 800.500.2672 for further information.

The Graphic Artists Guild Legal Defense Fund

The purpose of the Guild's Legal Defense Fund, founded in June 1997, is to support cases that may have industrywide impact or may set a precedent that could affect the working lives of graphic artists. Requests for assistance are referred to the Guild's National Public Affairs Committee, which makes recommendations to the Executive Committee. The Executive Committee makes the deciding vote on which cases will receive support from the Fund.

Some recent cases supported by the Fund include the National Association of Freelance Photographers v. the Associated Press, Kelly v. Arriba Soft, and Teri J. McDonald, et al. v. Advanstar Communications, Inc.

Contributions to the Fund are gladly accepted; checks should be made out to Graphic Artists Guild, with a note in the memo section indicating Legal Defense Fund.

14 The Graphic Artists Guild

On Joining the Guild

When you join the Guild, you're making a very definite statement of your conviction that graphic artists deserve the same respect society affords other professionals.

Joining the Guild affirms the value of artists working together to improve standards of pay and working conditions in the industry. Joining is an endorsement of the highest standards of ethical conduct in the marketplace.

Joining the Guild is joining the effort to advance the rights and interests of artists through legislative reform (as noted throughout this book). For example, our ongoing advocacy to end the widespread abuse of the copyright law's work-for-hire language, our successful campaign against unfair taxation of artists, our dedication to universal health care, and our commitment to creator empowerment. Joining the Guild may provide you with a vehicle for contract bargaining—with your employer if you are a staff artist or even with your client, under the proper conditions.

Joining the Guild puts you in contact with other artists who share your concerns. It's a way to share ideas, information, and business skills with your colleagues.

The Graphic Artists Guild is the only union in the United States dedicated to advancing the interests of professional artists and designers. If you want to work together to promote positive change for artists in the marketplace and in society, you belong in the Guild!

Graphic Artists Guild Membership Application

The Graphic Artists Guild, UAW Local 3030, is a national organization with local chapters. When you join the Guild, you join the National organization and are assigned to a local Chapter servicing your area. If there is no local Chapter near you, you will be assigned to the At-Large Chapter. For more information about the Guild, call 800.500.2672 or visit the Web site (www.gag.org).

Your membership is effective upon the Guild's receipt of a completed, signed application, the application fee, and the appropriate dues amount. Please allow three to four weeks to receive membership material.

For questions about membership, call the Membership Department at 212.791.3400 or e-mail to membership@gag.org.

Please complete all portions of the application (at the end of the book), sign it, and return it with the application fee and dues payment to: Graphic Artists Guild, UAW Local 3030 AFL-CIO, 90 John St., Suite 403, New York, NY 10038-3202. If paying by credit card, you may fax the completed application to 212.791.0333.

Chapter 15 Resources & References

Toc

TIC T_{OC} Graphic artists need a wide range of resources to keep up with the demands of their profession. The Graphic Artists Guild has collected the information in this chapter over the course This chapter lists the many valuable of its three decades and resources and references-books, publioffers it as a service to the cations, directories, related organizations, visual communications indusmerchandise markets and shows, Web try. Though every effort has sites—that the Guild recommends. been made to provide the glossary defining terms used throughout most up-to-date contact inforthe book is also provided. mation, things can change

Α

very quickly these days. Please notify the Guild of additional resources that can be included in the next edition.

[423]

The Graphic Artists Guild Bookshelf

These books and audiocassettes are available from the Graphic Artists Guild, 90 John St., Suite 403, New York, NY 10038 by prepaid check or by Visa/MasterCard. To order, call 800.500.2672, ext. 100 or e-mail sales@gag.org. Be sure to inquire about shipping and handling charges. New York sales tax of 8.25% is applicable on orders mailed to addresses in New York State. Guild members are entitled to a 15% discount off the list price.

The Artist's Complete Health & Safety Guide

Monona Rossol | 2d ed. 344 pages | \$19.95. Everything you need to know about the safe use of art or craft materials that may contain toxic chemicals or environmental pollutants so you can make your workplace safe.

Business & Legal Forms

for Graphic Designers Tad Crawford & Eva Doman Bruck | rev. ed. | CD-ROM (Mac/PC) | 240 pages | \$24.95.

Business & Legal

Forms for Illustrators Tad Crawford | rev. ed. CD-ROM (Mac/PC) 192 pages | \$24.95.

These two success kits for illustrators and graphic designers provide complete sets of business and legal forms, sample contracts, and a wealth of information to meet the needs of creative professionals.

The Business of Being an Artist

Daniel Grant | 3rd ed. 352 pages, | \$19.95.

How to get exhibited, find a dealer, understand contracts, sell work, use agents and publicists. Also covers education and work choices, health and safety issues, and how to obtain grants and commissions.

Careers by Design: A Headhunter's Secrets for Success & Survival in Graphic Design Roz Goldfarb | rev. ed.

224 pages | \$18.95.

The well-known president of a leading New York City graphic design personnel agency offers her prescription for success in the industry.

Caring for Your Art

Jill Snyder | illustrations by Joseph Montague 176 pages | \$14.95. Step-by-step guidance for the safekeeping of artwork, with the best ways to store, handle, document, photograph, pack, transport, insure, and secure your art.

The Digital Designer: The Graphic Artist's Guide to the New Media Steven Heller& Daniel Brennan

Steven Heller & Daniel Brennan 154 pages | \$29.95.

Examines the unique new forms of communication used in multimedia and how they challenge the role of today's graphic designer. Everyone who uses multimedia either as a creative medium or as a tool for everyday life will find this a valuable resource.

Digital Property: Currency of the 21st Century Leslie Harris

240 pages | \$16.95.

An essential and immensely readable guide to managing, protecting, and profiting from creative online content. In clear, nontechnical language, Harris, an expert in copyright law who consults on legal issues relating to the arts, entertainment, technology, and information, explains the tremendous value of intellectual property to content providers.

Director Demystified

Jason Roberts 500 pages | CD-ROM | \$39.95.

Real-world projects explain Macromedia Director. Each project can be assembled using and text graphics, sounds, CD-ROM. included on the Includes beginning level as Director well as advanced techniques and a primer on Director's Lingo, powerful scripting language.

Electronic Design & Publishing Business Practices

Liane Sebastian | 2d ed. 216 pages | \$19.95.

Guidelines for print production: ethics, roles, responsibilities, ownership, communication, policies, and procedures. Includes both traditional and computer production. Ideal for buyers of design, managers, writers, desktop publishers, graphic designers, art directors, photographers, illustrators, prepress houses, color separators, and printers.

How to Survive and Prosper as an Artist Caroll Michels | 4th ed.

316 pages | \$14.95.

Subtitled "Selling Yourself Without Selling Your Soul," this is a no-nonsense, practical, creative guide that has sold more than 70,000 copies. Designed to help artists launch and sustain their careers, this newly revised edition includes a chapter on career blocks as well as updated computer and Internet information.

Legal Guide for the Visual Artist

Tad Crawford | 4th ed. 272 pages | \$19.95.

Expanded and updated, the fourth edition is a complete revision, not only providing updated legal information, but also covering the ever-increasing importance of new media and electronic rights. Twentyfour chapters cover such topics as copyright, contracts, censorship, moral rights, sales (by artist, gallery, or agent), planning, taxation. estate museums, collecting, and grants. The book suggests basic strategies, gives information to help with further action, and contains many sample legal forms and contracts.

Legal-Wise: Self-Help Legal Forms

Carl Battle | 208 pages | \$18.95. Ready-to-use forms for a living trust, power of attorney, simple divorce, protecting ideas and copyrights, and much more.

Licensing Art & Design: A Professional's Guide to Licensing and Royalty Agreements

Caryn R. Leland | rev. ed. 128 pages | \$16.95.

A professional's guide to licensing and royalty agreements. Includes strategies for negotiating licensing agreements to help you maximize royalties and a negotiation checklist to help you evaluate the deals you are offered.

Looking Closer: Critical Writings on Graphic Design

Introduction • Steven Heller 256 pages | \$18.95.

A collection of the best contemporary writing about graphic design, including essays about inspiration, ethics, isms, the impact of the new technology, and the role of design in the larger culture.

The Macintosh Bible

Sharon Zardetto Aker | 7th ed. 1,040 pages | \$29.95.

Completely revised from the last, best-selling edition, the 7th edition is packed with information on computing basics, the Internet, Mac applications, and software updates, including coverage of MacOS8.5, kid's software, and multimedia.

Make It Legal

Lee Wilson

272 pages | \$18.95.

A guide to copyright, trademark, libel, and false advertising laws for graphic designers, advertising copywriters, art directors, producers, photographers, and illustrators.

Management for the Small Design Firm

Jim Morgan | 176 pages | \$45. Every problem that managers of small firms face is addressed in this thorough handbook. Chapters dealing with practice management, human resources management, financial management, and project management offer a wealth of detailed information about everything from budgets to time management to individual productivity. Advice is based on case studies of 20 successful small design practices in the U.S., ranging from solo practitioners to 15member firms.

A Practical Guide to Working with Graphic Designers

Albany Chapter of the Graphic Artists Guild | 16 pages 10/\$18 • 25/\$42.50 50/\$80 • 100/\$150.

A nifty, succinct pocket guide for graphic designers to give clients that will tell them almost everything they need to know. Packed into this 4 5/8 by 61/4-inch format is an amazing amount of information, including estimates, contracts, authors' alterations, scheduling, the approval process, questions to ask the designer, and the all-important pricing and payment process. Also includes a sample production schedule. Order in packs of 10, 25, 50, or 100 from the National Office.

Protecting Your Rights & Increasing Your Income

(60-minute audiocassette) Tad Crawford | 1990 | \$12.95. This 60-minute tape provides the basics of copyright law for authors, graphic designers, illustrators, photographers and covers everything artists need to know about handling contracts.

Real World Scanning and Halftones

David Blatner & Stephen Roth 296 pages | \$24.95.

Save time and money by mastering digital halftone processing—everything from scanning images and tweaking them on your Mac to imagesetting them. You'll learn about optical character recognition software,gamma control, sharpening, moires, PostScript halftones, Photo CD, and imagemanipulating applications like Photoshop and PhotoStyler.

Selling Graphic Design

Don Sparkman | 2d ed. 256 pages | \$19.95.

Discusses how to find clients, develop lasting relationships, write effective proposals, offer the right design solutions, and provide services to fit a client's needs and budget.

Time Management for the Creative Person

Lee Silber | 283 pages | \$14.

Designed for right-brain people who know all too well that creativity doesn't always follow a time clock, this book recognizes that their creativity and original thinking can also provide innovative solutions to these problems. Scores of practical tips on how to get control of time and see the clock and calendar as allies, rather than enemies.

Recommended Reading

Battle, Carl W. Senior Counsel: Legal & Financial Strategies for Age 50 & Beyond. New York: Allworth Press.

Caplin, Lee Evan. **The Business of Art**. Englewood, NJ: Prentice-Hall, Inc., 1982.

Clayman, Toby, and Steinberg, Cobett. **The Artist's Survival Manual: A Complete Guide to Marketing Your Work**. New York: Charles Scribner & Sons, 1984.

Cochrane, Diane. The Business of Art. New York: Watson-Guptill, 1978.

Colyer, Martin. **How to Find and Work with an Illustrator**. Cincinnati, OH: North Light Books, 1990.

Craig, James. **Designing with Type, 4th ed**. New York: Watson-Guptill, 1999.

Production for the Graphic Designer. New York: Watson-Guptill, 1990.

Crawford, Tad, and Kopelman, Arie. Selling Your Graphic Design & Illustration. New York: Allworth Press, 1981.

Davis, Sally. **The Graphic Artist's Guide to Marketing & Self-Promotion**. Cincinnati, OH: North Light Books, 1987.

Creative Self-Promotion on a Limited Budget: For Illustrators and Designers. Cincinnati, OH: North Light Books, 1992.

Evans, Poppy. Graphic Designer's Ultimate Resource Directory. Cincinnati, OH: North Light Books, 1998.

Fleishman, Michael. **Getting Started as a Freelance Illustrator or Designer**. Cincinnati, OH: North Light Books, 1990

Gordon, Elliott & Barbara. How to Sell Your Photographs & Illustrations. Cincinnati, OH: Writers Digest Books.

Starting Your Small Graphic Design Studio. Cincinnati, OH: North Light Books, 1993. Heller, Steve, and Fernandes, Teresa. **The Business of Illustration.** York: Watson-Guptill, 1995.

_____, Allworth Press, and the School of Visual Arts. **The Education of a Graphic Designer**. New York: Watson-Guptill, 1998.

_____, and Arisman, Marshall, eds. **The Education of an Illustrator**. New York: Allworth Press, 2000.

Howard, Rob. **The Illustrator's Bible**. New York: Watson-Guptill, 1992.

McCann, Michael. Artist Beware: The Hazards and Precautions of Working with Art and Craft Materials. New York: Watson-Guptill, 1979.

Magid, Lawrence J. **The Little Quicken Book**. San Francisco: Peach Pit Press,1996.

Metzdorf, Martha. **The Ultimate Portfolio**. Cincinnati, OH: North Light Books, 1991.

Miller, Lauri. **Promo 2: The Ultimate in Graphic Designer's and Illustrator's Self-Promotion**. Cincinnati, OH: North Light Books, 1992.

Newberry, Betsy. **Designer's Guide to Marketing**. Cincinnati, OH: North Light Books, 1997.

Oldach, Mark. Creativity for Graphic Designers. Cincinnati, OH: North Light Books, 2000.

Rixford, Ellen. 3-Dimensional Illustration: Designing with Paper, Clay, Casts, Wood, Assemblage, Plastics, Fabric, Metal, and Food. New York: Watson-Guptill, 1992.

Roberts, Jason. **Director Demystified**. San Francisco: Peach Pit Press, 2000.

Sedge, Michael. Successful Syndication: A Guide for Writers and Cartoonists. New York: Allworth Press, 2000.

Sellers, Don. ZAP! How Your Computer Can Hurt You—and What You Can Do About It. San Francisco: Peach Pit Press, 1994.

Sparkman, Don. **The Design & Printing Buyer's Survival Guide**. New York: Allworth Press, 1995.

Stewart, Joyce. **How to Make Your Design Business Profitable**. Cincinnati, OH: North Light Books, 1992.

Wilde, Judith, and Wilde, Richard. Visual Literacy: A Conceptual Approach to Graphic Problem Solving. New York: Watson-Guptill, 2000.

Williams, Theo Stephan. **The Streetwise Guide to Freelance Design & Illustration**. Cincinnati, OH: North Light Books, 1998.

Yeung, Mary. The Professional Designer's Guide to Marketing Your Work. Cincinnati, OH: North Light Books, 1991.

Useful Publications

Advertising Age

Crain Communications 740 Rush Street, Chicago, IL 60611 312.649.5200

Adweek

1515 Broadway, New York, NY 10036-8986 212.536.5336 | 800.722.6658

AIGA Journal of Graphic Design American Institute of Graphic Arts 164 Fifth Avenue, New York, NY 10010

212.807.1990 Airbrush Action

P.O. Box 2052, Lakewood, NJ 08701 732.364.2111 | 800.876.2472

American Printer 29 N. Wacker Drive, Chicago, IL 60606 312.726.2802

Archive

American Showcase 915 Broadway, New York, NY 10010 212.673.6600 | 800.825.0061

The Artist's Magazine

F&W Publications 1507 Dana Avenue, Cincinnati, OH 45207 513.531.2222 | 800.289.0963

Board Report for Graphic Artists

Drew Allen Miller, Publisher Box 300789, Denver, CO 80203 303.839.9058

Communication Arts 110 Constitution Road, Menlo Park, CA 64025 800.258.9111

Creative Business 275 Newbury Street, Boston, MA 02116 617.424.1368 | Fax 617.353.1391

Folio

11 Riverbend Drive S. P.O. Box 4272, Stamford, CT 06907-0272 203.358.9900

Graphic Design: USA Kaye Publishing 1556 Third Avenue, Suite 405, New York, NY 10128 | 212.534.5500

Graphis Magazine

141 Lexington Avenue, New York, NY 10016 212.532.9387 | 800.351.0006

HOW

F&W Publications 1507 Dana Avenue, Cincinnati, OH 45207 513.531.2222 | 800.289.0963

ID: Magazine of International Design F&W Publications 507 Dana Avenue, Cincinnati, OH 45207

507 Dana Avenue, Cincinnati, OH 45207 513.531.2222 | 800.289.0963

Letter Arts Review (formerly Calligraphy Review) P.O. Box 9986, Greensboro, NC 27429 336.272.7604

The Licensing Letter EPM Communications 160 Mercer Street, 3rd FI., New York, NY 10012 | 212.941.0099

Macworld

P.O. Box 54529, Boulder, CO 80323 415.243.0505 | 800.288.6848

PC Week

28 E. 28th Street, 8th Fl., New York, NY 10016 | 212.503.5340

PC World

Subscription Department P.O. Box 54529, Boulder, CO 80323 415.243.0500 | 800.234.3498

Photo District News

A/S/M Communications 1515 Broadway, New York, NY 10036 212.536.5222 | 800.669.1002

Print

RC Publications 3200 Tower Oaks Boulevard, Rockville, MD 20852 301.770.2900 | 800.222.2654

Printing News

Cygnus Publishing 445 Broad Hollow Road, Suite 21, Melville, NY 11747 516.845.2700 | 800.308.6397 Publish! P.O. Box 2002, Skokie, IL 60076-7902 415.243.0600 | 800.685.3435

Publishers Weekly 245 W. 17th Street, New York, NY 10011 212.463.6758/6631

Sign Business National Business Media 2800 W. Midway Blvd., Broomfield, CO 80020 303.469.0424 | 800.769.0424

Step-by-Step Graphics

Dynamic Graphics 6000 N. Forest Park Drive, Peoria, IL 61614 309.688.8800 | 800.255.8800

Women's Wear Daily

Fairchild Publications 7 W. 34th Street, New York, NY 10001-8191 212.630.4000 | 800.289.0273

Industry Directories

Artist's & Graphic Designer's Market

F&W Publications 1507 Dana Avenue, Cincinnati, OH 45207 513.531.2222 | 800.289.0963

The Design Firm Directory

Wefler & Associates P.O. Box 1167, Evanston, IL 60204 847.475.1866

Gale Directory of Publications

Gale Research 27500 Draker Road, Farmington Mills, MI 48331-3535 | 248.699.4253

Gift and Decorative Accessory Buyers Directory

Cahners 345 Hudson Street, New York, NY 10014 | 212.519.7200

National Association of Schools

of Art & Design Directory 11250 Roger Bacon Drive, Suite 21, Reston, VA 20190 | 703.437.0700

O'Dwyer's Directory of Public Relations Firms

J. R. O'Dwyer 271 Madison Avenue, New York, NY 10016 | 212.679.2471

Standard Directory of Advertising Agencies

Reed Reference Publishing 121 Chandon Road, New Providence, NJ 07974 908.464.6800 | 800.521.8110

Standard Periodical Directory

Oxbridge Communications 150 Fifth Avenue, Suite 302, New York, NY 10011 | 212.741.0231 | 800.955.0231 **Thomas Register of Manufacturers**

Thomas Publishing 5 Penn Plaza, New York, NY 10001 212.695.0500

Ulrich's International Periodicals Directory

Working Press of the Nation Reed Elsevier Publishing P.O. Box 31, New Providence, NJ 07974 908.464.6800 | 800.521.8110

Writer's Market

F&W Publications 1507 Dana Avenue, Cincinnati, OH 45207 513.531.2222 | 800.289.0963

Talent Databases

Creative Access

415 West Superior, Chicago, IL 60610 312.440.1140 | 800.422.2377 Graphic design firms, art buyers, corporations, ad agencies, illustrators, graphic designers, film directors, photographers, artist representatives, and production houses.

Steve Langerman Lists

148 Middle Street P.O. Box 7609, Portland, ME 04101 207.761.2116 | Fax 207.761.4753 Art directors in public relations firms, cosmetic companies, department stores, consumer magazines, and ad agencies.

Related Organizations

Advertising Photographers of New York 27 W. 20th Street, Suite 601 New York, NY 10011 | www.apany.com

212.807.0399 | Fax 212.727.8120

American Institute of Graphic Arts (AIGA)

164 Fifth Avenue New York, NY 10010 212.807.1990

American Society of Architectural

Perspectivists (ASAP) 1518 K Street, Suite 503 Washington, DC 20005 202.737.4401

American Society of

Media Photographers (ASMP) 14 Washington Road, Suite 502 Princeton Junction, NJ 08850

Art Directors Club

104 W. 29th Street New York, NY 10001 212.643.1440 | Fax 212.643.4266

Association of Medical Illustrators (AMI)

2965 Flowers Road South, Suite 105 Atlanta, GA 30341 770.454.7933 | Fax 770.458.3314

Direct Marketing Association 1120 Avenue of the Americas New York, NY 10036 | www.the-dma.org 212.768.7277 | Fax 212.391.1532

Greeting Card Association 1030 15th Street, NW, Suite 870 Washington, DC 20005 www.greetingcard.org 202.393.1778 | Fax 202.393.0336

Motion Picture Screen

Cartoonists Union (MPSC) Local 839 IATSE 4729 Lankershim Blvd. North Hollywood, CA 91602-1864 www.mpsc839.org/mpsc839 mpsc839@primenet.com | 818.766.7151

National Cartoonists Society 67 Riverside Drive

New York, NY 10024 212.227.8660

National Endowment for the Arts (NEA) 1100 Pennsylvania Ave., NW Washington, DC 20506 www.arts.gov | 202.682.5400

New York Mac Users Group (NYMUG) 873 Broadway New York, NY 10003 212.906.1037

The Newspaper Guild-CWA

501 3rd Street, N.W. Washington, DC 20001 | www.newsguild.org 202.434.7177 | Fax 202.434.1472

The One Club for Art & Copy, Inc.

32 E. 21st Street New York, NY 10010 | oneclub@inch.com 212.979.1900 | Fax 212.979.5006

Society for the Environmental

Graphic Designer (SEGD) 401 F Street, NW, Suite 333 Washington, DC 20001 | www.spd.org spdnyc@aol.com | 202.638.5555

Society of Illustrators

128 E. 63rd Street New York, NY 10021 212.838.2560 | Fax 212.838.2561

Society of Photographers &

Artists Representatives (SPAR) 60 E. 42nd Street, Suite 1166 New York, NY 10165 212.779.7464 | Fax 212.866.3321 Society of Publications Designers (SPD) 60 E. 42nd Street, Suite 721 New York, NY 10165 | spdny@aol.com 212.983.8585 | Fax 212.983.6043

Software Publishers Association 1730 M Street, NW, Suite 700 Washington, DC 20036 | www.spa.org/html 202.452.1600 | Fax 223.8756

Stencil Artisans League P.O. Box 920190 Norcross, GA 30092 Fax 770.455.7258

Type Directors Club 60 E. 42nd Street, Suite721 New York, NY 10165 | typeclub@aol.com 212.983.6042 | Fax 212.983.6043

Visual Artists & Galleries Association (VAGA) 350 Fifth Ave., Suite 6305 New York, NY 10118 212.736.6666 | Fax 212.736.6767

Merchandise Markets, Shows, & Expositions

Information is subject to change.

Atlanta Merchandise Mart 240 Peachtree Street, NW, Atlanta, GA 30303 404.220.3000 | 800.285.6278

Boston Gift Show

Contact: George Little Management, Inc. 10 Bank Street, Suite 1200, White Plains, NY 10606 | 914.421.3200 Fax 914.948.6180 | 800.272.SHOW

Chicago Gift Show

Contact: George Little Management, Inc. (see **listing above**) or *Chicago Gift & Novelties* 701 Michigan Avenue, Chicago, IL 60611 312.642.9557

Dallas Trade Mart

2100 Stemmons Freeway, Dallas, TX 75207 | 214.760.2852 Fax 214.749.5458 | 800.445.4577

Gourmet Products Show

(including Bed, Bath & Linen) San Francisco, CA Contact: George Little Management, Inc. (see Boston Gift Show)

Los Angeles Merchandise Mart

(including Invite L.A. Stationery Show & Western Tabletop Faire) 1933 South Broadway, Los Angeles, CA 90007 213.749.7911 | Fax 213.763.5860 | 800.LAMART4

Merchandise Mart Properties, Inc.

200 World Trade Center Chicago, Suite 470, Chicago, IL 60654 312.527.7600

National Stationery Show

New York, NY Contact: George Little Management, Inc. (see Boston Gift Show)

New York Home Textiles Show

(America's Premiere Bed, Bath, & Linen Show) New York, NY Contact: George Little Management, Inc. (see Boston Gift Show)

New York International Gift Fair

(including Accent on Design and American & International Crafts) New York, NY Contact: George Little Management, Inc. (see **Boston Gift Show**)

San Francisco International Gift Fair

(including Accent on Design West, American & International Crafts West, Just Kidstuff West, and The Museum Source West) San Francisco, CA Contact: George Little Management, Inc. (see **Boston Gift Show**)

San Francisco Mart

1355 Market Street, San Francisco, CA, 94103 415.552.2311

Surtex Show

New York, NY Contact: George Little Management, Inc. (see Boston Gift Show)

Toy Manufacturers of America

The Toy Building 200 Fifth Avenue, New York, NY 10010 212.675.1141

Washington DC Gift Show

Washington, DC Contact: George Little Management, Inc. (see Boston Gift Show)

Some Useful Web Sites

Adobe

www.adobe.com Tutorials, free newsletters, and free technical announcements via e-mail.

CNET Builder

home.cnet.com/webbuilding/0-3880.html
A cool site for all kinds of Web site construction
tips and tricks.

Dynamic Drive.com

dynamicdrive.com/dynamicindex1/index.html Help creating DHTML menus in the browser, pull down menus, cascading menus, etc.

Library of Congress

www.loc.gov/ Online exhibitions and access to several digital collections.

Matt's Script Archive

www.worldwidemart.com/scripts/
The place to go to tame your CGI and PERL
script nightmares!

Macintosh information

www.Macfixit.com|www.macintouch.com Technical information, tips, news, etc., for Mac users.

Myfonts.com

www.myfont.com/identafont Cool site that allows you to upload a typeface in order to identify it.

Neehah Paper

www.neenahpaper.com Resource center of postal requirements (size standards, business reply mail, etc.) and glossary of paper terms.

Search Engine Watch

searchenginewatch.com/

Want to know how all those search engines really work? Danny Sullivan's site has the answers.

Visibone

www.visibone.com/swatches/ Get Web-safe palettes for Photoshop and ImageReady.

Web Design Group

htmlhelp.com/

The Web Design Group was founded to promote the creation of nonbrowser-specific, nonresolutionspecific, creative, and informative sites that araccessible to all users worldwide.

WebMonkey

hotwired.lycos.com/webmonkey/ A killer Web site-building site from Wired magazine.

William House

www.williamhouse.com

Information about paper resources, envelopes, sizes for booklets, etc.

xpressobar.com

www.xpressobar.com Independent guide to Quark Express, updaters, tips, etc.

Glossary

account executive: Representative of an advertising agency who handles specific accounts and acts as a client liaison to the art director, creative director, and others creating advertising for the account.

advance: Amount paid prior to the commencement of work or in the course of work. It may be intended to cover expenses or it may be partial payment of the total fee. An advance as partial payment is common for a timeconsuming project.

advance on royalties or advance payment against royalties: Amount paid prior to actual sales of the commissioned item or work; sometimes paid in installments. Advances are generally not expected to be returned, even if unearned in sales. Both the terms and the size of the advance are negotiable.

agreement: See contract.

all-media rights: Media that convey art or design can take many forms: print media are books or magazines; electronic media are CDs or multimedia presentations; other media are television, radio, and the **Internet**. Contracts that ask for all-media rights are, in essence, asking the graphic artist to allow the buyer to distribute work in all media (often they include the clause "now known or invented in the future").

all-rights contract: Purchase of all rights of usage for reproduction of an artwork forever. All-rights contracts are different from workfor-hire contracts, which strip away not only the graphic artist's rights but the graphic artist's authorship. Under an all-rights contract the artist still retains statutory termination right. See also **perpetuity, termination rights**, and **work for hire**.

alphanumerics: Letters and numbers.

animatic: Limited-animation film using camera movements, a select number of drawings, some animation, and a sound track.

animator: Artist responsible for articulation of characters' movements in an animated film.

application: Software program that performs a specific task such as page layout, word processing, or illustration.

appliqué or applied work: To apply or stitch one layer of fabric over another so that the applied pieces form a motif.

arbitration: Negotiation in a legal dispute by a neutral party that results in a binding decision, enforced by a court.

art director: Usually employee of an advertising agency, publishing house, magazine, or other user of the graphic artist's work (some organizations hire freelance art directors to perform these duties). Responsibilities include selection of talent, purchase of visual work, and supervision of the quality and character of visual work.

art staff: Group of artists working under an art director's supervision for a company such as an advertising agency, publisher, magazine, or large design studio.

artwork: Any finished work of a graphic artist.

ASCII: American Standard Code for Information Interchange. This system assigns specific numbers to alphabetic characters and is one of the few ways different computers can exchange information.

assigning (transferring): Term commonly used for reselling or relicensing signed-over rights to artwork.

assistant animator: Cleans up the animator's drawings according to a model sheet and does in-betweens. In some larger studios the assistants only do cleanup work.

attribution: Basic artist's right whereby the artist retains authorship of a work and is acknowledged properly for its creation. Attribution ensures that an artist's name not be used on works he or she did not create. Also called **paternity**.

author's alterations (AAs) or author's corrections (ACs): Alterations or corrections of type that has been set made by the client (author). Can be errors, additions, or deletions. The typographer's or printer's charges for making AAs are usually passed on to the client. See also printer's error. **backgrounder**: One who paints backgrounds that have already been designed.

bailment: Obligation on the part of the individual(s) with whom art is left to take reasonable care of it. This is a legal requirement and applies to situations such as leaving a portfolio for review.

bid: To offer an amount as the price one will pay or accept.

binary: System with only two possible states: on or off, 1 or 0, high or low.

bitmap: Image created when coloration is added to pixels on-screen; the file that gives instructions for coloration.

blanket contract: Contract kept on file by a publishing firm covering all future (and sometimes past) assignments.

bleed: Small extra area on the outside edge of a page that allows for trim. Printing that runs into this area. Also called "trim area."

blues: Nonreproducible photographic prints made from negatives, used in platemaking (also known as browns, ozalids, or silvers), which enable an editor to verify that all art and text are in proper position and that pages are in sequence.

boilerplate: Contract or document containing formulaic language that can be used for a number of purposes or similar circumstances, requiring only minor alterations.

broker: Agent or representative.

built-up lettering: Letters, numerals, or ampersands used to create various forms.

bumpers: Short clips at the opening of a broadcast.

buyout: Imprecise term for an all-rights transfer.

C print or inter neg: Full-color positive print from a negative transparency.

CAD/CAM (Computer Aided Design/Computer Aided Manufacture): Software systems used to design and test parts and machinery, generate schematics, calculate manufacturing specifications, and so on.

camera-ready art or camera copy: Final mechanical or layout, including finished artwork, that is ready to be photographed for platemaking in preparation for printing.

cancellation fee: When a project is terminated or not used by the client for reasons outside the artist's control, this fee is paid as compensation for the artist's or studio's effort in developing the illustration or design. See also **kill fee**. **cartoonist**: Professional artist who works in a humorous and satirical style, including political commentary.

cast off: In publishing, to estimate the typeset number of pages based on the manuscript length. In knitting, to put stitches on a knitting needle. In textiles, sometimes used as a synonym for knockoff; refers to a pattern or design that a company wishes to alter to form a new pattern while retaining similarity to the original.

CD-ROM: Read-only-memory compact discs for computer use.

cel: Transparent sheet of celluloid on which finished animation drawings are inked. Short for "celluloid."

center truck: Center page spread in a magazine or newspaper (a premium space for the placement of advertisements).

CGI (Common Gateway Interface): Standard for running external programs from a World Wide Web HTTP server. CGI specifies how to pass arguments to the executing program as part of the HTTP request. It also defines a set of environment variables.

chips and tabs: Small squares of color used in surface/textile design to indicate colors when a color combination is not painted. The process is also called "pitching the pattern or design."

Chromalin proofs: Proprietary term for a color-proof process employing photosensitized clear plastic. Color separation film negatives are exposed to the plastic in such a way that process colors adhere to dots on the plastic. Four sheets (one for each process color) are exposed, treated with the separate process colors, placed in register, and laminated. Such proofs are used for presentations and for checking register, obvious blemishes, and size. The color may be very accurate but is subject to a variation due to exposure and the application of the process color. Also called "transfer key." See also **Color Key** and **progressive proofs**.

chrome: In printing, color transparencies usually larger than 35mm. See **transparency**. In digital design, amount and quality of graphics, animation, sound effects, interactivity, and so on.

Cibachrome: Proprietary term for a fullcolor positive photographic print made from a transparency.

claymation: Three-dimensional animation using clay figures or puppets.

client accommodation: To work at fees below the normal rate in order to accommodate budgetary restrictions and to preserve a long-term working relationship.

clip art: Public domain line art specifically designed for royalty-free reuse.

collateral: Materials created to support or reinforce a design or promotional concept.

Color Key: Proprietary term of the 3M Company; sometimes referred to as "3Ms." A method for obtaining separate film positives showing progressive color breakdown of three-color separation negatives. Such proofs are useful for presentation and for checking register, obvious blemishes, and size; they are not a true indication of final printed color. **Chromalin proofs** are preferred for more accurate (though still not exact) color representation. **Progressive proofs** using process inks on press are the most accurate method for checking color.

color map/palette: Synonym for the range of colors from which a computer artist/operator chooses the particular colors used in an individual image.

colorproofs: Firstfull-colorprinted pieces pulled off the press for approval before the press is considered ready to roll for the entire press run. Sometimes called "simple colored proofs," these proofs are useful for making on-press corrections, particularly for problems resulting from improper registration and the effects of overprinting. **Progressive proofs** are the preferred method of accurately checking color.

color separation: Photographic process that breaks up colors into basic components or separate pieces of film, which are later recombined to recreate the original image.

commission: (n) Percentage of a fee paid by an artist to an artist's agent or gallery for service provided or business transacted. (v) The act of giving an artist an assignment to create a work of art.

comprehensive/comp: Visualization of the idea for an illustration or a design, usually created for the client and artist to use as a guide for the finished work. "Tight comps" and "loose comps" refer to the degree of detail, rendering, and general accuracy used to create the comprehensive.

confidentiality: Standard clause in contracts that prevents disclosure of company secrets and information concerning the job; may include a clause to prevent discussion of the contract terms.

confirmation form: Contract used by an artist when no purchase order has been given or when the purchase order is incomplete with respect to important terms of the contract, such as amount of fee, rights transferred, and so on.

contact print: Photographic print made by putting the negative in contact with sensitized paper, plate, or film.

contingency fee: Fee dependent on or conditioned by other circumstances.

contract: Agreement, whether oral or written, whereby two parties bind themselves to perform certain obligations. Synonyms: "agreement" or "letter of agreement" (if the contract takes the form of a letter).

converter: Company that converts **greige goods** into finished printed or plain-dyed fabric for use by a manufacturer.

copy: Text of an advertisement, editorial content of a magazine or newspaper, or the text of a book.

copyright: Authorship of a creative work that provides the exclusive legal right to reproduce, publish, and sell that work. Any artist creating artwork automatically owns the copyright to that work unless provisions have been made prior to the start of the project to transfer authorship to the buyer (see **work for hire**).

copywriter: Writer of advertising or publicity copy.

corner(s): Beginning of a design (usually the upper left corner) that is rendered in the style, technique, color, and materials proposed for the finished artwork. If approved, the design will be used to complete the repeated design on all four corners. Commonly used in home furnishings for the design of a tablecloth, napkin, or scarf.

creative director: Usually an employee or officer of an advertising agency; his or her responsibilities include supervision of all aspects of the character and quality of the agency's work for its clients.

croquis: Rough sketches made by an artist, particularly in fashion illustration and textile design.

CSS: Powerful method for formatting text styles on Web site pages by having selected parts of a page reference master CSS style sheets. Note that visual implementations of CSS still vary between Microsoft Internet Explorer and Netscape Navigator.

deescalation: Clause in a contact that allows for a decrease in extent, volume, or scope.

design brief: Analysis of a project prepared by either the publisher or the designer. When the designer assumes this responsibility, it should be reflected in the design fee. The design brief may include (1) a copy of manuscript, with а selection of the representative copy for sample pages and a summary of all typographical problems, copy areas, code marks, and so on; (2) an outline of the publisher's manufacturing program for the book: compositor and composition method, printer and paper stock, binder and method of binding; (3) a description of the proposed physical characteristics of the book, such as trim size, page length, list price, quantity of first printing, and whether the book will print in one color or more than one. The publisher should also indicate whether any particular visual style is expected.

DHTML (Dynamic HTML): Extension of HTML that gives greater control over the layout of page elements and the ability to have Web pages that change and interact with the user without having to communicate with the server. DHTML was created by Microsoft and can be viewed in Internet Explorer 4.0 andNetscapeCommunicator4.0.TheDocument Object Model Group of the World Wide Web Consortium is developing standards for DHTML (www.w3c.org/DOM/).

digital: Representation of an electronic signal by a set of discrete numerical values, most commonly in binary form.

director: One who oversees an animated picture from conception to finish and has complete control over all phases: character design (which is usually supplied by an agency), layout, sound, and so on.

documentary design: Design adapted from a historical document or plate, usually in public domain because of their age, such as Art Deco, Art Nouveau, and Egyptian.

dummy: Book, brochure, or catalog idea in a roughly drawn form, usually made up to contain the proper number of pages and used as a reference for positioning and pagination.

dye transfer: Similar in appearance to a color photograph but different in that it is produced from a transparency by printing continuous tones of color dyes.

electronic rights: Rights specified in a contract to control electronic publication in addition to other media, often for no additional compensation. Graphic artists should make every effort to retain them or negotiate higher fees. embroidery: General term referring to decorating the surface of any fabric with free-form stitches that are based on plain sewing; stitches and fabric vary according to the designer's work. For example, embroidery with wool or a wool-like yarn on fabric is called "crewel embroidery." Includes (1) counted embroidery: formation of regimented stitches on even-weave fabrics on needlepoint canvas known by various names which denote their style of stitches (hardanger, black work, drawn thread work); (2) cross-stitch embroidery: either free-form embroidery over Xs printed on the fabric or counted embroidery worked on an even-weave fabric or canvas.

exclusive use: No one except the purchaser of the image may use the image without permission of the purchaser.

file conversions: Changing one kind of file to another, usually from one platform to another; for example, from a file for a D0S-compatible PC to a file for a Macintosh.

finished art: Usually an illustration, photograph, or layout that is prepared and ready for the printer.

first North American serial rights: The right to be the first magazine to publish art for use in one specific issue to be distributed in North America.

first rights: The right to be the first user of art for one-time use; frequently describes the right to publish art in a magazine serial or drawn from a book in which the art will appear.

fonts: Individual branches of a typeface design.

format: Arrangement of type and illustration that is used for many layouts; arrangement used in a series.

Fortune double-500 company: Fortune magazine's annual listing based on sales revenues of the 1,000 largest corporations in the United States.

freelance employee: Terms of freelance employment include work hours determined by the assignment and using one's own workspace and materials; freelancers generally provide their own benefits. The freelancer often collects state sales tax from clients and pays his or her own income taxes.

general apprentice: In animation, worker who does a little of everything except camera work.

generic works: Art that has the potential for wide application in a variety of markets.

graphic artist: Visual artist working in a commercial area.

graphic designer: Visual graphic artist and professional problem solver who works with the elements of typography, illustration, photography, and printing to create commercial communications tools such as brochures, advertising, signage, posters, slide shows, book jackets, and other forms of printed or graphic communications.

graphic film artist: One skilled in creating special effects on film by use of computerized stands and/or adding computerized movement to artwork (such as television logos with glows and set movement).

graphics: Visual communications.

greige goods: Fabric in its raw, but woven, state.

group head: Some advertising agencies divide their clients into groups under a group head who supervises the work of art directors on the various accounts.

guild: Association of like-minded professionals seeking to protect and better their status and/or skills. When employees are members in equal proportion to freelancers, such a guild qualifies with the U.S. government as a union. In this capacity, a guild may represent employees who are its members in collective bargaining.

gutter: Area in a magazine, newspaper, or book where the left (verso) and right (recto) pages meet. Important elements are often not placed in this area because of the fold.

hand letterer: Professional artist who creates letterforms for use in logotypes, alphabets, and specific titles or captions.

home page: Usually the first page of an organization's or individual's Web site.

HTML (H[yper]t[ext] M[arkup] L[anguage]): Programming language used to structure text and multimedia documents and to set up hyperlinks between documents; used extensively on the World Wide Web.

illustrator: Professional graphic artist who communicates a pictorial idea by creating a visual image for a specific purpose, using paint, pencil, pen, collage, computer, or any other graphic technique except photography.

image: Pictorial idea.

image processing: Manipulation of an image (usually video scanned), such as enhancement, colorizing, or distortions.

inbetweener: In animation, artist who does the drawings depicting motion in between the drawings that have been cleaned up by the assistant, thereby animating them. inker: In animation, one who inks onto cels the lines of finished drawings.

interactive: Describes productions and services that enable users to choose commands that purposefully influence the direction or outcome of their experience.

interface: In computer usage, the point where hardware, software, and user connect; the physical (electrical or mechanical) connection between elements of computer hardware.

Internet: Network of computers connected by telephone lines. First created by the U.S. Department of Defense to send information, particularly in the event of a war that destroyed one or more terminals. The Internet is now a "network of networks" with companies that provide access for a fee to anyone with appropriate equipment.

Internet service provider (ISP): Company that provides a hookup to the Internet. All vary in kind and level of service: some provide direct access; others provide added services such as news, chat rooms, downloadable software sections, and entertainment.

invoice: Statement given to a client showing the amount due in payment for an assignment. Usually submitted after work has been completed; if advance payments are made, the invoice should reflect these and show the balance due.

jacquard: Woven fabrics such as tablecloths, upholstery, and towels.

Java: Trademark used for a programming language designed to develop applications, especially ones for the Internet, that can operate on different platforms.

JavaScript: Netscape's simple cross-platform World Wide Web scripting language. Java-Script is intimately tied to the World Wide Web and currently runs in only three environments: as a server-side scripting language, as an embedded language in server-parsed HTML, and as an embedded language run in browsers. JavaScript should not be confused with Java; it is a Netscape, not a Sun, trademark.

junior checker (paint and ink only): In animation, one who inspects cels for the proper, thorough application of correct paint colors.

kerning: Process that changes the spaces between normally set individual letters.

kickback: Sum of money or a large figure paid to an artist by a supplier for the artist's part in passing on work such as printing. May be demanded by art buyers from artists in exchange for awarding commissions. Kickbacks are illegal. Often the supplier's kickback costs are hidden in invoices submitted to the client.

kill fee: Payment by the client to the graphic artist when the client does not use a commissioned work; includes two types of payments: **cancellation fee** and **rejection fee**.

knitting: Method of forming a lace or a textile structure from any yarn, fabric strip, or stringy material with two or more eyeless needles, pegged tools, or sticks, using various looped stitches to form the structure.

knockoff (n)/knock off (v): Term most often used in the textile design industry to identify a design that at the request of the client or stylist has been copied by a different artist than the one who created it. Broadly used to mean the copying of an artist's style or artwork when no creative input and/or significant changes are made by the artist creating it. Knockoffs are unethical and often illegal.

lace: General term for any openwork or sheer fabric with holes formed by any technique, including knitting, crochet, bobbin lace, netting, hairpin lace, tatting, eyelet, and needle lace.

layout: Design, usually in sketch form, of the elements of an advertisement, magazine or book page, or any other graphic work (such as brochures and catalogs) intended for reproduction. Usually executed by an art director or graphic designer to be used as a guide in discussions with the client.

layout artist: In animation, one who lays out and arranges backgrounds.

letter of agreement: See contract.

license: Right to sell or rent artwork or design for a specific use and period of time. It is in the graphic artist's interests to license use of work, rather than sign all-rights or work-for-hire contracts. Also see **sublicensing rights**.

ligatures: Letter combinations used in type design.

link: Connection between one area and another. A primary feature of interactive products is the ability of users to explore linked materials.

live area: Area on the camera copy of a page or a publication beyond which essential elements should not be positioned. **logo:** Mark or symbol created for an individual, company, or product that translates its use, function, or essence into a graphic image.

logotype: Any alphabetical configuration that is designed to identify by name a producer, company, publication, or individual.

lucey: One of several optical devices used to enlarge or reduce images.

markers: Felt-tipped pens often used for illustrating comprehensives or for sketching roughs in black and white or color. Proprietary synonyms: Magic Markers, Stabilo.

markup (n), mark up (v): Service charge added to the expense account to reimburse the artist for the time needed to process the billing of items to the client and the cost of advancing the money to pay such expenses; the process of adding such a charge.

mechanical: Layout created by a production artist for the printer to use in the printing process.

mediation: Negotiation in a legal dispute where an impartial person seeks to facilitate an agreement between the two parties. A mediator can be appointed by a judge or another third party, such as an arts mediation service, but the resolution is binding upon the parties only if the parties agree to it in writing.

montage: Image created from a compilation of other images.

moonlighting: Freelance commission taken by a salaried person to be completed in the person's spare time.

moral rights: Personal rights of creators in their original (not reproduced) works, regardless of the sale or transfer of copyrights, specifically: right of identification of authorship, and right of approval, restriction, or limitation on use or subsequent modifications.

no-assertion-of-rights clause: Contract item that clarifies that the rights licensed to the client are only the ones specified in the contract and that the artist retains all other rights. This clause should be included in every graphic artist's contract.

noncompeting rights: Uses other than the original commission that do not conflict or compete with the commissioning party's business or market.

nonexclusive use: Purchaser, along with the graphic artist, is allowed to reuse (or resell) a work in specified regions and situations; all uses need to be specified and clarified to avoid any future conflict of interest.

novelties: General term for gift or boutiquetype items or for a wide variety of clever decorative or functional items (some novelties can overlap as home accessories).

opaque projector: Projector that uses reflected light to project the image of a nontransparent object onto a canvas, board, or screen; image is then used by an artist to copy or show work.

overhead: Nonbillable expenses such as rent, phone, insurance, secretarial and accounting services, and salaries.

ownership of artwork: Graphic artist owns the original work even if rights of reproduction are transferred; he or she can sell the original and still keep rights of reproduction. The **copyright** is separate and distinct from the material work in which it is embodied.

packagers: Companies that coordinate all the components of a book publishing project and either present the finished concepts to publishers for execution or manufacture the books themselves and deliver bound volumes to the publisher.

page makeup: Assembling in sequence all the typographic and/or illustrative elements of a brochure, catalog, book, or similar item.

pass-through clause: Contract term that takes effect when an illustrator's share of a subsidiary sale exceeds a predetermined amount and for which payment is usually received within 30 days of receipt.

patent: Provision of intellectual property law that protects an invention rather than an image or a name.

per diem: Day rate given to a professional by a client to complete an assignment.

perpetuity: Term meaning "forever" that is increasingly used in contracts to define length of usage. It is recommended that graphic artists negotiate rights for a limited time period rather than perpetuity. See also **termination right**.

pixel: Smallest lighted segment on a computer monitor's screen or smallest segment of color in a digital image file; also the individual dots on the display device, arranged in a grid, that comprise the image.

plagiarism: Act of stealing and passing off as one's own the ideas or words of another; or the use of a created production without crediting the source.

platform: Set of hardware components, operating system, and delivery media that provides specific functions and capabilities for the production or playback of digital programming.

portfolio or artist's book: Reproductions and/or originals that represent the body of an artist's work.

preplanner/checker: One who checks that the animation is in sync and flows correctly before camera work.

presentation boards: Any preliminary design mounted on boards that the graphic designer shows a client. In the fashion industry, color illustrations of a grouping of styles from the design collection that a manufacturer wishes to feature during market week sales.

printer's error (PE): Mistake made in the film negatives, platemaking, or printing that is not due to the client's error, addition, or deletion. They are normally absorbed by the printer. See also **author's alterations**.

production artist: Professional artist who works with a designer to take a layout from conception through the printing process.

production coordinator: In animation, one responsible for making sure that everything is in order before it goes under the camera.

productivity tools: Software applications used by business professionals such as word processors, databases, and spreadsheets. Usually character-based, they allow users to organize and manipulate text and numbers in various ways.

professional: One who strives for excellence in business and follows fair practices in every professional endeavor.

profit: The difference remaining (net income) after overhead, expenses, and taxes are sub-tracted from income received (gross income).

progressive proofs or progs: Proofs of color separation negatives that have been exposed to offset plates and printed using process inks. Presented in the sequence of printing, for example, (1) yellow plate alone, (2) red alone, (3) yellow and red, (4) blue alone, (5) yellow, red and blue, (6) black alone, and (7) yellow, red, blue and black. The preferred way of checking the color of the separation negatives using the same inks, paper, ink densities, and color sequence as intended for the production run. See also **color proofs**.

proposal/estimate: Graphic designer's detailed analysis of the cost and components of a project. Used to firm up an agreement before commencing work on a client's project.

public domain: Works that have no copyright encumbrances and may be used freely for any purpose.

purchase order: Form given by a client to an artist describing the details of an assignment and, when signed by an authorized person, authorizing work to commence.

Raster system: Computer graphics system used to draw shapes pixel by pixel.

readers: Copies of type layout prepared for the author or client to proofread and mark corrections on. They are nonreproduction quality and their value is only in checking corrections.

ready-made: Clothing or fabric purchased in a store or available to the designer at the stage when it could have been purchased at retail.

reference file: Clippings compiled by an illustrator or designer from newspapers, magazines, and other printed pieces that are referred to for ideas and inspiration as well as technical information.

rejection fee: Payment made when the artwork does not satisfy the client's stated requirements. See also kill fee.

repeat: Textile design process by which consecutive press impressions are put together so imperceptibly that the textile appears as one consecutive image and the process run may be continued indefinitely.

representative/rep: Professional agent who promotes specific talent in illustration, photography, or surface design and negotiates contracts for fees and commissions. Usually receives a percentage of the negotiated fee as payment for services provided to the talent.

reprint rights: Right to print something that has been published elsewhere.

reproduction copy/repro: Proofs printed in the best possible quality for use as camera copy for reproduction. Also called "reproduction proof."

resident buying service: Purchases fashion illustrations depicting available styles and reproduces them on retail ad mats that are sent to subscribing retail outlets.

residuals: Payments received in addition to the original fee, usually for extended usage of a work. See also **royalty**.

resolution: Absolute number of pixels across and down on a computer display device. This determines the fineness of detail available, much like grain in a photograph.

retoucher: Professional artist who alters a photograph to improve or change it for reproduction. Used to work on transparencies or color and black-and-white prints; nowadays works more often on computer.

return of artwork: After the client uses original artwork during a project, the client is responsible to return the artwork undamaged to the graphic artist.

reversion rights: Book publishing contract provision that protects the artist in the event the publisher fails to publish within a specific period of time; after that, all rights revert back to the artist.

right to modify (alterations): Purchaser of rights to artwork holds the copyright only in the collective work, not in the underlying contribution (the art) itself. Since altered artwork is a derivative work of an original, if the artist does not grant the right to create a derivative work, the client has no right to alter the image. Any alterations to artwork should be made in consultation with the initial illustrator.

roughs: Loosely drawn ideas, often done in pencil on tracing paper, by an illustrator or designer. Usually several roughs are sketched before a comprehensive is developed from them.

royalty: Payments to the artist that are based on a percentage of the revenue generated through the quantity of items sold (books, cards, calendars). See also advance on royalties.

sales catalog/line sheet: Used by apparel manufacturer's sales staff as a handout to buyers; a black-and-white illustrated list of all the styles in a collection or line, showing available size, color, pattern, and prices.

sales tax: Each state government establishes the rate of taxation on items sold; it varies between 4 and 8 percent of the amount billed the client. The freelance graphic artist is often required to be licensed to charge, collect, and remit it to the state on a quarterly basis.

search engine: Web page that allows Web users to enter their own home-page information and URL in a database; also allows **Internet** users to search for specific **URLs** from a database list, using the needed home-page information as a search criteria.

second rights: Right to use art that has appeared elsewhere. Frequently applied to magazine use of art that has appeared previously in a book or another magazine.

server: Internet computer established by **ISPs** to respond to information requests from other computers on the network.

service mark: Provision of trademark law that identifies and protects the source of services rather than goods, indicated by the letters SM or by SM.

SGML [S(tandard) G(eneralized) M(arkup) L(anguage)]: A standardized markup language used to describe the logical structure of a computer document.

shareware: Software that users may test without initial payment; if use is continued, a fee must be paid.

shoot (n): In advertising, a day's filming or a day's shooting of still photography.

showroom illustrations: Color illustrations of key styles from an apparel manufacturer's design collection or line, used to heighten showroom atmosphere and promote showroom sales.

simultaneous rights: Right to publish art at the same time as another publication. Normally used when two publications have markets that do not overlap.

site: All the Web pages that branch from a home page.

sketch: Design for textiles not done in repeat. See also **roughs**.

specing: Part of the book design process whereby design specifications or codes are written for the sample manuscript.

speculation: Accepting assignments without any guarantee of payment after work has been completed. Payment upon publication is also speculation.

spine: Area between the front and back book bindings, on which the author, title, and publisher are indicated.

spot: (1) Small drawing or illustration used as an adjunct to other elements in an advertisement, editorial, or book page. (2) Television commercial.

storyboards: (1) Series of sketches drawn by artists in scale for a television screen to indicate camera angles, type of shot (close-up, extreme close-up), backgrounds. Essentially a plan for shooting a TV commercial; often accompanied by announcer's script and actor's lines. (2) Sketches of action for animation. Synonyms: story or story sketches.

stripping: Positioning and fastening of page and illustration films onto large sheets of paper or plastic that are the size of the printing plate. Also referred to as "image assembly."

studio: (1) Place where an artist works. (2) Organization offering complete graphic services. (3) In surface design, agency representing designs by more than one surface designer. **style:** Particular artist's unique form of expression; also referred to as "look." In surface design referred to as "hand."

stylists: Creative and managerial heads of departments, sometimes referred to as style directors or art buyers.

sublicensing rights: The right of the publisher to sell any of the rights granted to it to third parties. All such terms must be thoroughly spelled out in the contract so that the third party is under the same copyright limitations as any other client and so that the artist receives the same fee as any other client.

subsidiary rights: In publishing, those rights not granted to the publisher but which the publisher has the right to sell to third parties. Proceeds of such sales are shared with the artist.

surface designer: Professional artist who creates art to be used in repeat on such surfaces as fabric, wallpaper, woven material, or ceramics.

syndication: Simultaneous distribution to print or broadcast media of artwork or other creative work. Often refers to sales of cartoons or comic strips.

talent: Group of artists represented by an agent or gallery.

tear sheet: Sample of finished work as it was reproduced, usually in print media.

technique: Refers to the particular media used by a graphic artist.

telepad: A preprinted matrix with frames that are usually $2 3/4 \times 3 3/4$ inches.

termination right: Refers to (1) right provided in copyright law (see perpetuity) and (2) right to end a contract, most often with agent or broker.

textbook: Any book used for educational purposes.

thumbnail or thumbnail sketch: Very small, often sketchy visualization of an illustration or design. Usually several thumbnails are created together to show different approaches to the visual problem being solved.

trade book: Any book sold in bookstores to the general public.

trade dress: Part of trademark law that protects an established "look," such as a landmark building.

trademark (TM): Work, symbol, design, slogan, or a combination of works and designs that identifies and distinguishes the goods or services of one party from those of another. transparency or chrome: Full-color translucent photographic film positive. Also called "color slides."

typography: Style, arrangement, or appearance of typeset material.

union: Group of people in the same profession working to monitor and upgrade business standards in their industry.

URL (Uniform Resource Locator): Address for a file or location on the Internet.

utilities: Programs designed to improve, repair, or enhance a user's computer system or a specific computer program.

vector system: Computer graphics system that draws shapes in line segments rather than pixel by pixel. Many high-resolution drawings or presentation programs operate on vector systems.

virtual reality (VR): Use of computer hardware (visual displays and tracking and mobility devices) in conjunction with special software programs to produce an experience that immerses the user in a highly interactive environment.

VRML (Virtual Reality Modeling Language): Draft specification for design and implementation of a platform-independent language for virtual reality scene description. VRML 1.0 was released on May 26, 1995.

warranty/indemnification clause: Clause in a contract in which a graphic artist guarantees that the work created will not violate the copyright of any party.

weaving: Method of interlacing yarns or any stringy material in both a lengthwise and crosswise manner simultaneously. A traditional loom is generally used to control the interlacing technique, but other devices may also be used.

work for hire: For copyright purposes, "work for hire," or similar terms such as "done for hire" or "for hire," signifies that the commissioning party owns the copyright of the artwork as if the commissioning party had, in fact, been the artist.

World Wide Web (WWW): Part of the Internet made up of collective Web sites that are linked to various other sites to create a "web" of information. The Web is different from e-mail and newsgroups. wraparound: Book jacket design and/or illustration that encompasses front and back covers, sometimes including book flaps.

XML [Ex(tensible) M(arkup) L(anguage)]: A metalanguage written in SGML that allows one to design a markup language; allows for the easy interchange of documents on the World Wide Web.

Some of the definitions included here werereprinted from Collectibles Market Guide and Price Index with permission of The Collector's Information Bureau. ©1995 Collector's Information Bureau.

Index

a

AAs. See Author's alterations

Accessories illustration, 274-75

Account executive, 431 (definition)

Adobe, 54; Acrobat PDF files, 87-88; PageMaker, 208; Photoshop/Illustration, 335

Advance, 431 (definition)

Advertising, 173-76, 179, 230; advertorials, 174 (chart); and animation, 328; comps, 246, 247 (chart); designers, 169, 173-76, 173-74 (chart); directories, 19-20; graphic design of, 173-76; history, 230; illustration in, 231-33, 234-44 (charts); illustration of medical/natural science in, 285 (chart); in magazines, 174 (chart); in newspapers, 174 (chart); offline, 216 (chart), 217 (chart); online, 215 (chart), 217-18 (chart); outdoor, 175 (chart); page rates, 110; and promotion design, 173-76; and relationships with art reps, 7; revenues, 230; technical illustration in, 291 (chart); and trade practices, 232-33; on World Wide Web, 215 (chart)

Advertising Age, 110

Advertising agencies, 5-6, 173-75, 188, 232, 246, 307

Advertising Photographers of New York, 22

Adweek, 110

Agencies. See Advertising agencies

Agents, and computer games, 224. See also Artists' representative

AIGA Annual, The, 20

All-media rights, 431 (definition)

All-Purpose Illustrator's Letter of Agreement, 366-67 (contract)

All-Purpose Purchase Order, 368-69 (contract)

All-rights contract, 179, 188, 431 (definition). See also Work for hire

Alterations. See Original art, alteration/mutilation of

America Online (AOL), 208, 220

American Arbitration Association (AAA), 130, 361

American Bar Association Dispute Resolution Program, 361

American Civil Liberties Union (ACLU), 65

American Illustration, 20

American Institute of Architects (AIA), 196

American Institute of Graphic Arts (AIGA), 66, 413

American Showcase, 8, 20

American Society of Composers, Authors and Publishers (ASCAP), 40, 99

American Society of Media Photographers (ASMP), 99, 414

Americans with Disabilities Act (ADA), 196; Accessibility Guidelines of, 196 Animated films, 324

Animated television commercials, illustration in, 243 (chart)

Animatics, 244, 245, 431 (definition)

Animation, 283, 323-30; in audiovisual/multimedia design, 210 (chart); careers in, 326-27; claymation, 326; computer (including 2-D and 3-D), 324-25, 325 (chart), 328; job markets in, 327-28; multicultural aspect of, 326; pricing, 329; puppet, 326; salaries, 329, 329-31 (charts)

Animation companies/studios, 324, 326; employees of, 326-27

Animation magazine, 328

Animator, 103, 250, 252-53 (chart), 323-31, 325 (chart), 329-31 (charts), 431 (definition)

Annual reports, 170 (chart), 250, 252 (chart)

Anti-Royalty-Free Initiative (of Campaign for Illustration), 96,417

Apparel, 333-34, 336-37; and design licensing, 337-38, 339 (chart); illustration for, 274-75

Application, 225 (definition), 431 (definition)

Applique or applied work, 431 (definition)

Appraisal, 64; summary, 64

Arbitration, 24, 129-30, 354, 361, 431 (definition); binding, 75, 76

Arbitrator, 129-30, 354, 361; fees, 130

Architectural animation, 325

Architectural/interior illustrators, 292-95, 293 (chart); trade practices of, 294-95

Art buyer, 5, 100, 114

- Art contests and competitions, 76-81; and all-rights transfers, 77-79; criteria, 78-79; guidelines, 78-79; and insurance, 78-79; and jurors, 77-79; persistent problems, with, 80-81; types of, 77
- Art director, 4-5, 6, 89, 95, 100, 154, 158, 166, 179, 182, 327, 330 (chart), 431 (definition); and broadcast design, 200

Art Directors Annual, 20

Art Directors' Club, 77

Artist. See Illustrator

Artist-Agent Agreement, 8, 370-71 (contract). See also Artists' representative, agreements with

Artist-to-Artist Web Forum, 418

Artists for Tax Equity (AFTE), 28, 413

Artists' representative, 6-12, 135, 136-37, 142, 438 (definition); agreements with, 8-12, 137; and bankruptcy, 11-12; and billing, 10; choosing, 7-8; and differences with, 10; exclusivity or nonexclusivity of, 9; and expenses, 9; fees or commissions of, 8-9, 136; and finder's fee, 10; and house accounts, 9; sales, 136-37; and Society of Photographer and Artist Representatives, 137; termination of relationship with, 9, 11; and timely payment, 10. See also Agent

Artists United for Universal Health, 413

Art staff, 431 (definition)

Arts, Craft and Theater Safety, 101

Artwork Inventory Form, 372 (contract)

ASCII, 431 (definition)

"Ask First" campaign, 19, 28, 38, 100, 142, 414

Assignment of rights. See Rights

Assistant animator. See Inbetweener

Association of Medical Illustrators (AMI), 283

Audiocassette covers, 255

Audiovisual: design, 210 (chart); illustration, 244

Audiovisuals, 249

Author's alterations (AAs), 18, 171, 432 (definition)

Author's copies, 263

Automatic Renewal Act, 36

b

Background artist, 315, 317 (chart), 327, 328, 330 (chart), 432 (definition) Back-of-check terms, 99, 123, 348, 414; and contracts, 48, 414 Backup copy, 89, 90 Bailment, 113, 432 (definition) Bankruptcy: of artist's rep, 10-11; of client, 126-27 Bath products, fees for designing, 338-40 (charts) Bed linens, 339 (chart) Benefits, 71, 155, 316 Berne Convention, 41-42, 51, 60, 412 Better Business Bureau, 126 *Better Homes and Gardens*, 110, 309 (chart), 363 Bid, 119, 432 (definition)

Index

Billable expenses, 89, 111; for chart and map design, 204; for computerassisted graphics, 111; for graphic designers, 85-88, 111; and illustration, 85-88, 89, 91, 111

Billboards, 5, 175 (chart)

Billing, 121, 122; procedure, 10, 92, 122; for a sale, 121, 341-42

Biological illustrator. See Scientific illustrator

Bitmap, 225 (definition), 432 (definition); worms, 222, 225

Black Book, The, 8, 20

Blanket contract, 363

Blues, 432 (definition)

BMI, 40, 99

Boilerplate. See Contracts.

Book: cartoon, 319; design of, 184-87; hardcover, 254-55, 256; illustration in, 254-64; illustration in children's, 259-65, 260 (chart), interior illustration in, 256-59, 257-59 (charts); jacket design of, 182-84, 183 (chart), 189 (chart), 254-56; jacket illustration for, 254-55, 255-56 (charts); packagers of, 187, 254, 256-57, 259; paperback, 254-56; publishing of, 254-64; trade practices of children's, 264-65. See also Children's books, Foreign-language edition

Branding, 170 (chart), 172-73; designers, 173

Breach of contract, 97

Broadcast designer, 103, 160, 200

Brochures, 66; design of, 175, 176, 177 (chart); illustrations in, 239-40 (chart), 277 (chart)

Broker, 6, 432 (definition)

Browser, 98

Bureau of Labor statistics, health issues, 100

Business practices, 105-50; collecting, 124-34; negotiation, 114-20; preparation, 06-14; record keeping, 120-23; reuse and other markets, 134-50

Business Week, 110, 267 (chart)

Buyer's satisfaction, 76

Buyout, 5, 188, 432 (definition)

С

CAD. See Computer-aided design (CAD)

Calendars, illustrations in, 282 (chart)

California Newspaper Publishers Association, 65

Calligraphy, 188, 189-90 (chart)

Camera- or computer-ready art, 91, 432 (definition)

Campaign for Illustration, 96, 417; and Anti-Royalty-Free Initiative, 96, 417

Cancellation (kill) fees, 75-76, 112, 120, 342, 352, 363, 432 (definition); for stationery and gift design, 202; for Web design, 212

Carpal tunnel syndrome, 100

Cartography, 203

Cartoonist, 307-21, 432 (definition); editorial, 311; and electronic publishing, 314; and licensing and merchandising, 320-21; and magazines, 308-10, 309 (chart); and magazines, submitting art to, 308-10; and newspaper syndication, 311-13; and reprints, 319, 320 (chart); and sales tax (California), 65-66; self-syndicated, 311; trade practices, 310. See also Comic books

Cartoonist Guild, 412

Cartoonists Association, 309, 311

Cartoonists Legal Defense Fund, 65

Catalogs: design of, 167-77, 177 (chart); illustration in, 277-78 (chart); illustration in offline, 216 (chart)

CCNV v. Reid, 45-46

CD-ROM, 32, 84, 87, 91, 95, 99, 135, 137, 138, 209, 220, 271, 324, 432 (definition); and clip art, 140-41; and computer games, 222; cover illustrations for, 255; fees for illustration, 216 (chart), 217 (chart); and packaging illustration, 271, 273 (chart) Cels (celluloids), 324, 327, 432 (definition)

CGI, 325, 225 (definition), 432 (definition); salaries for animation artists, 330 (chart)

Character licensing, 55, 224, 304, 320-21

Chart design, 203-04, 204 (chart)

Checker, 327, 330 (chart)

Checklist, 115, 117

Checks with conditions. See Back-of-check terms

Chicago Talent, 20

Children's books: and cancellation fees, 112; illustration in, 259-65, 260 (chart); and relationship with art rep, 7; and royalty contract, 260-63; trade practices for, 264-65. *See also* Book, design

Children's Television Workshop, 411, 412

Chinaware, 339 (chart)

Chromalin proofs, 432 (definition)

Chrome, 226, 433 (definition)

Chwast, Seymour, 141

Cibachrome, 433 (definition)

Civil court, 131, 134

Claymation, 326, 433 (definition)

Client, 3, 4, 112-14, 121, 124-28, 131, 170-71, 196, 211, 213; accommodation, 433 (definition); and designing a Web site, 219-21; negotiating with, 115-20; and possible problems with graphic designers, 85-88; and possible problems with illustrators, 88-91; responsibilities of, 167, 342; and surface/textile designers, 341-43

Clip art, 84, 140-41, 433 (definition); and rights-free, 140-41

Coalition of Creators and Copyright Owners, 41

Coalition of Designers, 421

Code of Fair Practice, 21-23, 115, 127

Collage, 38, 88

- Collateral material, 17, 176-78, 433 (definition); and exhibition design, 199; fees for design of, 176-77 (chart); illustrations in advertising, 238-242 (chart)
- Collectibles, 142-46; clauses in contracts, 144; and freelancers, 143; and payments, 144; and rights, 144; and trade practices, 144-46
- Collection, 124-34; after a judgment, 131; agency, 130; fees, 124; and lawyers, 131-32, 134; methods of, 24, 127-28; preventing problems with, 126-27; remedies for, 131; sample letters for, 125, 128; sample phone script for, 124; services, 130; strategy, 124-25, 126; and suing in civil court, 134

Collective bargaining, 72, 74, 103; agreement, 72, 103

Collective works, 29, 31-32

Collector's items. See Collectibles

Color artist. See Colorist

Color: key, 433 (definition); line, 334, 335; and the Pantone color system, 335; printers, 87-88, 90-91; proofs, 85, 87-88, 89-91, 433 (definition); separation, 85, 87-89, 90 91, 92, 93, 433 (definition)

Colorist, 315-16, 317 (chart), 327. See also Cartoonist

Colorways, 339 (chart), 340 (chart), 330 (chart)

Comic books, 307, 314-19, 317 (chart); alternative, 317; and licensing, 315; an publishing, 315-17; and trade practices, 317-18

Comic syndicates, North American, 313-14

Commission, 6, 8-9, 78, 202-03, 433 (definition); and art contests, 78; form, 202-03. See also Fees; Royalties

Communication Arts Design Annual, 20

Communications Workers of America (CWA), 100-01

Community for Creative Non-Violence (CCNV), 47

Comp art, 183-84, 244, 247 (chart); order, 186

Compact discs. See CD-ROM

Competitions. See Art contests and competitions

Compositor, 92-93

Comps (or comprehensives), 18, 92, 93, 94, 97, 433 (definition)

Compulsory licensing, 40-41

Computer-aided design (CAD), 293, 335-37, 432 (definition)

Computer-colored comics, 315-16

Computer games, 96, 207, 222-23; and design fees, 217 (chart); and rights, 223; and royalties, 222-23

Computer-generated art, 84, 87-88, 90-91, 103

Computer-Generated Art Invoice, 375-76 (contract)

Computer-Generated Art Job Order Form, 373-74 (contract)

Computer-generated imagery (CGI), 325, 330 (chart)

Computer graphics, 200, 222-24; billable expenses for, 111

Computer-ready electronic files (CREF), 86

Computers, 69; and animation, 324-25; and games, 222-24; and production artists, 204-05; and textile design, 334, 335-37; and training, 225

Conference on Fair Use (CONFU), 39

Confidentiality, 363, 433 (definition)

Construction Specifications Institute (CSI), 196

Consultation fees, 67, 111; for graphic designers, 167

Consumer price index (CPI), 110

Contests. See Art contests

Contingency fee. See Fees

Contracts, 4-5, 17, 120-21, 344-407, 366-407 (contract forms), 433 (definition); all-rights, 362; back-of-check, 48; blanket, 432 (definition); boilerplate, 261, 263, 348, 349, 355-56, 432 (definition); breaches of, 360; and cancellation (kill) fees, 75-76, 112, 352, 363; for cartoons in newspaper syndication, 311-13: and checks, 349: clauses in collectibles', 144; of clients, 356-57; and computer games, 223; and confidentiality clause in, 363, 433 (definition); and confirmation form, 433 (definition); and copyrights, 350-52; and deescalation clause, 434 (definition); and electronic publishing, 86-87, 96-97, 363; glossary terms for, 362-65; and graphic artists, 316, 346, 347-50, 355; invoice, 348-49; letter of agreement, 347, 436 (definition); for greeting card and novelty design, 202-03; negotiations over, 346-47, 357-59; and no assertion of rights, 364, 437 (definition); oral, 347; pass-through clause in, 437 (definition); and payments, 352-53; and perpetuity, 364; postproject, 348-49: purchase order, 347-48: retainer, 349-50: for reuse sales, 140: and rights granted, 107-08, 351, 362; and stationery/gift design, 203; with stock agencies, 137-38; and taxes, 68-70; termination of, 365; terms for Web design, 212-13; and warranty clause, 365; working, 348. See also Work for hire

Converter, 337, 433 (definition)

Copyright, 29-44, 55, 90, 106, 182, 261, 433 (definition); arbitration royalty panels (ARPS), 40; and art contests, 79; Canadian, 58-61; and contracts, 350-52; in credit lines, 113; and derivative works, 94-95; and distribution rights, 95-96, 106; and electronic art, 84, 86, 88, 93, 94, 96, 100; extension, 41; and fair use, 38-39; fees, 29; infringement, 34, 39-40, 42-44, 93; international, 58-61; and joint works, 96; law, 27; legislation, 31-32, 41, 42, 44-45; licensing rights, 30; licensing, compulsory, 40; notice, 33; and original art, 53; ownership, 88; protecting, 96-99; rates of compensation, 40-41; registering, 28, 33-37, 44; registration fee, 28; renewal, 37; and reproduction rights, 94; and resale royalties, 53; risk of invasion, 39-40; sale of, 5, 6; and statutory damages, 34; transfer of electronic rights, 31-32; and warranty, 40; and Web design, 213, 221; and work for hire, 41

Copyright Act of 1909, 37

Copyright Act of 1978, 28, 29, 30, 31-32, 34, 44, 51, 58, 316; and works for hire, 44-45

Copyright Clearance Center (CCC), 422

Copyright Office, 29, 30, 44, 51, 53, 134, 142; address, 34, 44; and CORDS, 34; and Information Kit, 44; forms, 34, 35; registration with, 28, 33-37, 44; Web site, 34, 42, 44; and Web sites, 213, 221

Copyright Remedy Clarification Act, 44

Copyright Royalty Tribunal Reform Act, 40; and CARPs, 40

Copyright Term Extension Act, 41, 114

Corporations, 106, 169; and advertising, 106, 136, 173-75, 173-74 (chart); and branding, 170 (chart); 172-73; and billing, 170-71; and calendars, 250; and design projects, 169, 170-71 (chart), 181 (chart); and exhibition design, 198 (chart); and graphic design, 169-73; and identity, 106, 170-71 (chart), 172; and illustrations for World Wide Web, 215 (chart); illustrations used in print materials, 181 (chart), 250-51, 252-53 (chart); and logos, 106, 172; and offline illustrations, 216 (chart), 217 (chart); and project proposals, 169; technical illustrations used by, 292 (chart)

Cost consultant, 246

Cost-of-living increases, 110

Court cases, 24, 31-32, 42, 45-48, 50, 94, 98-99, 123, 297, 349, 413-15, 420

Covers. See Books

Creative director, 324, 327, 329 (chart), 433 (definition)

Creative fee. See Fees

Credit line, 113, 182; with computer games, 223; in surface/textile design, 342; in Web design, 213

Croquis, 334, 339 (chart), 340 (chart), 434 (definition)

CSS, 208, 225 (definition), 434 (definition)

Cure provision, 354

d

Damages, 33-34

Day rate. See Per diem

Deadlines, 91, 93

Debts, tracking, 123

Deductibility of artwork, 64

Deep discount, 262

Deescalation, 262

Deliverables, 212

Demand letter, 128

Demonstration rights. See Rights

Derivative works, 94-95, 97, 364; and copyright law, 94-95

Design: brief, 14-15, 185, 434 (definition); proposal. See Request for proposal

Designer. See Graphic designer

Designers Saturday (DS), 77

Design firm, 110, 166; hourly rates, 110, 116 (chart)

Desktop publishing (DTP), 84

DHTML, 208, 225 (definition), 434 (definition)

Digital: art, 65, 66; file, 92; games, 178 (chart); glossary terms, 225-27; proofs, 91; rights, 29, 60

Digital marketplace, 209-10; and contracts, 212-13; and other markets, 224-25

Digital Media Invoice, 377-79 (contract)

Digital Millennium Copyright Act (DMCA), 29, 42-43, 98, 221; and provider terms of service, 43; Section 512 of, 42-44, 98

Digitizing, 325, 326, 327

Dimensional illustrator, 295-300; and computer animation, 325, 325 (chart); an photographing artwork of, 295-97; and pricing, 297-98; trade practices of, 298-300 Direct mail, 176; design of, 176 (chart); illustrations in brochures, 277 (chart); as promotion, 176, 240 (chart)

Directory of Illustration. See Graphic Artist Guild

Directory of Syndicated Services, 313

Disability Access Symbols Project, 196

Disability insurance, 71

Display design, 197-99, 198 (chart)

Display faces, 191 (chart), 192

Distribution rights. See Rights, distribution

Domestic products: fees for designing, 338 (chart), 339 (chart); fees for Ilustration for, 282 (chart)

dot.com, 209-10

Drapery/upholstery, 340 (chart)

Drawing programs. See Computer-aided design (CAD)

Droit de suite, 53

Dummy, 434 (definition)

Dun & Bradstreet, 126

Dye transfer, 434 (definition)

e

E-commerce, 84

Editor and Publisher, 313

Editorial illustrator, 265-70; for magazines, 266-68, 266-68 (charts); of medical/natural science, 286 (chart); for newspapers, 268-70, 270 (chart); and newspapers' trade practices, 268-70; and relationship with art rep, 7; of technical subjects, 291 (chart); and the World Wide Web, 215

"Edutainment," 210

Electronic: bulletin boards, 98; color, 85, 89-91; color separation, 85, 87-89, 90-91, 92, 93; database, 31-32; defense, 97-99; file, 86, 88, 90, 91, 93; illustration, 65, 85, 88-89; licensing, 31-32; media, designing for, 13; prepress, 85, 86; production, 86-87, 92; retouching, 85; scanning, 86; typesetting, 86; watermark. See Watermarking

Electronic publishing, 83-84, 86, 92-93; and cartooning, 314, 319; rights, 46, 86-87, 434 (definition); and sales tax (California), 66

E-mail, 87, 88

Embroidery, 337, 434 (definition)

Employee, 153-62; freelancer as, 112-14; status, 72-73, 74

Employment: agencies, 19; benefits and insurance, 71; conditions, 155; issues, 71-74, 102; and job security, 72; temporary agencies, 101-02; and work for hire, 72

Encryption, 98

Entertainment licensing, 320-21

Environmental graphic design, 66, 195-97, 195 (chart)

Escalation, 262

Esquire, 52

Estimate, 86, 87, 93, 96, 119, 438 (definition); and confirmation form, 86, 87

Ethical issues, 4; and electronic art, 84, 93; and professional practices, 4, 100

Ethical standards, 3, 21-25; and Code of Fair Practice, 21-22

European stamp programs, 302, 304

Exclusivity, 9, 94, 96, 434 (definition)

Exemption, 64, 67, 88

Exempt-use certificate, 67, 68, 69

Exhibit design, 68, 197-99, 198 (chart); medical/natural science illustrations in, 286 (chart)

Expenses, 9-10, 73, 86, 90, 92, 179, 342; and cancellation/termination, 75-76; estimates, 86, 87; for graphic designers, 167; unreimbursable, 76; for Web design, 212

f

Fair Debt Collection Practices Law, 124

Fair market value, 64

Fair Practices Act, 54

Fair use, 38-39, 42, 60, 98, 249; and Conference on Fair Use (CONFU), 39; international, 60

Fashion illustrator, 274-78; fees for, 276-78 (charts); trade practices for, 275-76

Fees: for advertising, 234-44 (charts); for architectural/interior illustration, 295-96 (chart); and in art contests, 77, 81; in artist-agent agreement, 8-9; for artwork in audiovisuals, 249 (chart); for book interior illustration, 257-59 (chart); for book jacket design, 183 (chart); for book jacket illustration, 255, 256 (chart); for books, 184, 185 (chart); cancellation (kill), 436 (definition); for cartoon reprints, 320 (chart); for cartoons, 309 (chart); for chart and map design, 204 (chart); for children's books, 260 (chart); for collateral material, 176-77 (chart), 238-40 (chart); for computer animation, 325 (chart); consultation, 111; contingency, 433 (definition); in contracts, 352-53; and copyright, 29; for corporate graphic design, 170-71 (chart); for corporate illustration, 252-53 (chart); in design proposal, 15-16, 17-18; for digital illustration, 215-18 (charts); for editorial illustration, in magazines, 266-68 (chart); for editorial illustration, in newspapers, 269 (chart); and electronic art, 84, 91, 92, 95, 96; for environmental graphic design, 195 (chart); for exhibition design, 198 (chart), 240-242 (chart); for fashion illustration, 277-79 (chart); flat, 96, 112; for lettering and calligraphy, 189-90 (chart), 191 (chart); for medical/natural science illustration, 285-87 (chart); for merchandise design, 201 (chart); for online/digital illustration, 215-19 (chart); for outdoor ads, 175 (chart), 242-43 (chart); for package design, 178 (chart); for packaging illustration, 273-74 (chart); and payment, 121; for postage stamp illustration, 305 (chart); for preproduction illustration, 247-48 (chart); for production artists, 205 (chart); for promotion, 173-74 (chart); for publication design, 179, 180-81 (chart), 182; of recruitment agency, 19; rejection, 75, 76, 364, 436 (definition), 438 (definition); for retail illustration, 282-83 (chart); retainer, 349-50; for retouching, 193 (chart); setting of, 106; for surface/textile design, 338-40 (chart); for technical illustration, 291-93 (charts); terms for, 121; for Web design, 209 (chart). See also Cancellation (kill) fees, Rejection fees

FICA, 71

File: maintenance, 90; ownership, 90; transfer protocol (FTP), 88

Film: editor, 327; output, 89

Finder's fee, 10, 138

Fine art, 49-50, 52-53

First reproduction rights. See Rights, of reproduction

Flat fee. See Fees

Folio, 110, 266

Fonts, 86, 87, 191-192, 434 (definition); and programs, 86, 316

Forbes, 266, 319

Foreign-language edition, 254-255, 255 (chart), 256 (chart), 259 (chart), 260 (chart), 262

Forrester Research, 207

Freelancers, 5, 69, 71, 72-73, 98-99, 112, 179; and animation, 324, 326, 329, 330; and cartoons, 308, 311-13, 316; and collectibles, 143; as employee, 71, 103, 112, 435 (definition); full-time, 71, 73; and hourly rates, 166 (chart); illustration and design, 231; and kill fees, 75-76; and sales taxes, 70. See also Web designer

Fringe benefits, 71

Full-time workers, 73

g

Gag cartoons, 308, 317

Game developer, 222-24

Gift wrap, 340 (chart)

Gifts. See Novelties

Glossary terms: contracts, 362-65; general, 431-40; Web design, 225-27

Government works, 60-61. See also U.S. government works

- Graphic artist: and art contests, 76-79, 81; and billable expenses, 111; and computers, 84-88, 95, 101-03; and contracts, 346, 347-50, 366-407 (contracts); definition of, 435; as freelancer, 112; hourly rate for, 109-10; and international rights, 58-61; and negotiating, 115-17, 118-20; per-diem rate for, 108-09; salaried, 153-54, 156-57, 158-59 (chart); salaried, employment conditions for, 155; and sales tax, 65-70; and sales tax when cancellation and rejection, 112-13; and setting fees and rates, 106; and temporary work, 102-03
- Graphic Artists Guild, 20, 28, 41, 48, 65, 74, 77, 116, 409-21; and affiliation with United Auto Workers (UAW Local 3030), 415, 421; and art contests, 77-79; Artist-to-Artist Web Forum, 140, 359, 418; and Artists for Tax Equity (AFTE), 413; and Artists United for Universal Health, 414; "Ask First" campaign, 19, 28, 39, 100, 142, 414; benefits of membership, 130, 410-11, 418-19; Campaign for Illustration (C4I), 84, 415, 417; and Code of Fair Practice, 21, 22-23, 115, 415; and collective bargaining, 72, 74, 410, 414, 415; constitution, 28, 410, 416; contest surveys, 77, 80; Contract Monitor, 355, 359, 415, 418; Directory of Illustration, 8, 20, 96, 411-18; Disability Access Symbols Project, 196, 414, 420; and employment possibilities, 20; and equal pay standards, 156; and ethical standards, 21-23; Foundation, 77, 196, 412, 413, 414, 419; and Giolito Communications Center, 412, 413, 420; Grievance Committee, 21, 23-25, 126, 128-29, 411, 417, 419; Guild News, 142, 411, 418; help for staff artists, 161-62; history of, 410-15; Jobline News, 20, 416; and Joint Ethics Committee, 411; Legal Defense Fund, 134, 415, 420; Legal Referral Service/Network, 131, 132, 140, 412, 413, 419; and legislation, 28, 41, 48, 52, 54, 65, 96; and licensing, 202; Lifetime Achievement Award, 415; local Chapters, 20, 410-21; locator services, 419; logo, 54; long-range goals, 410; member benefits and services, 418-19; membership in, 417, 421; mission, 409; National Board of Directors, 411, 418, 419; and pay rates, 109-10; Seal of Compliance, 81; and USPS, 303; vision statement, 409-10; Walter Hortens Distinguished Service Awards, 415; Web site, 34, 359, 362, 415, 417-18, 421

Graphic Artists for Self-Preservation (GASP), 419

Graphic designer, 3, 4, 12-19, 165-205; and advertising and promotion design, 173 78; and bidding on project, 14-18; and billable expenses, 85-88, 111; and billing, 18, 171; and book design, 184-87; and book jacket or cover design, 182-84; and broadcast design, 200; and budget, 15; and chart and map design, 203-04, 204 (chart); and client relationships, 13-19; and collateral design, 17, 176-77 (chart); and contests, 76-79, 81; and contracts, 17, 18, 167, 380-83 (contracts); and computers, 84-88, 95; and corporate projects, 169-72, 170-71 (chart); and deadlines, 15; definition of, 435; and design directions, 18-19; and electronic media, 13; and employment and recruitment agencies, 19; and environmental design, 195-97, 195, (chart); and exhibit and display design, 197-199, 198 (chart); and fees, 15, 16-17, 18; hourly freelance rates (median), 166 (chart); and lettering and typeface design, 188-92, 189-90 (chart); and novelty and merchandise design, 200-03; and other graphic industry professionals, 13, 18; and possible problems with clients, 86-87; and production artist, 204-05; professional practices of, influenced by technology, 85-88; and publication design, 179-82, 180-81 (chart); reasons to hire, 14; role of, 13-14; and salary, 156-57, 158-59 (chart), 166 (chart); sources of, 19-20; and subcontracting, 18, 19; and trade practices, 167-68; and Web design, 207-21; working with, 12-19. See also Books, Branding, Broadcast designer, Brochures, Catalogs, Chart design, Children's books, Collateral material, Comps, Computeraided design, Computer games, Computer graphics, Design brief, Design firm, Direct mail, Request for proposal, Surface or textile designers

Graphic Designer's Estimate & Confirmation Form, 87, 380-81 (contract)

Graphic Designer's Invoice, 87, 382-83 (contract)

Graphics software. See Software

Graphis, 20

Greeting card: design of, 136, 200-03, 201 (chart), 340 (chart); illustration for, 278-79, 281 (chart); illustrations' trade practices, 280-83; publishers, 307; and trade dress, 57

Groening, Matt, 150

h

Hackers, 98

Hand-weaver. See Sample weaver Hanna-Barbera Productions, 326 Hardware, 84, 91-92 Headhunters, 19 Health illustrator. See Medical illustrator Health issues, related to technology, 100-01 High-res/high-resolution. See Resolution Holding work, 342; form, 342 Home: furnishings, 333-37, 338-40 (charts); office, 103; workers, 103 Hourly rate, 109-10; formula, 110 (chart) Hours of work, 73 House: accounts, 9; list, 142 *HOW* magazine, 156 HTML, 208, 211, 225 (definition), 435 (definition)

i.

Illustration: prices and trade customs, 228-305; stock house. See Stock house

Illustrator, 4-12, 88-90, 99, 229-304, 435 (definition); of advertising, 230, 231-33, 234-44 (charts); and art contests, 76-79, 81; billable expenses for, 111; of book jackets, 254-55, 255-56 (chart); of book interiors, 256-59, 257-59 (charts); of books, 254-65; of children's books, 259-65, 260 (chart); computer program for, 156, 157; and computers, 84, 88, 95, 111; and contracts, 112-14, 384-88 (contracts), 393 (contract); and corporate work, 250-51, 252-53 (chart); and credit lines, 113; of greeting cards, novelties, and retail goods, 278-81, 281 (chart); and institutional work, 250-51, 252-53 (charts); of onscreen artwork in motion pictures, television, and video, 249; of packaging, 271-74, 273-74 (charts); of postage stamps, 302-04, 304 (chart): professional practices of, influenced by technology, 88-91; and royalty contract, 260-63; and sales taxes, 65-70; sources of, 19-20; and stock houses, 137-39; working with, 4-12, See also Animator, Architectural/interior illustrator, Book, Cartoonist, Children's books, Dimensional (3-D) illustrator, Editorial illustrator, Fashion illustrator, Marbler, Medical illustrator, Preproduction artist, Scientific Illustrator, Technical illustrator

Illustrator's Estimate & Confirmation Form, 384-85 (contract)

Illustrator's Invoice, 386-87 (contract)

Illustrator's Letter of Agreement, All-Purpose, 366-67 (contract)

Illustrators' Partnership of America (IPA), 99

Illustrator's Release Form for Models, 388 (contract)

Image: manipulation, 83, 92, 95, 97, 100; processing, 83, 435 (definition)

Imaging center, 86, 90, 92, 93

Inbetweener, 327, 328, 330 (chart), 435 (definition)

Indemnification clause, 40. See also Liability insurance

Indemnity, 261, 354

Independent contractors. See Freelancers

Industrial Light and Magic (ILM), 325

Infant clothing. See Apparel

Index

Inflation, 110

Information architects. See Web designer

Infringement, 34, 39-40, 42-44, 93, 94, 97, 98; and fair use, 38-40; and reuse, 141-42; of trademark, 56

In-house publications, 181 (chart)

Inker, 315-16 (chart), 327, 330 (chart), 435 (definition). See also Animation, Cartoonist

Institutions: illustrations used in printed materials, 250-51, 252-53 (chart)

Instructional manuals, technical illustrations used in, 292 (chart)

Insurance, 71, 114; and art contests, 78-79; for buyers, 114

Intellectual property, 27; law, 27, 98, 99

Interactive media, 84, 225 (definition), 435 (definition)

Interface designer. See Web designer

Internal Revenue Code (IRC), 64

Internal Revenue Service (IRS), 64, 71, 72; and 20-factor control test, 72-73, 74

International Alliance of Theatrical Stage Employees (IATSE), 326

International Licensing Industry Merchandisers Association (ILIMA), 149, 321

International Motion Picture Almanac, 329

- Internet, 84, 88, 98, 135, 137, 138, 141, 207, 210, 225 (definition), 359, 435 (definition); and CAD, 335; design for, 170 (chart); illustration for, 215 (chart), 217-18 (charts)
- Internet service provider (ISP), 95, 208, 215-18 (chart), 219, 226 (definition), 435 (definition)

Invasion of privacy, 39

Invoices, 6, 66, 67, 70, 96, 120, 122, 348-49, 435 (definition); for computer-generated art, 375-76 (contract); for digital media, 377-79 (contract); for illustrator, 386-87 (contract); for surface/textile designer, 404 (contract)

i

Jacket illustration. *See* Book, jacket illustration Jacquard, 336, 435 (definition) Java and JavaScript, 226 (definitions), 436 (definitions) Job: description, 101-03; file, 122; ledger, 122, 123 *Jobline News*, 4, 20, 416 Joint: authorship, 96; venture, 103; works, 94-95, 96, 97 Joint Ethics Committee, 22, 115 Juried shows, 77-79 Juror, in art contests, 77-79, 80

k

Kelly v. ArribaVista, 42, 98, 415, 420 Kerning, 86, 92, 436 (definition) Ketubot, 191 Key frame, 244 Kill fee. See Cancellation (kill) fees Kiosks, 225, 242 (chart) Kitchen products, fees for designing, 338 (chart), 340 (chart) Knitted textiles, 336-37, 436 (definition) Knockoff, 162, 342, 436 (definition)

I

Labor market, 101-03 Lanham Act, 49, 57 Laptop presentations, 225 Laser proof, 88 Late fee. See Fees.

Lawsuit. See Court cases.

Lawyer, 124, 131-132, 134, 360; referral, 24. See also Volunteer Lawyers for the Arts Layout, 92, 186, 327, 436 (definition); artist, 327, 330 (chart), 436 (definition)

Legal expenses, 354

- Legal rights and issues, 28-61; and electronic art, 84, 93; related to technology, 93-100
- Letter of agreement (or confirmation), 96, 120; All-Purpose Illustrator's, 3 66-67 (contract)

Letterer, 315-16, 317 (chart); 435 (definition). See also Cartoonist

Lettering design, 188-92, 189-90 (chart), 432 (definition)

Letters of agreement, 5, 347

Liability: insurance, 39-40; and indemnification clause, 40; for portfolios and original art, 113-14; for Web design, 213

Library of Congress, 249, 301

License, 97, 149-50, 337, 364, 436 (definition); and audiovisual fees, 249; and broad rights, 97; of foreign book editions, 254-55; for surface/textile design, 337-38

Licensee, 149-50

Licensing, 108, 147-50, 148 (chart), 202; agent, 149; agreement, 149-50, 280, 337-38; of characters, 149, 320-21; and comic books, 315; electronic, 31-32; of greeting card and novelty design, 202; and payments, 150; product retail sales, 148 (chart); rights, 30, 149-50; for surface/textile designs, 337-38. *See also* Merchandising

Licensing Agreement: long form, 390-92 (contract); short form, 389 (contract)

Licensing Letter, The, 149

Licensor, 149-50

Life Plus, 36, 41, 50, 51, 59, 70

Limited: edition prints, 146-47; rights. See Rights

Link-jacking, 221

Litigation. See Court cases

Logo, 172, 436 (definition); design for corporations, 170 (chart), 179; and taxes, 66, 68

Low-res/low-resolution. See Resolution

m

Magazine Purchase Order for Commissioned Illustration, 393 (contract)

Magazines, 87-88, 266-68, 307; advertising, 87-88; advertising and promotion design in, 174 (chart); and cartoons, 308-10; and cartoons, fees for, 309 (chart); design of, 179-82 180-81 (chart); illustrations in, 30, 266-68, 266-68 (charts); illustrations in advertising in, 234-35 (chart)

Map design, 203-04, 204 (chart)

Marbler, 300-02; and Japanese suminagashi, 300; trade practices of, 301-02

Market: categories, 107 (chart); niches, 94, 96

Marketing, 20-21, 73; consultants, 20

Markup, 92, 93, 111, 436 (definition)

Mass-market books, 256

Mechanicals, 64, 67, 436 (definition); and sales tax, 64, 67

Media kit. See Press kit

Media Photographers Copyright Agency (MP©A), 99

Mediation, 75, 76, 129-30, 354, 361, 436 (definition)

Mediator, 129, 354, 361

Medical coverage. See Benefits

Medical illustrator, 282-86; fees for, 285-86 (charts); trade practices of, 282-84

Merchandising, 108, 147-50, 201 (chart); of cartoon characters, 319-21; income, 320

Millwork, 161-62, 338 (chart) Model fees. See Fees

Modelmaker, See Dimensional illustrator

Models, 296-97, 299

Model sheets, 328

Modem, 88, 91

Moral rights, 51, 52-53, 58, 60, 364, 436 (definition); and the Berne Convention, 51, 53, 60; international, 58, 60; legislation, 51, 52-53, 60, 364; protections, 51, 52-53

Morphing, 325

Motion pictures: artwork in, 249, 249 (chart); computer animation, 243 (chart), 324, 325; posters in, 243 (chart)

Motion Picture Screen Cartoonists (MPSC), 326, 328, 329, 330 (chart)

Mugs. See Novelties

- Multimedia, 96, 225; design, 210 (chart); designers, 91
- Musical recordings, illustrations in packaging for, 273

n

Napkins, 339 (chart)

National Association of Freelance Photographers v. the Associated Press, 420

National Endowment for the Arts (NEA), 77, 196, 420,

National Writers Union, 99, 414

Natural science illustration, 285-87 (charts)

Negotiation, 29, 86-87, 89, 114-20; agenda, 115-16; of contracts, 346, 357-59, and meetings, 117-18; and money, 118-20, 358; tactics, 116-17; by telephone, 117

New York Committee for Occupational Safety and Health (NYCOSH), 101

New Yorker, The, 266, 267 (chart), 291 (chart), 308, 309 (chart)

New York Gold, 20

New York State Department of Taxation and Finance, 70; Web site, 70

New York Times, The, 101, 268

- Newsletters: design of, 170 (chart); in-house, illustrations in, 252 (chart); prototype design for, 252 (chart)
- Newspapers, 87-88, 268, 307; advertising and promotion design in, 174 (chart); and cartoonists, 311-14; design of, 179-80; illustrations in, 268-70, 270 (chart); illustrations in advertising in, 236-37 (chart); syndicated cartoons in, 311-14; trade practices for illustrations in, 268-69

Noncommercial educational broadcasting stations, Web design for, 213

Noncomplete clause, for Web design, 213

Nondisclosure Agreement for Submitting Ideas, 394 (contract)

Nonexclusivity, 9, 437 (definition); rights, 93

Nonpayment, 126-27

Nonprofit organizations, and art contests, 77, 79, 81

North American Licensing Industry Buyers Guide, 149

- Novelties, 437 (definition); design of, 200-01; design fees for, 338 (chart), 340 (chart); illustrations for, 278, 281 (chart); merchandising of, 201 (chart); products, 201 (chart)
- Novelty, retail goods, and surface design, 201-02, 279-80, 282 (chart), 338-40 (charts)

0

Occupational Safety and Health Administration (OSHA), 101

Offline illustration, fees for, 216 (chart), 217 (chart)

- Online: cartoons, 314; illustration, fees for, 215 (chart), 217-18 (chart); sales, 141;service, 29
- Onscreen artwork (in motion pictures, television, and video), 249; fees for usage, 249 (chart)

Opaquer. See Inker

Original art, 29, 33-35, 114, 351, 355, 364; alteration/mutilation of, 52-53, 94-95, 261, 364, 438 (definition); and appraisals, 114; and art contests, 77-79; in audiovisual works, 249, 249 (chart); and cancellation fees, 112; and computers, 84, 87, 88, 93, 94; and fair use, 38-39; and liability, 113-14; in portfolios, 113; and rejection fees, 113; for retail goods, 279, 334; royalty-free, 95-96; sale of, 5, 6, 53-54, 64, 87, 106; and sales tax, 64, 65; transfers of, 29; versus derivative art, 94-95

Outdoor advertising, 175 (chart)

Output methods, 90-91

Overhead, 91-92, 437 (definition)

Ownership of the art, 54, 437 (definition)

р

Package: design, 178 (chart); illustration, 271-73, 274 (charts) Packager, 6, 437 (definition)

Packaging: illustrations in, 273-74 (charts); technical illustrations used in, 292 (chart); trade practices for illustrations in, 271-72

Page: composer, 90, 103; makeup, 85, 89, 92, 93, 437 (definition); rate pricing, 110 Paper: products, 283 (chart); trail, 98, 121, 127, 358, 360 Panerback books. 256, 262

Pass-through clause, 263

Patent, 55, 437 (definition)

Patent and Trademark Depository Libraries, 55

Patent and Trademark Office (PTO), 55

- Payment, 73, 352-53; extension of time, 127-28; for graphic designers, 167; terms, 121, 352-53; terms for Web design, 212
- Penalties, 121

Pencilers, 315-16, 317 (chart). See also Cartoonist

- Pension, 71
- Per diem, 108-09, 437 (definition); rate formula, 109 (chart)
- Performance rights. See Rights, of performance

Permission, 84, 87, 88

Perpetuity, 364, 437 (definition)

Photograph: and computers, 85; retouched, 95

Photography, 65, 297-98

Photo illustration, 192-94, 193 (chart)

Photoplay, 244

Photoshop, 156, 157, 211

Photostats, 90

Picture books, 260 (chart)

Pixel, 226 (definition), 437 (definition)

Placemats, 339 (chart)

Plagiarism, 437 (definition)

Playboy Enterprises, Inc. v. Dumas, 46, 48, 99, 123, 349,422

Point-of-purchase (or sale) display material, 5, 201 (chart), 224

Popular Mechanics, 110, 266

Portable document format (PDF), 87-88

Portfolios, 4, 6, 8, 118, 437 (definition). See also Samples

Postage stamp illustration, 302-04, 304 (chart)

Posters, 175; illustrations in motion picture and theater & event, 243 (chart); station, 175 (chart)

Prepress: process, 92, 93; specialist, 103

- Preproduction artist, 244-47; fees, 245-46, 248 (chart); and trade practices, 246-47
- Preproduction illustration, 244-47; comparative fees for, 247-48 (chart); trade practices for, 246-47

Index

Presentations, 118; boards, 437 (definition); medical/natural science illustration in, 285-86 (chart)

Preseparated art, 89

Press kit, 175, 176 (chart), 239 (chart)

Preston v. Board of Equalization, 65

Pricing, 91-93, 106-11; for animation, 329, 329 (chart), 330 (chart); and computergenerated art, 91-93; for exhibition design, 198-99; by production artists, 205; for Web design, 214, 215-18 (charts). See also Fees

Printed textiles, 337

Print Regional Annual, 20

Production artist, 157, 158-59 (chart), 204-05, 205 (chart), 437 (definition); and pricing, 205 (205 (chart)

Product and service catalog, 177 (chart)

Professional: education, 92; issues, 62-81; relationships, 3-25

Profit-sharing, 71

Project fee. See Fees

Project team, 219

Promotion. See Advertising

Proposal. See Design brief

Protection of Artists Act, 54

Public Broadcasting System (PBS), 40

Public domain, 39, 88, 438 (definition); art, 221

Publication designers, 179, 180-81 (chart), 182

Puppet animation, 325, 328

Purchase order, 4-5, 6, 120, 347-48, 438 (definition); usage rights and categories, 5

q

Quality control, 96, 263 Quantity orders, 343 Quark, 156, 157, 208, 211

r

Raster system (or RIP), 91, 438 (definition) Rates of compensation by CARPs, 40-41 Reader's Digest, 266, 266 (chart), 291 (chart) Recording covers, 271; illustration for, 271-73, 273-74 (chart) Record keeping, 120-23; system, 121-22 Recruitment and search agencies, 19 References: checking, 8; file, 438 (definition) Rejection fee, 75-76, 113, 352, 364. See also Cancellation (kill) fee Releases, 100 Remaindering, 263 Repetitive motion disorders (or strain injuries), 100-01 Representative. See Artists' representative Reproduction (repro) copy, 90, 438 (definition) Reproduction rights. See Rights, reproduction Request for proposal (RFP), 14-18, 169, 196; development of, 15-18; parts/phases of, 16-17 (chart); specifications to include in, 15 Resale, 67, 136; certificate, 64, 68, 69; number, 68; royalties, 53 Resin-coated (RC) paper, 90 Resolution, 85 90-91, 96, 100, 438 (definition) Retail catalogs, 277-78 (chart) Retail products, 333; and agreement, 349-50; design of, 178 (chart); and fees for surface/textile design, 338 (chart), 340 (chart); illustration for, 278, 281

(chart); packaging, illustration for, 273 (chart); trade practices for illustra-

tion for, 279-80, 281 (chart)

Retainer, 17, 175, 349-50

Retoucher, 192, 193 (chart), 194, 438 (definition)

Retouching, 95, 100, 192-94, 193 (chart); digital versus handwork, 193; and pricing, 194

Return of artwork, 263, 343, 438 (definition)

Reuse, 94, 108, 134-42, 439 (definition); fee, 136; prices, 136; rights, 135, 140; sales by artists, 135-36; sales by artists' representative, 136-37; sales by stock houses, 137-39; sales online, 141; and taxability, 66; and technology, 135; unauthorized, 141-42

Reversionary interest proviso, 59

Reversion rights, 30, 59, 438 (definition)

Revision, 93

Rights: to artwork, 99, 106-08; assigning, 431 (definition); and attribution, 431 (definition); cancellation/termination, 75, 76, 99, 113, 365; celebrity and privacy (including exceptions), 48-50; and computer games, 223; copyright, 29-30; of deceased, 49; of derivative works, 94-95; discharge, 73; distribution, 95-96; electronic, 5, 31, 86, 95, 262-63, 363, 414; exclusive unlimited, 5, 38, 93, 106; first, 434 (definition); first North American serial, 434 (definition); for graphic designers, 167; limitations, for surface design, 343; to modify, 438 (definition); moral, 51-53; noncompeting, 437 (definition); nonexclusive, 93, 106, 364; outdoor use, 5; performance, 96; publicity, 48-49; of quitting, 73; reprint, 438 (definition); reproduction, 67, 68, 87, 89, 90, 91, 93, 94-95, 96, 106-08, 182, 337, 364; reuse, 108, 134-35, 140; royalty-free distribution, 95-96; simultaneous, 439 (definition); sublicidiary, 439 (definition); sublicitary, 439 (definition); subsidiary, 439 (definition); subsidiary, 13, 245-55, for Web design, 213. See also Termination rights

Rights-free art. See Clip art

Rogers v. Koons, 297

Rollover contract, 137-38

Roughs, 327, 438 (definition)

Royalties, 96, 108, 438 (definition); and agreements, 108; and cartoonists, 316; and computer games, 222-23; and contracts, 260-63; and electronic art, 84, 95-96; and resale, 53; and surface/textile designers, 337-38, 338 (chart)

RSVP, 8, 20

Rush work, 343

S

Salaried employees, 153-62; animators as, 328-30, 329 (chart), 330 (chart); broadcast designer as, 160; design staff as, 156-57; production staff as, 157; reviews, 155; salaries of, 156-57, 158-59 (chart), 162; surface/textile designer as, 161-62

Sale of rights. See Rights

Sales tax, 64-70, 88, 122-23, 353, 439 (definition); California, 65-66, 88-89; collection of, 122-23; exemptions for, 64, 67-70; Massachusetts, 66; Minnesota, 66; New York, 66-70; reporting form, 70; special, in New York City, 69-70

Samples, 8, 113; in stationery and gift design, 203

Sample weaver, 336

Scanning, 92, 94

Scarves and handkerchiefs, fees for designing, 339 (chart)

Schedule C of IRS Form 1040, 109

Scientific American, 110

Scientific illustrators, 286-88; trade practices of, 287-88

Scitex Graphic Arts Users Association, 86

Second-use (or secondary) rights. See Reuse

Self-promotion, 6, 20-21

- Service: bureau, 85, 90, 111, 205; mark, 54, 55, 439 (definition)
- Service Employees International Union (SEIU), 101

Service fee. See Fees

SESAC, 40

- SGML, 226 (definition), 439 (definition)
- Shareware, 222, 226 (definition)
- Sheets and pillowcases, 339 (chart)
- Shower curtains, 340 (chart)
- Showroom illustrations, 439 (definition)
- Signage, 195-96; project proposals, 196-97
- Simeonov v. Tiegs, 50
- Sketches, 89, 439 (definition); and additional fees, 89
- Sliding scale, 96
- Small-claims court, 24, 130-31, 361
- Small-country stamp programs, 302, 304, 304 (chart)
- Social Security payments, 71, 122
- Society of Environmental Graphic Designers (SEGD), 66, 196, 413
- Society of Illustrators, 22; Annual, 20
- Society of Photographer and Artist Representatives (SPAR), 22, 137
- Software, 84, 85, 86, 87-88, 89, 91-92, 97, 207, 224; design of, 178 (chart), 217 (chart); designing programs, 224; graphics, 324-25, 326; packaging illustration for, 273 (chart); and textile design, 335, 336-37
- Speculation, working on, 76, 173, 341, 439 (definition). See also Art contests
- Spot illustration, 266, 439 (definition)
- Spread illustration, 266
- Stamp illustration. See Postage stamp illustration
- Standard Rate & Data Service, Inc., 110, 116
- Stationery design, 201-02, 201 (chart); for corporations, 170 (chart); lettering for, 190 (chart)
- Stock art (or illustration), 134, 137; online, 219 (chart)
- Stock house (or agency), 84, 95, 99, 100, 134-35, 137-39, 142; pros and cons of using, or reuse sales, 137-39
- Storyboard, 244-45, 439 (definition); and animation, 325, 327, 328, 329 (chart), 330 (chart); fees for, 248 (chart)
- Stress:in negotiations, 115; in workplace, 102
- Studio policy, setting up, 356
- Subcontracting, 19; and sales tax, 64
- Sublicensing, 365
- Subsidiary rights. See Rights
- Subsidiary sales, in children's book publishing, 262
- Surface or textile designer, 160-62, 333-43, 338-40 (charts), 439 (definition); and CAD, 335-37; fees or commissions for, 9, 338-40 (chart); of knitted textiles, 336-37; and licensing of work, 337-38; of printed textiles, 337; royalties for, 337-38, 338 (chart); seasonal trends affecting, 334; trade practices for, 341-43; working with reps, 341; of woven textiles, 336, 339 (chart)
- Surface/Textile Designer-Agent Agreement, 8, 395-00 (contract)
- Surface/Textile Designer's Estimate & Confirmation Form, 401-02 (contract)
- Surface/Textile Designer's Holding Form, 403 (contract)
- Surface/Textile Designer's Invoice, 404 (contract)
- Syndication, 439 (definition); and newspaper cartoon, 311-13

t

- Tabletop products, fees for designing, 338-39 (charts) *Tasini v. The New York Times*, 31-32, 94, 99, 407 Tax: deductions, 71; lawyer, 70 Tax-exempt organizations, 64, 67 Technical illustrator, 288-92, 290-92 (charts); trade practices of, 288-89 Technology issues, 82-103; pricing considerations with, 91-93
- Telephone negotiating. See Negotiation

- Television: animatics, 245; and animation, 324; fees for animated commercials, 243 (chart); fees for preproduction, 248 (chart); onscreen artwork for 249, 249 (chart); salaries for animation artists in, 329 (chart), 330 (chart); storyboards for, 244-45, 248 (chart)
- Temporary employment agencies: and compensation, 102; contracts offered by, 102; and graphic artists, 102-03; and unions, 102
- Teri J. McDermott, CMI, et al. v. Advanstar Communications, Inc., 94, 423, 428
- Termination: of agent by artist, 11; of agreement, 263; rights, 30, 440 (definition)
- Textbooks, 136, 187, 440 (definition); design fees for, 185 (chart); interior design of 258 (chart)
- Textile designer. See surface or textile designer
- Textiles, 336; knitted, 336-37; and licensing, 337-38; printed, 337; woven, 336
- Texture maps, 325
- Thermal wax (or transfer), 91
- 3-D illustrator. See Dimensional illustrator
- Tie-ins, 271
- Time to market, 87
- Towels, 340 (chart)
- Trade books, 186-87, 256; design fees, 185 (chart)
- Trade dress, 56-57, 440 (definition); and the Lanham Act, 57
- Trade magazines, 116; and contests, 77, 78, 81, 94, 180-81 (chart)
- Trademark, 50, 54-56, 440 (definition); and federal registration, 55-56; and landmark buildings, 55-56; in a painting, 50; protection, 55-56
- Trade practices: for advertising illustration, 232-33; for architectural/interior illustration, 294-95; for book illustration, 264-65; for cartoons in magazines, 310; for collectibles industry, 144-46; for comic book illustration, 317-18; for corporate illustration, 250-51; for dimensional illustration, 299-01; for editorial illustration, 268-70; for fashion illustration, 275-76; for graphic designers, 167-68; for marbling, 302-03; for medical illustrators, 284-85; for packaging illustration, 272-73; for preproduction illustration, 246-47; or reuse sales, 140; for retail goods illustration, 280-81; for scientific illustration, 288-89; for surface/textile design, 341-43; for technical illustration, 289-90
- Trade show exhibit design, 197, 198 (chart), 199
- Training costs, 92; and computer-based programs, 225
- Translation, 94
- Transparency, 89, 90, 91, 92, 440 (definition)
- Trapping, 85, 89-90, 92
- 20-factor control test, 72-73, 74
- 2-D illustrator. See Dimensional illustrator
- Typefaces (or typography), 97, 191-92, 440 (definition); design of, 188-92, 191 (chart)

u

Unauthorized use, and contracts, 347 Unemployment insurance, 71 Unions: and home workers, 103; and temporary employees, 102, 103 United Auto Workers, 415 United Nations Postal Administration (UNPA), and stamp illustration, 302, 304, 304 (chart) Universal Cartoon Studios, 326 Universal Copyright Convention (UCC), 51 Unpublished work, 35 UPA Pictures, 326 Upgrade requirements, 92 URL, 226 (definition), 440 (definition) Usage, 106-08; international, 108; nonexclusive, 437 (definition)

Index

Use tax. See Sales tax

U.S. Department of Justice, 196

U.S. Department of Labor, Women's Bureau of, 156

U.S. government works, 61

U.S. Patent and Trademark Office, 39, 55

U.S. Postal Service (USPS), and stamp illustration, 302-04, 304 (chart)

V

Vector system, 440 (definition)

Video, 91, 96; artwork used in, 249, 249 (chart); packaging illustration for, 273 (chart) Video games. See Computer games

Virtual reality (VR), 227, 440 (definition)

Visual Artists Rights Act, 52-53, 60, 147, 364

Visual development (vis-dev) artist, 326, 329 (chart)

Volunteer Lawyers for the Arts, 130, 131-32, 361; state listings of, 132-33

VRML, 221, 226 (definition), 440 (definition)

w

Walt Disney Pictures and Television, 326

Warner Bros. Animation, 326

Warranty, 261, 353, 365, 440 (definition). See also Copyright

Washington Post, 268

Watermarking, 98, 142, 221

Wayfinding, 195

Web. See World Wide Web (WWW)

Web (site) design, 207-21; contract terms for, 212-13; and copyright, 213, 221; glossary for, 225-27; pricing for, 214, 215-19 (chart); project team for, 218-19; proposal for, 211; questions to ask about, 219-21; and usage rights, 87

Web designer, 91, 101; 103, 156, 166, 208-09, 209 (chart), 210-11; and salary, 156-57, 159 (chart), 215-19 (chart)

Web Site Design & Maintenance Order Form, 405-07 (contract)

Web sites, 87, 98; design of, 208-21; and etiquette, 222; home page of, 435 (definition); and resale, 136; and surface design, 335. See also Web designer, Web (site) design

Wendt v. Host International, Inc., 50

Window display design. See display design

Workbook, The, 8, 20

Workers' compensation insurance, 71

Work for hire, 27, 44-47, 58, 71, 72, 94, 179, 440 (definition); abuses, 46-47; and cartoonists, 316; categories of, 45; and computers, 84; contracts, 45-46, 48, 107-08, 121, 352, 365; and copyright terms, 41, 99; and employees, 45-46, 72; by independent contractors, 45-46, 47; international, 58, 59-61; legislation, 45-46, 47, 48;

Workstations, 100-01

World Intellectual Property Organization, 29

World Wide Web (WWW), 13, 20, 84, 98, 137, 141, 166, 226 (definition), 440 (definition); pricing of design and illustration for, 214, 215-18 (charts)

Woven textiles, 336-37, 339 (chart)

Writer, 316, 317 (chart). See also Cartoonist

W-2 forms, 74

X

XML, 208, 226 (definition), 440 (definition)

Membership Application

The Graphic Artists Guild, UAW Local 3030, is a national organization with local chapters. When you join the Guild, you join the National organization and are assigned to a local chapter servicing your area. If there is no local chapter near you, you will be assigned to the At-Large Chapter.

Your membership is effective upon our receipt of this completed, signed application, the application fee, and the appropriate dues amount. Please allow 3-4 weeks to receive your membership material.

For questions about membership please call the Membership Department at 800.500.2672 or e-mail membership@gag.org.

Please complete all portions of this application, sign it, and return it with your application fee and dues payment to: Graphic Artists Guild, UAW Local 3030 AFL-CIO CLC, 90 John Street, Suite 403, New York, NY 10038-3202

If paying by credit card, you may fax the completed application to 212-791-0333.

Please print legibly.

Social Security Number	
Name	
Position/Title	
Organization	

Business Address

(Please provide a shipping address for UPS deliveries)

City	State
Postal Code	Country
Business Phone	
Alternate Phone	
Fax	
E-mail address	
Web address	

Home Address

City	State
Postal Code	Country
Home Phone	

Would you prefer our mailings to be delivered to your:

Employment Status

If you are on staff and do freelance work as well, please mark "1" for staff and "2" for freelance.

□ Staff □ Freelance

(includes business owners, partners, and corporation principals)

Retired Graphic Artist

Student _____ Expected year of graduation (Students must include photocopy of current college ID.)

Discipline

In order of importance, please indicate up to three disciplines (e.g., illustration, graphic design, artist's rep, cartoonist, etc.).

Primary Discipline

Secondary Discipline

Tertiary Discipline

Markets

In order of importance, please indicate up to three markets in which you work (e.g., advertising, book publishing, corporate, packaging, etc.).

Primary Market

Secondary Market

Tertiary Market

How did you learn about the Guild?

Guild meeting (where?)

Direct mail

Internet (what Web site?)

□ Friend/Associate (who?)

Advertisement (where?)

Handbook: Pricing & Ethical Guidelines (which edition?)

Other

Membership Status

There are two categories of membership: Full Member and Associate Member. Only working graphic artists who derive more than 50% of their income from their graphic art are eligible to be full, voting members. All other interested persons in related fields who support the goals and purposes of the Guild are welcome to join as Associate Members, as are graphic arts students and retired artists. Associate Members may participate in all Guild activities and programs and serve on committees but may not vote or hold office.

- □ I earn more than half of my income from my own graphic work.
- □ I wish to join the Guild as a Full Member.
- I wish to join the Guild as an Associate Member.

continued...

Membership Application continued

Dues and Application Fee

Guild dues are based upon your ability to pay and depend upon your membership category and your income for the previous year. "Income" refers to your total adjusted gross income (after business expenses are deducted).

To offset the administrative expense of processing new memberships, the Guild collects a \$25 fee with each membership application. Please note that membership dues and application fees are not refundable. \$12 of your dues is for your subscription to the national *Guild News*.

Full Member Dues Per Year (please check category):

Income under \$12,000/yr	\$120
□ Income \$12,000-\$30,000/yr	\$165
□ Income \$30,000-\$55,000/yr	\$215
Income over \$55,000/yr	\$270
Senior [new]: age 60 (with10 years of membership)	\$120

□ Collective Bargaining Unit Member: 1.15% annual gross income (but no less than the minimum constitutionally mandated full membership dues) for staff artists for whom the Guild negotiates and enforces contracts. Please call for special information.

Associate Member Dues Per Year

Lifetime [new]: age 65 and/or retired with 15 years past membership	\$55
Students* (enclose copy of current ID)	\$55
All Other Associates	\$115

*The Student category is available to full-time students carrying at least 12 credit hours. It is valid for one year beyond graduation. A photocopy of the current student ID is required.

Method of Payment

Check	
Money Order	
🗆 Visa	
MasterCard	
Card No.	
Expiration Date	
Signature	
Duce	\$

Dues	Ψ
(at least one half of the chosen category)	
Initiation fee	\$25.00
Total enclosed	\$
(dues plus application fee)	

_____ Initial here if you wish to enjoy uninterrupted benefits and services by authorizing the Guild to annually renew your membership using the credit card listed above. We will charge the appropriate dues amount each year and send you a receipt itemizing the specific charges. We will also offer you an opportunity to adjust your status.

Any payment of less than one half of your dues will be automatically returned. Returned checks are subject to a \$20 service charge.

Membership Statement (signature required) Please read and sign the following:

For Full Members Only

I derive more income from my own work as a graphic artist than I do as the owner or manager of any business, which profits from the buying and/or selling of graphic artwork. I agree to abide by the Constitution and By-Laws** of the Graphic Artists Guild and do hereby authorize the Guild to act as my representative with regard to negotiation of agreements to improve my wages, fees, hours, and conditions of work. I further assign nonexclusive agency rights to the Graphic Artists Guild and extend to it my power of attorney to represent my contractual interests.

I further understand that my membership in the Graphic Artists Guild is continuous and that I will be billed for membership dues annually on the anniversary of my original application. If I wish to resign from the Graphic Artists Guild, I understand that I must do so in writing, and that I will be responsible for the payment of any dues owed prior to the date of my resignation.

Signature

Date

For Associate Members

I agree to abide by the Constitution and By-Laws** of the Graphic Artists Guild. I understand that my membership in the Graphic Artists Guild is continuous and that I will be billed for membership dues annually on the anniversary of my original application. If I wish to resign from the Graphic Artists Guild, I understand that I must do so in writing and that I will be responsible for the payment of any dues owed prior to the date of my resignation.

Signature

Date

**Your membership package will contain a copy of the Guild's Constitution and By-Laws. To review it prior to joining, a copy may be downloaded from our Web site http://gag.org/about/constitution.html/, or send your request to the National office. The document is also on file at National and Chapter offices for inspection.

Privacy Policy

The Graphic Artists Guild will not give, share, or divulge any information provided to it to any outside entity. All communications you receive will be within the Guild's normal course of business. Any offerings bearing the Guild logo reflect authorized member services and benefits.

		0 TISTS
	For office use of	only :
PEGs	CARD	AZW